# Hogarth

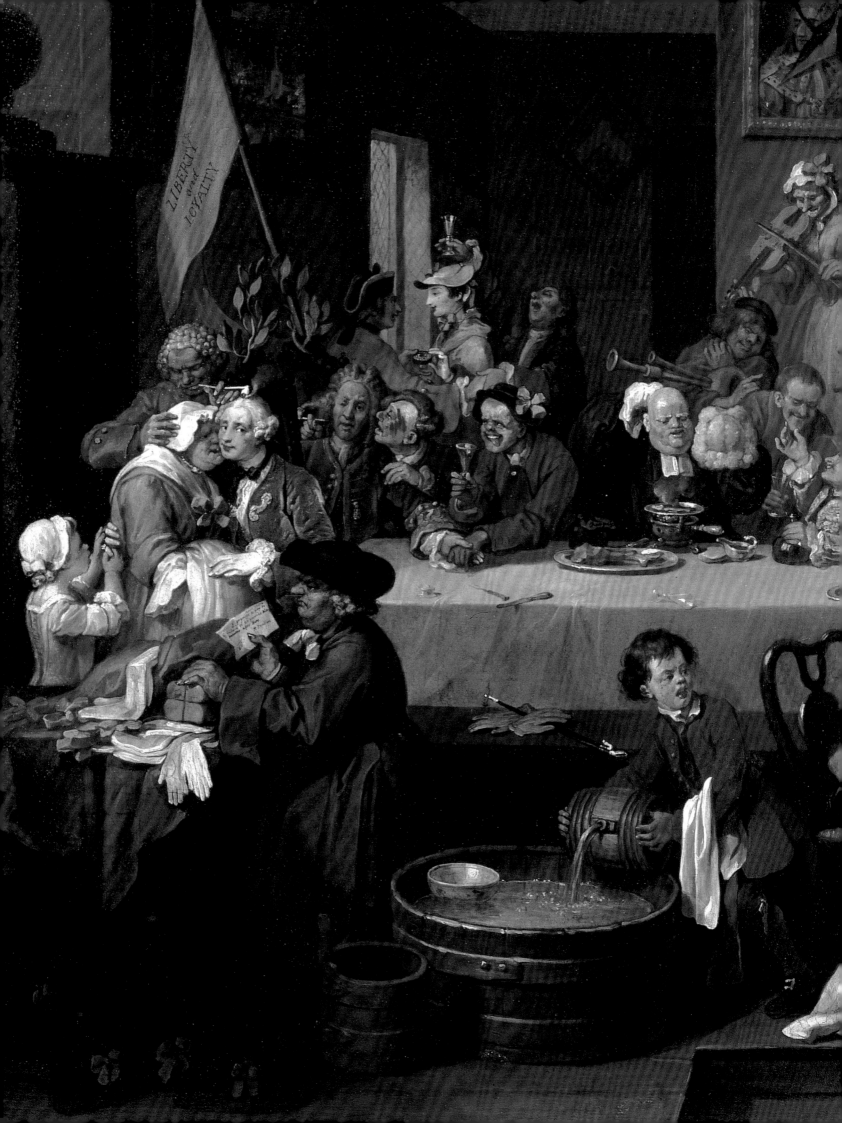

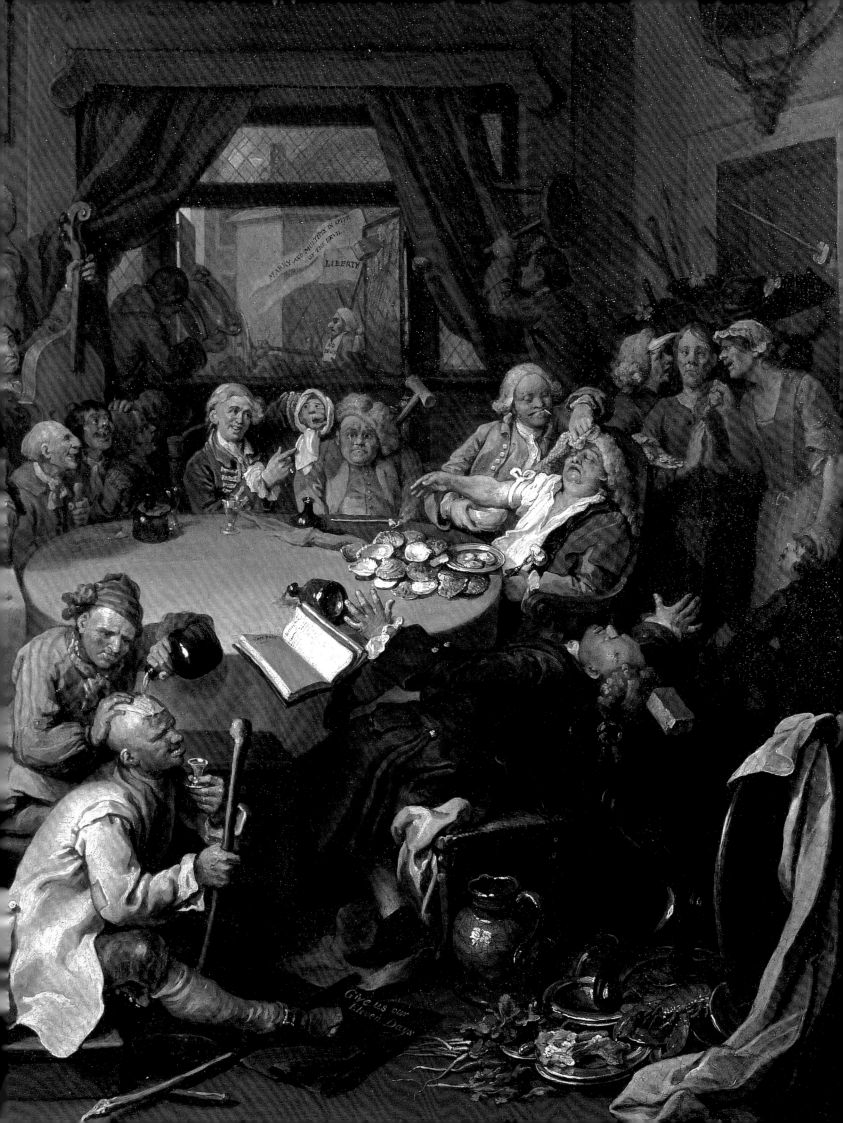

Mark Hallett
Christine Riding

With an essay by
Frédéric Ogée and
Olivier Meslay
and additional catalogue
contributions by
Tim Batchelor

# Hogarth

Tate Publishing

Supported by
TATE MEMBERS

First published 2006 by order of the Tate Trustees
by Tate Publishing, a division of Tate Enterprises Ltd,
Millbank, London SW1P 4RG
www.tate.org.uk/publishing

on the occasion of the exhibition
Hogarth

Musée du Louvre, Paris
18 October 2006–7 January 2007

Tate Britain, London
7 February–29 April 2007

La Caixa, Madrid
29 May–26 August 2007

*British Library Cataloguing in Publication Data*
A catalogue record for this book is available from the
British Library

ISBN-13 978-185437-696-1 (HBK)
ISBN-13 978-185437-662-6 (PBK)
ISBN 10 1-85437-696-9 (HBK)
ISBN 10 1-85437-662-4 (PBK)

Distributed in the United States and Canada by
Harry N. Abrams, Inc., New York

*Library of Congress Cataloging in Publication Data*
Library of Congress Control Number: 2006926368

Designed by Esterson Associates
Printed in Italy by Conti Tipocolor, Florence

Paperback cover: *Marriage A-la-Mode: 2,
The Tête à Tête* 1743–5 (no.77, detail)
Hardback jacket: (front) *Marriage A-la-Mode: 2,
The Tête à Tête* 1743–5 (no.77, detail); (back) *The Painter
and his Pug* 1745 (no.4, detail)
Pages 2–3: *An Election Entertainment* 1754
(no.120, detail)
Page 4: *The Painter and his Pug* 1745 (no.4, detail)
Pages 30–1: *Southwark Fair* (or *The Humours of a Fair*)
January 1733 (no.65, detail)

Measurements of artworks are given in centimetres,
height before width. Catalogue entries by Tim
Batchelor are identified by the initials 'TB'.

# Contents

Sponsor's Foreword 8

Foreword 9

Acknowledgements 10

Hogarth's Variety 13
*Mark Hallett*

William Hogarth and Modernity 23
*Frédéric Ogée and Olivier Meslay*

1 Introducing Hogarth: Past and Present 33
*Christine Riding*

2 Pictorial Theatre: The 1720s 55
*Mark Hallett*

3 The Harlot and the Rake 73
*Christine Riding*

4 Pictures of Urbanity: The Conversation Piece 95
*Mark Hallett*

5 Street Life 119
*Christine Riding*

6 Marriage A-La-Mode 141
*Christine Riding*

7 The English Face: Hogarth's Portraiture 159
*Mark Hallett*

8 Crime and Punishment 181
*Christine Riding*

9 High Art 197
*Mark Hallett*

10 Patriotism, Portraiture and Politics 215
*Mark Hallett*

Notes 242

Bibliography 246

Chronology 248

List of Exhibited Works 254

Lenders and Credits 260

Index 261

# Sponsor's Foreword

Tate Members are delighted to support *Hogarth* – the most comprehensive exhibition of Hogarth's work in recent times; it examines his entire career and unique contribution to the development of British art. Famed for his moral and satirical images and as a portraitist and urban commentator, Hogarth created a visual documentary of eighteenth-century life.

The charity Tate Members was founded in 1958 specifically to support the work of Tate; it has proved one of the most successful schemes of its kind. Last financial year Members gave nearly £3 million in direct funding to Tate. This included £250,000 to the Collections campaign, the second instalment of an overall commitment of £1 million to develop the Collection of British and International Modern Art.

Tate Members are central to the success of all four galleries. They help build and care for the Collection and extend exhibition, educational and outreach programmes. Members also play an important role in helping Tate fulfil its duty to increase public knowledge, understanding and enjoyment of art. We hope that many of you who view the exhibition and read this catalogue will join us in supporting Tate's vision.

*Francine Stock*
*Chair, Tate Members*

# Foreword

William Hogarth (1697–1764) has long been recognised as an artist of very great importance. The nature and constitution of his reputation have, however, shifted significantly over time. His contemporaries found him always 'ingenious', variously zealous, flamboyant and self-righteous – a consummate operator if occasionally naive. Though admired as a (self-appointed) commentator on the morals of his age, and as a tireless promoter of other artists' interests as well as his own, his art was rarely considered to lie amidst the realms of greatness occupied by the Old Masters, whose uncritical devotees he so readily mocked. And after his death, despite the fame he had by then undoubtedly acquired, the proliferation of public exhibitions wrought changes in the very nature of the public consumption of art, bringing new artists, new concerns, and new issues rapidly to the fore. Hogarth became for some associated only with a past, pre-modern age, the elevating society portraiture of Reynolds and Gainsborough now taking centre-stage well before the end of the century, succeeded by the romanticism of Turner, Blake and Constable in the early nineteenth – each in different ways becoming central reference points for many generations of artists to follow. Hogarth's incomparably varied contribution, meanwhile, was relegated to the relatively peripheral spheres of satirical printmaking and social commentary. He was to have his later admirers, of course – Whistler among them – and no published history of art in Britain could ever realistically ignore him, but, regardless of his conspicuous skills as a painter and draftsman, the diversity and distinctiveness of both his output and personality seemed to mitigate against, rather than facilitate, his acceptance near the pinnacle of British artistic achievement.

Even as recently as 1971, the year of the last major Hogarth exhibition at Tate, it was noted (by the then Tate Director Norman Reid) that he 'has always been a rather awkward figure to cope with in the context of British art as a whole. In fact for some years now at the Tate Gallery he has been carefully isolated in a room of his own ... his appeal to an audience far wider than the normal art-loving public has perhaps made him slightly suspect to the connoisseur and aesthete.' In the generation since then, however, he has become considerably less 'suspect', partly as a result of that revelatory exhibition, which was to be followed by a number of important and influential publications, notably Ronald Paulson's outstandingly original *Hogarth: His Life, Art and Times*, published in the same year. Moreover, he seems today to have become quite naturally re-integrated within narratives of British art, not least because of the recent revolution in art history which has led us to think it normal, rather than eccentric, to consider works of art in intimate relationship to the complexities of the particular social world in which they were originally created.

The present exhibition has been conceived within that framework of modern art history, and its approach to and interpretation of the artist have undoubtedly profited substantially from advances in scholarship in British art over the past twenty years in particular. The show has been curated by Professor Mark Hallett of the University of York and Christine Riding, Curator of Eighteenth- and Nineteenth-Century British Art at Tate Britain. I greatly admire the intelligence of their selection and the fresh incisiveness of their analysis, embedding Hogarth deeply within the various contexts in which he operated – professional, political, urban – and at the same time bringing home his sheer dexterity as a maker of uniquely memorable pictures. I would like to thank them both for meeting the challenge of this exhibition with such fluency and skill, and also for working so readily with our curatorial partners at the Musée du Louvre, Olivier Meslay and Frédéric Ogée, in the adaptation of the show for a French audience. Bringing the famously xenophobic Hogarth to Paris (in rather happier circumstances than his own visit to Calais in 1748) has been a delightful

challenge, and I would like to thank Henri Loyrette and Vincent Pomarède for helping us to meet it in style. Likewise Imma Casas and Joan Cejudo in Madrid, where the exhibition travels after London, have been excellent collaborators. Hogarth's presentation to the publics in France and Spain is long overdue, and I hope it will be judged a worthwhile and ultimately influential undertaking.

Mark Hallett's and Christine Riding's acknowledgements detail the debts we owe to many collaborators and lenders of works of art to the exhibition. I would like to reiterate our thanks especially to the lenders, ever conscious that projects of this kind happen only through their sustained generosity and public-spiritedness. So widespread has their kindness been, in fact, that it is perhaps unfair of me to mention one or two in particular, but I must pay tribute above all to Andrew Edmunds, who has lent most of the large number of prints included in the exhibition, enabling us to reduce the burden on other public collections, and to the Foundling Museum, who in lending us all their major Hogarths effectively agreed to put the interests of this show and its public above those of their own institution for the duration of the project. Finally, I am very pleased that the Tate Members have chosen to provide financial support to the exhibition. They have a wide choice of Tate projects every year and it is truly heartening that Hogarth has won their vote. My thanks are due to their Chair, Francine Stock, and to the individual Members themselves who provide such a vital body of encouragement and support to Tate's programmes as a whole.

*Stephen Deuchar, Director, Tate Britain*

# Acknowledgements

Any major project on William Hogarth owes an immense debt to Ronald Paulson, whose meticulous published research is essential reading and was much consulted during the preparation of this exhibition. While developing our ideas, we had discussions with many people who were most generous in giving their time and expertise. In particular we would like to thank Brian Allen, Tabitha Barber, David Bindman, Judy Egerton, Elizabeth Einberg, Douglas Fordham, Martin Myrone, Sheila O'Connell, Aileen Ribeiro, Jacqueline Riding, Michael Rosenthal, Hallie Rubenhold and David Solkin. Two individuals at Tate Britain have made important contributions to the shaping of the exhibition as a whole: Tim Batchelor, who has curated the contemporary art included in the project and written for the catalogue; and Mackenzie Moon, whose research during her internship at the gallery has informed a number of sections. Our colleagues in Paris, Olivier Meslay and Frédéric Ogée, have contributed an important and illuminating essay to the catalogue. It has been a great pleasure working with them and other members of staff at the Louvre and the Réunion des musées nationaux, in introducing Hogarth to a Paris audience. We would also like to thank our colleagues at the Fundación 'la Caixa', in particular Casilda Mora and Isabel Salgado Gispert, who have taken on the challenge of staging the first Hogarth retrospective in Spain with enthusiasm and professionalism.

The response from lenders has been impressive and we are most grateful to all the institutions and individuals who have given their support. We owe a deep debt of gratitude to Andrew Edmunds, who has lent the vast majority of the prints included in the exhibition in London and Madrid, and who has been both patient and good-humoured in response to the project's administrative and photographic demands, as well as providing us with specific information on his works. Special thanks should also go to Adrian Le Harivel, National Gallery of Ireland; Rhian Harris, Foundling Museum; John Fisher, Guildhall Library, City of London; Margaret Richardson and Tim

Knox, Sir John Soane's Museum; Barbara O'Connell, British Library; Susan Foister, National Gallery, London; Alastair Laing, National Trust; The Hon. Lady Roberts, The Royal Library; Julian Treuherz, National Galleries of Liverpool; Mark Bills and Anna Wright, The Museum of London, and Scott Wilcox, Yale Center for British Art, New Haven. In addition, we are most grateful to the following individuals: Chezzy Brownen, Emily Butler, Tim Clarke, Susan Cleaver, Joanne Davenport, Helen Dorey, Tim Egan, Caroline Ellis, Martin Ellis, Laura Fleischmann, Anna Forrest, Katarina Grant, Antony Griffiths, Tim Goodhue, Claire Hallinan, Andrew Harper, Diane Hart, Jeffrey Haworth, Sally Hibbard, Laura Houliston, Hannah Hunt, Alec Kennedy, Rachel Kennedy, Ben Lawrence, James Marshall, Frank McGarry, David Graves, David McNeff, Andrew Moore, Jane Munro, Varshali Patel, Lisa Patterson, Matt Peacock, Lucy Peltz, Angela Roche, Francis Russell, Kirsten Samson, Shannon Schuler, Jon Seydl, Desmond Shawe-Taylor, Eileen Sheikh, Rowena Shepherd, Jacob Simon, Kim Smit, Thyrza Smith, Kathleen Stuart, Felicia Tan and Geoff Quilley.

At Tate Britain the project has been guided from the start by Stephen Deuchar and Judith Nesbitt. A number of our colleagues deserve special recognition. Our thanks again to Tim Batchelor, who has tackled the logistics of this complex project with consummate professionalism and humour. Sionaigh Durrant, as exhibition registrar, has brought her extensive knowledge and practical knowledge to bear. Sarah O'Reilly has managed the tour and contractual elements of the project with great diligence and patience. Rica Jones, painting conservator and an acknowledged authority on Hogarth, has made numerous visits to see works and given advice throughout. In Tate Publishing Nicola Bion has approached the challenges presented by a French and English edition of the catalogue with patience and care, and Lillian Davies and Emma Woodiwiss have been equally professional in carrying out the picture research and production. Our thanks also go to Simon Esterson and Jay Prynne of Esterson Associates, who created a fresh and dynamic design for the exhibition catalogue. We would also like to acknowledge the following members of Tate staff for their help and advice: Phillipa Allsopp, David Blayney Brown, Gair Boase, Melanie Greenwood, Richard Humphreys, Hayley James, Anne Lyles, Martin Postle, Siobhan McCracken, Lizzie Carey-Thomas and Ben Tufnell.

In 2004, Christine Riding was awarded a Visiting Fellowship at the Yale Center for British Art, New Haven to research William Hogarth and his contemporaries. She would like to thank Amy Meyers and her colleagues at the British Art Center, for their advice, support and above all their tremendous hospitality during her time in New Haven, which was greatly appreciated.

Mark Hallett would like to register his appreciation of the collegial support offered at the University of York by John Barrell, David Peters Corbett, Jason Edwards, Anthony Gerarghty, Harriet Guest, Helen Hills, Mark Jenner, Amanda Lillie, Richard Marks, Jane Moody, Lawrence Rainey, Jane Rendall, Miles Taylor and Michael White. He would also like to thank John Brewer, Sarah Burnage, Matthew Craske, Rosie Dias, Judy Egerton, Bernadette Fort, Geoff Quilley, Richard Johns, Sarah Monks, Lucy Peltz, Helen Pierce, Marcia Pointon, Kate Retford, Adrian Randolph, Angela Rosenthal, Ruth Stewart, Katie Scott and Stella Tillyard, whose work and conversations have helped shape his understanding of Hogarth and the visual culture to which he belonged. He is particularly grateful to Bart, Jacqueline and Maia Hallett, who – as always – have proved perfect hosts on his innumerable research trips to London. Most of all, he would like to thank Lynda and Katherine Murphy for being so supportive, patient and good-humoured throughout this project.
*Mark Hallett and Christine Riding*

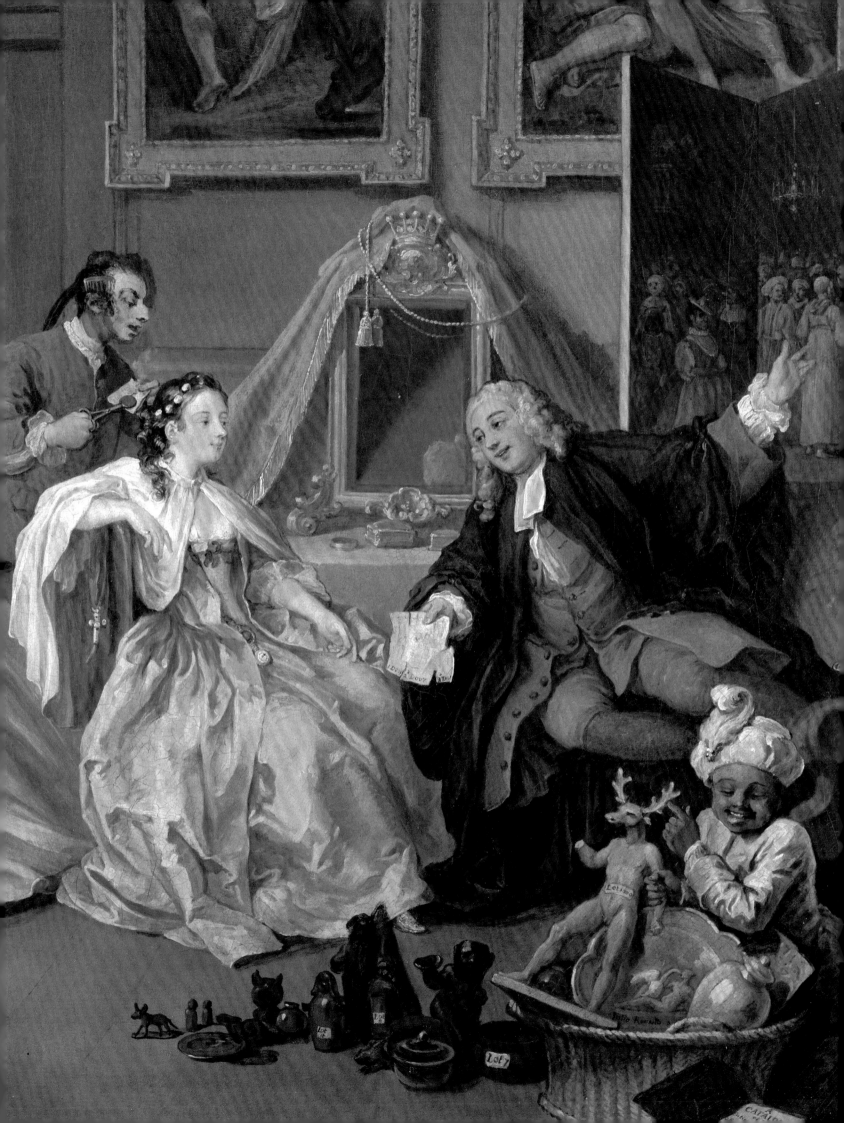

# Hogarth's Variety

*Mark Hallett*

In the spring of 1753 William Hogarth published *The Analysis of Beauty*, an aesthetic treatise in which he offered his own, highly original interpretation of beauty's formal characteristics. The title page of the *Analysis* is decorated with a small wood engraving, which offers a visual synopsis of his theories (fig.1). This pictorial vignette depicts a snake trapped in a pyramid of glass standing on a plinth inscribed with the single word, 'VARIETY'. While the curve of the snake's body embodies the twisting, serpentine line that the artist saw as central to all forms of beauty, and the pyramid of glass refers to a classical ideal of perfect proportion, the inclusion of the word 'variety' signals the crucial role granted to this concept by the artist. Indeed, a chapter of the *Analysis* is entitled 'On Variety', and in it Hogarth argues that 'composed variety' is a vital component of beauty and points to the way in which nature itself is full of shapes and colours geared to 'entertaining the eye with the pleasure of variety'.[1]

As he was fully aware, the term 'variety' was also highly applicable to the remarkably diverse body of paintings and engravings that he himself had produced over the previous thirty years or so, and that he was to continue to generate until his death in 1764. Indeed, the word was one that eighteenth-century writers regularly used to describe the artist's work. Early in Hogarth's career, in the 1730s, the poet John Bancks was already lauding the 'varied grace' of the artist's imagery, and George Vertue, a successful engraver who was also an assiduous commentator on the London art scene, was noting the 'great variety' of Hogarth's pictures.[2] In the years following the artist's death, the same terms of praise were still being used to describe his output: in 1768, for example, William Gilpin celebrated the

*Marriage A-la-Mode: 4, The Toilette 1743–5* (no.77, detail)

FIGURE 1
*The Analysis of Beauty* 1753
(title page)
ANDREW EDMUNDS,
LONDON

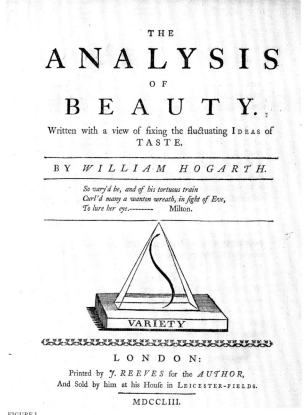

THE

# ANALYSIS

OF

# BEAUTY.

Written with a view of fixing the fluctuating IDEAS of TASTE.

BY *WILLIAM HOGARTH.*

*So vary'd he, and of his tortuous train*
*Curl'd many a wanton wreath, in sight of Eve,*
*To lure her eye.-------- Milton.*

VARIETY

LONDON:

Printed by *J. REEVES* for the *AUTHOR,*
And Sold by him at his House in LEICESTER-FIELDS.

MDCCLIII.

FIGURE 1

FIGURE 2
*The Analysis of Beauty* 1753
Plate 1 '*The Sculptor's Yard*'
ANDREW EDMUNDS,
LONDON

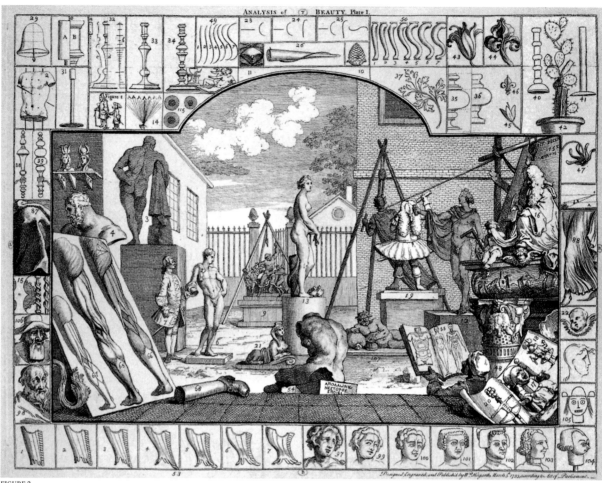

FIGURE 2

'endless variety that is displayed through Hogarth's works'.[3]

The images with which the artist illustrated the *Analysis of Beauty* – described by one writer as making up a 'variety of entertaining engravings' – suggest why the artist was understood in this way.[4] As well as designing the pictorial vignette on the treatise's title page, Hogarth produced two prints to accompany the *Analysis*, which he advertised as 'serious and comical' works of art in their own right, 'fit to frame for furniture'[5] (fig.2, no.6). They picture, respectively, a sculptor's jumbled yard and an assembly of eager dancers, and share a diagrammatic pictorial border that in both cases is dense with heterogeneous images. In the first of Hogarth's two plates a collection of classical statues, a wooden leg, a foppish gentleman and a miscellany of anatomical illustrations and caricatures are juxtaposed with a series of corsets, a succession of flowers, a cluster of candlesticks, a children's drawing and even a cactus! In the other the graceful and awkward bodies of numerous dancers flit past a medley of portraits, while the pictorial border displays a crowd of faces, a series of shells and a trio of rippling torsos. These two engravings, as well as illustrating the key concepts of Hogarth's text, clearly revel in the visual pleasures and artistic possibilities of pictorial variety.

A glance at the kinds of work the artist was creating in the years immediately before the publication of the *Analysis* dramatically confirms the extent to which Hogarth's 'variety' encompassed not only the visual character of his images but also the kinds of art he produced. In February 1751, for instance, Hogarth published his famous print *Gin Lane* (no.98), a horrific social satire in which anonymous, poverty-stricken alcoholics, their features depicted in the boldest of engraved lines, sprawl, fight and die among the ruins of a collapsing city. At the print's centre a monumental, stupefied and disease-ridden drunk pinches snuff as her wizened child spills into the bowels of a subterranean gin-cellar. Yet only a year later, in February 1752, Hogarth published an engraving after his picture of *Moses Brought to Pharaoh's Daughter* (no.107), which flaunted his achievements in the very different, far more elevated genre of history painting. In this image he focuses on a pair of idealised biblical figures – the cherubic, anxious figure of Moses and the beautiful, luxuriously clothed daughter of a pharaoh – who are placed in an exotic Egyptian palace and drawn into a tender narrative of benevolence that is in utter contrast to the drama of maternal neglect found at the centre of *Gin Lane*.

The artist who so successfully moved between different genres in this way, and who was seen to generate a stream of images of an unparalleled visual variety as he did so, had long been recognised by his peers as the most important English painter and engraver of his time. Hogarth's reputation as an exceptionally original and inventive artist who was profoundly responsive to the social and cultural developments of his era has continued to grow.

Today, he tends to be appreciated in particular as a great satirist, someone who offered an acidic and sometimes comic vision of a society mired in corruption and hypocrisy, and who told remarkable pictorial stories about the flawed and ill-fated individuals – prostitutes, rakes, alcoholics, yokels, thieves and murderers – who lived and died outside the boundaries of respectable society.

What is less often recognised is that Hogarth's brilliance as a satirist was only one part of his achievements. He was also – as we have already begun to see – an unusually innovative and ambitious figure in a number of other artistic fields, including those of portraiture, history painting and art theory. Not only this, Hogarth was hugely important in helping to promote contemporary British painting and engraving as art forms that could successfully stand comparison with the greatest works being produced on the continent. To begin understanding this rich artistic legacy, we need to get a better sense of Hogarth's life and career, of the diverse visual culture to which he belonged, and of the heterogeneous city in which he lived.

William Hogarth was born on 10 November 1697 in a small house in Bartholomew Close, just off Smithfield meat market in the City of London. He was thus very much a Londoner, part of a metropolis that was continually growing throughout his lifetime and that – by the time of his death in 1764 – was the largest city in Europe, with a population of nearly three-quarters of a million.[6] Over this same period the English capital developed a strikingly bifurcated identity. The City of London in the east maintained its strongly mercantile and financial character, while also becoming increasingly associated with the poverty and crime that characterised a number of its grimmer districts. On the other side of the capital London's 'West End' – part of the old City of Westminster – came to enjoy a fashionable and genteel status as a residential quarter for an increasingly urbanised aristocratic elite. This was the era of the West End square, where the 'Quality' lived during the winter season. The centre of London, meanwhile, became busy with the enterprises that serviced the cultural needs of the West End elite and also catered to the capital's increasingly influential and self-consciously 'polished' community of professionals and affluent tradesmen. Areas such as Covent Garden, St Martin's Lane, Charing Cross and the Strand were full of printshops, clothes shops, jewellers, theatres, bookshops, artist's showrooms, auction houses, coffee shops and music rooms. Even in these commercially dynamic sectors of the city, however, there were pockets of great deprivation and squalor, including the slums of St Giles pictured in *Gin Lane*. Eighteenth-century London, as Samuel Johnson observed, was a place of 'wonderful extent and variety', and its unique mixture of environments and activities generated an exceptionally vibrant urban culture – one that Hogarth was to depict and draw upon continually in his art.[7]

Hogarth grew up in the East End, and his childhood was unstable and often troubled. His father Richard

Hogarth had moved to the capital in the 1680s and married the artist's mother Anne in 1690. Richard was a scholarly man of modest social status who sought to make his way as a schoolmaster, a linguist and an author. In a rather improbable venture he also opened a coffee house in which customers were encouraged to speak Latin. Catastrophically, but perhaps unsurprisingly, Richard was arrested for debt in the winter of 1707/8, and he and his family, which by this time included his daughters Anne and Mary as well as his ten-year-old son William, were suddenly forced to live in debtor's lodgings near the infamous Fleet Prison. They were to remain there for four miserable years, before being set free in 1712 following the passage of a parliamentary Insolvent Debtors Bill that provided relief for such families. Richard, who continued to dream of success as a man of letters, was never to enjoy the fruits of his scholarship. He died in 1718, leaving behind a son who, now a young adult, remained forever embittered about the manner in which his father had been betrayed by the aristocrats who had falsely promised him patronage, and by the tradesmen who had continually exploited his intellectual gifts. His father's harrowing example haunted Hogarth throughout his life and undoubtedly fuelled the astonishing determination with which he pursued his artistic enterprises.

As a child, Hogarth demonstrated considerable artistic precocity, and by the time of his father's death, he had already spent four years as an apprentice to the Westminster-based silver-plate engraver, Ellis Gamble. There he learnt the rudiments of accurately inscribing metal with the sharp engraver's instrument known as a burin. In 1720, however, he broke off his apprenticeship with Gamble and set up shop as an independent copperplate engraver. Over the next decade, during which he settled down in the centre of the city, the young artist produced a wide range of graphic works that included book illustrations, trade cards and theatrical benefit tickets. Most importantly of all, he designed a succession of increasingly ambitious pictorial satires that targeted the excesses and fashions of urban life. In doing so, he drew on a rich graphic tradition, for throughout the previous hundred years artists and print-publishers had regularly published satirical prints commentating on social, political and cultural affairs.[8] This tradition was newly invigorated in the early decades of the eighteenth century, when pictorial satire came to be appreciated as one of the most ambitious, experimental and complex forms of contemporary printmaking.[9] Hogarth played a central role in this development, and in the 1720s began crafting a distinctively satiric image of the modern city as a delusional and fragmented environment overrun by swarming crowds of individuals in thrall to a multiplicity of perverse desires and attractions.

Even as he gained recognition for his abilities as a graphic satirist, Hogarth was already turning to the parallel sphere of painting. In 1720 he enrolled in the newly founded Academy of Painting in St Martin's Lane, run by the French history painter Louis Cheron

and the English artist John Vanderbank.[10] There he was given the opportunity to develop his skills in a medium that had traditionally enjoyed a higher aesthetic and cultural status than graphic art and was being practised by a diverse group of practitioners. It has been too rarely noted that London's art world in the first decades of the eighteenth century was strikingly cosmopolitan. In the absence of an established school of British painting or any binding forms of guild protection, the community of painters living and working in London was strongly European in character. Painters born in France, Italy, Germany and the Low Countries enjoyed an unusual prominence and provided a highly stimulating example for native artists like Hogarth both to emulate and to compete against.[11] Typically based in the area around Covent Garden (no.58), the immigrant painters and engravers brought with them the habits, skills and preoccupations that marked the continental art worlds from which they had emerged. Hogarth, who by the middle of the 1720s was living close to Covent Garden, could not fail but be inspired by their works and by the opportunity that the St Martin's Lane Academy, and the artist-frequented taverns and coffee shops of the district, provided to discuss and debate the role of painting in modern Britain.

Evidently eager to develop his skills, Hogarth also seems to have become involved in another artist's academy in the 1720s, that run from his Covent Garden house by James Thornhill, whose distinguished career as a history painter provided a celebrated if unusual instance of a British artist who had successfully competed with his foreign-born rivals.[12] Hogarth's attendance at Thornhill's Academy brought other benefits, for there the young artist met Thornhill's daughter Jane, whom he married in 1729 after an elopement. Their relationship seems to have developed into a stable and mutually supportive one, with Jane becoming, alongside Hogarth's unmarried sisters Anne and Mary, part of an intimate, familial circle of women with whom he felt at ease and to whom, throughout his life, he felt responsible. Significantly, his marriage to Jane proved childless, which seems to have given added impetus to Hogarth's later, highly energetic and clearly heartfelt involvement in Thomas Coram's Foundling Hospital for abandoned children.

By the time he married Jane, Hogarth was confident enough as a painter to have begun producing small satirical canvases. His breakthrough in the medium came, however, with a series of pictures he painted between 1728 and 1731 depicting a scene from the great theatrical success of the period, John Gay's *The Beggar's Opera* (nos.38–9). Gay's mock opera offered a satirical, humorous and sometimes sympathetic representation of the underside of urban life and featured highwaymen, prostitutes, corrupt lawyers and brutal gaolers among its colourful cast of low-life characters. Hogarth's responses to this work see him developing his abilities as a painter and producing canvases that are marked by an increasingly confident and intricate orchestration of figures across pictorial space. Their success – one was bought by John Rich, the impresario

who had first staged *The Beggar's Opera* – emboldened the artist to produce the first of what he later described as his 'modern moral subjects': *A Harlot's Progress* (no.43).[13]

This series of six paintings and prints was displayed to the public in the Covent Garden house of Hogarth's father-in-law James Thornhill in the spring of 1732. It offered a remarkably novel, multi-layered and compelling depiction of a fictional prostitute's doomed journey through the streets, apartments, prisons and garrets of London. Hogarth's pictorial series was a critical and commercial sensation, and was lauded as a work that combined a satiric form of moral commentary with the richest kinds of visual pleasure. In the words of an address to the artist by the contemporary poet John Bancks, 'Thy *Harlot* pleas'd and warn'd us too – | What will not gay instruction do?'[14] As well as bringing him instant artistic celebrity, *A Harlot's Progress* brought Hogarth new-found wealth. Thanks to the profits he made from the sale of the engravings of the series, Hogarth and his wife were able to move from the bohemian but increasingly disreputable area of Covent Garden to a house in the more fashionable West End square of Leicester Fields. Hogarth was soon to produce two more celebrated pictorial series from this location: *A Rake's Progress* (no.44) and *The Four Times of Day* (no.67). These two works, while maintaining the *Harlot's* focus on the more dubious and hypocritical figures of urban society, also demonstrate the development of his vision of London as a space of contrast, flux and overflow. Furthermore, they confirmed his increasing mastery of the series as a pictorial format: in both cases meaning and narrative are generated not only by a highly innovative manipulation of figures, architecture and space within individual paintings and engravings, but also by the subtle pictorial relationships that he sets up between the different images that make up each series.

At the same time as he was enjoying great success as a creator of a new, satirical imagery of metropolitan life, Hogarth was also producing another highly innovative kind of modern painting. Throughout the 1730s the artist executed a series of the modestly scaled group portraits that contemporaries called 'conversation pieces'. These typically showed gatherings of men and women enjoying the kinds of convivial activity – drinking tea, playing cards, admiring works of art and pursuing the pleasures of conversation – that were being promoted as central to the increasingly fashionable practice of polite sociability. In these paintings Hogarth subtly explores and illuminates the relationships between the men, women and children of a new social elite made up not only of the aristocracy but also of families whose wealth came from the worlds of finance and commerce. These pictures are organised around an exquisitely choreographed succession of looks and gestures, in which the turn of a head, the pointing of a finger, the overlap of one body against another, even the resting of a hand on a chair-back, become pregnant with meaning and possibility. Hogarth's conversation pieces provided an important

counterpoint to the artist's riotous, low-life satires, offering as they did an ideal of restrained, elegant and inclusive social interaction, played out in the most decorous of settings. This was a pictorial ideal with which Hogarth's elite patrons could comfortably identify, and which his supporters could point to as evidence of the artist's ability to produce the most refined as well as the most raucous of images.

In yet another confirmation of the variety and ambition of Hogarth's output this same period also saw him turning to history painting, a pictorial genre that demanded a learned pictorial response to the great texts of literature, history, religion and mythology. The British cultural elite, who tended to associate history painting with the works of continental Old Masters, had hitherto regarded success in the genre as beyond the talents of any living English artist; the recognition enjoyed by Hogarth's father-in-law James Thornhill in the early decades of the century was the exception that proved the rule. Seeking to confound such prejudices, the artist produced a pair of remarkable paintings of scenes from Milton and Shakespeare in the early 1730s (nos.103, 104). Then, in 1736 and 1737 he installed two enormous historical canvases in the newly extended St Bartholomew's Hospital in London, both of which depicted biblical episodes of a suitably charitable and medical nature. *The Pool of Bethesda* (see fig.38) and *The Good Samaritan* (fig.3) are monumental pictures that continue to hang in the grand stairwell for which they were painted. These works, while alluding to earlier treatments of both subjects by continental Old Masters, offer a radical mode of history painting in which the idealised figures and storylines associated with the genre are brought into disturbingly intimate contact with those of a lower, often quite grotesque character.

Throughout his later career Hogarth was to pursue and develop this adventurous and often controversial agenda for history painting.

Alongside his professional activities as a painter and engraver during the 1730s, Hogarth became heavily involved in the teaching of art. Following Thornhill's death in 1734, Hogarth inherited the equipment of his father-in-law's old academy and set up a new Academy of Painting at St Martin's Lane in London. Over the next twenty years this was to provide an important artistic centre in the capital. At Hogarth's Academy established and aspiring artists regularly gathered together to draw from the living model and to learn from the example of a series of distinguished teachers, both native and foreign. Hogarth ran the Academy on unusually egalitarian and informal lines: there was no rigid distinction made between governors and pupils, and there were few prescriptions regarding the ways in which the model might be posed or drawn – indeed, subscribers were allowed, in turn, to 'place the man or woman in such attitude, in the middle of the room, as suits their fancy'.[15] Copying from other artworks was frowned on; instead, stress was placed on observation and on the subtly varied 'prospects' of the model enjoyed by the students as they sat in their different seats around the drawing room. Here, then, Hogarth's ideal of 'composed variety' was inculcated at the level of pedagogy as well as in theory and practice.

Having become established as the leading satirist, history painter and painter of conversation pieces in the capital, Hogarth, at the beginning of the 1740s, made a sustained attempt to become similarly successful within the highly competitive sphere of portraiture. In this decade, following the completion of his spectacular portrait of Thomas Coram (no.84), a mercantile

FIGURE 3
*The Good Samaritan* 1737
ST BARTHOLOMEW'S
HOSPITAL, LONDON

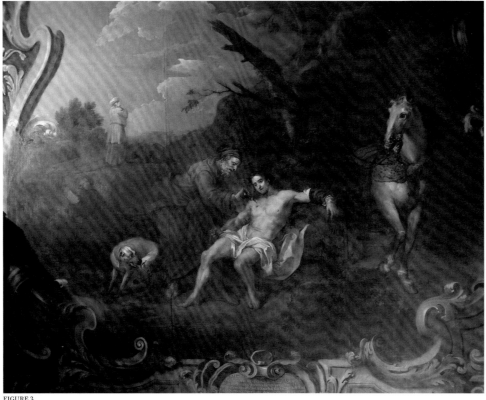

FIGURE 3

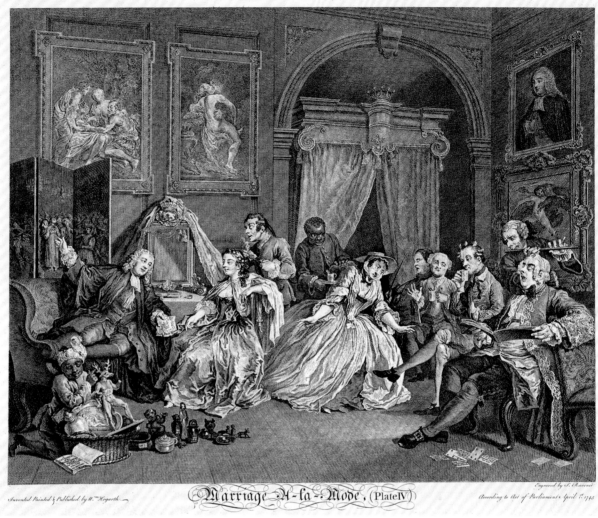

FIGURE 4

philanthropist who had recently set up a celebrated hospital for foundling children, Hogarth produced a succession of ambitious portraits. In these works the artist typically manipulates the lineaments of the face, the gestures of the body, the surfaces of costume, and the tones and textures of paint in order to communicate the values and aspirations of an increasingly confident and self-consciously patriotic community of non-aristocratic men and women. In so doing, Hogarth continually challenged the practices and expectations of his peers and – in the case of masterpieces such as *The Graham Children* (no.93) and *Archbishop Thomas Herring* (no.92) – infused British portraiture with a new degree of emotional depth and pictorial subtlety.

As well as concentrating on portraiture, during the 1740s Hogarth returned to and reformulated the satirical pictorial series. Between 1743 and 1745 he worked on *Marriage A-la-Mode* (no.77), a searing pictorial critique of foreign art and fashion, aristocratic affectation, bourgeois aspiration and arranged marriage. *Marriage A-la-Mode* was also characterised by a new level of pictorial complexity and stylistic elegance. Painted in an exquisitely polished manner, and engraved not by the artist himself but by men whom he described as 'the best Masters in Paris', the series is organised around dizzying forms of pictorial juxtaposition.[16] In an image such as *The Toilette* (fig.4),

for instance, a mass of different representations – the symbolic still lifes that litter the floor, the frieze of figures that spans the picture surface, the painted screen, the draped mirror, the parted curtains of the bed, and the quartet of paintings that hang on the walls – are laid one upon the other. Such works invite an almost archaeological form of visual excavation, in which we can dig deeper and deeper into the dense palimpsest of the pictorial surface. The six paintings of *Marriage A-la-Mode* also contribute to another profound meditation on the English capital, for if we stand back and look at the series as a whole, we find that it offers us a sweeping panorama of contemporary London, which begins in the lavishly appointed West End house of an aristocratic earl and ends in the meanly furnished East End room of a miserly merchant, complete with a view of old London Bridge through its window.

While the prints of *Marriage A-la-Mode* sold well, the enormous amount of money and time that Hogarth had expended on the project encouraged him to change direction yet again. In 1747 he produced another remarkable pictorial series, *Industry and Idleness* (no.97), which offered a sharp contrast to his earlier sets of satirical works, in terms of procedure and scale. Rather than producing a sequence of paintings and then publishing engravings after these canvases, Hogarth engraved his prints directly from preliminary drawn

sketches. This speedy method also encouraged him to extend his pictorial narrative: the series, at twelve images, is by far the longest of his 'modern moral subjects'. Just as important were innovations at the level of subject matter and style. In this series, which pictures the divergent paths of two young apprentices, Francis Goodchild and Tom Idle, Hogarth focuses on the East End, and on the polarised cultures of commerce and criminality associated with his birthplace. Interestingly, however, Hogarth's ostensible praise of Goodchild's ambition and work ethic, and his seeming critique of Idle's delinquency, are continually revealed as ambivalent and unsure – the certainties of bourgeois propaganda are mixed with a satiric suspicion of civic authority and mercantile self-aggrandisement. *Industry and Idleness* also inaugurates a new, strikingly bold and self-consciously 'graphic' visual rhetoric on the artist's part, one that is far removed from the exquisite assemblages of *Marriage A-la-Mode* and that renounces any kind of painterly effect. Finally, the compositional organisation of his twelve prints plays an unusually expressive role in communicating the distinctions between his two protagonists – thus, while the images depicting Goodchild's progress are marked by a near-geometrical patterning of 'upright' verticals and sharp right-angles cutting the picture space into neatly ordered sections, those representing Idle's decline are characterised by disordered, sprawling compositions dominated by irregular horizontals and crowded, messy forms of pictorial overlap.

The combination of propaganda and satire found in *Industry and Idleness* also typifies a set of six similarly strident engravings that Hogarth released in 1751, which consisted of *Gin Lane* and *Beer Street*, and *The Four Stages of Cruelty* (nos.98–9). These images, even as they focus on the twin vices of alcoholism and violence, also develop *Industry and Idleness*'s vision of a city split into two shockingly contrasted halves: while the workers and petty tradesmen who cluster around the public house in *Beer Street* belong to a capital undergoing reconstruction and enjoying plenty, the denizens of *Gin Lane* and the brutal anti-hero of *The Four Stages of Cruelty*, Tom Nero, belong to and emerge from a far darker, more violent side of the capital. These prints, which in Hogarth's words were designed to 'reform some reigning vices' of the day, also express his own increasingly anxious and conservative attitude to the urban problems of the period.[17] Significantly, the artist himself was now spending substantial amounts of time away from what he seems to have perceived as an increasingly threatening metropolitan environment, regularly staying in the elegant villa in Chiswick that he had purchased in 1749 (fig.5).[18]

While much of the late 1740s and early 1750s was taken up with designing, engraving and publishing these 'popular prints', this same period also saw Hogarth pursuing his ambitions as a history painter, and continuing to work alongside other artists in promoting a modern school of British art.[19] In 1746 his picture of *Moses Brought to Pharaoh's Daughter* (no.107) was installed in Coram's Foundling Hospital alongside three history paintings by Francis Hayman, Joseph Highmore and John Wills, all dealing with appropriately charitable themes.[20] At the Foundling Hospital these canvases were available to be admired as part of an impressive and varied collection of British

FIGURE 5
Hogarth's house
in Chiswick

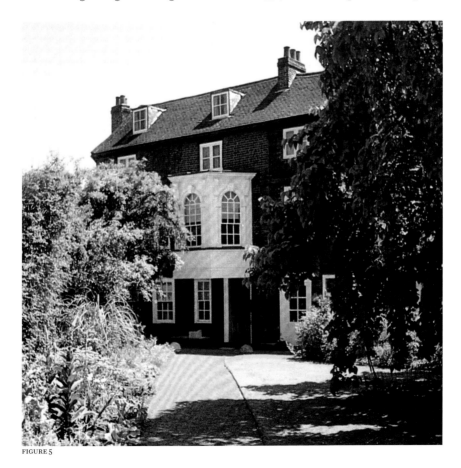

FIGURE 5

paintings headed by Hogarth's portrait of Thomas Coram and – from 1750 – his patriotic satire *The March to Finchley* (no.113). On display in the public rooms of the Hospital, this group of works offered something resembling Britain's first ever gallery of modern art, at which visitors could enjoy the range of paintings now being produced in the capital and appreciate Hogarth himself as the central figure in this development.[21] Hogarth's desire to prove that he – a British artist – could create history paintings as well as his continental predecessors and contemporaries was continued in one of the grandest of all his projects, the huge canvas of *Paul before Felix*, which was installed in the great hall at Lincoln's Inn in 1748 and subsequently generated a remarkable series of prints in the early 1750s (nos.108–10). In both the painting and the prints that followed Hogarth wrestled with the possibilities and difficulties offered by what he and his contemporaries considered the most demanding of all pictorial genres.

In the mid-1750s, having recently published the *Analysis of Beauty* and thus asserted his intellectual credentials as an art theorist, Hogarth entered the sphere of political satire with his *Election* series (nos.120–3). In this set of four substantial, beautifully realised canvases and engravings, which fused together the pictorial conventions of political printmaking and high art, Hogarth turned his attention to the forms of corruption and hypocrisy that attended contemporary politics, and to a rural environment far removed from the metropolis. Intriguingly, this allowed the artist not only to confirm his brilliance at rendering the foibles and delusions of the various figures thronging the streets, inns and polling-stations of the fictional village of Guzzledown, but also to demonstrate his skills as a painter of landscape. In the *Election* series, almost uniquely in the artist's painted output, he includes the kinds of subject matter – leafy, full-bodied trees, picturesque clumps of woodland, rolling fields and glimpsed church towers and steeples – that were also being painted by contemporary landscape artists such as Thomas Gainsborough.[22] It was as if, yet again, Hogarth wanted to prove that he could paint anything and that he could do so as well as, if not better than, anyone else. And when Hogarth was appointed Serjeant Painter to the King in 1757, it must have seemed that this aggressive confidence was well placed.[23]

Hogarth's combativeness, however, was to generate increasing resentment and criticism. His fellow painters and engravers – themselves becoming increasingly confident as a group and less happy to entertain his artistic, aesthetic and institutional ideals – became ever more willing to resist his example. Significantly, in the mid-1750s *The Analysis of Beauty* was ridiculed in a brilliant and highly personalised series of graphic satires by the artist Paul Sandby (see no.7), and Hogarth seems to have become estranged from his own Academy at St Martin's Fields.[24] Other forms of criticism and suspicion came from the aristocratic connoisseurs with whom Hogarth always enjoyed a fraught relationship. Matters came to a head in 1759, when the aristocratic art patron Sir Richard Grosvenor

refused to buy the ambitious picture of *Sigismunda* (no.111), which he had commissioned from Hogarth and which offered a characteristically disturbing combination of the sentimental and the abject. This form of rejection was soon followed by an even more public testament to the growing antagonism characterising Hogarth's relationship with the artistic and cultural establishment, again revolving around the painting of *Sigismunda*.

In 1761 the extensively reworked canvas was one of seven pictures Hogarth sent to an exhibition of paintings organised by the newly created Society of Artists. His submission – the largest and most wide-ranging of any of the sixty-seven exhibitors – promoted the artist's long-held ideal of pictorial variety and advertised his involvement within another crucial stage of modern British art's development: the onset of fully fledged art exhibitions geared to a broad and increasingly well-informed urban public. On its opening the Society of Artists exhibition promised to be a high point of Hogarth's career in which his artistic brilliance and range would be triumphantly confirmed – newspaper critics were uniformly effusive, and one writer described him as 'the wonder of the world'.[25] However, the 1761 exhibition also saw Hogarth's reputation become inextricably entwined with the narratives of controversy and conflict. For, in a startling and highly public demonstration of defiance and self-pity Hogarth, hearing that his painting of *Sigismunda* was attracting waves of criticism from exhibition visitors offended by its lack of pictorial decorum, withdrew the canvas from the display altogether. He was never again to submit any paintings for public exhibition.

In the immediate aftermath of this shocking event the artist – rather than shying away from any further controversy – seems instead to have courted the antagonism of his peers. In 1762 he issued *The Times* (no.124–5), which marked yet another change of artistic direction, in which Hogarth made explicitly personal and party-political attacks on the opponents of the ruling English court and ministry. In particular, the work's pictorial critique of the former Prime Minister, William Pitt, and the Pittite journalists and activists, John Wilkes and Charles Churchill, drew withering condemnation. A spate of graphic lampoons ridiculed the artist for having moved from the more generalised satire of political life represented by the *Election* series into this more specific and individualised mode of political satire. Furthermore, Wilkes and Churchill wrote rapidly published counterblasts to *The Times*, in which they mounted a particularly vicious assault not only against the print but also against Hogarth himself, whom they described as having fallen into a pathetic, irredeemable form of moral, mental and physical decline. Hogarth, who had so profoundly dominated the field of pictorial satire over the previous forty years, was now increasingly finding himself on the receiving end of satiric insult.

The final years of Hogarth's life were dominated by his continuing satirical feud with Wilkes and Churchill

(see nos.126, 129–31), and by his felt need to protect his artistic reputation through both graphic and written means. He began assembling a definitive portfolio of his prints and in the summer of 1763 sat down to compose an artistic memoir. This projected autobiography was never finished, but the notes of this text that survive provide a vivid testament to Hogarth's pride in his achievements as both a painter and engraver: indeed, they begin by declaring that his graphic works are universally appreciated for being 'descriptive of the peculiar manners & characters of the English nation', and that the 'curious of other Countries frequently send for them in order to be informed and amused'.[26] At the same time Hogarth's notes also betray his bitterness as his life drew to a close – tellingly, they end not with the kind of confident rhetoric found at the opening of his text but with words that convey a powerful sense of a man under siege: 'the torrent was against me. I ever had the worst on't.'[27] Soon after writing these words, Hogarth was dead. On the night of 25 October 1764 he died from a ruptured artery in his home at Leicester Fields; on 2 November he was buried in a graveyard near his country house in Chiswick.

Of course, the pessimism expressed in the final jottings of Hogarth's autobiographical notes proved spectacularly ill founded. His loyal widow Jane continued to supervise the sale of his prints, which she advertised as being available 'as usual, at his late dwelling-house, the Golden-Head, at Leicester Fields; and no where else'.[28] She also commissioned John Trusler to write a detailed prose commentary on her late husband's engravings, which became the first and one of the most popular of many extended texts devoted to Hogarth's art. And since the publication of Trusler's *Hogarth Moralised* in 1768, the artist's paintings, prints and drawings have continually been discussed, collected, exhibited and written about.[29] This remains the case today. Indeed, recent decades have seen enormous strides in our understanding and appreciation of the artist and his work. A large-scale exhibition devoted to Hogarth, which was curated by Lawrence Gowing, opened at the Tate in 1971 and coincided with the publication of Ronald Paulson's seminal biography of the artist, later revised and expanded, which has enormously enriched our knowledge of his life and works.[30] Subsequent monographic studies and exhibition catalogues by David Bindman and Mary Webster have brought to bear new research on Hogarth and his milieu and offered a range of original insights into his paintings and prints, while the writings of scholars such as Elizabeth Einberg, Judy Egerton, David Solkin and Matthew Craske continue to sharpen our sense of his art's meanings and functions.[31] The tercentenary of Hogarth's birth in 1997 saw two major exhibitions on the artist: one, curated by Bindman at the British Museum, concentrated on his prints; the other, curated by Einberg at the Tate, focused instead on his paintings.[32]

The exhibition that this catalogue accompanies brings together these two intimately related aspects of Hogarth's art and allows a new generation of international gallery visitors to appreciate the full, exceptionally varied range of the artist's output. Both the exhibition and this catalogue are also intended to recover the wider cultural and social contexts shaping Hogarth's output, and the specific contemporary debates in which he and his work were involved. Walking through the different sections of the display, and leafing through the pages of this book, will reveal the recurring, often overlapping preoccupations that made Hogarth's paintings and engravings so 'descriptive of the peculiar manners & characters of the English nation': the joys, dramas, fantasies and tragedies of life in a modern metropolis; the intimacies and evasions of human relationships within high and low culture; the complex functions of community and class in an increasingly commercialised society; and the character of Englishness itself in a period of acute international conflict and intensive cultural competition from the continent.

The opportunity to look at Hogarth's works in such an all-embracing way also allows us to recognise the remarkable inventiveness with which he manipulated the tools and materials of his trade, and reworked the artistic categories and conventions that he inherited as an early eighteenth-century painter and engraver. Whether picturing a dying prostitute's profile, a servant's patient gaze, a philanthropist's discarded hat, a family's cluttered tea-table or the careering passage of a rake across a sequence of squalid urban interiors, Hogarth was always inventing anew, experimenting with the formal properties of his medium, engaging with the art of his peers and predecessors, exploring the possibilities of pictorial composition, narrative, expression and humour, and creatively manipulating line, light and tone. It is no wonder that, in his own, late words, so many of the 'curious of other Countries' sent for his works 'in order to be informed and amused'. Today, a similarly international audience has the chance to enjoy the same kinds of varied pleasures.

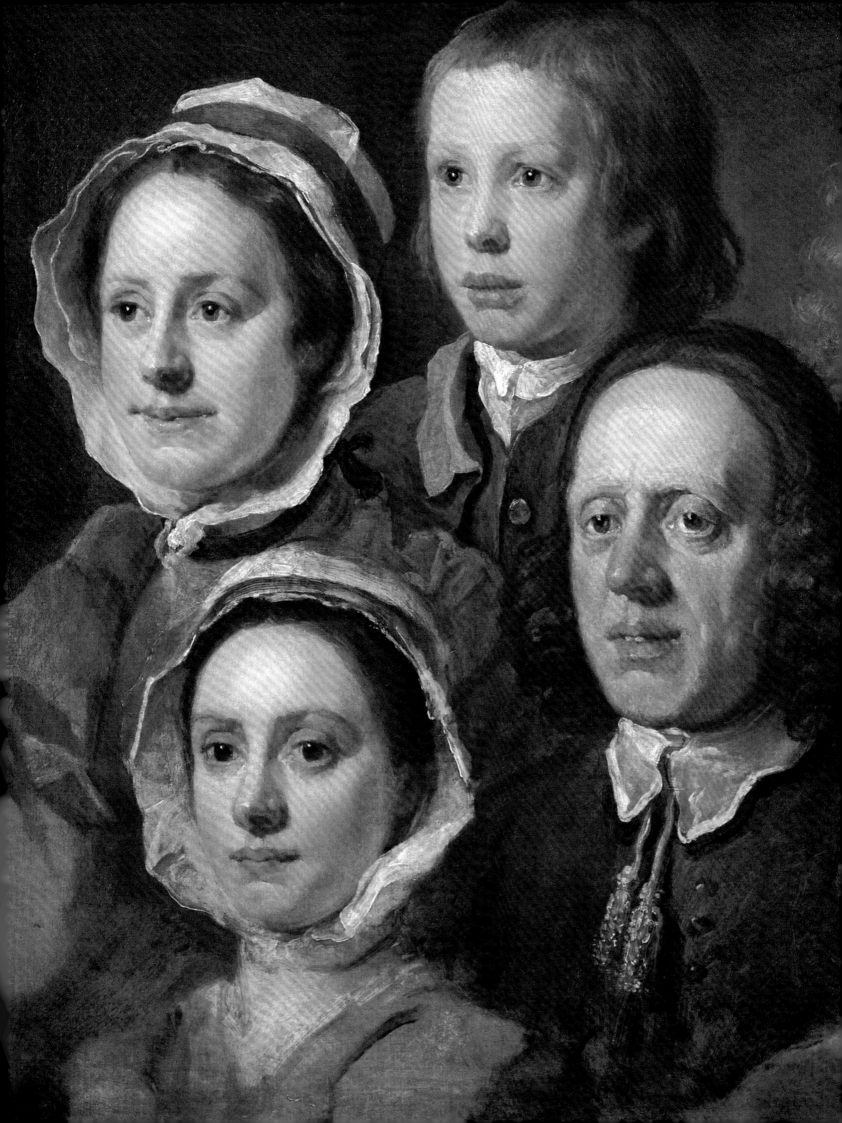

# William Hogarth and Modernity

*Frédéric Ogée and Olivier Meslay*

When Walter Richard Sickert (1860–1942) exhibited his *Camden Town Murder* painting in 1911 in London (fig.6), he did so in the context of Roger Fry's recent introduction of 'modernism' to England in an exhibition of the works of the French Post-Impressionist painters, most prominently Cézanne, Gauguin and Van Gogh. Going against Fry's pronouncements in favour of a 'modern' art that extolled 'plastic design' and the aesthetic emotion of pure form, Sickert reminded his fellow citizens that modernity in English art had, from its origins, always been founded on narrative and a sensorial truth to nature. The *Camden Town Murder* painting was itself part of a series of drawings and oils that he had produced in the immediate aftermath of the actual crime and that combined to tell a story within a time-bound and quotidian framework. This was meant to appeal to the viewer's inner sense of the real and was true to an *English* tradition of 'modernity' that went back to one of the first prominent members of an English school of art, William Hogarth. Instead of abstraction, of formal idealism and of the elimination of the contingent, modernity in English art must, according to Sickert, stand against continental conceptual influences and rely on a dynamic, narrative conception of visual representation. Rooted in the particulars of shared experience, it was meant to draw its beholders into a world of poignant, tangible details that espoused the contours of their anxieties about modern life. Strikingly, it was exactly in the same, apparently insular terms that Hogarth positioned his own enterprise in the world of eighteenth-century London, both in relation to foreign 'high art' and in his adoption of a compositional grammar that expressed his conception of modern art.

## English modernity

William Hogarth's arrival onto the London artistic scene took place at a time – the 1720s and 1730s – when modernity was understood and advertised as a synonym for Englishness or, since the 1707 Act of Union with Scotland, Britishness. To be modern meant to promote and represent the values – economic, political, religious, philosophical, artistic – in terms of which the new nation was determined to define itself, mostly in reaction against what was increasingly described as the 'yoke' of continental (read French) domination

*Heads of Six of Hogarth's Servants* c.1750–5 (no.116, detail)

FIGURE 6
Walter Sickert
(1860–1942)
*The Camden Town Murder*
c.1908–9
YALE CENTER FOR BRITISH ART, PAUL MELLON FUND

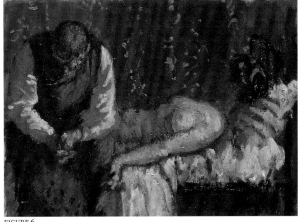

FIGURE 6

over the European scene.

With the legitimate pretender to the throne of England exiled across the Channel, the issue had a burning topicality. Declaring one's modernity became a political declaration of allegiance to the overall framework put into place since the Glorious Revolution of 1688, which had adroitly laundered the replacement of the pro-Catholic, pro-continental members of the Stuart dynasty with some of their more or less distant, pliable and largely disempowered Protestant relatives. By setting up the truly revolutionary principle of a political contract, to a large extent inspired by commercial thought, between the people and its rulers, which legitimised the replacement of the latter when they were deemed to have failed, the English shook one of the oldest pillars of European tradition – the divine right of kings – and thereby paved the way for the emergence of the two most important features of the nascent Enlightenment, and of our own modernity: public opinion and individual liberty.

Such a revolution, prepared by the Reformation's profound questioning of a closed, vertical and theological organisation of human affairs, was fuelled in England not only by the resistance to 'popish monarchy' and absolute tyranny but also by a new intellectual climate promoted by a generation of 'thinkers' – scientists, philosophers, preachers – who developed and broadcast a radically new comprehension of the world based on a free, personal and empirical apprehension of it. In effect, just as in religion, where a less mediated, more individual relationship to the deity was being sought, they encouraged a direct, consensual observation of God's creation rather than the contentious doctrinal debates about God Himself, which had led to so many bloody conflicts at home throughout the seventeenth century.

The foundation of 'The Royal Society for the Improving of Natural Knowledge' in London in the early 1660s – over which Isaac Newton was to preside at the turn of the century – fostered the emergence of a new scientific method that, instead of the verification of preconceived hypotheses, advocated an 'objective' observation of the 'particulars' of Nature and the writing of 'histories' of the causes and effects of natural phenomena, from which laws and theories could only subsequently be deduced. This new method was most famously illustrated by Newton's Law of Gravity and his *Opticks* (published in 1704). The philosopher John Locke, already behind the principles of the new political 'contract', formalised this approach in his *Essay Concerning Human Understanding* (1690–1700), in which he developed the principles of the new empirical epistemology, with great emphasis on the importance of a sensorial acquisition of knowledge.

Made possible largely thanks to the remarkable freedom of print after the lapse of the Licensing Act in 1695, the circulation of these new ideas quickly percolated through the various layers of society not only with the regular publication of the Royal Society's *Philosophical Transactions*, which recounted their experiments in all fields, but also in the new periodicals (*The Tatler, The Spectator, The Gentleman's Magazine*) that were widely circulated and eagerly read in clubs and coffee houses from the early decades of the eighteenth century. As could be expected, writers and artists were quick to discuss and represent the consequences of all those changes and of this new approach to nature – including human nature – and developed 'modern' forms of expression that could publicise and analyse them in a recognisably English, and free, idiom. Quite remarkably, these forms all appeared between the 1720s and 1740s.

In gardens, after trying to rival the French in Baroque grandeur (as at Castle Howard or Blenheim Palace), landscape designers (Charles Bridgeman, William Kent, Lancelot 'Capability' Brown) replaced the geometrical and architectural framing of nature with a more painterly and increasingly irregular, serpentine and 'natural' form of garden, which, while being in fact as sophisticated as its French counterpart, was presented as an emblem of English liberty and allowed the visitor a much more personal, sensory contact with God's creation. Soon known as 'the English landscape garden', it was often imitated throughout Europe, not least in France (*jardin anglais*), in the second half of the eighteenth century. Similarly, in literature there developed a genre of long prose narrative – later designated as 'the novel' – which problematised the causes and effects of an individual's integration within the new society. After Daniel Defoe's first attempts at 'realistic' stories (*Robinson Crusoe*, 1719, and *Moll Flanders*, 1722), Samuel Richardson, in his best-sellers *Pamela* (1740) and *Clarissa* (1748), developed the epistolary novel to examine the frictional energy released by the confrontation of several one-sided viewpoints, while Henry Fielding, with *Joseph Andrews* (1742) and *Tom Jones* (1749), explored what he called his 'new province of writing', offering panoramic, epic narratives of his heroes' progress through modern England. Finally, in art a new generation of painters and engravers laid the foundations of what was to emerge later in the century as the 'English school of art', by taking advantage of the new situation to redefine the traditional academic categories to their advantage and to steer portraiture – the quasi-exclusive genre in demand – towards modern 'realism'. Prominent among them was William Hogarth, whose initial handling of group portraiture known as 'conversation painting' developed into the representation of what he called 'modern moral subjects', based on a dynamic use of variety and narrative, two qualities that remarkably encapsulated the new priorities of the age and soon became, as Sickert was later to observe, the hallmarks of modernity in English art.

The freer expression of individual opinion, combined with a great increase in population and the disruption of social hierarchies by the dissemination of commercial prosperity, made diversity and variety conspicuous features in eighteenth-century society. This development was a source of wonder as much as of anxiety, and it fostered a great demand for guidelines and models of behaviour, which books of conduct,

periodicals, but also 'modern' social portraiture, undertook to satisfy. Hogarth was one of the first artists to capture this phenomenon, and devised or appropriated (in the case of conversation painting) pictorial forms that would represent and stage the contours of this modernity.

**Modern conversation**
One of the great originalities of eighteenth-century England could be said to be the invention of the first person, in a dynamic, empirical sense, resulting from a discovery and an exploration. As stated above, the pressures of the market economy put social hierarchies and rank under real stress and shook the notion of immutable identity, which now increasingly became a matter of individual experience and 'progress', developing over time. The acknowledgement of the complexity, variety and specificity of each individual became the central issue in all branches of knowledge, from physiology to aesthetics, from travel expeditions to fashion. It was the topic of most if not all of the 'modern' novels, as indicated by their titles (*Moll Flanders*, *Joseph Andrews*, *Tom Jones*, *Tristram Shandy*, etc.).

Besides, the diffusion of an empirical theory of knowledge, presented and put forward (not least by Voltaire in his *Lettres philosophiques*) as the expression of a 'modern' and authentically British form of thinking, accompanied this evolution by explaining how individual existence was crucially linked to experience and duration, the individual being no longer conceived as a stable moral and social fact, but as the result of a progress and a series of exchanges: 'I experience myself progressing in time therefore I am.'

This conception of human existence as the experience of duration played a decisive role in the emergence of English painting, whose practitioners were thus entitled to give new meaning to the highest academic genre, history painting. Now understood in a dynamic, empirical way, 'modern history painting' became a genre that would tell stories or rather, to use the term as scientists understood it, 'histories' (Locke recommended the 'history of particulars', while Newton described his own enterprise as a 'History of causes and effects'). Hogarth's most famous artistic gesture, the adoption of a sequential form of representation, perfectly encapsulated this evolution. His numerous series, whether obviously narrative (*A Harlot's Progress*, *A Rake's Progress*, *Marriage A-la-Mode*, *Industry and Idleness*, the *Election* pictures: nos.43, 44, 77, 97, and 120–3 respectively) or more circular (*The Four Stages of Cruelty*, *The Four Times of Day*: nos.99–100 and 67–8 respectively), all express the new, dynamic, experiential conception of portraiture and representation. This great idiomatic choice of the series is discussed further below, but it is striking to realise that it also inspired his design of single images, even in the codified genre of commissioned portraiture.

Presented directly in two of his most remarkable images, *Characters and Caricaturas* and *Heads of Six of Hogarth's Servants* (no.116), the variety of human individualities is constantly explored in his work in all its social and visual consequences, from exhilarating energy to downright chaos. As Mark Hallett explains in the introductory essay to this catalogue, variety became the central tenet of his aesthetics. What Hogarth paid attention to was the way that these individual 'progresses' could combine or collide, and for this he used (and shook up) the fashionable concept of conversation. Whether in clubs, coffee houses or in various functions at home, the art of conversation, praised as the desirable form of modern social behaviour, was described as the best way to channel differences and diversities into 'polite' harmony. As David Solkin has put it: 'Defined as a forum in which individuals learned to refine their behaviour in response to the needs of others, and to create a community based on sympathy and mutual understanding, conversation provided eighteenth-century commercial ideologies with the perfect vehicle for constructing an idealised representation of the social relations that existed at the heart of the marketplace.'[1] Increasingly, however, Hogarth suggested the artificiality of such polishing and the sham character of its play-acting.

Classical aristocratic portraiture, in Van Dyck for instance, imposed its models as ideal, or idealised presences, the details of whose individual existence were left out in favour of an abstract, atemporal representation. But since the beginning of the eighteenth century the elitist artistic ideology on which such portraiture rested had been eaten up by the profound social evolutions caused by the increasing hegemony of banking and commerce and by all the 'progresses' that the dizzying circulation of wealth allowed. Inspired by trade, conversation, which defined identity in terms of exchange and interrelations, became an 'epistemological metaphor' for the age.[2] There swiftly emerged what Jürgen Habermas has described as a bourgeois public sphere,[3] when a certain number of private individuals began to meet more publicly (in coffee houses, clubs and theatres) thus becoming aware of themselves, exchanging ideas and values, and gradually constituting these as public opinion, if not dominant ideology. Prominent among them were a group of Whig 'intellectuals' – politicians (Lord Somers, Robert Walpole, William Pulteney), financiers (Lord Halifax, Thomas Hopkins) and men of letters (William Congreve, John Vanbrugh, Joseph Addison) – who, before they got into power on the death of Queen Anne in 1714, polished their conversational strategy at the Kit-Cat Club and then deployed it in the daily instalments of the periodicals (*Tatler*, *Spectator*). They were immortalised by the famous 'kit-cat' portraits that Godfrey Kneller made of each of them (fig.17, p.38), while the informal, conversational composition of the works themselves gave a decisive boost to this form of portraiture, soon installing the 'conversation piece' as the fashionable English genre.

With such an aestheticisation of social relations and such attention paid to the image that society wished to give of itself, conversational portraiture became

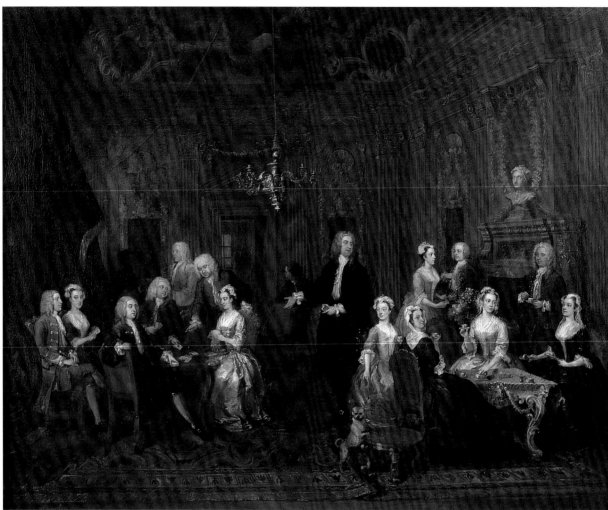

FIGURE 7

emblematic of 'modern' behaviour. As Jonathan Richardson explained in his *Essay on the Theory of Painting* of 1715: 'The Painter's People must be good Actors; they must have learn'd to use a Humane Body well; they must Sit, Walk, Lye, Salute, do everything with Grace.'

The basic idea was that the social interaction of individuals allowed each of them to control and refine their passions and desires by rubbing and polishing them within the group. They could thus reach that equilibrium, that 'happy medium' which writers and artists all sought to figure out and which, in effect, was the ideological designation of a social space, the public sphere of the 'middle class', whose territory was to keep expanding by pushing the aristocracy and 'the vulgar' increasingly to the sides. Conversation painting, which became extremely fashionable in the 1720s and 1730s, thus appears as the visual evidence of this search for the perfect balance, as the representation of the refinement of passions allowed by social commerce.

The genre was itself the refinement of a type of painting that had existed in seventeenth-century bourgeois Holland and had been introduced into England by a certain number of Dutch (and Flemish) artists like Marcellus Laroon, Egbert van Heemskerk II, Pieter Angelis or Joseph van Aken, who came primarily in the wake of the court of Orange, in the 1690s. The form was then 'polished' under the influence of the

French *fêtes galantes* à la Watteau, whose visit to London in 1719–20 had left a fresh imprint, prolonged by his pupil Philip Mercier, who was a friend of Hogarth's. But the spirit of French *galanterie* and the fancy erotic atmosphere that bathe these paintings were not really in tune with the pragmatic considerations of the new English clients, who wished primarily to reconcile wealth and virtue and offer a harmonious display of self-satisfaction. Hogarth came at the right time, with the perfect compromise.[4]

Engraver and art critic George Vertue, a contemporary of Hogarth, described the latter's conversation paintings as 'models of universal agreeableness'. Of *The Wollaston Family* 1730 (fig.7), he wrote: 'This is really a most excellent work containing the true likeness of the persons, shape aire & dress – well disposed, genteel, agreeable – and freely painted & the composition great variety & Nature.'[5] In all those works we see the staging of a whole array of well-gendered conversational signs, and each character seems engaged in an attitude of pleasant exchange (marital harmony, tea drinking, card-playing, etc.) within the group. The great quality of these works, which explains Hogarth's success in the genre, comes from the way he managed to 'compose' the diversity of often numerous individual postures into what David Solkin has called 'a collective tapestry of politeness'.[6] The pictures offer the narrative of a perfectly balanced

social game, symbolised by activities like card playing, in which rules must be followed and competition understood to aim for the satisfaction of all involved and not for private benefit, unlike, perhaps, the ruthless commercial business that often provided the prosperous ease of the protagonists.

However, one can always feel an element of 'staginess' in these tableaux, occasionally underlined by the presence of a dark curtain on the side (see *The Strode Family*, no.54). The primary impression, possibly desired by those who commissioned the pictures, is that a veil has been lifted from over this 'genteel comedy', allowing the beholder to 'dis-cover' its characters, who are caught apparently unawares in their natural private conversation. Yet, the theatrical framing also suggests that here is a collection of players, acting well-distributed parts and expressing a very precise ideological programme.

In his 'Autobiographical Notes', which he wrote late in life, Hogarth explained: 'I have endeavoured to treat my subjects as a dramatic writer; my picture is my stage, and men and women my players, who by means of certain actions and gestures, are to exhibit a dumb show.'[7] It seems indeed that he gradually became aware of the play-acting and the element of artificial self-display involved in such an idealised social dialogue, and was increasingly inclined to reveal the hidden face, the wings of this allegedly virtuous prosperity. While his own success as an independent artist allowed him to turn down commissions, he repeatedly borrowed from the genre and its format to suggest the essential vulgarity that the ideology of politeness wished to keep hidden. More starkly and darkly than his contemporaries, the novelists Richardson and Fielding, Hogarth surreptitiously destabilised the beautiful social model, in a manner that certainly contributed to his isolation in the last ten years of his life.

Thus, what was the refined description of a family reunion (*The Strode Family*) could become the first scene of a tragedy (*Marriage A-la-Mode*, Scene 1, no.77), the exterior harmony of a couple (*Ashley Cowper with his Wife and Daughter* 1731, Tate) was contradicted by the mirrored but never disclosed representation of their 'interior' discord (*Marriage A-la-Mode*, Scene 2, no.77), while the polite conversation of gentlemen (*The Hervey Conversation Piece*, no.56) was shown to degenerate into some sordid binge once the masks had fallen (*A Midnight Modern Conversation*, no.49). And *The Beggar's Opera* (nos.38–9), which he painted several times, provided him with a most eloquent opportunity to blur the limits between town and stage.

## Visual disorder

Once Hogarth had begun to acquire some professional autonomy, a striking characteristic of his *oeuvre* became his recourse to a kind of visual tangibility, or tactility, through a constant proliferation of details. Filling up the pictorial space to the limit, they tend to saturate his images, often making them difficult for the beholder to apprehend, especially at first glance. *Gin Lane* (no.98), the last two plates of *Industry and Idleness* (no.97), *Night*

(last scene of *The Four Times of Day*, no.67) or the first and fourth images of the extraordinary *Election* series (no.120–3) provide remarkable examples of this.

In exterior group scenes like *Southwark Fair* or *The March to Finchley* (nos.65, 113), although we see things taking place at various levels, it is undeniably the crowd that forms the long horizontal strip – a bit like a tidal wave – that serves as the main structural axis of the picture. From a 'plastic' point of view it is clear that Hogarth's main compositional motif is profusion, and the extraordinary variety of the proliferation that representations of the crowd allow adds to the density of his pictures. The crowd is used as a great source of energy and 'intricacy', a sort of shimmering fabric of individuals of all proportions and textures. In the chapter in his *Analysis of Beauty* devoted specifically to proportion, Hogarth wrote:

> We find ... that the profuse variety of shapes, which present themselves from the whole animal creation, arise chiefly from the nice fitness of their parts, designed for accomplishing the peculiar movements of each ... Yet, properly speaking, no living creatures are capable of moving in such truly varied and graceful directions, as the human species; and it would be needless to say how much superior in beauty their forms and textures likewise are.[8]

The disorder of such crowd scenes, for all their suggestion of formal anarchy, constitutes nonetheless a crucial constituent element of Hogarthian aesthetics, too recurrent to be seen merely as the mimetic or metaphorical transposition of some social disorder. Such pictures are striking primarily for their immediate illegibility. It is impossible to get a clear idea at first sight, as these images are deliberately laid out so as to blur, even impede, the first scanning by the eye, and thus force the beholder to either turn away or look closer. For that reason, the use of graphic excess, or the proliferation of visual disorder, seem as tactical as the use Hogarth makes of the 'serial' format, which is examined further below. Instead of being subservient to some global architectonic structure, a centrifugal whole, the forms of these images of disorder, which, as Alexander Pope put it, may only be 'harmony not understood',[9] are divided into local units of meaning, which invite the eye from one area of the picture to another, and produce a network of perception each time renewed and different, from which moral as much as aesthetic beauty will perhaps emerge. Hogarth defined 'intricacy' as 'that peculiarity in the lines, which compose it, that *leads the eye a wanton kind of chace*, and from the pleasure that gives the mind, intitles it to the name of beautiful'.[10] In *Southwark Fair* the crowd seems little fascinated by the numerous fairground activities that surround it, since the true spectacle is the crowd itself, presented in so many contiguous cells formed by groups of three characters, and if we follow the line of their heads from one side of the picture to the other, it draws a remarkable serpentine shape,

Hogarth's famous emblem of beauty.

Hogarth thus produced numerous scenes in which the traditional central (and single) action, recommended in academic discourse, is in a way redeployed into a multiplicity of active graphic signs. The richness and ambivalence of his pictures result from his boldest artistic originality: the adoption of a polycentric stage, on which the 'dumb show' exhibited by his players offers concomitant areas of meaning that strengthen each other and create that variety and intricacy so central to his aesthetics, by inviting the beholder to a serpentine act of deciphering. Wishing to account for the bubbling, changing and therefore complex reality in all domains of eighteenth-century England, 'modern' artists like Hogarth had to deal with the tension, if not the contradiction, between their urge to describe empirically the new effervescent multiplicity and the necessity to 'compose' that variety. The concept of 'unity of action' is generally defined in terms of elimination of the superfluous, the secondary, or what might be perceived as such. Hogarth's polycentric scenes – their 'composed variety' – offer a form of alternative to this, since, far from abandoning the idea of such a unity, their compositions rely on effects of simultaneity and plural occupation of space, which permanently ensure a perceptive dynamic that is surreptitiously substituted for the former understanding of action as subject. It is the *action of perception* that becomes fundamental in that it alone will provide the work with some form of unity. By experimenting with and performing a series of perceptive moves suggested by the works' various centres, the beholder will *experience* the work. Most of Hogarth's pictures are designed as so many contiguities of signifying units, which compose themselves and combine under the private eye of each individual spectator and only then give sense (direction and meaning) to their perception.

**Narrativity**

This emphasis on the activity of perception, on the pleasure derived from an active, empirical perception of images, was given even stronger expression with Hogarth's adoption of a serial form of representation. One of the most striking aspects of his *oeuvre* is the number of works he designed as sequences of images, in which the polycentric stage of single images described above is, as it were, opened up and spread out over several successive pictures.

Such a narrative conception of art, relying on a kind of syntactic, left-to-right 'reading' of his images, has largely encouraged the reception of Hogarth as a 'literary' artist predominantly engaged in the telling of stories, and Charles Lamb's famous appreciation in this respect has framed the artist's reputation to this day: 'His graphic representations are indeed books: they have the teeming, fruitful, suggestive meaning of words. Other pictures we look at – his Prints we read.'[11] However, while it is undeniable that the visual and the verbal are constantly at play in his works and that he was undoubtedly influenced by the remarkably

buoyant 'paper culture'[12] that allowed him to start his career as a book illustrator, such an assimilation can be misleading, and gives little credit to his decisive contribution to the emancipation of the visual from the verbal. As has been explained elsewhere, he played an important part in the development not only of English art but also, more globally, of a proper visual culture in eighteenth-century England (which could only exist once a public for it had emerged), primarily because his *oeuvre* surreptitiously promoted the aesthetic and social parity of text and image. While before him pictures or images that could be seen by a large public were few and far between, at his death engravings of his works could often be found occupying the same place as books in middle-class interiors.[13]

It is interesting to notice the extent to which the most important creations of the first half of the eighteenth century in England – Addison and Steele's periodicals, Richardson and Fielding's novels, the landscape gardens at Stowe, Stourhead or Rousham, Hogarth's *Harlot*, *Rake* or *Marriage A-la-Mode* – relied on a sequential principle, the series, which was understood in its mathematical sense as a succession of elements gathered together by a common law but acquiring their true meaning in their final summation. At a time when empiricist discourse and practice were becoming so important, this comes as no surprise. Be they series of daily essays, of letters or adventures, of viewpoints and garden structures, or of images, these 'modern' works expressed the two fundamental axioms of empiricist philosophy, the conception of time in terms of duration and series of moments, and the definition of knowledge as the result of some 'progress' and a series of experiments. All of them embark their receivers onto experimental journeys based on a dynamic perception and discrimination of the various layers of temporal progression – history, story, reading – and a conscious management of the gaps left between the various stages, those openings so essential to the aesthetics of the series.

The functioning principle of the series is pedagogically demonstrated in the rather crude but cleverly enticing pair of works entitled *Before* and *After* (nos.40–2). The visual and moral effect comes as a result of the confrontation of the two images,[14] and the humour from the suspense and the withholding of information. The title of the first picture is clearly programmatic. It opens a space of expectation and invites a temporal, left-to-right reading, while that of the second picture abruptly closes the 'sentence' on a note of frustration. Meanwhile, the suspended fall of the vanity, or dressing table, in the first picture, a metaphorical anticipation of that of the young lady, underlines the artificial interruption of the passing of time, just as its subsequent fall in the second picture allows the beholder to discover, indicated by the risen ray of sunshine, a second image of Cupid, now cheekily laughing at the success of his 'shot'. The 'story' of the dog, erect then recoiled, is a rather obscene transposition of the successive movements of the man's 'animal parts'.

FIGURE 8
Jean-Baptiste Greuze
(1725–1805)
*Le fils ingrat* 1777
MUSÉE DU LOUVRE, PARIS

FIGURE 9
Jean-Baptiste Greuze
*Le fils puni* 1778
MUSÉE DU LOUVRE, PARIS

FIGURE 8

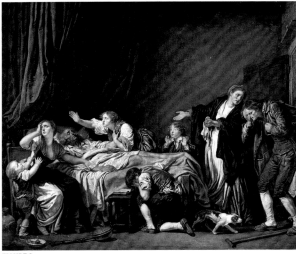

FIGURE 9

One soon also becomes aware, of course, of the absence of a central image, an empty space that the beholder's imagination is invited to fill. Hogarth, in his definition of the 'line of beauty', wrote that 'by its twisting so many different ways, [it] may be said to inclose (tho' but a single line) varied contents; and therefore all its variety cannot be express'd on paper by one continued line, without the assistance of the imagination.'[15] Set side by side, the two images – and the couple's two positions – form a suggestive 'V' that seems to point accusingly at the gap that the beholder's voyeuristic leanings are filling with graphic details. The two tenses of the narrative (before/after) create a tension that, a little like dissonance in music, calls for a resolution.

The same dynamic principle informs the structure and perception of Hogarth's more elaborate series. Thus the gap between Plates 1 and 2 of *A Harlot's Progress* implies a tragic corruption of the young country girl, which is left entirely to the beholder's imagining. Hogarth's novelty was to introduce more variety and complexity in this basic structure by examining the successive bounces of the pebbles of destiny. *A Harlot's Progress*, *A Rake's Progress* and *Industry and Idleness* are narratives of Newtonian causes and effects: before and after, and after, and after, etc. Similarly, in *Marriage A-la-Mode* the first image, *The Marriage Settlement*, triggers off a whole series of 'after-effects'. Their gradual unrelenting discovery by the beholder, who makes the connections and provides the missing links, reaches pathetic levels, which Jean-Baptiste Greuze across the Channel would soon exploit to the full: see, for instance, his *Le fils ingrat* 1777, and *Le fils puni* 1778 (figs.8, 9).

Hogarth's great series consist in breaking the continuum of time into significant moments, in order to dramatise the histories of tragic destinies by reducing them to a few (between four and twelve) crucial episodes. Each of these wordless stories pictures its characters' few 'Choices of Hercules', reducing the dumb show of their lives to a terrifyingly laconic sequence. Not unlike the Stations of the Cross, these 'progresses' lead unremittingly to madness or death. The beholder, meanwhile, is invited both to contribute the missing scenes but also, in the end, to step back and understand how things went wrong. The sequential acquisition of experience and knowledge is much more centrally the beholder's business than the characters' concern, as the latter are never really left a chance to progress.

In all aspects of his art Hogarth gives pride of place to the operation of perception and invites beholders to play an active part in the realisation of the work and devise their own course within it. In *The Analysis of Beauty*, after rejecting the elitist notions of abstraction and exclusive *je ne sais quoi*, and defending the idea that beauty could be explained and made accessible to all, he deployed a whole aesthetic programme in which he tried, however clumsily at times, to sum up his various priorities. The line of beauty, which serves as the emblem of his theory, perfectly encapsulates his idea that aesthetic pleasure results from the dynamic variety of the beholders' perceptive pursuits and asserts boldly that modernity in art results primarily from the diverse ways their imagination will contribute to the *work* of art.

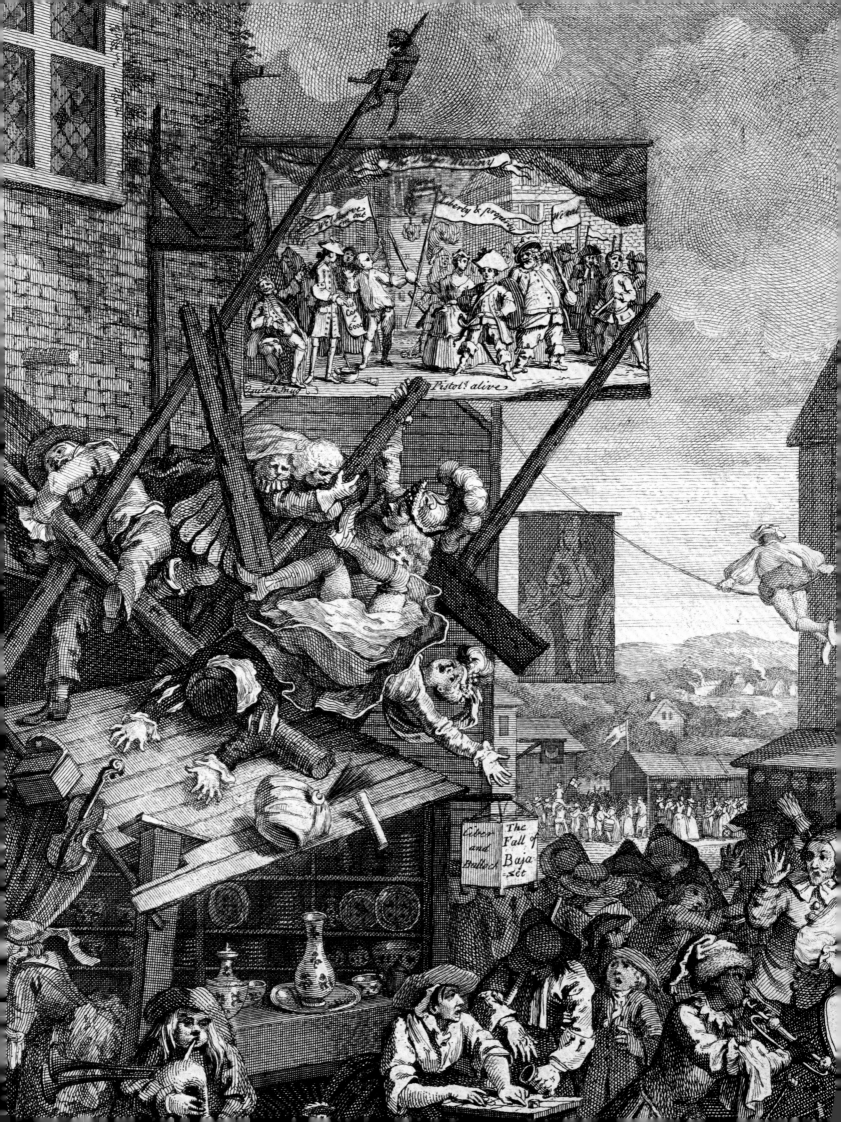

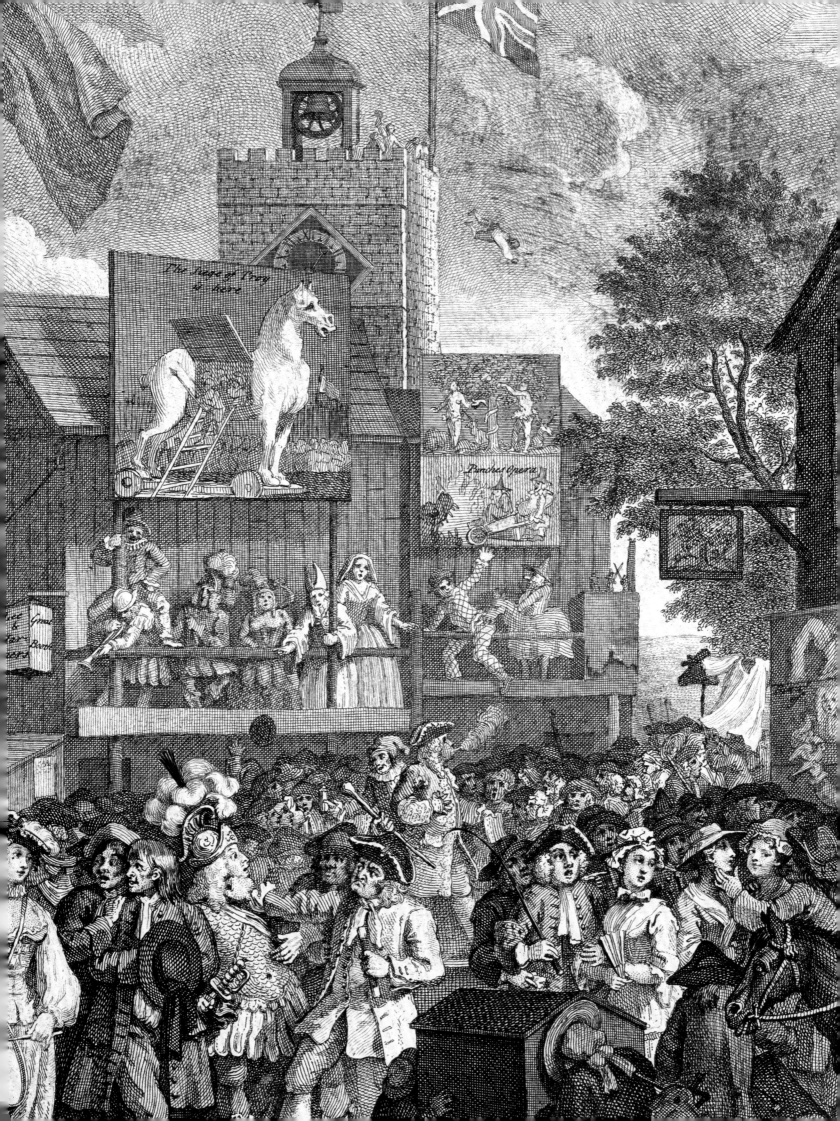

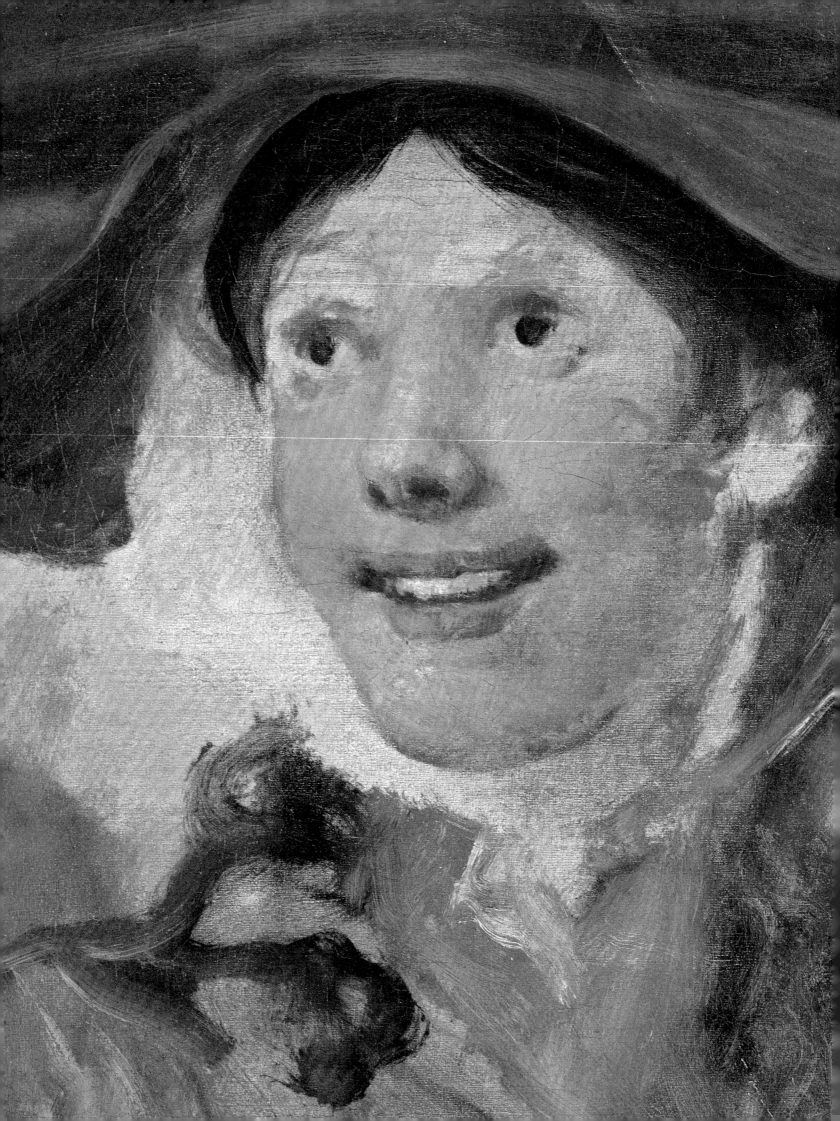

# 1
# Introducing Hogarth: Past And Present

*Christine Riding*

In 1901 James McNeill Whistler (1834–1903) sent an angry note to the committee for the Fund for the Preservation of Hogarth's House. Enclosing a subscription to save the artist's villa in Chiswick (fig.5), Whistler wrote, 'I am told that nothing official has in the matter been done, either by the Government, or The Royal Academy, to keep in respect the memory of [the nation's] one "Master" who, outside of England, still is "Great".'[1] Why did the supreme artist of the Aesthetic Movement and champion of 'Art for Art's Sake' think so highly of William Hogarth?

In common with the majority of people in the nineteenth century, Whistler was introduced to Hogarth through engravings, having been given a book of Hogarth's prints as a child. But Whistler responded to Hogarth as both a printmaker *and* a painter whose brushwork and skilful use of colour he greatly admired. His interest in the painterly qualities of Hogarth's work was highly unusual in the Victorian period and remains so, even today. However, Whistler's appreciation of the artist as the great interpreter of modern urban life was more widely held. Indeed, Hogarth's ability to capture the throb of the city's streets and the diversity of its occupants within complex, multi-focal compositions was the starting point for a number of pictorial panoramas of nineteenth-century society, including David Wilkie's *Chelsea Pensioners Reading the Waterloo Dispatch* 1822, William Powell Frith's *Derby Day* 1858 and Ford Madox Brown's *Work* 1852–65. Whistler in his early career also focused on explicitly contemporary subjects, albeit in different mood to other Victorian artists. *Wapping* (fig.10) – a tavern scene on the Thames riverfront with a prostitute, her pimp and a sailor – exemplifies Whistler's detached,

unsentimental observations on the urban experience, paralleling Hogarth's own attitude towards the subject (see p.119–21). Whistler's later painting of a street hawker, *The Chelsea Girl* (Private Collection), executed in 1884, can be seen as homage to Hogarth's now celebrated *Shrimp Girl* (no.63), which had been acquired for the National Gallery in the same year.[2] For Whistler and others such street characters were central to Hogarth's powerful and enduring vision of London. In moving among the urban crowd, taking pleasure in the sights and sounds of the street, Hogarth was indeed the *flâneur* of his day.

Whistler's open-minded appreciation of Hogarth allowed him to position the artist's work within a canon of seventeenth- and eighteenth-century European painters; he was described as 'never tiring in his praise of the luminosity of Claude, the certainty of Canaletto, the wonderful tones of Guardi, the character and colour of Hogarth'.[3] To commentators in the decades after Hogarth's death, however, his genius was primarily that of the satirist. In his *Anecdotes on Painting in England* (1780) the aristocrat and art-connoisseur, Horace Walpole, celebrated Hogarth's pre-eminence as a satirical printmaker. Significantly, Walpole located Hogarth's work within the world of literature and drama, rather than of art, describing him as 'a writer of comedy with a pencil' in the spirit of Molière and William Congreve.[4] This comment in some measure echoes Hogarth's own description of his work in theatrical terms. But Hogarth also took great pains to promote himself as an original thinker and as an artist of substance within a range of genres. This is powerfully demonstrated by his self-portraits included in this section, which as

*The Shrimp Girl* c.1740–5
(no.63, detail)

FIGURE 10
James McNeill Whistler
(1834–1903)
*Wapping* 1860–4
NATIONAL GALLERY
OF ART, WASHINGTON

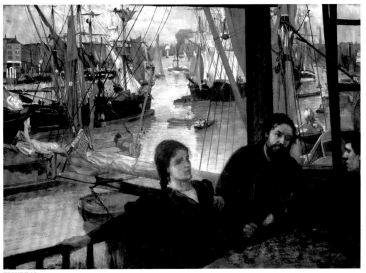

FIGURE 10

a group represent a sophisticated and wide-ranging artistic manifesto (see nos.1, 4, 8). However, both Walpole and Sir Joshua Reynolds, the first president of the Royal Academy, sought to edit and fix Hogarth's legacy, dismissing outright his contribution to British history painting. Indeed, Reynolds noted in his fourteenth *Discourse* (1788) that, while Hogarth should be celebrated for inventing 'a species of dramatick painting' and for his ability 'to explain and illustrate the domestick and familiar scenes of common life', his ambitions in 'the great historical style' were not only imprudent but presumptuous.[5]

Such partial evaluations and outright condescension towards Hogarth were to be expected in the British art world of the second half of the eighteenth century, given the theoretical dominance of Reynolds's Grand Manner style with its seductive, idealising tendencies, and the creation in 1768 of a hierarchical, continental-style Academy, against which the work of all native artists, dead or alive, was now measured. Hogarth's aversion to flattery, his penchant for satirical irony and his unflinching observations of urban life did not chime with an age that also spawned the 'cult of sensibility' and a vogue in British society portraiture for sitters cast as 'men and women of feeling', paralleled by sentimentalised representations of prettified poverty and rustic idylls. Reynolds was not alone in grouping Hogarth with seventeenth-century Dutch and Flemish genre artists, 'who', as Reynolds stated, 'have applied themselves more particularly to low and vulgar characters'.[6] That Hogarth's modern moral subjects and political series were also too forceful and unmitigated for a certain kind of eighteenth-century French spectator is suggested by a French connoisseur's comments on seeing the paintings of the *Election* series (nos.120–3) at David Garrick's house in 1765. 'These pictures', he noted, 'are in the taste of old Breughal ... It is pure nature but nature too naked and too true; a truth very different from that displayed by two of the masters of the present French school, Messieurs Chardin and Greuze.'[7] Nevertheless, Jean-Baptiste Greuze showed more than a passing interest in Hogarth's work during the 1760s. His *Le malheur imprévu* (before 1763), for example, was influenced by the *Before* and *After* prints of 1736 (no.42, see also p.29). But such moral genre subjects by Greuze were invariably imbued with modish *sensibilité* and thus lacked Hogarth's characteristic sting.

FIGURE 11

FIGURE 12

Perhaps not surprisingly, it was in graphic satire that Hogarth's influence was most obviously seen in late eighteenth-century Britain. Indeed, his highly successful modern moral subjects and other satires had given this genre a new artistic and commercial credibility (tellingly, satirical prints were excluded from the Royal Academy). Hogarth's 'successors', in particular James Gillray (1757–1815), acknowledged their enormous debt to him by continually alluding to or borrowing from his compositions, even those that were not intended to be satirical. To give a famous example, Hogarth's *Satan, Sin and Death* (no.103), inspired by Milton's *Paradise Lost*, was deftly reworked by Gillray in 1792 (fig.11) as a political satire concerning the power struggle between the Prime Minister William Pitt and the Chancellor Edward Thurlow, with Queen Charlotte intervening.[8] While referencing the work of other artists was a staple of such prints, it is worth noting that the 'golden age' of British graphic satire (from the 1780s to the 1820s) was concurrent with a boom in the art market for Hogarth's prints, largely for use as private entertainment, a phenomenon described by the scholar Edmund Malone in 1781 as 'Hogarthomania'.[9]

One aspect of Gillray's approach was, however, distinctly un-Hogarthian, namely his use of caricature. In *Characters and Caricaturas* (fig.12) Hogarth sought to disassociate his work from caricature, visually setting out its boundaries and limitations and underlining that the depiction of character made far greater intellectual and artistic demands than distorting facial features merely for the purposes of ridicule. The same argument was made in the preface to Henry Fielding's *Joseph Andrews* (1742), no doubt in collusion with Hogarth, who was a close friend. Hogarth, it was stated, was not a 'Burlesque painter' but a 'Comic History Painter', who seeks to 'express the Affections of Men on Canvas'. Thus, according to Fielding, Hogarth's figures – resulting from the close observation of Nature – not only 'seem to breathe' but 'appear to think'.[10]

Hogarth's critical fortunes changed dramatically during the nineteenth century. During this time his reputation as the bluff, plain-speaking, patriotic Englishman, whose art was based on instinct and observation rather than learning, was all but set in stone.[11] This reassessment – in many ways as flawed and partial as Walpole's and Reynolds's previously described – developed during an extended period of national crisis and international conflict, the French Revolutionary and Napoleonic Wars (1792–1815), which was more intense even than that experienced during Hogarth's own lifetime. The result was a strong impulse to celebrate past 'British Masters': both Reynolds and Hogarth were, for example, the subjects of public exhibitions at the British Institution in 1813 and 1814 respectively. Another was to locate qualities that distinguished the

FIGURE 13

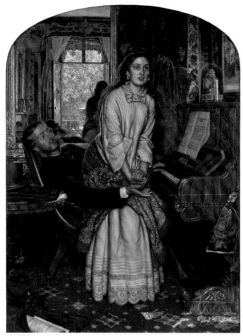

FIGURE 14

British school of art from its French counterpart. One source of national pride was that the classical tradition and academic hierarchy of genres had not taken hold in Britain as it had across the Channel, demonstrated by the thriving school of contemporary-life painters led by David Wilkie (1785–1841). Wilkie was the most innovative genre painter of his generation, who achieved international renown and was admired by such luminaries of French Romanticism as Théodore Géricault and Eugène Delacroix, particularly for his acute and varied characterisations.[12] Nineteenth-century commentators admired the exact same qualities in Hogarth.[13] Unsurprisingly Wilkie was perceived as the Hogarth of his day (despite the fact that his work fused humour and social criticism with Romantic sensibility and pathos). *The Village Holiday* (fig.13), which represents the kind of narrative/moral genre painting that established his reputation, takes the topical subject of drunkenness in society as its theme and the outskirts of London as its setting. The inn itself is based on one situated in Paddington. Wilkie had been inspired by a scene of drunkenness that he had witnessed as he wandered round the city's streets. In this sense *The Village Holiday* exemplifies Hogarth's own emphasis on personal observation and experience as the cornerstone of the artist's practice (see nos.5–6).

Wilkie, more than any other artist, established the fashion in Britain for genre painting during the nineteenth century,

especially narrative genre. But it is possible that he also provided a contemporary context for Hogarth through works such as *The Chelsea Pensioners* and *The Village Holiday*, and thus an opening for a wider audience to appreciate Hogarth's work per se. *The Village Holiday* was, for example, in the collection of John Julius Angerstein, who also owned Hogarth's *Marriage A-la-Mode*. Both were transferred to the National Gallery in 1824 and quickly became the favourite paintings of the British public.[14] This also serves to remind us of the importance of public exhibitions in establishing reputations and stimulating artistic responses, in addition to the ongoing impact of engravings and the print market. For example, the architect John Soane acquired *A Rake's Progress* (no.44) in 1802 and the *Election* series (nos.120–3) in 1823. Both were assigned to his purpose-built museum in 1833 and made accessible to students, artists and members of the public.[15] These permanent displays were supplemented by temporary exhibitions, such as the massive Manchester Art Treasures exhibition in 1857, which included *Southwark Fair* (no.65), *March to Finchley* (no.113), *The Beggar's Opera* (nos.38–9), *David Garrick as Richard III* (no.105) and numerous other works by Hogarth.

It is surely no coincidence that the notable increase in artistic responses and Hogarthian echoes executed in the middle decades of the nineteenth century, and beyond, occurred at the moment when

FIGURE 14
William Holman Hunt
(1827–1910)
*The Awakening Conscience*
1853
TATE. PRESENTED BY
SIR COLIN AND LADY
ANDERSON THROUGH THE
FRIENDS OF THE TATE
GALLERY 1976

FIGURE 15
Edward Matthew Ward
(1816–1870)
*Hogarth's Studio in 1739*
1863
YORK CITY MUSEUMS
TRUST (YORK ART
GALLERY)

FIGURE 16
Steve Bell (born 1951)
*Free the Spirit, Fund the
Party* 1995
COURTESY STEVE BELL

FIGURE 15

FIGURE 16

many more examples of Hogarth's painted works were introduced into the public domain. Benjamin Robert Haydon's *The Mock Election* (1827) and *Chairing the Member* (1828) brought scenes from the *Election* series up to date with topical resonances. Similarly William Powell Frith painted a contemporary series entitled *The Road to Ruin* (1877), which he described as 'a kind of gambler's progress, avoiding the satirical vein of Hogarth'.[16] John Everett Millais explored different aspects of contemporary marriage in a series of drawings entitled *Married for Rank*, *Married for Money* and *Married for Love* (1853).[17] Augustus Egg based his trilogy, *Past and Present* (1858), on a Hogarthian format of 'cause and effect', taking as its subject the discovery of a wife's adultery and its consequences to the family. Similarly William Holman Hunt's *The Awakening Conscience* (1853–4) engages with the contemporary subject of the 'fallen woman', showing a kept mistress with her wealthy lover (fig.14). The scene is set in the parlour of a 'maison de convenance' in north London, the gaudy extravagance of which rivals the Squanderfields in *Marriage A-la-Mode*, as does the plethora of symbolic detailing. And so it goes on. Perhaps not surprisingly, Hogarth became the subject of a number of historical genre paintings during this time. Frith, for example, provided a sequel to Hogarth's *O The Roast Beef of Old England* (no.112) entitled *Hogarth before the Commandant at Calais* (1851). And in 1863 Edward Matthew Ward exhibited *Hogarth's Studio in 1739* (fig.15), with Hogarth

and Thomas Coram hiding behind Hogarth's portrait of Coram on the right, listening to the admiring chatter of visitors and children from the Foundling Hospital, as Mrs Hogarth cuts a cake on the left.

These examples, to a greater or lesser extent, underline the enthusiasm for, and wide-ranging practice in, narrative genre paintings, as well as a 'Hogarthian' engagement with modern urban life, described at the beginning of this essay. But a number also reflect the then prevailing ethos of 'art as moral teacher'. Their association with Hogarth thus highlights another aspect of his life and work that was appropriated and exaggerated by commentators and subsequently entered the popular consciousness, namely Hogarth's identity as the great moral painter of his time. That his cautionary tales were perceived as relevant to a contemporary audience is also underlined by the numerous pamphlets that appeared, such as Reverend T.B. Murray's verse narrative *The Two City Apprentices; or, Industry and Idleness Exemplified; a London History* (1846). Over and above the evidence of his work, Hogarth himself was seen to personify the kind of industriousness, drive for self-improvement and aversion to all manner of voguish 'humbug' that chimed with middle-class attitudes to work and society in general. And his position as a highly suitable role model was heightened by his reputation as a philanthropist and champion of the underdog, as evoked in Ward's fanciful painting.

The modern and contemporary responses to Hogarth by David Hockney, Paula Rego and Yinka Shonibare included in this section underline how adaptable his output continues to be in the present (see nos.9–13). Moreover, Hogarth remains a rich source for graphic satirists, as demonstrated by Steve Bell's use of *Gin Lane* (no.98) in his political cartoon *Free the Spirit, Fund the Party* (1995; fig.16), which deftly conflates Hogarth's celebrated image of a gin-soaked society, the advertising campaign of the 1990s for Smirnoff vodka and Bell's ongoing representation of Prime Minister John Major as a dull version of Superman. But while Hogarth can be recognised as a satirist, a patriot and a political and social commentator – to name but a few of his identities that have been absorbed and discussed up to the present – what of Hogarth the painter? No one who has seen his portrait of *Mrs Salter* (no.89), *The Shrimp Girl* (no.63) and a gamut of other works could possibly doubt that Hogarth was deeply concerned with both composition and surface values, including the application and texture of paint and the nuances of colour. Perhaps the layers of symbolic meaning and narrative that are so crucial to Hogarth's art still distract us from his astonishing abilities with the brush. Others have been more attentive. In the 1880s Whistler's friend and pupil, Harper Pennington described a trip to the National Gallery, where he was immediately drawn to *Marriage A-la-Mode*:

Upon that day, I had supposed that what I was told, and had read, of Hogarth was the truth – the silly rubbish about his being *only* a caricaturist and so forth and so on; so that when I was confronted with those marvels of technical quality, I fairly gasped for breath.

He rushed over to Whistler and exclaimed:

'Why! – Hogarth! – He was a great Painter!' to which Whistler replied, 'Sh-sh!' ... (pretending he was afraid that some one would overhear us). 'Sh-sh-yes! – I know it! ... But don't you tell 'em!'[18]

# 1

*Self-Portrait with Palette* c.1735
Oil on canvas
54.6 × 50.8
YALE CENTER FOR BRITISH ART.
PAUL MELLON COLLECTION

Hogarth seems not to have been a prolific self-portraitist, with only three oil portraits having survived into the present. These remained in the artist's possession and were most likely displayed in his studio. *The Painter and his Pug* 1745 (no.4) and *Hogarth Painting the Comic Muse* c.1757 (no.8) are two of Hogarth's most famous images. Painted neither for pleasure nor for private consumption, they were carefully and deliberately conceived as public statements of artistic achievement, ambition and status. They were thus always intended to be engraved and widely circulated.

This lively, unfinished painting is generally held to be Hogarth's first self-portrait. If the approximate date is correct, he would have been in his mid- to late thirties. As with the other self-portraits, it can be viewed as a self-advertisement. By 1735 Hogarth had achieved fame as an innovative pictorial satirist and carved a niche for himself as a painter, primarily of conversation pieces (see p.95). In the mid-1730s Hogarth took on new and ambitious projects, which were more emphatic declarations of 'the gentleman artist'. His professional and social aspirations were signalled by his move to a residence in the highly respectable Leicester Fields in 1732; above the front door he placed a bust of Van Dyck, the seventeenth-century court painter. After this came his leadership of the St Martin's Lane Academy, re-formed in 1735, and his first attempt at grand history painting at St Bartholomew's Hospital (1734–7). Despite these artistic developments, for most of the 1730s Hogarth was primarily known for his satirical prints. The fact that he wanted to assert his identity as a painter may explain the absence of references to engraving in the self-portrait and the presence of the artist's palette, which, given its cramped position in the lower corner, was perhaps a later addition.

In general terms, the composition presents Hogarth first and foremost as a gentleman, demonstrated by the 'public' costume of a powdered wig, frock coat, white shirt and cravat, accompanied by a pleasing ease of manner and distinct lack of ostentation. A similar tone was employed by the most successful portrait painter in early eighteenth-century London, Godfrey Kneller, in his ensemble of forty-four Kit-Cat Club portraits c.1703–17 (fig.17). Hogarth owned an engraved set of these portraits.[19] Kneller's approach was to simplify the dress, minimising the details of fashion (as well as professional 'attributes'), thus drawing attention to the personalities and decorous poses assumed by the sitters. In the context of early eighteenth-century portraiture the Kit-Cat series are characterised by their gentlemanly informality. Some of the sitters wear shirts opened at the neck, and most are in plain brown or occasionally blue velvet coats (a small group are wearing loose gowns). The vast majority wear periwigs, a standard accoutrement of 'the gentleman' at this time, with a few sporting soft caps (see p.40). What would have made this corporate image of understated gentility and conviviality particularly appealing to an ambitious man like Hogarth is that the sitters include a range of professional men, i.e. publishers, playwrights, essayists and scientists, such as Isaac Newton, Richard Steele, Jacob Tonson (see no.4) and Joseph Addison, who are presented on an equal footing with the aristocratic members of the club. That this kind of representation had become de rigueur for 'gentleman artists' by the 1730s is underlined by Gawen Hamilton's *A Conversation of Virtuosis* 1735 (National Portrait Gallery, London), showing members of a club of artists, including the engraver and antiquary George Vertue (p.40), the engraver Bernard Baron (p.46) and the designer and painter William Kent (p.59).

Importantly, the famous dining club The Sublime Society of Beefsteaks was also formed in 1735, headed by Hogarth and the theatre impresario, John Rich. Thus Hogarth's strategy in his first self-portrait was clearly to present himself as a 'clubbable' gentleman, allowing his ability as an artist to speak largely for itself through the assured, energetic brushwork, the subtle use of colour and tone, and the natural and expressive qualities of his face.

FIGURE 17
Godfrey Kneller
(1646–1723)
*Joseph Addison* 1703–17
NATIONAL PORTRAIT
GALLERY, LONDON

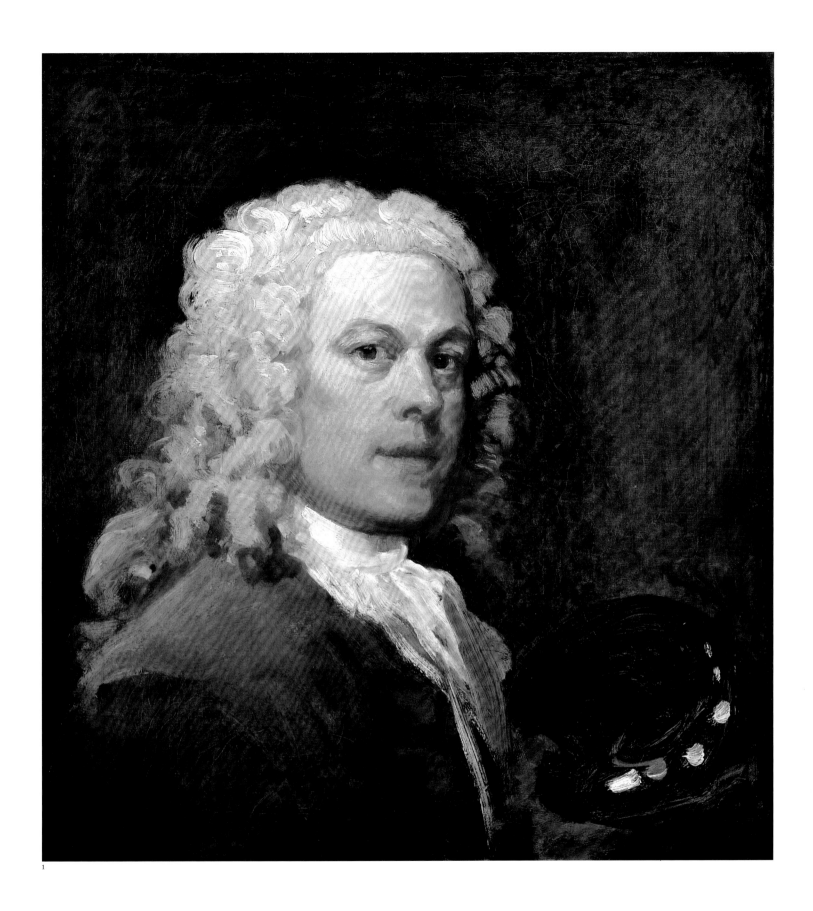

1

# 2

Louis-François Roubiliac (c.1702–1762)
*William Hogarth* c.1741
Terracotta
71.1 high
NATIONAL PORTRAIT GALLERY, LONDON

Roubiliac was one of the foremost foreign artists working in London during Hogarth's lifetime and the leading exponent of a highly expressive and animated style of sculpture, which was thus the antithesis of 'classical' restraint. He was born in Lyons in about 1702. As part of his early training, he may have travelled to Dresden and Rome before entering the Académie Royale in Paris in the late 1720s. After arriving in London in 1730, he promptly associated himself with the Freemasons and the Huguenot community and became a prominent figure in Hogarth's cosmopolitan circle and habitué of Old Slaughter's coffee house. These interrelated

groups and venues provided him with valuable contacts and/or commissions. Roubiliac was also a member of the St Martin's Lane Academy and taught sculpture there in the 1740s.

It was probably via his association with Hogarth and the other Academy members that Roubiliac was commissioned by Jonathan Tyers, owner of the fashionable Vauxhall Gardens, for the statue of the celebrated composer George Frideric Handel. Hogarth was a friend of Tyers and encouraged him to display art at Vauxhall, thus giving Academy artists, such as Roubiliac and Francis Hayman, greater public visibility (the decorations included, for example, authorised copies of two scenes from Hogarth's *The Four Times of Day* series). Roubiliac's statue of Handel was installed in April 1738 and caused an immediate sensation. The life-size figure

was characterised by its expressiveness and informality of dress and pose (conventionally used for bust portraits), which struck commentators as intimate, characterful and dignified. This approach proved highly influential for subsequent portraits by Academy painters, in particular those by Hayman, and may have acted as a cue to Hogarth, especially in his full-length portrait of Thomas Coram (no.84).

Roubiliac was renowned both for his extraordinary technical facility and for capturing a likeness. In 1741 George Vertue noted that the sculptor had modelled 'several Busts or portraits' of the poet Alexander Pope, the architect Isaac Ware, Hogarth and others, which were 'very like' and 'exact Imitations of Nature.'[20] It is generally held that no.2 is the portrait of Hogarth mentioned by Vertue, which remained in Hogarth's possession until his death. He is shown wearing a gown with braid fastenings, a shirt opened at the neck, and a soft cap. The sheer volume of eighteenth-century portraits showing a male sitter in similarly informal, gentlemanly 'undress' underlines the vogue for what Joseph Addison described in 1711 as 'agreeable Negligence'.[21] In the early decades of the century, however, this style of representation in portraiture was associated with virtuosi, artists and the like, who were sometimes shown holding attributes of their professions or intellectual pursuits, or momentarily pausing while reading or composing. The format was more widely adopted during the 1740s.

What Roubiliac brought to this convention, particularly evident in the bust of his friend Hogarth, was an uncanny sense of a momentary state, frozen in time. The turn of his head, the parted lips and attention to the details of the face, which include a long scar above the right eye, makes tangible Hogarth's strength of character, individuality and dynamism, just as the cap pulled jauntily over one ear to reveal the short-cropped hair and the slightly dishevelled shirt lends the portrait both movement and a raffish air, which Hogarth would have undoubtedly enjoyed.

2

# 3

3

Attributed to Jean André Rouquet
(1701–1759)
*William Hogarth* c.1740–5
Enamel on copper
4.5 × 3.7
NATIONAL PORTRAIT GALLERY, LONDON

Rouquet, a member of the Académie Royale
in Paris, was born in Geneva into a family
of refugee French Protestants. He came to
London in about 1722 and worked as a
painter of portrait miniatures in enamel
for the next thirty years. Like Roubiliac,
he was a long-standing friend and associate
of Hogarth. Today he is primarily
remembered as the author of *The Present
State of the Arts in England* (*L'État des Arts en
Angleterre*) published in Paris and London
in 1755, which, as R.W. Lightbourn has
noted, was the only contemporary survey
of English art published between 1730 and
1755.[22] Importantly, Rouquet also authored
two accounts of Hogarth's works in French,
with the intention of promoting sales and
greater appreciation of the artist on the
continent. The first, published in 1746,
was *Lettres de Monsieur [Rouquet] à un de
ses Amis à Paris, pour lui expliquer les
Estampes de Monsieur Hogarth*, which
included commentaries on the engraved
versions of *A Harlot's Progress*, *A Rake's
Progress* and *Marriage A-la-Mode*.[23] The
second, *Description du Tableau de Mr.
Hogarth, qui Represente La Marche des Gardes
à leur rendez-vous De-Finchley, Dans leur
Route en Ecosse*, was published between
1749 and 1750, at which point all four
commentaries were printed in the same
pamphlet. Hogarth included copies of
Rouquet's commentaries when despatching
sets of his prints abroad.[24]

The present portrait miniature,
attributed to Rouquet, is of interest
primarily because of its relationship with
the development of Hogarth's *The Painter
and his Pug* (no.4). Hogarth is shown
wearing a similar costume to that worn in
no.1. Interestingly, there is no artist's palette
or any other indication of his profession.
It thus follows the same formula of plain,
unaffected gentility employed, for example,
in Hogarth's portrait of George Arnold
(no.86). By 1745, however, this kind of
representation (and in particular the style
of wig) would be deemed conservative and
thus sartorially unremarkable. Indeed,
Aileen Ribeiro has recently noted that the
powdered wig, through its wholesale
deployment among the middle and upper
classes, was thought in some quarters to
undermine individuality and character and

was, by its very nature, 'unnatural'.[25]
Importantly, no.3 closely follows Hogarth's
original composition for *The Painter and his
Pug* (no.4). Given that the latter portrait is,
in its finished state, a carefully constructed
manifesto of Hogarth's artistic beliefs, with
an emphasis on innovation, individuality
and 'Nature', it is not surprising that he
decided to rework dramatically the
composition of no.4. In this context, it is
important to note that Hogarth was at this
time formulating his ideas on beauty and
aesthetics that eventually materialised as a
treatise entitled *The Analysis of Beauty* (no.5).

# 4

*The Painter and his Pug* 1745
Oil on canvas
90 × 69.9
TATE. PURCHASED 1824

This commanding self-portrait is one of Hogarth's best-known works. In general terms, the oval, half-length or bust portrait (normally set within an architectural composition) follows a well-established formula for portrait engravings of poets and writers that were used as frontispieces in books. Indeed, Hogarth engraved this work in 1749 as the frontispiece for published folios of his own prints (see p.236). In its original conception (revealed through X-rays of the canvas) Hogarth pictured himself as a public figure in a shoulder-length wig and plain clothes, similar to that exhibited in the miniature portrait shown above (see no.3). This conventional, gentlemanly representation was superseded during the early 1740s by the present image, which emphasises the

intellectual and artistic. Perhaps not surprisingly, given his burgeoning ambitions as an art theorist at this time, Hogarth had chosen to depict himself in 'the practical attire [associated with] the man of letters at work, at home or in the company of intimates'.[26] In addition, the clothes are arranged in such a manner as to appear more generalised or timeless, thus imbuing the sitter with dignity and authority. The line of the red silk morning gown, gathered in folds across Hogarth's chest, is echoed by the green draperies flanking the oval canvas. The fur-trimmed cap with gold-thread tassel replaces the soft cap, which was more frequently seen in portraits of gentlemen dressed *en déshabillé* (as seen in nos.2 and 8) and thus may have been intended by Hogarth as an 'exotic' or quirky flourish.[27]

While the oval format was common in engraved and painted portraiture, the oval self-portrait as part of a still-life composition (although used in engravings)

was more ambitious and unusual in painted form. A seventeenth-century precedent was that executed by the Spanish artist, Bartolomé Esteban Murillo (fig.18). Hogarth may have known the portrait, as it was imported to England in the early eighteenth century. It shows the artist bare-headed and sombrely dressed, looking out towards the viewer, his hand resting on the oval frame. Murillo painted the portrait for his children as a testament to his artistic achievements and status. The composition thus includes the instruments of his profession, a palette, brushes, pencils and a drawing. Similarly, Hogarth includes brushes and a palette in the foreground. In the print version he added an engraver's burin (see no.128).

The foreground of no.4 is dominated by the presence of the dog, which is generally accepted as a portrait of Trump, Hogarth's pug. On one level, this is a humorous, highly personal element of the composition, as Hogarth is said to have often remarked on the physical resemblance between himself

FIGURE 18
Bartolomé Esteban
Murillo (1617/18–1682)
*Self-Portrait* 1670–3
THE NATIONAL GALLERY,
LONDON

Bart.<sup>mt</sup> Murillo seipsum depingens pro filiorum votis acprecibus explendis

FIGURE 18

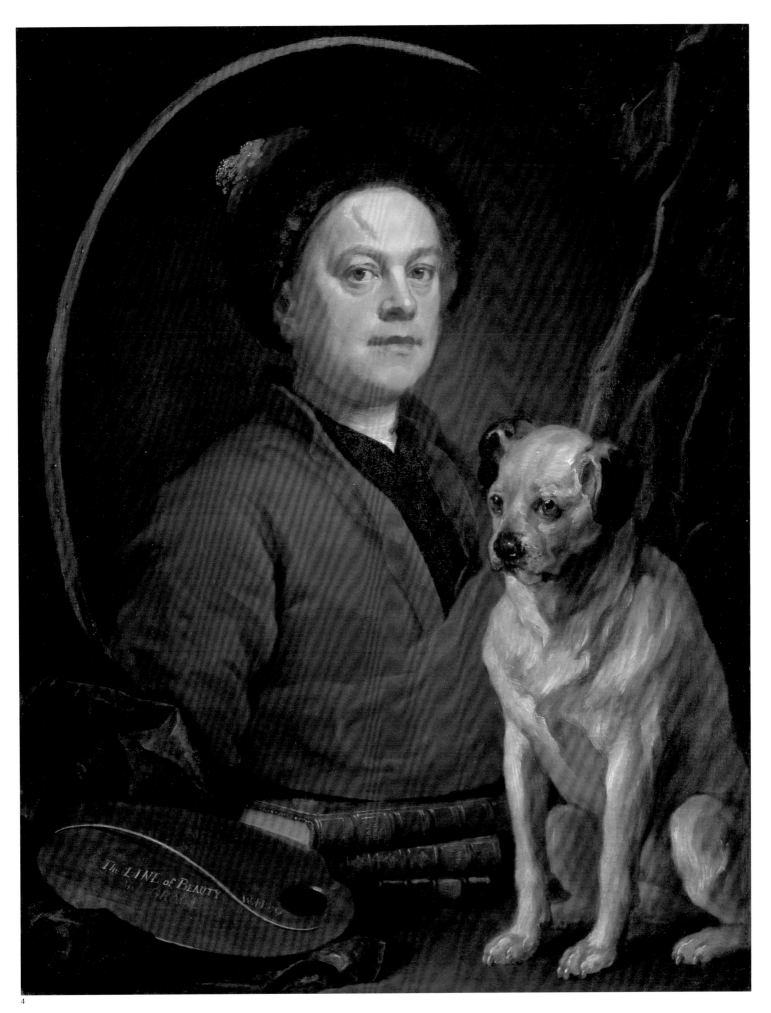

4

and his pet. And it may also represent a pun on the word 'pugnacious', which was one of Hogarth's defining characteristics. In an artistic context, however, the pug may represent 'Nature', the observation of which was key to Hogarth's approach to art and his treatise *The Analysis of Beauty* (no.5). As if to underline the point, Hogarth proudly sports his long scar above his right eye, rather than edit it out as an 'imperfection'.

Thus, while Murillo concentrated on his identity as an urbane and skilful artist, Hogarth's portrait is clearly a more layered and emphatic statement. This is underlined by the inclusion of the three volumes on which his portrait rests. These read 'SHAKE/SPEARE', 'SWIFT/WORKS' and 'MIL[TON]/P[ARADISE]/LOST' respectively on their spines. Hogarth states that his art draws inspiration from, and parallels with, English drama, satire and epic poetry, thus establishing a broader cultural context and national agenda within the self-portrait. In addition, the books may signal Hogarth's ambitions as an author. By 1745 William Shakespeare (1564–1616) was widely perceived as a national hero and representative of a particular brand of English genius. Hogarth created a number of Shakespearean works, including the spectacular *David Garrick as Richard III* (no.105) completed in the same year as the present self-portrait. Importantly for Hogarth, Shakespeare was lauded above all for the power and scope of his characterisations. And his plays embraced a range of theatrical and literary genres, from history and tragedy to comedy and romantic tragic-comedy. In Hogarth's self-portrait, therefore, Shakespeare not only represents the very best of English drama but also 'variety', a key concept in Hogarth's theoretical ideas on beauty in art and nature. Indeed, Hogarth quoted Shakespeare in *The Analysis of Beauty*. Focusing on a phrase gleaned from *Antony and Cleopatra*, Hogarth noted: 'Shakespear[e], who had the deepest penetration into nature, has sum'd up all the charms of beauty in two words, INFINITE VARIETY.'[28]

Like Shakespeare, John Milton (1608–74) was perceived as a cornerstone of the English literary tradition. He wrote *Paradise Lost* (1667/1674) at a time when epic poetry was thought to be a dying art. Importantly, it is a biblical epic composed in the English language, which adapts the conventions of revered classical literature, such as Virgil's *Aeneid* and Homer's *Iliad* and *Odyssey*. Milton's work was soon acknowledged to be a masterpiece. Indeed, the poet and playwright John Dryden (1631–1700), whose own ambitions in epic poetry came to nothing, described it as 'one of the greatest, most noble, and most sublime POEMS, which either this Age or Nation has produc'd', a sentiment echoed by numerous seventeenth- and eighteenth-century British and continental commentators including Voltaire.[29] The high status of the poem and its author was signalled by the publication from 1688 of deluxe, illustrated editions by Jacob Tonson (see no.38). Hogarth's responses to *Paradise Lost* included *Satan, Sin and Death* (1735–40), one of his earliest history paintings (see no.103), and a quotation from *Paradise Lost* featured prominently on the title page of *The Analysis of Beauty* (fig.1).

While Shakespeare and Milton were in many ways obvious choices for Hogarth, the reference to his contemporary Jonathan Swift (1667–1745) is more intriguing. During his long and controversial career Swift, an Anglo-Irishman, was a poet, historian, journalist, political writer and Anglican priest. Most importantly to Hogarth, he was also the outstanding prose satirist of his day. Among his numerous published works were *A Tale of a Tub* (1699/1704), a satire on religious practice and contemporary 'hack' writing (see p.137), and *Travels into Several Remote Nations of the World* (1726), a satire on human pride and pretence in the context of contemporary politics and society. Now familiarly known as *Gulliver's Travels*, it was a huge, if controversial, success and much commented on in Britain and on the continent. Hogarth executed a print within months of its publication, in December 1726 (no.26).

By making reference to Swift, Hogarth was inviting his audience to draw parallels between them as satirists. In 1728 Swift wrote in *The Intelligencer* that 'There are two Ends that Men propose in writing Satyr', which were 'private Satisfaction' and 'a *publick* Spirit', prompting Men of *Genius* and Virtue, to mend the World as far as they are able'.[30] While Swift and Hogarth clearly had personal agendas and played to the crowd in the name of entertainment, they both sought to encourage critical thinking, in the understanding (to quote Michael Suarez on Swift) 'that satire, for all its comic laughter, must lead us to the painful knowledge of the world's falsity and of our own shortcomings'.[31] Despite this highly moral subtext, Swift's work was misunderstood by some as misanthropic and gratuitously vulgar. His mental state was also queried, especially at the time of his death in 1745.[32] Of course, Hogarth's career was not without its controversies, which might be described as an occupational hazard of a satirist. And that he was sensitive to criticism of being a 'Burlesque' or vulgar painter at the time of the present self-portrait is underlined by Henry Fielding's comments in the preface to *Joseph Andrews* (1742) quoted above (see p.33). But Hogarth, as we know, also revelled in the provocative. That he was preparing to be just that within the contentious and rarefied world of art theory is underlined by the 'Line of Beauty' tantalisingly displayed on his palette.

**5**

*The Analysis of Beauty*, London, 1753
Bound volume
THE BRITISH LIBRARY, LONDON

**6**

*The Analysis of Beauty, Plate II*
[*The Country Dance*] 5 March 1753
Etching and engraving
42.7 × 53.2
ANDREW EDMUNDS, LONDON

**7**

Paul Sandby (1730–1809)
*The Analyst Besh[itte]n: in his own Taste* 1753
Etching with engraving
Cut to 26.3 × 18
ANDREW EDMUNDS, LONDON

Hogarth published *The Analysis of Beauty* in 1753. That his ideas on beauty in art and nature had been developing from at least 1745, however, is underlined by the opening pages of the treatise. Here Hogarth describes how he had published a frontispiece, the print version of *The Painter and his Pug* (no.4), to his engraved works, which included a 'serpentine line' on the palette called 'THE LINE OF BEAUTY'. 'The bait soon took,' he continues, 'and no Egyptian hieroglyphic [*sic*] ever amused more than it did for a time, painters and sculptors came to me to know the meaning of it, being as much puzzled of it, as other people, till it came to some explanation.'[33] To an extent, *The Analysis of Beauty* was born out of discussions that Hogarth had had with his fellow artists at St Martin's Lane Academy and within the cosmopolitan environment of Old Slaughter's coffee house. And he certainly received advice on the text, especially from the scholar, critic and librettist Dr Thomas Morell. However, the finished product is fundamentally Hogarth's, with the clear intention of establishing him as a highly original thinker, as well as offering a theoretical context for his art.

The world of European aesthetic debate was rarefied and contested, and its pitfalls were amply demonstrated by Paul Sandby's acerbic satirical responses to *The Analysis of Beauty* (no.7; see also p.20). Hogarth would have known such books as *The Idea of a Perfect Painter* (English translation 1706) and *Cours de peinture par principes* (1708) by Roger de Piles, and *Essay on the Theory of Painting* (1715) and *Two Discourses* (1719) by the painter Jonathan Richardson. And he underpinned his intellectual credentials by referring within the text to the Italian Renaissance painter and art-theorist Gian Paolo Lomazzo and the 3rd Earl of Shaftesbury, who published the moral theory entitled *Characteristicks of Men, Manners, Opinions, Times* in 1711. That Hogarth was courting controversy with his treatise was demonstrated at the beginning, where *The Analysis of Beauty* was described as both an attempt to fix 'the fluctuating IDEAS on TASTE' and an alternative to the classicising aesthetic of the 'Connoisseurs'. This theoretical position was demonstrated

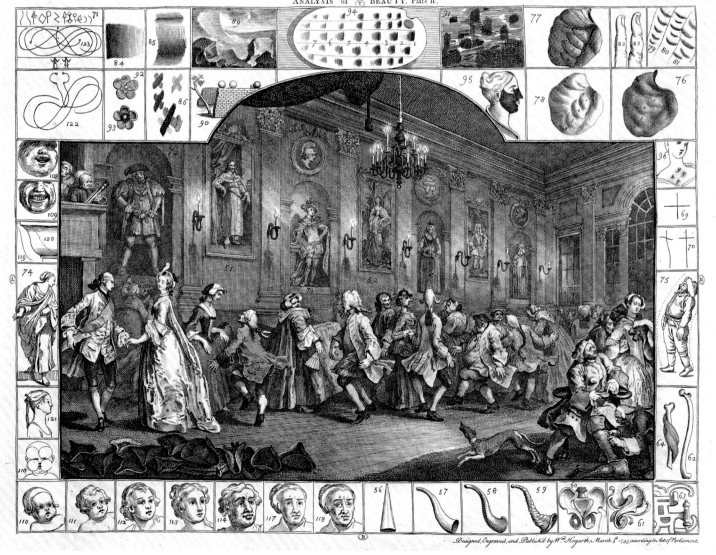

by the serpentine line that featured on the title page (see p.13) and was held by Hogarth to be the essence of beauty, as opposed to the straight lines that were emblematic of classicism and the vulgar, exaggerated curve, both of which lacked 'variety'. Hogarth also advocated the empirical observation of Nature as a cornerstone of artistic practice, noting that artists, in particular those who had studied in Rome, were 'apt to pursue the shadow, and drop the substance' and thus 'take the infectious turn of the connoisseur, instead of the painter'.[34]

Hogarth's emphasis on 'looking' was underlined by two prints that accompanied *The Analysis of Beauty*, now known as *The Sculptor's Yard* and *The Country Dance*. These were referred to throughout the text, their function being 'to point out to the reader what sorts of objects he is to look for and examine in nature, or in the works of the greatest masters'.[35] The first plate is dominated by the scene of a sculpture yard (see fig.2), thought to be one owned by John Cheere at Hyde Park Corner. The works displayed include casts after revered classical sculptures, which were a staple in study collections at art academies such as the St Martin's Lane Academy, as well as featuring in gardens and elsewhere. The central scene of the second plate (no.6) shows a dance staged in an assembly hall hung with portraits of British monarchs. The overarching theme is movement and the shape of the human body. The elegant couple on the left represents the ideal, their bodies forming a series of serpentine lines. The other dancers act as a foil to them through their clumsy, graceless movements and figures.

The second plate thus underlines that *The Analysis of Beauty* was not a treatise purely for the consumption of an art-privileged audience but an accessible and entertaining publication for 'the Curious and Polite of both Sexes, by laying down the Principles of personal Beauty and Deportment, as also of Taste in general'.[36] In this sense Hogarth's *Analysis* resembles eighteenth-century conduct books, such as *The Dancing-Master; or, The Art of Dance Explained* (1728) by John Essex and *The Rudiments of Genteel Behaviour* (1737) by the French dancer Francis Nivelon.[37] Hogarth's commentary, which is often anecdotal, continually underlines the importance of personal experience and observation in the implementation of his ideas. For example, Hogarth encourages the reader to move through London's streets appraising

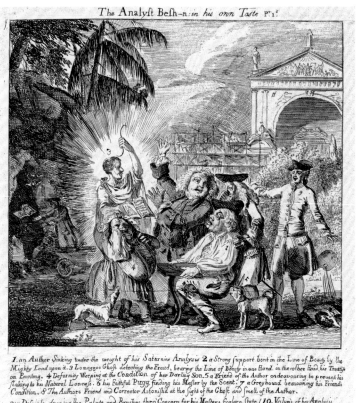

perspective views in the context of 'variety' and 'the line of beauty', and even discusses specific buildings and events, such as St Paul's Cathedral and Bartholomew Fair. In so doing, he also suggests a similar method of appreciating his own urban scenes, such as *Southwark Fair* (no.65).

The emphasis on personal observation also extends to social interaction. His discussion on 'intricacy', for example, is illustrated by his observations of a country dance, 'particularly when my eye eagerly pursued a favourite dancer, through all the windings of the figure, who then was bewitching to the sight'.[38] Thus the moving female figure is not only appreciated as a pleasurable spectacle but results in a 'kind of chace [sic]' between it and the eye of the spectator. Such comments were calculated to make links between beauty and nature, and visual sensation and sexual attraction, with a living woman rather than an idealised, classical sculpture as the focus (see p.126).[39] *The Analysis of Beauty* was thus a complex, innovative and thoroughly modern theory on art, beauty and life.

# 8

*Hogarth Painting the Comic Muse* c.1757
Oil on canvas
45.1 × 42.5
NATIONAL PORTRAIT GALLERY, LONDON

On 16 July 1757 Hogarth was awarded the title of Serjeant Painter to the King, which prompted the present self-portrait. The position had previously been held by James Thornhill and then, after his death in 1734, by Thornhill's son, John. While lucrative and an acknowledgement of Hogarth's pre-eminent position in London's art world, it was by no means the most prestigious artist's appointment at court, as it came under the Board of Works. Hogarth thought enough of the honour to add to the print version of no.8 the title of 'Wm Hogarth / Serjeant Painter to His Majesty'. The print was used as a frontispiece to bound volumes of Hogarth's works. This title may have been tinged with irony, however, as the print also includes a paint pot, which as Jenny Uglow has noted, is similar to the one held by the jobbing sign-painter in *Beer Street* (no.98).[40]

Despite such ambiguities, the finished portrait presents us with a robust image of Hogarth as a painter. In general, the composition follows a long established format of the artist at work. For example, it has been suggested that Hogarth may have taken a cue from Rembrandt's early self-portraits, especially *The Artist in his Studio* (Museum of Fine Arts, Boston, c.1628). Hogarth would also have known Francis Hayman's genteel self-portrait of 1750, in which Hayman presented himself seated at an easel, brush and palette in hand (Royal Albert Memorial Museum, Exeter). While the composition of no.8 is essentially different to *The Painter and his Pug* (no.4), being a full-length image of the artist 'in action', there are a number of parallels between the two works as self-advertisements. In a formal context, Hogarth's figure shows the same naturalism and individuality evident in no.4. The exposed shaved head, forward-tilting body, gently splayed legs and palette knife poised ready to begin the application of paint suggest that Hogarth is totally absorbed in what he is doing, rather than striking a more conventional, decorous pose. His elegant, curvilinear armchair, while a fashionable piece of furniture for the 1750s, also serves to remind the viewer of the serpentine 'Line of Beauty' that was central to Hogarth's thesis on beauty, art and aesthetics and that he applied to the everyday, including furniture. Indeed, the engraved version of no.8 also included a volume of *The Analysis of Beauty*, propped up against the easel. The range of carefully rendered oil colours on Hogarth's palette may also be an allusion to the chapter 'On Colouring' within *The Analysis of Beauty*, in which Hogarth stated 'that the utmost beauty of colouring depends on the great principle of varying by all the means of varying, and on the proper and artful union of that variety'.[41]

Finally, the figure that Hogarth has sketched on the canvas is Thalia, the classical Muse of Comedy. She holds a book, representing Rhetoric, under her arm and a mask of Comedy in her left hand. The mask, of course, is additionally reminiscent of the theatre, which Hogarth considered central to his modern moral subjects (see p.27). The figure of Thalia thus personifies comedy in its most elevated form. What Hogarth sought to represent in this self-portrait was the very essence of his identity as an artist, mirroring Fielding's earlier declaration that his friend, the 'ingenious Mr Hogarth', was a 'Comic History Painter' (see p.35).

8

# 9

David Hockney (born 1937)
*A Rake's Progress* 1961–3
Series of sixteen prints
Etching and aquatint,
Each approx. 30 × 40
TATE. PURCHASED 1971

1. *The Arrival*
1a. *Receiving the Inheritance*
2. *Meeting the Good People (Washington)*
2a. *The Gospel Singing Good People (Madison Square Gardens)*
3. *The Start of the Spending Spree and the Door Opening for a Blonde*
3a. *The Seven Stone Weakling*
4. *The Drinking Scene*
4a. *Marries an Old Maid*
5. *The Election Campaign (with Dark Message)*
5a. *Viewing a Prison Scene*
6. *Death in Harlem*
6a. *The Wallet Begins to Empty*
7. *Disintegration*
7a. *Cast Aside*
8. *Meeting other People*
8a. *Bedlam*

9 4a MARRIES AN OLD MAID

David Hockney was born in Bradford in 1937, and came to prominence in the British Pop art movement of the 1960s, working as a painter, graphic artist and printmaker. As a student at the Royal College of Art in London, Hockney was fully aware of the graphic work of Hogarth in telling a cautionary tale. In the summer of 1961 the artist travelled to New York City for the first time, a trip that informed the content of a series of sixteen etchings based on Hogarth's *A Rake's Progress*. Hockney later wrote: 'To any English art student, William Hogarth is a great artist. It always seemed to me that he had a very human eye. He understood mankind's follies and had a soft spot for them, but his work also shows a certain delight in condemning low life.'[42]

As in Hogarth's work, the series is a progressive narrative tale concerning a loss of innocence, but set in modern times. The artist had planned to follow the structure of the original series and produce eight plates, but was encouraged to increase the amount so that they could be published as a book. The first plate shows the young Hockney arriving in New York, confronted with the skyscrapers of the metropolis. He is almost immediately forced to sell one of his works to a collector who bargains a 20 per cent discount. Testing the adage that blonds have more fun, he dyes his hair, but remains insecure when confronted with the physical beauty of two male athletes. Drinking and a marriage of convenience (no.9, 4a)

compound his disintegration, a descent that ends in a private hell, a modern technological Bedlam in which he is a mere automaton without any freedom or individuality.

Though not used by Hogarth in any autobiographical sense, the *Rake* has been identified by contemporary artists as an appropriate vehicle to present and visualise their own personal experience. Like Hockney, the Scottish artist Peter Howson (born 1958) also used Hogarth's *Rake's Progress* in a semi-autobiographical manner as the basis for his series *The Rake's Progress* (1995) – the narrative tale of the fall of the rake emulating aspects of the life of the artist at this time – as well as drawing on Stravinsky's opera of the same title (see nos.10–11). The final scene of Howson's seven-part series, *A night that never ends* (fig.19), is closest in its composition to Hogarth's original, showing the rake in Bedlam. The rake is presented lying, slightly upright, in the foreground; three barred windows run the length of the side wall of the cell; a figure with a pointed hat is pictured alongside the rake – all visual features that mirror Hogarth's earlier design. TB

FIGURE 19
Peter Howson (born 1958)
*A night that never ends* 1995
FLOWERS EAST, LONDON

# 10

David Hockney
*Programme cover for the Glyndebourne Festival Opera production of* The Rake's Progress 1975
Offset lithography on paper
30 × 25
TATE LIBRARY AND ARCHIVE

# 11

David Hockney
*Poster for the San Francisco Opera production of 'The Rake's Progress'* 1982 featuring Hockney's design for the 'Bedlam' scene
Ink on paper
99.1 × 86.4
PRIVATE COLLECTION

10

11

In the summer of 1974 David Hockney was asked to produce designs for the forthcoming Glyndebourne Festival Opera production of *The Rake's Progress*. Stravinsky had used Hogarth's original tale for his opera, completed in 1951, with a libretto written by W.H. Auden and Chester Kallman. The invitation came at an opportune time for the artist as he was looking for alternatives to the compulsive pursuit of academic drawing that had overcome him, and this project provided the vehicle for his release into a more adventurous style. In an attempt to convey his ideas as comprehensively as possible, Hockney not only produced drawings but also made scale models of the sets.

Hockney studied both the libretto and Hogarth's original series of paintings and prints in great depth for inspiration. He also looked beyond this individual series to Hogarth's work as a whole. Indeed, Hogarth's method of design for the prints accompanying *The Analysis of Beauty* (no.6, fig.1) – having a central tableau with boxes containing studies around the edge – had a great bearing on Hockney's initial design for the drop curtain of the production (fig.20). Small details of the musical score, colours and etching technique are contained in boxes beneath the introductory design. Hockney also made a feature of these

studies for the cover of the programme accompanying the production (no.10) and in the final scene of the opera showing the rake in Bedlam, although here the elements are released in anarchic disarray from their containment. The characters in Hockney's *Bedlam* scene refer back to Hogarth's original, such as the figure wearing a pointed hat with crosses on it and the musician with a musical score on his head. For the decoration of the interiors Hockney turned to elements of Hogarth's early series *Hudibras* (nos.28–34), most notably the bizarre stuffed crocodile hanging from the ceiling, taken from *Hudibras and Sidrophel* (1725/6).

Hockney took inspiration from Hogarth's original prints, not only their composition, design and aesthetic but also their technique. Crosshatching, a method so prominently used by Hogarth in his graphic work, was also employed by Hockney in an exaggerated scale on the architectural elements and costumes throughout the design. However, Hockney expanded on the usual monochrome of graphic work by introducing colour, though based on the standard printing colours of the period: red, blue, green and black. In directly

referencing the eighteenth-century work, Hockney mirrored Stravinsky's approach to the score, which was written in a classical mode looking back to the age of Mozart. In addition, Hockney's design compliments the jagged linear character of Stravinsky's music.

Hockney's research into the work of Hogarth for the production of these designs led him to produce the painting *Kerby (after Hogarth) Useful Knowledge* (1975), in the collection of the Museum of Modern Art, New York. Based on Hogarth's print *Satire on a False Perspective* 1754, it presents, at first glance, a harmonious rural scene. However, on closer inspection one notices that the false use of perspective causes many anomalies, such as figures in the foreground impossibly interacting with those in the background. *Kerby*, and the influence of the print by Hogarth, marked a key moment in the development of Hockney's art. The treatment of space is entirely subjective and the traditional values of perspective are suspended, yet the painting remains convincing in its verisimilitude. This was to be a feature of much of Hockney's subsequent work. TB

FIGURE 20
*Design for the Drop Curtain*
ARTS COUNCIL

FIGURE 21
*Brothel Scene from*
The Rake's Progress
*as performed at
Glyndebourne Festival
Opera* 1975 (Tom
Rakewell: Leo Goeke;
Mother Goose: Thetis
Blacker; Nick Shadow:
Donald Gramm)
ARTS COUNCIL

FIGURE 20

FIGURE 21

# 12

Paula Rego (born 1935)
*The Betrothal: Lessons: The Shipwreck, after*
*'Marriage a la Mode' by Hogarth* 1999
Overall display 165 × 500
Pastel on paper and aluminium
TATE. PURCHASED WITH ASSISTANCE FROM
THE NATIONAL ART COLLECTIONS FUND
AND THE GULBENKIAN FOUNDATION 2002

Born in Lisbon in 1935 and trained at the
Slade School of Art, London, from 1952 to
1956, Paula Rego first attracted widespread
interest in Britain following a retrospective
exhibition of her figurative painting in
London in 1988. As a painter and graphic
artist, Rego's work is narrative in its format,
her imaginative subjects drawn largely
from childhood memories, nursery rhymes,
fantasy and fairy tales. Difficult and
controversial scenarios from human
experience often feature in her work, such
as the *Abortion Series* (1999), powerful and
haunting in its emotive charge.

*The Betrothal: Lessons: The Shipwreck, after*
*'Marriage a la Mode' by Hogarth*, a large-scale
pastel triptych, was produced by Rego for
the exhibition *Encounters: New Art from Old*,
held at the National Gallery, London, in
2000. The exhibition curators invited
contemporary artists to make new work
in response to paintings in the National
Gallery collection, and Paula Rego chose
Hogarth's *Marriage A-la-Mode*. The artist
takes the theme of the narrative, an

arranged marriage, and transposes it to her
native Portugal in a time curiously mixing
the 1950s and 1980s.

The left-hand panel, *The Betrothal*, is
based on the first painting in Hogarth's
series, *The Marriage Settlement*. Rego shows
the mothers brokering the marriage (rather
than the fathers, as in Hogarth's original)
with the husband overlooking the events
reflected in the mirror. The social structure
is also reversed, as here it is the girl's family
who have fallen on hard times, the boy's
nouveau-riche mother having been the
former maid. The young intended bride
slumbers in a red armchair, while her
prospective groom in his best suit crouches
behind his mother, clinging to her
protectively. As with Hogarth's original
painting, the boy and the girl, the two
protagonists of the proposed marriage,
show no interest in each other whatsoever.
An image in the background indicates what
the future holds for this ill-arranged
relationship, devoid of affection or respect –
a scene in which a girl is raped by her suitor.

The central panel, *Lessons*, refers to
Hogarth's fourth painting in the series, *The*
*Toilette*. Hogarth's scene of hair crimping is
transposed to a modern-day beauty parlour
where the girl's mother is having her hair
done. The daughter looks admiringly at her
mother in the mirror, seeing in her what she
hopes she might become. The mother takes
a controlling influence over the education of

her daughter, teaching her all she needs to know
about looking good – the 'tricks of the trade',
so to speak. As the artist has commented,
'My scene differs from Hogarth's ... because the
girl is not yet married. She is still learning.'[43]

The right-hand panel, *The Shipwreck*, is based
on Hogarth's fifth painting of the series, *The*
*Bagnio*. The tragic scene of Hogarth's painting
in which the earl is killed is represented by the
artist as a contemporary *pietà*, the pathetic
figure of the husband cradled by his wife as she
sits in their desolate dwellings. The story has
moved on some time and things have changed
considerably, the dreadful condition of the room
symbolising the state of their relationship. They
are shown alone, the family that brought them
together having deserted them in their hour of
need. Rego explains:

In my story what has happened is that he's
spent all their money. There they are in
the leftovers of what they own. They've
had to sell the rest of the property ...
Anyway, everything has been dissipated.
But, despite the misfortune, she's holding
him on her lap to comfort him. The blind
cat's there to defend them against the
world. In Hogarth's last scene, The Lady's
Death, the Countess kills herself, but my
woman is left to do the clearing up and get
things back to normal.[44]

TB

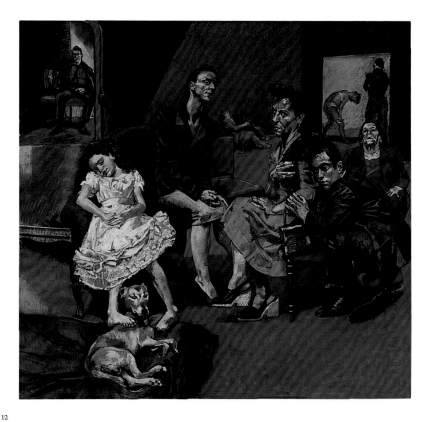

12

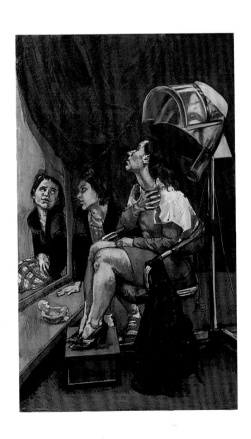

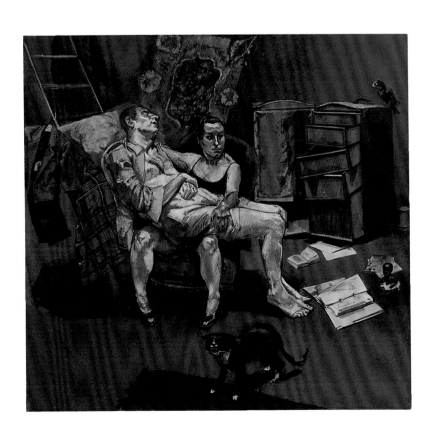

# 13

Yinka Shonibare (born 1962)
*Diary of a Victorian Dandy: 11.00 hours, 14.00 hours, 17.00 hours, 19.00 hours, 03.00 hours*
1998
C-type photographic prints, each 183 × 228.6
COLLECTIONS OF PETER NORTON AND
EILEEN HARRIS NORTON, SANTA MONICA.
COURTESY OF STEPHEN FRIEDMAN
GALLERY, LONDON AND JAMES COHAN
GALLERY, NEW YORK

Yinka Shonibare grew up in London and Lagos, Nigeria, and in 2004 was nominated for the Turner Prize. Much of his work focuses on notions of representation and identity, mediated through the art and culture of the eighteenth and nineteenth centuries, for example in his installation *The Swing (after Fragonard)* (2001; Tate). In 1998 Yinka Shonibare was commissioned by the Institute of International Visual Arts (InIVA) to produce a new work to be displayed on the London underground. This resulted in the series of five photographs collectively known as the *Diary of a Victorian Dandy*. Among other influences, the work is loosely based on Hogarth's earlier series *A Rake's Progress*. However, Shonibare inverts traditional modes of representation by casting himself, a black man, in the central role of the dandy. As with Hogarth's original, the series is a progressive narrative tale. However, rather than stretching over an extended period of time, the events happen within one day. In this respect it mirrors Hogarth's other series, *The Four Times of Day* (no.67).

*Diary of a Victorian Dandy* begins with *11.00 hours* showing the dandy in his sumptuous bed as he awakens late in the morning, a number of chamber maids and a valet attending to his every need. By *14.00 hours* he is in an impressive library, centre stage, holding forth among his admiring friends. *17.00 hours* shows a similar scenario, this time set in the billiard room – the dandy sparring with a fellow in sport and his contemporaries looking at him in awe. Later that evening, at *19.00 hours*, the dandy has the ladies and gentlemen of the household captivated in the opulent drawing room, entertaining them following dinner. The early hours of *03.00 hours* descend into an orgiastic scene of sexual excess and abandon, a time that Hogarth had previously chosen for Scene 3 of *A Rake's Progress*. This, too, is a scene of debauchery. All the scenes are highly orchestrated and finely composed, the exaggerated gestures and postures of the figures mirroring the theatricality of Hogarth's work.

Unlike Hogarth's version it does not represent the decline and fall of the individual portrayed, but revels in the leisure, opulence and luxury of the events and environment. It therefore does not share

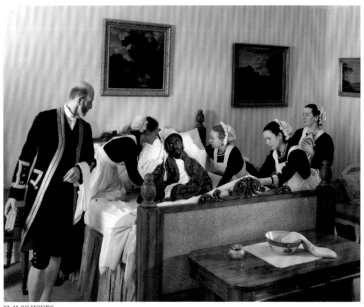

13 11.00 HOURS

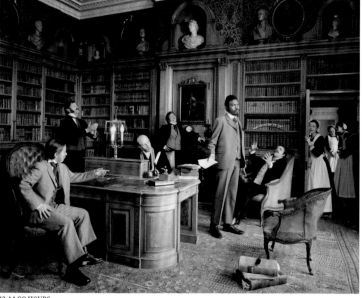

13 14.00 HOURS

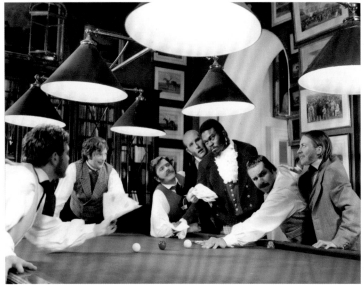

13 17.00 HOURS

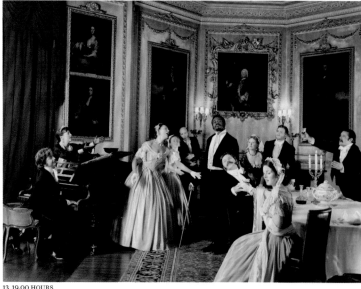

13 19.00 HOURS

Hogarth's overt moral message conveyed through the actions of the main character, but the presence of the central black figure suggests other issues at work in the decadent display. From the early eighteenth century Britain became increasingly rich from its imperial activities, reaching its apogee in the late nineteenth century. The epicurean world that the dandy occupies displays the fruits of the empire, from the silks of ladies' gowns to the ivory billiard balls in the games room. Much of this wealth was underpinned by the lucrative trade in African slaves and the highly profitable businesses, such as sugar production, to which it was linked.

The unusual figure of the black dandy highlights the contrast in the ordinary experience between the races in this period, and the disparity in social and economic standing between blacks and whites. The position of the vast majority of black people in society is reflected in their representation in eighteenth-century paintings, including Hogarth's, where they are seen by the artist as generally anonymous and part of the crowd. Shonibare overturns this hierarchical tradition, moving the black man from the periphery to centre stage. As the artist himself has stated:

> In Diary of a Victorian Dandy, I wanted to explore the history of the representation of black people in painting, who usually occupied not very powerful positions, as in Hogarth's work. Therefore, in my photographic tableaux I wanted to recreate a history of art from fantasy, where interpreting the role of the protagonist I used my own image of a black person in order to reverse the state of things.[45]

TB

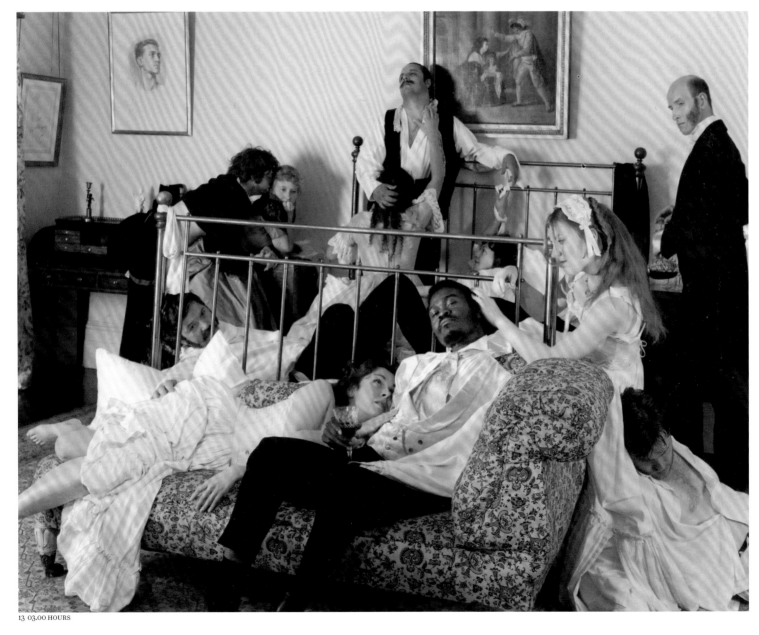

13 03.00 HOURS

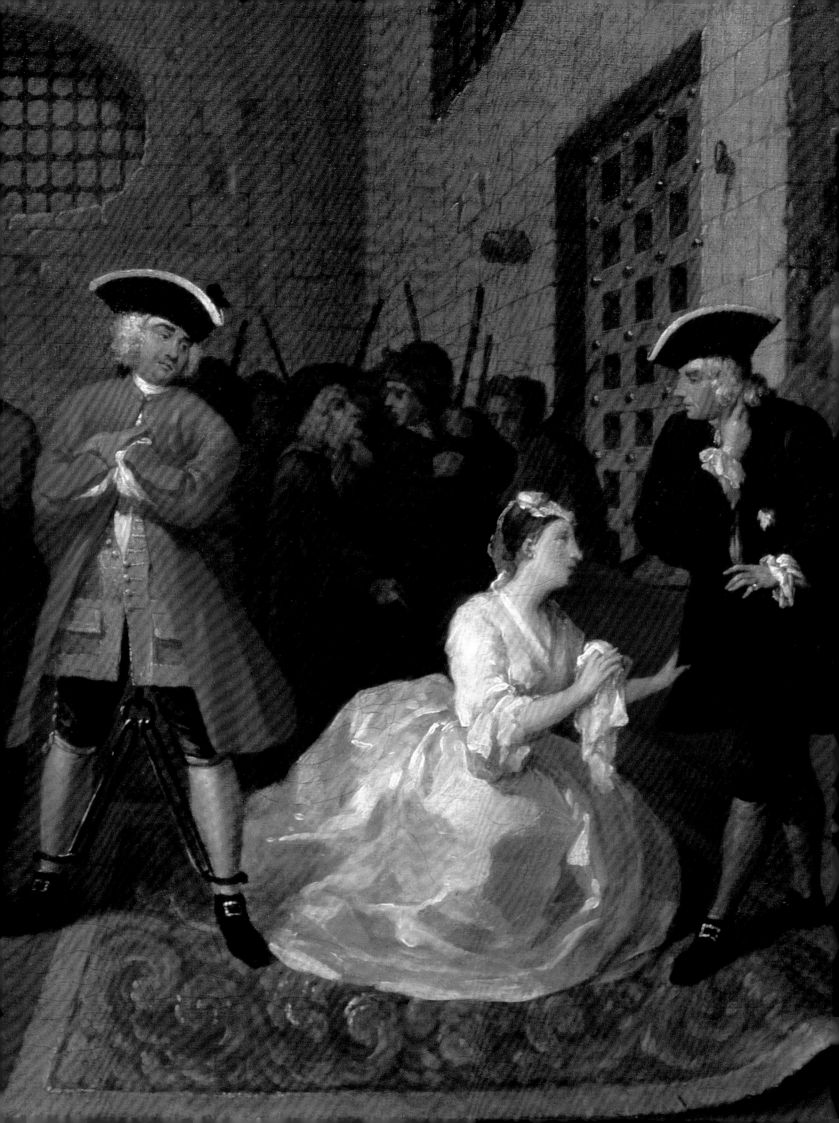

# 2
# Pictorial Theatre: The 1720s

*Mark Hallett*

On 12 June 1730 the jobbing poet Joseph Mitchell finished writing the first of three 'Poetical Epistles' celebrating 'Masters in the Art of Painting' in England.[1] The poem, which was published the following year, was devoted to the art of William Hogarth. Mitchell's piece confirms that Hogarth, only a decade after setting up as an independent artist in London and two years before the display and publication of his celebrated *Harlot's Progress*, was already being fêted as a leading artist in the capital. Mitchell declares that

> Self-taught, in your great art excel,
> And from your rivals bear the Bell

and goes on to laud Hogarth's brilliance at capturing facial expression, his unique fusion of Dutch and Italian pictorial styles, and his sensitivity to all aspects of contemporary society:

> Painting alone is not your Praise
> You know the World, and all its Ways.
> Life, high and low, alike command,
> And shew, each work, a Master-
> Hand.[2]

However hyperbolic, Mitchell's verses usefully indicate the range of skills admired in Hogarth, and the variety of subjects – both high and low – that he was seen to have successfully tackled. This remarkable versatility was only partly the product of Hogarth's own innate abilities, however. It was also the result of an artistic training and development that had been unusually diverse, and that produced someone who, by the time Mitchell had penned his poem, had become exceptionally adept in two quite distinct artistic spheres.

Hogarth began his career as an engraver, and in his late, unpublished 'Autobiographical Notes' he declared that 'engraving on copper was at twenty [my] utmost ambition'.[3] Having spent a number of years apprenticed to the silver plate engraver Ellis Gamble, Hogarth achieved his goal in 1720. In that year, at the age of twenty-two, he opened his own shop and studio, and published his own trade card, proudly emblazoned 'William Hogarth, Engraver' (no.14). The world of printmaking that he was now entering was crowded and competitive, geared to a city in which the display of graphic art was one of the backdrops of everyday life. London was full of places where prints were exhibited, perused and purchased. Printshops and bookshops dotted the centre of the city, spilling their graphic wares out onto the capital's streets. Coffee houses regularly held print auctions, in which thousands of locally produced and imported etchings and engravings were exhibited and sold. Finally, English and European engravers working in the capital typically ran shops making their work available to passers-by. This world of graphic art was not only highly visible at street-level; it expressed itself on a daily basis in the capital's newspapers, where individual prints, and sales of prints, were continually being advertised and described, often in great detail.[4]

In making his way within this environment, Hogarth, as well as producing the kind of work that was typical of his profession – book illustrations, trade cards and the like – soon began to specialise in graphic satire. This particular genre of printmaking, long established in London, typically combined humorous, acidic commentary on contemporary issues with a highly eclectic form of pictorial practice, often involving the witty juxtaposition of different visual and textual materials drawn from a wide range of sources. Graphic satire allowed the individual engraver an unusual degree of artistic independence and creativity, offering as it did an alternative to the more conventional task of reproducing existing images, whether painted or engraved. The graphic satire that Hogarth produced in the 1720s saw him engaging with the great social and political issues of his time, ranging from the South Sea Bubble crisis to the fashionable craze for masquerades, and developing a highly experimental and self-consciously allusive form of printmaking. This kind of satire also helped him gradually build a distinctive reputation within the world of printmaking, so that by the end of the decade he was widely recognised as someone whose graphic art, in the words of contemporary newspaper advertisements, was especially 'diverting', 'rare' and 'curious'.[5]

As well as pursuing his ambitions as an engraver during the 1720s, Hogarth entered the world of painting, which enjoyed a similarly cosmopolitan and urban character to that of printmaking. The painters based in London in the opening decades of the eighteenth century made up a relatively small community of native and foreign-born artists. In the absence of any substantial form of court, state or religious patronage, and in the face of a strong degree of prejudice about the worth of locally produced painting, this community sought

*A Scene from 'The Beggar's Opera'* 1731 (no.39, detail)

to advance its artistic status and commercial profile through the formation of informal academies of painting in the capital. At the Academy of Painting in St Martin's Lane, which he joined soon after setting up shop as an engraver, Hogarth had the opportunity not only to become adept in a new art form but also to learn the etiquette and manners required for success in a milieu that tended to be more urbane than that centred around the engraver's workshop. The Academy was a gentleman's club as much as it was a teaching institution, and there a young artist such as Hogarth had the chance to rub shoulders with established painters, meet visiting connoisseurs and woo potential patrons.[6]

Towards the end of the decade this alternative, more informal kind of apprenticeship began to pay off for Hogarth, as he started selling paintings as well as prints. Significantly, these were not for single-figure portraits, which most aspirant painters tended to specialise in, but for rather more innovative types of work. They include paintings such as *The Denunciation* (no.35) and *The Christening* (no.36), which fuse the traditional vocabulary of Dutch genre painting with the contemporary preoccupations and forms of pictorial satire. Such paintings are noticeable not only for their darkly comic focus on deviant sexuality, professional corruption and fashionable excess but also for their concentration on highly theatrical forms of legal and religious exchange, in which groups of spectators gather around men and women acting out choreographed forms of ritual. This kind of pictorial theatricality – something that is also a distinctive feature of the graphic satires produced by Hogarth in the first decade of his career – was made even more explicit in another type of canvas produced by the artist at the end of the decade: paintings such as *Falstaff Examining his Recruits* (no.37) and the famous *Beggar's Opera* series (nos.38–9) in which Hogarth painted subjects drawn from canonical and contemporary drama. These theatrical pictures established an entirely new genre within English painting, in which, for the first time, the dramatic works of writers such as William Shakespeare and John Gay were translated into painted form. At the same time they reveal the rapid development of Hogarth's skill in using the human figure to create intricate, flowing forms of pictorial narrative and see him promoting himself as both an exceptionally inventive pictorial satirist *and* a highly refined painter.

# 14

*Shop Card* 1720
Engraving
7.6 × 10.2
THE BRITISH MUSEUM, LONDON

14

The trade card was a ubiquitous feature of commercial life in eighteenth-century London, and Hogarth was to produce a number of such cards in the early years of his career. As well as announcing his entrance into the London print market in the spring of 1720, his own card functioned to advertise his skills as a 'penman', a term used by contemporaries to denote someone who was equally adept at engraving lettering and imagery. His name and profession are inscribed with a calligraphic flourish, and are surrounded by pictorial details suggestive of elegance, learning and invention. The gracefully posed figure of Art and the intellectually active figure of History stand on either side of the card; a cherub signifying Design holds aloft an architectural drawing; and a richly gilded frame is adorned with heavy swags, two sculpted heads, and an elaborate cartouche. However modest in scale and significance compared to his later work, this card has an allegorical and decorative richness that suggests the unusual extent of Hogarth's artistic ambitions right at the beginning of his career.

# 15

*Ellis Gamble's Shop Card* c.1723
Engraving
7.5 × 6
THE BRITISH MUSEUM, LONDON

Before embarking on a career as an independent engraver in 1720, Hogarth had been apprenticed to the silver-plate engraver Ellis Gamble, from whom he learnt many of the basic skills of his craft. Although the younger artist broke off his apprenticeship before it was due to end and turned to the more promising activity of copperplate engraving, his production of this trade card in 1723 suggests that relations between the two men remained cordial. In this handsome card, which announces his old master's advance to the status of a 'goldsmith', Hogarth depicts the 'Golden Angel' that identified Gamble's premises and that was presumably to be found standing above the shop's exterior. Hogarth's increasing facility with the engraver's burin is demonstrated by the stipple on the angel's neck and the cross-hatching that shadows her wing, as well as by the variety of line he uses for the clouds that scud across the background. The French text that occupies the right-hand side of the caption, and that aligns Gamble with the prestigious community of Huguenot goldsmiths who had settled in London, indicates the extent to which Hogarth's career developed in the context of a cosmopolitan urban culture crowded with European artists and artisans.

15

# 16

*The South Sea Scheme* c.1721
Etching and engraving
Cut to 26.5 × 32.7
ANDREW EDMUNDS, LONDON

# 17

Bernard Baron (1696–1762), after
Bernard Picart (1673–1733)
*A Monument Dedicated to Posterity* 1721
Etching and engraving
21 × 34.3
THE BRITISH MUSEUM, LONDON

The autumn and winter of 1720–1 witnessed the financial crisis known as the South Sea Bubble. In the summer of 1720 thousands of investors and brokers across Europe became caught up in a feverish bout of financial speculation in which the price of stocks and shares rocketed and huge amounts of money were invested in non-existent or highly risky trading ventures. One commentator, drawing on the traditions of allegory, noted the ways in which both the rich and the less affluent were falling under the thrall of the alluring but fickle figure of Fortune:

high and low
Court Fortune for her graces
And as she smiles and frowns, they show
Their gestures and grimaces.[7]

The subsequent collapse of the European financial markets in the last months of 1720 generated a spate of Dutch-produced satirical engravings that were quickly adapted for use in the English marketplace. Bernard Picart's and Bernard Baron's *A Monument Dedicated to Posterity* was the most elaborate of these prints and was widely

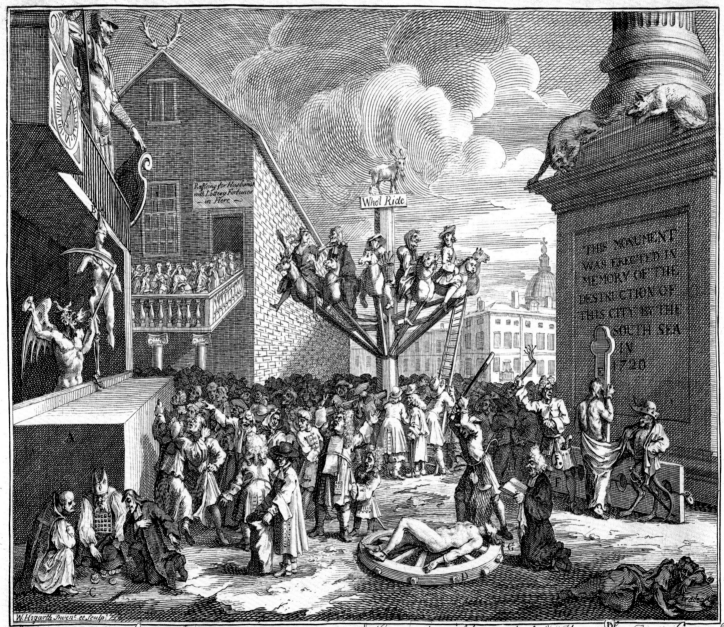

advertised in the London newspapers during the spring of 1721. The English version of Picart's image shown here is set in the capital's financial district, Exchange Alley, while also incorporating a succession of doorways inscribed with the names of London asylums and poorhouses, suggested as the inevitable destinations of many of the print's deluded and soon-to-be bankrupted protagonists. The alluring allegorical figure of Fortune again assumes a prominent role, distributing stock debentures and subscriptions to a swarm of eager investors from the top of a chariot driven by the grotesque, extravagantly dressed figure of Folly.

Picart's print and its companions must have struck Hogarth as offering a particularly exciting and ambitious template for graphic satire, in which pictorial allegory, graphic inscription, architectural detail, grotesque forms and complex combinations of figures were all deployed to depict and interpret contemporary urban breakdown. *The South Sea Scheme* sees him responding brilliantly to the Dutch satirists' example, and offering his own, even more brutal image of the crisis. In Hogarth's print, which focuses as much on the aftermath of the affair as on its fantastical workings, the grossly mutilated figure of Fortune is now shown blindfolded, hanging by her hair from the balcony of London's Guildhall. Her body is being hacked by a scythe-wielding devil, who throws hunks of her flesh to the crazed speculators below. This horrific imagery of corporeal violence

extends to the similarly unclothed, exposed figures of Honesty and Honour, who are being respectively battered by the figure of Self-interest and scourged by the two-faced figure of Villainy. An ape, a traditional satiric emblem of corrupt emulation, seeks to drape itself in Honour's robe. Meanwhile, the frantic whirl of speculation is allegorised by the merry-go-round that spins in the mid-distance, carrying a disreputable group of passengers, and another form of gambling is highlighted on a nearby balcony, where a procession of spinsters queue to take part in a raffle for lottery-winning husbands.

As in Picart's image, Hogarth juggles with a succession of resonant architectural icons: the Guildhall is transformed into 'ye devil's shop' and depicted with a careering perspective that tallies with the crazed perspectives of the print's protagonists; the Monument to the Great Fire of London of 1666 is newly decorated with prowling foxes, and recast as a monument to the Bubble; finally, the dome of St Paul's, so symbolic of London's regeneration after the Great Fire, now presides over a scene of urban mayhem and chaos. Supplementing this imagery of moral and social dissolution, a trio of Roman Catholic, Jewish and Puritan clerics are shown gambling on the left, while their Anglican equivalent sanctimoniously presides over the beating of Honesty. In the shadowed right-hand corner of the print the collapsed figure of Trade slowly expires, ignored by all around her.

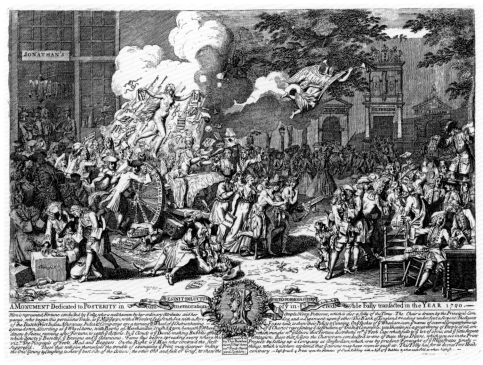

## 18

*The Bad Taste of the Town ('Masquerades and Operas')* 1724
Etching and engraving
13 × 17.5
ANDREW EDMUNDS, LONDON

## 19

Anonymous
*Berenstadt, Cuzzoni and Senesino* 1723
Engraving
18.7 × 26
THE BRITISH MUSEUM, LONDON

In the spring of 1724 Hogarth decided to design, execute and publish a graphic satire on his own, rather than produce a work intended for sale by the established print-publishers of the city. In the resultant engraving he suggested that the fevered enslavement to a foreign form of financial speculation satirised by *The South Sea Scheme* (no.16) had been succeeded by a new addiction to the ephemeral and alien pleasures of masquerade, opera, magic, pantomime and, not least, Italianate art.

On the left of the print the exterior of the London opera house is dominated by a huge sign, its imagery derived from a recently published satire by another engraver (no.19). In this earlier, anonymously produced work three foreign singing stars are depicted as grotesquely proportioned, extravagantly dressed figures strutting awkwardly across the opera house stage. Hogarth appropriates and revises that image, showing the three singers receiving bags of money from a trio of prostrate noblemen. As was actually the case in this period, the same venue is shown housing other spectacular entertainments: the conjuring acts of Isaac Fawkes and the masquerades that had been introduced into the English capital by the Swiss impresario John James Heidegger. The latter leans out of an upstairs window looking down at a crowd of masqueraders being shepherded towards the opera house by the figures of a devil and a fool.

Opposite stands John Rich's Lincoln's Inn Theatre, which had recently enjoyed enormous success through the performance of spectacular, acrobatic and risqué *commedia dell'arte* pantomimes. One such pantomime, *Harlequin Doctor Faustus*, is promoted by the canvas hoarding that bedecks the theatre wall like a fairground placard, and by the animated figure of Harlequin himself, who ushers in the same kind of captive, deluded crowd of consumers satirised in *The South Sea Scheme*.

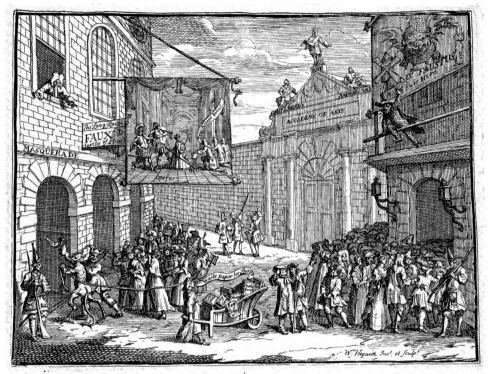

O how refin'd how elegant we're grown!
What noble Entertainments Charm the Town!.
Whether to hear the Dragon's roar we go,
Or gaze surpriz'd on Fawks's matchless Show.

Or to the Opera's, or to the Masques,
To eat up Ortelans, and empty Flasques
And rifle Pies from Shakespear dinging Page;
Good Gods, how great is the gusto of the Age.

Price 1 shill. 1724.

18

The 'Accademy of Arts' shown in the background, which in fact depicts the doorway to Burlington House in London, signals another bastardised form of contemporary taste – the cult of Italian and classical art and architecture being fostered by Richard Boyle, 3rd Earl of Burlington, and his protégé, the artist and designer William Kent, whose sculpted portrait towers above the ludicrously downgraded figures of Michelangelo and Raphael. The three deluded connoisseurs who stand studiously admiring Kent's statue echo the trio of aristocratic opera-enthusiasts in the sign hanging immediately above their heads.

As a point of contrast, Hogarth depicts a female scrap merchant pushing along a wheelbarrow laden with the works of Shakespeare, Otway, Congreve, Dryden and Addison, and shouting 'Waste paper for shops'. The argument is clear: English cultural traditions, whether theatrical, literary or artistic, are being threatened with redundancy by meretricious, foreign forms of spectacle and entertainment.

## 20

*The Lottery* (second state) 1724
Etching and engraving
Cut to 26.2 × 32.7
ANDREW EDMUNDS, LONDON

## 21

Study for *The Lottery* 1724
Pen and black ink over slight pencil,
grey wash
22.9 × 32.4
THE ROYAL COLLECTION

On 19 September 1724 the London *Daily Post*
advertised that 'On Monday next will be
publish'd, A curious Print, call'd, The
Humours of the LOTTERY, by the author of
the little Satyrical Print, call'd the Taste of
the Town ... price 1s'. *The Lottery* not only
maintains the theatrical themes of *The Bad
Taste of the Town* (no.18) but also extends the
satiric attack on delusive investment found
in *The South Sea Scheme* (no.16). In this case
the drama is set in the interior of the
Guildhall, depicted as 'ye Devil's Shop'
in Hogarth's Bubble satire, but here
transformed into a stage-like arena framed
by the heavy curtains of a playhouse and
populated by a series of allegorical figures
who satirically commentate on the state
lottery system.

National lotteries had been exploited by
parliament as a means of generating extra
public income since the end of the previous
century. And while the figures distributed
on the rostrum in the centre of the print –
Public Credit, Apollo, Britannia and Justice
– seem to allegorise the benefits brought to
the nation by these lotteries, things are not
quite as sanguine elsewhere in the image,
where virtuous figures are repeatedly
paired with those who embody the dangers,
seductions and misfortunes of this state-
sanctioned form of gambling.

On either side of the central grouping
Wantonness and blindfolded Fortune
draw tickets from two great lottery wheels.
At lower left Misfortune, who has drawn
a blank ticket, is simultaneously tugged
downwards by Grief and supported by
Minerva, whose finger points to the
redeeming figure of Industry; immediately
behind them Despair is being called by
Fraud, who leans out of a window like a
prostitute touting for business. In the lower
centre of the print the figure of Suspense
spins to and fro between Fear and Hope.
At lower right, meanwhile, the embodiment
of Good Luck stands on a pedestal and – like
his unfortunate counterpart on the other
side of the depicted stage – is asked to make
a fateful choice: he is pulled one way by the

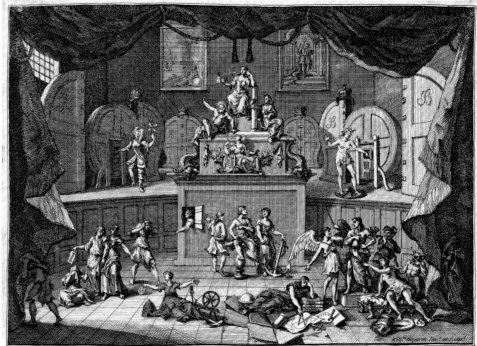

The Explanation. *1. Upon the Pedestal* National Credit *leaning on a Pillar supported by* Justice. *2* Apollo *shewing* Britannia *a Picture representing the Earth receiving enriching Showers drawn from her self (an Emblem of State Lottery's).* 3 Fortune *Drawing the Blanks and Prizes.* 4 Wantonness *Drawing ye Numb?* 5 *Before the Pedestal* Suspense *turnd to & fro by* Hope & Fear.

The LOTTERY

*6. On one hand,* Good Luck *being Elevated is seized by* Pleasure & Folly; Fame *persuading him to raise sinking* Virtue, Arts &c. 7. *On ye other hand* Misfortune *opprest by* Grief Minerva *supporting him, points to the Sweets of* Industry. *8.* Sloth *hiding his head in ye Curtain: 9. On ye other side,* Avarice *hugging his Mony. 10* Fraud *tempting* Despair *n? Mony at a Trapdoor in the Pedestal.*

*Price one Shilling.*

20

beautiful but dangerous figure of Pleasure
(herself accompanied by a devil) and by
imp-like Folly, but he is pulled in another
direction by the winged figure of Fame,
who seeks to persuade him to help raise
the figure of 'sinking Virtue, Arts &c.' lying
dejectedly across a collapsing section of the
floor. Hogarth's print thus dramatises both
the potential benefits and the dangers of
the lottery. And while we might assume
that the print's overall tone is a critical one,
particularly when we spy Sloth and Avarice
skulking in the shadows, it is interesting to
note that Misfortune, Suspense and Good
Luck are all shown facing the figures who
embody the more virtuous of the choices
on offer.

In articulating this delicately balanced
narrative of choice and contrast, Hogarth –
in both the print and the careful drawing
that he produced as he developed this work
(no.21) – not only deployed the imagery
found in his and his contemporaries' satires
on the South Sea crisis but also drew on the
classical iconography of Hercules choosing
between Virtue and Vice. These references,
and the ways in which *The Lottery* also
relates to the compositional and allegorical
conventions of decorative history painting,
again indicate the extent to which Hogarth's
early satires exploited a wide variety of
pictorial models.

# 22

*The Mystery of Masonry Brought to Light by ye Gormagons* (second state) 1724
Etching and engraving
Cut to 25.1 × 35.2
ANDREW EDMUNDS, LONDON

# 23

Gerard Vandergucht (1696–1776), after
Charles-Antoine Coypel (1694–1752)
*Don Quixote Takes the Puppets to be Turks and Attacks them to Rescue Two Flying Lovers*
c.1723–5
Engraving
26.7 × 28.3
THE BRITISH MUSEUM, LONDON

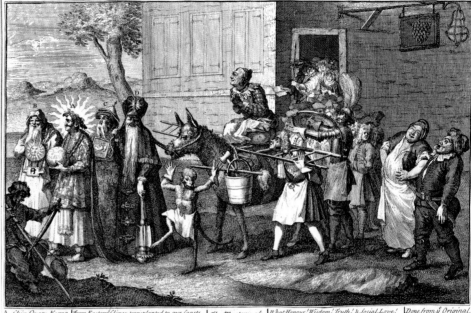

A. *Chin-Quan-Kypo*  |  *From Eastern Climes, transplanted to our Coasts,*  |  *The Mystery of*  |  *What Honour! Wisdom! Truth! & Social Love!*  |  *Done from y Original,*
  1.st *Emperor of China.*  |  *Two Oldest Orders, that Creation boasts*  |  *Maſonry*  |  *Sure such an Order had its Birth Above.*  |  *Painted at Pekin by Mata*
B. *The Sage Confucius.*  |  *Here meet in Miniature, expos'd to view*  |  *brought to Light by y.*  |  *But Mark Free Masons! what a Farce is this!*  |  *chanter, Grav'd by Ho Oe.*
C. *In chin present Deci-*  |  *That by their Conduct Men may Judge their Due.*  |  *Gormagons.*  |  *How wild their Myst ry! what a Bum they Kiſs!*  |  *and Sold by y Printsellers*
  *menial Poter, chi-*  |  *The Gormagons, a Venerable Race*  |   |  *Who would not Laugh when such Occasions had?*  |  *of London Paris & Rome.*
D. *The Mandarin Hang*  |  *Appear Distinguish'd with peculiar Grace.*  |   |  *Who should not Weep, to think y World so Mad.*  |  *Hogarth inv et Sculp*

22

This dense, exotic and obscene print (no.22) saw Hogarth extending his satiric investigation of urban culture into the world of Freemasonry. The Freemasons, who developed as an organisation in the decades following the Great Fire of 1666, had recently gained an increased prominence and respectability thanks to the establishment of their Grand Lodge in 1717, the publication of their Constitutions in 1723 and the institution of an annual Masonic procession through the capital. However, the order was also riven with faction, and 1724 saw a succession of mock advertisements being published in the London newspapers that caricatured one particular Masonic grouping – led by the Duke of Wharton – as a body devoted to a grotesque amalgamation of Chinese mysticism and Catholic devotion, and called the Gormagons. This kind of satire was extended in a contemporary poem, which scandalously described the mysterious rites of Masonic initiation as exercises in sodomitical arse worship and sado-masochistic pleasure. In the poem a Masonic novitiate 'close salutes' the Grand Master's exposed posterior with his lips, and puts 'his sword up in his scabbard', before being whipped by a prostitute and released back into the streets with his fellows,

> as fine as any Beau
> With gloves and aprons made of
>    leather
> A sword, long wig, and hat and
>    feather
> Like mighty Don Quixote then they
>    stagger
> And manfully they draw the dagger
> To prove they're all men of mettle
> Can windmills fight, and treatises
>    settle.[8]

Hogarth's print translates this kind of critique into pictorial form. *The Mystery of Masonry Brought to Light by the Gormagons* pictures a grotesque parody of the annual Masonic procession, in which a group of Eastern mystics, accompanied by a dancing monkey dressed in Masonic gloves and apron, lead a donkey carrying an old woman freakishly twisted at the waist, whose pock-marked buttocks are exposed to view and kissed by a trapped Masonic novitiate. Behind her the Masons who file out of the pictured tavern are obscured by the ridiculous figure of Don Quixote, who lurches towards the old woman; his familiar companion, Sancho Panza, reels back in shock nearby, accompanied by the figure of a laughing butcher.

Hogarth again alludes to an eclectic range of imagery. On one hand, his print parallels the Dutch Bubble prints that had flooded into London three years previously – in particular, images like Picart and

Baron's *A Monument Dedicated to Posterity* (no.17), which featured a similarly outlandish urban procession led by a group of exotically dressed worthies. Even more strikingly, however, *The Mystery of Masonry* draws on no less than four works from a celebrated pictorial series representing the adventures of Don Quixote. This series, produced by the French artist Charles Antoine Coypel, was being engraved for the English print market in this period and included such images as *Don Quixote Takes the Puppets to be Turks* (no.23), in which we find the familiar figures of Sancho Panza and the laughing butcher, together with the old woman and the girl holding a candle, all of whom Hogarth transplants to his print.

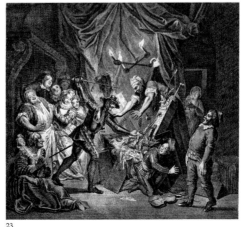

23

## 24

*Royalty, Episcopacy and Law* c.1724–5
Etching and engraving
Cut to 18.8 × 24.6
ANDREW EDMUNDS, LONDON

According to the eighteenth-century writer on Hogarth, John Nichols, this work was advertised in a 1724 newspaper as 'a very rare Hieroglyphic Print, representing Royalty, Episcopacy, and Law, composed of emblematic attributes, and no human features or limbs; with attendants of similar ingredients'.[9] Here Hogarth drew on an old satiric tradition of substituting emblematic attributes for the head and body, and contributed to the broader satiric analysis of the nation's institutions and office-holders that was taking place in the aftermath of the South Sea Bubble. The surreal result sees a coin standing in for a king's face, a pump acquiring eerily human characteristics as it spurts cash into a bishop's money-chest, and a teapot taking the place of a fashionable woman's head. The image is rendered even more outlandish by the fact that the three figures and their retainers are shown floating in the clouds, as if seen through the lens of a telescope. Here, as is indicated in the print's caption, Hogarth is alluding to a celebrated lunar eclipse that had taken place earlier in 1724.

## 25

*Cunicularii, or the Wise men of Godliman in Consultation* December 1726
Etching and engraving
18.8 × 25.6
ANDREW EDMUNDS, LONDON

This image was one of a slew of pictorial and textual satires dealing with the case of Mary Tofts, who in the autumn of 1726 declared that she had given birth to rabbits. Remarkably, her claims were initially supported by a number of eminent medical authorities, including the Swiss anatomist to the royal household, Nathaniel St André ('A' in the print), and the German Cyriacus Ahlers ('C'), the royal surgeon. That Tofts was performing an elaborate hoax was only confirmed in December, and writers and artists were quick to lampoon not only Tofts herself, but also men such as St André and Ahlers, whose ignorance and gullibility were seen to be indicative of the corruption of British medicine by foreign-born adventurers. These satires often exploited the gynaecological nature of the affair to obscene effect; Hogarth, too, pointedly shows the celebrated male midwife Sir Richard Manningham ('B'), who in fact discovered the deception, groping under Tofts' skirt and exclaiming, in a crude double entendre: 'It pouts it swells, it spreads it comes.'

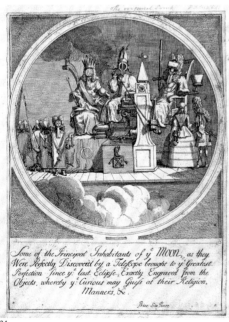

24

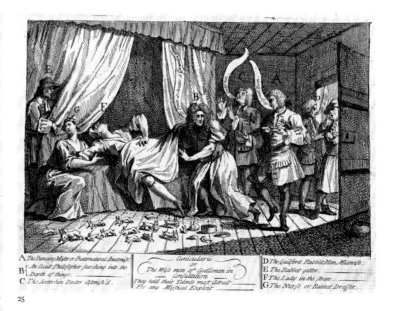

25

# 26

*The Punishment inflicted on Lemuel Gulliver ...*
December 1726
Etching and engraving
21.2 × 32
ANDREW EDMUNDS, LONDON

In this dystopian satire on the state of contemporary Britain Hogarth responds to the recent publication of Jonathan Swift's *Gulliver's Travels* and returns to the anal imagery that that he had already deployed in *The Mystery of Masonry* (no.22). Swift's eponymous protagonist, visible only as an exposed posterior, serves as a metaphor for a benign but gullible Britain, while the swarming Lilliputians inserting an enema between his buttocks stand in for the contemporary Whig ministry and the Church, who are attacked for having dispensed a similarly invasive and violent form of political and religious medicine to the nation. Their political leader, a surrogate for the Prime Minister Sir Robert Walpole, supervises proceedings while being held aloft in a thimble, and a Lilliputian cleric preaches from a chamber pot. Elsewhere a more general form of malaise is suggested by the rat that carries a helpless child across a ruinous archway, and by the deluded worshippers who make votive offerings to the libidinous term of Priapus.

# 27

*Masquerade Ticket* 1727
Etching and engraving
Cut to 20.5 × 26.5
ANDREW EDMUNDS, LONDON

This mock masquerade ticket sees Hogarth returning to one of the subjects of *The Bad Taste of the Town* (no.18), but here, rather than being herded together in the street, the pictured crowd of masqueraders circulate within a fantastical interior, littered with emblems of the erotic and excessive pleasures on offer. The wonderfully named 'lecherometers' stand ready to measure the sexual temperature of those who walk towards them. On one side of the room, in a detail that recalls the background of *The Punishment Inflicted on Lemuel Gulliver* (no.26), an altar to Priapus is decorated by numerous antlers, the traditional emblem of cuckoldry, while on the right a raging fire warms the suggestively interlocked figures of Venus and her attendant Cupid, the latter of whom is about to fire his arrow into the crowd. 'Provocative' food and high art provide extra stimulation to the participants: rows of shelves are loaded with culinary aphrodisiacs, while in the background a bacchanalian painting is replete with reclining nudes and dancing nymphs. Above, a clock decorated with the portrait of the Swiss impresario Heidegger, and suggesting the late hour at which masquerades typically took place, is tellingly decorated with the royal attributes of the unicorn and the lion. Through their inclusion Hogarth gestures to the support given to Heidegger's masquerades by the newly crowned George II, and reinforces his attack on the perverted kinds of pleasure such events were seen to encourage: both animals, it will be noted, hold their tails between their legs in an unmistakably obscene manner.

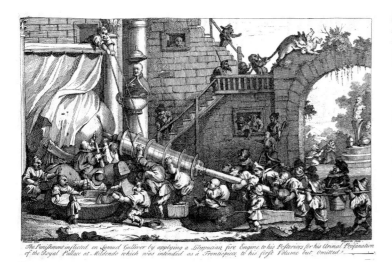

The Punishment inflicted on Lemuel Gulliver by applying a Lilliputian fire Engine to his Posteriors for his Urinal Profanation of the Royal Pallace at Mildendo which was intended as a Frontispiece to his first Volume but Omitted

26

A. a sacrifice to Priapus. B. a pair of Lecherometers shewing y.º Companys Inclinations as they approach 'em. Invented for the use Ladys & Gentlemen by y.º Ingenious M.ʳ H————r price 2.s 6.d

Masquerade Ticket

27

# 28–34
*Hudibras*

28
Frontispiece to *Hudibras* (first state) 1725/6
Etching and engraving
26.5 × 35.5
ANDREW EDMUNDS, LONDON

29
*Hudibras's First Adventure* (second state)
1726
Etching and engraving
27.2 × 31.2
ANDREW EDMUNDS, LONDON

30
Samuel Butler (1612–1680)
*Hudibras* (London, 1710)
Bound volume
THE BRITISH LIBRARY, LONDON

31
*Burning ye Rumps at Temple-Barr* c.1721–6
Etching and engraving 10.8 × 12.7
THE BRITISH MUSEUM, LONDON

32
Study for *Burning ye Rumps at Temple-Barr*
1725–6
Pen with brown ink, brown washes,
over pencil
24.7 × 21.2
THE ROYAL COLLECTION

33
*Burning ye Rumps at Temple-Barr* 1726
Copperplate 28 × 52
HOGARTH'S HOUSE, LONDON

34
*Burning ye Rumps at Temple-Barr*
(second state) 1725/6
Etching and engraving
27.2 × 31.3
ANDREW EDMUNDS, LONDON

30

Samuel Butler's *Hudibras* (1662), a long satirical poem exposing the personal, political and religious delusions generated by the English Civil Wars, continued to enjoy great popularity in the early decades of the eighteenth century, when it was regularly lauded as an English counterpart to *Don Quixote*. A monument to Butler was installed in Westminster Abbey in 1721, and in the years that immediately followed this event Hogarth engraved two sets of works depicting episodes from the poet's famous work. The first, modestly sized set, probably executed in the early 1720s but not published until April 1726, was intended as

a series of book illustrations (no.18); the second, larger in scale and more sophisticated in style, was produced as a collection of thirteen freestanding engravings, and published in the spring of 1726 by the major printseller, Philip Overton (nos.28, 29, 33, 34).

In embarking on his two sets of works, Hogarth once again turned to an available pictorial source: in this case the anonymously produced illustrations that accompanied an edition of Butler's poem published in 1710. Hogarth unashamedly uses these earlier designs as a starting point for his own series of works, while continually adding to and elaborating on their example. In this process, for the first time, we see Hogarth beginning to experiment with the series format that was to become so indelibly associated with his name, and to exploit its pictorial and narrative possibilities as a vehicle for satire.

The series of independent engravings published by Overton opens with an elaborate, allegorical frontispiece (no.28). Guided by a kneeling satyr, a putto sculpts a marble relief depicting 'Mr Butler's Genious' – also personified by a satyr – passing Mount Parnassus in a chariot, and driving on the anti-heroic protagonists of the poem, Hudibras and Ralpho, while scourging the figures of 'Rebellion, Hypocrisy and Ignorance' who trail behind. This frieze of figures is surmounted by Butler's garlanded portrait, while in the distance the figure of Time is shown bowing down before the poet's recently installed monument. In the right foreground a smiling Britannia gazes at a mirror held by yet another satyr. Significantly, the lines inscribed on the copy of *Hudibras* held by the satyr on the left highlight the ways in which the poem's eponymous anti-hero

offers a distorted 'mirroor' of knighthood; the clear mirror gazed at by Britannia complements this allusion, suggesting that Butler's satire itself generates a more truthful reflection, not only of Hudibras himself but also of the nation.

*Hudibras's First Adventure* (no.29) typifies the main body of illustrations that Hogarth produced for Overton. The engraving shows the deluded knight-errant on horseback, confronting a motley collection of stave-wielding countrymen, who are accompanied by a disabled fiddler and a miserable bear. Here Hogarth's representation of Hudibras's ridiculous display of pistol-wielding authority is combined with a telling anatomisation of the mob: as so often in his work, the plebeian crowd is depicted as both comically grotesque and threatening.

In *Burning ye Rumps at Temple-Barr* (no.34) Hogarth ties a similarly doubled imagery of the mob to a particular historic event – the riotous burning of rump steaks in the streets that followed the reassembly of the Rump Parliament in the spring of 1660 – and to a specific urban location, Temple Bar in London. Hogarth fuses the bonfires, the hunks of roasting meat, and the cheering figures of defiant Londoners found in the 1710 illustration to *Hudibras* (no.30) with an elegant if anachronistic depiction of the modern gateway erected at Temple Bar. At the same time he adds a portrait of Hudibras in effigy, shown being carried along on a pole by two of the marchers. No longer pompously gesticulating from the back of a horse, he is instead presented as a deflated, disembodied ragbag of clothes, straw, mask and wooden sword, just about to be thrown into the flames.

The Baffo Releivo, on the Pedeftal, Reprefents the— **Frontifpiece** Lafhing around mount Parnafsus, in the Perfons—
general Defign, of Mr BUTLER, in his Incomparable ———and its of Hudibras, Ralpho, Rebellion, Hypocrify, and ——
Poem, of Hudibras, Viz. BUTLER's Genious in a Car. **EXPLANATION.** Ignorance, the Reigning Vices of his time

28

The Catalogue and Character Whom in a bold Haranque &c **Hudibras** Hinranters Talgol routs the Bear Conveys him to Enchanted Caftle
Of th'Enimies beft Men of War; Defies, and Challenges to fight; and its And takes the Fidler Prefoner, There fhuts him faft in Wooden Baftile.
**ADVENTURE.**

29

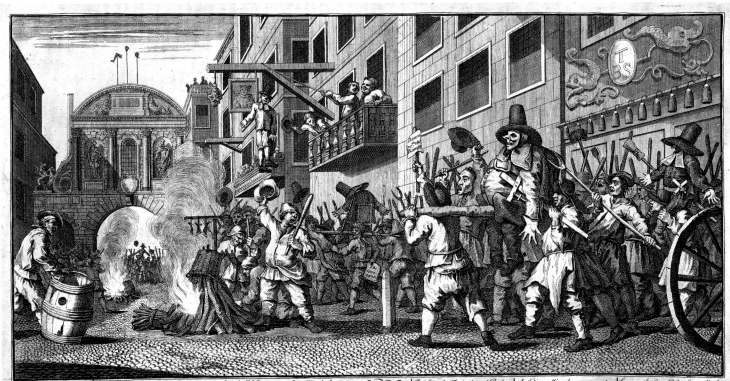

That Beaftly Rabble that came down—— For th'Caufe ——up heretofore And all ye Grandees of our Member **Burning ye Rumps** That ferve for Characters & Badges And 'tis a Miracle we are not Some on the Sign Poft of an Ale houfe
From all the Garretts in the Town And bawl the Bifhops out of Door Are Carbonading on the Embers; To Reprefent their Perfonages Already, Sacrific'd Incarnate Hang in Effigie, on the Gallows,
And ftalls & Shop-boards in vaft fwarms Are now drawn up in greater fhoals Knights, Citizens and Burgefses **at TEMPLE-BARR.** Each Bonfire is a Funeral Pile, For while we Wrangle here & jar, Made up of Rags to perfonate
With new chalk'd Bills & rufty Arms To Roaft and Broil is on the Coals Held forth by Rumps of Rag & Geefe In which they Roaft & Geo.h & Broil W'are Grylled all at Temple-Bar. Refpective Officers of State

34

# 35

*The Denunciation* 1729
Oil on canvas
49.5 × 66
NATIONAL GALLERY OF IRELAND, DUBLIN

# 36

*The Christening (Orator Henley Christening a Child)* c.1729
Oil on canvas
49.5 × 62.8
PRIVATE COLLECTION

Painted at roughly the same time and displaying strikingly similar themes and dimensions, these two works may well have been painted as companion pieces: that contemporaries thought this was the case is suggested by the publication in the early 1730s of a pair of prints after the two canvases by Joseph Sympson Jr. In their shared focus on professional misconduct, false witness, sexual immorality, marital discord and effeminacy *The Denunciation* and *The Christening* images signal many of the preoccupations that were to feature in Hogarth's later, more famous pictorial series: in this instance the two pictures work together to condemn the corruption that can attend the conception and christening of a child.

In *The Denunciation* a pregnant unmarried woman stands before a magistrate and falsely declares that the father of her unborn child is the dour, miserly dissenter who stands nearby with his arms and eyes raised theatrically upwards. While the wrongly accused man is berated by his enraged wife, his accuser – who may well be a prostitute – is being coached in her performance by the whispering figure of the real father, who trains her up just as the girl sitting next to the magistrate trains up her puppy. We are invited to imagine that the venal Justice – described in Sympson's print as someone who 'makes his market of the trading Fair' (that is, makes money out of exploiting prostitutes) – will declare on the pregnant woman's behalf, having already come to some kind of financial arrangement with her; significantly, Sympson's engraving concludes: 'The Jade, the Justice and Church Ward'ns agree, and force him [i.e. the accused man] to provide Security.'[10] As so often in Hogarth's works, the canvas is crowded with an array of supporting actors: the intimately posed pair of fops who watch the scene while whispering and sniffing a flower; the line of other dubious, flirtatious women who await their turn to appear before the corrupt magistrate; and the figures who try to push through the distant doorway.

In *The Christening*, meanwhile, the role of the deviant worthy is taken by what Sympson describes as the 'wanton' clergyman standing at the centre of the picture, who is distracted from his duties by the sight of the bosom of the young woman standing next to him.[11] Around this central pairing Hogarth introduces a gallery of types familiar from *The Denunciation*: another mother, this time sitting in the background, who is once again being whispered to by a man who may be the father of her newly born child; another fop, who exaggeratedly admires himself in a mirror; another young girl, who clumsily spills the christening bowl; and another small dog, who worries away at the hat that lies on the floor. Such eloquent details helped make this kind of painted satire instantly successful, as is confirmed by the contemporary chronicler of the London art world, George Vertue, who noted in 1729 that 'a small piece of several figures representing a Christening being lately sold at a publick sale for a good price got him [i.e. Hogarth] much reputation'.[12]

35

36

## 37

*Falstaff Examining his Recruits* 1730
Oil on canvas
49.5 × 58.5
THE GUINNESS FAMILY

This work is the earliest surviving painting
of a scene from Shakespeare. In his *The Bad
Taste of the Town* (no.18) Hogarth had
bemoaned the relegation of the playwright's
works to the status of waste paper; this
canvas, in contrast, was executed at a time
when a version of Shakespeare's *Henry IV,
Part 2* was again being successfully
performed on the London stage, and depicts
a scene (Act III, Scene ii) in which the great
comic character Sir John Falstaff
'impresses' recruits for his army. Falstaff
uses one hand surreptitiously to accept a
bribe enabling two of the newly impressed
soldiers – shown on the right – to escape
military duty, while simultaneously using
his other hand to point to their gullible
replacements, and to distract the attention
of his buffoon-like cronies gathered around
the table.

    *Falstaff Examining his Recruits* seems
pictorially poised between the kinds of
pictorial satire embodied in Hogarth's
illustrations to Samuel Butler's *Hudibras*
and the explicitly theatrical imagery of his
*Beggar's Opera* canvases. On one hand, the
interior setting, grotesque physiognomies
and table-bound narratives of *Falstaff
Examining his Recruits* duplicate the imagery
of *The Committee*, one of the plates in the
*Hudibras* series. On the other hand, the
Shakespearian episode depicted by Hogarth
also evokes the scenic conventions,
heightened gestures and physical intimacies
of contemporary stage performances, and
invites being understood as a pendant to
such pictures as the Birmingham Museum
*Beggar's Opera* canvas (no.38), which is of
precisely the same size and similarly
focuses on a famous theatrical anti-hero.
However one situates this work, *Falstaff
Examining his Recruits* is noticeable for its
early deployment of pictorial devices that
Hogarth was to reuse and refine throughout
his career: in particular, the inclusion of
figures passing through an open doorway,
and the exploitation of the wall as a site of
emblematic and pictorial commentary,
exemplified by the heroic figure portrayed
in the canvas hanging above the table, who
offers such a pointed contrast to the
ridiculous figures sitting below.

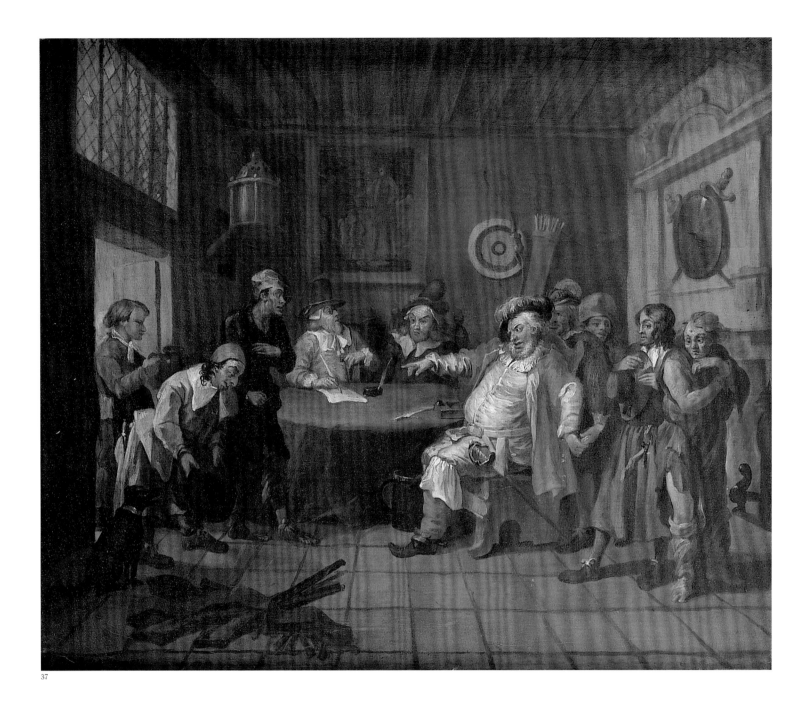

37

# 38–9

*The Beggar's Opera*

38
*A Scene from 'The Beggar's Opera'* c.1728
Oil on canvas
49.2 × 56.6
BIRMINGHAM MUSEUMS & ART GALLERY

39
*A Scene from 'The Beggar's Opera'* 1731
Oil on canvas
57.2 × 76.2
TATE. PURCHASED 1909

Between 1728 and 1731 Hogarth painted numerous versions of a climactic scene from John Gay's *The Beggar's Opera*, the great theatrical sensation of the period. Gay's work, first performed in January 1728 at John Rich's Lincoln's Inn Theatre, was a multi-faceted satire that simultaneously parodied the fashionable rhetoric and appeal of opera and made provocative comparisons between the criminal subcultures of contemporary London and the corrupted realms of politics and fashionable society. Through the character of Polly Peachum, famously played by Lavinia Fenton (see no.88), *The Beggar's Opera* also offered a touching portrayal of tender-hearted femininity. Gay's juxtaposition of a wide variety of theatrical and musical forms, both high and low, and his sustained, humorous critique of elite fashion and contemporary politics, closely paralleled the kinds of pictorial satire practised by Hogarth himself. Rather than responding to *The Beggar's Opera* in graphic form, however – as did a number of other engravers – Hogarth exploited the commercial success and cultural impact of Gay's work to gain attention as a painter.

Hogarth concentrates on a scene set in Newgate Gaol in which the play's leading character, an imprisoned highwayman called Macheath, is shown at the centre of a tug-of-love. The characters of Lucy Lockit and Polly Peachum, both of whom believe themselves married to Macheath, plead with their fathers – respectively a corrupt prison-warden and a crooked lawyer – to set him free. As well as picturing this particular scene, Hogarth depicts the trappings and protagonists of the theatrical environment in which Gay's work was first staged. An elaborate curtain hangs over the proceedings, establishing the setting as Rich's theatre, and Hogarth paints recognisable portraits of the actors who performed the leading roles, including Fenton herself, who in the first painting holds a handkerchief to her breast with her left hand, and in the second does so with her right. Furthermore, Hogarth shows the most fashionable members of the theatre audience sitting on the stage, as was commonplace at Lincoln's Inn Fields in this period.

In the early, Birmingham canvas the juxtaposition of the corrupt low-life characters on stage with the caricatured aristocratic audience that clusters around them seems especially acidic, maintaining the satiric edge that first attracted the attention of playhouse audiences. However, as Hogarth painted new versions of this work, notably for John Rich himself, the appearance and character of his *Beggar's Opera* paintings underwent a subtle transformation. More specifically, the increasing fame and respectability enjoyed

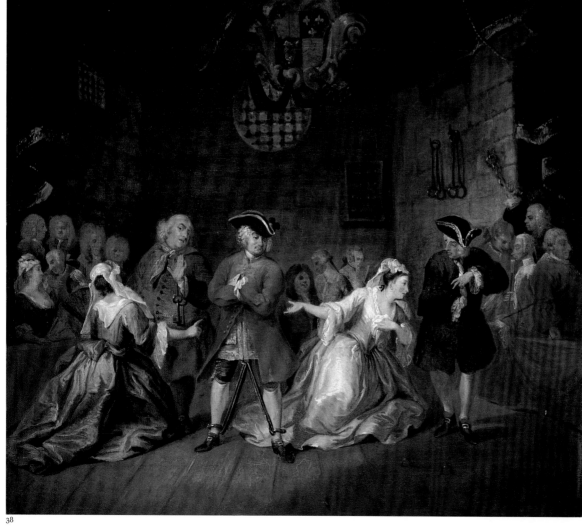

38

by Gay's play, and the rapid development of Hogarth's own skills and ambitions as a painter, seem to have encouraged the artist to produce grander, more elegant portrayals of the scene, and to dilute the satiric intensity found in his earlier canvases. Thus the later Tate picture is substantially larger and more slickly painted than the Birmingham work. The tearful figure of Polly Peachum is rendered even more delicately than before, as are the figures of her father and Macheath – and all three are shown standing on a luxurious carpet that has been newly imported into the image. A pair of sculpted satyrs gives the setting a more classical and allegorical character, and greater emphasis is assigned to the learned Latin quotations stitched into the curtain's ribbon, which consist of the phrases 'veluti in speculum' (as in a mirror) and 'utile dulci' (usefulness with pleasure). Most interestingly of all, the members of the audience – now including, on the far right, the figure of the Duke of Bolton, who had installed Fenton as his mistress after seeing her play Polly Peachum – are no longer lampooned through the deployment of

caricature, but are depicted in a far more decorous manner.

The overall effect of these changes is to turn the pictured scene from *The Beggar's Opera* into something that, even as it continues to carry dissonant, satiric overtones – note, for instance, the now familiar imagery of the stave-wielding mob introduced into the picture's background – also strikingly resembles the polite, highly theatrical conversation pieces with which Hogarth was also beginning to make his name (see section 4). As in such works, the figures in the Tate canvas are bound together by a skilfully choreographed flow of gestures and looks that stretches from one side of the picture to another and that – quite differently to the Birmingham painting – serves to emphasise a shared form of refined performance on the part of the painting's thespian and aristocratic protagonists.

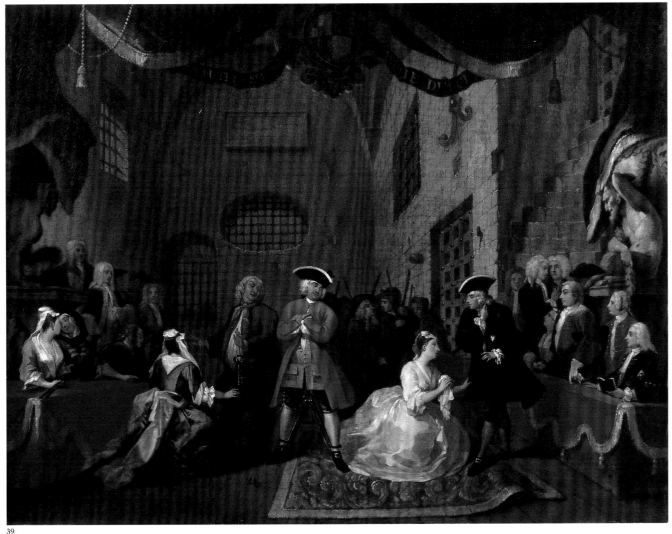

39

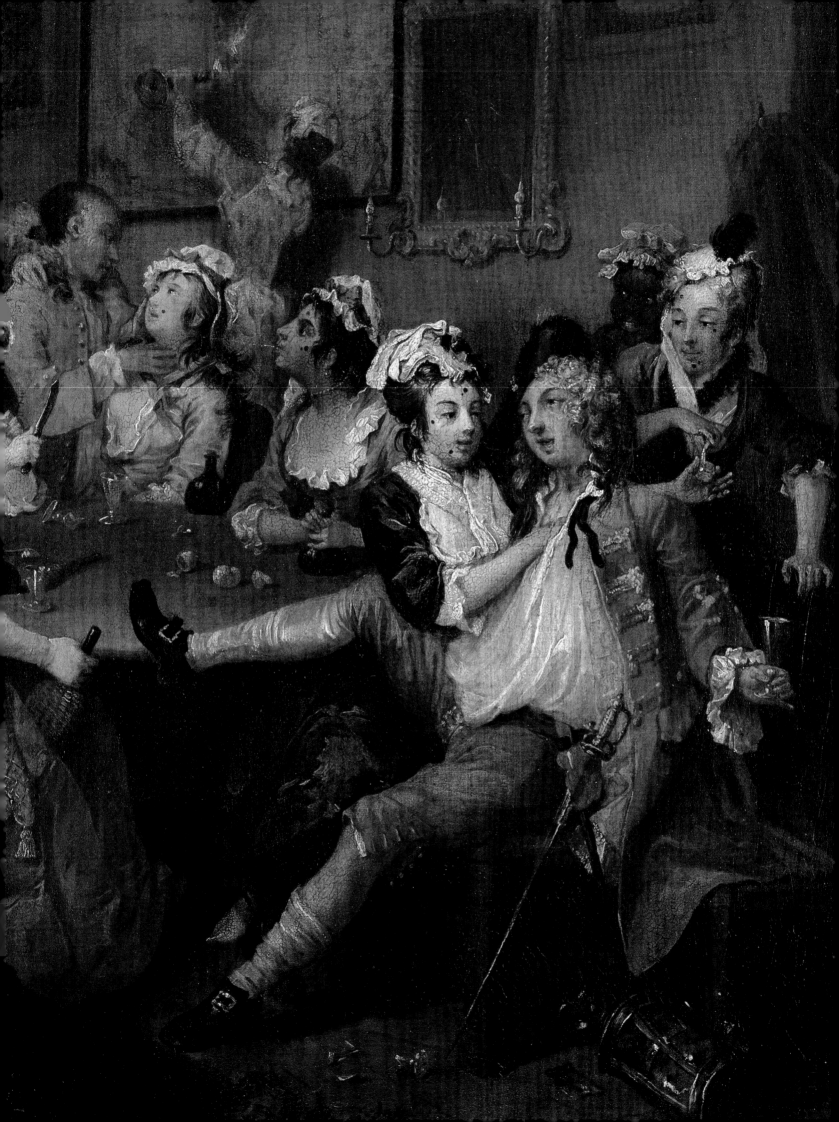

# 3
# The Harlot and the Rake

*Christine Riding*

A *Rake's Progress*
Scene 3 *The Rake at the Rose Tavern* (no.44, detail)

FIGURE 22

At some point in the early 1730s Hogarth turned to a category of art that was to bring him wealth and celebrity. Later in life he described this significant artistic development as a 'new way of proceeding, viz painting and Engraving moder[n] moral subject[s] a Field unbroke up in any Country or any age'.[1] While he overstated the absolute novelty of his 'modern moral subjects', the formula of a sequence of scenes that told a story of the artist's own invention but was anchored in contemporary life was indeed ground-breaking. As recorded by George Vertue, the concept came to Hogarth in a piecemeal fashion, beginning with 'a small picture of a common harlot, supposed to dwell in drewry lane, just riseing about noon out of bed, and at breakfast, a bunter waiting on her'. According to Vertue, 'this whore's desabille' and her 'pretty Countenance & air' was so admired by the (male) visitors to Hogarth's studio that 'some advisd him to make another, to it as a pair. which he did. then other thoughts encreas'd, & multiplyd by his fruitful invention, till he made six. different subjects which he painted so naturally ... that it drew every body to see them.'[2]

This 'small picture' was thus the starting point for *A Harlot's Progress*, which focused on the life of Moll Hackabout, a fictional London prostitute. The paintings were completed in 1731, by which point subscription for engraved versions had been advertised (fig.22). The subsequent clamour resulted in the purchase of 1,240 sets. That Hogarth's series had caught the public's imagination well beyond the collectors' market was underlined by the numerous pirated versions commissioned by opportunistic printsellers, as well as printed descriptions (at least one of which was pornographic) and literary and theatrical responses, including *Mr Gay's Harlot's Progress*, published in 1733, and Theophilus Cibber's *The Harlot's Progress; or, the Ridotto al'fresco*, staged at the Theatre Royal, Drury Lane, in the same year. Hogarth followed this runaway success with *A Rake's Progress* (no.44), which was similarly fêted. The series, incorporating eight individual images, charted the dissolute life and ignoble demise of another fictional character, Tom Rakewell, the unprincipled son of a wealthy middle-class financier who pursued the lifestyle of an aristocratic roué. In order to stymie pirate versions, Hogarth delayed publishing the prints until the Engravers' Copyright Act (popularly known as 'Hogarth's Act')

became law on 25 June 1735.[3]

With the harlot and the rake, Hogarth had selected two social archetypes, whose interwoven 'professions' and habitual environments were sleazy, perverse and thus fascinating to a wide social spectrum and, of course, rich with satirical possibilities. In part, the success of Hogarth's *Progresses* was thus a straightforward case of prurience and voyeurism. Irrespective of his audience's personal experiences, Hogarth in a masterly way presented each scene with a realism and intimacy that established his artistic identity as the roving satirist who observes with an unflinching eye the seedier side of London life. Indeed, Hogarth clearly relished portraying its evident temptations while exposing the absurdity and hypocrisy of its protagonists. This is particularly true of the third scene of *A Harlot's Progress*. Hogarth's alluring image of a pretty young prostitute seated on her bed in a state of undress, gazing out at the viewer, was clearly calculated to titillate his male visitors. However, Hogarth counteracts the salacious pleasure of contemplating Moll Hackabout as a desirable and willing sexual conquest by weaving into the narrative a series of male characters including a clergyman, a rake, a middle-class parvenu, a magistrate, a gaoler and two doctors, who collectively exploit and punish her, and fail to offer her protection or a guiding hand, or even to alleviate her suffering. While Moll and Tom are flawed in themselves, Hogarth makes it clear that they are by no means alone as transgressors within a world that is, by turns, self-serving, indifferent and unforgiving.

Hogarth's interpretation of the life of a prostitute and a rake thus encourages a variety of reactions in the spectator: prurience, derision, disgust and perhaps pity. Even Tom, who is more blatantly the architect of his own downfall, can inspire the love and loyalty of the long-suffering Sarah Young and cannot, therefore, be beyond our compassion as he slides into poverty and madness. But Hogarth's *Progresses* were also remarkable for absorbing, reworking and subverting prevailing stereotypes and narrative formulas. The wide variety of printed material such as biographies of celebrated prostitutes and whore directories underlines the schizophrenic attitude towards prostitution and deviancy in general in the eighteenth century. While the courtesan or kept woman (a position held by Moll Hackabout in the second scene)

FIGURE 23
Anonymous
*A Rake's Progress* 1732
THE BRITISH MUSEUM,
LONDON

FIGURE 24
Peter Lely (1618–80)
*Elizabeth, Countess of
Kildare* c.1679
TATE. PURCHASED 1955

But three Days past — Oh! Needles, poynts of Pins,
My Back — My Head — My XXXX Oh! my Shinns,
Lets see my Shirt Oh! Spots of Green and Yellow
What will my Father say — A Pretty Fellow.

FIGURE 23

convicted for the rape of a maidservant in his employ. Among the numerous satires that were published before and after his death in 1732 we find *Scotch Gallantry displayed: or the life and adventures of the unparrel'd* [*sic*] *Colonel Francis Charteris* (1730) and *Don Francisco's descent to the Infernal Regions, an Interlude* (1732), which cast him as a contemporary Don Juan.

When Hogarth embarked on his second *Progress* in 1733, 'the rake' was a long established embodiment of masculine waywardness and depravity. An inveterate consumer and 'man of leisure', the rake of convention fritters his fortune, usually inherited, on sex, drink, gambling and other entertainments. Along the way he amasses lavish debts and seduces, impregnates and abandons at least one young woman, often resulting in her financial and social ruin. As with the prostitute, a literary convention had developed in which the rake starts life as an impressionable young man from the country who comes to the city after inheriting money and swiftly embarks on a dissolute life. His typical fate was venereal disease, debtor's prison and death. Hogarth's series was pre-empted by the publication of an illustrated poem in 1732 entitled *The Rake's Progress, or Templar's Exit* (fig.23). The rake of the title, diseased and destitute, commits suicide by hanging from a nail on which hangs a framed print of Scene 3 of *A Harlot's Progress*:

Thus like a Hero Dick did swing,
A prettier Spark ne'er grac'd a String;
And till the am'rous Youth was
    strangled,
Beneath Moll Hackabout he
    dangled.[4]

Such bleak storylines were complemented by conversion narratives, an example being *The Rake Reform'd*, a poem published in 1717, where the main protagonist realises the error of his ways and retires to the country. And the reformed rake resisting the temptation of his previous life was used to comical effect in John Vanbrugh's ironically titled play *The Relapse, or Virtue in Danger* (1696). However, while Tom rails against his fate and eventually despairs, he is not repentant and doggedly ignores the possibility of salvation as represented by his abandoned lover Sarah. Indeed, his persistence as a rake would be almost heroic, if it were not so spectacularly foolish.

In fact Tom is a conflation of male types over and above 'the rake'. A middle-class

could achieve a degree of respectability, being 'exclusive' and historically associated with royalty and aristocracy, those in brothels and on the streets tended to be characterised as vain, artful temptresses who were, through their promiscuity, directly responsible for moral corruption and the spread of disease. Very rarely was such an onus put on their clients, however. Hogarth's image of Moll in Scene 3 thus underlines the perceived danger of the prostitute, whose outward desirability disguised a body already corrupted by venereal disease. This sense of menace is played out in Scene 3 of *A Rake's Progress*, when Moll and Tom's worlds intermingle.

*A Harlot's Progress* burst onto the London scene just after an official crackdown on prostitution had been instigated, focusing specifically on Covent Garden. The most prominent figure in this initiative was Justice John Gonson, whose missionary zeal

in 'cleaning up' the streets was regularly reported in the London press. By the 1730s the emphasis on blame and revulsion was partially tempered by a journalistic convention that promoted 'the prostitute' as an innocent country girl who arrives in the city, alone and vulnerable, and is tricked into prostitution by a devious brothel keeper. Hogarth incorporated these inconsistent representations into *A Harlot's Progress*, giving them greater resonance and topicality by folding into the storyline references to real-life characters, including Gonson himself. In Scene 1 Moll is met by Elizabeth 'Mother' Needham, a notorious brothel keeper who died in 1730 after being brutally assaulted by the London crowd as she stood in a pillory, a form of corporeal punishment. In the background stands Colonel Francis Charteris, an infamous Scottish rake nicknamed 'The Rape-Master General of Britain'. In March 1730 he was

male aspiring to be an aristocrat was known as a 'cit'. And Tom's inordinate concern with outward display finds parallels with 'the fop'. His pretensions and self-delusion in assuming a lifestyle above his class are mercilessly lampooned by Hogarth throughout the series via absurd juxtapositions between himself and, for example, classical deities and Roman emperors. An equally absurd parallel was that of the Restoration rake, most famously John Wilmot, 2nd Earl of Rochester, who, in addition to being a libertine, was a celebrated wit, courtier, man of letters and patron of the arts. Thus we find Tom not only conforming to the profile of the carousing rake but at various moments patronising musicians and poets, going to an audience at court and even writing a play.[5] The ironic allusion to the glamorous, promiscuous and cynical court of Charles II is evident in *A Harlot's Progress*. Moll's representation in Scene 3, which made such an impression on Hogarth's clients, clearly mimics the air of indolent languor and sleepy-eyed beauty characteristic of late seventeenth-century court portraiture. Provocative and openly sensual, with fashionable undress and low décolleté, such images were most closely associated with royal mistresses such as the actress and prostitute Nell Gwyn; Louise de Kéroualle, Duchess of Portsmouth; and Elizabeth, Countess of Kildare (fig.24). In this context we might interpret Moll in Scene 3 as an eighteenth-century 'male fantasy figure'. However, despite her consummate play-acting, she is not glamorous or exclusive but a common prostitute, available to anyone with the cash.

Such wide and varied visual, literary and cultural references, past and present, underline how rich and innovative Hogarth's *Progresses* would have seemed to his contemporaries. They also signal his personal crusade to establish modern urban life, including low life, as an appropriate subject for high art. Via the *Progresses*, Hogarth presented himself as both the roving satirist and an intellectual, gentleman artist. This is evident from the titles themselves. Hogarth's use of the word 'progress' would have immediately recalled John Bunyan's *Pilgrim's Progress* (1678 and 1684), which is thought to have been the most widely read book after the Bible in early eighteenth-century England. The story is a Puritan conversion narrative in which the progress of Christian, the main protagonist, constitutes an allegorical journey from burden to freedom, via

FIGURE 24

various trials and conflicts (Bunyan's work was also significant in the development of satiric realism and use of name symbolism). In addition, the biblical associations and parable character of both *Progresses* – the Prodigal Son or the penitent Magdalen are obvious precedents – underscore Hogarth's ambitious approach. However, the positive connotations of 'progress' in terms of personal development and advancement are comically diverted by Hogarth into a relentless downward spiral.

## 40

*Before* and *After* 1730–1
Oil on canvas
*Before* 44.7 × 37.2
*After* 45.1 × 37.2
FITZWILLIAM MUSEUM, CAMBRIDGE

## 41

*Before* and *After* c.1731
Oil on canvas
Each 38.7 × 33.7
THE J. PAUL GETTY MUSEUM,
LOS ANGELES

## 42

*Before* and *After* 15 December 1736
Etching and engraving
*Before* 42.6 × 32.8
*After* 40.9 × 33
ANDREW EDMUNDS, LONDON

In the 1730s Hogarth produced three
versions of paired works entitled *Before*
and *After*. One of the painted sets was
reputedly executed 'at the particular
request of a certain vicious nobleman'.[6]
The first of these had an outdoor
setting, in which Hogarth parodied
fashionable *fête galante* subjects by
Antoine Watteau, Nicolas Lancret and
others, as well as the *tableaux de mode*
of Jean-François du Troy (see p.145).
In *Before* we find an amusing scene
of studied elegance with gallant
persuasion on the part of the man and
affected coyness on the part of the
woman, the type of vignette that was
common in *fête galante* compositions.
Far from leaving the consequences to
our imagination, Hogarth shows the
young couple after sexual intercourse,
mutually dishevelled and bewildered
from their physical exertions, but
importantly without the inference
of exploitation. The *Before* and *After*
format was to take a cynical turn,
however, in the other series. The oil
versions, this time with an indoor
setting, were probably executed just
after *A Harlot's Progress*. The engraved
versions (with some changes and
additions) were published in 1736,
the year after those of *A Rake's Progress*.
The *Before* scene, set in a lady's
bedchamber, is violent, with the woman
cast as a reluctant, even frantic prey,
pushing over her dressing table in an
effort to escape, and the man as a
heartless predator pulling her towards
the bed. In the painted version his red
breeches with a strip of gold braiding
strategically placed in his bulging

40 BEFORE

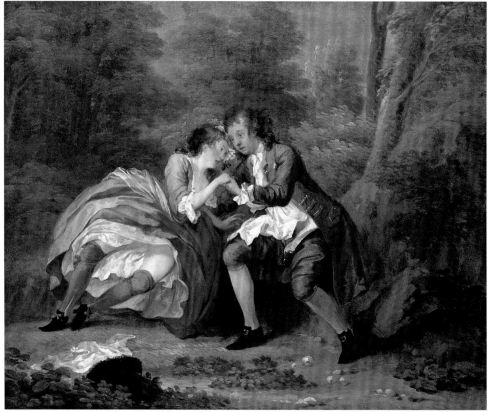

40 AFTER

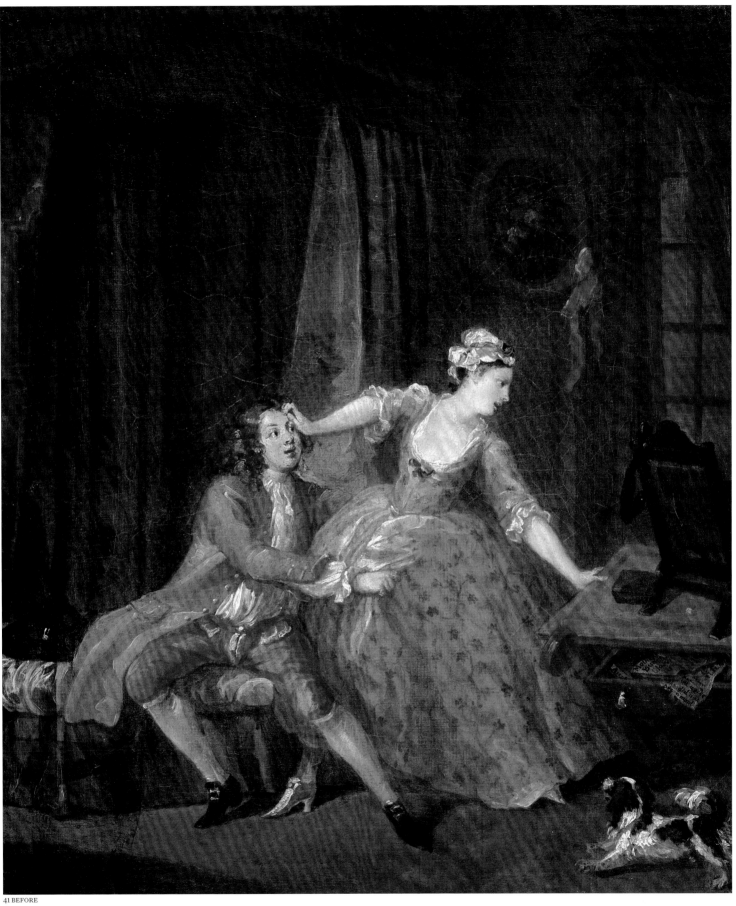

41 BEFORE

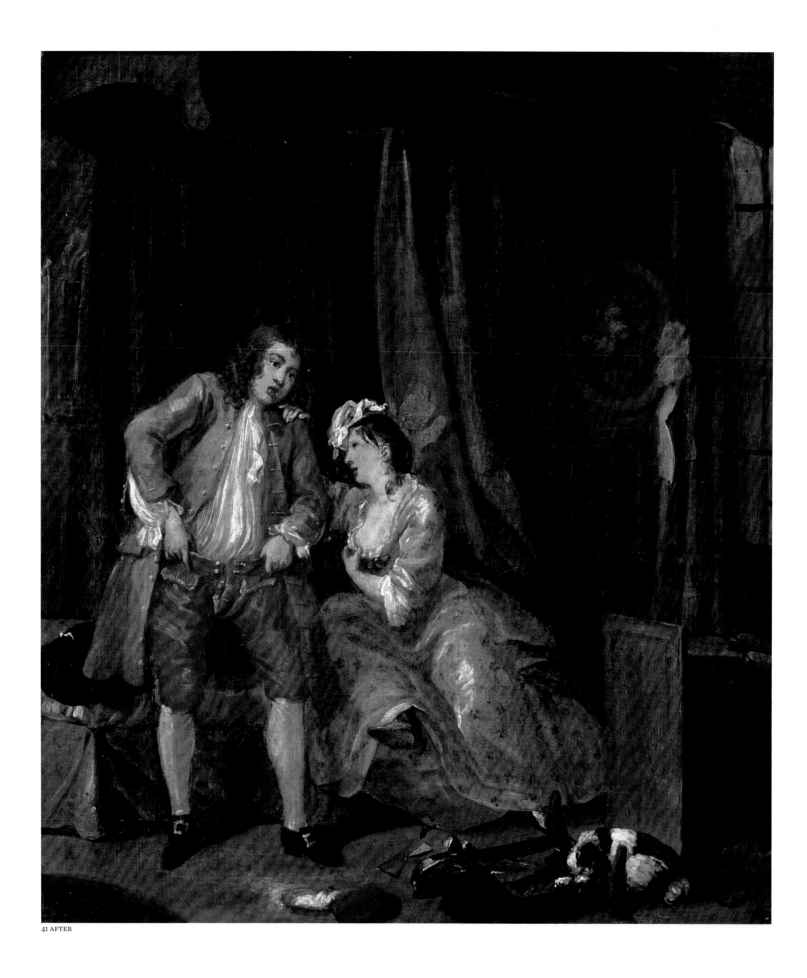

41 AFTER

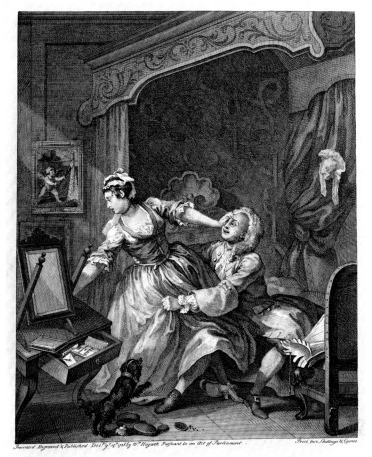

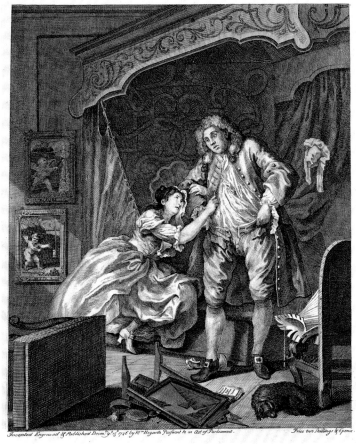

42 BEFORE

42 AFTER

crotch underline his sexual aggression, as does his exaggerated expression in the engraved version. The falling dressing table and broken mirror in both sets denote her lost virginity and subsequent 'fall'. Both versions thus appear to represent a rape scene.

A dog depicted scampering and sleeping representing awakened and sated desire (as seen in the foreground of the paintings) formed part of the iconography of *fête galante* and *tableau de mode* paintings (see p.145). In the engraved versions Hogarth emphasised the theme of arousal by showing the dog jumping up in *Before*, and by replacing the oval-framed flower painting on the wall with two images suggestive of erection and ejaculation, one showing a cupid lighting the fuse of a rocket, the other with the cupid gesturing at the same rocket, now spent. In the painted version of *After* the man stares into the distance as he pulls up his breeches, the woman dishevelled with flushed cheeks appears to be appealing to him, perhaps for his discretion. In the engraved version the woman's imploring gesture and facial expression are ambiguous; is she looking for reassurance or more sex? If the books seen on the falling dressing-table in the *Before* print are meant to be

read as belonging to the woman, then their subjects would seem to contradict each other. One volume refers to John Wilmot, 2nd Earl of Rochester, a notorious rake, wit and poet at the court of King Charles II. His poetry, published at various times in the early eighteenth century, was renowned for its blunt references to sexual subjects, including seductions. Another, *The Practice of Piety, directing a Christian how to Walk, that he may please God* (1602), was written by Dr Lewis Bayly, chaplain to King James I and Bishop of Bangor. This highly respected treatise had reached its fifty-ninth edition in 1735. Rather than casting doubt on the woman's show of reluctance, it is likely that the books are meant to symbolise innocence or virtue being corrupted. She is, after all, as modestly dressed as Moll Hackabout at the beginning of *A Harlot's Progress* and Sarah Young, Tom Rakewell's abandoned lover in *A Rake's Progress* (nos.43, 44). Indeed, we can imagine the brutal seduction scenario of *Before* and *After* taking place between Plate 1 and Plate 2 of *A Harlot's Progress*, when Moll is converted – by inference through Colonel Charteris, the infamous rake and convicted rapist – from a naive country girl into a kept mistress.[7]

That these paintings and prints form part of the *Harlot* and *Rake* project is made clear from their overwhelming moral message. In the *After* print Hogarth positioned a book at the man's feet referring to Aristotle's dictum 'Omne Animal Post Coitum Triste' (every animal is sad after sex). This gives additional significance to the Rochester reference in *Before*, elevating Hogarth's works beyond prurience and titillation. While Rochester's writings often concentrate on the sexual itch and base appetites in general, their cynical tone also makes clear that sensual fulfilment is ultimately no fulfilment at all.

# 43

*A Harlot's Progress* April 1732
Six prints (the original canvases were
destroyed in a fire in 1755)
Etching and engraving
Each approx. 32 × 38–9
ANDREW EDMUNDS, LONDON

## Plate 1

Mary (Moll) Hackabout has arrived at
the Bell Inn in Cheapside, fresh from the
countryside. She stands, seemingly
innocent and modestly attired, in front of
Mother Needham, who has met her from
the York stagecoach (exiting to the left).
Needham is seen inspecting Moll's youth
and beauty, which are as natural and
unblemished as the rose displayed at her
bosom. Her attractiveness is also
represented by the pub sign showing a bell,
which is a pun on *belle*, the French word for
a beautiful woman. It also comically refers

to Needham, whose figure has a bell-like
shape. That Moll is seeking employment
as a domestic servant or seamstress is
suggested by the scissors and pincushion
hanging below the purse on her right arm.
Unfortunately, as indicated by the label
around the goose's neck on the right ('For
my lofing [*sic*] Cosen in Tems Stret in
London'), a cousin living in London who
was meant to have met her has failed to turn
up. The word 'goose' is slang for a silly
person, thus underlining that Moll is naive
and gullible.

Needham has an alternative, potentially
more lucrative career in mind for Moll. She
may be acting on behalf of Colonel Francis
Charteris, who stands in the doorway to
the right with his manservant. Charteris
fondles himself while ogling the new
arrival, the inference being that Moll will
be seduced by him. That characters such as

Needham and Charteris are able to prey
almost unimpeded on vulnerable and
impressionable females – such as Moll and
the two country girls seated at the rear of the
stagecoach – is emphasised by the parson
on horseback. As a churchman and 'pillar
of society', he might be expected to provide
moral guidance or practical assistance at
this crucial moment and thus prevent Moll
from straying into a life of prostitution.
However, he is oblivious to what is
happening around him, peering instead at
his letter of introduction to a high-ranking
churchman. Meanwhile, his horse,
munching on some straw, has upset a stack
of pots, an allusion to Moll's imminent 'fall'.

## Plate 2

Moll is now the kept mistress of a wealthy
London Jew and lives in a well-appointed
town house. The scene is set in her

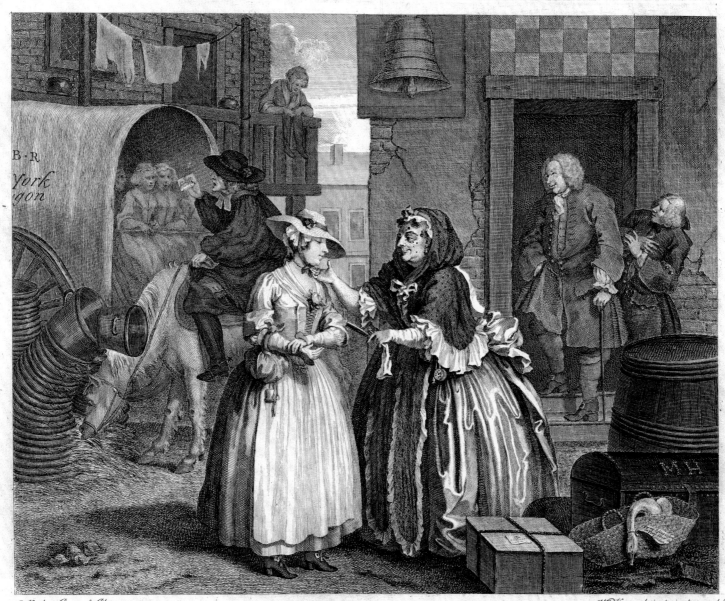

*A Harlots Progress Plate 1.*

*W.ᵐ Hogarth inv.ᵗ pinx.ᵗ et sculp.ᵗ*

43 PLATE 1

bedroom, which is richly furnished with silk wall coverings and fashionable Rococo frames and table, and hung with Old Master paintings. Her modish lifestyle is underlined by the scene itself resembling an aristocratic *toilette* (see p.149), the reference to masquerade balls denoted by the mask on the dressing table, and the presence of a turbaned black pageboy. Thus her career as a prostitute has initially brought her rapid social advancement and the trappings of high society.

Moll and her young aristocratic lover have been interrupted by the unexpected arrival of her wealthy keeper. Their act of betrayal towards him is symbolised by the Old Testament scene hanging above on the right, which shows Uzzah being stabbed in the back as he steadies the Ark of the Covenant. In order to create a diversion, Moll is kicking over the small table and

clicking her fingers at him dismissively. Meanwhile, her lover sneaks out, clutching his unsheathed sword, with his stockings slipping to his ankles, as the maidservant opens the door. The gesture he makes with his fingers is a lewd comment on the diminutive size of the merchant's penis. Although Moll is clearly beautiful and desirable, her keeper's look of disbelief, paralleled by the figure of Jonah in the biblical scene hanging above, suggests that she is overplaying her hand and misjudging the security of her position. This is emphasised by the presence of the pet monkey, which signifies exoticism and (over) indulgence and, like Moll, is an amusing plaything that can be discarded. The parallel in their status is demonstrated by the 'fichu' wrapped around the monkey, which mimics Moll's mop cap and ribbons. Startled by the action of its mistress, the

monkey escapes the falling table and broken crockery, all of which represent the fragility of Moll's position and therefore portend her fate. The monkey's appearance also relates to the expression and full-bottomed wig of the Jewish keeper. Thus the creature neatly symbolises the whole scenario: a pretentious façade that merely 'apes' high social rank and fashionable behaviour.

Plate 3
The precariousness of Moll's profession and social position is underlined by Plate 3. Having insulted and betrayed her wealthy keeper, she has now been cast out and 'demoted' to the position of a common prostitute. As indicated by the tankard in the lower right corner, the dingy garret she now occupies is situated around Drury Lane, Covent Garden. This was not only

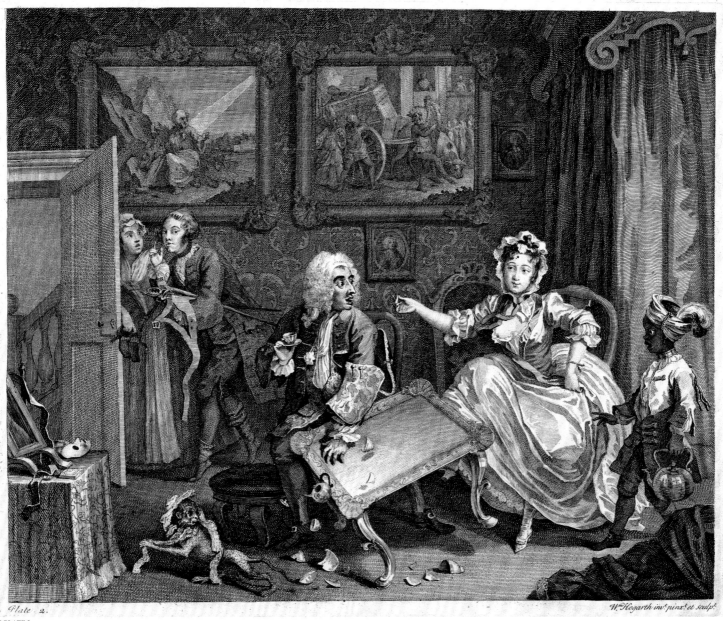

Plate 2.

43 PLATE 2

W.ᵐ Hogarth inv.ᵗ pinx.ᵗ et sculp.ᵗ

renowned in the eighteenth century for its theatres, coffee houses and taverns, but also its brothels (see p.122). In the previous scene she was attended by a maidservant and pageboy and surrounded in luxury. Here the furnishings are plain and functional and Moll is served by a nose-less, syphilitic 'bunter' (common servant). She sits on the bed in a state of undress, holding up a fob watch (possibly stolen from a client), and looks alluringly towards the viewer. Given the context, the posture of the cat at Moll's feet is highly suggestive, just as the birch rod and witch's hat on the wall imply that flagellation and role play are 'services' she offers her clients. Stored on top of the bed frame is a wig box that belongs to the real-life highwayman James Dalton (a wig also hangs on her bed). This may indicate that Moll counts among her clientele members of the criminal class or, as was often

reported in the newspapers, that brothels frequently harboured known felons.

Moll is unaware of the arrival of Justice Gonson with a group of bailiffs. He pauses at the door, contemplating her physical attractions. This, coupled with the biblical scene of an angel intervening as Abraham is about to sacrifice Isaac (hanging above the window on the left), suggests that Gonson may show leniency towards her. The notion is complemented by two portraits underneath representing the theatrical character Captain Macheath (see pp.70–1) and the real-life clergyman Dr Sacheverell, who were, respectively, sentenced to hang and impeached but subsequently both reprieved. Or perhaps the inference is that Moll may prove too tempting even for this vigilante magistrate. Given Gonson's well-publicised quest to rid the capital's streets of prostitutes, however, it is inevitable that

Moll will be arrested and taken off to Bridewell Prison, where she will be punished by hard labour. Moreover, the bottles of medicine around the room suggest that the small black spots on her face (also evident in Plate 2) are more than just fashionable face patches and are in fact hiding the tell-tale signs of syphilis. Moll is thus already under 'sentence of death', underscored by the positioning of Dalton's name above her head. He was executed at Tyburn in 1730.

Plate 4
The scene takes place in Bridewell Prison. This was the house of correction for prostitutes, procuresses, wayward apprentices and petty criminals (see p.182). Moll is seen beating hemp with inmates including a well-dressed gambler on the right (note the torn playing card on the

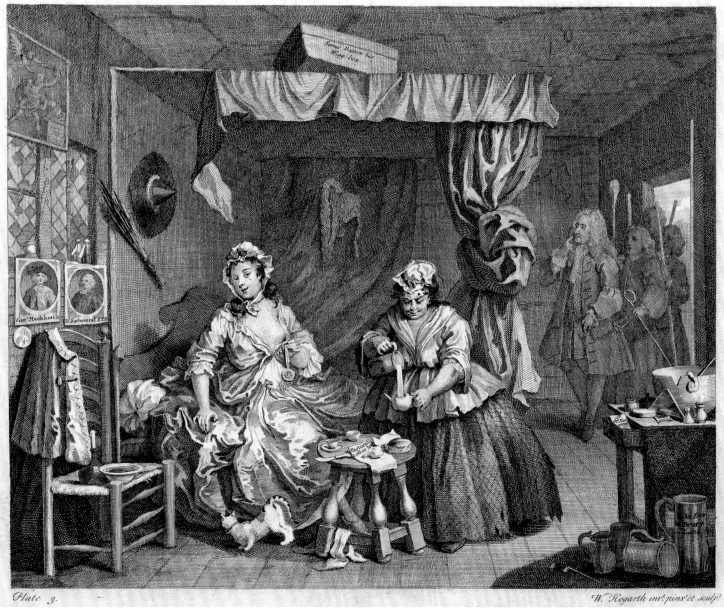

floor). The irony of the situation, given that she had previously engaged in whipping as a recreational activity, is reinforced by the prison warder to the left, who raises his cane to discipline her for slackness. He points at the ankle chain and weight (centre foreground) as an additional incentive to work harder. The marked change in her circumstances and the distress that she feels as a result are emphasised by the incongruity of her fine clothes within the cheerless prison environment. Her appearance, which indicates her aspirations and hubristic fall, clearly amuses some of the female inmates in the room. On the right, one, perhaps her bunter from the previous scene, turns towards Moll laughing as she adjusts her garter. Another mockingly touches the lace and silk of Moll's clothing, while directing a wink and wry grin at the viewer. Behind them an inmate is held in a raised stock with an inscription above the hand holes that reads, 'Better to Work than Stand thus'. The theme of corporeal punishment continues with the whipping post to the right of the gambler, on which is written 'The Wages of Idleness'.

## Plate 5

Moll has left Bridewell and returned to the garret. After the enforced labour and humiliation of her prison confinement she is now dying from venereal disease, indicated by the shroud-like 'sweating' blankets that swathe her body and the woman on the far left, who rifles through a trunk for suitable burial clothes. The bunter who tends her turns angrily on two doctors quarrelling over the efficacy of their respective cures, meanwhile ignoring the evident distress of their patient. In any case, they are both quacks. The corpulent figure on the left is Doctor Richard Rock, whose name appears on a piece of paper on the cylindrical coal container (far right). The teeth placed on this paper are Moll's, which have fallen out as a result of syphilis. Rock was well known for inventing and peddling medicines including 'The famous, Anti-Venereal, Grand, Specifik Pill' and, ironically, cures for toothache. The other doctor is not identified by Hogarth but is probably Dr Jean Misaubin, an émigré French doctor.

The precarious future of Moll's illegitimate son, seated near her chair, is indicated by him reaching for food in front of the open fire. He is the innocent victim of this series, and we are left to wonder if he, too, will be preyed on and enter the world of vice and crime. The upturned table and broken crockery in the foreground recall the incident in Plate 2, which might be said

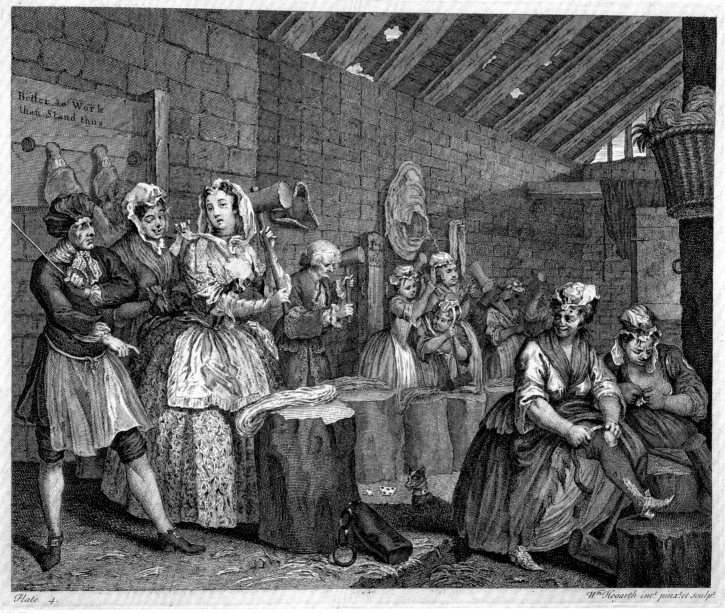

to have initiated the spectacular decline in Moll's fortunes.

## Plate 6

The indifference shown towards Moll in Plate 5 is mirrored by the final scene, where 'mourners', most of whom are fellow prostitutes, gather round the coffin. Even her bunter is showing disrespect by using the lid as a table. The plaque on the coffin indicates that Moll was only twenty-three when she died. Her son sits nearby in his mourning clothes. Left alone, he amuses himself with a toy top. How genuine are the lamentations of the various women in the room is difficult to determine and could as easily denote concern that Moll's fate awaits them, too. However, one appears to be weeping over an injured finger! Out of curiosity, a young prostitute pulls back the lid of the casket to look at Moll's face, the sight of which seems to cause a moment of reflection. At the same time another prostitute, at the back on the right, admires or examines her own reflection in the mirror. The sprigs of yew on the coffin lid and on the platter in the foreground relate to the convention of using yew at funerals as a precaution against infection. Traditionally, yew trees are grown in churchyards.

That the cautionary lesson of Moll's short life remains unheeded by many in the room is underlined by two prostitutes taking the opportunity afforded by the event to ply their trade. On the right the undertaker leans with a besotted expression on his face towards an attractive but probably syphilitic prostitute. He is pulling a glove onto her arm, which, given the context, is suggestive of a condom, as she steals the handkerchief from his pocket. On the other side a parson, staring into space, spills his drink (suggestive of erection and ejaculation) as his right hand delves beneath the skirt of the young and beautiful prostitute next to him. His sexual excitement is also intimated by the angled sprig of rosemary that the prostitute holds in her left hand. She looks out towards the viewer with half-closed eyes and a faint smile on her lips, reminiscent of Moll's alluring expression in Plate 3. In concert with Plate 1 of *A Harlot's Progress*, Hogarth seems to suggest that the cycle of innocence corrupted, sex, decay and death will continue unabated, ignored and/or abetted by members of the established church.

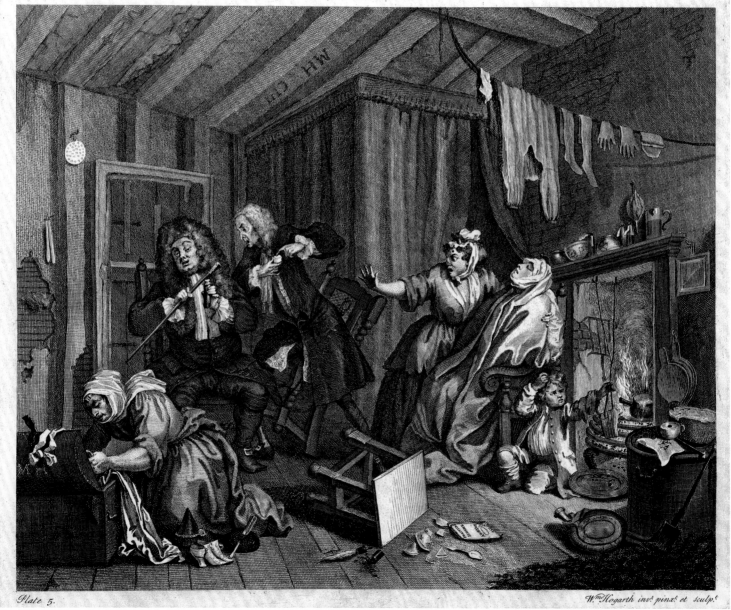

Plate 5.

W.ᵐ Hogarth inv.ᵗ pinx.ᵗ et sculp.ᵗ

43 PLATE 5

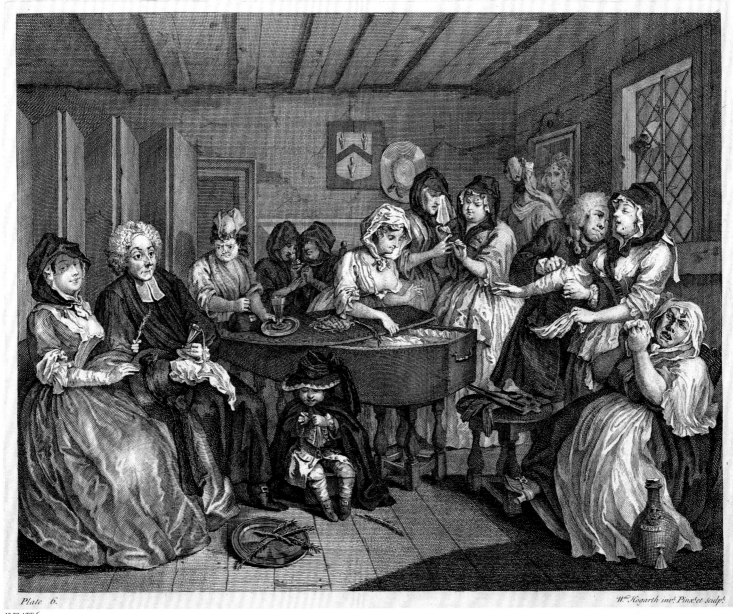

Plate 6.                                                                        W<sup>m</sup> Hogarth inv<sup>t</sup> Pinx<sup>t</sup> et sculp<sup>t</sup>

# 44

*A Rake's Progress* 1734
Eight scenes
Oil on canvas
Each 62.2 × 75
SIR JOHN SOANE'S MUSEUM, LONDON

# 45

William Hogarth partly assisted by Gérard
Jean-Baptiste Scotin (1690–after 1755)
*A Rake's Progress* June 1735
Eight scenes
Etching and engraving
Each approx. 35.5 × 40.5
ANDREW EDMUNDS, LONDON

# 46

William Hogarth (? assisted by Gérard
Jean-Baptiste Scotin)
*A Rake's Progress* Plate 4, early 1740s
Etching and engraving
35.8 × 41
ANDREW EDMUNDS, LONDON

Scene 1: *The Rake Taking Possession of
his Estate*
The chief protagonist of the series, Tom
Rakewell, is the son of a rich moneylender.
He has arrived back from Oxford University
after inheriting a fortune from his miserly
father who has recently died. The scene is
full of details underlining the wealth that
has been hoarded in this unkempt, gloomy
house, such as the silver plate and bags of
money in a trunk and pile of indentures,
leases, mortgage papers and so on in the
foreground, and the open door and hatch
to the right revealing still more stored
possessions. The father himself is
represented by the painting over the
fireplace, counting money. Above this, a
servant pinning mourning cloth to the wall
has disturbed a stash of coins that can be
seen falling out of a hole in the cornice.
Meanwhile, the family steward seated at
the table, ostensibly compiling a list of
possessions, looks furtively towards Tom,
as he steals some money.

Oblivious to the thieving occurring
behind his back, Tom stands in the middle
of the room being fitted for a new suit.
Unlike his father, he is a spendthrift with
every intention of taking on the lifestyle of
an aristocratic roué. This is emphasised by
the heartless manner in which he attempts
to pay off his pregnant lover/fiancée Sarah
Young, who stands weeping at the door
holding a wedding ring in her hand.
A modestly dressed country girl (note the
similarities between her appearance and
that of Moll Hackabout in Plate 1 of
*A Harlot's Progress*), she believed Tom's
previous assurances that they would be
married, as indicated by the letters in her
mother's apron to her left. Meanwhile,
Sarah's mother angrily rejects the handful
of gold coins being offered by Tom, which is
small change in comparison to the riches
that surround them.

Scene 2: *The Rake's Levée*
In direct contrast to the manner in which
his father lived, Tom has quickly adapted
himself to a life of luxury in imitation of the
aristocracy. Not only is he dressed in
expensive clothes and living in a well-
appointed town house but he is seen here
aping the fashionable aristocratic practice
of the morning levée. Adopted by members
of the British social elite from French court
culture, the levée involves an audience with
visitors and tradesmen while the aristocrat,

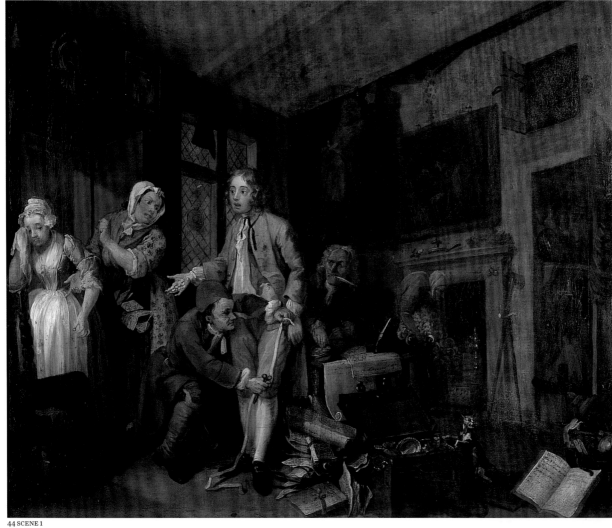

44 SCENE 1

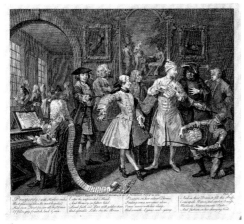

45

having just risen, prepares for the day. Thus Tom is wearing an informal housecoat and cap.

The crowd of people vying for Tom's attention, including those in the adjoining room, is meant to appear absurd, thus satirising both the taste and entertainments associated with high society and those members of the middle class, like Tom, who indiscriminately aspire to it. The mixed assemblage of sportsmen, tradesmen and hangers-on, all of whom are either in Tom's employment or attempting to secure his patronage, includes, standing from left to right, a lunging fencing master, a quarter-staff instructor (a sport involving wooden staves and associated at this time with prize fighting), a French dancing master posturing with a 'kit' (small violin), a landscape gardener holding a design, a thuggish bodyguard reaching for his sword, a huntsman blowing a horn and, kneeling far right, a jockey holding a trophy. The inscription reveals that Tom owns at least one prize-winning racehorse, which Hogarth has pointedly named 'Silly Tom'. The musician or singing teacher seated at the harpsichord is about to play from the score of a fictitious opera entitled *The Rape of the Sabines* (see below).

That Tom also participates in cock fighting is suggested by the two paintings of gaming cocks on the wall (see p.195), which flank a mythological scene. The inappropriateness of this juxtaposition underlines that Tom has no discernment in displaying works of art or, indeed, in anything else. Thus the subject of the central painting, the Judgement of Paris, is crucial to the satirical resonance of the present scene and the series as a whole. Paris, the Trojan prince, was told by Zeus to judge who among the goddesses Venus (goddess of love and sexual desire), Minerva (goddess of wisdom and warriors) and Juno (goddess of heaven and motherhood) should be given the apple of discord, which is marked 'For the Fairest'. The goddesses each make offers to Paris to win the prize. However, he decides on Venus who has offered him the most beautiful woman in the world. Paris's imprudent choice leads to the abduction of Helen, the destruction of Troy and his own downfall. Thus Hogarth is making a satirical comparison between the flawed hero and deities of classical literature, and the pretentious anti-hero and motley assembly of his 'modern moral subject' (note the comic juxtaposition of Paris choosing Venus and Tom's preference for the bodyguard, who is laughingly described as a 'man of Honour' in the written recommendation in his hand). Tom's lack of sound judgement and insatiable pursuit of pleasure will be his undoing.

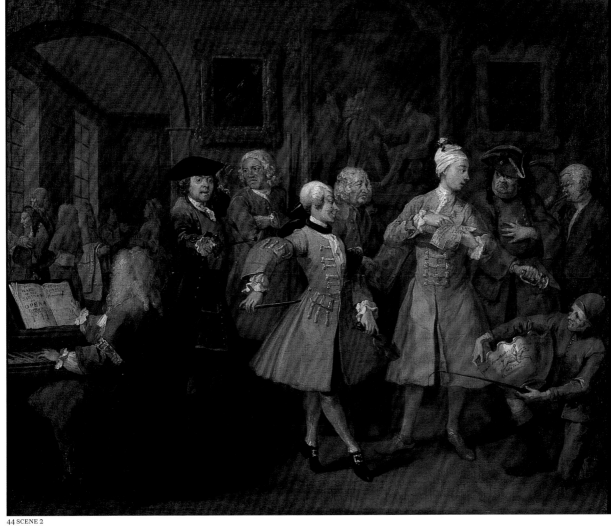

44 SCENE 2

In the engraved version of *The Rake's Levée* (no.45) Hogarth added details that are germane to Tom's voguish patronage of the arts. The musician seated at the harpsichord is probably meant to represent both the celebrated German composer George Frideric Handel and Niccola Porpora, the Italian operatic composer and singing teacher, who was Handel's rival at this time. The reference to an opera entitled *The Rape of the Sabines*, previously noted, is in keeping with other classical references within the series. Thus it could be an ironic allusion to Tom's fondness for prostitutes, demonstrated in the next scene, and his seduction of Sarah Young and others like her. However, the inclusion of real-life opera singers in the cast list, which Hogarth added to the opera score in this engraved version, demonstrates how rich and topical his commentary was. Some of those cited, like Anna-Maria Strada del Pò ('Senra Stra-dr'), were members of Handel's company at the Royal Opera House. Others, like Francesca Cuzzoni ('Sen Coz-n'), had recently defected to perform for Porpora's rival company, hence the loaded reference to

abduction. And Hogarth's audience would have acknowledged the irony of casting Il Senesino ('Sen: Senno') and Il Farinelli ('Sen: Farilli'), the celebrated Italian castrati, as 'ravishers' of women.

The roll falling from the back of the musician's chair amplifies the predominant theme of Tom mimicking fashionable high society in the context of Italian opera (see also p.59). Carlo Broschi (Il Farinelli) had made his triumphant London debut in October 1734, only a month before the advertisement inviting potential subscribers to view Hogarth's series of paintings. Echoing actual events, the roll records the 'List of the rich Presents Signor Farinelli ... Condescended to Accept of ye English Nobility & Gentry for one Nights Performance in the Opera Artaxerses', which includes 'A Gold Snuff box Chac'd with the Story of Orpheus charming ye Brutes by T: Rakewell Esq' (as classical legend has it, Orpheus was so skilful on the lyre that he could even enchant wild beasts, a satirical allusion to the effect Farinelli's voice had had on his English audience). The end of the roll partially covers an engraved

title page showing Farinelli on a pedestal being worshipped by an adoring crowd. The inscription at the bottom of this image reads 'A Poem dedicated to T. Rakewell Esq.'

Scene 3: *The Rake at the Rose Tavern*
This chaotic scene is set in the notorious Rose Tavern, a brothel-cum-tavern in Drury Lane. It is three o'clock in the morning. As with the previous scenes, Tom is surrounded by people who seek to divest him of his wealth, this time those involved in the sex trade, recalling Paris's selection of Venus in the previous scene. Tom is seen lolling drunkenly on the right. His vacant expression, uncouth posture and dishevelled appearance make a risible contrast with his studied elegance in Scene 2. His yobbish nature is suggested by his sword, conceivably unsheathed during a brawl, and the nightwatchman's lantern and staff on the floor by his chair, no doubt stolen while carousing in the streets. A syphilitic prostitute slips her hand in his shirt while handing his fob watch to another seated behind him, aping the theft by the steward in Scene 1. Around the table

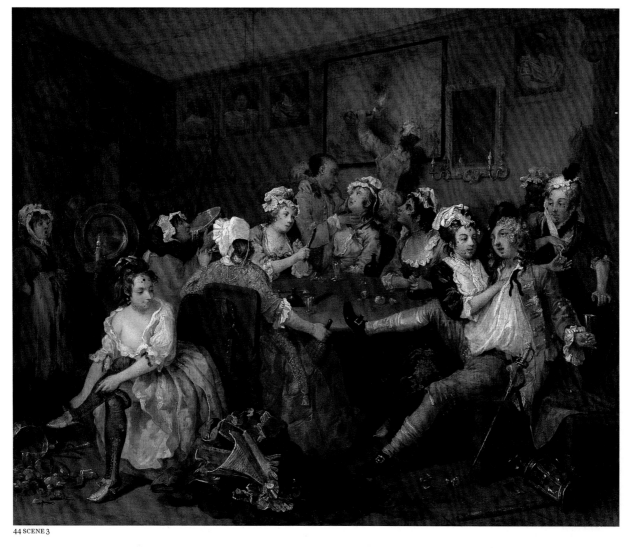

44 SCENE 3

a Chinese tradesman fondles a prostitute flanked by two women involved in a spitting match. Near the doorway on the left, a street singer performs a bawdy song called 'Black Joke', which, we can imagine, is more suited to Tom's musical taste than the opera being played at the harpsichord in Scene 2. Standing to her left is a waiter (or porter), who holds a burning candle in one hand, which is pointedly reflected in the large, polished salver that he holds with the other. This will be put on the table and used as the 'stage' for the prostitute-cum-stripper, seen in the foreground removing her clothes. Presumably the added titillation will be a glimpse of her genitals, as she spins and poses during the performance.

As in *The Rake's Levée*, the paintings displayed in the background make allusions to the classical past. They include portraits of Roman emperors, thus drawing humorous parallels between the dissipation of this ancient, and in Hogarth's time revered, civilisation and the present scene, as well as mocking Tom's social pretensions and self-delusion. The only face that remains intact among the imperial portraits

is that of Nero, who famously watched Rome burn after a night of unprecedented debauchery. Tom is, of course, no match for this notorious Roman emperor. But the detail of a prostitute holding a candle perilously near to the global map on the wall is in fact a prophecy: Tom's world will indeed 'go up in flames'.

Scene 4: *The Rake Arrested, Going to Court*
The upshot of Tom's profligate lifestyle is shown in Scene 4. This takes place in St James's in Mayfair on 1 March, which was Queen Caroline's birthday as well as St David's Day, commemorating the patron saint of Wales (note the two Welshmen wearing a leek, the national symbol, in their hats). Tom is in sumptuous court dress and on his way to St James's Palace (seen in the background) to be presented at court and attend a royal audience. While the occasion ought to have marked the high point in his albeit superficial identification with aristocratic life, we find instead a moment of hubris. His hired sedan chair with curtains drawn to conceal his identity has been stopped by a bailiff who is about to arrest

him for debt. Tom's startled expression underlines that he does not have the cash to rectify this humiliating position and thus appears to be on his way to a different kind of 'court' from the one he had anticipated. Given Tom's dire circumstances, it is possible that his purpose in going to St James's was to secure royal or aristocratic patronage, an ironic twist to the scene we witnessed in *The Rake's Levée*.

He has been saved by the timely intervention of Sarah Young, whom we last saw being abandoned and humiliated by him. In Scene 1 Tom had offered her mother a derisory sum of money to buy off Sarah who was pregnant with his child. In a reversal of fortune it is she who has money, honestly earned as a seamstress (note her modest dress and the haberdashery falling from the open case). Far from enjoying a well-deserved moment of *schadenfreude*, however, she offers the bailiff her hard-earned wages, echoing and thus parodying Tom's previous action. This demonstrates her generous, loyal spirit and enduring, if misplaced, love for him. That Sarah has presented Tom with the opportunity to

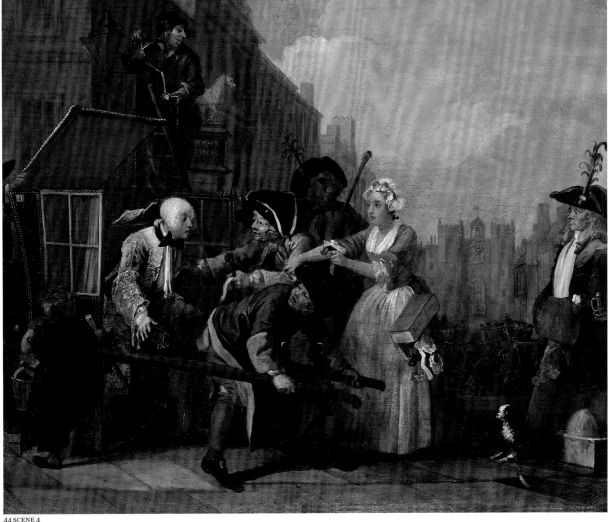

44 SCENE 4

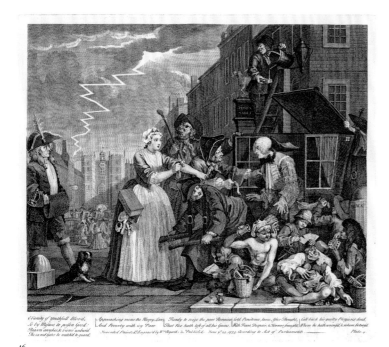

The additions to the painted version employed in the engraving dated from the early 1740s (no.46) focus primarily on gambling and its impact on Tom's life. In *The Rake's Levée* we saw that Tom was patronising sports associated with gambling. The saddler's sign positioned above Tom's head recalls his connections with horseracing. Here, we are introduced to his addiction to cards, dice and other games played at clubs and gambling dens. St James's was the location for a number of such establishments. The sign on the building near to St James's Palace reads 'WHITES', a well-known gambling house in St James's Street. That it is a 'den of iniquity' is underlined by the storm-filled skies and bolt of lightning about to strike its roof, suggestive of divine wrath and judgement. Interestingly, the bolt ends in an arrow and thus is 'pointing' to yet another venue where Tom has frittered away his fortune. However, the fact that the lightning has not yet struck, continuing the theme of imminent destruction, may relate to Sarah's timely intervention and Tom's temporary reprieve, thus amplifying the religious

repent his sins and reform his ways is suggested by the quasi-religious action of oil dropping onto his head from the streetlighter's tin can, as if he were being anointed. The scene also draws parallels with the biblical story of the angel intervening as Abraham is about to sacrifice Isaac (see Plate 3 of *A Harlot's Progress*, no.43). Thus Sarah is cast as an angel of mercy.

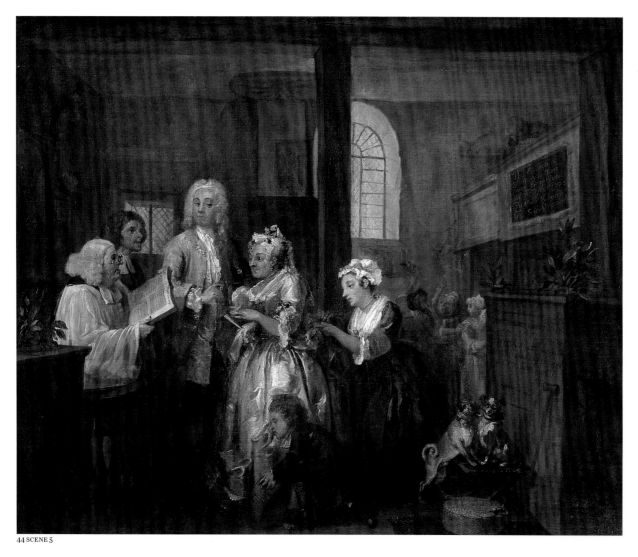

44 SCENE 5

allusions previously discussed.

In the right foreground Hogarth has also removed the single figure in the painting and added seven other figures, whose presence augments the theme of gambling. All are poor street hawkers, four of whom are either playing at cards or dice (see fig.27, p.125). To the left of the card player in a hat sits a boy who is cheating by signalling to his bewigged accomplice seated opposite. Appropriately, as a knave (rogue) himself, he is about to play a knave of clubs. The dice player with sunken eyes (to the right) has literally won the clothes from the other player's back, which are piled in his lap. The boy on the far left is smoking a pipe while reading *The Farthing Post*, a low-cost newspaper containing gossip, politics and other news. Meanwhile, the boy at the back of the group steals Tom's handkerchief, corresponding with the actions of the steward and the prostitute in previous scenes. On the right of the group is a post on which is written 'BLACK', which relates to 'WHITES'. The group of boys thus parody the goings-on within the gaming house down the street.

Scene 5: *The Rake Marrying an Old Woman*
The scene is set in Marylebone Old Church, north of Hyde Park, which was renowned for clandestine weddings. Having squandered his fortune, Tom attempts to appropriate another one, not through gainful employment, of course, but marriage. In Scene 1 he had rejected marriage with the young, pretty and faithful Sarah. In Scene 2 Hogarth had mockingly compared him to Paris, who chose Venus, goddess of love, in a contest, having been promised the most beautiful woman in the world. Here, Tom's 'Helen of Troy' is an ageing, dumpy, one-eyed heiress, who appears to be inordinately excited by the prospect of married life with a young, 'virile' man. On the right hand side an overly eager dog jumps up at another with one eye, thus parodying the bride and groom. Meanwhile, Tom's sideways glance seems to take in the glaring contrast between his grotesque bride and the pretty young maid who attends her. Given his history, Tom is probably eying up the girl as a sexual conquest.

The dilapidated interior of the church

indicates the lack of spiritual integrity and social care shown by the clergy present. This is poignantly underlined by the shattered tablet carved with five of the Ten Commandments (situated behind the parson) and the undisturbed spider's web growing over the poor box (on the right). Of course, these details are germane to Tom's own moral redundancy and voguish patronage, as opposed to charity and philanthropy. It also reminds us (as was evident in *A Harlot's Progress*) that the established church is failing to offer an alternative to a life of vice. This, however, is provided by the ever-faithful Sarah, who can be seen entering with her mother and Tom's child in the background. Her attempt to interrupt this shameful ceremony is prevented by a brawl between her mother and an overzealous church attendant brandishing a bunch of keys. Any hope of salvation for Tom, as represented by Sarah, now appears to have gone.

Scene 6: *The Rake at the Gaming House*
Recalling the engraved version of *The Rake Arrested* (Scene 4), this painting shows Tom

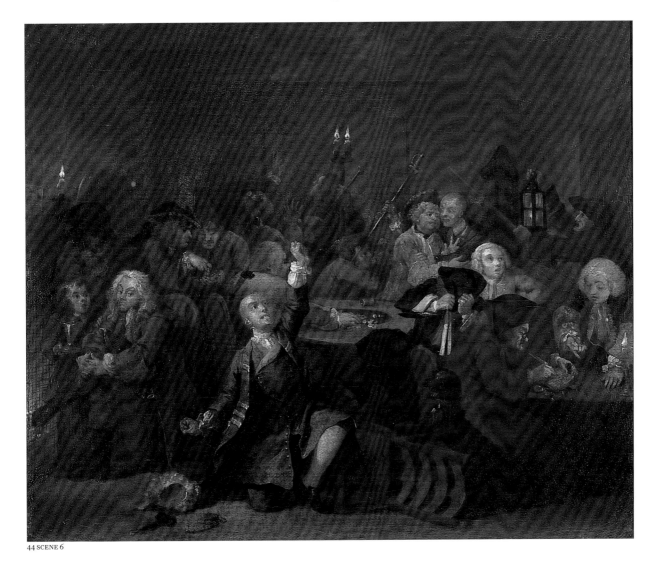

44 SCENE 6

losing another fortune, frittered away in a dingy gaming den, probably in Covent Garden. That a number of fortunes are changing hands is underlined by the reactions of the men around the card-table in the centre: a clergyman with clenched fists turns away in despair, and an angry aristocrat behind him, brandishing a sword, is restrained by another who is drunk, while a seated figure with his back towards us calmly gathers up his winnings. On their right, at another table, a moneylender is writing a note for an aristocrat that reads 'Lent to L[or]d Cogg 500l'. To the far left a despondent man, seated by the fire, ignores a child's offer of a drink. His dress and possession of a pistol suggests that he is a highwayman who, having lost his booty, is perhaps considering who among the gamblers would be worth robbing.

The prophetic allusion in Scene 3 to fire is here fulfilled; a nightwatchman on the right alerts those towards the back of the room, including the croupier holding a money rake and lighted candles, that smoke is pouring through the ceiling. In yet another ironic twist the money rake recalls

Tom's miserly father but is here being used to rake away the remnants of his 'rakish' son's fortune. In the foreground Tom kneels on the floor. Like the majority of the people in the room, he is too obsessed with gambling to notice or care that the building is on fire. The overturned chair suggests that he was playing at the card-table and, having lost everything, has fallen violently to his knees. Distraught, he looks angrily towards heaven – comically suggested by the billowing clouds of smoke above – with his arms extended and his fists clenched, railing against God or fate. That his mental health is suffering is indicated by a black dog, the traditional symbol of melancholy and depression, which jumps up towards him, barking.

Scene 7: *The Rake in Prison*
Tom is in The Fleet, the debtors' prison. His previously plump wife, standing to his left, is now emaciated, indicating how desperate their circumstances have become. In order to raise some cash, Tom has written a play, which lies rolled on the table next to him. Of course, this is as madcap a scheme

as the 'alchemist' seated at the back, attempting to make base metal into gold. Indeed, the letter next to Tom's script indicates that it has been rejected by John Rich, the former manager of Lincoln's Inn Fields and proprietor of Covent Garden Theatre (see p.70). This latest failure has infuriated his wife, who clenches her fists and scolds him, aping Tom's gesture in Scene 6. Meanwhile, a surly boy holding a tankard of beer awaits payment, as does the jailer behind Tom's chair who is pointing at a ledger. With no course of action left to him, Tom appears to have gone into a paralytic stupor.

The female figure swooning opposite Tom has traditionally been identified as Sarah Young, overcome at the sight of her deranged former lover. Thus the child to her right is hers and Tom's. Two women are attempting to revive her. Presumably her bodice has been unlaced to allow her to breathe. The costume wings positioned overhead may allude to her previous identification as an angel of mercy. However, this representation sits uneasily with her modest appearance and decorous

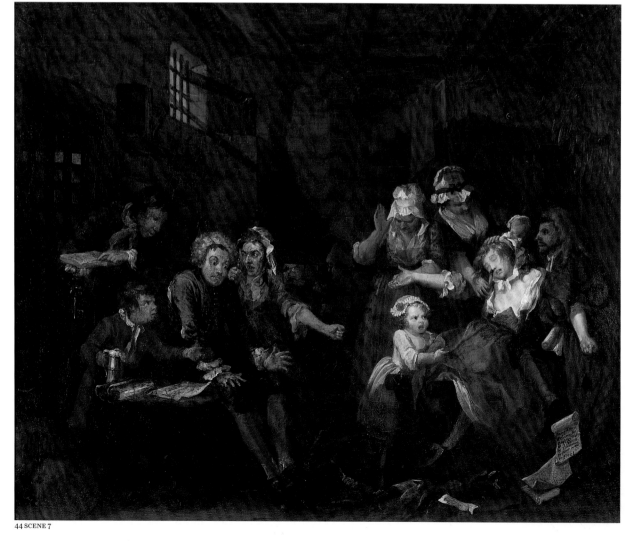

44 SCENE 7

demeanour established from the beginning and reintroduced in the final scene. An alternative reading would be that this woman is another inmate, like Tom, whose dire circumstances have caused her to lose her wits and who is oblivious to her dishevelled clothes, exposed breasts and thus complete loss of dignity. She and Tom are both incapacitated in their respective ways and therefore epitomise despair, just as Tom and fellow inmates in the final scene personify forms of madness. In this context the wings could underline the absence of Sarah and thus hope.

Scene 8: *The Rake in Bedlam*
The final scene is set in Bethlehem Royal Hospital (Bedlam), an institution whose inmates were poor and insane. Whereas in Scene 1 Tom was being fitted for a new suit, here he is lying in the foreground almost stripped of clothes and thus his social pretensions. His appearance and pose echo the sculptures by Caius Gabriel Cibber of *Raving* and *Melancholy Madness* (c.1675) that were displayed at this time over the hospital's portal (these sculptures are also

echoed by the praying figure seen through the doorway to the right). Sarah weeps by his side sure in the knowledge that Tom is beyond her help, while a prison attendant appears to be shackling his leg.

Two cells off the main room contain inmates who are suffering from delusions of religious and secular authority. The one on the left is wearing a makeshift crown and sceptre and seated as if on a throne, meanwhile urinating. The one on the right, lying on a bed of straw, is in saintly ecstasy in response to some divine revelation or visitation induced by the light pouring through the window and onto the cross. Neither saint nor king, they parody Tom's own pretensions in assuming the role of an aristocrat. Others around him seem to recall earlier scenes in the series: the deranged tailor (centrally positioned) recalls Scene 1, and the musician playing a violin, Scene 2. The globe on the wall behind Tom echoes the map in Scene 3, underlining that his world is now that of madmen, as previously it had been gamblers and prostitutes. In the engraved version of Scene 8 (second state) the seated figure on the stairs, a melancholic

lover, is accompanied by an inscription on the banister, 'Charming Betty Careless', alluding to a contemporary prostitute and thus Tom's own addiction to pleasure. The 'pope' figure (far left) could represent corruption and excess (as well as superstition), popularly associated with the papacy at this time, and thus neatly parallels the allusion to Nero and Rome in Scene 3.

Like prisons and other hospitals, Bedlam was open to paying visitors and considered one of the sights of London (see pp.119, 128). Within this scene an aristocratic lady and her maid are standing towards the left, amused and disgusted by the antics of the unfortunate people around them. The final irony is that, while Tom had set out to mimic the aristocratic lifestyle, he finishes by being one of its entertainments.

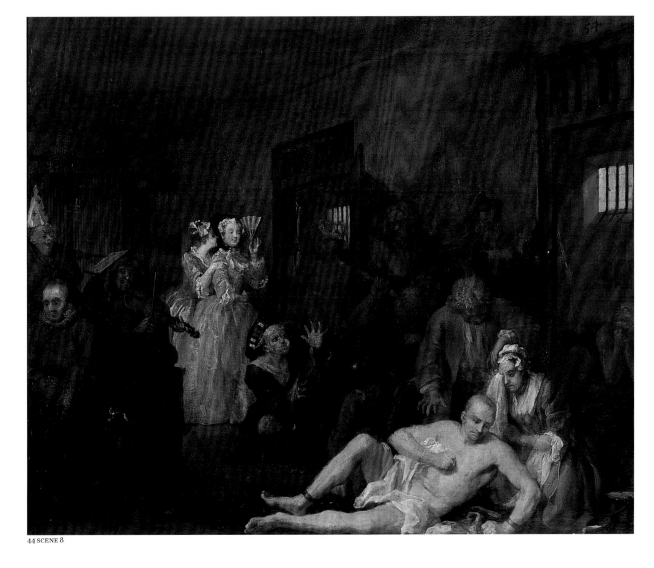

44 SCENE 8

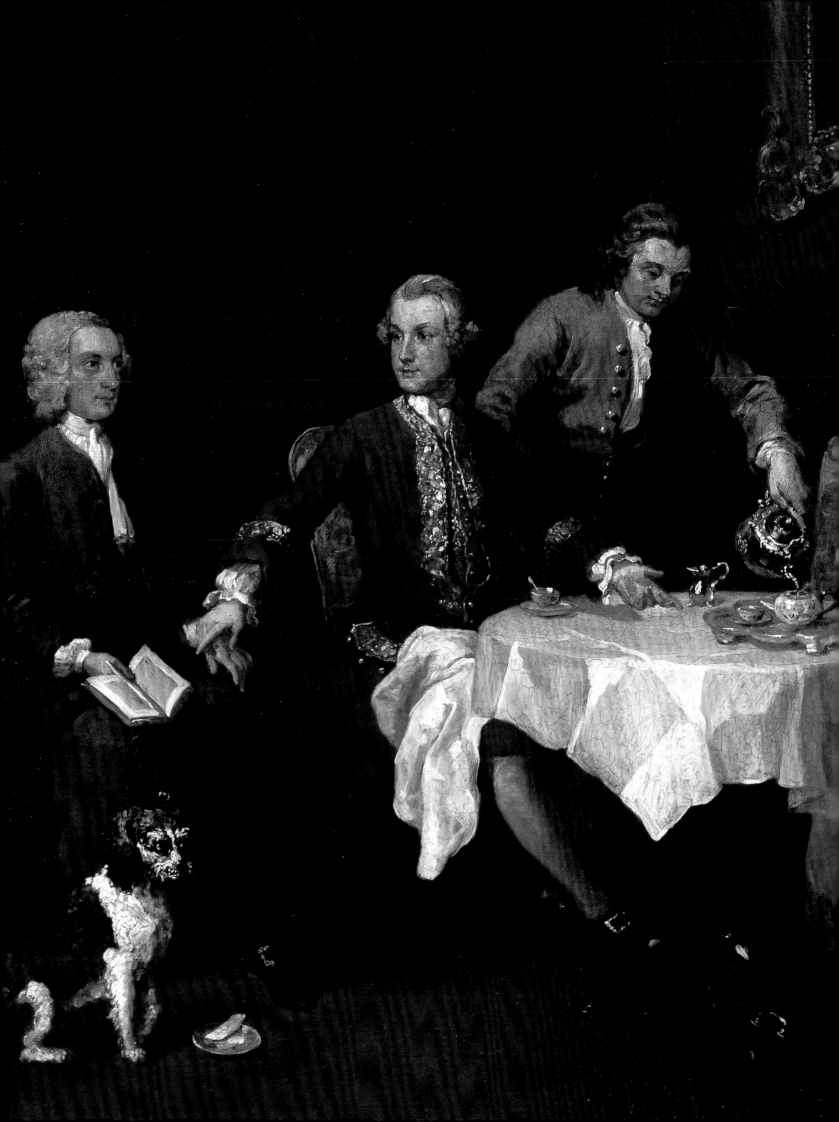

# 4
# Pictures of Urbanity: The Conversation Piece

*Mark Hallett*

In 1729 George Vertue noted in his journal that Hogarth was enjoying 'daily success ... in painting small family pieces & Conversations with so much Air & agreeableness [as] causes him to be much followd, & esteemd. wherby he has much imployment and like to be a master of great reputation in that way.'[1] A year later the same writer returned to Hogarth's abilities as a painter of 'family peices and conversations consisting of many figures. done with great spirit a lively invention & a universal agreableness'.[2] Vertue's comments alert us to the popularity and character of one of the most important and innovative branches of Hogarth's art, the conversation piece, which typically depicts groups of figures – often quite large in number – who have come together for some kind of convivial or familial occasion.[3] These works, which had their pictorial origins in Dutch and French group portraiture, tend either to picture the male and female members of a single family, often with their relations, friends, servants and dogs, or else to represent groups of male companions gathered affably together. The settings of such pictures, which range from grandly appointed ballrooms to fictionalised country estates, function as pictorial stages for particular kinds of sociable performance: as David Solkin has demonstrated in his book *Painting for Money*, Hogarth's conversation pieces show men, women and children acting and interacting according to the modern ideal of politeness.[4]

The concept of politeness emerged in this period as older, aristocratic models of identity and behaviour were adapted to take account of the appearance of a new kind of elite community – one made up not only of the traditional landed aristocracy but also of urbanised, commercialised and self-consciously modern individuals who were increasingly seeing themselves as central to the workings of contemporary society and culture. This new elite, and its philosophical, literary, journalistic and artistic spokesmen, promoted 'politeness' – a term associated with the virtues of a restrained, polished and tolerant sociability – as an all-embracing concept that promised to bring a hitherto fragmented society into harmony and allowed men and women of different characters and backgrounds to meet, talk and live together in a sphere of mutual exchange and respect. As the historian John Brewer has recently written,

'the aim of politeness was to reach an accommodation with the complexities of modern life and to replace political zeal and religious bigotry with mutual tolerance and understanding. The means of achieving this was a manner of conversing and dealing with people which, by teaching one to regulate one's passions and to cultivate good taste, would enable a person to realize what was in the public interest and for the general good. It involved learning a technique of self-discipline and adopting the values of a refined, moderate sociability.'[5]

Hogarth's conversation pieces see the values of 'refined, moderate sociability', 'good taste' and 'mutual tolerance and understanding' – values typically associated with the newly fashionable urban institutions of the coffee house, the assembly rooms and the club – being articulated in pictorial form and, in many cases, being extended into the realms of family life. The tenets of politeness come to suffuse the environments of the domestic interior, the garden and the estate. Within these settings Hogarth depicts the art of politeness being practised and demonstrated through particular kinds of social ritual: the drinking of tea among family and friends, which contemporaries lauded as a highly civilised and sociable pleasure open to both the male and female members of elite society; the playing of card-games like whist, which involved working closely with a partner and which one writer lauded as 'both genteel and allowable ... especially, when one plays rather for amusement than gain'; the appreciation of works of art, of books and of private forms of theatre; and, finally and most importantly of all, the ritual of conversation itself.[6] Through polite conversation, it was understood, affluent and educated individuals of both sexes were given the opportunity to prove their taste, wit and open-mindedness and to display their responsiveness to the preoccupations and accomplishments of their interlocutors. In so doing, such individuals acquired exactly that 'Air & agreeableness' noted by Vertue as a central characteristic of Hogarth's own painted conversations, which can now be seen as works that both depicted and embodied the good taste, the wit and the attentiveness to others that were considered to be the cornerstones of polite culture.

Significantly, the politeness found in Hogarth's canvases is not solemn or stiff, but tender, good humoured and animated. This concentration upon affectionate and

*The Strode Family* c.1738
(no.54, detail)

lively interaction points to another important context for Hogarth's conversation pieces. In those examples of the genre in which he focused on familial groupings – what Vertue called his 'small family pieces' – the artist was not only extending the rhetoric of politeness into the domestic realm. He was also responding to, and helping represent, a new 'affective' ideal of the family being developed in the period, one that promoted the family as an institution that also fostered the virtues of equable companionship, tolerance and sympathy. In Hogarth's family conversations, the benefits associated with the polished public sphere are fused with those that were simultaneously being seen to emanate from the everyday, intimate exchanges of family life itself.[7]

Finally, it is worth noting that the patrons Hogarth attracted for his conversations were drawn from a variety of backgrounds: they included not only aristocratic courtiers such as Sir Andrew Fountaine but also men whose wealth derived from the City of London: Richard Child, William Strode and William Wollaston, for whom Hogarth painted a conversation piece (fig.7, p.26) that Vertue described as being 'a most excellent work containing the true likeness of the persons, shape aire & dress – well disposd, genteel, agreeable'.[8] What also attracted such patrons, and what distinguished Hogarth's conversations from those produced by competitors such as Gawen Hamilton and Charles Phillips, was what Vertue praised as their 'great variety' and 'lively invention'.[9] The artist himself, looking back on his early career and remembering his portraits of 'subjects … in conversation', noted that they 'gave more scope to fancy than common portrait'.[10] In these terms, what is most striking about Hogarth's conversation pieces is how they convey remarkably subtle forms of pictorial narrative: as well as painting vivid likenesses of his male and female subjects, the artist continually invites his viewers to decipher the intimate human events and encounters that unfold – or seem just *about* to unfold – within his heavily populated canvases and that are revealed and expressed as his subjects enjoy their convivial pleasures.

# 47

*Woodes Rogers and his Family* 1729
Oil on canvas
35.5 × 45.5
NATIONAL MARITIME MUSEUM, LONDON

This early example of Hogarth's group portraiture depicts the family of the famous British sailor and colonial administrator, Captain Woodes Rogers, who had recently been restored to the Governorship of the Bahamas after having been controversially relieved of this post earlier in the decade. In Mary Webster's words the picture was painted 'to celebrate this vindication of his past career in the Bahamas and his restored dignity'.[11] The painting is of a more awkward character than Hogarth's later conversations, suggesting that the artist, at this point, was still in the process of developing the format that would soon bring him so much commercial and critical success. The picture is organised in two uncertainly related parts, with a left half laden with an intimate, feminised imagery of elegant but informal accomplishment and a right half that, by contrast, is packed with the symbols of the captain's public achievements.

Woodes Rogers is portrayed in a fictional outdoor setting, sitting grandly in front of a monument inscribed with what he clearly saw as a highly appropriate motto: 'Dum Spiro Spero' (While I breathe, I hope). Next to him a globe signifies his circumnavigation of the world during the War of the Spanish Succession (1701–13). In the background the pictured bay is presumably that of Nassau, while the smoking warship reinforces the sitter's status as both a veteran maritime commander and someone who famously eradicated piracy from the seas around the Bahamas. On the other side of the canvas, meanwhile, the captain's daughter Sarah sits with a book on her lap and a pet spaniel by her side, and a maid stands with a tray of fruit behind her.

Bridging the two halves of the picture, Sarah's brother William, swathed in an ostentatiously flowing robe, ceremoniously presents his father with a map inscribed 'Part of the Island of Providence', which refers to the largest of the Bahamian islands, and thus to the territory to which Woodes Rogers was imminently returning. William, it seems, bears the burden of two rather different pictorial demands. On one hand, his actions and attributes reinforce and celebrate his father's successes, and indicate that he, too, will follow in his father's footsteps and become a public

figure – as actually turned out to be case. On the other hand, his presence together with that of his sister also suggests – if somewhat tentatively – the tenderness of the relationship between two siblings and their parent, and their shared pleasure in each other's company. In subsequent years this second, more sympathetic and sociable storyline was to play a far greater role in Hogarth's conversation pieces, while the artist was to abandon the former, more formal and public kind of narrative. Indeed, we can imagine that, if Hogarth had been given the chance to repaint the central figure in the late 1730s, he would have taken away that map and robe, and let William's face and hands do all the talking.

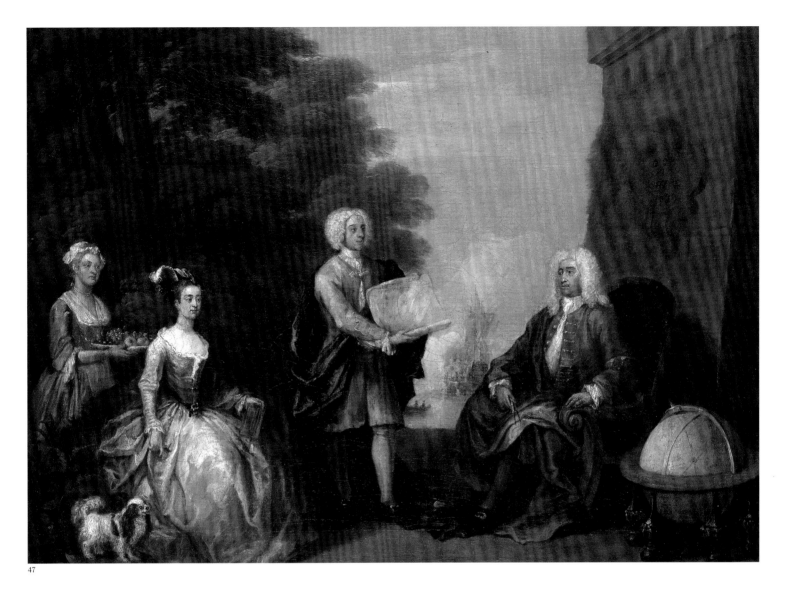

47

# 48

*An Assembly at Wanstead House* 1728–31
Oil on canvas
64.7 × 76.2
PHILADELPHIA MUSEUM OF ART. THE JOHN
HOWARD MCFADDEN COLLECTION, 1928

This painting was commissioned by
Richard Child, Viscount Castlemaine,
who was the heir to a substantial banking
fortune. Castlemaine had spent part of his
inheritance on a lavishly decorated house
at Wanstead designed by the Palladian
architect Colen Campbell. Hogarth's picture
is set in the long ballroom at Wanstead and
flaunts the luxuriousness of this interior –
the upper half of the picture space is
crowded with tapestries, sculptures,
paintings, furniture and extensive marble-
work. The lower half of the painting,
meanwhile, is populated by a dense array of
figures – twenty-five in all – whom Hogarth
studiously distributes across the full width
of the canvas. They are shown as having
gathered together to play cards and drink
tea in the late afternoon, accompanied by
their dogs and a household servant, who
is discreetly lighting a chandelier in the
distance.

The picture's most prominent figures are
Castlemaine and his immediate family: the
viscount's three youngest children, one of
whom sits on a poodle, are on the left; his
wife Dorothy is at the exact centre of the
composition, turning from the card-table
with an ace in her hand; and Castlemaine
himself, together with his two eldest
daughters, sits on the far right of the
picture. Hogarth, as well as foregrounding
these figures, links them together through
a subtle sequence of actions and looks. The
two boys on the left can be seen gesturing
towards, and seeking to gain the attention
of, their father; Castlemaine's wife similarly
reaches out to, and looks at, her husband,
while one of his two elder daughters gazes
affectionately at him as she pours tea. While
these details help reinforce Castlemaine's
patriarchal status as head of the family, it is
also noticeable that he deliberately relegates
himself to the picture's margins;
interestingly, it is his wife who occupies the
pictorial centre of Hogarth's canvas. This
ceding of pictorial authority might be linked
to the fact that, as Richard Dorment has
pointed out, this conversation piece was
probably commissioned to commemorate
the twenty-fifth anniversary of the
viscount's marriage to Dorothy.[12]
Significantly, a number of the art works
in the room celebrate wifely virtues and
steadfastness. Perhaps the painting was

intended to function at least partly as a
present to Dorothy from her husband,
and was therefore designed with a view to
giving her an unusual degree of pictorial
attention.

As well as highlighting their bonds as a
family, Hogarth's conversation piece subtly
integrates the viscount, his wife and their
children into the larger grouping of figures –
presumably a combination of other family
members and friends – who surround
them. Seen as a whole, the twenty-five
subjects of Hogarth's portrait are not only
linked by ties of kinship, marriage and
friendship but also by their shared
participation in the quintessentially polite
activities of tea-drinking and card-playing.
In this painting the privately resonant
exchanges between the viscount and his
family are embedded into the all-
encompassing flow of looks, gestures,
expressions and poses that binds the entire
assembly together and that – like a piece
of choreographed theatre – conveys the
allegiance of every depicted actor, from
Castlemaine onwards, to a collective ideal
of polite interaction. Here, it is worth
observing the way in which none of the men
and women stand or sit alone – instead, all
their bodies are shown overlapping each
other. Similarly, we can note the pictorially
interlocking sequence of hands, which
delicately point to, or rest on, other
members of the assembly, and study the
subtle interplay of expressions that convey
shared forms of ease, interest and affection.
Finally, it can be suggested that the picture,
however silent in reality, also asks us to
imagine the fusion of these people's voices
into the equable hum of elegant
conversation – one that fills the room with
the sound of politeness itself.

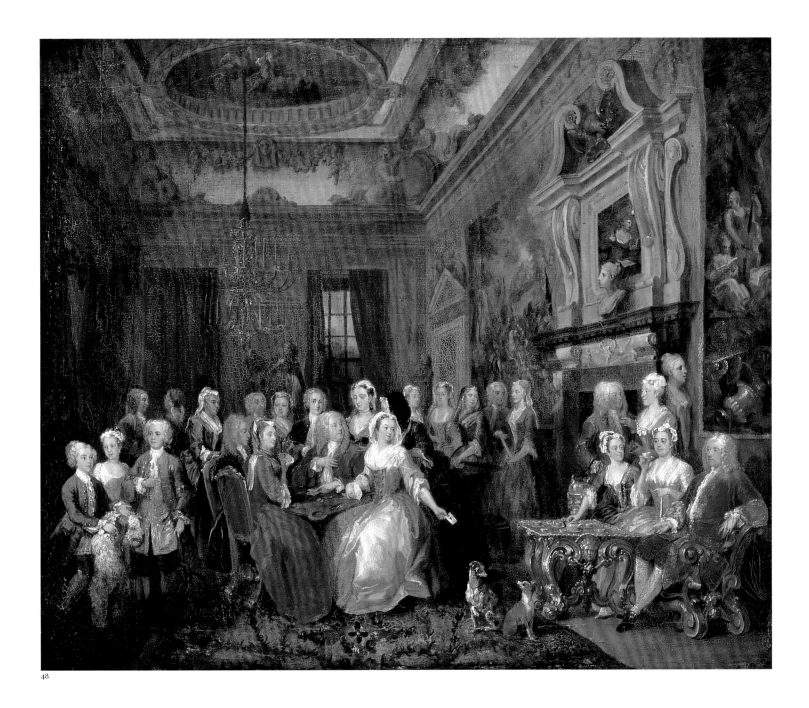

48

# 49

*A Midnight Modern Conversation* c.1732
Oil on canvas
76.2 × 163.8
YALE CENTER FOR BRITISH ART,
PAUL MELLON COLLECTION

This painting offers a riotous, satirical contrast to Hogarth's more respectable conversation pieces. Rather than sipping tea or even – as in some conversation pieces of the period – decorously drinking wine, Hogarth's male protagonists, gathered around a table dominated by a huge punch bowl, are pictured in a state of extreme inebriation: they variously guzzle, expostulate, smoke, snore and sprawl across their tilted seats, or totter and stumble across the litter-strewn floor. A bottle smashes, a carelessly held candle is about to set fire to a cuff, and piles of discarded lemons and bottles accumulate in the corner. This midnight modern conversation has clearly being going on for some time: the clock on the table tells us that it is just past four o'clock in the morning.

In this work the artist humorously satirises the activities that took place in the drinking clubs that had sprung up in early eighteenth-century London to cater to a male clientele drawn from the 'middling' and professional classes – clubs, indeed, that we know Hogarth himself regularly frequented in this period. The pictured gathering seems to include a physician, a cleric, a military veteran, a lawyer, a tradesman and a fop, who, his hand covering his aching forehead, is clearly about to vomit all over his snoozing, self-immolating companion. Hogarth's satire, which metaphorically pulls back the curtain hanging on the painting's left-hand side, looks beyond the façade of respectability maintained by such men in their public lives and reveals the excesses and vices they exhibited behind closed doors. It might even be suggested that *A Midnight Modern Conversation* mischievously calls into question the imagery of politeness maintained in the artist's more decorous conversation pieces. However, it would seem more appropriate to argue that Hogarth's work ultimately functions as a kind of humorous, admonitory anti-conversation piece, dramatising the debilitating and ridiculous consequences of deviating from the rules of restraint and moderation.

However we might wish to understand the work's relationship with Hogarth's other painted conversations, contemporaries were happy to laud it as a masterpiece of satiric wit. Thus John Bancks, in a mid-1730s poem dedicated to this picture, rhetorically asked:

Who can be dull, when to his Eyes
Such various scenes of Humor rise?
We wonder, while we laugh, to see
Even [Samuel] Butlers' wit
improve'd by thee.[13]

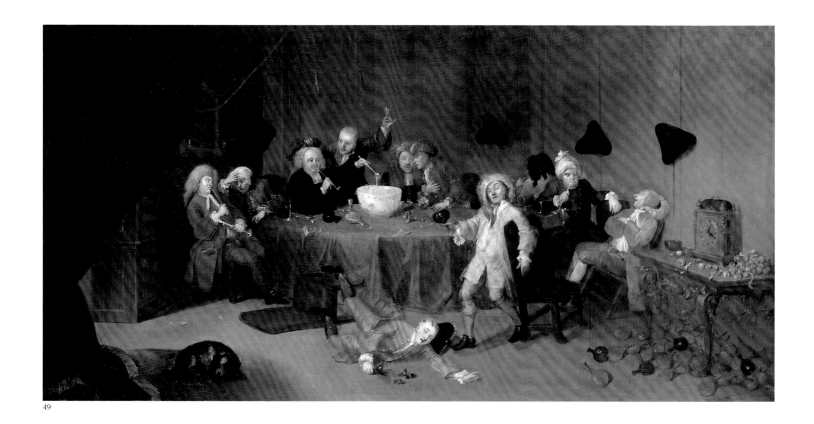

49

# 50

*The Jones Family* c.1730
Oil on canvas
72 × 91.8
AMGUEDDFA CYMRU – NATIONAL MUSEUM
WALES

In an essay entitled 'The Art of
Conversation', published in 1731, John
Taperell declared that 'agreeableness of
conversation ... for the most part, lies in the
merry meanders and turns of wit'.[14] Wit, as
long as it did not descend to vulgar ridicule,
was seen as an essential lubricant of polite
sociability, and was also something that
Hogarth discreetly introduced into his
conversation pieces, particularly through
the cheerful comparisons he regularly made
between his human subjects and the dogs
he portrayed alongside them. In the case of
*The Jones Family* the artist has been allowed
an unusual degree of comic latitude, for here
Hogarth sets up a playful contrast between
the genteel poses and behaviour of the
figures found in the painting's foreground
and the indecorous activities of the 'low'
rural figures who occupy the further
reaches of the depicted landscape.

Hogarth's picture was commissioned
by Squire Robert Jones of Fonmon Castle in
Wales and portrays Jones, his three siblings
and his widowed mother as if pausing on a
walk through their country estate. Befitting
her widowed status, the elder Mrs Jones sits
in subdued, reflective isolation, leaning
against a classicised fountain and
distractedly playing with her pet spaniel.
While the squire's two younger siblings,
Oliver and Elizabeth, are given a relatively
passive and innocent role, sitting next to a
stream with a basket of flowers in their laps,
Jones and his elder sister Mary are assigned
a more authoritative and active position
within the canvas – indeed, they are
depicted as if commenting on the sights and
activities that surround them. Interestingly,
Mary's outstretched right hand can be
understood as directing our and the squire's
gaze not only to the idyllic, pastoral-like
tableau provided by their younger sister
and brother but also, more playfully, to the
plebeian figures who occupy the pictorial
space between the two polite groupings –
the urchin-like servant who wrestles with
a monkey; the working and resting
haymakers in the distant field; and, most
provocatively of all, a man and woman
coupling on a hayrick.

Mary and Robert's smiles tell us that
they, just like Hogarth himself, are quite
aware of the comic discrepancy between
the polite version of the pastoral that their
family acts out – aided by the two women's
fashionable shepherdesses' hats – and more
earthy rituals of work and pleasure. If the
pairing of the monkey, a traditional satiric
figure of vain emulation, with the tousle-
haired urchin incongruously dressed in
servant's livery serves to emphasise the
irreconcilable distance between plebeian
and polite cultures, the picture as a whole
ultimately promotes a more positive ideal
of social cohabitation. *The Jones Family*
suggests that, while the ancient rhythms
of work, rest, play and sex will continue to
structure the rural landscape, they will do
so only under the watchful, benevolent eyes
of the local landowners, who themselves are
seen to enjoy not only the traditional
attributes of landed authority – here we can
note the silhouette of Fonmon castle on the
horizon – but also the more modern, highly
refined forms of appearance and behaviour
associated with urbane politeness.

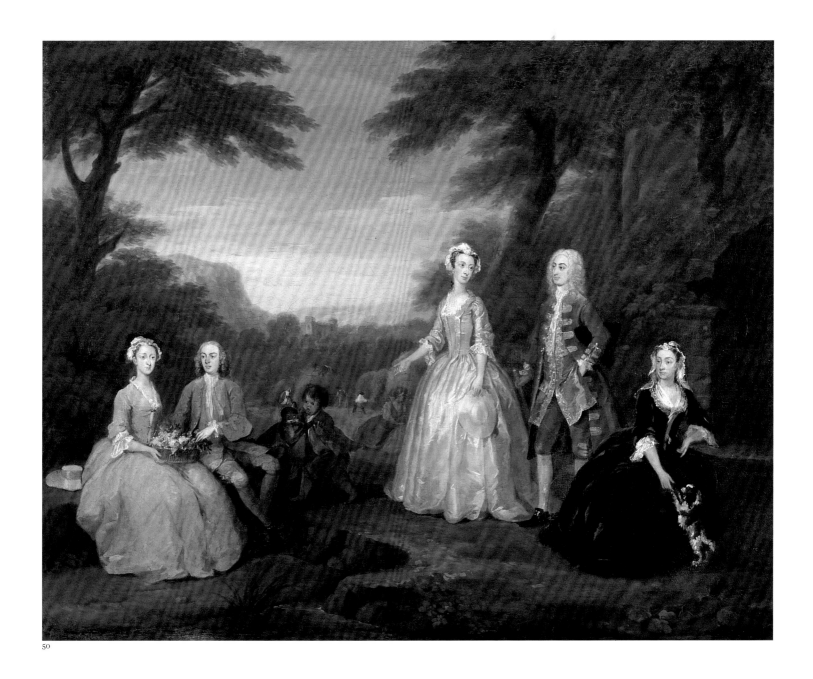

50

# 51

*Conversation Piece (Portrait of Sir Andrew Fountaine with Other Men and Women)*
c.1730–5
Oil on canvas
47.6 × 58.4
PHILADELPHIA MUSEUM OF ART. THE JOHN HOWARD McFADDEN COLLECTION, 1928

Hogarth's conversation pieces were designed to stimulate as well as depict conversation, and this painting has attracted an unusual degree of debate concerning its participants, history and meanings: in Richard Dorment's words, this is 'a picture that will be argued about for many years to come'.[15] This is partly because the work originally included a fourth male figure, painted out sometime before 1817, who sat in front of the two women on the left. There has also been a great deal of uncertainty over the identity of the various sitters, despite the painting's secure provenance as a work commissioned by the leading aristocratic collector and connoisseur Sir Andrew Fountaine.

Following Dorment's convincing suggestions on these issues, it seems most likely that the figure standing with his hand tucked into his jacket is Fountaine himself, who is shown admiring a painting in the company of the prominent auctioneer Christopher Cock, who points out the work's merits. A stooped servant holds up the picture to view. Meanwhile, on the left side of the picture, two women – Mrs Cock, dressed in brown and holding a magnifying glass in her left hand, and Mrs Elizabeth Price – are also admiring and discussing the displayed painting, if from a rather less intimate vantage point. The missing male seems to have been a portrait of Elizabeth's husband, Captain William Price, the nephew and heir of Sir Andrew, who inherited the Fountaine name and arms in 1769. Why he should have been painted out remains a mystery.

This abbreviated cast of characters is placed at the entrance to a grand avenue of trees in an idealised country estate. The landscaped, English version of the pastoral, dotted with a classical urn, books, silverware, wine and food, provides a local and modernised equivalent to the mythological landscape of Parnassus – the realm of the Muses – seen within the Italianate picture being admired by Sir Andrew and his companions. While the fountain against which the pictured Muses lean offers a witty play on Sir Andrew's surname, Hogarth would seem to be making a broader, more complimentary analogy between ancient and modern spheres of aesthetic refinement.

More immediately, however, Hogarth portrays a group of individuals distinguished by their collective adherence to a form of connoisseurship born of sustained looking and discussion. Here, interestingly, women are included within the ambit of art appreciation as well as men, and Fountaine himself is depicted not as someone who clings to rigid aristocratic prejudices regarding art – the conventional critique of the connoisseur – but as someone who is prepared to listen to, and learn from, others. This conversation piece, of course, confirms that Fountaine is someone whose appreciation of painting extends not only to the collection of Old Master pictures but also to the patronage of young, contemporary English artists like Hogarth himself. Significantly, the artist could fully expect that his own painting, when hanging on the walls of the Fountaine family seat at Narford Hall in Norfolk, would receive the same kind of prolonged study and provoke the same kind of informed conversation as that idealised within his canvas. Ironically, given that one of the original figures in this painting ended up being painted out altogether, we might suppose that the debates around Hogarth's picture must eventually have become all too vociferous and animated.

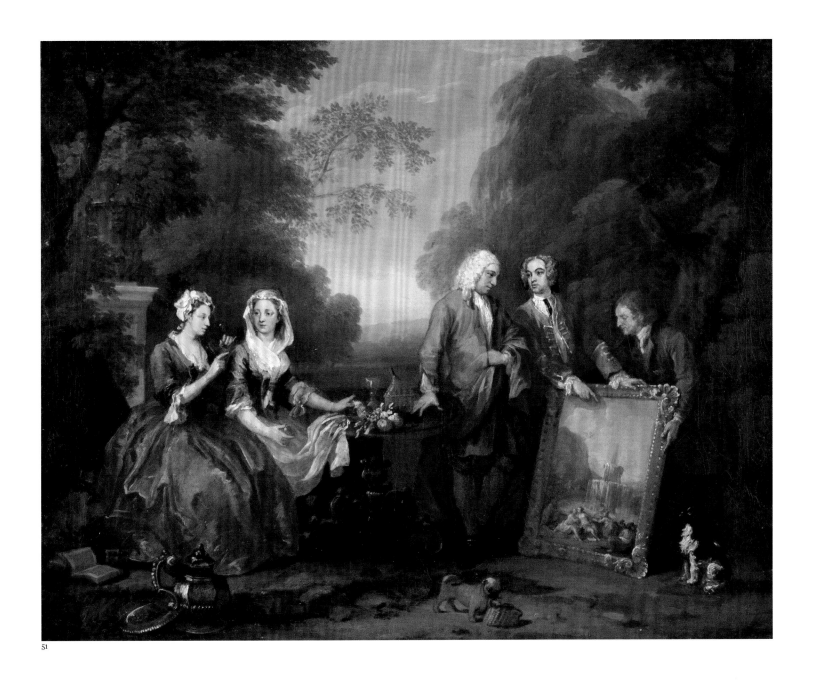

51

# 52

*The Cholmondeley Family* 1732
Oil on canvas
71 × 90.8
PRIVATE COLLECTION

This elaborate conversation piece was commissioned by George Cholmondeley, Viscount Malpas, seemingly as a memorial to his wife Mary, pictured on the far left of the canvas. She had died of consumption in France the previous year, and her body had been tragically lost at sea while being brought back home to England. The posthumous inclusion of individuals, their status pictorially indicated by such symbols as the putti seen hovering over Mary's head, was not unusual in group portraits of this period. In Hogarth's painting, which is set in an interior that is part-library, part-picture gallery, the viscount's wife is shown sitting with their youngest son Frederick under the affectionate – and, we are to suppose, reflective – gaze of Malpas himself. The viscount's brother, James, a colonel of the 34th Regiment of Foot, leans on the back of a chair, his gaze turned towards Malpas's two elder sons George and Robert, the latter of whom stands precariously on a chair with one leg while pushing over a pile of books with the other. George, seemingly recognising that both the books and his younger brother are about to topple over, is depicted rushing over in order to prevent the imminent accident. A dog curls up rather mournfully in the corner.

As all writers on this picture have noted, Hogarth's painting is ordered into two pictorial zones, divided most obviously by the dramatically foreshortened bookshelf and by the edge of the luxurious rug, but also by the division of the foreground into two groupings of tables and chairs, the left of which faces us, the other of which is turned away. These polarised zones invite being read as ones that highlight, respectively, adult civility, learning and authority and childish playfulness and innocence. Hogarth, through these means, dramatises not only the distance between childhood and adulthood, but also the remarkable transformation that elite individuals undergo as they pass from the one stage of life to the other.

On closer inspection, however, more melancholy narratives seem to be in play. For Elizabeth Einberg points out that underneath the family coat of arms set directly above the viscount's head is to be found the quote 'ferar unus et idem' – roughly translating as 'I shall remain one and the same' – which, rather than being a family motto, seems to have been chosen by Malpas himself.[16] The quote comes from Horace's *Epistles* but, more significantly perhaps, had been used as a motto of resilience by Robert Burton while discussing appropriate 'remedies to discontents' in his famous *Anatomy of Melancholy* (1621): 'I have learned in what state soever I am, therewith to be contented ... Come what can come, I am prepared. Nave ferar magna an parva, ferar unus et idem. I am the same.'[17]

In the context of such words we might follow Einberg in interpreting the picture as one that meditates on the aftermath of a loved one's death. On this reading Malpas, having retired to his library to find literary and philosophical sustenance during a period of profound mourning, and having gathered together a pile of books in order to do so, is forced to confront not only the absence of his wife – who must be read as a kind of nostalgic mirage sitting next to him – but also the implications of her absence for his children. They, of course, can find no solace in learned books; rather, vulnerable and unsupervised, they kick over the assembled readings, and cry out for attention. Malpas, the picture suggests, will have to take stock and recognise that, however buffeted by the tragic circumstances of his wife's passing, he must retain his identity and integrity: 'I shall remain one and the same'. With the aid of his brother, moreover, he will need to take his children in hand, and – with the inspiring memory of his wife in view – steer them successfully towards adulthood.

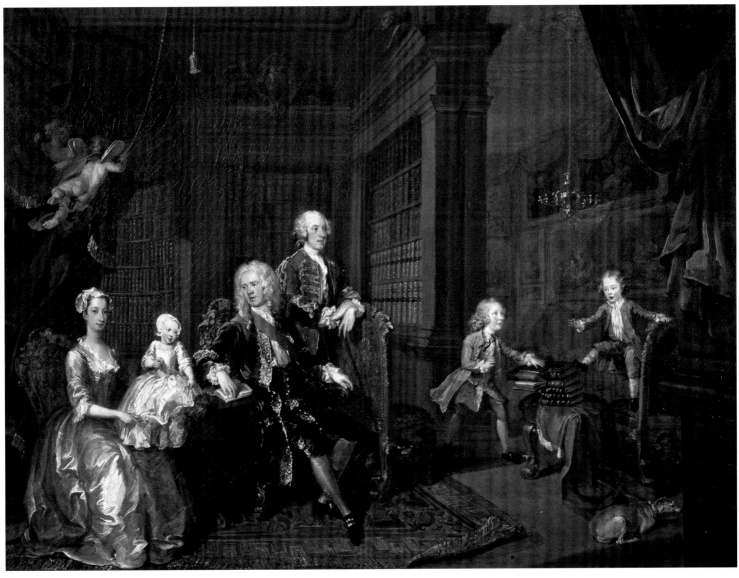

52

# 53

*A Performance of 'The Indian Emperor or The Conquest of Mexico by the Spaniards'*
1732–5
Oil on canvas
80 × 146.7
PRIVATE COLLECTION

This picture commemorates a private, children's performance of John Dryden's play *The Indian Emperor*, which had taken place in the spring of 1732 in the house of John Conduitt, Master of the Mint. The actors and audience come from a select social milieu: the Conduitts' only child, Catherine, is depicted on the far right of the stage, wearing black; next to her stands Lady Catherine Lennox, the daughter of the Duke and Duchess of Richmond, while further to the left, we see the Earl of Pomfret's two children – his son Lord Lempster, standing shackled in irons, and his daughter Lady Sophia Fermor, who listens to Lady Catherine as she holds centre stage. The audience includes the royal prince, William, Duke of Cumberland, and his two sisters Mary and Louisa, who are watching and discussing the play from what seems to be an improvised box; this is placed directly underneath a bust of Sir Isaac Newton, to whom the Conduitts were closely connected by birth and profession. Sitting in the front row of chairs, just behind her own two daughters, the royal children's governess Mary, Lady Deloraine, leans down pointing to a fan she has just dropped, which she seems to be asking her daughter to pick up. Next to her, the Duke and Duchess of Richmond – the former leaning on the back of his wife's chair – are shown enjoying their daughter's performance, while behind them can be seen a cluster of other aristocrats and worthies, including the Earl of Pomfret, who, like the Duke of Richmond and Lady Deloraine, is pictured from the rear and is distinguished by the red riband of the Order of the Bath swathed across his shoulder. Conduitt and his wife are included only as portraits on the wall, hanging directly above the 'living' portrait of the Duke of Montagu and sharing his outward gaze.

Hogarth's painting, as well as celebrating a highly prestigious episode in the Conduitt household and commemorating their familial attachment to the most famous scientist of the age, can also be understood as a refined sequel to his *Beggar's Opera* pictures, the last of which had been painted only the year before (see nos.38, 39). The scene from Dryden's play that Hogarth and his patron have chosen to focus on – Act IV, Scene iv – revolves around the fervent declarations of love made by two princesses to the heroic figure of Cortez, who listens to his suitors while locked in chains. As such, it offers an obvious parallel to that pictured in Hogarth's earlier images of Gay's work. That the scene of *The Indian Emperor* is set within a cavernous prison interior emphasises the connection between the two pictures. The pictorial dialogue thus created must have added an element of wit to his depiction of the children's private performance, which invited being understood as an endearing counterpart to that found in the professional theatre. At the same time Hogarth's references to his earlier *Beggar's Opera* paintings end up accentuating the differences between this private, genteel form of theatrical display and that found in the more public, raucous environment of the playhouse.

Finally, it is worth pointing out that in this painting, more than any other of his conversation pieces, Hogarth makes it seem as if we, the spectators of his picture, are actually part of the audience he depicts. Indeed, we are given the viewpoint of someone standing not far behind the figures shown with their backs to us, one that can be aligned quite precisely with the viewing position that Conduitt and his wife can be imagined to have enjoyed on the night of the performance of *The Indian Emperor* in their house. We look at the scene before us with their eyes and from their position as a man and wife, who, as they stood or sat alongside their elite guests, must not only have enjoyed watching their daughter's performance on stage but also have revelled in the exclusivity of the audience their private theatre had attracted.

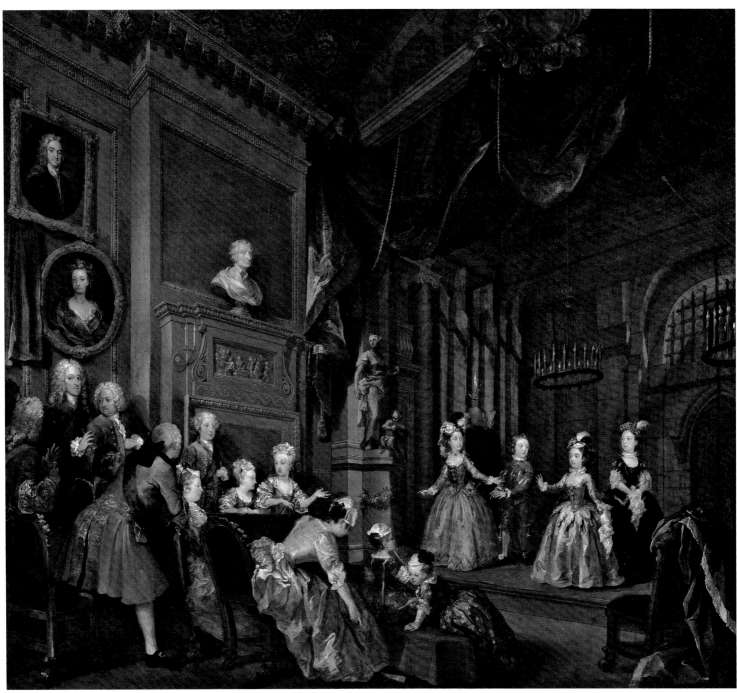

53

# 54

*The Strode Family* c.1738
Oil on canvas
87 × 91.5
TATE. BEQUEATHED BY REV. WILLIAM
FINCH 1880

In this heavily reworked, beautifully
painted canvas Hogarth pares down the
indoor conversation piece to its pictorial
essentials: rather than the choreographed
crowds and packed interiors of the *Assembly
at Wanstead House* (no.48) or even of *The
Indian Emperor* (no.53), we are presented
with five elegantly interrelated figures
placed in a refined and uncluttered interior.
The most prominent figure, seated at the
left of the depicted tea table, is Hogarth's
patron, William Strode, who – like the
patrons of the two earlier paintings –
derived his wealth from the city. He is
shown leaning across to his old tutor,
Dr Arthur Smyth, who had accompanied
him to Venice earlier in the decade and
sits with an open book in his right hand.
On the other side of the table sits Strode's
new, aristocratic wife, formerly Lady Anne
Cecil. The family butler, Jonathan Powell,
replenishes the pot. On the right we see
Strode's brother, Colonel Samuel Strode,
standing stiffly by a doorway, a cane in
hand. Two dogs are pictured on either side
of the canvas, uncertainly eyeing each
other up.

As well as commemorating Strode's
recent marriage, this painting celebrates his
learning and connoisseurship – here we can
note the massed ranks of books lined up on
his library shelves, and the three Italian
paintings, including a view of Venice, that
tower over Lady Anne. Just as importantly,
Hogarth's work offers a pictorial distillation
of the ideal of politeness or, rather, focuses
on a moment that immediately precedes
the realisation of this ideal. Politeness
promoted conversation and other social
pleasures like tea-drinking, as activities that
brought people of different characters and
backgrounds together into a harmonious
whole: as long as every participant enjoyed
a certain degree of wealth, refinement and
learning, differences of temperament and
rank could be temporarily suspended.
Here we see Strode himself in the process
of transforming this somewhat fragmented,
disjointed group of people into such a polite
unity. Thus Hogarth asks us to imagine him
amiably entreating his non-aristocratic
friend to abandon his admirable but rather
pedantic and anti-social activity of reading,
pull over his chair and join in with his more
socially elevated companions in the

convivial pleasures of conversation and tea.
The straight-backed figure of Lady Anne,
smiling blankly with a teacup in her hand,
is poised for this conversation to begin,
when we can imagine that she will become
far more animated and engaged with those
around her. The stiff figure of the colonel,
meanwhile, is shown as if waiting for Smyth
to join the table before he, too – on his
brother's invitation – will sit in the empty
yellow chair next to Lady Anne. Once he is
there, it is implied, he will be able to shed
the rather rigid, public persona of the army
officer that he currently adopts, and enter
the more informal and intimate realm of
polite conversation.

Here, in contrast to pictures like
*An Assembly at Wanstead House*, the ideal of
politeness has been extended to incorporate
the figure of the servant. Powell, although
he is given a distinctly subservient role
within the image, nevertheless takes his
place within the semicircle of figures
gathered around the table, a further sign,
perhaps, of both Strode's benevolence as
an individual and the inclusiveness of
the polite culture that he embodies. This
inclusiveness will also, of course, need to
extend to the two very different dogs, which
are pictured as if awaiting a proper
introduction, just like their masters.

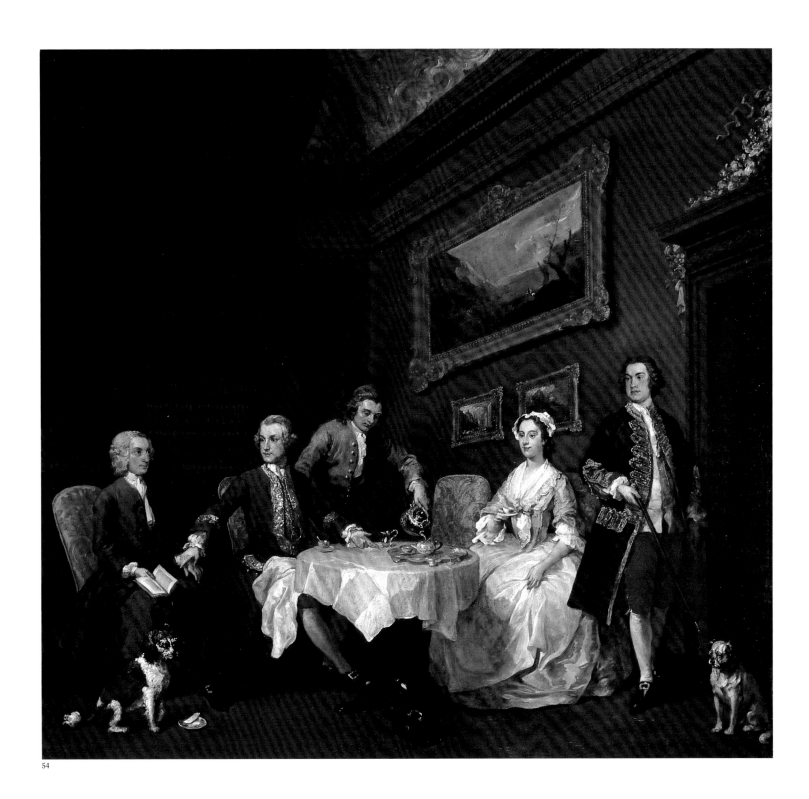

54

# 55

*The Western Family* 1738
Oil on canvas
71.8 × 83.8
NATIONAL GALLERY OF IRELAND, DUBLIN

This picture, which offers a perfect counterpart to *The Strode Family* (no.54) in its handling of figures, themes and paint, depicts various members of the Western family socialising with the clergyman – probably Archdeacon C. Plumptre – shown sitting on the right. As in the Strode painting, Hogarth captures the moment just before this group of individuals gathers together for tea. The artist's patron, Thomas Western, whom Hogarth had already painted in a single-figure portrait of 1736, is pictured carrying a trophy of the hunt and as wearing the hat that suggests he has just come in from outside. His wife Anne Callis, who is placed directly under the coat of arms that surmounts a distant doorway, stands expectantly at his side. Meanwhile, Western's mother, assuming the hospitable role played by William Strode in *The Strode Family*, reaches towards her son's bird with her right arm while simultaneously tugging at the robe of the sitting clergyman, who has become momentarily distracted by the entrance of a servant, to whom he gives instructions regarding a letter. The Western's young daughter peers over the tabletop, while in the background a servant returns his master's gun to its cover.

We are asked to imagine that, once the clergyman's attention has been captured and Western's bird has been admired by all, the bird – and the aggressively manly, outdoor and aristocratic pursuits that it symbolises – can be put to one side; then, we might reasonably expect, everyone – male and female, huntsman and clergyman, adult and child – will sit around the tea-table and enjoy both the drink and the conversation it stimulates. Once again, a collection of individuals of varying characters, ages and stations in life will have been turned, however temporarily, into a coherent, harmonious group. Hogarth provides an appropriately genteel set of props for this elegant storyline: the English harpsichord, ready to provide a suitably polished musical accompaniment when required; the ornately decorated, silvered tea-table; the intriguing screen, which is decorated with the imagery of a country house and gives the whole scene an especially theatrical air; and, finally, the painting hanging over the right-hand doorway, which, in a typically subtle touch by the artist, depicts the same kind of game that we see hanging from Western's left hand.

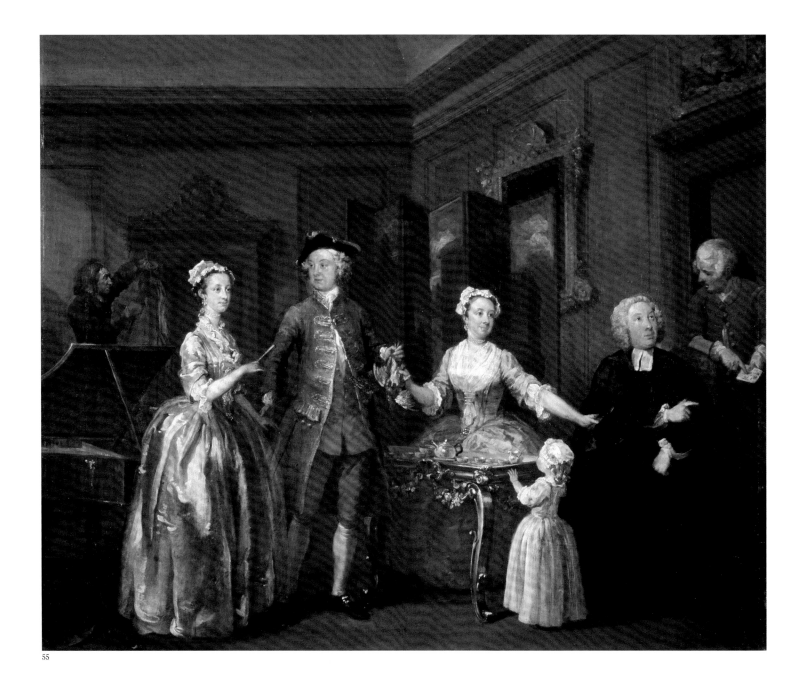

55

## 56

*The Hervey Conversation Piece* c.1740
Oil on canvas
101.6 × 127
ICKWORTH, THE BRISTOL COLLECTION
(THE NATIONAL TRUST)

This enigmatic group portrait was commissioned by John, Baron Hervey of Ickworth, seemingly to celebrate the political and personal companionship enjoyed by a small but highly influential coterie of Whig aristocrats, politicians and courtiers. Hervey, a well-known supporter of the Prime Minister Sir Robert Walpole and, at the time this picture was painted, Vice-Chamberlain of the King's Household, is shown gesturing to an architectural drawing held by Henry Fox, Surveyor-General of the King's Works, and leaning informally on the back of a chair occupied by Charles Spencer, 3rd Duke of Marlborough, who had recently defected from the political grouping loyal to Frederick, Prince of Wales, and come over to the court party. Standing on the right, his left leg resting on a lawn-roller, is Thomas Winnington, a Lord of the Treasury, while at the table sits Henry Fox's brother Stephen, who – thanks to Hervey's influence – was created a baron soon after this picture was painted. The final figure depicted by Hogarth is a clergyman standing precariously on a chair that – possibly nudged backwards by Stephen Fox's cane – tilts towards the river flowing nearby. His telescope is trained on the church tower in the far distance. Horace Walpole, an important commentator on contemporary painting in this period, identified this rather comic figure as Dr John Theophilius Desaguliers, an influential Freemason and physicist. The six men are shown in a fictionalised parkland setting, complete with a statue of Minerva and dotted with the signs of luxurious ease and plenty – a punt lies waiting on the riverbank, a bottle and glasses stand on the table, and fruit spills across the table and over the edges of a generously laden basket lying on the ground.

This picture has attracted a great deal of speculation concerning its themes and narratives. Alistair Laing has suggested that Desaguliers's presence indicates a Masonic subtext to this gathering, and has noted that Stephen Fox and the Duke of Marlborough, as well as Hogarth himself, were Masons in this period.[18] On this reading – which is strengthened by the painting's explicit references to architecture, an art that Freemasonry regularly described as offering a model for ideal forms of social organisation – the Hervey conversation piece might seem to be celebrating a specifically Masonic form of fellowship. Other writers, including Jill Campbell and Ronald Paulson, have focused instead on the possible homoerotic dimensions of the work.[19] Hervey was well known in elite circles for his bisexuality and, while married with children, seems to have enjoyed a long-term sexual relationship with Stephen Fox. Such an association, as one might expect, attracted vitriolic condemnation, most famously from Alexander Pope, who had attacked Hervey in verse as a modern version of Nero's castrated lover Sporus.[20] Hogarth, in contrast, can be seen to have painted a work that, under the guise of a conventional conversation piece, commemorates the necessarily surreptitious relationship between Hervey and Stephen Fox, and the exclusive realms of masculine fellowship within which this relationship was allowed to flourish. In this respect it is interesting to note that a second version of the painting was owned by Stephen Fox himself.

While both interpretations carry weight, on their own they seem to tell only part of the story. What does seem clear, however, is that Hogarth's painting, through suggesting the range and intimacy of the relationships enjoyed between his subjects, actively celebrates Hervey's masculine coterie as one in which both political *and* personal interests successfully overlapped and entwined. We still, however, need to explain the rather incongruous figure of the toppling, non-aristocratic clergyman. Significantly, he seems not to fit very neatly into the group gathered around Hervey. Rather, he is the pictorial equivalent of the figure of Dr Smyth in *The Strode Family* (no.54) – someone, that is, who is partly an outsider and who, if he is to become fully integrated into the depicted coterie, needs to abandon his dangerously blinkered and isolated activity, return to the table and join the rest of the gentlemen in their confident, good-humoured and highly collaborative pursuit of personal pleasure and political power.

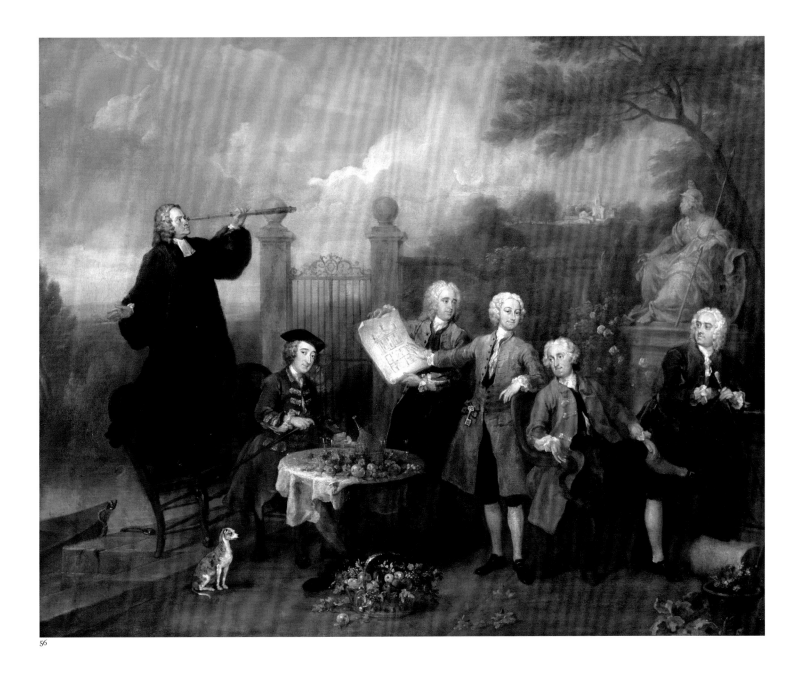

56

## 57

*Captain Lord George Graham in his Cabin*
c.1745
Oil on canvas
68.5 × 88.9
NATIONAL MARITIME MUSEUM, LONDON

This picture celebrates the kinds of
masculine conviviality that Hogarth,
more than a decade earlier, had satirised
in *A Midnight Modern Conversation* (no.49).
Lord George Graham was an aristocratic
naval officer who, at the age of twenty-five,
was granted command of his own ship and
made Governor of Newfoundland. This
painting is set in the captain's elegantly
appointed cabin and shows him relaxing at
his table with a group of male companions:
one of the ship's crew sings a song to the fife
and drum-music played by the exquisitely
dressed black servant standing on the right;
another, more senior and sober figure, sits
with an open logbook at the table, as if
having just discussed the day's business
with Graham. A cabin boy, who looks out
cheerfully at the spectator, approaches with
dinner for the seated men; his concentration
lapsing, he has failed to notice that the sauce
from his dish is beginning to spill down the
back of the man sitting directly in front of
him. As so often, Hogarth integrates dogs
into his narrative: one, sitting next to the
purser, howls along with the music, while
another, standing on a chair and encased
in Graham's wig, is pictured as yet another
performer, playfully dressed up to sing from
the sheet of music resting against an empty
wine beaker.

Graham cuts a particularly dashing and
nonchalant figure in his red, fur-lined cloak
and tasselled cap and is defined as an
aristocratic man of the world who has
momentarily stepped down from his more
onerous public duties as a naval captain.
He is shown already enjoying the manly
pleasures of puffing on his pipe and
listening to sea-shanties as he prepares
to eat from his plate and sup from the full
punch bowl that, we can presume, will be
brought to the table in a moment. His more
soberly dressed companion, this picture
seems to suggest, will need to put down the
logbook and relax a little if he is to partake
in the atmosphere of convivial merriment
that surrounds him – and very soon, no
doubt, after what we can imagine will be his
shocked reaction to the strange sensation
of hot gravy dripping down the back of his
jacket, he will have to laugh along with all
the others at the comedy of his predicament.

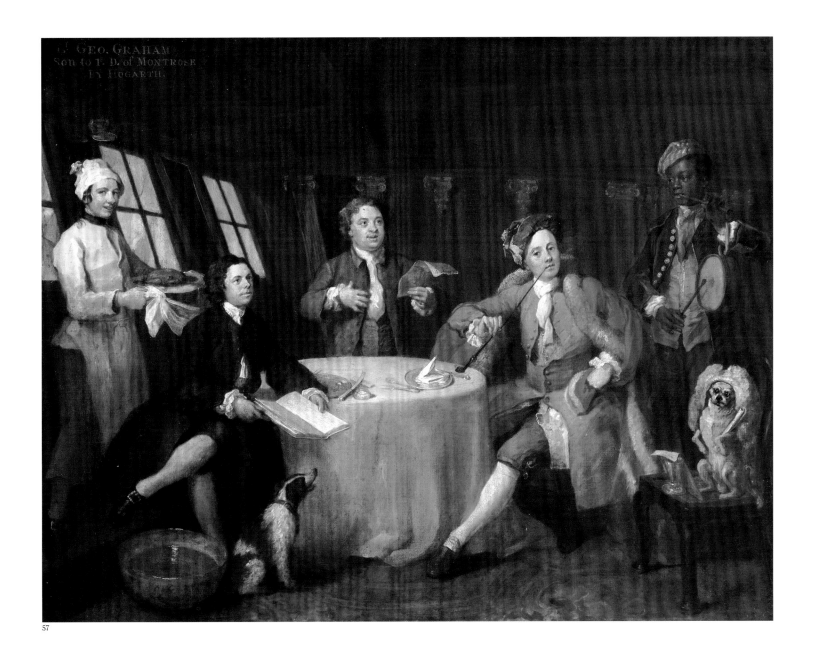

57

# 5
# Street Life
*Christine Riding*

In the 1730s Hogarth developed an identity as a roving satirist who explores the city, exposing the folly and vice of its inhabitants while at the same time revelling in the chaotic vitality of its streets. In urban scenes, such as the first plate of *A Harlot's Progress* 1732 (no.43) or *The Enraged Musician* 1741 (no.72), Hogarth places the viewer in an intimate, if not claustrophobic, relationship with his or her surroundings. Thus London is presented as it might be encountered by someone walking in a crowd, rather than as a sanitised experience involving elegant and regulated thoroughfares, with Londoners as a spruced-up and well-behaved supporting cast. Hogarth's vision is bustling and dynamic, and sometimes grubby, confrontational and dangerous; the street is a truly 'public' space through which people meander and jostle. Nowhere is this better demonstrated than in *The Four Times of Day* 1736 (no.67), which takes us on a humorous walking tour through four distinct areas of the city: Covent Garden, Soho, Islington and Charing Cross.

Hogarth's images thus underline his first-hand knowledge of London's geography, neighbourhoods and communities and the texture of everyday urban life. In *Morning* (from *The Four Times of Day*), for example, Hogarth brings together both the 'polite' and the 'impolite' worlds of Covent Garden – the elegant square with the celebrated flower and vegetable market during the day, and the haunt of prostitutes, rakes and drunkards at night – by selecting the moment, early in the morning, when these worlds temporarily coexist. At the same time, however, these closely observed but distinctly unsentimental images also remind us that Hogarth, the roving satirist *and* gentleman artist, moves among the crowd, but is not necessarily of the crowd.

Hogarth's approach finds some important parallels with the writings of Edward 'Ned' Ward (1667–1731), which represent a brand of 'popular' journalism that developed in the late 1690s. Ward was a satirist, burlesque poet, political writer and some-time tavern owner who made a living by his pen. He might therefore be described as the archetypal 'Grub-Street hack', ever mindful of sale figures and grabbing the attention of the widest possible audience. Some of his most popular writings took the form of 'trips' around London and its environs, such as *A Walk to Islington* (1699) and *The Merry Travellers: or, A Trip upon Ten-toes, from Moorfields to Bromley* (1721). The most influential was the monthly journal, *The London Spy* (1698–1700), in which Ward proposed 'to expose the Vanities and Vices of the Town, as they shall by any Accident occur to my knowledge'.[1] The journal's success was due to its innovative formula, which presented London locations, entertainments, festivals and character types as they were witnessed and experienced by 'the spy', a newcomer to the city. Through his fresh eyes and insatiable curiosity, the familiar and the everyday become invigorated, newly fascinating and richer with satirical possibilities, as the spy wanders from taverns and coffee houses to fairs and parades, taking in the sights with an old school friend, who, like Hogarth, acts as a knowing guide.

In their representations of London's outdoor life both Hogarth and Ward concentrated more on the prosaic and the seamy than the official, the historic or the grand, which tended to be the focus of published travelogues, guides and graphic views of the city. The church of St Martin-in-the-Fields and St James's Palace, both significant architectural landmarks and symbols of church and state, are just part of the backdrop in *Beer Street* and Scene 4 of *A Rake's Progress* respectively (nos.98, 44). This also applies to public entertainments and spectacles. In *Industry and Idleness* Hogarth shows two crowd scenes: the Lord Mayor's procession through Cheapside and a public execution at Tyburn. In both cases the mayor and the criminal are but one, albeit important, detail in scenes that are teeming with keenly observed characters and incidents (see pp.188–9). Similarly, Ward's spy and his guide pay as much attention to the goings-on of the crowd as they do to the grand ceremonial of the Lord Mayor's parade passing by.[2] And it can be fairly stated that Hogarth, like Ward, also played to the bawdy and prurient instincts of his audience, while cataloguing urban life in all its variety. In *Morning* and *Noon* (*The Four Times of Day*) and *Beer Street*, market girls, maidservants and street sellers are fondled by drunken rakes, footmen and tradesmen; in *Strolling Actresses Dressing in a Barn* (no.69) a group of provocatively [un]dressed actresses, strut, posture and prepare for an evening performance; and in the final scene of *A Rake's Progress* some visitors to Bedlam hospital stroll among the insane, entertained by their bizarre antics (see p.93). Ward's spy, on a similar visit to Bedlam, even addresses some of the unfortunates, with comic results, but also wryly observes the prostitutes plying their trade with the other visitors. He concludes

FIGURE 25

that the hospital is 'an Alms-House for Madmen, a Showing Room for Whores, a sure Market for Leachers, and a dry Walk for Loiterers'.[3]

Ward's target audience was the broader, literate middle classes, not scholars and cognoscenti. Hence his scatological observations, albeit interspersed with more learned references, smacked more of ground-level experience than revered literary prototypes. This earthy approach was underlined by such colourful comments as 'a Fig for St *Aug[us]tin* and his Doctrines, a Fart for *Virgil* and his Elegency, and a T[ur]d for *Descartes* and his Philosophy'.[4] Hogarth, as we know, could

be equally irreverent in tone. But his work habitually represented a complex interaction between high and low culture, which mirrored his own identity as both satirist and artist and indicated that his primary aim was the exclusive collectors' market. In this context works such as *The Four Times of Day, Strolling Actresses in a Barn* or *Southwark Fair* (no.65) correlate with the more elevated ambitions of Jonathan Swift's urban-themed poems, 'Description of the Morning' and 'Description of a City Shower' (both 1709), or John Gay's *Trivia; Or, The Art of Walking the Streets of London* (1716). In *Trivia* Gay makes ironic reference to classical works – Virgil's

celebrated *Georgics* (poems on rural life and farming) and Juvenal's third Satire, which describes the dangers of walking in the streets of ancient Rome – to create a satire in the form of a survival guide to the 'rough and tumble' of the city ('Through Winter Streets to steer your Course aright, | How to walk clean by Day, and safe at Night'[5]). Gay's allusions to classical literature and mythology ('Trivia', for example, not only means 'inconsequential details' but is also the Roman goddess of crossroads, witchcraft and the night) were aimed at an educated audience who would appreciate such ribaldries, just as they would enjoy Hogarth's ironic image in *Strolling Actresses*

The Cov.t Garden Morning Frolick

*Invented & Engravd by L.P.Boitard, / Published According to Act of Parliament. Oct. 9, 1747. / Price one Shilling.*

FIGURE 26

*Dressing in a Barn* of an immodest street-player posing as Diana, the virginal goddess of the hunt, or, in *Southwark Fair*, the theatre troupe comically tumbling from their collapsing stage next to a sign that reads 'The Fall of Bajazet'.

Despite their varying literary ambitions, the common thread in the work of Ward, Swift and Gay is their evocative descriptions of the street as an overwhelming sensory experience. Thus Ward's spy exclaims:

> My Ears were Serenaded on every side, with the Grave Musick [*sic*] of sundry *Passing Bells*, the rat[t]ling of Coaches, and the melancholly [*sic*] Ditties of Hot Bak'd *Wardens* and *Pippins* that had I had as many Eyes as *Argos* and as many Ears as *Fame*, they would have been all confounded, for nothing could I see but *Light*, and nothing hear but *Noise*.[6]

And similarly in *Trivia* Gay writes:

> Now Industry awakes her busy Sons,
> Full charg'd with News the breathless
>   Hawker runs:
> Shops open, Coaches roll, Carts shake
>   the Ground,
> And all the Streets with passing Cries
>   resound.[7]

Hogarth's work constitutes a pictorial representation of such sights and sounds. Henry Fielding, for example, described *The Enraged Musician* as 'enough to make a man deaf to look at'.[8] The same could be said for the crowd scenes of *Industry and Idleness*, *Southwark Fair*, *The Cockpit* (no.101) or *The March to Finchley* (no.113). Indeed, Hogarth's urban scenes are often characterised by noisy action and suspended animation: objects are dropped, coaches are overturned, structures collapse, guns are fired, drums are beaten, instruments are played, children cry and scream, and people cheer, shout, argue and fight, just as they would in real life.

Hogarth's representation of urban life is thus far removed from the order and sanity habitually evoked by perspective views of the city or the 'polite' genre-cum-topographical scenes of Balthasar Nebot, Joseph Nicholls and others, which were brought to a high point of sophistication and grandeur with the arrival of Antonio Canaletto in London in 1746 (see fig.25). In this context Hogarth's crowd scenes find greater parallels with graphic satires, for example, by Louis Philippe Boitard and Charles Mosley (fig.26). They also compare and significantly contrast with a popular genre of art known as 'Cries', which originated in Europe and first appeared in England in the late sixteenth century. These usually involved a series of single images of pedlars, such as milkmaids, chimney sweeps, and fruit- and fish-sellers, and the street cries associated with their trade or produce. Until the mid-eighteenth century this artistic genre was dominated in England by foreign artists. The most influential and sought-after series during Hogarth's lifetime was *The Cryes of the City of London* by Marcellus Laroon, first published in 1687 (no.60). That these distinctive cries were a primary feature of London street life is underlined by the references made to them by Ward and Gay, in the quotations above, as well as Hogarth's energetic characterisations, which are clearly meant to evoke sound. Thus, unlike Laroon's hawkers, who are dislocated from the city and each other, Hogarth's pedlars wind through the street, actively competing with each other for attention, their faces contorted with the effort of yelling, singing or trumpeting, because, of course, their livelihoods depend on it. Perhaps this is why Hogarth's vision of London is so exhilarating – it lives and breathes.

# 58

Balthazar Nebot (active 1730–after 1765)
*Covent Garden Market* 1737
Oil on canvas
64.8 × 122.8
TATE. Purchased 1895

In the 1630s the Covent Garden area was redeveloped into an elegant, arcaded square with fashionable town houses that were inhabited by members of the aristocracy. By the 1730s, however, the residents were mainly artists, craftsmen and shopkeepers, and the location itself was at the heart of London's theatre world, as well as other entertainments and social venues such as taverns, coffee houses and brothels. Indeed, despite its smart reputation by day – augmented by the fruit and vegetable market, which was one of the sights of London – by night the piazza was from the early eighteenth century increasingly associated with vice and immorality. Hogarth lived in the Covent Garden area from about 1730 but moved to Leicester Fields (now Leicester Square) in 1733.

Probably of Spanish origin, Nebot was a painter of outdoor genre scenes and topographical landscapes. He seems to have been associated with a group of artists working in Covent Garden, including Pieter Angellis (see fig.28) and Joseph van Aken, all of whom painted scenes of everyday urban life. Here Nebot has combined genre with townscape painting, creating a panoramic image of the piazza and open-air market with a variety of people going about their daytime business. In the background can be seen St Paul's Church and the sundial column, which, with the arcade, were the piazza's characterising architectural features and thus were invariably included in the numerous perspective views produced by eighteenth-century printmakers. The composition on the left is dominated by the market stalls with fruit- and vegetable-sellers. On the right a pair of prize-fighters has attracted a crowd, and in the foreground a well-dressed couple taking a stroll pause as their child gives money to a beggar. Meanwhile, a dog urinates on a fence post. Such incidental details, common in Hogarth's work, suggest that the painting is an authentic record of London street life. However, unlike Hogarth's representation of Covent Garden in *Morning* (*The Four Times of Day*; no.67), the vantage point for the viewer is at a distance, resulting in physical and thus psychological detachment. In this context every Londoner, whether rich or poor, becomes a picturesque detail.

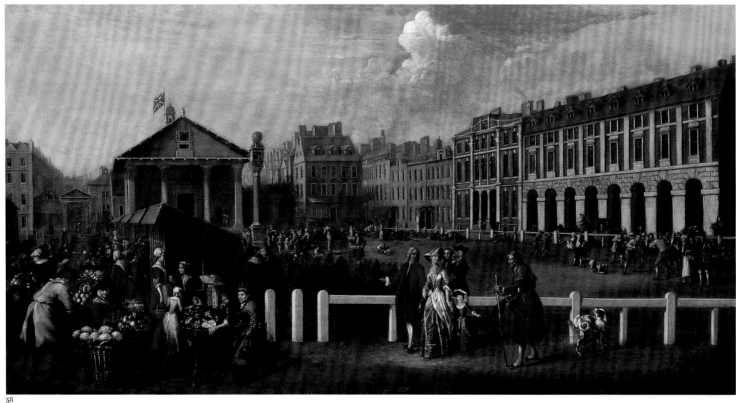

58

# 59

Joseph Nicholls (active 1726–1755)
*A View of Charing Cross and
Northumberland House* 1746
Oil on canvas
60.9 × 73.6
THE ROYAL BANK OF SCOTLAND GROUP

Nicholls painted a number of city views, which, like Nebot's *Covent Garden Market* (no.58), are both topographical, in detailing actual buildings and landmarks, and filled with miniaturised incidents of everyday life. This painting shows the Charing Cross area with Hubert Le Sueur's equestrian statue of Charles I, beyond which is the Strand and Northumberland House, the London residence of the Duke of Northumberland, with its two towers. The thoroughfare is lined with shops and populated with soldiers walking and on horseback, beggars, street urchins, pedlars and well-

dressed ladies and gentlemen, as well as carts and coaches. Canaletto painted a similar view for the Duke of Northumberland in 1752, which proved highly influential on British view paintings through copies and engravings.

Charing Cross is also the setting for Hogarth's *Night* (*The Four Times of Day*; no.67). Unlike Nicholls's composition, which concentrates on architectural grandeur with an impression of urban life, *Night* is claustrophobic and chaotic with the viewer positioned as if walking down the side street, confronted by a jumble of seemingly unconnected incidents. This area of London, however, had associations with the English Civil War (1642–9) and thus political and social fracture. King Charles I had been executed nearby at Whitehall in 1649. Le Sueur's sculpture, which was cast in 1633, was relocated to Charing Cross in

1660. This was deeply symbolic, as the Stuart monarchy was re-established in that year and a number of those who had signed the king's death warrant were executed in the immediate area. About one such execution Samuel Pepys noted in his diary (13 October 1660): 'Thus it was my chance to see the King beheaded at White-hall and to see the first blood shed in revenge for the blood of the King at Charing-cross.'[9] While Nicholls's painting seems to consign these events to the past, the present being marked by order and stability, Hogarth's *Night*, with its emphasis on anti-governmental protest and popular Jacobite sympathies, underlines that this violent history makes its impact on the present.

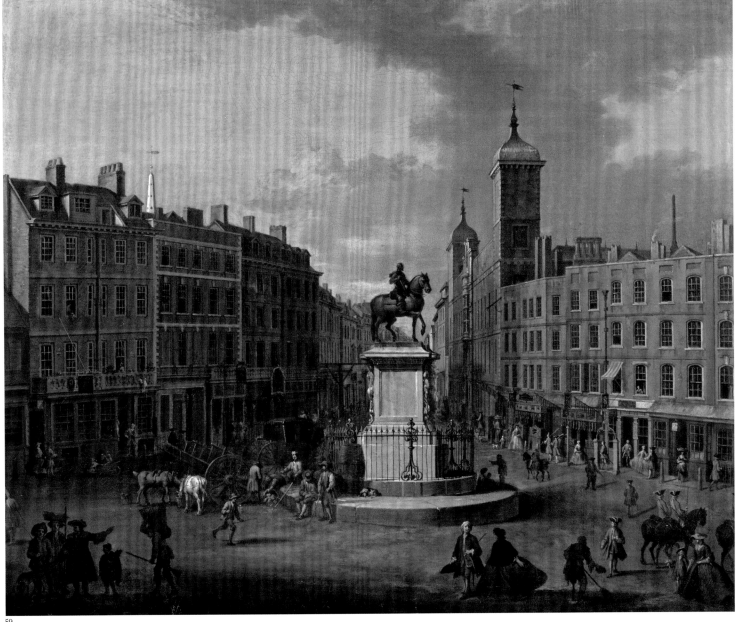

59

# 60

Marcellus Laroon/Lauron (1653–1702)
Five etchings from *The Cryes of the City of London Drawne after the Life* 1688
'The famous Dutch Woman' 25 × 16.5
'London Curtezan' 25 × 16
MUSEUM OF LONDON
'Crab Crab any Crab' 25 × 17
'Knives or Cisers to Grinde' 29 × 21
'The merry Milk Maid' 27 × 16
GUILDHALL LIBRARY, CITY OF LONDON

Born in The Hague in 1653, Laroon was the son of a Frenchman who had settled in Holland. By 1674 he was living in London and in 1680 had taken up permanent residence in Bow Street near Covent Garden. His main source of income probably came from working in Godfrey Kneller's studio, primarily as a drapery painter, although he executed some history paintings and portraits in his own right.

Series of graphic images that show single or paired street pedlars and their shouts, and are described as 'Cries', date back to the early sixteenth century and originate in France, Germany and Italy. This supplemented the extant genre of depicting artisans and their trades. Drawings executed by Annibale Carracci in the 1580s, for example, were published by Simon Guillain in 1646 as a series of images entitled *Le arti di Bologna*. Also in the 1640s two series entitled *The Cries of Paris* by Pierre Brebiette and Abraham Bosse, respectively, were published. In England *Cries* were produced as broadsheets and habitually showed isolated figures with titles describing the cry with which they advertised their wares in the street or their professions, such as (from Laroon's series) 'The merry Milk Maid' (fig.30, p.138) and 'Chimney Sweep'. By the late seventeenth century the broadsheet format had been replaced by sequential prints. The genre continued to thrive in England until the 1890s.

Laroon's *Cryes* were first published in 1687 and probably comprised thirty-six plates. It is possible that the artist was prompted by the publication of Jean-Baptiste Bonnart's *Cris de Paris* in about 1686. The fifth edition, 1689, included seventy-four plates, some of which depicted characters from street theatre (see *Southwark Fair*, no.65). The series was reprinted and adapted on numerous occasions and purchased by aristocrats and middle-class patrons such as Samuel Pepys and Joseph Addison. The first publisher, Pierce Tempest, incorporated French and Italian titles into the early editions to promote interest from continental collectors. It has been more recently demonstrated that Hogarth knew the series well and possibly conceived prints such as *The Enraged Musician* 1741 as a spirited 'English' riposte (see pp.138–9).[10] The similarities between Laroon's milkmaid and the central figure of *The Enraged Musician* strongly suggest that Hogarth drew inspiration from Laroon's work, and furthermore that he was inviting comparisons to be made between them.

Laroon's artistic interpretation of London's bustling street commerce is solid, robust and unsentimental. The majority of the figures are seen walking or turning, their flapping clothes adding to the sense of movement. Some are shown shouting or sounding their wares with instruments, which, with the accompanying titles (e.g. 'Buy a fine singing Bird', 'Crab Crab any Crab' (no.60), 'Twelve Pence a Peck Oysters'), attempts to evoke sound. That this was an important element of Laroon's *Cryes* and the genre in general is underlined by the observation, made in 1710 by Zacharias Conrad von Uffenbach, that 'One can also obtain them with notes, for the curious tones that they call or sing can be freakishly imitated on the violin'.[11]

Crab Crab any Crab
*Qui veut des cancres*
*Granci freschi*

60

# 61

Josef Wagner (1706–1780) after
Giacomo Amiconi (1682–1752)
*Golden Pippins* 1739
Etching
25.5 × 20.5
THE BRITISH MUSEUM, LONDON

# 62

Josef Wagner after Giacomo Amiconi
*Shoe-Black* 1739
Etching
23 × 18.5
GUILDHALL LIBRARY, CITY OF LONDON

Amiconi, also known as Jacopo Amigoni, was an Italian artist who executed history paintings, decorative schemes and portraits. He arrived in England in 1729 and worked in and around London for ten years. Initially he was patronised exclusively by royalty and members of the aristocracy. Having been out-manoeuvred by Hogarth for the decorative scheme at St Bartholomew's Hospital, he left for Venice in August 1739 (see p.138).

Created for the collectors' market, Amiconi's highly romanticised images of four low-class children are the first London *Cries* with the figure set in a townscape, including a distant view of the city and the façade of a well-appointed town house. Apart from the inclusion of St Paul's Cathedral in *Golden Pippins*, these appear to be generic London backdrops rather than the specific locations that are habitually represented in Hogarth's work. Amiconi offers a vision of picturesque rather than abject poverty, with healthy and appealing children going about their business, uncomplaining and reassuringly docile or cheerful. This sentimental bias, accentuated by the inclusion of a pet dog and kittens in two of the scenes, is in direct contrast to Hogarth's more robust, realistic approach, in which street urchins can be shown diseased and malnourished, wily and delinquent. In *Noon* (*The Four Times of Day*; no.67), for example, a hungry child eats food dropped onto the street (note also the dead cat lying nearby.) And in the early 1740s Hogarth added a group of grubby, street-wise hawkers into Scene 4 of *A Rake's Progress*, who are shown smoking, gambling, cheating and thieving (see fig.27 and no.44). Given Hogarth's intense professional rivalry with Amiconi in the late 1730s, it is possible that this vignette was a deliberate response to the Italian artist's sanitised representation of the city's infant poor. Equally, *The Enraged*

*Musician* (no.72), first conceived in 1739, the same year that Amiconi left England, can be read more generally as a triumphant rebuttal of his 'polite', cosmopolitan interpretation of London street life. This would certainly chime with the print's theme of elite culture, as represented by the continental musician, being frustrated by the overwhelming clamour of the indigenous throng.

A comparable approach to Hogarth's can be seen in Paul Sandby's *Twelve London Cries Done from Life* published in 1760 (fig.29, p.126).

62

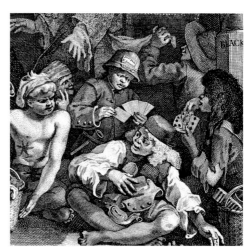

FIGURE 27
*A Rake's Progress* Scene 4
early 1740s (no.46, detail)

# 63

*The Shrimp Girl* c.1740–5
Oil on canvas  63.5 × 52.5
THE NATIONAL GALLERY, LONDON

This now celebrated oil sketch remained in Hogarth's studio and was sold only after his wife's death in 1789. The title, *The Shrimp Girl*, was first used in the Christie's sale catalogue of 1780. Selling shellfish in the London streets was normally the work of the wives or daughters of fishmongers who ran stalls in markets. Here the young woman balances a characteristically large dish-shaped basket on her head, in which can be seen mussels, shrimps and a half-pint pewter jug for measuring purposes.

The painting's scale strongly suggests that Hogarth had embarked on this work as a portrait in its own right, rather than as a preparatory sketch for a multi-figured work. The individuality and expressiveness of the face also point towards a life study, in a similar vein to the later portraits of his servants (see no.116). Its unfinished state underlines Hogarth's supreme technical assurance at this time. The rapid, broad brushstrokes and thin layers of paint accentuate the sense of movement and spontaneity in the turning figure, as if Hogarth had literally captured the woman walking past in the street. Given his intimacy with London street life, Hogarth would have had ample opportunity to observe and sketch a fish-seller (he incorporated two female herring-sellers, for example, in *Beer Street*, no.98). The image is also remarkable for its distinct lack of idealisation or sentiment. In Pieter Angellis's *The Vegetable-Seller* c.1728 (fig.28) the seated figure of the pretty market girl seems positively frail and vulnerable in comparison to Hogarth's robust shrimp-seller, and is seen making the kind of elegant gesture that is more reminiscent of a *fête galante* scene than an open-air market. Such romanticised and sentimental representations relate to Amiconi's child hawkers (p.125) and presage the fancy pictures of the second half of the eighteenth century by Thomas Gainsborough, Joshua Reynolds, Francis Wheatley and others.

Albeit presenting a more realistic approach, Hogarth's *Shrimp Girl* is nevertheless a far more appealing individual than the terrifying creature selling mackerel in Paul Sandby's *Twelve London Cries Done from Life* 1760 (fig.29). Hogarth's focus on an attractive female subject is in keeping with earlier

FIGURE 28

FIGURE 29

compositions involving street scenes, such as *Southwark Fair* and *The Enraged Musician* (nos.65, 72), where the central figures are a pretty drummer-girl and milkmaid, respectively. In *Morning* and *Noon* (*The Four Times of Day*) and *Strolling Actresses Dressing in a Barn* (nos.71, 69) the young working women are portrayed more overtly as objects of male desire. This may reflect Hogarth's personal attitude towards female beauty and sexual attraction expounded, for example, in *The Analysis of Beauty* (see p.45). But it also suggests in the case of street sellers that their bodies as well as their produce might be for sale, thus acknowledging the interrelationship between street trading and prostitution at this time.

FIGURE 28
Pieter Angellis
(1685–1734)
*The Vegetable-Seller* c.1728
YALE CENTER FOR
BRITISH ART, PAUL
MELLON FOUNDATION

FIGURE 29
Paul Sandby (1731–1809)
'Rare Mackarel Three a
Groat Or Four for Sixpence'
1760
MUSEUM OF LONDON

63

# 64

*The Laughing Audience (or A Pleased Audience)*
December 1733
Etching
18.8 × 17.1
ANDREW EDMUNDS, LONDON

As with a number of crowd scenes in this section, the theme of *The Laughing Audience* is that of everyday life being dramatised as a piece of theatre or entertainment. The print originally served as the subscription ticket for *A Rake's Progress* and *Southwark Fair* (nos.44, 65). The scene shows part of the interior of a theatre, compositionally divided into three sections. In the foreground sit three members of the orchestra. The audience members standing in the pit are laughing uproariously at the play being performed in front of them. Only one person appears not to be enjoying himself. Although contorted with laughter, each face denotes individuality and genuine enjoyment, underlining Hogarth's artistic pursuit of character rather than caricature.

In the background, standing in a theatre box, are two rakish aristocrats who are oblivious to the goings-on around them. One flirts with an orange-seller, while another orange-seller attempts to attract his attention from the pit. The other aristocrat, with studied elegance, 'gallantly' offers a lady a small box of snuff. Given that this print advertised *A Rake's Progress*, we might imagine that the theatrical performance that is causing so much unadulterated mirth among the lower levels of society is in fact the story of Tom Rakewell, whose ill-fated career as an aristocratic roué is ruthlessly satirised by Hogarth. In which case the 'gentlemen' at the back, who bear more than a passing resemblance to Tom in Scene 4 of *A Rake's Progress*, would be well advised to pay attention.

# 65

*Southwark Fair (or The Humours of a Fair)*
January 1733
Etching and engraving
36.2 × 47.3
ANDREW EDMUNDS, LONDON

# 66

William Dicey (active 1730s and 1740s)
*The Humours and Diversions of Bartholomew Fair* c.1735
Etching
45.5 × 56
MUSEUM OF LONDON

*Southwark Fair* was conceived as a kind of epilogue to *A Rake's Progress*, the final scene of which shows Tom Rakewell consigned to Bedlam (see no.44). He is surrounded by inmates who, lost to all reason, are acting out a variety of personas, including a saint, a king and a pope. As with the unseen players in *A Laughing Audience* (no.64), their collective performance is the cause of great amusement to members of the public, who have come to 'the madhouse' to be entertained. *Southwark Fair* transfers the viewer from a claustrophobic scene of delusion and insanity to a chaotic London street fair, with its theatrical troupes, street performers, puppet shows and carnival characters. At first glance, the images seem unrelated. However, the folk custom of fairs and street theatre closely relates to the role-playing and 'performance' seen in Bedlam, as elsewhere in *A Rake's Progress*, as well as reflecting Hogarth's own description of his pictorial narratives as 'dumb shows'.[12] The topsy-turvy world of the carnival, by its very nature, involved role play and role reversal, and the interchange between the elevated and the low, the wise and the foolish, the tragic and the farcical. It was also irreverent towards secular and ecclesiastical offices, rituals and institutions, and social pretensions, thus chiming with Hogarth's satirical agenda. Tom Rakewell's spectacular fall is comically paralleled (far left) by the troupe of players in costume tumbling downwards as their stage collapses. And the theme continues with the 'elevated subject matter' of the theatrical productions on offer at the fair (e.g. 'The Fall of Bajazet', 'The Siege [or Fall] of Troy' and the biblical fall of Adam and Eve).

Hogarth advertised this scene as 'A Fair' or 'The Humours of a Fair', only referring to it later in life as 'Southwark Fair'. As with *The Laughing Audience*, the theme is the interrelationship between theatre and everyday life. In this context the crowd

milling around on the street are both spectators and part of the spectacle, as well as potential subject matter for Hogarth's satirical eye. The image also underlines that Hogarth's work could be at once allegorical and literal. This becomes obvious when comparing and contrasting *Southwark Fair* with the near contemporary print by William Dicey entitled *The Humours and Diversions of Bartholomew Fair* c.1735, which is a straightforward representation of an actual event. Southwark, on the south bank of the Thames, was long associated with London's theatre world (Shakespeare lived in Southwark for a time and his plays were performed at The Globe nearby). Southwark Fair was also called the 'Lady Fair', perhaps explaining the prominence of the drummer-girl in Hogarth's print. It was held in the area around the church of St George the Martyr, the square tower of which can be seen in the background. The composition also incorporates actual events, characters, theatre companies and the productions (mentioned above) that were performed at Southwark or elsewhere in London. On the right, for example, is a broadsword fighter seated on horseback, who has been identified as James Figgs, a well-known figure at the time. And the performer on a suspended rope (centre background) is thought to represent either Signor or Signora Violente. Rope dancers featured in London fairs from at least the seventeenth century. Laroon's expanded *Cries* of 1689 included a number of named street-theatre characters, such as 'Clark the English Posture Master' and 'Merry Andrew', but also two images of a rope dancer titled 'The famous Dutch Woman'.

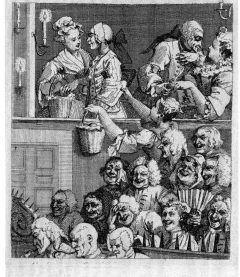

64

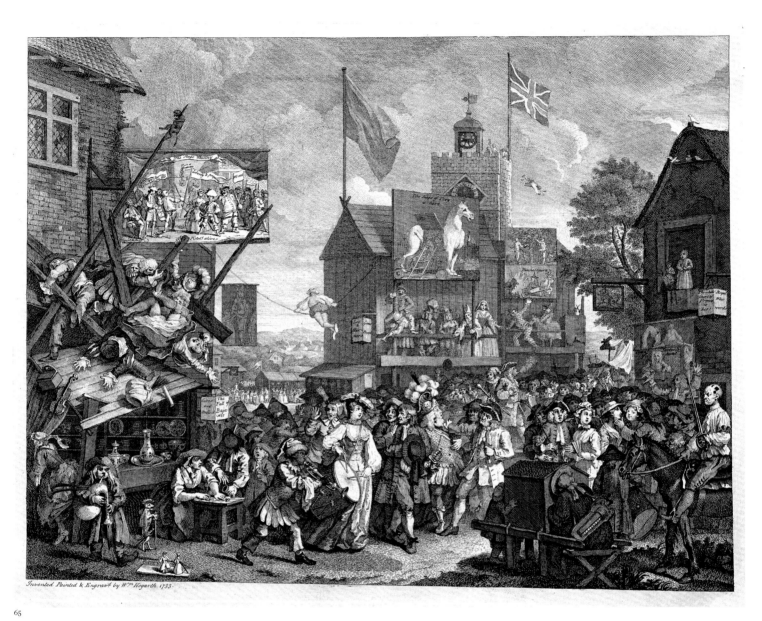

Invented Painted & Engrav'd by Wᵐ Hogarth. 1733.

65

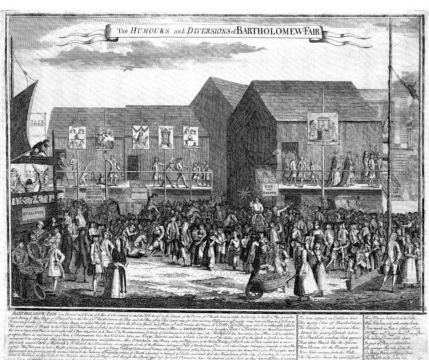

66

# 67

*The Four Times of Day* 1736
Four scenes: *Morning, Noon, Evening, Night*
Oil on canvas
Each approx. 74 × 62
UPTON HOUSE, THE BEARSTED COLLECTION
(THE NATIONAL TRUST): *Morning and Night*
PRIVATE COLLECTION: *Noon and Evening*

# 68

*The Four Times of Day* 1738
Four prints: *Morning, Noon, Evening, Night*
Etching and engraving (*Evening* with
colour ink and watercolour)
Each approx. 48.8 × 40.9
THE BRITISH MUSEUM, LONDON

The sequential format of *The Four Times of Day* has antecedents in European pictorial traditions, particularly in other *Times of Day* works but also *The Seasons* and *Ages of Man*. In eighteenth-century French art the subject matter tended to reflect the pastimes of the fashionable elite. Thus in Nicolas Lancret's *Les Heures du Jour* (*The Four Times of the Day*) 1739–41 *Morning* shows a *toilette* scene set in a lady's bedchamber (fig.31, p.149); *Midday* and *Afternoon* portray aristocrats in a garden, picking flowers and playing backgammon respectively; and in *Evening* ladies bathe by moonlight, thus parodying the myth of Diana and her handmaidens. These scenes, as with Lancret's *Seasons* of 1738 (Musée du Louvre, Paris) and those of François Boucher of 1755 (The Frick Collection, New York), are composed in the manner of *fête galante* and *tableau de mode* paintings (see p.76). Another variation can be seen in Claude-Joseph Vernet's *Four Times of Day* (1751, Uppark House, Sussex), which depicts four coastal scenes with varying weather conditions as well as different moments of the day. The literary context for Hogarth's series, as discussed on p.120, is evident in the poems of Swift and Gay and the satirical tour narratives of Ned Ward, in particular *The London Spy*, which was often reprinted in the eighteenth century.

As a series, *The Four Times of Day* relates to *A Harlot's Progress* and *A Rake's Progress* (nos.43, 44). However, what unites each scene to the other is not the individual characters, none of whom are repeated, but the passage of time itself. Hogarth seems to accentuate the notion of the 'progress of the day', as well as that of an urban tour, by showing prominent figures walking across the compositions (in *Morning, Noon* and *Evening* they are walking in the same direction).

Hogarth engraved *The Four Times of Day*

himself with the assistance of Bernard Baron, who worked on *Evening*. In some early published impressions of the *Evening* print included here red ink has been added to the lady's face, in reference to the balmy weather, and blue 'stains' the hands of her husband, underlining that he is a dyer by trade.

*Morning*
The scene is set on the west side of Covent Garden piazza in front of the portico of St Paul's Church. The clock shows 7.00 a.m. The Latin inscription underneath reads 'Sic Transit Gloria Mundi', reminding us that none of this world's glories is permanent. The snow on the rooftops and icicles hanging from the roof of Tom King's Coffee House, which in real life was situated on the south side, underline that this is a winter morning. On the right vegetable and fruit-sellers and market-stall holders are preparing for the day. Among the crowd, a man can be seen standing by a hoarding that advertises various pills and cures. This is possibly Dr Richard Rock (1690–1777), the quack doctor previously seen in *A Harlot's Progress*, who was famous for peddling medicines for venereal disease and toothache.

Just as the day is beginning for some inhabitants of the piazza, for others the previous night is coming to a riotous end. A fight has broken out in the coffee house on the left with someone's wig flying out of the door. A group of beggars are huddled around the fire. Meanwhile, two aristocratic rakes find an alternative method of keeping warm by fondling and kissing young market girls. They are observed by a well-dressed woman, traditionally described as a spinster, who pauses on her way to church. She presses her closed fan to her lips, in disapproval or perhaps in contemplation of the earthy passion that is absent from her own life. Her shivering footboy, his nose bright red from the cold, follows her holding a prayer book.

The spinster figure has been interpreted as a hypocrite, who, despite attending church, shows a distinct lack of Christian charity, as indicated by her indifference to the freezing footboy and the starving beggar who sits before her, holding a hand out for money. An additional observation on this character can be made in relation to the miniature portrait hanging from her hip, temporarily revealed from under her pink apron by the gentle breeze. In *Tom Jones* (1749) Henry Fielding referred back to *Morning* in his description of Miss Bridget

Allworthy, the bad-tempered sister of the well-meaning Squire Allworthy: 'I would attempt to draw her Picture, but that is done already by a more able Master, Mr. Hogarth *himself*, to whom she sat many Years ago, and hath been lately exhibited by that Gentleman in his Print of a Winter's morning, of which she was no improper emblem.'[13] Towards the end of the novel Miss Bridget makes a deathbed confession that Tom Jones is, in fact, her illegitimate son by Mr Summers, a young clergyman, who died before they could be married. Thus the spinster in *Morning* might also represent someone who was disappointed in love, hence her interest in the amorous couples and the significance of the portrait hanging at her side.

*Noon*
The spire of the church of St Giles-in-the-Fields, seen in the background, indicates that *Noon* is set in Soho, probably in Hog Lane, which is now part of Charing Cross Road. The clock on the church's tower reads 12.10. The area was generally associated with London's French community and in particular the Huguenots (French Protestants). On the left a soberly dressed congregation spills out onto the street. In front of them are a lavishly dressed couple and their son. Their strutting and posturing are probably meant to indicate that they are French and thus pre-empt Hogarth's representation of pretentious Francophile connoisseurs in *Taste in High Life* (no.74) and the foppish Lord Squanderfield in *Marriage A-la-Mode* (see p.77).

The composition is divided by a drain. This seems to suggest a division between those represented on either side, between the joyless piety of the churchgoers and modish affectation of the couple and the more spontaneous and earthy inhabitants on the other side. The visual counterpart to the chapel is the tavern situated opposite, which appropriately sports a religious subject of St John the Baptist's head on its sign. A young, buxom servant girl is being fondled by a footman. Her flaxen hair, red lips, pale skin and flushed cheeks are probably meant to be read as a healthy, natural alternative to the sickly, artificial face and body of the 'French' woman on the left. With her attention understandably diverted, the servant girl inadvertently tips some of the juice from her pie onto the small boy standing beneath, the result being that his platter has broken and the contents have fallen onto the floor. He stands rubbing his head and bawling uncontrollably, which

67 MORNING

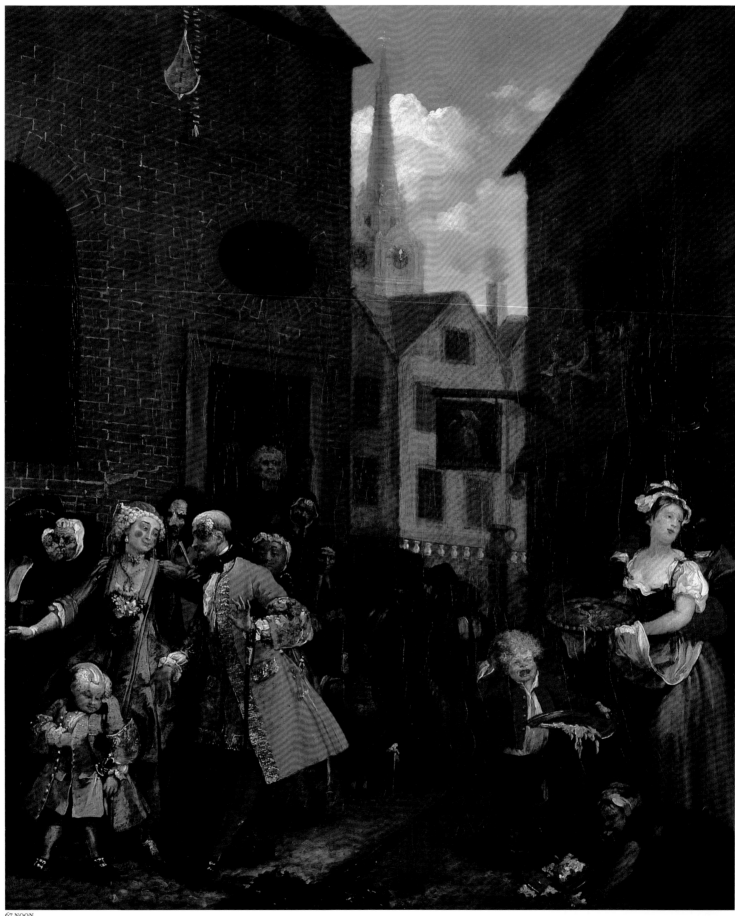

67 NOON

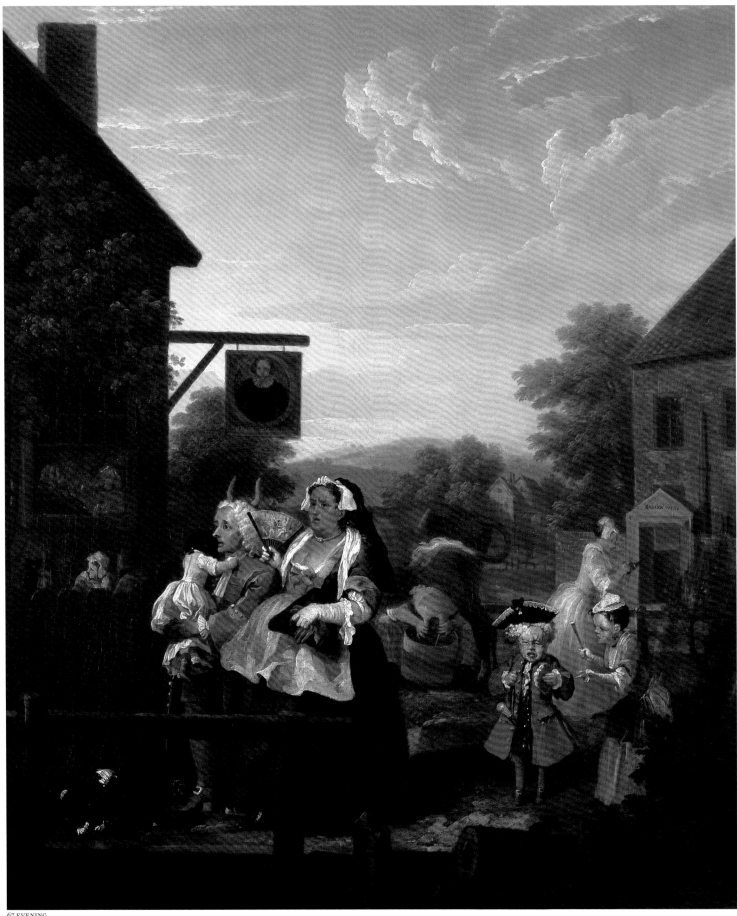

67 EVENING

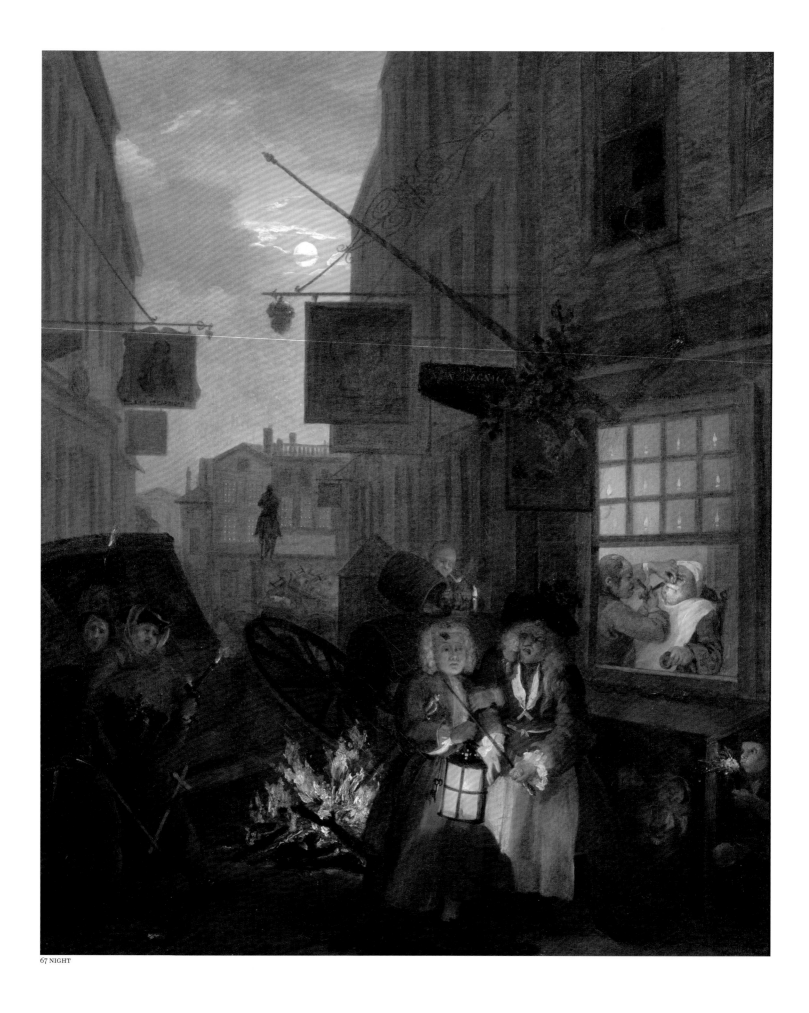

67 NIGHT

contrasts with the silent figure of the boy on the left, who seems more interested in his rich clothes. Meanwhile, a street urchin takes advantage of the accident and is busy eating the remnants. At the tavern next door an angry woman tips a leg of mutton out of the upper window, while a man (probably her husband) attempts to stop her. Comically, the tavern sign shows a picture of a woman that ends at the neck, thus inferring that a 'Good Woman', the tavern's name, is a silent one.

*Evening*

Unlike the other scenes in *The Four Times of Day*, this composition includes a wide-open sky and a vista of rolling hills. The glorious, golden sunset suggests a summer evening. The cow being milked in the middle ground underlines the near-rural setting as well as the end of the day. The milkmaid squeezing the cow's teats may also be a humorous allusion to the fondling of female breasts in the previous scenes. On the left the inn sign shows a portrait of Sir Hugh Middleton, the Welsh philanthropist celebrated for bringing fresh running water to London in 1613 (note the water in the foreground). The balmy weather has enticed customers to sit outside in the garden drinking and chatting.

The location is Islington at the northern edge of London. In the later seventeenth century the area had established itself as a popular retreat from the city following the development of Islington Spa, opposite Sadler's Wells, as a resort. The stone entrance of Sadler's Wells Theatre can be seen on the right. The theatre was originally the seventeenth-century 'Musick House' built by Richard Sadler, which became the haunt of London's fashionable elite. By the 1730s, however, Sadler's Wells was satirised for having a down-market clientele consisting of tradesmen and their overbearing, snobbish wives. Poignantly, therefore, the focus of the composition is a dyer and his family strolling wearily across a footbridge by the New River. The large, heavily pregnant wife dwarfs the husband, who holds a sleeping infant in his arms. The overdressed boy and girl following behind are probably their children, too. Their ages suggest that the children's births have occurred in quick succession. Given the wife's formidable figure we can imagine that the balance of power within the marriage is decidedly in her favour and that her sexual demands explain not only the size of the family but the husband's rather haggard appearance. Another perspective is suggested by the cow's horns, which are

comically positioned as if protruding from his head, the traditional sign of a cuckold (a man whose wife has committed adultery). Hot and flushed, the wife fans her face on which is painted a mythological subject, most likely that of Diana and Actaeon. By accident, Actaeon, the mortal hunter, witnesses Diana, the virginal goddess of the hunt, bathing naked in a stream. As punishment, he is transformed into a stag and savaged to death by Diana's hounds (see p.150). These symbols reinforce the idea that the wife is domineering and the husband is submissive. Indeed, the children behind have a similar relationship with the wailing boy being bullied by his sister for a piece of his gingerbread man.

*Night*

This scene is set in a narrow street in Charing Cross, Westminster. Le Sueur's equestrian statue of Charles I is situated in the background, below the full moon that is seen briefly through the break in the clouds. The oak leaves decorating the barber-surgeon's striped pole (on the façade on the right) indicate that the date is 29 May or 'Oak-Apple Day', which marked the restoration of the Stuart dynasty by Charles I's son (Charles II), who claimed the throne on that date in 1660. During the English Civil War the future king famously avoided capture after the Battle of Worcester (1651) by hiding in an oak tree. The day was also commemorated by the lighting of bonfires and candles in windows, as seen in the foreground and background of the painting, and fireworks (an exploding firework is visible above the distant buildings). In fact, after the accession of King George of Hanover as George I in 1714, commemorating Oak-Apple Day was prohibited. But the practice continued in London as an anti-Hanoverian and/or pro-Jacobite gesture under the guise of celebrating George I's birthday, which by chance fell on the following day.

Charles II was notorious for his mistresses and patronage of brothels. Thus the commemorative oak leaves are displayed appropriately near a sign reading 'New Bagnio'. Bagnio, in early eighteenth-century parlance, meant a brothel or an establishment where rooms were hired and no questions asked (see p.150). The street is occupied by two taverns, the Earl of Cardigan on the left and the Rummer Tavern on the right (a 'rummer' was a short-stemmed drinking vessel). Both had functioned as Freemason Lodges in the 1730s. The foreground of *Night* is dominated by the figure of a drunken Freemason in full

regalia being helped home. He is being sprayed with urine, which has been thrown 'accidentally' out of an upper window, ricocheting off the wall. Fortunately, the urine misses the poverty-stricken family sleeping under the barber-surgeon's shop window, their faces lit by the torch held by a crouching 'link-boy' (a child hired to light the way at night). Appropriately with this near miss, the barber-surgeon can be seen giving his client 'a close shave'.

By tradition, the drunken Freemason represents Sir Thomas de Veil (d.1747), a magistrate who was well known at the time for the severity of his sentencing, in particular for gin-sellers. Indeed, his attempts to enforce the Gin Act of 1736 were met with hostility among distillers, vendors and the London poor, who were the principle consumers. The Act itself provoked riots and was finally repealed (see p.190). With great irony, therefore, not only is de Veil represented in *Night* as drunk and thus a hypocrite, but behind his back a man can be seen nonchalantly pouring gin into a barrel. Hogarth was himself a Freemason. This fact alone might explain the Masonic reference. But his rationale in referring to Freemasonry, the Stuart dynasty and Jacobitism in one image is possibly that Scottish Freemasonry was linked from the late seventeenth century to the Stuart cause, with members actively participating in the Jacobite Rebellion of 1715. English Freemasonry was formalised in 1717 with the establishment of the Grand Lodge. From then on, the society aligned itself more overtly with the Hanoverian dynasty and for the first time published a constitution (1723), thus deflecting accusations, as a 'secret' organisation, of intrigue and subversion against the state.[14] That rumours still abounded, however, is underlined by an article published in *The Gentleman's Magazine* in 1737, which referred to the Freemasons as 'that mysterious Society' and declared that 'no Government ought to suffer such clandestine Assemblies, where Plots against the State may be carried on, under the Pretence of Brotherly Love and Good Fellowship'.[15]

One might therefore interpret the scene of chaos in the foreground, dominated by the bonfire overturning a coach, as a humorous allusion to popular protest and unrest erupting into violent disorder and to contemporary conspiracy theories surrounding Freemasonry. Appropriately, as a member of a 'secret' society, the Freemason is seen walking under the cover of night.

# 69

*Strolling Actresses Dressing in a Barn*
25 March 1738
Etching and engraving
51 × 62.7
ANDREW EDMUNDS, LONDON

Hogarth had begun the painted version of *Strolling Actresses Dressing in a Barn* before the passing of the Licensing Act of 1737, which was introduced by Sir Robert Walpole. This legislation resulted in the closure of non-licensed theatres, leaving open only Drury Lane Theatre and Lincoln's Inn Fields.

This busy, complex print shows a troupe of actresses and child actors 'behind the scenes', preparing for an evening performance in a makeshift dressing room. One of the playbills on the mattress in the left foreground registers the imminent closure of the theatres, described above. The playbill positioned underneath lists the various roles being performed by those present ('Jupiter', 'Diana', 'Siren', 'Flora', 'Juno', 'Eagle', 'Cupid'), some of which echo *The Four Times of Day* (e.g. 'Aurora' and 'Night'). The dilapidated barn is littered with pieces of stage scenery, props and musical instruments, such as celestial clouds, a chariot drawn by dragons and Roman standards, which set the scene for the numerous visual plays on high and low culture within the composition. In the background, for example, we see 'Cupid' on a ladder reaching for a pair of stockings, directed by 'Apollo' (note the sun on his hat) using his bow.

As actresses were associated with prostitution at this time, Hogarth's audience would have noted the ambiguity of the women's appearance and some of their actions, as well as the irony of their mythological roles. On the far left an actress in contemporary male dress is playing Ganymede, who in Greek mythology was the beautiful youth abducted by Zeus, king of the Gods. She is suffering from toothache, which could be a symptom of syphilis, just as the face patches sported by all the women might be fashion accessories and/or concealing flea bites or evidence of venereal disease. As with *Southwark Fair* and *The Enraged Musician* (nos.65, 72), the scene is dominated by a pretty young woman standing in the centre. Her alluring figure is as sexually charged as that of Moll Hackabout in Scene 3 of *A Harlot's Progress*. She is dressed only in a shift, the upper part of which exposes her breasts just as the lower half lifts upwards to reveal her stockings and thighs, stopping just short of her genitals. As the viewer takes in her provocatively displayed body, she acknowledges their presence with a sideways look and faint smile, while striking an absurd pose and stepping out of her petticoats. However, her hair ornaments include a moon, the symbol of Diana, the virgin huntress. Thus she is both undressing and 'performing' as the goddess, with the viewer humorously cast as a latter-day Actaeon (see *Evening*, no.67).

The conflation of the elevated with performance and the mundane is also represented in the figure wearing a small crown on the far right, who is rehearsing her lines as Juno, the goddess of heaven and motherhood. She is seen looking heavenwards like a saint or martyr in a Renaissance or Baroque painting, this artistic reference accentuated by the swag of fabric impossibly suspended above 'Juno's' head, a conceit used by Van Dyck and others to denote an airborne, otherworldly figure (for example, see Van Dyck's *Rachel, Countess of Southampton, as Fortune*, c.1640, National Gallery of Victoria, Melbourne). Meanwhile, Juno's leg is inelegantly propped up as the actress playing 'Night' (note the stars on her headdress) darns her stockings.

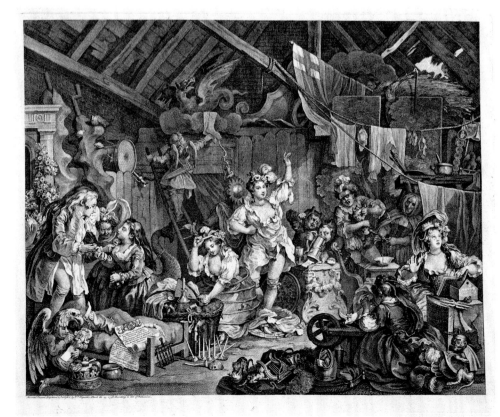

69

# 70

*The Distrest Poet* 1736
Oil on canvas
65.9 × 79.1
BIRMINGHAM MUSEUMS & ART GALLERY

# 71

*The Distrest Poet* (third state) 15 December
1740
Etching and engraving
36 × 41
ANDREW EDMUNDS, LONDON

The inspiration for *The Distrest Poet* was
probably Alexander Pope's satirical poem
*The Dunciad* (a play on Homer's *Iliad* and
*Aeneid*), first published in 1728. The earlier
version of Hogarth's print included a
quotation from Pope's poem and a pictorial
reference to the then ongoing battle of
words between the author and his
detractors. *The Dunciad* specifically
lampoons a group of contemporary poets,
scholars, critics and popular writers who
are described as 'dunces' in the kingdom
of Dulness. The wider context was the
author's passionately held view, also held
by his friends John Gay, and Joseph
Addison and Richard Steele (authors of
*The Spectator* and *The Tatler* journals),
that the nation's literary and cultural
inheritance was being undermined by sham
scholars and commercial hacks, causing the

impoverishment of society as a whole.
Perhaps not surprisingly, Ned Ward, the
author of *The London Spy*, was featured as
a prime culprit in *The Dunciad*.[16]

In the print of *The Distrest Poet* a copy of
*The Grub-street Journal* can be seen on the
floor. Published from 1730 to 1737, the
journal was a satire on 'popular' journalism
and hack writing, euphemistically known
as 'Grub Street', coined after an actual street
in the City of London. Its stated aim was to
'attack lewd and vicious Nonsense' or
'wicked stupidity' and to 'reform the taste
of the generality of Readers which is very
much depraved'.[17] Pope was an occasional
contributor. On one level Hogarth's *Distrest
Poet* visualises the stereotype of the 'Grub-
Street hack' established by the early 1730s:
a man who, despite his limited talent and
poverty-stricken circumstances, doggedly
pursues a living as a writer. By convention,
he is the habitué of a run-down garret.
Hogarth underlines the desperate
circumstances of 'the poet' and his family,
by showing the one-room garret sparsely
furnished with empty cupboards and a
milkmaid shouting at the door proffering
a long, unpaid bill. Meanwhile the wife
darns a suit, looking anxiously at her and
their hungry baby cries. The aspiring poet
sits at the table, scratching his head with
frustration at his lack of inspired thoughts.

Near him lies a copy of Edward Bysshe's
guide to composition entitled *The Art of
English Poetry* (1702).

The poet clearly has dreams that his
work will bring him a large fortune and
high social status. This is demonstrated by
the poster above his head in the print
version that reads 'A View of the Gold Mines
of Peru', as well as the wig, sword and other
gentlemanly accoutrements that feature in
the composition. Finally, he is seen
labouring over a work called 'A Poem to
Riches'. Interestingly, Ned Ward's first
published work was *The Poet's Ramble after
Riches* (1691), a satire on his own struggle to
make a living, which was reprinted several
times in the first half of the eighteenth
century. That the poet is doomed to fail,
however, to the utter ruin of his family, is
underlined by the dog stealing their last
piece of food by the open door. Clearly, what
luck the poet had is just about to run out.
As someone who, in his youth, had had first
hand experience of Grub Street and poverty,
Hogarth was almost certainly more
sympathetic than Pope towards such
pathetic figures (see pp.15, 182). Given this,
perhaps the moral message of *The Distrest
Poet* is that we might pity him for his evident
failure and misery but not for his misguided
aspirations.

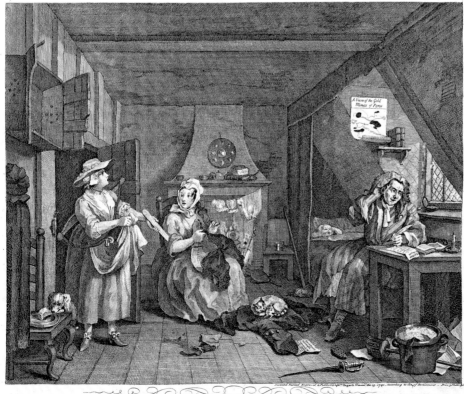

THE DISTREST POET.

71

# 72

The Enraged Musician 30 November 1741
Etching and engraving
35.9 × 41.1
ANDREW EDMUNDS, LONDON

Hogarth advertised this print in November 1740, with the title 'The Provok'd Musician', as a companion print to *The Distrest Poet* and another on the subject of painting, which appears not to have been executed. In his *Journal of a Voyage to Lisbon* Henry Fielding described the image as 'enough to make a man deaf to look at'.[18] On one level *The Enraged Musician* is indeed about noise. The street pedlars to the right include an Irish paviour (paver) beating the ground, a dustman holding a basket on his head while ringing a hand bell, a sow-gelder on horseback blowing his horn, a fish-seller with his hand cupped to his face as he shouts, and (in the foreground) a knife-grinder sharpening a meat cleaver, while a boy beats a drum and a dog barks. On the left a heavily pregnant ballad-seller sings, mimicked by the squawking parrot above her head. The babe in her arms cries. At her feet the little girl holds a rattle. A Jewish haut-boy (type of oboe) player stands directly beneath the musician's window, and in the centre a young milk-seller balances a large pail on her head, calling her wares and looking directly out at the viewer. In the background the flag on the church tower, probably St Martin-in-the-Fields, suggests a celebration of some kind, thus the church bells are probably ringing. The sign on the building (far right) reads 'John Longo pewterer' (pewter workshops were noisy businesses), and on the roof, while two cats spat, a sweep emerges from the chimney stack.

The cacophony of the street has interrupted the violinist's practice session. He responds to the assault on his hearing and musical sensibilities by clamping his hands over his ears and looking furiously out of the window. His musical score, with its ordered staves and notes, is in direct contrast to the unrehearsed ensemble outside. The poster on the wall to the left anachronistically advertises John Gay's *Beggar's Opera* with the cast from its first season of 1728 (see p.70). In *The Dunciad Variorum* (1729) Alexander Pope had celebrated the extraordinary success of his friend's ballad-opera, which 'drove out of *England* the *Italian Opera*, which had carry'd all before it for ten years'.[19] The violinist in *The Enraged Musician* has been identified by commentators as various foreign/Italian musicians of the time, including Pietro

Castrucci who was the leader of Handel's orchestra. It is likely therefore that *The Enraged Musician* not only references Laroon's *Cryes* and satirises the art of Giacomo Amiconi, as previously discussed (see p.125), but also refers to specific developments in London's contemporary music scene. Amiconi, for example, had strong professional and personal ties to Italian opera: his wife was an Italian mezzo-soprano and the celebrated castrato Il Farinelli was of one his patrons (Farinelli owned two of Amiconi's London *Cries*). In 1737 Farinelli left London, never to return (another celebrated castrato, Il Senesino, had departed the previous year, see p.86).

The year 1741 proved to be a watershed in Handel's career. From 1710 he had been largely identified with the promotion of Italian opera in London and was himself satirised in *The Beggar's Opera* (some of the music was adapted from Handel's work) and in Hogarth's *Rake's Progress* (no.44). Realising that there had been a sea-change in public taste and consequently that there was no future in Italian opera, from the mid-1730s Handel had increasingly composed and performed English oratorio and theatre works, which included the setting to music of Dryden and Congreve (as well as Milton), the same English authors whom Hogarth had described as neglected literary geniuses in *The Bad Taste of the Town* (no.18). In 1740 Handel gave his first all-English season at Lincoln's Inn Fields. And the following year, when Hogarth's print was published, he gave his last London performance of Italian opera. In *The New Dunciad* of 1742 Pope specifically referred to Handel's new musical direction as a strident attempt to overthrow Italian opera.[20] This was the year when Handel's now famous oratorio *Messiah* was premiered. In this context Hogarth's print might be interpreted as celebrating the 'silencing' of a foreign musical tradition, as well as presenting a humorous confrontation between high culture and low life.

FIGURE 30
Marcellus Laroon/Lauron
(1653–1702)
*The merry Milk Maid* c.1688
GUILDHALL LIBRARY, CITY
OF LONDON

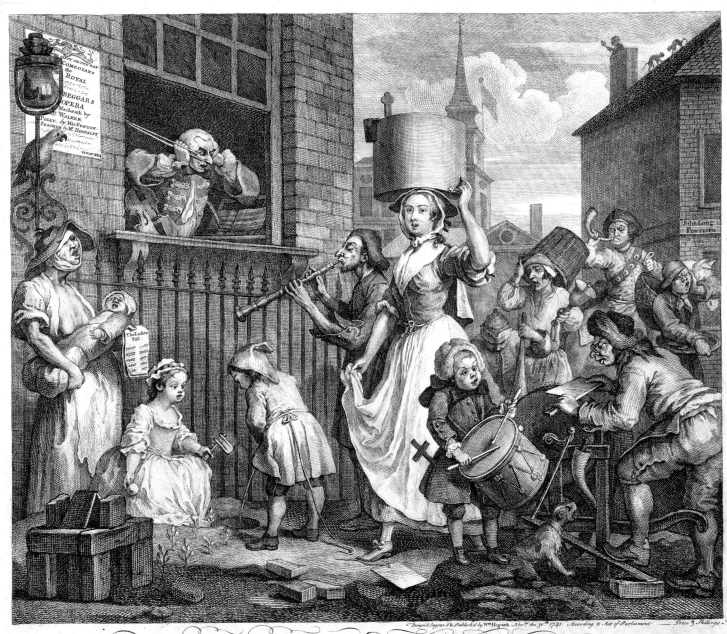

THE ENRAGED MUSICIAN.

72

# 6
# Marriage A-la-Mode
## *Christine Riding*

Hogarth's *Marriage A-la-Mode* tells the story of a disastrous marriage of convenience between a profligate aristocrat's son and the daughter of an aspirant bourgeois. The sole purpose of the union is the exchange of wealth for social status. Without mutual affection, respect or companionship, the newly married couple conduct their emotionally empty lives pursuing an expensive, modish lifestyle and seeking sexual gratification with others. The tragic-comic plot concludes in a sensational, if not deliberately melodramatic fashion, with a murder, an execution and a suicide.

The title was taken from John Dryden's *Marriage à la Mode*, first performed in 1672 (see no.73). 'A-la-mode' means that something is merely of the fashion and not enduring. Thus the 'marriage *à la mode*' is, by definition, a travesty of marriage itself. On one level, then, Hogarth's acerbic analysis of the values and motivations of London's *beau monde* forms part of the ongoing debate on marriage and sexual ethics that thrived from the late seventeenth century. This was largely in response to the perceived promiscuity and immorality of contemporary society and manifested itself in a wide range of printed material including conduct books (the eighteenth-century equivalent of etiquette or self-help books), moral treatises, novels and pictorial satires. In 1727, for example, Daniel Defoe published his provocatively titled *Conjugal Lewdness; or, Matrimonial Whoredom*. While the focus was impermissible behaviour (predominantly sexual) within marriage, Defoe's treatise – in tandem with numerous contemporary commentaries – set out arguments against various forms of 'unsuitable' marriages, such as marrying without love and respect or for material considerations, marriages between people of unequal ages or social status, or marriages to satisfy family. Hogarth deftly combined all these 'unsuitable' circumstances, bar the age factor, into the marriage between Lord Squanderfield and the alderman's daughter.

In keeping with the anti-luxury discourse of the early eighteenth century, Defoe also argued that the spread of sexual excess correlated with increased wealth and consumption, leading to disease and physical decay. 'Our Luxury', he noted, 'is encreased; and with our Luxury, our Vices, and other Extravagances, our Lasciviousness, Sensuality, and, in a Word, our Impudence, and with all these our Distempers.'[1] A similar correlation is made throughout *Marriage A-la-Mode*. The marriage itself is brokered in a luxurious high-society setting with the elderly aristocrat and his effete son portrayed as vain, self-indulgent and ailing with gout and venereal disease respectively. The effects of cultural, social and physical corruption are carried forward in the narrative primarily through Lord Squanderfield's increasingly enfeebled, contaminated, yet resplendently attired body, and finally to his sickly infant child. In this context the most shocking of all the episodes is Scene 3, when Squanderfield visits a surgery. He is seen protesting about the ineffectiveness of mercury pills (then touted as a cure for syphilis) prescribed by the quack doctor. Everyone in the room is infected with the disease, including a very young girl who appears to be the aristocrat's mistress. As previously underlined in *A Harlot's Progress* (no.43), prostitution and the spread of disease were perceived as synonymous in eighteenth-century society. While contemporary commentaries largely assigned blame to the female prostitute for trading her body for money (rather than her clients who voluntarily paid for the 'service'), such a responsibility could hardly be imposed on someone who is barely more than a child. Thus we are left to marvel at the perverse depths to which Squanderfield's self-gratification has sunk.

If the aristocrats in *Marriage A-la-Mode* are presented as hopeless dissolutes, the members of the middle classes do not fair any better. The thrifty alderman, dazzled by rank, sells his daughter into the Squanderfield family in the anticipation of her becoming a countess. The daughter is initially distraught at the prospect of this marriage but speedily abandons herself to the 'pleasures' of high life and follows her husband's lead in squandering money and conducting extramarital liaisons. Hogarth had previously satirised 'the aspirant bourgeois' who embarks on a dissipated life in *A Rake's Progress*, which also included a marriage of convenience (see no.44). But Hogarth's plot involving the marriage of a rakish aristocrat to someone lower-born would have had particular resonance in the wake of Samuel Richardson's *Pamela; or, Virtue Rewarded,* a literary phenomenon that was praised and vilified, pirated and parodied from the moment it first appeared in 1740. The interconnected themes of the novel are marriage, love, virtue and class identity, with the heroine, an educated lady's maid who resists the sexual advances of, and finally reforms and marries, her aristocratic master. Importantly,

*Marriage A-la-Mode*: 6
*The Lady's Death* 1743–5
(no.77, detail)

Richardson began writing *Pamela* as a conduct book. And his subsequent revisions to the novel included adapting Pamela's speech to resemble a more overtly 'middle-class' figure – in contrast to the character's low-born origins – thus making her marriage to a nobleman significantly less scandalous. It also reinforced the particular appeal of Pamela to a bourgeois audience, in that the character's industry, moral virtue and sexual restraint chimed with the self-identity of the middle classes who were consolidating their power and challenging the aristocracy's social and cultural pre-eminence. At the same time Pamela's innate 'nobility' is an attribute that the 'real-life' aristocrat, Mr B., blatantly fails to live up to, until, of course, his own character transforms for the better under Pamela's influence. Hence, after an unpromising start, their relationship develops into one of mutual affection, fidelity and companionship, i.e. the model marriage by contemporary middle-class standards.

That *Marriage A-la-Mode* was, in part, a jibe at Richardson's novel is underlined by the final scene entitled *The Lady's Death*. Here Hogarth parodies an illustration by the London-based French artist, Hubert-François Gravelot, from an edition of *Pamela* published in 1742, which shows the heroine turning to receive her baby from the family nurse (no.79). The loving mother/child vignette is reworked by Hogarth to show a distraught nurse proffering a sickly infant towards the distinctly un-maternal countess, who has just expired. This skit on another artist's work also reminds us that the satirical thrust of *Marriage A-la-Mode* was as much about patronage, aesthetics and taste as it was about marriage and morals. The series is, in fact, an unremitting attack on the absorption by the social elite of foreign and in particular French luxury goods, cultural values and lifestyle. Over and above the title itself, *Marriage A-la-Mode* includes Italian and Dutch Old Masters, French portraiture and furnishings, oriental decorative arts, an Italian castrato singer and a French dancing master, a turbaned black pageboy, a masquerade reference and a bagnio. Just as the parvenu Tom Rakewell had conducted a levée in *A Rake's Progress*, so the alderman's daughter adopts the aristocratic *toilette*. Both are rituals associated with the French court. And even syphilis, which Lord Squanderfield probably contracts abroad, was popularly known as 'the French pox'. Thus his emasculated and diseased body is

additionally emblematic of the spread of 'foreign' culture that has infected and weakened British identity, society and commerce. Hogarth's concerns were, in fact, widely held. The Anti-Gallican League, for example, was founded in the same year that the prints of *Marriage A-la-Mode* were published, with the explicit aim of extending 'the commerce of England', discouraging 'the introduction of French modes' and opposing 'the importation of French commodities'.[2] And high society's appropriation of French culture struck many as perverse, given that Franco-British political relations were often strained, if not openly hostile. In 1745 British forces were defeated by the French at the Battle of Fontenoy and immediately recalled to counter a French-backed Jacobite rebellion with an invading army marching southwards towards London (see no.73).

Hogarth's references to foreign culture were thus topical and multifaceted. The Italian Old Masters in Scenes 1 and 4, for example, signalled the British aristocracy's continuing predilection for such paintings by foreign artists, to the detriment of native talent. But they also drive the narrative forward and establish a visual correlation between the sophisticated programme of symbols, allusions and gestures employed in Hogarth's modern moral subjects and that in history painting, then appreciated as the most intellectually and artistically rigorous of all the painting genres. In this context it is worth noting Hogarth's concurrent ambitions as a history painter and, in particular, the episode in the mid-1730s when he prevented the appointment of the Italian artist Giacomo Amiconi at St Bartholomew's Hospital by offering his services free of charge (see p.125).

It must also be remembered that *Marriage A-la-Mode*, whether in painted or engraved form, was conceived and executed as a sophisticated, luxury commodity, equal, if not superior, to any of the *objets d'art* so meticulously represented within each scene. Hogarth claimed that he travelled to Paris in 1743 for the express purpose of finding the best engravers for his *Marriage A-la-Mode* paintings, the formal qualities and palette of which corresponded to, and sometimes deliberately evoked, French contemporary art and Rococo design, which originated in Paris. What Hogarth saw during his visit is not known. That French art informed the style and composition of *Marriage A-la-Mode*, however, is beyond doubt. The final scene, for example, includes a still life of a table

covered in white cloth and laid with food and utensils, which is reminiscent of the work of Jean-Baptiste-Siméon Chardin (1699–1779), in particular *The White Tablecloth* of 1731–2 (fig.32). But such 'quotations' do not simply demonstrate Hogarth's tremendous technical facility and familiarity with cutting-edge European art; they enrich the satirical content. In Jean-François de Troy's *The Declaration of Love* (no.76) the harmonious palette and skilfully rendered figures, costumes and furnishings are of an elevated artistic quality that corresponds (visually at least) with the 'people of quality' seated on the sofa. Leaning languorously on a silk cushion, the lady listens to her admirer's elegant protestations of love, the erotic subtext intimated by the mythological scene of seduction hanging behind their heads. In Scene 1 of *Marriage A-la-Mode* Squanderfield and his fiancée, seated on a sofa, are dressed in similar fashions to the aristocrats in de Troy's painting (note the identical black bow of his purse wig, knotted at the cravat, and her loosely fitted dress with sack-back and small lace cap trimmed with flowers). But instead of a scene of gallantry and courtship, they are turned from each other, the aristocrat besotted only by his reflection in the mirror, the parvenue inelegantly slumped forward, the misery on her face amplified by the image above of a screaming Medusa. Thus Hogarth at once emulates and subverts de Troy's art and at the same time underlines the richness of his own.

## 73

Gerard Vandergucht (1696–1776) after
Hubert-François Gravelot (1699–1773)
Frontispiece (and title page) to John
Dryden's *Marriage A-la-Mode* (1735;
first published in 1673)
Bound volume
THE BRITISH LIBRARY, LONDON

The relationship between Dryden's play
and Hogarth's series goes beyond the title.
The main protagonists of the comic plot
are Palamede (a Sicilian courtier) and
Melantha, who are to enter an arranged
marriage concocted by their respective
fathers. As Palamede explains to a friend,
'the articles are drawn, and I have given my
consent for fear of being disinherited; and
yet know not what kind of woman I am to
marry'.[3] The play itself was written during
the reign of Charles II, who after the English
Civil War (1642–9) had spent over a decade
in exile at the French court of Louis XIV,
along with many courtiers. When the Stuart
dynasty was restored in 1660 with Charles
as king, the court was markedly
Francophile, importing many French
customs and tastes into England. In the play
Melantha believes wholeheartedly in the
cultural supremacy of all things French,
which she demonstrates through her
mannerisms, her love of court culture and,
above all, her absurd adoption of French
words, which pepper her speech. On
meeting Palamede, she enquires, 'I suppose,
sir, you have made the tour of France; and,
having seen all that's fine there, will make
a considerable reformation in the rudeness
of our court: For let me die, but an
unfashioned, untravelled, mere Sicilian, is a
*bête* [beast]; and has nothing in the world of
an *honnête homme* [honourable man].'[4]

Finally the play was contemporary with
the Third Dutch War (1672–4), which was
conducted by Charles II in alliance with
France against William III of Orange and
Holland, a Protestant nation. In an ironic
turn of events, after the so-called 'Glorious
Revolution' of 1688 and the dethronement of
Charles's Catholic brother James II, it was
William of Orange who became king. These
facts and associations would have resonated
with Hogarth's audience. It was the
descendant of James II, James Edward
Stuart (the so-called Old Pretender), who
attempted with French assistance to regain
the throne during the first Jacobite
Rebellion of 1715. And during the War of the
Austrian Succession (1740–8) the British
army was defeated by French forces at the
Battle of Fontenoy in Belgium in 1745, after
which the soldiers were quickly redeployed

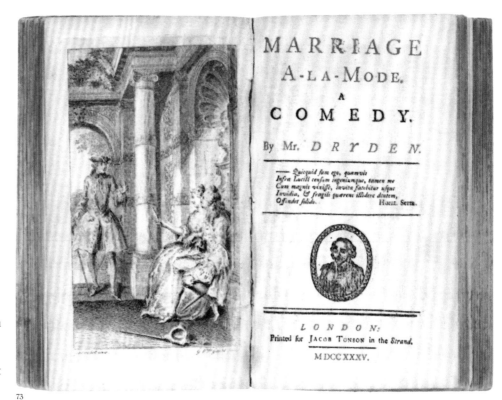

73

at home to deal with the second Jacobite
Rebellion.

Dryden's play was performed and the
text reprinted at various times during the
early decades of the eighteenth century.
This version includes an illustration by the
French artist Hubert-François Gravelot, a
pupil of Jean Restout and François Boucher
in Paris. He arrived in London in 1732, well
versed in French design and figure drawing.
As Jean André Rouquet noted in 1755,
Gravelot 'greatly contributed to diffuse a
taste of elegance among the English artists'
and his 'easy and fertile genius was a kind
of oracle, to which even the most eminent
occasionally applied'.[5] While the Rococo
style had already made its mark in England,
Gravelot introduced a sophistication and
delicacy to native art and design,
particularly in book illustration. And as
drawing master at the St Martin's Lane
Academy and through his own drawing
school off the Strand, Gravelot influenced
the next generation of artists, which
included the young Thomas Gainsborough
(see below for his illustrations to
Richardson's *Pamela*).

## 74

*Taste in High Life* c.1742
Oil on canvas
63 × 75
PRIVATE COLLECTION

## 75

Gerard Vandergucht (1696–1776) after
John Wootton (1682–1764))
*The Monkey Who had Seen the World*
Illustration in John Gay's *Fables* 1727
Bound volume
THE BRITISH LIBRARY, LONDON

A number of key themes in *Marriage A-la-Mode* had been explored by Hogarth in previous works, the earliest being *The Bad Taste of the Town ('Masquerades and Operas')* in 1724 (no.18), which focused on elite patronage of Italian arts and culture. Both *A Harlot's Progress* and *A Rake's Progress* (nos.43, 44) satirised those who aspired to higher social position or the appearance of it. This is particularly true of the second scene of each, where Moll Hackabout, her Jewish keeper and Tom Rakewell assume an upper-class lifestyle, to which none of them was born. *Taste in High Life* concentrates specifically on the folly and superficiality of aristocratic taste with an emphasis on foreign influences. Two effete 'connoisseurs', dressed in exaggerated French fashions, are in raptures over a tiny and thus seemingly insignificant cup and saucer. Meanwhile, a richly dressed lady examines another 'luxury item', a black pageboy in a turban. He holds a tiny porcelain 'pagod' figure (seated Chinese deity). Both represent the contemporary vogue for 'exotic' Turkish and Chinese imports. The pageboy, as a servant, acts as a satire on his 'masters', who are themselves 'slaves' to fashion and fripperies. But he also embodies the perceived eroticism of 'the Orient', in particular the Turkish harem, which for Europeans was the embodiment of sexual excess and fantasy. Significantly, a similar pageboy figure appears in Plate 2 of *A Harlot's Progress* and Scene 4 of *Marriage A-la-Mode*, which involve, respectively, a kept mistress and an adulterous wife.

The paintings hanging in the background feature pointless and absurd subjects including (on the left) a dance mannequin stiffly posed, thus lacking expression and individuality, and (on the right) a peculiar composition of wigs, shoes, stays and other fashion accessories. These works act as a thematic frame to the central painting, which features classical/ideal subjects and contemporary fashion. The scene suggests that natural or ideal beauty,

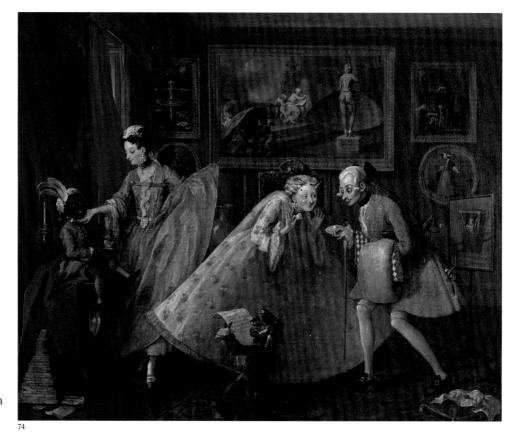

74

as represented by the nude female sculpture on the right, is disguised or made a mockery of by voguish clothing with which it has been inappropriately 'dressed'.

The inclusion of a monkey in the foreground is meant to signify mimicry (i.e. 'aping'). In contrast to Plate 2 of *A Harlot's Progress*, where a monkey was depicted as a real-life pet, here the representation – with the animal dressed as a gentleman peering intently at a list of exotic dishes – conforms more closely to seventeenth- and eighteenth-century *singerie* subjects by, for example, David Teniers the Younger and Antoine Watteau. It thus functions as an overt parody of human behaviour. Hogarth's representation of Lord Squanderfield in Scene 1 of *Marriage A-la-Mode* relates directly to such simian figures, as underlined by John

75

Wootton's illustration (no.75) to *The Monkey Who had Seen the World* (Fable XIV) from John Gay's popular *Fables* (first volume published in 1727). The fable describes how a monkey 'to reform the times, | Resolved to visit foreign climes'. Having adopted courtly manners and fashions, he returns to his native wood (as shown in the illustration) and becomes an object of envy and emulation among the other monkeys ('The hairy sylvans round him press, | Astonished at his strut and dress').[6] In Scene 1 of *Marriage A-la-Mode* Lord Squanderfield has just returned from 'foreign climes', aping the latest French fashions. Importantly, the monkey was also an ancient symbol of luxury and vanity and was sometimes depicted looking into a mirror, lost in self-love. So, too, is Lord Squanderfield.

# 76

Jean-François de Troy (1679–1752)
*The Declaration of Love* 1724
Oil on canvas
64.8 × 54.6
WILLIAMS COLLEGE MUSEUM OF ART,
WILLIAMSTOWN, MASSACHUSETTS.
GIFT OF C.A. WIMPFHEIMER, CLASS OF 1945

Jean-François de Troy was a Paris-born artist of historical, mythological and modern high-life subjects (*tableaux de mode*). Painted during the 1720s and 1730s, de Troy's *tableaux de mode* were greatly admired in the French art world and sought after by wealthy European collectors. Many were subsequently engraved. Their particular appeal for the ruling elite can be gleaned from a 1724 review in the Paris journal *Mercure de France* that described *The Declaration of Love* as 'a work that brings much honour to [de Troy's] brush, thanks to the harmony, the gallant taste, and the truthfulness with which it is composed'.[7] The highly detailed settings and costumes suggest a more accurate representation of the *beau monde* at leisure than the poetical and ambiguous *fêtes galantes* of Antoine Watteau, with which Hogarth was most likely familiar through engravings. For example, de Troy rarely missed the opportunity to present his male protagonists in red-heeled shoes (*les talons rouges*), an honour conferred only on the highest-ranking members of the French nobility who had been presented at court (note that both the male connoisseur in *Taste in High Life*, no.74, and Lord Squanderfield in *Marriage A-la-Mode*, no.77, are wearing such shoes). Even so, these carefully choreographed and highly selective scenes also idealised existing notions of aristocratic sociability and culture, thus offering a powerful affirmation of class identity.

A number of de Troy's paintings were 'gallant' subjects involving amorous suitors and lovers, for example, meeting in secrecy (*The Rendezvous at the Fountain* c.1727), flirtatiously playing children's games (*The Game of Pied-de-Boeuf* 1725) or engaging in the explicitly adult and sexually loaded world of the masquerade (*Before the Ball* 1735, and *After the Ball* 1737). The frissons afforded by these social occasions were, however, subtly dramatised and reliant on a telling look or rhetorical gesture and occasionally incorporated the signs and symbols suggesting burgeoning desire that were utilised in *fête galante* paintings, such as the restless dog jumping up in the foreground of *The Declaration of Love*. While the setting of the present painting is characteristic of fashionable Rococo interiors and the style's epicurean bias, certain details also assist in the narrative. The shell, for example, is a stock-in-trade Rococo motif and a symbol of Venus, goddess of love. The sofa (from the Arabic 'suffah') was a form of seat furniture that allowed couples to sit together and was of oriental inspiration. The exoticism of the East is also present in the voluptuous cushion that the lady leans on, made of Islamic-patterned silk. The theme continues with the seduction scene above the couple's heads, involving a shepherd and shepherdess. Such pastoral subjects relate to the outdoor *fêtes galantes* and also classical mythology and epic poetry. Thus parallels are flatteringly drawn between the aristocratic lovers and the inhabitants of an Arcadian idyll. The 'picture within a picture' also neatly underlines the elevated artistic and narrative ambitions of de Troy's *tableaux de mode*, which derive from his experience as a history painter. A similar ambition – with an additional satirical agenda but with a comparable market to de Troy's in mind – can be observed in Hogarth's earlier series *A Harlot's Progress* (no.43) and *A Rake's Progress* (no.44) and is brought to a high point of sophistication in *Marriage A-la-Mode*.

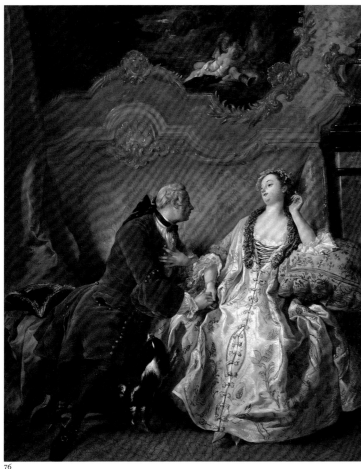

76

# 77

*Marriage A-la-Mode* 1743–5
Six scenes
Oil on canvas
Each approx. 70 × 90.8
THE NATIONAL GALLERY, LONDON

# 78

Bernard Baron (1696–1762), Simon François
Ravenet (1706–1774) and Gérard Jean-
Baptiste Scotin (1698–after 1755), with
William Hogarth
*Marriage A-la-Mode* 1 April 1745
Six prints
Etching and engraving
Each approx 38.5 × 46.5
ANDREW EDMUNDS, LONDON

In the spring of 1743 Hogarth advertised the
publication by subscription of six prints for
his forthcoming series 'representing a
Variety of *Modern Occurences in High-Life*,
and call'd 'MARRIAGE À-LA-MODE'. These, the
advert stated, would be 'engrav'd by the best
Masters in Paris, after his own Paintings

(the Heads for the better Preservation of the
Characters and Expressions to be done by
the Author).'[8] In the event Hogarth did not
engage 'Masters in Paris', which he later
claimed was frustrated by France and
Britain's deteriorating political relationship.
Instead he employed three Frenchmen
already established in London, Bernard
Baron, Gérard Jean-Baptiste Scotin and
Simon François Ravenet, who executed
two scenes each. Baron had worked with
Hogarth on *The Four Times of Day* (no.67)
and owned a lucrative business importing
and selling European prints. And Scotin is
thought to have assisted him on *A Rake's
Progress*.

The titles given for each scene are those
cited in Hogarth's printed *Proposals*, dated
25 January 1743.

Scene 1: *The Marriage Settlement*
This scene shows the conclusion of
negotiations between the Earl of Squander
(seated on the right) and the alderman

(seated in the centre). Each has their
reasons for arranging a marriage between
the earl's son, Lord Squanderfield (seated
on the far left), and the alderman's daughter
(seated beside him). The alderman, a rich
merchant, desires a higher social position
for his family and thus is buying his way
into the aristocracy. The aristocrat needs
money to fund his overly extravagant
lifestyle. That the earl is living beyond his
means is underlined by the view from the
window of a grandiose Palladian house
under construction. Work has stopped
because of lack of funds. The completion
of this house appears to be part of the deal
(note the mortgage papers held by the
steward). It is but one indication of the
earl's life of excess, which includes his
collection of 'Old Masters', his gold-
trimmed court dress and gout-ridden body.
The alderman clearly believes the pompous
bluster of the earl, who, despite the
discomfort of his bandaged foot, attempts
an elegant, gentlemanly pose and points at

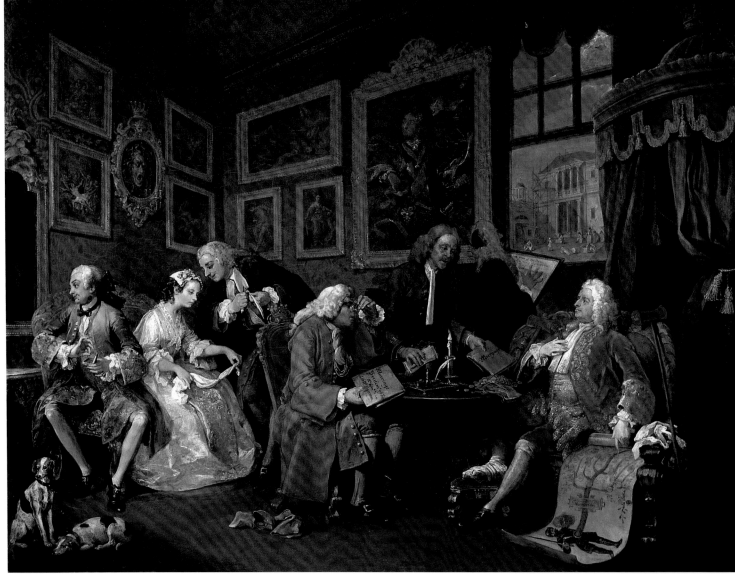

77 PLATE 1

a family tree that purports to stretch back to the medieval period. However, the ostentatious display of gilded coronets on the bedroom furnishings suggests the self-consciousness of a social upstart. In contrast, absorbed by the details of the marriage contract, the alderman sits inelegantly with his sword point poking out between his legs. Although he is dressed in practical clothing, emphasising his wily attitude towards money, his vanity and interest in social position are underlined by his inappropriate wearing of the chain of civic office, visible below his neckerchief.

Meanwhile, their children sit to the left displaying either supreme indifference or misery at the proceedings. Lord Squanderfield stares into a mirror, his eyes glazed in admiration of his own reflection. He is dressed in the latest Paris fashions, signifying his recent return from the continent as well as his extravagant nature. His red-heeled shoes suggest that he has been presented at the French court. As only

the highest-ranking members of the French nobility were eligible for this honour (and thus to wear such distinctive shoes), Hogarth is alerting a knowing audience to the fact that the young aristocrat's show of superiority is as fake as the family tree. That he has returned with more than an exaggerated sense of self-worth and a modish wardrobe is indicated by the black spot on his neck, Hogarth's symbol for syphilis. Meanwhile, the alderman's daughter is inconsolable and toys with her wedding ring threaded through a handkerchief. She is being comforted by the lawyer Silvertongue, who, as his name suggests, is probably highlighting the social advantages of the marriage. His flushed face and sexually suggestive action of 'sharpening his quill' indicate that he either anticipates the beginning or continuation of a love affair with her. However, while she will undoubtedly have a degree of sexual freedom in her new life, given her future husband's lack of interest, the fact that the

couple will be bound together in an ill-matched, loveless marriage is made clear by the chained dogs situated nearby.

Scene 2: *The Tête à Tête*
The scene is set in a Palladian house in the West End of London, most likely the one under construction in Scene 1. That the couple are leading separate lives is neatly underlined by the table laid with tea for one. The clock on the wall, far right, shows that it is past midday. The viscount has just returned from a night on the town. In stark contrast to the studied elegance of his pose in Scene 1, he is slumped in a chair, bored and exhausted. A dog sniffs at the woman's cap in his pocket and his sword lies broken on the floor, a ribbon tied to the hilt. His wife has also been up all night (as indicated by the yawning servant to her left), ostensibly playing cards (note the gaming tables in the adjoining room). However, her sly look and satisfied stretch suggest that she, too, has had a sexual dalliance and, unlike her

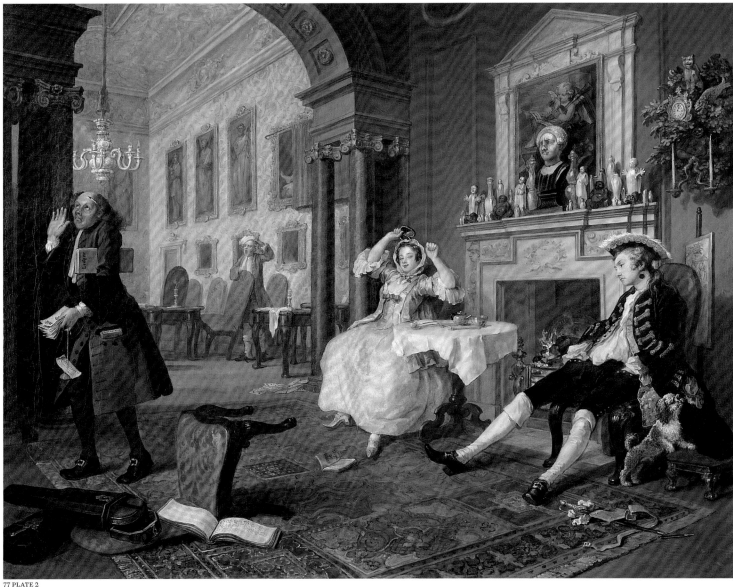

77 PLATE 2

apathetic husband, is for the moment enjoying the novelty of life as a fashionable lady of leisure. She appears to be signalling to someone out of view with a pocket mirror. This and the upturned chair indicate that her lover (the music master or Silvertongue?) had to exit quickly, perhaps disturbed during lovemaking (as the violin case on top of another suggests) by the arrival of the husband. The painting of a bedroom scene hanging nearby, all but covered by a green curtain, adds to the theme of sexual intrigue, just as the painting above the fireplace showing cupid playing a musette (small bagpipe) with an open musical score (mirroring the one discarded on the floor) denotes sensual pleasure.

That the couple have inherited the gaudy extravagance and lack of discernment of the earl is clear from the cluttered mantelpiece. Here are crammed fashionable chinoiserie figures, jars, snuff bottles and a frowning antique bust – with a broken nose. The comical clock-cum-wall-light sports an absurd array of foliage, fish, a cat and a smiling Buddha, which can be read as a critique of the more fantastical, bordering on grotesque, aspects of the Rococo style and its novelty-seeking devotees. Buying job lots of 'collectables' is repeated in *The Toilette* (Scene 4). Unlike the penny-pinching alderman, neither the viscount nor his wife displays any financial acumen or interest. This is evidenced by the pile of unpaid bills held by the steward, who, despairing, raises his eyes to heaven. A Methodist sermon entitled *Regeneration* can be seen in his pocket. The household is presented as one of unmitigated extremes and thus imbalance: excess and indulgence on one side, abstinence and self-righteousness on the other.

Scene 3: *The Inspection*
This scene takes place in a surgery. Lord Squanderfield leans towards the doctor holding a pillbox in one hand and brandishing a cane with the other, thus displaying all the bluff and bluster shown by his father in Scene 1. Clearly he has visited there before, seeking a cure for syphilis. However, the mercury pills he was prescribed are not working and he is making a half-hearted demand for compensation. The doctor seems unconcerned, polishing his glasses with a soiled handkerchief, while the angry woman turns on the viscount, opening a pocket knife. Neither she nor the doctor inspires much confidence: both have syphilis (by the sunken bridge of his nose, thick lips and bowed legs, his is at an advanced stage) and she is most likely a convicted prostitute. The skull on the table (to the left) has black holes in the forehead resulting from syphilis, and thus portends the fate of everyone in the room including, it would seem, the young girl on the right who dabs a sore on her mouth, an early

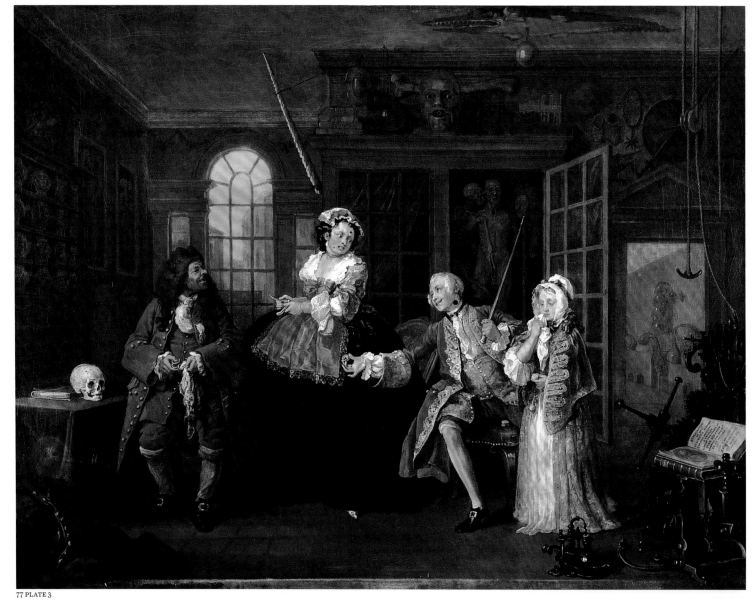

FIGURE 31
Nicolas Lancret (1690–1743)
*Morning (The Four Times
of the Day)* 1739
THE NATIONAL GALLERY,
LONDON

symptom. Given the close proximity between the girl and the viscount and the fact that he is seated while she stands, we can assume that she is a low-born prostitute currently in his pay. Her overskirt and the older woman's sleeve are made from the same fabric. It is therefore probable that they are connected, perhaps procuress and prostitute and/or mother and daughter. Thus the woman's anger and the child's action may, in fact, be a well-rehearsed ruse to lay blame on the viscount for transmitting the disease and to extort money from him.

Scene 4: *The Toilette*
Like other members of London's fashionable elite, the alderman's daughter has adopted the *toilette*, an urban custom established by the French court of receiving visitors in the bedroom or boudoir while the aristocrat dressed. It was used as a subject in French art, habitually showing a lady

dressing, such as in Nicolas Lancret's *Morning* 1739 (fig.31), which Hogarth may have known through an engraving of 1741.

The display of coronets on the bed and dressing mirror in *The Toilette* suggest that the old earl has died and the alderman's daughter has been elevated to the position of countess. Like the newly rich Tom Rakewell, she is surrounded by hangers-on (see Scene 2 of *A Rake's Progress*, no.44). These include an Italian castrato singing, accompanied by a flautist, an effeminate French dancing master sipping chocolate and a gentlewoman swooning in exaggerated rapture over the music, the absurdity of which is amplified by the servant's amused expression as he offers her a drink. Meanwhile, a French hairdresser is curling the countess's hair (note she is wearing a white powdering mantle to protect her sumptuous silk dress). She leans on the back of her chair, from which hangs a rope of coral, used by

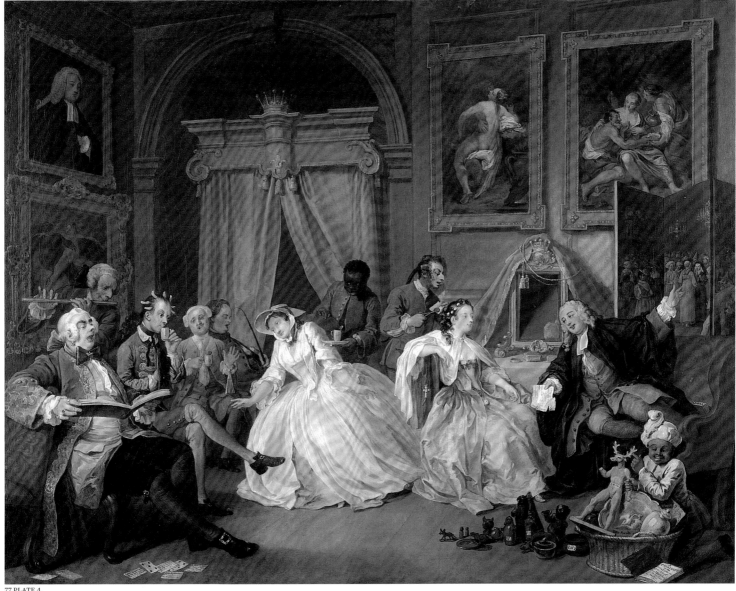

teething children. Her child, however, is nowhere to be seen, suggesting a lack of maternal interest on the part of the countess. The lawyer Silvertongue has reappeared, lounging on a sofa. Clearly at ease in the countess's bedroom, he holds a ticket in one hand and points to a screen showing a masquerade ball with the other. The Old Master paintings above their heads, showing mythological and biblical seduction scenes (Correggio's *Jupiter and Io* and *Lot and his Daughters*), and similarly the tray in the basket (right foreground), showing Leda and the Swan, underscore the fact that the countess and Silvertongue are having an affair. Indeed, his portrait is prominently displayed on the far left. The exotically dressed child-servant has pulled out a figure of Actaeon from the basket and points at the horns, a reference to the new earl as a cuckolded husband. In classical mythology Actaeon surprises Diana, the goddess of hunting, while she bathes in

secret. His punishment is to be transformed into a stag and killed by Diana's pack of dogs. Hogarth's allusion to this myth presages the next scene of *Marriage A-la-Mode* set in a bagnio (originally meaning a public bathhouse in Italy or Turkey), where the earl discovers the adulterous couple in bed and dies following a sword fight with Silvertongue.

Secrecy, disguise and seduction are the themes of *The Toilette*. The ritual itself was imbued with sexual connotations in French art and literature, as, for example, in François Boucher's *Lady Fastening her Garter (La Toilette)* 1742 (fig.33, p.155), or in the novels of Crébillon *fils* and Prévost's *Manon Lescaut* (1731), in which the *toilette* was established as a principle literary motif. Silvertongue arranges an assignation with the countess at a masked ball, where disguise aided and abetted illicit encounters. On the cushion beside Silvertongue is an edition of the erotic novel

*Le Sopha* (The Sofa) by Crébillon *fils*, first published in Paris in 1742 and available in English the same year. The story is set in the Orient, thus underlining both the vogue for licentious French literature and the exotic frisson of the East as represented by the Orient-inspired sofa and the turbaned black servant. Interestingly, the plot of *Le Sopha* revolves around a man who by magic has been turned into a piece of furniture. Thus concealed, he voyeuristically observes the unwary 'Arabian' women and their gallants and even provides a stage for their lovemaking.

Scene 5: *The Bagnio*
In England the original meaning for a bagnio was a coffee house that provided Turkish baths. By the time that Hogarth painted *Marriage A-la-Mode*, the word had additional significance as a place where rooms could be hired without questions and where prostitutes could be made available.

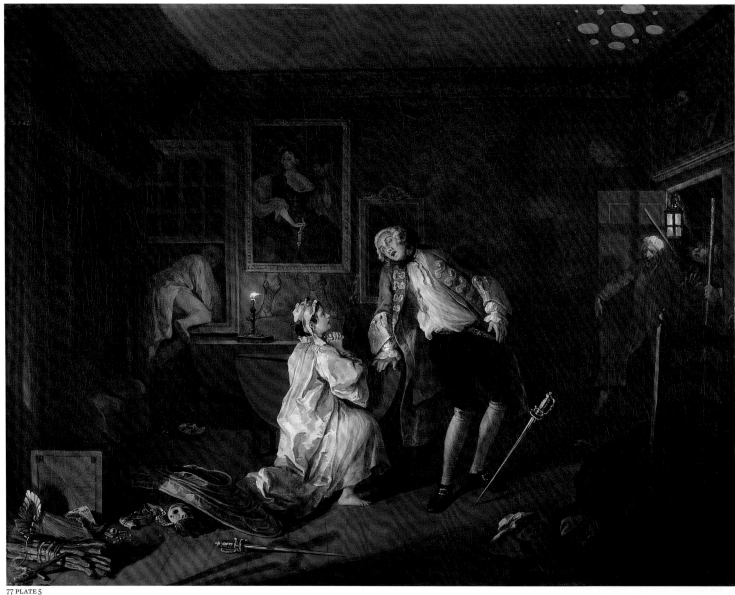

77 PLATE 5

FIGURE 32
Jean-Baptiste-Siméon
Chardin (1699–1779)
*The White Tablecloth*
1731–2
THE ART INSTITUTE OF
CHICAGO

Having left the masquerade, the countess
and Silvertongue continue their assignation
in such an establishment, their costumes
discarded on the furniture and floor in the
heat of passion (note the red-hot stick in the
left foreground). The rumpled bedclothes
suggest that the couple have been caught
'in the act' by the earl. It is possible that he,
too, was hiring a room down the corridor
and was tipped off. Given his complete
indifference to his wife from the beginning,
it seems out of character that he should now
act the jealous husband. A more believable
explanation would be that he is seeking
satisfaction for the perceived slur on his
aristocratic name. This is in keeping with
the behaviour of his pompous father in
Scene 1.

A sword fight between the earl and
Silvertongue has ensued. Here the earl is
seen in a death swoon, a wound to his chest.
Meanwhile, Silvertongue attempts to escape
through the window, his bloody sword lying

in the foreground. This 'pierces' the shadow
of a pair of fire-irons, aping the crumpling
legs of the earl and signalling that syphilis
has already ravaged his body. Unlike the
mercury pills, Silvertongue has put the earl
out of his misery. The countess, seemingly
overcome with remorse, shock or fear,
kneels before her dying husband, perhaps
begging his forgiveness. Her tears suggest
that this is a genuine show of emotion,
although she may (as in Scene 2) be
diverting attention from her fleeing lover.
As a whole, this action-packed scene
resembles the denouement of a theatrical
performance. Indeed, the penitent, pleading
or conniving female kneeling before her
father or husband was common in dramas
at this time. The figure of the countess
recalls Hogarth's *Beggar's Opera* series,
when Lucy Lockit and Polly Peachum kneel
before their respective fathers (see
nos.38–9). And Joseph Highmore included
such a scene in his illustrations to Samuel

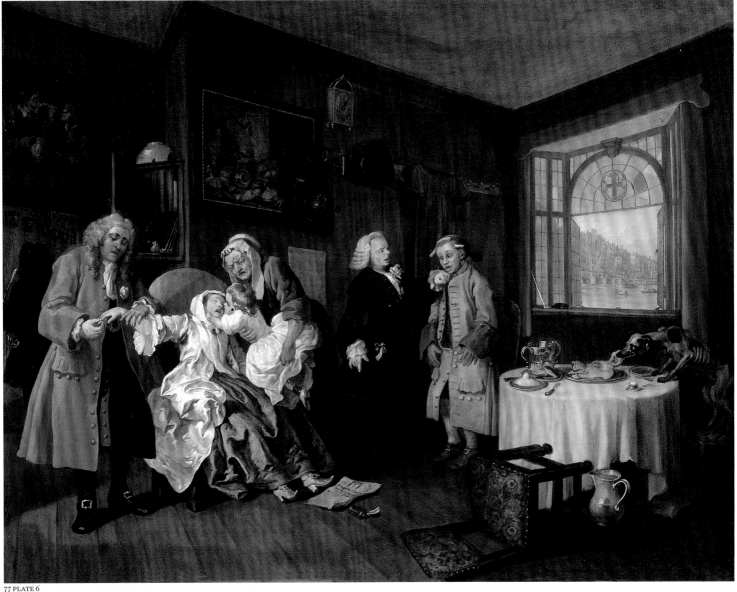

77 PLATE 6

Richardson's *Pamela*, when the eponymous heroine persuades her father-in-law to give his blessing to hers and Mr B.'s marriage (see below).

People are entering the room on the right. They include a nightwatchman whose lantern casts the shadow of a cross on the door, intimating the arrival of death, and seemingly throws light onto the ceiling in the form of spots. This deliberate detail may allude to the black spots symbolic of disease and death throughout the series. Here their presence seems to accentuate the darkness of the room, as if the occupants were all tainted or doomed. As we shall see, the earl's death is quickly followed by that of Silvertongue and the countess.

Scene 6: *The Lady's Death*
The last scene of *Marriage A-La-Mode* takes place in the home of the countess's father, the alderman, situated in the City near the Thames (old London Bridge can be seen through the window). In contrast to the aristocratic extravagance of Scene 1, we find a house of bourgeois miserliness. The interior is plain and old-fashioned with a bare floor. The coarseness and lack of modish savoir-faire demonstrated by the alderman in Scene 1 is here underlined by the display of Dutch 'merry company' paintings. One shows a man urinating against a wall. This contrasts with the cosmopolitan pretentiousness of the old earl's Italianate taste, slavishly copied by his son and the young countess. Whereas the culinary excess of the old earl was signified by his gout-ridden body, the meal on the table here comprises a boiled egg on a mound of rice. Thus we might begin to understand why his daughter embraced so wholeheartedly the life of aristocratic indulgence, after such a joyless upbringing.

The countess has returned home in disgrace. She is dying from an overdose of laudanum after reading of the execution of her lover Silvertongue for the murder of her husband. The broadsheet near the laudanum bottle at her feet records the lawyer's 'last dying Speech' and includes an image of the distinctive tripod structure of the Tyburn gallows (see p.182). As she passes away in her chair, the grieving nurse holds the countess's child towards her for a last embrace. Unfortunately, the child displays signs of disease including the telltale black spot and legs strapped in callipers. It will not live long. While the old nurse shows pity for mother and child, the avaricious merchant thinks only of saving what he can from this disastrous

'investment', as he would see it, and pulls the gold ring from his daughter's hand. This vignette seems calculated to evoke sympathy for the countess, who after all was forced into a loveless marriage, and even more for her blameless and unloved offspring. However, Hogarth juxtaposes the tragedy with a moment of pure comedy; the apothecary upbraiding the dim-witted servant to the right. Recalling an earlier scene in the doctor's consulting room, this may be an attempt by the apothecary to deflect responsibility for the overdose towards the hapless idiot. After all, a person who cannot even button up his coat successfully is unlikely to be competent in administering drugs.

Hogarth's final comment on the whole sorry tale is encapsulated by a detail on the far right. The starving dog pulling at the head of a pig on the table is, on one level, another indication of the alderman's parsimony. However, it may also allude to the sixteenth-century proverb 'You cannot make a silk purse out of a sow's ear': that is, you cannot make a thing of quality out of inferior materials. It thus neatly underlines that the ambitions of the alderman and the old earl were doomed from the start.

Hubert-François Gravelot (1699–1773)
Illustration in Samuel Richardson (1689–1761), *Pamela; or, Virtue Rewarded*, (1742)
Bound volume
THE BRITISH LIBRARY, LONDON

In 1742 Samuel Richardson published a deluxe version combining *Pamela* and its sequel *Pamela, Part II* (first published in 1741) with twenty-nine illustrations after Gravelot and Francis Hayman. The moralising sequel presented Pamela as the perfect wife and an adoring mother. Indeed, in *The Lady's Death* (last scene of *Marriage A-la-Mode*, no.77) Hogarth parodied the illustration by Gravelot shown here, which shows Pamela turning from writing a letter to her husband to receive her baby ('Just now, dear Sir, your Billy is brought into my Presence, all smiling'[10]). Richardson had been provoked into writing the sequel because of the furore surrounding the original novel and the various spin-offs that it inspired. These included John Kelly's *Pamela's Conduct in High Life* (1741), in which the heroine is revealed as having noble blood. Most famous, of course, were Henry Fielding's satirical responses, *An Apology for the Life of Mrs Shamela Andrews* (1741), where Squire Booby is tricked into marriage by Pamela, a lascivious, scheming social climber, and *Joseph Andrews* (1742), which begins as a Pamela spoof (see p.33).

79

# 80–1

Two sketches from 'The Happy Marriage'

80
*The Staymaker (The Happy Marriage:*
*The Fitting of the Ball Gown)* c.1745
Oil on canvas, 69.9 × 90.8
TATE. PURCHASED WITH ASSISTANCE FROM
THE NATIONAL ART COLLECTIONS FUND
1942

81
*The Dance (The Happy Marriage:*
*The Country Dance)* c.1745
Oil on canvas, 67.7 × 89.2
TATE. PURCHASED WITH ASSISTANCE FROM
THE NATIONAL HERITAGE MEMORIAL FUND
1983

80

81

These two oil sketches are generally accepted as part of a group of preparatory works for 'The Happy Marriage' series, which Hogarth seems to have planned as a sequel or pendant to *Marriage A-la-Mode* (no.77). In the event Hogarth did not produce another painted series until the *Election* canvases of the 1750s (nos.120–3). As evidenced by these surviving sketches, 'The Happy Marriage' would have been set in the country with the down-to-earth virtues of the rural community played off against the affectation and shallowness of London high society. Although the proposed narrative of 'The Happy Marriage' is not known, the so-called *Staymaker* would have acted as a revealing contrast, for example, to *The Toilette*. Whereas the countess dressed in her bedroom, surrounded by hangers-on and her lover, here the young squire's wife is being fitted for a dress surrounded by a loving family and devoted servant. The setting appears to be the nursery (note the children's clothes hanging in front of the fire). In *Marriage A-la-Mode* the neglected and sickly child of the countess and the young earl only appears in the last scene, thrust by a grieving nurse towards its dying mother. Here the nurse and husband, seated on the right in a blue dressing gown and cap, are doting over the baby on the settee. Meanwhile, a child pours milk into the tricorn hat for the cats (on the right) and the eldest boy marches like a soldier (centre). These details and the location within which they occur serve to underline the sincere affection and unpretentiousness of the couple's home life, contrasting with the affectation and joyless vacuity of the Squanderfields.

In this context the sketch known as *The Dance* stands as a stark contrast to the licentiousness of the masquerade, alluded to in *The Toilette* and *The Bagnio*. The scene is set at night-time in the hall of a Jacobean country mansion. The composition would clearly have made a hearty and joyous conclusion to the series, emphasising the wider significance of a respectable, well-matched couple within their community, in opposition to the futility and destructive repercussions of the marriage *à la mode*. Why Hogarth abandoned the series is not known. Certainly the focus on virtue and its rewards, as opposed to folly, was rare in his satirical work, the successful career of the industrious apprentice in *Industry and Idleness* being a unique example (see no.97). However, *The Dance* composition, described by Hogarth as 'a Country Dance', was developed further as the second plate of his *Analysis of Beauty*, published in 1753 (no.6). In the *Analysis* plate the dance is dominated by the elegant figures of a young couple, who are comparable to the husband and wife dancing on the far right of 'The Happy Marriage'. That Hogarth was formulating his theoretical ideas at the time of *Marriage A-la-Mode* and 'The Happy Marriage' is underlined by his *The Painter and his Pug* 1745 (no.4), which famously includes the serpentine line of beauty displayed on the artist's palette. In his advertisement of 1753 Hogarth informed the public that he had sought to make the *Analysis* 'useful and interesting to the Curious and Polite of both Sexes, by laying down the Principles of Personal Beauty and Deportment' and 'of Taste in general'.[9] Deportment and taste are fundamental to the satirical agenda of *Marriage A-la-Mode*. The sketch entitled *The Dance* thus forms part of Hogarth's theories on social and moral harmony as inseparable from aesthetics.

# 82

Joseph Highmore (1692–1780)
Two scenes from Samuel Richardson's
*Pamela*
*VII Pamela in the Bedroom with Mrs Jewkes
and Mr B.* 1743–4
62.7 × 75.7
*XI Pamela Asks Sir Jacob Swinford's Blessing*
1743–4
63.2 × 75
Oil on canvas
TATE. PURCHASED 1921

The complete series of paintings comprises twelve scenes from Richardson's *Pamela*. The heroine is the virtuous and educated lady's maid, Pamela Andrews, whose mistress on her deathbed confides her to the care of her son, 'Mr B.' He abuses his position of authority and attempts to seduce Pamela on numerous occasions. Her honourable nature and spirited defence of her virginity, however, affect a reformation in his character and he marries her instead. The subsequent story deals with Pamela charming Mr B.'s relatives, who initially consider her too low-born to be worthy of him. They eventually admire her for the innate nobility of her character and she is accepted into the family.

The *Pamela* paintings were on exhibition in Highmore's studio at the same time as Hogarth's *Marriage A-la-Mode* series. And Highmore's paintings were also engraved by French artists (Antoine Benoist and Louis Truchy) and published in July 1745. As works exactly contemporary to *Marriage A-la-Mode*, they would have presented a visual counterpoise to Hogarth's series in the minds of their audiences. In fact, Highmore's *Pamela* compositions resemble closely Gravelot's graceful illustrations (see no.79). Highmore was extremely well versed in French contemporary art and visited the studios of leading practitioners in Paris during 1734. Each scene is marked by an elegant, attenuated style, which borders on the balletic, and by a dramatic bias towards the sentimental. And, unlike the profusion of significant detail in *Marriage A-la-Mode*, there are few visual distractions from the central action. Thus each scene can be appreciated almost at a glance, unlike Hogarth's more demanding narratives. This strategy clearly results from the audience's prior knowledge of Richardson's novel, whereas *Marriage A-la-Mode* was Hogarth's own invention. The fact that the main protagonists in *Pamela* are eventually happily married may have persuaded Hogarth to abandon his own 'Happy Marriage' project.

A number of Highmore's *Pamela* compositions echo the decorous poses and mannerisms associated with the conversation pieces for which he was known. Scene 11 entitled *Pamela Asks Sir Jacob Swinford's Blessing*, however, is strongly reminiscent of a theatrical performance (see Scene 5 of *Marriage A-la-Mode*). The figure of Pamela may take its cue from Hogarth's earlier *Beggar's Opera* (nos.38–9) series, which show Polly Peachum and Lucy Lockit kneeling before their respective fathers. Indeed, Highmore seems to have adapted the figure of Polly Peachum for Pamela in the present scene and the figure of Lucy Lockit in the eighth scene, entitled *Pamela Greets her Father*. That Highmore drew inspiration from Hogarth is underlined by the seventh scene entitled *Pamela in the Bedroom with Mrs Jewkes and Mr B.*, which is a 'polite' adaptation of Scene 3 of *A Harlot's Progress* (no.43). Appropriately, the moment depicted is sexually charged and forms part of an attempt by Mr B. to seduce Pamela, assisted by his conniving housekeeper Mrs Tewkes who sleeps in the same bed as her. Mr B. sits to the left disguised as a female servant, watching Pamela undress. Oblivious to his presence she ingenuously unties her garter, turning towards Mrs Tewkes. The viewpoint, position of the bed and the seated Pamela correspond to the scene showing Moll Hackabout in *A Harlot's Progress*. Pamela's alluring state of undress, with a low décolleté exposing her shoulder and the curve of her breasts, also mimics that of the prostitute and was clearly calculated to appeal to male viewers or deliberately recall Hogarth's earlier image. Whereas Moll acknowledged the presence of the viewer with her sleepy, sideward gaze, thus underlining her immodesty and sexual availability, this scene casts the spectator as a voyeur, who, like Mr B., surreptitiously gazes on Pamela's evident attractions, while she, a modest and virtuous girl, looks in another direction. In this context Highmore's composition shows striking parallels with erotic scenes of women dressing and undressing by French contemporary artists, in particular François Boucher's *Lady Fastening her Garter (La Toilette)* painted in 1742 (fig.33).

82 XI

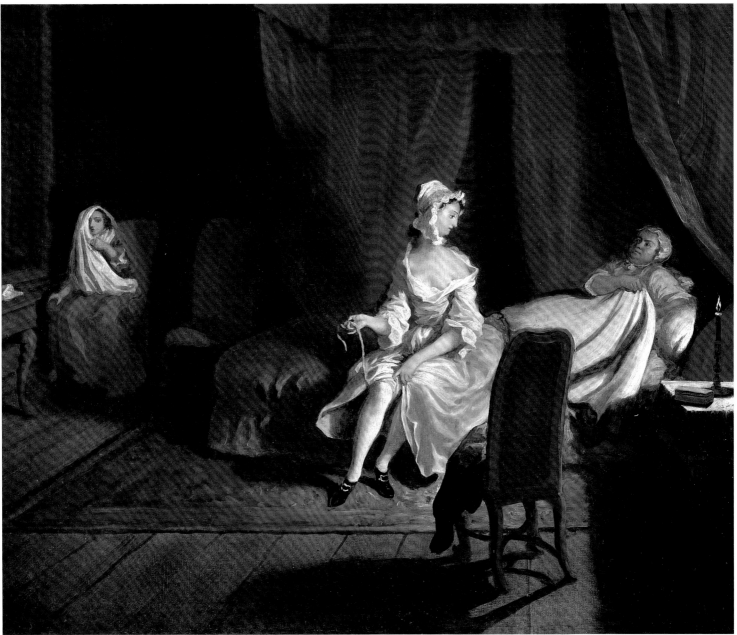

82 VII

FIGURE 33

FIGURE 33
François Boucher
(1703–1770)
*Lady Fastening her Garter
(La Toilette)* 1742
MUSEU THYSSEN-
BORNEMISZA, MADRID

# 83

*Piquet: or Virtue in Danger (The Lady's Last Stake)* 1759
Oil on canvas
91.4 × 105.4
ALBRIGHT-KNOX ART GALLERY, BUFFALO, NEW YORK. GIFT OF SEYMOUR H. KNOX, JR., 1945

In 1758 the Irish peer James Caulfield, 1st Earl of Charlemont, persuaded Hogarth to paint one last satirical painting by offering him remarkably generous terms: he would allow the artist to choose his own subject and to name his own price. The resultant, luxuriously painted canvas returns to the territory of aristocratic vice and sexual subterfuge that the artist had explored in *Marriage A-la-Mode* – indeed, this painting's setting and narratives offer a suggestive pictorial echo of the second image of that series.

Hogarth's painting draws on a famous theatrical comedy, Colley Cibber's *The Lady's Last Stake* (1708), and depicts a married aristocratic woman who, addicted to gambling, has just lost her fortune to a glamorous young army officer. The cards have been despairingly thrown on the floor and onto the fire, while the woman's jewels, trinkets and banknotes are piled high in the soldier's hat. Hogarth pictures the officer as he offers his victim the chance to regain her fortune. The soldier's terms, according to Cibber's play, are as follows: the two will play one more game, and if she wins, she will regain her fortune, and have no obligation to him; if she loses, however, she will still have her goods returned but be obliged to take him as her lover. In the artist's own words his female protagonist is shown 'wavering at his suit whether she should part with her honour or no to regain the loss which was offered to her'.[11]

Hogarth's heroine is someone who can either be interpreted as a virtuous woman clinging desperately onto her respectability – and this is the reading suggested by the artist's theatrical source – or, more insidiously, as someone who is highly aware of her own erotic appeal and who, under the guise of coyness, is excited by the soldier's offer. Her body language is left decidedly ambiguous: is her glance outwards at the viewer vulnerable or flirtatious? Are her blushing cheeks a signal of shame or of dawning desire? Is her gesture of reaching across to the fireguard a sign of her determination to protect herself from the flames of lust, or rather of her wish to extend another graceful, exposed forearm and hand in front of her fellow-gambler's eyes? Hogarth leaves such questions unanswered, while filling the environment with a series of symbolically resonant but ambiguously juxtaposed objects: in the words of Mary Webster, while 'the clock with its motto NUNC N.U.N.C. invites her to profit from love and the moment, the penitent Magdalen of the picture warns of her future repentance if she surrenders'.[12] One last clue seems to suggest the way events are likely to unfold: a letter from the woman's husband lies forlornly in the corner, abandoned like the cards that lie on the hearth nearby. MH

84

# 7
# The English Face: Hogarth's Portraiture

*Mark Hallett*

Writing his unpublished 'Autobiographical Notes' towards the end of his life, Hogarth reflected with both pride and bitterness on his career as a portraitist. At one point in this text he notes that his monumental portrait of Captain Coram at the Foundling Hospital (no.84) had stood 'the test of twenty years as the best portrait in the place notwithstanding all the first portrait painters in the kingdom had exerted their talents to vie with it'.[1] Elsewhere, however, he jots down that his 'attempting portrait painting' had brought him more abuse than any other of his artistic activities.[2] He sums up by declaring that his portraits 'met with the like approbation Rembrandt's did, they were said at the same time by some [to be] Nature itself by others exicrable [*sic*]'.[3]

The career in portraiture that generated such ambivalent reflection began in earnest with the picture of Coram, which was installed at the Foundling Hospital in 1740. With this painting Hogarth had hoped to establish himself at one stroke as a leading practitioner of the genre and as a worthy successor not so much to Rembrandt as to the most celebrated portraitist ever to have settled in Great Britain, the seventeenth-century painter Sir Anthony Van Dyck. In his 'Autobiographical Notes' Hogarth remembers that 'one day at the academy in St Martin's Lane I put this question, if any at this time was to paint a portrait as well as Van Dyck would it be seen and the person enjoy the benefit? They knew I had said I believed I could.'[4] The portrait of Coram, according to Hogarth, was painted to test this point, and inaugurated a series of ambitious portraits that took up much of the artist's energies in the early 1740s.

In launching himself as a portraitist, Hogarth entered an artistic sphere rife with rivalries and jealousies. The artist later remembered that 'the whole nest of Phizmongers [portraitists] were upon my back every one of whom has his friends, and all were turn[ed] to run them down – my women harlot[s] and my men charicatures'.[5] The acidic response with which Hogarth's works were met was partly the consequence of the fact that the market for portraiture was exceptionally competitive. In the words of the commentator Jean André Rouquet writing in 1755, 'portraiture is the kind of painting the most encouraged, and consequently the most followed in England'.[6] Rouquet notes the ways in which portraiture had been turned into a slick, highly efficient form of artistic manufacture, involving speedy execution, extensive use of studio aids like the 'lay-man' (a wooden dummy that could be arranged into a variety of poses), the parcelling out of drapery painting to specialists and the furnishing of elegant studio spaces in which to entertain clients. He goes on to discuss two of the most prominent practitioners of the genre, Allan Ramsay and Jean-Baptiste Van Loo, who had settled in London in 1738 after having honed their skills on the continent. Rouquet commends the Scottish-born Ramsay for having 'brought a rational taste of resemblance with him from Italy', while his discussion of Van Loo concentrates on the spectacular success he enjoyed on his arrival from Paris, which 'was flattering to a very high degree. Scarce had he finished the pictures of two of his friends, when all London wanted to see them, and to have theirs drawn ... Crowds of coaches flock'd to Mr Vanloo's door, for several weeks after his arrival, just as they crowd the playhouse.'[7]

Hogarth, as we might expect, seems to have been stung into action by the artistic eminence and financial rewards enjoyed by these two newcomers to the London art world. Indeed, it was Van Loo's rise to fashion that prompted Hogarth's claim to paint portraits as well as Van Dyck, and Ramsay to whom – among other artists at the St Martin's Lane Academy – he had made this boast. But in preparing to enter the crowded market for portraiture and compete with such men, and with prominent English artists like Thomas Hudson and Joseph Highmore, Hogarth was faced not only with stiff competition: he was also confronted with the challenge of adapting to the specific demands of portraiture as an artistic genre. Most obviously, portraiture is about capturing an individual's likeness, something that he later declared required a level of 'constant practice' that he had never been able to enjoy.[8] Dauntingly, however, achieving an accurate likeness was only one aspect of ambitious portraiture: in the words of Jonathan Richardson, the most sophisticated commentator on this branch of art in the early eighteenth century, 'a portrait-painter must understand mankind, and enter into their characters, and express their minds as well as their faces'.[9] Finally, portraiture was in many ways a more stringent, conservative and confined form of image-making than the other artistic categories – graphic satire, history painting, the conversation piece – in which Hogarth specialised. Richardson usefully contrasted it to history painting in this respect:

*Mrs Salter* 1741 or 1744
(no.89, detail)

A History-Painter has vast liberties; if he is to give life, and greatness, and grace to his figures, and the airs of his heads, he may chuse [*sic*] what faces, and figures he pleases; but the [portrait painter] must give all that (in some degree at least) to subjects where it is not always to be found; and must find, or make variety in much narrower bounds than the History-Painter has to range in.[10]

For Hogarth, then, the challenge was, firstly, to fabricate works that communicated the likeness, temperament, calling and histories of his sitters; and secondly, to translate the invention, variety and narrative flair for which he was already famous into the relatively 'narrow bounds' of paintings that typically featured only one or a few figures.

Hogarth responded to the commercial and aesthetic circumstances in which he found himself by cultivating a clientele and a mode of portraiture that distinguished itself from that of his competitors in a number of ways. First of all, the great majority of Hogarth's patrons for portraits were drawn not from the fashionable, metropolitan, aristocratic society courted by artists like Van Loo and Hudson, but from communities who defined themselves in relation to different forms of status and value. In particular, many of Hogarth's subjects were members of the mercantile, professional, ecclesiastical and scientific spheres; many, too, were linked by their shared involvement in such philanthropic enterprises as the Foundling Hospital. This stream of patronage was a consequence not only of Hogarth's prickliness when dealing with more socially elevated patrons but also of the particular kind of portrait he painted. For Hogarth specialised in producing images that, rather than stressing cosmopolitan sophistication or aristocratic languor, promoted other kinds of virtues: directness, benevolence, energy and lack of pretension for his male subjects; and modesty, ease, sincerity and polite restraint for his female sitters. His subjects do not project a haughty, self-conscious sense of privilege but are typically rendered as if accessible, benevolent and aware of our presence – as polite men and women without any great 'airs'.

These qualities are reinforced by the relative absence of flattering effect or pictorial flashiness in Hogarth's portraits – hence the opprobrium they sometimes received as mere 'charicatures'. The faces of his men and women are typically illuminated by a lucid and unadulterated light, and Hogarth tended to record, rather than refine, those features – a wide nose, for instance, or a corpulent chin or a mole – that did not correspond precisely to a fashionable facial model. Similarly, the bodies of his sitters – particularly those of his squat, solidly built male subjects – consistently refuse to conform to the elongated bodily ideal prized in more elite circles. Finally, and with the exception of his grandest ecclesiastical portraits, the dress and settings in which he enveloped his subjects are rarely elaborate or ostentatious. For both artist and sitters, it seems, this form of pictorial plain-speaking suggested a welcome lack of affectation and vanity. At the same time Hogarth ensured that this modesty did not extend to an unwelcome, puritanical extreme: his portraits – particularly those of his female sitters – typically grant their subjects an understated good taste, and are also characterised by subtle forms of painterly display that confirm both the artist and his sitter's refinement.

If these kinds of pictorial characteristics seemed to chime with the values of the 'middling' community for which he catered, it can also be suggested that Hogarth saw those same characteristics as expressive of national virtues. Significantly, the artist signed a portrait he executed in 1741 with the words 'W. Hogarth Anglus pinxit'.[11] His explicit identification with Englishness can be understood as a marker of artistic defiance, whereby Hogarth distinguishes himself from the foreign-born artists who had long dominated the field of portraiture. At the same time, this nationalistic tag gestures to the 'Englishness' of the portraiture that Hogarth produced and of the people whom he pictured. These men and women – individuals such as the philanthropist Thomas Coram, the cleric Bishop Benjamin Hoadly, the actress Lavinia Fenton and the merchant George Arnold – embody those supposedly 'English' virtues of sobriety, energy, directness and sincerity that, in a period of European conflict and growing anxieties about the impact of French culture on English society, were being emphasised as a counterweight to the excessive refinement associated with the French and with an aristocratic class in thrall to Parisian fashions. It is no coincidence that Hogarth produced the great majority of such 'English' portraits in the same decade in which he executed his scathing satiric attack on the impact of foreign mores,

*Marriage A-la-Mode* (no.77).

Hogarth's portraiture was also driven by a range of other, more local concerns to do with the artistic traditions and possibilities of portraiture as a genre. Thus in his portraits of Coram, Hoadly and Thomas Herring (nos.84, 91, 92) the artist not only expresses a certain set of cultural values but explores the narrative, symbolic, compositional and painterly potential of the full-length and episcopal portrait, while in his great depictions of filial devotion and interaction, the paintings of the Graham and Mackinen children (nos.93, 94), Hogarth pushes modern British portraiture to new degrees of iconographic, narrative and emotional complexity. In his portraiture, no less than in any other sphere of his art, Hogarth was regularly testing, changing, adapting and inventing. Just like so many of the dynamic individuals he loved to paint, he was never standing still.

*Thomas Herring,*
*Archbishop of Canterbury*
1744–7 (no.92, detail)

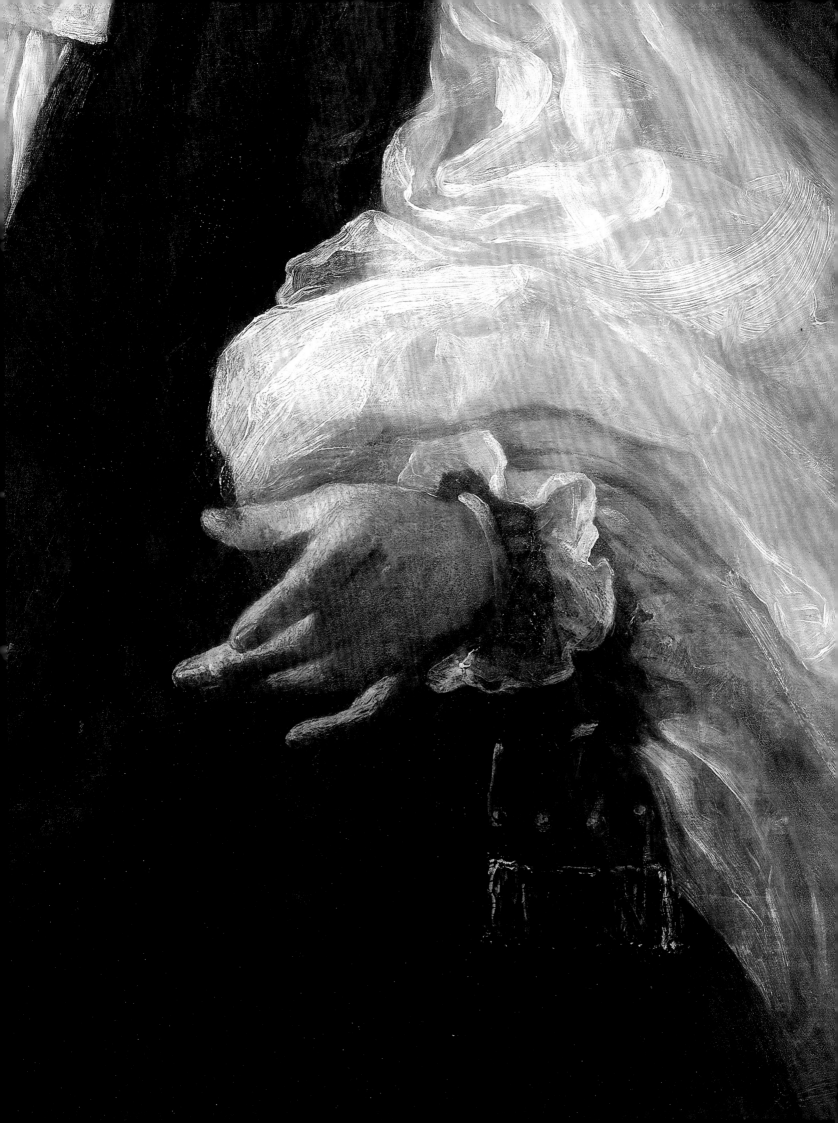

# 84

*Captain Thomas Coram* 1740
Oil on canvas
239 × 147.5
THE CORAM FAMILY IN THE CARE OF THE
FOUNDLING MUSEUM, LONDON

This canvas, of all his portraits, was the one that Hogarth was to look back on with most satisfaction, particularly given the fact that, as he jotted down in his 'Autobiographical Notes', it 'was done without the practis of having done thousand[s] which every other face painter has before he arrives at doing as well'.[12] The monumental portrait of one of Georgian England's greatest philanthropists was painted to showcase Hogarth's commitment to the ideals of Coram's Hospital for Foundling Children, of which the artist was a highly active governor, and – just as importantly – to advertise his abilities as a portraitist. Given free, Hogarth's full-length image was ensured plenty of attention in the Foundling Hospital's public painting gallery, where it towered over the hospital's numerous visitors, proclaiming both Coram and Hogarth's virtues as the entrepreneurial and artistic representatives of a modern culture of benevolence.

The hospital's founder, who had made his fortune in shipping, is pictured in a fictionalised setting that allows a glimpse of the sea beyond, which originally included the vessels that had brought Coram his vast wealth. Sitting with an unusually open stance in front of a substantial column, a swathe of green drapery and a now-faded depiction of Charity nurturing children, Hogarth's celebrated subject is shown displaying the seal of the hospital with his right hand and clasping a pair of gloves in his left. He wears a heavy red overcoat and a plain black suit. Coram, instead of donning a wig, displays his own fine silver hair, which sets off a distinguished but unpretentious face: craggy, unpolished and pulled into an expression that, rather than suggesting an easy assumption of authority, conveys a controlled energy, as if he is impatient to press ahead with his philanthropic scheme. A nearby table is loaded with documents, including the hospital's royal charter, and in the foreground a globe, swivelled to display the 'Western or Atlantic Ocean', offers a further allusion to the sitter's mercantile background. Coram's hat lies casually at his feet, at the top of a step that is proudly inscribed with the words 'Painted and given by Wm. Hogarth 1740'.

In this painting Hogarth aligned both his sitter and himself with prestigious forebears: more particularly, his ambitious work seems to have been modelled on the great Sheldonian portrait of Christopher Wren that had been worked on by no fewer than three of the artist's most famous predecessors, Antonio Verrio, Godfrey Kneller and Hogarth's father-in-law James Thornhill (fig.34). Through such a comparison – which is powerfully invited by the compositional, gestural and iconographic similarities between the two paintings – Coram is defined as an equivalently heroic and patriotic figure to Wren, and as someone whose hospital offered a worthy successor to the great public buildings erected by the architect; at the same time, of course, such a comparison also dramatised Hogarth himself as an artist who was not only following in the footsteps of the great early eighteenth-century portrait painters but who also – on the evidence of this first essay in grand portraiture – promised to exceed their achievements.

The comparison with the Wren portrait also serves to indicate the ways in which Hogarth departed from pictorial convention in this portrait and sought to construct a new kind of heroic identity for his sitter.

Here, what is particularly noticeable are the ways in which Coram shares so little of Wren's poise or elegance; rather, he is depicted as if has just come in from the outdoors, quickly discarded his hat on the floor, pulled off his gloves, unbuttoned his jacket and sat down without bothering to settle into the grandiose pose traditionally expected of the seated full-length – indeed, his left leg swings rather uncertainly from the chair, and his right barely reaches the ground. He is painted as if only sitting briefly for his likeness before hurrying outside again to pursue his business. All these details dramatise Coram's refusal to assume the more static, formal persona associated with grand portraiture, even as he is also aligned with the kinds of ambition and achievement embodied in the portrait of Wren. A fascinating dialectic ensues, in which Hogarth's sitter, and the artist himself, can be seen as both conforming to and confounding the legacies of the past. They thereby identify themselves as men who, while recognising the traditions of civic virtue and, in Hogarth's case, grand portraiture, were also seeking to create something that was strikingly modern.

FIGURE 34
James Thornhill
(1675/6–1734), Godfrey
Kneller (1646–1723),
Antonio Verrio
(1639?–1707)
*Portrait of Christopher
Wren* c.1708
SHELDONIAN THEATRE,
UNIVERSITY OF OXFORD

FIGURE 34

The Royal Charter

Painted and given by W.ᵐ Hogarth 1740

84

# 85

*William Jones* 1740
Oil on canvas 127 × 102.2
NATIONAL PORTRAIT GALLERY, LONDON

Hogarth's sitter was a distinguished mathematician who, having been born in modest circumstances, had risen to become a collaborator of Isaac Newton and Edmund Halley; a member of the Royal Society; and the tutor to a succession of scientifically minded aristocrats, most recently the 2nd Earl of Macclesfield, with whom Jones and his family lived at Shirburn Castle, Oxfordshire. This painting seems to have been commissioned by the 2nd Earl, whose status as a governor of the Foundling Hospital would have brought him into contact with the artist, a fellow-governor.

The artist's depiction of Jones shares many of the characteristics of his portraits of Thomas Coram (no.84) and George Arnold (no.86), both of which were painted around the same time. In particular, Hogarth's painting combines an impression of dignity – reinforced by the detail of the classical column – with one of vitality and alertness. Here, we can note that Jones leans slightly forward in his chair, that he still holds his hat in his left hand and that his right hand, rather than resting calmly on the arm of the chair, as was commonly the case in such portraits, seems unusually alive and active: it is as if Jones is exploring or tapping the end of the chair's arm with his finger-tips.

Interestingly, Jones's portrait is bereft of all signs of his profession and achievements. His intellect, rather than being conveyed by symbolic attributes, is suggested by the alertness of his body language and gaze, and by the subtle passages of light that fall on and surround his head. Jones, we are invited to imagine, wears his learning just as lightly as his picture does. Indeed, he is portrayed not so much as a mathematician as a polite gentleman. Dressed in an elegant but unspectacular brown suit, pictured with a discreetly noted wart as well as a flowing wig, and looking out at us with a studied but benign expression, Jones is presented as a man whom one can imagine fitting comfortably and unobtrusively into the circles of polite conversation and intellectual exchange that linked the environments of landed culture with those of the metropolitan public sphere. In his case these stretched from the aristocratic castle in which he lodged to the London headquarters of the Royal Society, of which he had recently become vice-president.

85

# 86

*George Arnold* c.1738–40
Oil on canvas
88.9 × 68.6
FITZWILLIAM MUSEUM, CAMBRIDGE

# 87

*Frances Arnold* c.1738–40
Oil on canvas
88.9 × 68.6
FITZWILLIAM MUSEUM, CAMBRIDGE

Despite its modest scale, Hogarth's portrait of George Arnold is deservedly one of the artist's most celebrated works, in which he crafts an image of pugnacious, non-aristocratic masculinity that is quite new in British art. Hogarth's sitter was a successful merchant and alderman who, like so many of the patrons for his portraits, had been involved in the establishment of the Foundling Hospital. Having made his fortune, Arnold had built himself a substantial country house in Northamptonshire, where this painting was destined to hang alongside the similarly sized pictures of his son and daughter (no.87). While this familial display fitted into the traditions of country house portraiture, the images themselves – in particular that of George – boldly eschew any hint of aristocratic pretension. Hogarth depicts Arnold as squat of body and open of stance, as respectable but restrained in his dress, and as defiantly direct in his facial address to the viewer. Like Thomas Coram and William Jones (nos.84, 85), he is pictured as if temporarily pulled from a life of activity and business. Hints of refinement – the swirling cuffs of his shirt, the gleam of a chair's hand-rest – are overwhelmed by the far greater pictorial stress placed on markers of sobriety and weightiness: the thick, noticeably unadorned material of Arnold's suit, and – most powerfully of all – his heavy-jowled, ruddy-cheeked, no-nonsense face.

The face, of course, is the portraitist's most important territory, and Arnold's, when looked at in detail, is one loaded with landmarks eloquent of hard-earned respectability: the blunt contour of a jutting chin as it emerges out of its bloated double; the down-turned mouth, clamped shut; the illuminated mole; the flecks of shadow on the upper-lip; the gaping caverns of the exposed nostrils, and the wide bridge of the nose above; the furrowed lines under the eyes; the two eyes themselves, one dark and sombre, the other paler and injecting a note of liveliness; the echoing eyebrows, heavy and direct in their signals; and then the

wide, illuminated expanse of forehead and cheek, which, alive with ridges, contours and patches of colour, is quite different to the smooth, polished and bleached surfaces of the faces that stared out from the walls of older country houses.

The impact of this self-improved, commonsensical merchant's face is accentuated by the artist's decision to depict Arnold's torso and stance as aggressively square-on, and by the way in which Hogarth brings his sitter into dramatic close-up, so that the mass of his body presses up against the picture plane and his arms and elbows push against the painting's edges. Arnold does not so much occupy this portrait as jostle against its boundaries. In picturing his sitter in this way, Hogarth has created one of the first portraits of modern bourgeois man.

In his portrait of Frances Arnold, Hogarth's subject plays an equivalently receptive and polite role to that performed by Lady Anne Cecil in *The Strode Family* (no.54): she is pictured sitting with a straight back on a smartly upholstered red chair, raising her left hand from the edge of a gleaming table and gazing directly and calmly out at the viewer. Painted as if fully aware of the spectator's presence, she

presents herself as a poised, domesticated figure with whom any genteel interlocutor would be happy to engage in amiable conversation. As in so many of Hogarth's female portraits, her appearance and dress are shorn of any signs of ostentation: the directness of Frances Arnold's gaze, which refuses all signs of flirtation or coyness, is matched by the refined simplicity of her necklace and the uncluttered surfaces of her skin and dress. The picture's formal character – and, it is worth pointing out, its size – are as undemonstrative as Hogarth's polite subject.

These portraits of father and daughter seem to have hung in the dining room at the family's country home. As such, they would have formed part of a fittingly sociable arena of conversation and relaxation in which the Arnold family and their friends would regularly have gathered together. In this environment Hogarth's portrait of Frances would have maintained the impression of directness and simplicity conveyed by that of her father, while simultaneously offering guests a more accommodating, passive and elegant subject on which to rest their eyes.

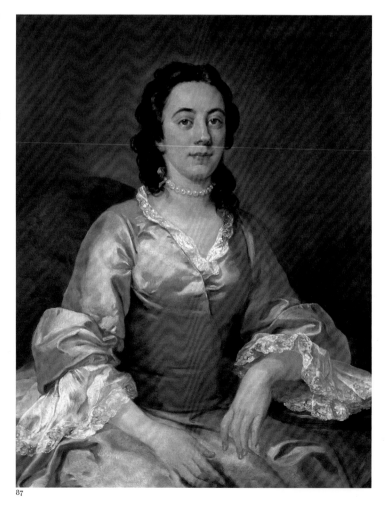

87

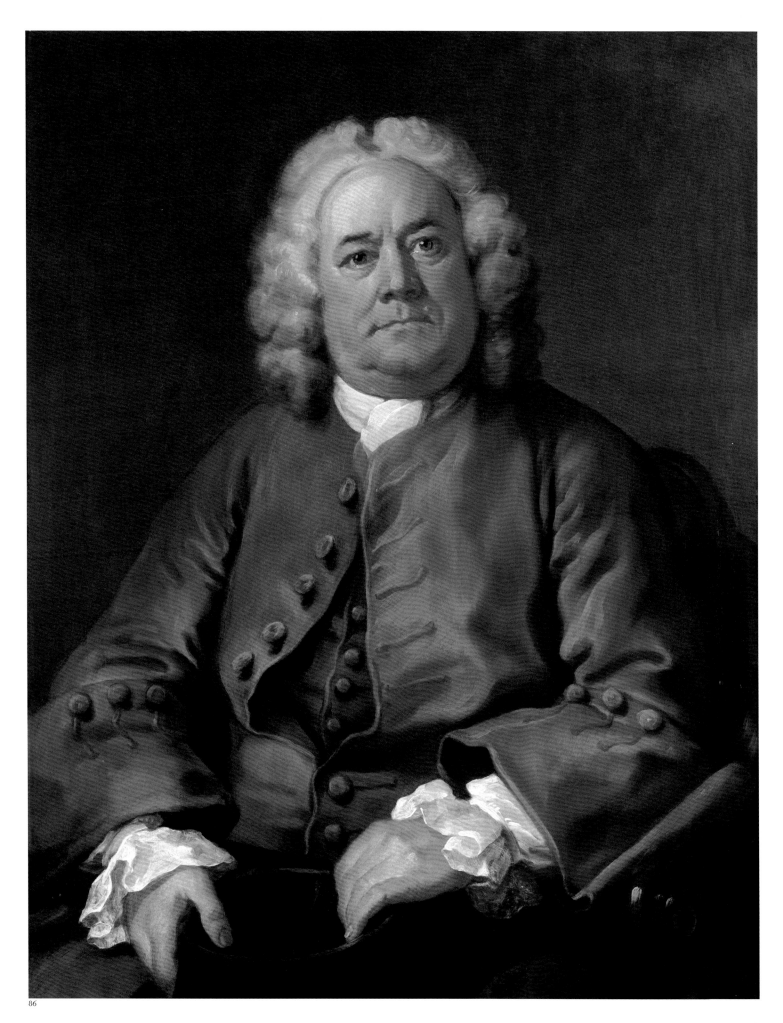

# 88

*Lavinia Fenton, Duchess of Bolton* c.1740–50
Oil on canvas
73.7 × 58.4
TATE. PURCHASED 1884

This work was identified in the late eighteenth century as a portrait of Lavinia Fenton, Duchess of Bolton. Fenton was an actress who rose to fame with her portrayal of the virtuous and affecting character of Polly Peachum in Gay's *Beggar's Opera* in 1728, and who featured in the artist's early paintings of a climactic scene from this play (nos.38–9). After her performance as Polly she abandoned the stage to become the mistress of Charles Paulet, 3rd Duke of Bolton, whom she eventually married in 1751. Hogarth's portrait, which seems to have been painted some time after Fenton had given up her acting career, gestures gently to her status as a celebrated and privileged 'beauty'. The artist pictures her with a swivelled head and an averted gaze, which invites the viewer to linger on the gracious flow of her neck down into the smooth-skinned expanse of her décolletage, and to appreciate her elegant earring, ribbon, pearls and costume.

These details, and the associations with feminine display that they might prompt, are kept in check, however; it is interesting that Hogarth, in an earlier version of the portrait that has been revealed by X-ray analysis, seems to have portrayed his subject in a much more spectacular manner, wearing what Elizabeth Einberg and Judy Egerton have described as a 'rakishly tilted hat with a tall tuft of feathers on the right' and holding what seems to have been a basket of flowers with her left hand.[13] Hogarth's sitter apparently found this earlier composition altogether too flamboyant, and the artist turned instead to a more restrained and respectable imagery, one that would be seen as fitting for a figure who now circulated in refined society.

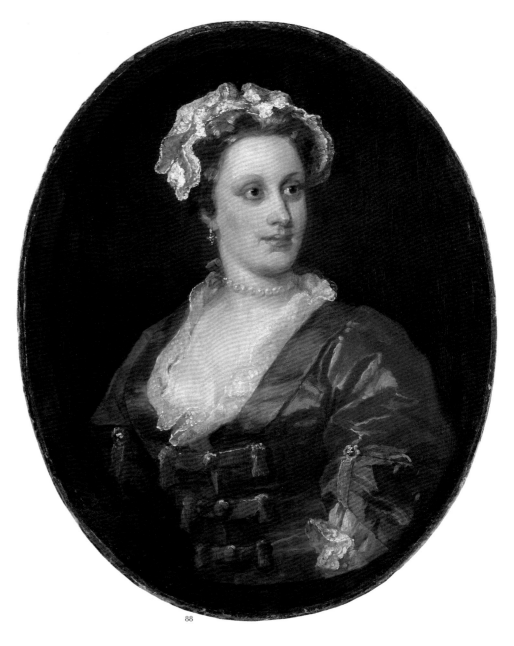

88

# 89

*Mrs Salter* 1741 or 1744
Oil on canvas
76.2 × 63.5
TATE. PURCHASED 1898

This portrait, which may well have been
commissioned to commemorate the sitter's
marriage in her mid-twenties to the Reverend
Samuel Salter in 1744, offers a fascinating
example of how Hogarth could convey the
supposed personal qualities of his female
sitters not only through a particular
representation of a woman's face and dress but
also through his handling of line and paint.
Elizabeth Salter is pictured as someone whose
expression, hairstyle and clothing typify the
'decency in manners, discourse and dress' that
was noted as a characteristic of ideal English
femininity by the artist's friend Jean André
Rouquet.[14] Elizabeth Salter is stripped of all
traces of extravagance: her face, in particular,
has an openness of address and lack of
adornment that is surely meant to signify her
sincerity and lack of 'airs'. Here we can note
her clear skin, emphasised by the dabs of light
that fall on her forehead, nose and upper
cheeks; her calm gaze, emerging from eyes that
lack make-up; her fullness of chin; and her
unaffectedly bunched hair. At the same time
Salter is assigned a subtle but unmistakable
stylishness, animation and confidence,
conveyed by her half-smile, by the string of
pearls in her hair and, most obviously of all,
by her swirling clothing which, although not
extravagant, is both fashionable and luxurious.

This interplay between two modes of
feminine identity extends to the formal
qualities of this portrait. Thus at times
Hogarth seems keen to suggest a painterly
simplicity complementing his sitter's
suggested lack of artifice: the pictorial
language of the face and the background, for
instance, is understated, operating by means
of quiet tonal transitions and muted colours.
Other aspects of the picture, however – in
particular, the flurry of white silk that winds
around Salter's neck, flows down to and twists
around the flower pinned to her bosom, and
emerges from beneath her yellow sleeve –
are painted in an indisputably eye-catching
manner. The rippling, animated outlines
found in this passage of painting, the dramatic
transitions that Hogarth effects between
transparency, translucency and opaqueness,
and the flickering, busy dots and dashes of
paint representing the decorative patterns
woven into the silk itself, all exhibit a brilliance
that is designed to attract the viewer's
attention and to suggest that Hogarth's sitter
herself, as well as his brushstrokes, enjoys a
certain ease, animation and flamboyance.

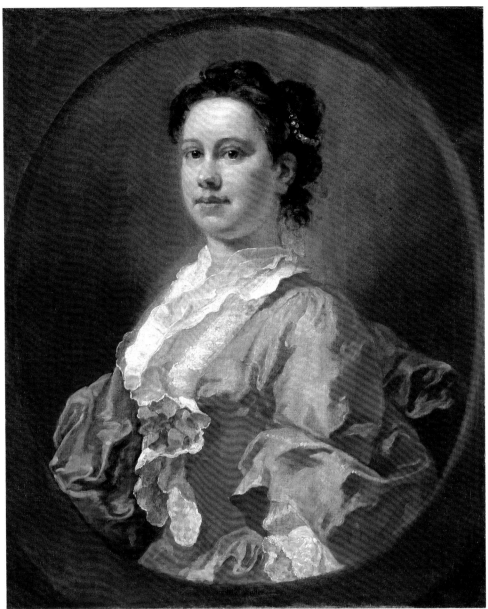

89

# 90

*Mary Blackwood, Mrs Desaguliers* c.1745
Oil on canvas
Diameter 68.5
PRIVATE COLLECTION

Hogarth famously claimed to be able to paint a portrait as well as Van Dyck, and Elizabeth Einberg has pointed out that this work offers an unusually intimate homage to the conventions of courtly seventeenth-century portraiture as developed by the great Flemish artist and by such successors as Peter Lely.[15] Of particular note here are the details of Mrs Desaguliers's historicising costume, with its stiffened bodice and pendant jewel, and the ringlets of her hair, which – as in the case of so many of Van Dyck and Lely's portraits – subtly trespass the sitter's cheek, forehead and shoulders. Through this kind of visual reference Hogarth not only promoted his own claims and ambitions as an artist but also assigned his sitter a more polished and aristocratic appearance than that enjoyed by most of his female subjects. Indeed, the portrait is studded with lustrous details and effects: the bowed orange ribbon that so luxuriantly wraps itself around Mrs Desaguliers's upper body, the glittering jewel that hangs at her breast, the shimmering, golden sleeves, and the painted red lips – so different to those of Elizabeth Salter (no.89) – with which she smiles rather knowingly out at the viewer. The exquisitely ornate, original frame that encircles this portrait completes the impression that, rather than seeking to promote an ideal of English modesty and simplicity, the artist here flaunts his ability to paint portraits of a more obviously cosmopolitan and courtly character.

In so doing, Hogarth was probably also wishing to demonstrate his ability to reproduce the kind of elegant effects associated with his more fashionable and foreign-trained rivals; it is interesting in this regard that his sitter had already been portrayed by Allan Ramsay and that she was the daughter of a successful dealer in continental paintings. Finally, it is perhaps significant that Hogarth's subject seems to have eloped rather scandalously with her husband-to-be from Ranelagh Pleasure Gardens in Chelsea.[16] This painting, which may have been commissioned to celebrate Mary Blackwood's marriage at the tender age of seventeen to Captain Thomas Desaguliers in the spring of 1745, can be understood as communicating the youthful glamour, confidence and theatricality that seems to have attracted the captain's attention.

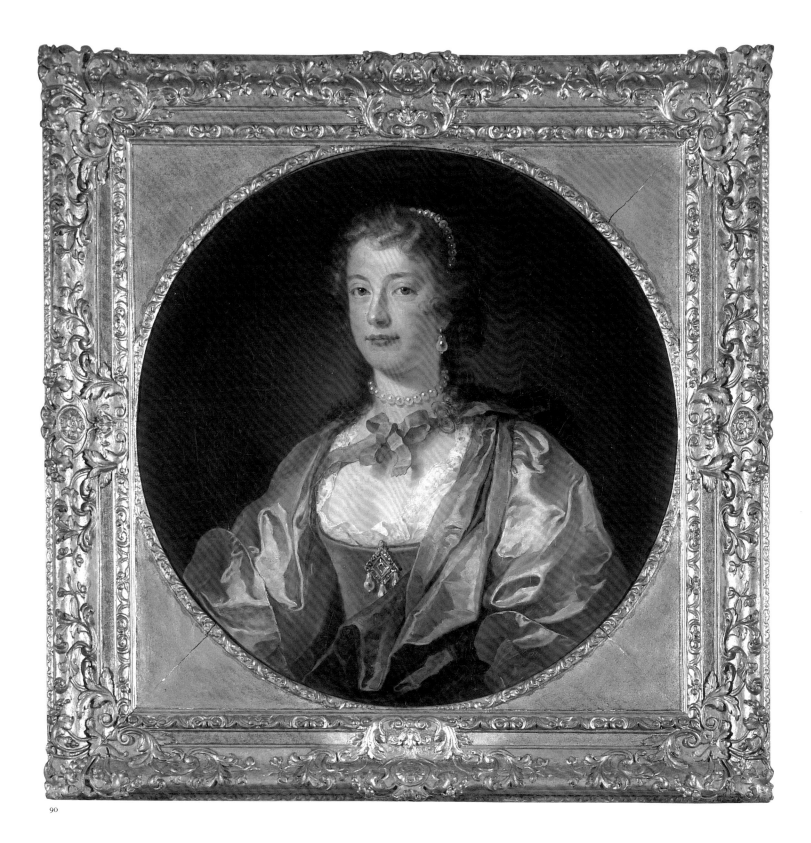

90

# 91

*Benjamin Hoadly, Bishop of Winchester* 1741
Oil on canvas
127.3 × 101.5
TATE. PURCHASED 1910

The episcopal portrait was a prestigious but highly conservative branch of portraiture in this period, with long-established pictorial conventions that were rarely breached. In this powerful canvas Hogarth, while following the basic rules of this format, nevertheless manages to animate and enrich his portrayal through a sophisticated manipulation of gesture, expression and iconography and through a remarkable representation of his sitter's formal dress.

When he sat for this painting, Hoadly, an old intimate of Hogarth's, was both Bishop of Winchester and Prelate of the Order of the Garter. As was traditional in such portraits, he is portrayed wearing the robes and insignia of these offices. This mode of portrayal, which sees the depicted body and arms enveloped in regalia, places added pictorial stress on the hands and the head as vehicles of individual identity. Hogarth, recognising this, coordinates his sitter's hand gestures and facial expression in an especially subtle and animated manner. Hoadly is pictured as if actively responding to our presence: he raises one hand in blessing or greeting, while discreetly lifting the forefinger of his other in our direction. Meanwhile, his face, turned gently towards us, is given what Mary Webster has properly described as a 'seriously benign' expression, communicating not only the gravity of his official responsibilities but also the virtues of benevolence and polite conduct promoted by Hoadly in his latitudinarian theology – virtues that made him a kind of Anglican counterpart to Thomas Coram.[17] Here, the depiction of Hoadly's eyes and mouth is crucial: they manage to convey both dignity and good-humoured solicitude.

This expressive language of the hands and face is coupled to an unusually dense symbolic iconography. The leather-bound volume seen behind Hoadly's raised hand was a staple of such pictures; in this case the book may well also allude to the cleric's published sermons. In the background, meanwhile, Hogarth pictures a stained-glass window, with on the right a crowned angel holding the arms of the see of Winchester and on the left a figure of St Paul. The juxtaposition of Hoadly with the biblical apostle emphasises the bishop's strongly Pauline theology, which closely aligned itself to what contemporaries perceived as Paul's practical, conciliatory and moderate qualities. While the figure of the saint offers a theologically resonant and personally flattering point of comparison for Hogarth's subject, the visual contrast that is set up between the bearded, severe-faced St Paul, buried in his book and carrying a sword, and the bewigged, corpulent cleric, with his open stance and avuncular expression, is also eloquent of the historical development of the church and its iconography into the polite, more worldly ideals and imagery of the modern Anglican establishment.

Alongside his thoughtful handling of expression, gesture and symbolism, Hogarth devotes much of his artistic energies to the depiction of Hoadly's robes. It must be remembered that for the artist's contemporaries such dress was richly expressive and central to the portrait's meanings. The episcopal portrait, which tended to be displayed together with other such portraits rather than in isolation, celebrated not only the individual buried under his regalia, but also the continuing history and dignity of the office that was signified by that regalia. Accordingly, Hogarth is highly attentive to the iconographic details and material richness of Hoadly's Garter costume: the medallion of St George that hangs from his neck, the badge placed on his shoulder, the elaborately knotted, braided and tasselled fastening, and the grandiloquent, dark-blue mantle with its artfully exposed silk lining. Similarly, Hogarth is keen to display the wide black expanses and overflowing white folds of Hoadly's episcopal robes. This attentiveness is accentuated through stylistic means such as the remarkably animated brushwork of Hoadly's right sleeve, the subtly varied lights and folds of Hoadly's black robe, and the waterfall of yellow dots that articulates the threaded gold of a tassel: all invite us to linger on and appreciate not only the artist's brilliance in representing dress, but the living meanings and majesty of the dress itself.

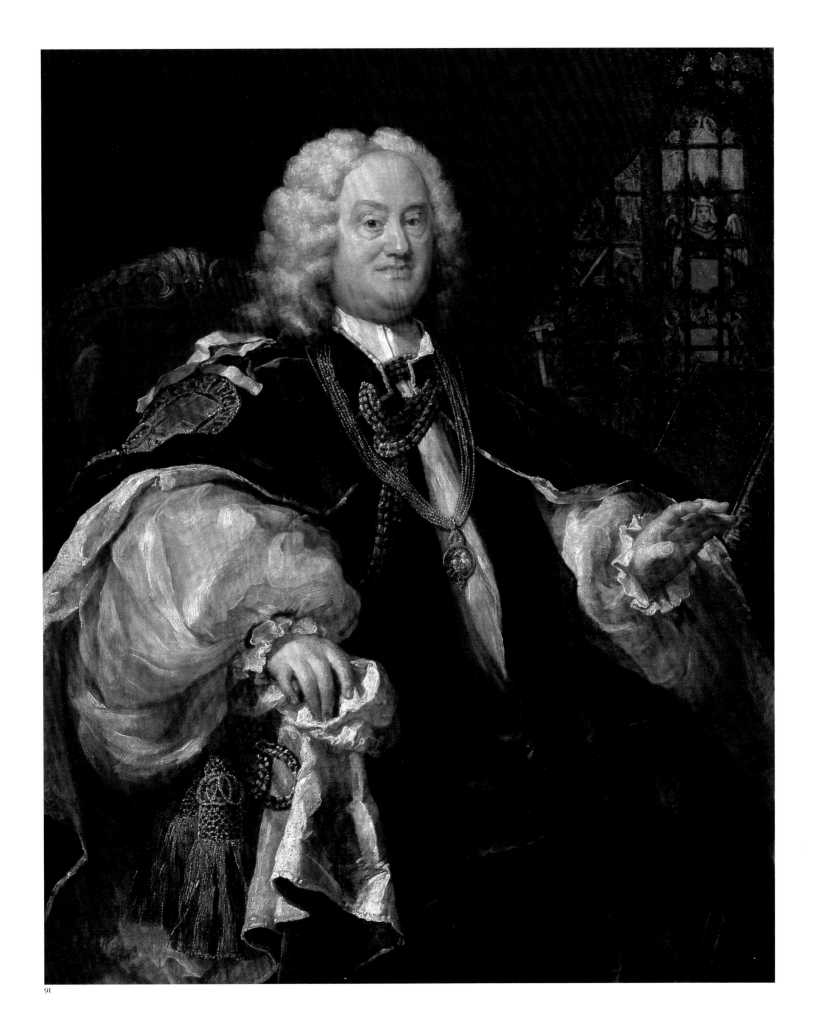

91

# 92

*Thomas Herring, Archbishop of Canterbury*
1744–7
Oil on canvas
127 × 101.5
TATE. PURCHASED 1975

Hogarth's second great episcopal portrait, begun some three years after his monumental depiction of Benjamin Hoadly (no.91), is of an equivalently ambitious kind. Indeed, Hogarth is supposed to have made the following stirring promise to Herring while painting his portrait: 'Your Grace, perhaps, does not know that some of our chief dignitaries in the church have had the best luck in their portraits. The most excellent heads painted by Vandyck and Kneller were those of Laud and Tillotson. The crown of my works will be the representation of your Grace.'[18]

Herring was Hogarth's most distinguished ecclesiastical subject. The cleric's portrait was begun while he was Archbishop of York and was revised when in 1747 Herring was promoted to the see of Canterbury. In representing this unusually distinguished figure, Hogarth stripped his image of the symbolic paraphernalia with which he had surrounded Hoadly, and – as in Van Dyck's famous image of Archbishop Laud – produced instead an image that focused almost exclusively on Herring's face, hands and bishop's robes.[19] The manner in which Hogarth did this caused Herring and his intimates some discomfort. Hogarth's sitter, in a letter to a colleague, declared that 'none of my friends can bear the picture'; and even after Hogarth made some substantive changes to the painting, an ecclesiastical insider, the Reverend John Duncombe, noted that the image 'exhibits a caricature rather than a likeness … the features all aggravated and *outrés*'.[20] The terms of the criticism are telling: Hogarth was seen to have added too much animation and character to the face and, in doing so, to have distorted an imagined facial ideal and strayed into the vulgar realms of 'caricature'. In retrospect, it seems clear that the cause of this consternation was Hogarth's attempt to distance his own episcopal portrait from the more static, impassive imagery of such contemporary works as Andrea Soldi's portrait of Edmund Gibson, Archbishop of London (fig.35); however, in depicting Herring as if on the point of conversation, with pursed, half-smiling lips, twinkling eyes and a gesticulating left hand, Hogarth

clearly upset his audience's sense of ecclesiastical and pictorial decorum.

An equally innovatory aspect of Hogarth's episcopal portrait is his handling of Herring's robes. It is worth remembering that contemporaries were highly sensitive not only to the symbolic and historic meanings of this kind of dress but also to the more subliminal effects and associations generated by a particular manipulation of drapery: thus Jonathan Richardson, in a chapter in his canonical *Theory of Painting* of 1725 dealing with the twin virtues of 'Greatness' and 'Grace', had declared that 'the draperies must have broad masses of light, and shadow, and noble large folds to give a greatness; and these artfully subdivided, add grace'.[21] Hogarth brilliantly maps Richardson's complementary categories of 'Greatness' and 'Grace' onto the black and white robes worn by Herring: while the black folds are deep, noble and large, undulating slowly and heavily across the picture space, the white folds – the sleeves in particular – gracefully swirl and twist in a rapidly flowing stream of silk winding its way down from shoulder to cuff.

Furthermore, it should be noted that the portrait as a whole is formally structured around the interplay of what Richardson called those 'Masses, Light and Dark', which initially define and animate a picture when it is seen 'at a distance'.[22] Hogarth harnesses these formal concerns to his picture's dual preoccupations as an episcopal portrait. On one hand, the dignity and 'greatness' of an important ecclesiastical office are symbolically reinforced and confirmed by the stately and sombre swathes of black

and olive-green paint that extend across some two-thirds of the picture surface. On the other, Herring's animation and 'grace' as an individual are further highlighted by the artist's orchestration of light masses in the painting, which encompass and illuminate not only those translucent, sparkling streams of white silk, but the cleric's expressive head and mobile, elegant hands.

FIGURE 35

FIGURE 35
Andrea Soldi (c.1703–1771)
*Edmund Gibson, Bishop of London* c.1740-5
LINCOLN CATHEDRAL

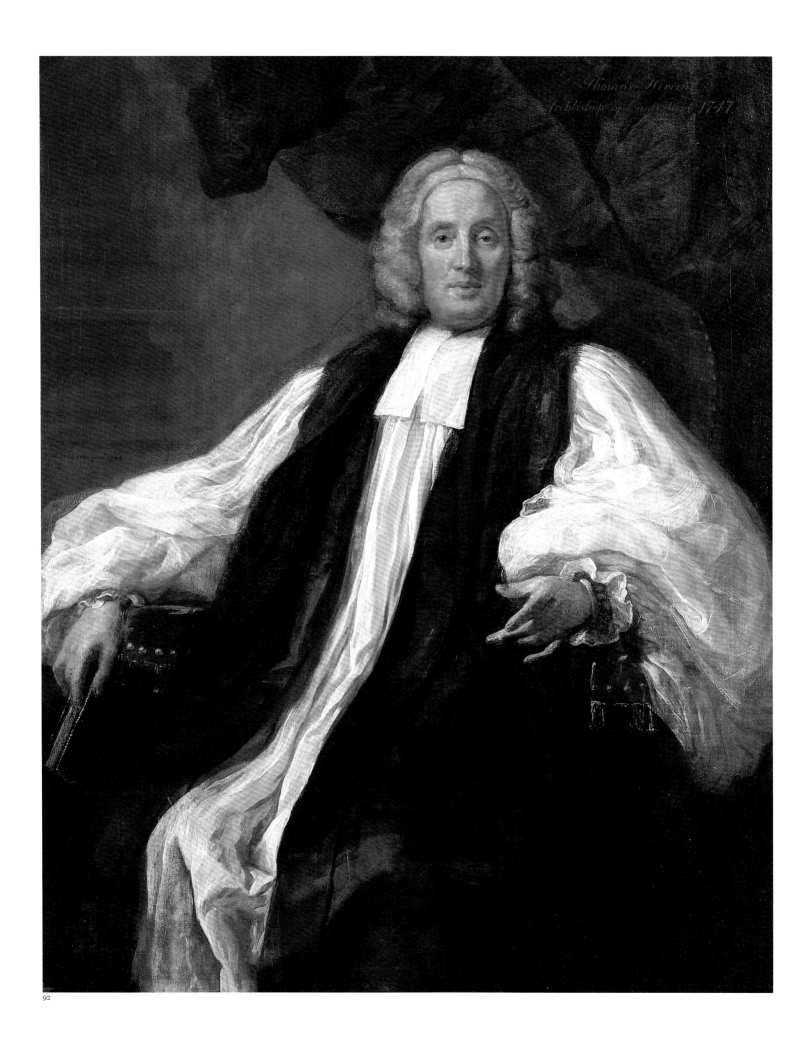

92

# 93

*The Graham Children* 1742
Oil on canvas
160.5 × 181
THE NATIONAL GALLERY, LONDON.
PRESENTED BY LORD DUVEEN THROUGH
THE ART FUND, 1934

This justifiably famous painting, one of Hogarth's largest group portraits, pictures the four children of Daniel Graham, contemporary London's most successful apothecary. Hogarth represents this youthful quartet as if at play in the Graham family home at Pall Mall. Their uniformly smiling faces suggest that they are happily enjoying each other's company, while their graceful poses, exquisite dress and luxuriously appointed surroundings confirm both their individual refinement and their exceptionally privileged social status. However, as Mary Webster confirmed in a ground-breaking article of 1989, things are not quite as untroubled as they might seem.[23] Webster, as well as conclusively identifying the subjects of Hogarth's painting, also revealed that the youngest child, Thomas, shown sitting on a toy go-cart on the left and reaching upwards towards either the hanging cage or the pair of dangled cherries, had actually died during the period in which this picture was being painted. Hogarth and the Grahams, rather than glossing over this tragic event, decided to incorporate it into the canvas's iconography and narratives. Accordingly, the artist, as well as celebrating the polite virtues of the Graham children, and picturing Thomas as if still alive, also offers an elaborate pictorial commentary on mortality, vulnerability and the passage of time and childhood.

The more melancholy elements of Hogarth's picture begin with the decorative figure standing on the clock placed directly above Thomas's head. Rather than the more conventional figure of old Father Time, Hogarth – in a tender allusion to the recent victim – depicts a winged cherub holding the symbolic attribute of a scythe, the blade of which curves downwards towards the ill-fated baby. The two crossed carnations that lie on the floor directly below the young boy's feet are a second symbolic tribute to Thomas's transient presence. Significantly, Hogarth does not confine this kind of sombre symbolism to the pictorial area immediately surrounding Thomas – the right-hand side of the painting is also loaded with a threatening narrative. Here, the seven-year-old Richard Robert Graham is shown winding the handle of an elaborate

bird-organ, decorated with a scene depicting Orpheus charming a circle of animals with his lyre. Judy Egerton has noted that 'this type of small domestic barrel-organ first became popular in France as a well-meaning aid to teaching caged birds to sing'.[24] Richard uses the instrument to encourage a caged bullfinch to sing and, looking upwards, is delighted by what he takes to be the bird's eager, squawking response to his music. Of course, we know better: the real reason for the bird's animation is the cat that has suddenly appeared at the top of the chair behind Richard's back and stares at its tantalisingly inaccessible prey with hypnotic intensity. *The Graham Children* can now be recognised as a painting incorporating twin narratives of vulnerability and danger taking place on either side of the picture and linked by such details as the curved dove on Thomas's go-cart, which offers a subtle visual echo of the similarly flapping bird in the hanging cage.

Ultimately, however, the picture's darker iconography, restricted to the edges, remains subordinate to the painting's celebration of the Graham children's beauty, amiability, elegance and companionship. In articulating these quintessentially 'polite' qualities, Hogarth also offered his patron an exquisitely observed pictorial meditation on the different stages of childhood. Thus Thomas is shown to be a creature of appetite and instinct, nibbling a rusk and reaching for things that lie beyond his grasp. The younger daughter, meanwhile, five-year-old Anna Maria, has begun to imitate the activities of her elders – she elegantly raises her dress as if preparing to dance to her brother's music. At the same time her youthfulness and naivety are touchingly demonstrated by the dependent nature of her gaze across at her older sister. Richard, in abandoning such filial dependency and asserting his active, authoritative status as a boy, is someone who still has to learn that his own perspective on the world is only a limited one. And, finally, the elder daughter, Henrietta Catherine, although still inhabiting the realm of childhood, is on the point of confidently breaking out of this phase of her life. She not only enjoys a wider perspective than her younger siblings – she is the one figure who looks out of the picture space and confronts our own gaze – but has already begun to take on adult responsibilities and challenges. Here, Hogarth's decision to show her tenderly holding the wrist of her younger brother is particularly telling: the gesture is both delicate and authoritative, and as such

suggests the kinds of maternal qualities that she would be expected to exhibit in later life.

What, however, are we to make of the two cherries that she holds up with her other hand and that seem to inform her knowing expression outwards? Some writers have suggested that they are an erotic counterbalance to the protective, maternal gesture of her other hand, alluding to her pristine virginity and her future desirability.[25] Or do they allude instead – as other commentators have suggested – to the iconographic trope of the 'fruit of paradise' traditionally dangled by the Virgin in front of the Christ Child, but which in this case will never be reached by the fruitlessly stretching infant?[26] The meaning of this pictorial detail remains uncertain, but the contrasting interpretative possibilities that it suggests offer us a final confirmation of the complex, enigmatic status of *The Graham Children* and of the almost impossible task that Hogarth set for himself: to produce an image that celebrates the vivacity, development and accomplishments of its four subjects while simultaneously evoking the most profound narratives of transience, danger and loss.

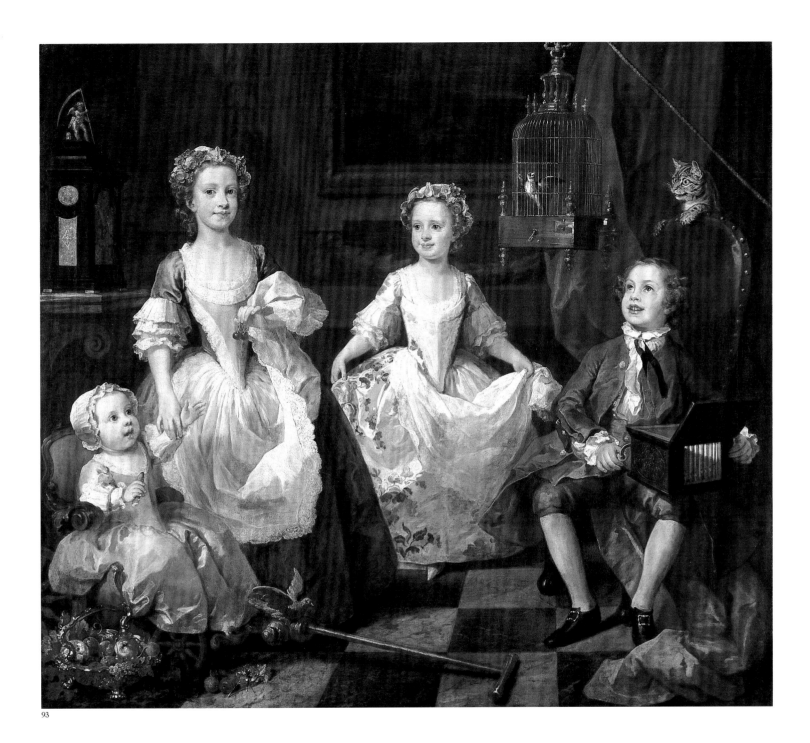

93

# 94

*The Mackinen Children* c.1742-3
Oil on canvas
182.9 × 143.5
NATIONAL GALLERY OF IRELAND, DUBLIN

This painting, set on the terrace of a fictionalised country villa, fuses a sentimental, pastoral imagery of childhood innocence and devotion with a more contemplative engagement with themes of devotion, absence and time. Hogarth's two subjects are Elizabeth and William Mackinen, born into a wealthy West Indian sugar dynasty. They were being educated in England in the period that Hogarth painted this work; once completed, their double portrait was despatched to the family home in Antigua. Elizabeth, born in 1730 and seemingly in her early teens, is shown seated next to a prominent potted sunflower, her apron bulging with a collection of exotic shells; her brother, who was three years younger, is depicted walking across to the sunflower and reaching out towards a butterfly that has just landed on its petals.

The painting cries out for symbolic interpretation. Thus Richard Wendorf has pointed out that the sunflower had been deployed by previous artists – Van Dyck in particular – as a symbol of devotion and has suggested that its presence in this picture might well allude 'to the devotion this young brother and sister share for each other, or the devotion their parents share for the children whose portraits they have commissioned'.[27] Adapting this suggestion, it seems likely that the exotic flower – famous, of course, for turning towards the sun, and here seen transplanted to the environs of an English arcadia – in some way functions as a pictorial allusion to the sun-drenched and distant territory of the West Indies, and to the parents who continued to live there. Meanwhile, Ronald Paulson, focusing on the butterfly, has noted that it 'appeared in many Dutch flower pictures as an emblem of transient beauty' and has argued that its presence here 'has to do with the children's future – with fleeting time, lost beauty, and lost innocence'.[28] And, certainly, what is striking about the narrative suggested by Hogarth is that the butterfly is actually under threat from the young boy's outstretched hand: there is every chance that its fragile beauty will not survive the clutch of his impulsive fingers. Here, we might argue, rather as in the case of the children staring at the caged bird in *The Graham Children* (no.93), the confident, sunny gaze of youth is sometimes misplaced, and only the adult onlooker – in this case, the absent parents themselves – can recognise the dangers that lie in wait not only for the beautiful but vulnerable objects of the children's admiration but also – it is implied – for the beautiful but vulnerable children themselves. Of course, what is so powerful about Hogarth's image is that, in capturing the moment just before the butterfly is caught, and before Elizabeth and William themselves have grown into more knowing adults, the artist ensures that their youthful delicacy and confidence will forever be frozen in time.

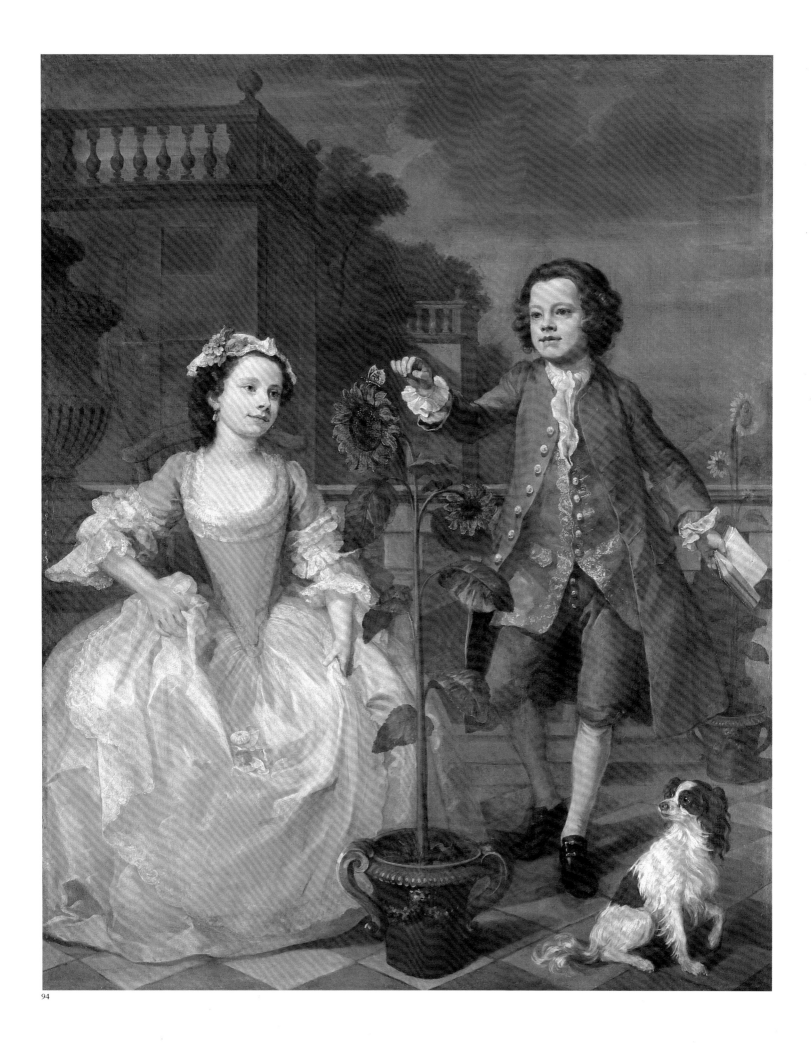

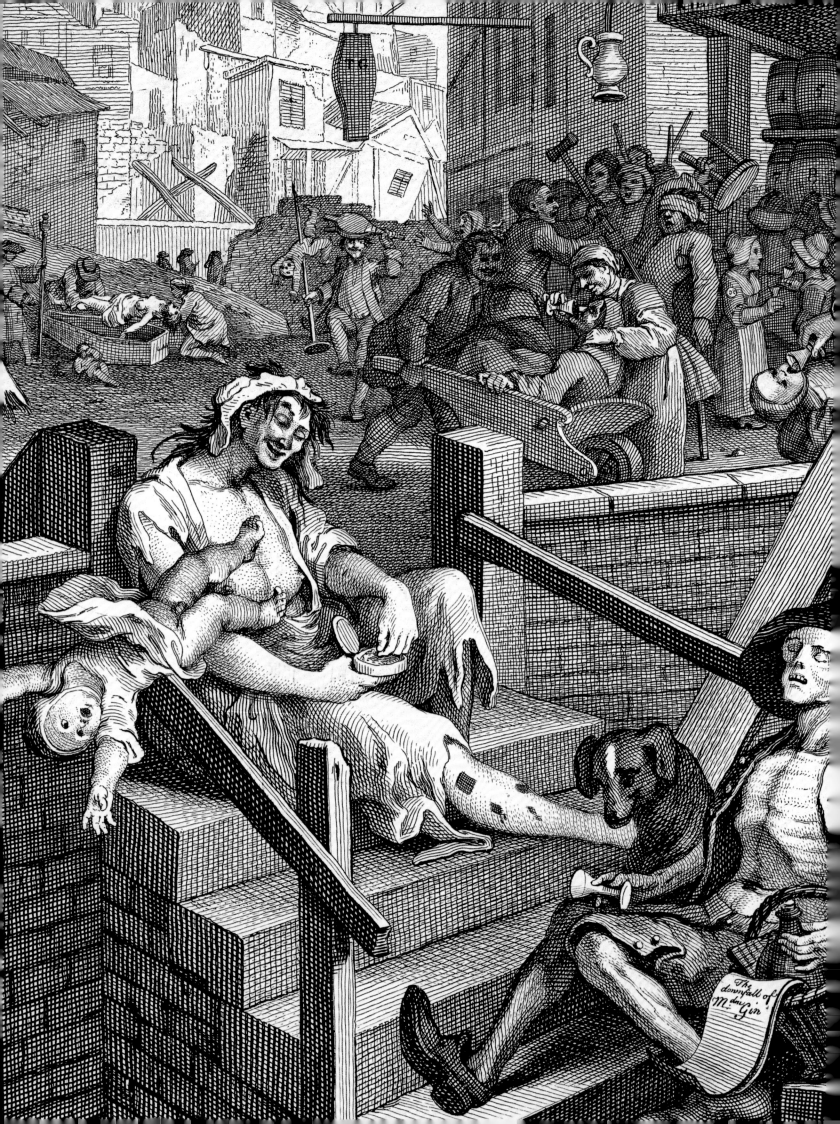

The downfall of Mdm Gin

# 8
# Crime and Punishment

*Christine Riding*

The increase in poverty and overcrowding in London during the first half of the eighteenth century was related to the unprecedented migration of people from the countryside. Perhaps not surprisingly, the growth in population led to a rise in crime and social unrest. Whether London was essentially a more dangerous and anarchic environment than in the late seventeenth century is debatable. However, the ruling elites certainly thought so and feared for their persons, their property and their commercial interests. Indeed, contemporary pamphlets and legal deliberations from the 1720s onwards underline a mounting sense of crisis. Concomitant, but not the cause of the social problems, was the dramatic upsurge in gin drinking among 'the lower orders'. Drunkenness affected all levels of society. However, the middle and upper classes took a very dim view of it when appraising its impact on the rest of society, those whom the grand jury of the County of Middlesex classified in 1736 as 'the meaner, though useful Part of the Nation'.[1] Thus the 'gin epidemic', from about 1720 to 1751, was increasingly held to be the primary cause of wider social evils, the repercussions of which were thought to be endangering England's prosperity and security, enfeebling its labour force and diminishing its population.

At the height of this perceived crisis Hogarth created *Industry and Idleness*, *Gin Lane* and *Beer Street*, and *The Four Stages of Cruelty* (nos.97, 98, 99–100). These works continued the satirical series last seen in *Marriage A-la-Mode* (no.77) but eschewed its elegance and wit in favour of a hard-hitting, propagandist agenda. This body of work presented mid-eighteenth-century London as a city of divided and alienated communities, an effect achieved through the juxtaposition of opposing values and social conditions – of virtue and vice, diligence and indolence, prosperity and poverty – thus reflecting the concerns described above. These prints are remarkable in Hogarth's *oeuvre* for their rigorous examination of disorder, crime and punishment. Perhaps not surprisingly, they complement the pamphlet writings of Hogarth's friend Henry Fielding, who from the late 1740s was London's chief magistrate and Justice of the Peace at Bow Street Court. In 1751 Fielding published his influential *Inquiry into the Causes of the Late Increase in Robbery*. Among the reasons for the escalation in crime, Fielding cited the expectation of an easy life by a large

proportion of those arriving in London, that the poor were no longer frugal and perceived crime as an easier, more lucrative option than honest, hard work. He also highlighted drunkenness among the poor (induced primarily by gin drinking), corruption in government, and the ineffectiveness of crime prevention and areas of the judicial process.

In tandem with the overwhelming focus of Fielding's treatise, Hogarth's prints concentrate on 'the lower orders'. He described *The Four Stages of Cruelty*, for example, as 'calculated to reform some reigning vices peculiar to the lower class of people'.[2] And he recorded a similar agenda for *Industry and Idleness*, which 'was calculated for the use & Instruction of youth' and represents the careers of two low-born City apprentices in terms of industry and virtue versus idleness and delinquency.[3] In contrast to the earlier modern moral subjects, these later works were produced as prints only, with less elaborate designs and priced at a comparatively lower level. *The Four Stages of Cruelty*, *Gin Lane* and *Beer Street* are commonly considered 'popular' prints, but they were priced at 1 shilling, a sum well beyond the means of the majority of Londoners. Hogarth's prints – and their stark message – could only have reached the wide audience he purportedly sought through public display, in shop windows or workshops, or through the production of low-cost copies. Hogarth attempted to address this latter possibility by commissioning woodcut prints, a far cheaper technique than copperplate etching and engraving, for *The Four Stages of Cruelty*. Only the last two plates were executed in this format.

Despite Hogarth's description of *Industry and Idleness* as for 'use & Instruction of Youth', the series clearly responded to specific middle-class concerns involving delinquency as a preamble to criminality among young working men. Hogarth later noted (with some satisfaction) that a report had reached him of a sermon inspired by *Industry and Idleness* and that masters purchased sets of prints as Christmas gifts for their apprentices. And from 1749 the series seems to have inspired the annual Christmas production of George Lillo's tragic play, *The London Merchant; or The History of George Barnwell* (1731), at the Theatre Royal, Haymarket. Interestingly, this play influenced Hogarth and has clear parallels with *Industry and Idleness*, involving as it does an honest and virtuous

*Gin Lane* February 1751
(no.98, detail)

FIGURE 36
Paul Sandby (1731–1809)
*London Cries: 'Last Dying
Speech and Confession'*
c.1759
YALE CENTER FOR
BRITISH ART

FIGURE 36

merchant named Thorowgood, his modest daughter Maria and his two apprentices, the industrious Trueman and the wayward Barnwell, who is eventually hanged for theft and parricide. The subject of Lillo's play was adapted from an existing urban fable and printed for a popular audience in broadsides (such as 'The Excellent Ballad of George Barnwell' from about 1680). Thus the story of Barnwell and the bad apprentice as an archetype was already long established by the time that Hogarth created *Industry and Idleness*.

Popular urban culture also provided positive role models. For example, in Plate 1 of *Industry and Idleness* Hogarth refers to *The Valiant London Apprentice*, the story of a hard-working and courageous young man, also in wide circulation through broadsides, and to the legendary Dick Whittington, Lord Mayor of London during the early fifteenth century. The office of Lord Mayor combined both outstanding success in business and the highest achievement of civic service in the City. Reference to Whittington underlined how venerable and time-honoured the position was and why it was promoted as the ideal for an aspiring City apprentice. However, while the series appears to be a straightforward piece of middle-class propaganda, Hogarth's commentary is laced with satire. Thus the seemingly exemplary virtues and consequent rise of the good apprentice, Francis Goodchild, can also be read as an ambiguous if not critical observation of the bourgeois values that the series ostensibly promotes. A comparable satirical streak can be detected in *Gin Lane*, *Beer Street* and *The Four Stages of Cruelty*.

In general, Hogarth's work provides an astonishing panorama of the institutions, conditions, processes and entertainments relating to crime and punishment. Moll Hackabout in Scene 4 of *A Harlot's Progress* is punished with hard labour at Bridewell Prison, a house of correction in the City (see no.43). In Scene 7 of *A Rake's Progress* (nos.44–5) Tom Rakewell is imprisoned for debt in the Fleet Prison, which was situated off the Farringdon Road in the City. By the 1750s Fleet Prison was used mainly for debtors and bankrupts. Hogarth's father Richard was confined there in late 1707, when Hogarth was only ten years old, after his Latin-speaking coffee house failed. Newgate Prison, where Tom Idle in *Industry and Idleness* and Tom Nero in *The Four Stages of Cruelty* would be held after arrest, was the most notorious of all the London prisons. Used primarily for prisoners awaiting trial

at the central criminal court at the Old Bailey, it was filthy, overpopulated and chaotic, and was described in *A Compleat History of the Lives and Robberies of the Most Notorious Highway-Men* (1719) as 'a Place of Calamity ... a habitation of Misery ... a bottomless Pit of Violence, and a Tower of *Babel*, where all are Speakers and no Hearers'.[4]

The vast majority of crimes tried at the Old Bailey were punishable by death. This was primarily because the sentencing system did not allow for long-term imprisonment (consequently the number of convicts transported to North American colonies rose during this period). Throughout the eighteenth century, however, about 50 per cent of those sentenced were pardoned. To act as a deterrent, the executions (usually by hanging) were public events, as was often the case with corporeal punishments such as whipping and standing in a pillory. Most defendants, whose death penalties were carried out in London, were hanged at Tyburn, which was positioned at the north-east corner of Hyde Park. The 'Tyburn tree' was a distinctive tripod-shaped wooden construction on which numerous criminals could be executed at once. Between 1745 and 1754, 342 men and 28 women were hanged there. Highway robbery was by far the most common offence, accounting for approximately 45 per cent of the executions. Murder constituted about 10 per cent.

Prior to execution the most notorious and celebrated criminals were often visited in prison by members of the public. Hogarth's father-in-law, James Thornhill, visited the thief and jail-breaker Jack Sheppard in 1724, and executed a vivid portrait of him in his cell (no.96). Both Thornhill and Hogarth visited the thief and murderess Sarah Malcolm at Newgate in 1733. These visits resulted in prints (see nos.95, 96) that formed part of the buoyant market for convict portraiture, trial and execution images and keepsakes, and criminal biography (Daniel Defoe, for example, published a biography of Jack Sheppard in 1725). In Scene 11 of *Industry and Idleness* Tom Idle, who is found guilty of robbery and possibly murder, is taken to Tyburn surrounded by a huge crowd of spectators. The condemned often addressed the throng, and as shown in this print and Paul Sandby's watercolour (fig.36), the speeches were published by opportunist printsellers and sold by street hawkers. Hogarth included the last speech of the murderer Silvertongue in Scene 6 of

*Marriage A-la-Mode*, p.151. After the execution there was sometimes a struggle for possession of the corpse between the assistants of surgeons, who required it for the research and teaching of anatomy, and friends and family, who wanted to give the body a Christian burial. In order to increase the terror and shame of execution, the Murder Act of 1752 dictated that those hanged for murder should be delivered to the surgeons or hung in chains. Published the year before the Act, Hogarth's macabre image, *The Reward of Cruelty*, depicts Tom Nero being anatomised after execution.

Both the execution scene of Tom Idle and *The Reward of Cruelty* chimed with Fielding's views on law and order. The paradox of the eighteenth century, as previously mentioned, was that, although the criminal code was extremely harsh, the number of acquittals by juries and pardons procured by those with influence, in Fielding's opinion, undermined the value of punishment, and in particular execution, as a deterrent to others. This was exacerbated by the celebrity accorded to hanged criminals, such as Jack Sheppard, who was one of the inspirations for Captain Macheath in *The Beggar's Opera* (see pp.70–1). Accordingly, Hogarth shows Idle, not heroic and defiant, but almost out of his wits with terror at the prospect of his hanging, and the gruesome destruction of Nero's body is flanked by the skeletons of two anatomised criminals, James Field and James Macleane, the so-called 'Gentleman Highwayman' whose trial and execution in 1750 made him a popular hero. There is no glamour or celebrity in these scenes, however: only cold reality, humiliation and death.

# 95

*Sarah Malcolm* March 1733
Etching and engraving
19.6 × 17.9
ANDREW EDMUNDS, LONDON

# 96

James Thornhill (1675/6–1734)
*Jack Sheppard* 1724
Pen and ink and chalk on paper
33 × 24.5
MUSEUM OF LONDON

Sarah Malcolm was convicted and hanged for the brutal murder of an elderly widow and her two servants, which occurred during a robbery in the Inns of Court in February 1733. Over and above the extremity of the alleged crime, her youth, gender, middle-class background, steadfast Catholicism and spirited self-defence in court served to draw attention to the case, which was reported at length in the press. Hogarth visited her in Newgate Prison a few days before her execution. The subsequent portrait, now in the Scottish National Portrait Gallery, shows her figure in full length, seated at a table in the prison cell, her arms folded with a rosary prominently positioned in front of her. The present engraving, which was priced at 6 pence, resembles the figure of Malcolm in the painting, but reduced to half-length. Most other details are omitted.

Hogarth allegedly remarked: 'I see by this woman's features that she is capable of any wickedness.'[5] However, he does not portray her as a vicious, deranged

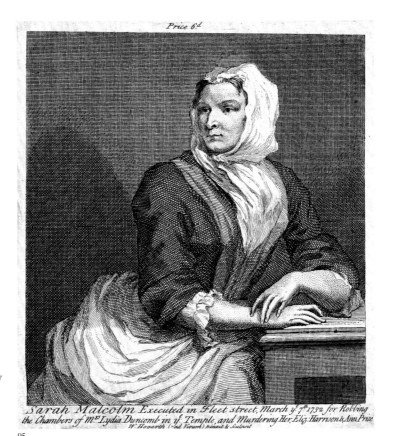

Sarah Malcolm *Executed in Fleet street, March y.* 7*.ᵗʰ 1732 for Robbing the Chambers of M.ʳˢ Lydia Duncomb in y.ᵉ Temple, and Murdering Her, Eliz Harrison & Ann Price*
*W. Hogarth (ad Vivum) pinxit & Sculpsit*

95

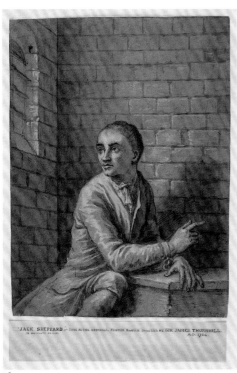

"JACK SHEPPARD." TAKEN FROM THE ORIGINAL SKETCH DRAWN IN NEWGATE PRISON BY SIR JAMES THORNHILL. A.D. 1724.

96

murderess but as a composed, intelligent and attractive woman albeit without the demureness associated with portraits of 'gentle women'. In general terms, the purpose of producing such portraits was to capitalise on the topicality of the event and the notoriety of the criminal. Moreover, Malcolm's life represented the kind of cautionary narrative that Hogarth utilised within *Industry and Idleness*, *The Four Stages of Cruelty* and other series. She was born into an Anglo-Irish merchant family in Durham but moved to London and into service after her father lost the family fortune. Her circumstances took another downward turn, when during her employment at a public house near Temple Court she came into contact with London's criminal world.

Malcolm was executed in Fleet Street in March 1733 before a huge crowd of onlookers. Although she had confessed to the robbery, Malcolm protested her innocence of the murders to the very last. Her 'confession' was printed in *The London Magazine* and *The Gentleman's Magazine* and as a pamphlet entitled 'A true copy of the paper, delivered the night before her execution by S Malcolm on the night before her execution to the Rev. Mr. Piddington, and published by him' (see Plate 11 of *Industry and Idleness*, below). Although some contemporary accounts reported that she was buried after execution, Hogarth's

*Anecdotes* states that her body was anatomised and the skeleton later donated to the Botanic Garden at Cambridge (see *The Reward of Cruelty*, nos.99–100). Malcolm did not achieve the lasting fame of two other murderesses, Catherine Hays (burned at the stake in 1726) and Mary Blandy (hanged 1752). That she was considered a paradigm of female wickedness, however, is underlined by Henry Fielding including her in a list of criminal or impassioned women in his novel *Amelia*, published in 1752.

# 97

*Industry and Idleness* 30 September 1747
Twelve prints
Etching and engraving
Each approx. 26.5 × 34.5
ANDREW EDMUNDS, LONDON

Comprising twelve individual images, *Industry and Idleness* is the largest of Hogarth's completed series. Although it deals specifically with the careers of two City apprentices and was 'calculated for the use & Instruction of Youth', the inclusion of biblical proverbs and quotations in cartouches at the bottom of each plate lend a religious context and universal significance to the work, as if *Industry and Idleness* constituted a modern-day Christian parable. Unusually in Hogarth's work, the sequence shows the rewards of diligence and decency as well as the consequences of fecklessness and criminality. These are represented throughout by the trophies positioned to the upper left and right of each scene, the rewards of virtue symbolised by the chain, sword and mace of civic office and those of vice represented by irons (prison detention), a whip (corporal punishment) and the hanging rope (capital punishment).

The 'good' apprentice, Francis Goodchild, and 'bad' apprentice, Tom Idle, are seen together in Plates 1 and 10. Throughout the rest of the series their respective 'careers' are compared and contrasted. The apprentices' physical appearance is also contrasted. Goodchild's expressions are serene and polite, his attire is orderly and his demeanour ever more elegant and gentlemanly, while Idle's features become increasingly contorted and grotesque, and his posture slovenly and misshapen. The theme of order and disorder presented by the figures of Goodchild and Idle is mirrored by their respective environments. Initially, they share the same workroom space, underscoring the parity in their social positions and potential. As the series continues, however, Goodchild is physically separated from the street and its unruly occupants. He exists within the structured, orderly world of the polite, dutiful and successful middle class, as represented by the church, the guildhall and the ceremonial coach. Hogarth underlines these qualities with compositions that are literally upright, structured and solid. Idle, on the other hand, operates outside these locales and their associated values, whether by choice or by force. His realm is the graveyard, the sea, the garret and the night cellar; these compositions are fluid, untidy and thus appear undisciplined. Consequently, while Goodchild's triumphal procession as Lord Mayor occurs at the heart of the City, Idle's ignominious execution takes place in the outskirts.

Plate 1: *The Fellow 'Prentices at their Looms*
As indicated by the tankard on the left, this

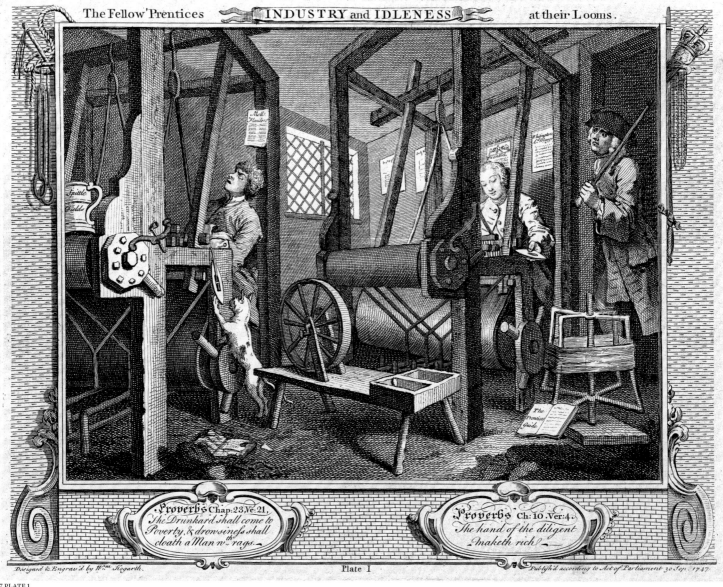

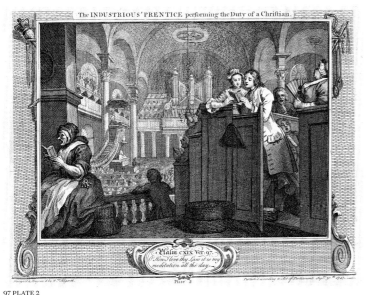

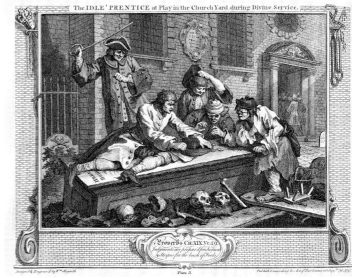

scene takes place in a workroom located in Spitalfields, the centre of London silk-weaving at this time. Goodchild works diligently at the loom. Meanwhile, Idle is fast asleep. Two volumes entitled 'The Prentices Guide' are strategically placed near them both, symbolising their respective attitudes to work and authority. The one nearest Goodchild is in pristine condition, carefully propped against a thread winder and the other is soiled, ripped and discarded on the floor. Thus the direction that each apprentice's career takes is presented as a personal choice. Above the apprentices' heads are ballads and broadsheets representing their respective role models and thus indicative of their futures. Near Goodchild's head, we read the celebrated name 'Whittington | Ld Mayor' and the title 'Valiant London 'Prentice'.

Richard ('Dick') Whittington, whose career is largely copied by Goodchild, was a historical figure around whom legends were to develop. The youngest son of a landowner, he travelled to London and was apprenticed as a mercer (dealer in cloth). After completing his apprenticeship, Whittington became a member and eventually the Master of the Mercer's Company and a wealthy and successful merchant. At the same time he moved up the civic ladder, rising from common councillor to alderman, sheriff and finally Lord Mayor of London, a position to which he was elected three times. After his death in 1423 Whittington's estate was used for charitable purposes, which included improvements to Newgate Prison and St Bartholomew's Hospital and providing almshouses for the poor. Some of Whittington's charitable bequests were benefiting society during Hogarth's lifetime.

Above Idle's head is the fictive transgressor 'Moll Flanders', the eponymous heroine of Daniel Defoe's novel, published in 1722. Born in Newgate Prison, thus the child of a convict, Moll initially works as a servant, but soon embarks upon an eventful life of prostitution, incest, adultery, bigamy and thievery, which leads her to trial at the Old Bailey and the death penalty. Her sentence to be hanged is transmuted to transportation to New England.

As with a number of scenes involving Idle, an authority figure stands nearby. Here, the master weaver enters the workroom holding a stick with which, we can imagine, Idle is about to be soundly beaten. From the beginning transgression and punishment are established as the dominant themes of his life, just as diligence and reward are those of Goodchild's.

Plate 2: *The Industrious 'Prentice performing the Duty of a Christian*
Plate 3: *The Idle 'Prentice at play in the Church Yard during Divine Service*
These scenes are meant to be read as temporally concurrent and featuring the same location. The church is representative of the establishment and indicates social and religious conformity. Thus Goodchild is in the church, while Idle is outside. In Plate 2 Goodchild's preferment in the workplace and acceptance into polite society are underlined by his occupying the master weaver's church pew and sharing a hymn book with his daughter. However, Hogarth describes Goodchild as 'Performing the Duty of a Christian', an ambiguous comment that casts doubt over the sincerity of his faith and infers that he is a social climber.

Meanwhile, Idle is shown to be more than just lazy; he is a gambler and a cheat. Clearly

at home with the criminal underclass represented by his grotesque companions, he prefers to gamble rather than attend the church service. Idle also cheats by hiding money under his hat and is sprawled over a coffin signalling his disrespectful and progressively brutalised character. The skulls and bones scattered on the ground presage his fate and remind us of the biblical 'Day of Judgement'. At the same time he is oblivious to the punishment that is about to be served by the man behind him wielding a stick.

Plate 4: *The Industrious 'Prentice a Favourite, and entrusted by his Master*
Plate 5: *The Idle 'Prentice turn'd away and sent to Sea*
Plate 4 highlights Goodchild's rise in the master weaver's business. Once he had worked at the looms on the shop floor (as seen in the background), but now he occupies the master weaver's counting office. The master leans on his shoulder in a gesture of affection and trust. The gloves on the desk, positioned like a handshake, symbolise the concord between the two men, but also suggest that a deal has been made concerning the master's business and that they are in partnership. This is made explicit in Plate 6, where the shop sign reads 'Goodchild and West'.

In contrast, Idle sets out for a life at sea, probably paid for by his mother in the hope of him finding paid employment (she sits weeping in front of him). He is accompanied on the journey to an awaiting ship by two additional characters, who take delight in goading him. One points to the vessel, the other, with his hand on Idle's shoulder (paralleling the master's gesture in Plate 4), holds a 'cat-o'-nine-tails' in his hand (a whip

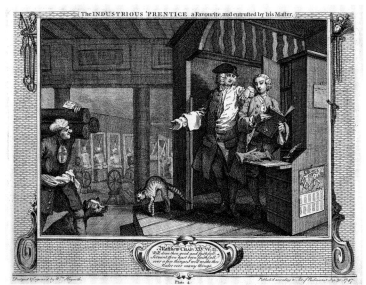

The INDUSTRIOUS 'PRENTICE a Favourite, and entrusted by his Master.

97 PLATE 4

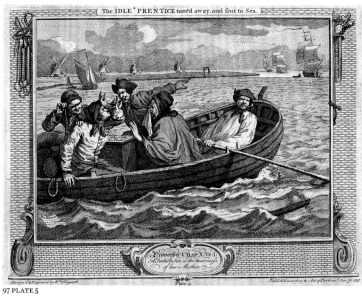

The IDLE 'PRENTICE turn'd away, and sent to Sea.

97 PLATE 5

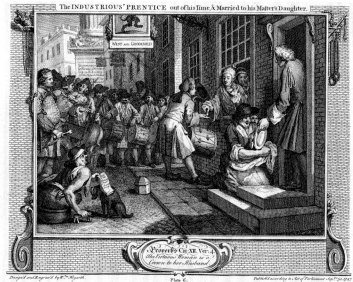

The INDUSTRIOUS 'PRENTICE out of his Time, & Married to his Master's Daughter.

97 PLATE 6

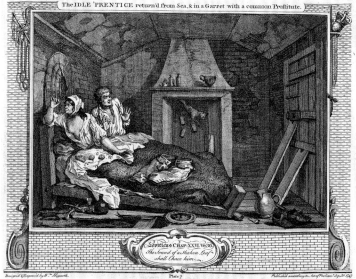

The IDLE 'PRENTICE return'd from Sea, & in a Garret with a common Prostitute.

97 PLATE 7

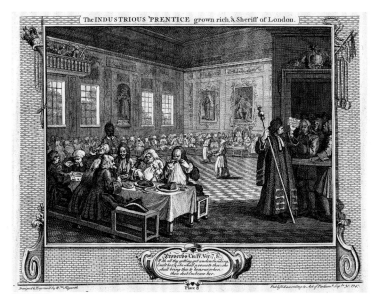

The INDUSTRIOUS 'PRENTICE grown rich, & Sheriff of London.

97 PLATE 8

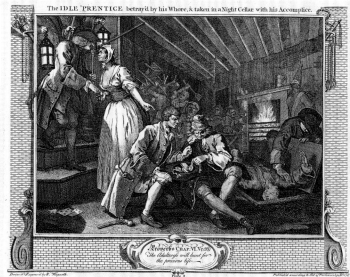

The IDLE 'PRENTICE betray'd by his Whore, & taken in a Night Cellar with his Accomplice.

97 PLATE 9

that ends with short, knotted ropes), a common form of punishment on board ship. The choppy waves and storm-filled skies portend the violence and insecurity of Idle's future.

Plate 6: *The Industrious 'Prentice out of his time, & Married to his Master's Daughter*
Plate 7: *The Idle 'Prentice return'd from Sea, & in a Garret with a common Prostitute*
In these two plates the contrasting lives of Goodchild and Idle are revealed through their relationships with the opposite sex. Goodchild has married the master's daughter, thus their union is legal and respectable. Idle's situation is the direct opposite: he is conducting a 'liaison' with a 'common Prostitute'. The consequences of these unions are played out in Plates 8 and 9.

Plate 6 takes place in Fish Street Hill near the Monument (a memorial to the Great Fire of London in 1666), the base of which can be seen in the background. The well-appointed

house occupied by Goodchild and his wife functions as both the couple's home and a work place (note the shop sign), which was common practice at this time. A servant gives the leftovers from the wedding feast to a woman kneeling at the door, which might be read as signalling Goodchild's generosity or the kind of charity that would be perceived as appropriate to his new social position. The couple have been interrupted while taking tea by a large and potentially unruly band of musicians, drummers and butchers holding bones. Although at first glance this appears to be part of the wedding celebrations, as has been noted, treating a newly-wedded couple to 'rough music' was a method of registering disapproval at marriages involving people from different social levels. The scene thus neatly underlines that Goodchild's wealth and social advancement have not resulted solely from his exemplary attitude to work. Unruffled, he drops coins into the hand of

a drummer, presumably to keep the noise/protests in check. This action may, in addition, be read as presaging his positions as sheriff, alderman, magistrate and mayor, responsible for the maintenance of public order.

Idle, too, has been interrupted by noise from outside in Plate 7. But whereas Goodchild acts calmly, having nothing to fear, Idle is startled and terrified. Contrasting with Goodchild's open door, his is locked, bolted and reinforced with planks of wood. The reason is clear. He and his partner in crime are thieving for a living, the 'rewards' of which are examined by the prostitute.

Plate 8: *The Industrious 'Prentice grown rich & Sheriff of London*
Plate 9: *The Idle 'Prentice betray'd by his Whore, & taken in a Night Cellar with his Accomplice*
Goodchild is now a wealthy man and one of

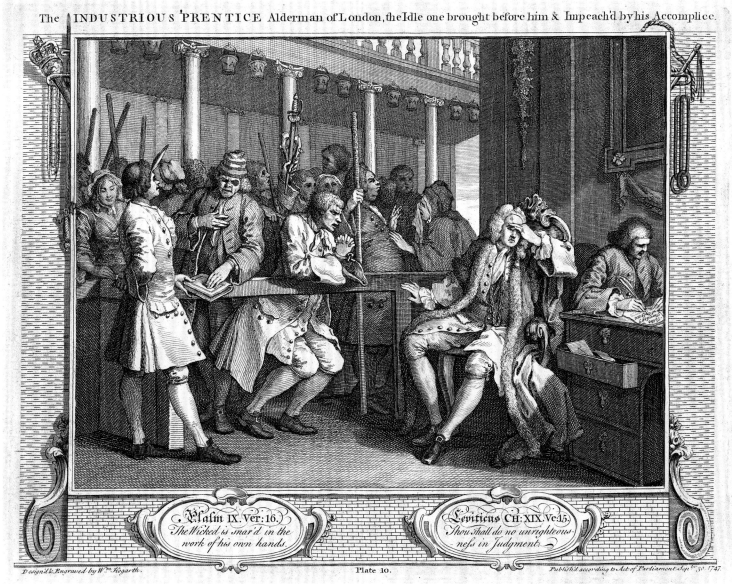

The INDUSTRIOUS 'PRENTICE Alderman of London, the Idle one brought before him & Impeach'd by his Accomplice.

*Psalm IX. Ver: 16.*
*The Wicked is snar'd in the work of his own hands.*

*Leviticus CH: XIX. Ve:15.*
*Thou shall do no unrighteous-ness in Judgment.*

Design'd & Engraved by W.m Hogarth.   Plate 10.   Publish'd according to Act of Parliament Sep.tbr. 30. 1747.

two sheriffs of London. He and his wife are guests of honour at a City banquet. They are seated in the background under a portrait of King William III. The setting has been identified as Fishmonger's Hall near London Bridge. To the right a group of men have handed a petition to an official. Meanwhile, to the left a row of merchants and lawyers gorge themselves on slabs of meat, soup and alcohol. The ambiguity suggested by Goodchild's highly advantageous marriage, introduced into Plate 7, is developed further by the proverb accompanying Plate 8: 'Exalt her, & she shall promote thee: she shall bring thee to honour, when thou dost Embrace her.' This suggests that his marriage has not only secured his position within the master's business but brought further advancements. Did he achieve the position of sheriff by his own merit or through the agency of a well-connected wife?

In contrast, Idle has been 'betrayed by his Whore'. She is rewarded for her 'treachery' by the constable who enters the night cellar. Idle, oblivious to his imminent arrest, inspects a hat full of trinkets with his grotesque accomplice. The pistol on the floor near Idle and the body being pushed through a trap door by another man on the right indicates that the robbery has ended in murder, although who is responsible is not entirely clear. Thus through the influence and actions of their respective female partners, Goodchild's and Idle's fortunes have changed abruptly and significantly. This sets the scene for their reunion in the next plate.

Plate 10: *The Industrious 'Prentice Alderman of London, the Idle one brought before him & Impeach'd by his Accomplice*
Goodchild and Idle are reunited. Whereas they had occupied the same social space in Plate 1, denoting the equality of their positions, albeit not their characters, here the social gulf that divides them is visually represented by the wooden bar. Goodchild is an alderman and a magistrate; Idle is a common criminal. The latter's partner-in-crime (from Plate 9) places his hand on a bible, swearing that his testimony against Idle is the truth. Meanwhile, in a gesture of either sorrow or revulsion Goodchild turns away from Idle, who is pleading for mercy or for a chance to tell his version of events. Either way, Goodchild cannot or will not respond to his former colleague. Equally, the court official, holding a long stick to the right, dismisses the pleas of Idle's weeping mother. The quotation from Leviticus (below Goodchild) reads: 'Thou shalt do no unrighteousness in Judgement.' Clearly Goodchild has no choice but to condemn Idle. Or has he? While Goodchild's hand gestures, especially the covering of the eyes, may represent the impartiality of the justice system, it could as easily denote 'blindness' and hence a miscarriage of justice. After all, why would the testimony of one criminal carry weight over another? That the testimony is, in fact, suspect or false is underlined by the court official who holds the bible with one hand, while receiving a bribe with the other.

Plate 11: *The Idle 'Prentice Executed at Tyburn*
Plate 12: *The Industrious 'Prentice Lord Mayor of London*
These complex, incident-filled scenes show Goodchild and Idle as the focus of crowded

The IDLE 'PRENTICE Executed at Tyburn.

Proverbs CHAP: I.Verf: 27,28.
When fear cometh as desolation, and their destruction cometh as a Whirlwind; when distress cometh upon them, then they shall call upon God, but he will not answer.

Design'd & Engrav'd by W.ᵐ Hogarth.     Plate 11.     Publish'd according to Act of Parliam.ᵗ Seb.5.ᵗ 17.t

public events: one is the Lord Mayor's procession through Cheapside in the City of London, the other, the cart ride to the gallows at Tyburn. Thus both men have achieved a kind of 'celebrity'. However, while Goodchild's continuing fame and good fortune are underlined by the cornucopias displayed in the border of the print, for Idle (as presented by the skeletons) there is only imminent death. Both Goodchild and Idle are placed towards the background, the focus being the rowdy audience and pervading carnivalesque atmosphere that seem in both cases to have the potential for a riot. In Plate 11 people are scrambling for good vantage points, doling out alcohol (centre right) and fighting (centre foreground). Nearby a man cruelly holds a dog by the tail (see *The Four Stages of Cruelty*, no.99) and a pickpocket steals from a street seller (bottom right). Such behaviour was a well-established accompaniment to public hangings: in a pamphlet entitled *An Enquiry into the Causes of the Frequent Executions at Tyburn* (1725), for example, Bernard Mandeville noted that 'from *Newgate* to *Tyburn*, is one continued

Fair, for Whores and Rogues of the meanest Sort'.[6] However, while Plate 12 appears to be more controlled and good natured, unruly behaviour is also exhibited, notably by those employed to keep the peace. In the foreground members of the militia stagger around drunk or fire indiscriminately into the air with their guns.

Earlier in the series Idle had chosen gambling and cheating in the churchyard rather than attending the church service. Now he desperately reads a Book of Common Prayer, while a Methodist clergyman evangelises over sin and damnation beside him. In the centre foreground a woman holding a child sells copies of Idle's final speech (see also fig.36, p.181). Convention dictated that convicts should have the opportunity to address the crowd, make a full confession and repent their sins. These speeches were often published afterwards as pamphlets or broadsheets by entrepreneurial printers. As demonstrated by Plate 11, however, some were issued before the execution itself. Occasionally, this was propagated by the criminals themselves in order to protest

their innocence and/or complain about perceived injustices during the legal process. Another possibility is that the clergyman seated in the coach near the gallows was responsible. From the early eighteenth century the Ordinaries of Newgate (prison chaplains who had access to criminals awaiting execution) had been publishing accounts of trials, confessions and hangings. Such accounts, as with hangings themselves, accorded with the public's prurient interest in the details of crime and subsequent punishment. But they also paralleled the basic ethos behind public hangings as a necessary deterrent, the irony being that the execution crowd proved a magnet for thieves and prostitutes. The coffin accompanying Idle suggests that he will be buried post-execution. However, the skeletons displayed either side of the print indicate that his body will be anatomised.

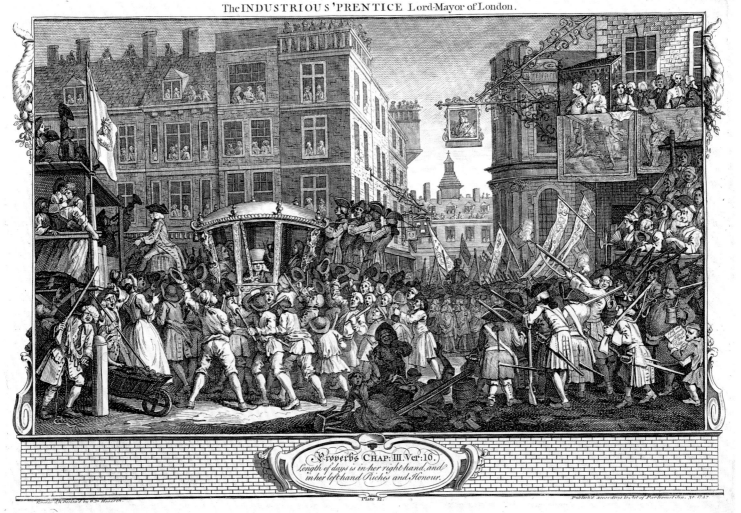

## 98

*Beer Street* and *Gin Lane* 1 February 1751
Two prints
Etching and engraving
Each approx. 38 × 32.1
ANDREW EDMUNDS, LONDON

These famous prints formed part of the successful campaign in support of the Gin Act of 1751. Despite attempts by the British government to control its production and distribution, including the unpopular Gin Act of 1736, gin drinking was at an all-time high during the first half of the eighteenth century among the poorer levels of society. This had itself resulted from an Act of Parliament in 1689 that banned the import of French wine and spirits, and encouraged the distillation of spirits from indigenous crops, thus benefiting landowners and increasing state revenue.

Unlike beer, which was relatively low in alcohol, gin (an abbreviation of the Dutch word *geneva*) was very potent and widely used as a fast-acting, inexpensive antidote to boredom, suffering and deprivation. Gin was popularly associated with working women, one of its pseudonyms being 'the ladies' delight' and was symbolised by 'Madam Geneva' or 'Mother Gin'. And while it was held responsible for numerous social ills, including a rise in crime, its effect on mothers and their children was thought to be particularly devastating, resulting in lower birth rates and an increase in child mortality. Significantly, a woman representing the antithesis of feminine modesty and decorum, as well as of maternal love and protection, is the focus of Hogarth's hellish vision of a gin-soaked society. This vision was made all the more immediate to his contemporary audience by being set in a London location, St Giles, a poverty-stricken area to the west of Bloomsbury (the steeple of St George's, Bloomsbury, with its figure of King George II, is in the distance). Conversely, *Beer Street* is staged in a relatively prosperous area within sight of the church of St Martin-in-the-Fields, the spire of which is visible in the background. By 1750, while approximately one in fifteen houses sold gin in the City of London and Westminster as a whole, in St Giles, as in other poor areas, the ratio was estimated at one in five. That St Giles was emblematic of wider concerns involving the interrelationship between poverty, social breakdown and criminality is underlined by the location being referred to in *The Four Stages of Cruelty*.

In the interest of polemics *Gin Lane* and *Beer Street* conform to the kind of polarised

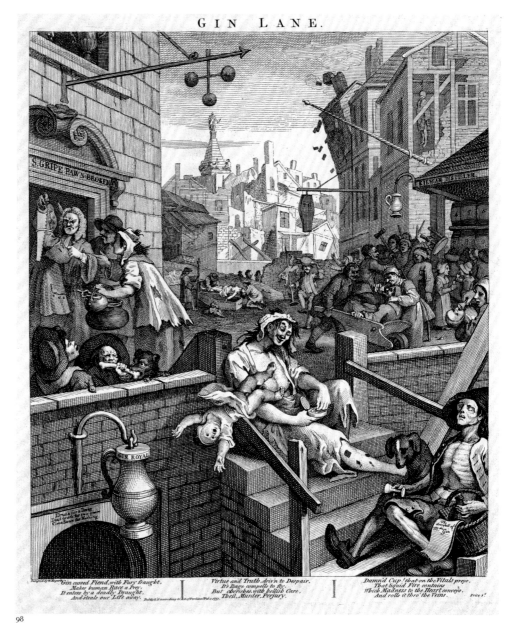

98

circumstances previously utilised by Hogarth in *Industry and Idleness* (no.97). Each represents an imagined 'reality'; two contrasting urban scenes of order and disorder, prosperity and ruination, contentment and despair. The verses at the bottom emphasise a patriotic agenda, beer being the 'happy Produce of our Isle', that 'warms each English generous Breast | With Liberty and Love', while gin, which originates in Holland, is the 'Damn'd cup' that 'cherishes with hellish Care, Theft, Murder, Perjury'. The celebratory mood of *Beer Street* is given a national context, as the day depicted is George II's birthday (30 October), denoted by the flag flying on the church spire. A copy of the king's 1748 speech to Parliament lies on the table to the left, in which he encourages 'the Advancement of Our Commerce and the cultivating Art of Peace'. A correlation appears therefore to be established between

the drinking of native beer and the political, economic and social well-being of the nation.

At first glance, the only business failing in these circumstances is the pawnbroker, whose dilapidated premises are situated on the right. In *Gin Lane*, however, the reverse is true, with the pawnbroker shop, the undertakers and the distillery being the only premises in good order. The rest of the townscape is marked by buildings that are toppling or derelict. In the streets the alcohol-fuelled crowds are being incited to riot or are pouring gin into their own or others' mouths, including the very young. The descent into barbarity is underlined by the child impaled on a spike in the centre of the composition and the man and dog sharing a bone on the left. The central figure seated on the stairs emphasises the ravages of alcoholism. Dishevelled, half-naked and oblivious to all but the snuff that she is

# BEER STREET.

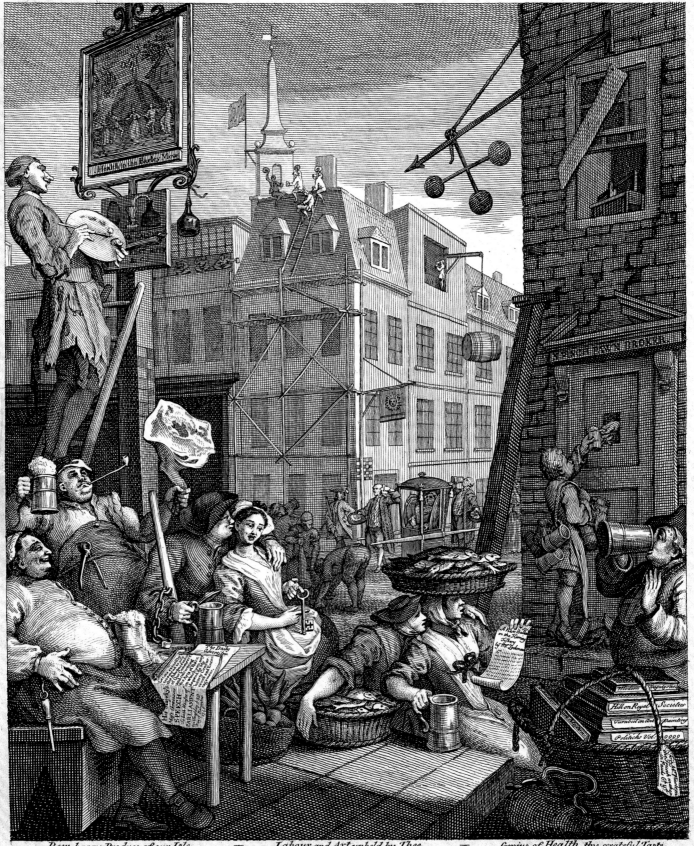

Beer, happy Produce of our Isle
   Can sinewy Strength impart,
And wearied with Fatigue and Toil
   Can chear each manly Heart.

Labour and Art upheld by Thee
   Successfully advance,
We quaff Thy balmy Juice with Glee
   And Water leave to France.

Genius of Health, thy grateful Taste
   Rivals the Cup of Jove,
And warms each English generous Breast
   With Liberty and Love.

Design'd by W. Hogarth.    Publish'd according to Act of Parliament Feb.1.1751.    Price 1s. 6d.

taking, she allows her child to fall headlong into the stairwell of a gin-cellar and to certain death. To her right sits the emaciated figure of a ballad-seller, who clutches a drinking vessel and bottle, and is drunk or perhaps dead. The black dog, a symbol of melancholy and depression, sits next to him.

The inclusion of an artist in *Beer Street* (standing on the ladder to the left) is open to a number of interpretations. Even though society as a whole prospers, his sole means of employment is to paint signs. Also his impoverished, scrawny appearance is in jarring contrast to the corpulent figures around him. Hogarth may have included him as a poignant reminder of society's neglect of native artists. Interestingly, the artist is painting a sign that advertises gin. This is the only direct reference to the liquor and its contemporary associations within *Beer Street*. It may therefore constitute a warning that the utopia of *Beer Street* is conditional rather than secure. Another reading would be that the artist is from the community represented in *Gin Lane*. Thus the two scenes are concurrent and connected. A statue of the reigning monarch presides over the havoc of *Gin Lane* (note the sign in the stairwell reads 'Gin Royal'). Given that the gin craze had been fuelled by government policy in the first place, with many profiting from its production and retail, Hogarth may be suggesting that the wealth in *Beer Street* has resulted directly from the exploitation of the community in *Gin Lane*.

## 99

*The Four Stages of Cruelty* 1 February 1751
Four prints
Etching and engraving
Each approx. 38 × 32
ANDREW EDMUNDS, LONDON

## 100

John Bell (active 1750s) after William Hogarth
*Cruelty in Perfection* and *The Reward of Cruelty* 1751
Two prints
Woodcut
Each approx. 45 × 38
ANDREW EDMUNDS, LONDON

The main protagonist of this series is Tom Nero, who starts out in the care of the parish of St Giles-in-the-Fields, the same location represented in *Gin Lane* (no.98). While *Gin Lane* showed gin drinking (and its consequences) as an epidemic, here we see another albeit related social epidemic – that of wanton cruelty. In his 'Autobiographical Notes' Hogarth tells us that the images 'were done in the hopes of preventing in some degree that cruel treatment of poor Animals which makes the streets of London more disagre[e]able to the human mind, than any thing what ever[,] the very describing of which gives pain'.[7] Indeed, the very first scene shows youths already comfortable in their abuse of animals. As the series progresses, however, it becomes apparent that society as a whole is either indifferent to or encouraging violent behaviour. In the second scene four lawyers (representing the legal system) are depicted with facial features that are as grotesque as those who are beating animals in the street. They show a complete lack of concern for the cruelty inflicted on the horse pulling their cart, thus inadvertently giving licence to Nero, the perpetrator. The extended moral of the whole series, therefore, is that cruel children, if left unchecked by society, become cruel adults. Indeed, Hogarth suggests that it is a natural progression from Nero's abuse of animals to his life of crime, culminating in his vicious attack on another human being. Only then, belatedly, does the establishment intervene with an act of legalised violence: hanging. The final scene continues the theme to startling and ironic effect, when, after execution, Nero's body is brutally and gratuitously dissected, watched by lawyers, physicians, surgeons and gentleman onlookers.

*First Stage of Cruelty*
This street scene shows a group of youths, almost all of whom are participating in or encouraging the abuse of animals and birds. Boys are seen tying a bone to a dog's tail, cauterising the eyes of a bird, stringing up kittens from a signpost or cockfighting. A dog savages a cat in the foreground, applauded by an onlooker. Arguably, the worst abuse, however, is being inflicted by Nero, who, dressed in a ragged uniform with 'St G' [St Giles] on the sleeve, pushes an arrow into the anus of a terrified dog being restrained by two other boys. Another youth, better dressed and 'of gentler Heart', is distressed by what Nero is doing and attempts to stop him by offering a tart as an incentive. His finer features and compassionate expression contrast with the grotesqueness of Nero and others around them. As the legend below states, 'Cruelty disgusts the view, while Pity charms the sight.' To the left of Nero a boy, not unlike a young Hogarth, draws a hanged man on the wall and points at him, underlining the inevitable: that Nero's behaviour will deteriorate further and cost him his life.

*Second Stage of Cruelty*
This scene, set in Holborn, suggests that the abuse of animals is widespread on the streets of London. On the left Nero (now grown-up) beats his horse, the poor creature having collapsed under the strain of the cart. This is overladen with four lawyers, who are too penny-pinching to hire two carts and insensitive to the suffering they are causing. One person, however, is jotting down Nero's carriage number, so that he can report him to the authorities. Nearby a donkey is similarly overburdened and prodded with a pitchfork. On the right an exhausted lamb 'dies beneath the Blows' and a child is crushed under the wheels of a cart, while the driver sleeps. The last is the first indication in the series that cruelty is directed towards human beings. On the left the posters displayed near the door of 'Thavies Inn Coffee House' underline that violence and cruelty are utilised in the name of popular entertainment. One poster advertises 'Broughton's Amphitheatre', a well-known venue for boxing. 'James Field' and 'George Taylor', named below, were celebrated pugilists. Importantly, Field was hanged for highway robbery eleven days before Hogarth's print was published, thus establishing an interrelationship between violent sports, entertainments and criminality. The poster beneath advertises cockfighting, recalling an incident in Plate 1.

## FIRST STAGE OF CRUELTY.

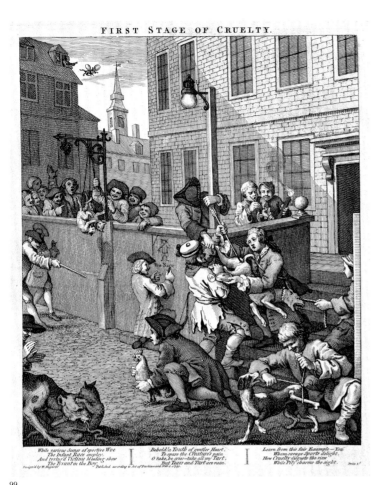

While various Scenes of sportive Woe
The Infant Race employ.
And tortur'd Victims bleeding shew
The Tyrant in the Boy.

Behold! a Youth of gentler Heart,
To spare the Creature's pain,
O take, he cries—take all my Tart,
But Tears and Tart are vain.

Learn from this fair Example—You,
Whom savage Sports delight,
How Cruelty disgusts the view,
While Pity charms the sight.

Designed by W. Hogarth.     Published according to Act of Parliament Feb.y 1. 1751.     Plate 1st.

99

## SECOND STAGE OF CRUELTY.

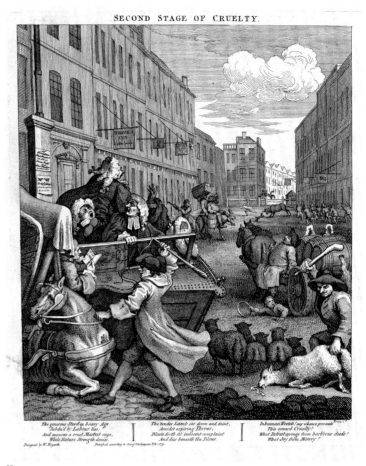

The generous Steed in hoary Age
Subdued by Labour lies;
And mangled by a cruel Master's rage,
While Nature Strength denies.

The tender Lamb o'er drove and faint,
Amidst expiring Throws;
Bleats forth its innocent complaint
And dies beneath the Blows.

Inhuman Wretch! say whence proceeds
This coward Cruelty?
What Int'rest springs from barb'rous deeds?
What Joy from Misery?

Designed by W. Hogarth.     Published according to Act of Parliament Feb.y 1. 1751.     Plate 2.

99

## CRUELTY IN PERFECTION.

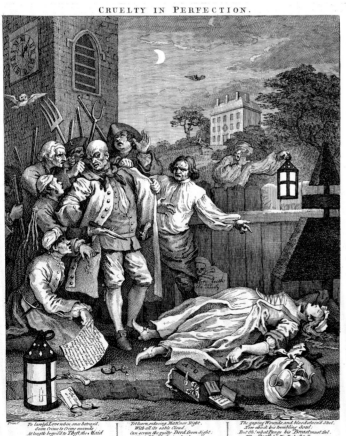

To lawless Love when once betray'd.
Soon Crime to Crime succeeds:
At length beguil'd to Theft, the Maid
By her Beguiler bleeds.

Yet learn, seducing Man! nor Night,
With all its sable Cloud,
Can screen the guilty Deed from sight;
Foul Murder cries aloud.

The gaping Wounds and bloodstain'd Steel,
Now shock his trembling Soul:
But Oh! what Pangs his Breast must feel,
When Death his Knell shall toll.

Published according to Act of Parliament Feb.y 1. 1751.     Designed by W. Hogarth.

99

## THE REWARD OF CRUELTY.

Behold the Villain's dire disgrace!
Not Death itself can end.
He finds no peaceful Burial-Place,
His breathless Corse, no friend.

Torn from the Root, that wicked Tongue,
Which daily swore and curst!
Those Eyeballs from their Sockets wrung,
That glow'd with lawless Lust!

His Heart expos'd to prying Eyes,
To Pity has no Claim:
But, dreadful! from his Bones shall rise,
His Monument of Shame.

Published according to Act of Parliament Feb.y 1. 1751.     Designed by W. Hogarth.

99

### Cruelty in Perfection

Nero has embarked on a life of highway robbery. He is seen here being apprehended after committing a murder in the dead of night. As with Tom Idle in *Industry and Idleness*, Hogarth underlines that the reality of being a highwayman is far from the glamorous, romantic existence presented by popular heroes such as Captain Macheath in *The Beggar's Opera* (see nos.38–9). Indeed, Nero's grotesque appearance conveys the inherent viciousness of his character and brutalising way of life. His victim, Ann Gill, his lover and partner-in-crime, lies prostrate on the floor, her throat slit. Her swollen stomach makes it clear that she was pregnant. Scattered around the body are personal effects, including a Book of Common Prayer, and stolen goods, wrapped in a cloth. In the note addressed to Nero, near the lantern on the left, Gill expresses guilt at her crimes. She has evidently resorted to stealing from her employer's house (seen in the background) for love of Nero, but confesses that 'my Conscience flies in my face as often as I think of wronging [my mistress]'. Thus Nero is presented as a corrupting influence on a decent but impressionable young woman. It is possible that he has killed her because he feared betrayal. That Nero regrets his actions, or at least the extreme punishment he will receive because of them, is suggested by the horror in his face and the accompanying verse that reads: 'But oh! what Pangs his Breast must feel, | When Death his Knell shall toll.'

### The Reward of Cruelty

This macabre scene takes place in the Cutlerian theatre near Newgate Prison, which was used by the Company of Surgeons between 1745 and 1751. Nero has been hanged at Tyburn (the rope remains around his neck). As was the case with other executed criminals, his body is being dissected for the purpose of studying anatomy. Those present are either looking on impassively or talking among themselves. The chief surgeon sits in the centre on a high-backed chair with the royal coat of arms hanging above, thus resembling a high court judge. This neatly represents the official process of judgement and punishment, which in the case of hanged criminals could extend beyond death itself. The badge of the Royal College of Physicians can be seen on the back of the chair, which shows a hand taking another hand's pulse. This denotes the College's mission to preserve life, the pursuit of which is the justification for the present scene of barbarity. The chief surgeon's expression is detached, even vaguely disdainful, as he prods the body with a pointer. Nero's head is lifted by a rope and pulley, which have been screwed into his skull. One eye is being gouged out. Meanwhile, the intestines are pulled roughly from his chest and fed into a bucket. The dog in the foreground eats Nero's heart, an act of poetic justice. The evident relish with which Nero's body is being pulled apart is mirrored by the cannibalistic display of skulls and bones in a boiling cauldron.

As a piece of propaganda, this image was calculated to deromanticise criminality and its consequences. The skeletons of dissected criminals were usually refused a Christian burial and subsequently displayed as specimens. In niches to the left and right the skeletons of James Field, the boxer-turned-thief (mentioned in *Second Stage of Cruelty*), and the 'gentleman highwayman' James Macleane are exhibited. In life both men were celebrities. In death their skeletons point towards each other, jaws opened in macabre laughter, as if mocking their ignoble fate.

# 101

*The Cockpit* (or *Pit Ticket*) 5 November 1759
Etching and engraving
31.8 × 38.5
ANDREW EDMUNDS, LONDON

This tumultuous scene is set in the Royal Cockpit in Birdcage Walk near St James's Park. In his *London Journal* (1763) James Boswell gave a vivid account of a cockfight: 'The uproar, and the noise of betting, is prodigious. A great deal of money made a quick circulation from hand to hand.'[8] As Hogarth shows, cockfighting was a popular sport enjoyed by men from all levels of society. The diverse crowd includes aristocrats, tradesmen, a farrier, a chimneysweep, a footman, a butcher, a carpenter, a Quaker and even a hangman (with a gibbet drawn on his back, bottom right). Although women were not allowed to attend these events, the wall on the right sports a portrait of Nan Rawlings, the 'Duchess of Deptford', a well-known cock feeder and trainer. In the centre the figure of the blind Lord Albermarle Bertie presides over the fight, taking bets. An inveterate

gambler, Bertie was the second son of the 2nd Duke of Ancaster and thus a member of one of the wealthiest and most important aristocratic families in the country.

Hogarth had made reference to cockfighting and obsessive gambling in *A Rake's Progress*. The cold reality of the sport is here underlined by the men's insensitivity to the cruelty inflicted in the name of entertainment as they jostle each other, scramble to make bets and shout encouragement at the sparring birds in the centre. As Boswell noted in his *Journal*, 'I looked round to see if any of the spectators pitied [the cocks] when mangled and torn in a most cruel manner, but I could not observe the smallest relenting sign in any countenance'.[9] In this context the scene relates directly to *The Four Stages of Cruelty* (nos.99–100). In the *First Stage of Cruelty* cockfighting is portrayed as one of a number of abuses against animals. As the series progresses, the behaviour of the main protagonist, Tom Nero, degenerates further, ending in a brutal murder for which he is executed, as is presaged in the first scene by

the drawing of a hanged man on the wall.

*The Cockpit* demonstrates that society as a whole both tolerates and encourages violence. The presence of the hangman in the foreground, who appears to be observing rather than participating, repeats the connection between animal cruelty and criminality established in *The Four Stages of Cruelty*. Given this, it is telling that the compositional focus of *The Cockpit* is a high-ranking aristocrat. Commentators have noted how the scene echoes *The Last Supper* by Leonardo da Vinci, with Lord Bertie correlating with the centrally positioned Christ figure. However, Bertie's frontal pose also resembles that of the chief surgeon in *The Reward of Cruelty* (note that the royal coat of arms is prominently displayed in both scenes). Hogarth described *The Four Stages of Cruelty* as 'calculated to reform some reigning vices peculiar to the lower class of people'. *The Cockpit* underlines the fact that members of the ruling elite actively participated in these 'reigning vices' and were thus, ironically, leading 'the lower class of people' by example.

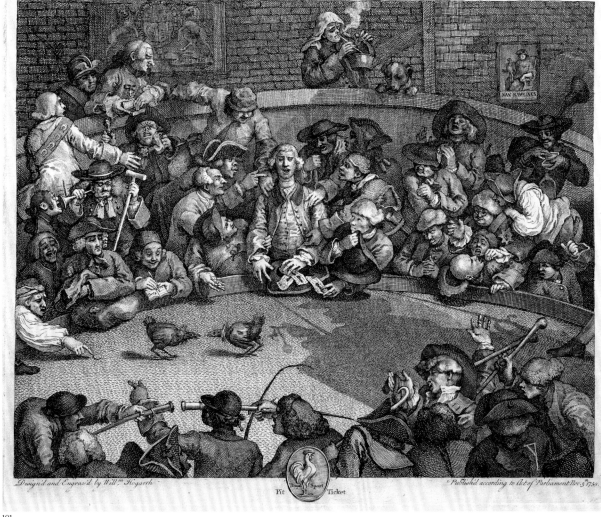

101

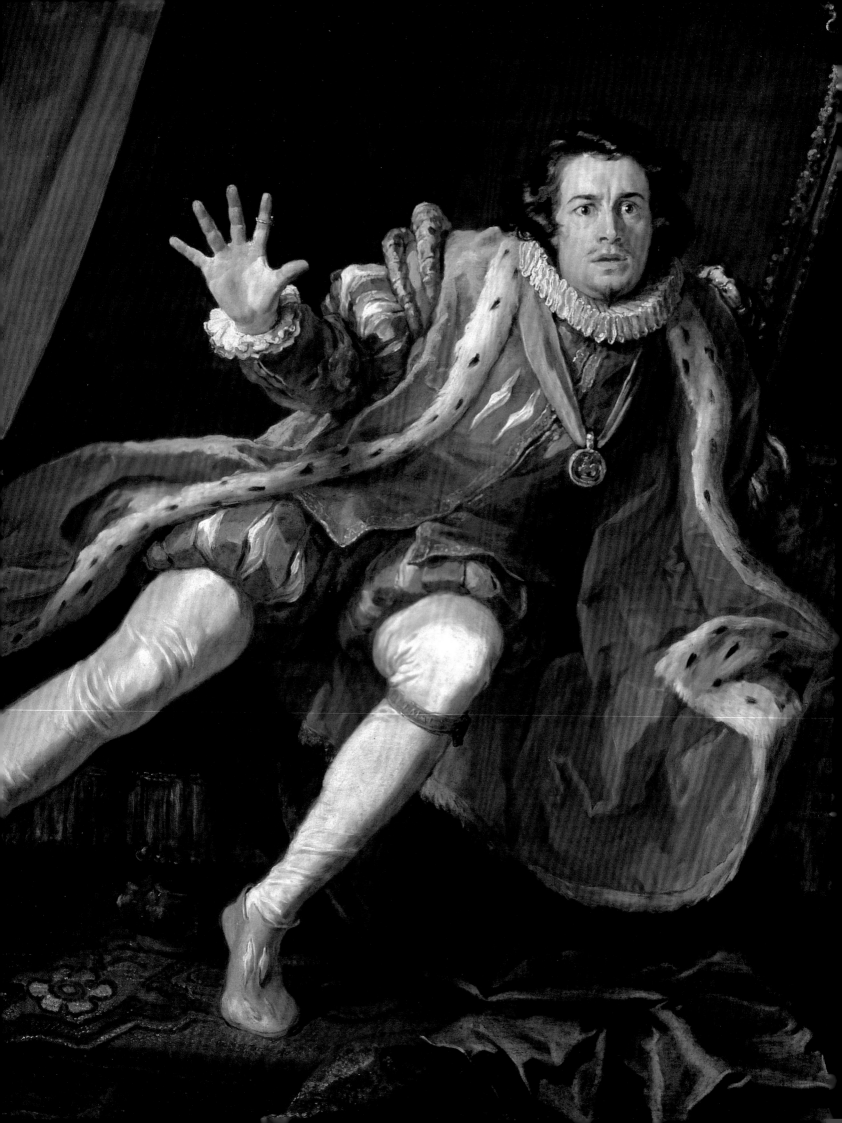

# 9
# High Art
## *Mark Hallett*

In a period during which high art – that is, large-scale works of art dealing with canonical literary, historical and religious subjects – received precious little stimulus in Britain, Hogarth succeeded in producing a number of ambitious history paintings, including such monumental works as the Ascension altarpiece he painted for St Mary's Church in Bristol in 1756 (fig.37). Given the absence of any sustained patronage for history paintings from the state, the church and the English aristocracy, it is noteworthy that he managed to monopolise the most prestigious commissions that did emerge from these quarters during his career, and exploit the potential of the new London hospitals as sponsors and venues for such canvases. In pictures such as *David Garrick as Richard III* (no.105), meanwhile, he successfully imbued portraiture with the trappings, gravitas and thematic depth expected of history painting.

Yet, of all Hogarth's works, his exercises in high art remain the least studied and understood.[1] This is partly to do with the fact that the scale, condition and location of a number of his most ambitious historical and religious paintings have meant that they have rarely been presented to a wide public. A more important reason for the neglect that this branch of Hogarth's activity has suffered is a long-standing assumption that the artist's true talents lay elsewhere, particularly in the sphere of pictorial satire, and that his history paintings represented an unwise foray into a genre for which he was artistically unsuited and untrained. In the words of Sir Joshua Reynolds, writing later in the eighteenth century,

*David Garrick as Richard III* 1745 (no.105, detail)

FIGURE 37
*The Altarpiece of St Mary Redcliffe* 1756
BRITSTOL'S CITY MUSEUMS, GALLERIES & ARCHIVES

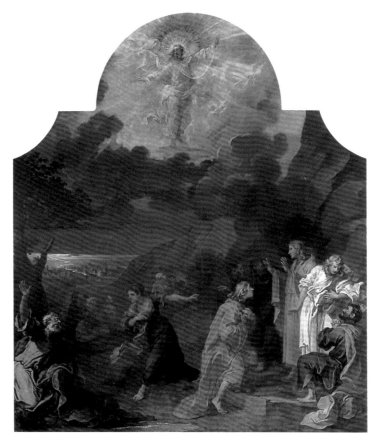

FIGURE 37

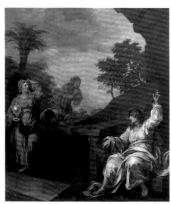

Hogarth 'very imprudently, or rather presumptuously, attempted the great historical style, which his previous habits had by no means prepared him ... it is to be regretted, that any part of the life of such a genius should be fruitlessly employed.'[2]

Reynolds's comments offer a milder example of the vicious, elitist forms of criticism that the artist's historical works had sometimes attracted during his own lifetime. The tragic literary heroine of his *Sigismunda* (no.111), for example, was described by the aristocratic connoisseur Horace Walpole as 'a maudlin whore tearing off her trinkets that her keeper had given her, to fling at his head'. Walpole goes on to note that 'her fingers are bloody with [her lover's] heart, as if she had just bought a sheep's pluck [heart] in St James's market'.[3] The tone of Walpole's words suggests a final reason why Hogarth's history paintings were not always given the respect so freely granted to his other works: the perception that they were somehow infected and undermined by the pictorial traces of the 'low' urban culture from which the artist himself had emerged, and which he depicted so brilliantly in his satires.

This kind of criticism has cast a long shadow, one that still obscures the richness and interest of Hogarth's history paintings. The time has perhaps come for a sustained reassessment of his essays in high art, not so much in terms of their respective success or failure, or in terms of their merits when compared to his other inventions, but rather in terms of their continual refusal to cleave to the ingrained conventions of the genre, and their project of bringing together the noble and the grotesque within the same image. Over and over again, as we look at his history paintings, we find Hogarth exploring and experimenting with the relationship between the ideal and the abject, the high and the low. In so doing, the artist challenged and redrew high art's boundaries in fascinating ways. Far from operating in a sphere of dignified remove, or demonstrating the pictorial decorum expected by observers such as Walpole, Hogarth's history paintings, in their restless engagement with the issues of illness and suffering, sexual desire, patricide, racial difference, familial breakdown, tyranny, corruption and the inequalities of class, and in their continuous experimentation with pictorial narrative and form, emerge as vital, critical and highly animated works of art. They fuse the storylines of history, religion and literature with the themes and preoccupations of the early eighteenth century, and rework the pictorial vocabulary and structures of high art in exceptionally inventive ways. It is not perhaps so much that these pictures 'fail', as that – even today – they challenge too radically the expectations that we, following in the footsteps of Reynolds and Walpole, bring to the genre of eighteenth-century history painting.

# 102

*Study for 'The Pool of Bethesda'* c.1735
Oil on canvas
62 × 74.5
MANCHESTER CITY GALLERIES

This painted study, as well as alerting us to Hogarth's first major project as a history painter, helps us to understand better how he embarked on a particularly ambitious canvas. The study is for the enormous picture of *The Pool of Bethesda* that continues to hang alongside its pendant, *The Good Samaritan*, at St Bartholomew's hospital in London (fig.38). These works, the artist's first attempts at history painting on such a large scale, were painted after Hogarth, hearing that the Italian painter Jacopo Amigoni was negotiating with the governors of St Bartholomew's to decorate the hospital's newly built ceremonial stairwell, offered his own artistic services for free. In *The Pool of Bethesda* Hogarth depicts the episode from the New Testament when Christ moves amidst a gathering of 'impotent, blind [and] withered' sufferers at the sacred pool of Bethesda, whose waters, when disturbed by the seasonal visit of an angel, supposedly had the power to cure the first person who entered them (John 5: 7). Hogarth focuses on the central moment of this parable, when Christ miraculously heals a lame man whose poverty and disability had precluded him from ever enjoying the pool's benefits. In the sketch, as in the finished painting, Hogarth surrounds his central protagonists with a host of diseased men and women, many of whom are grotesquely disfigured; he also incorporates into both images the reclining, near-nude figure of an infected courtesan, who is seen – in somewhat different poses – ordering her servants to hinder the passage of a poor woman and her suffering baby towards the pool.

The final painting has attracted particular notice for its combination of the heroic and the grotesque, which provides an early testament to the artist's unwillingness to conform to the conventions of pictorial decorum. In *The Pool of Bethesda* the idealised imagery of Christ, the lame man and the flying angel – familiar from numerous Old Master paintings of the subject – is on the point of being overwhelmed by the shockingly frank iconography of the abject, the brutalised and the corrupt that spills out from the painting's sides. Hogarth's oil study makes it clear that this was always his intention, and also alerts us to the artist's interest – at this stage of such a project – in the dynamics

of movement, gesture and narrative, and in the image's compositional and tonal structure. In the sketch action is more compressed than in the final painting, and the group of figures are mapped onto a simplified backdrop, made up of two great arches, a shadowed wall and a sign-posted tree. The facial features of most of the protagonists are summarily blocked in – only those of a young woman, her hand raised to her head as she looks up at the sign, are pictured in any detail. Instead, Hogarth seems preoccupied with organising figures across space and exploring the pictorial relationships between them. We can see, for instance, how the posture and semi-nudity of the lame man echo those of the courtesan, and the way in which Hogarth, in the sketch, tries showing Christ with his right arm gesturing outward to the lower corner of the image, whereas by the final painting he has decided instead to depict Christ as gesturing with his left arm towards the lame man at the picture's centre. In the sketch Hogarth also experiments with the dramatic juxtaposition of silhouetted arches and shadowed heads against the illuminated sky, and with the arrangement of colours: it is interesting to note, for example, that in the move from sketch to painting the colours of Christ's robes are reversed, presumably to make his figure stand out better against the murky background.

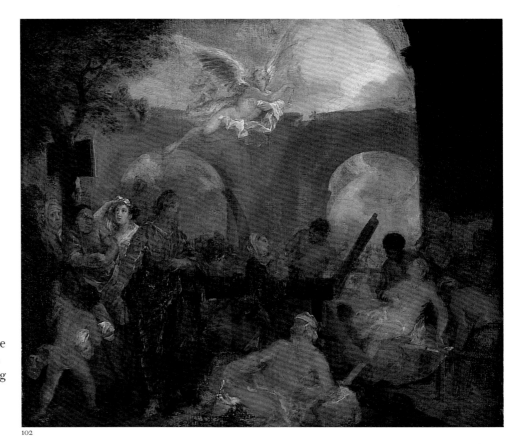

102

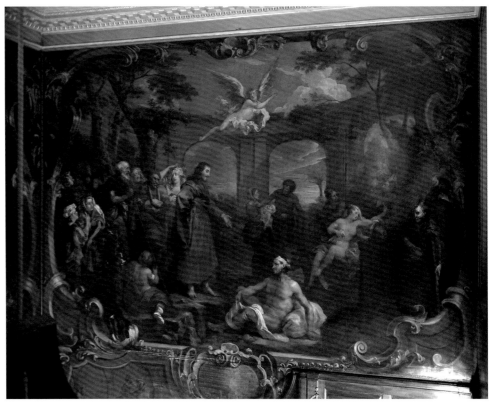

FIGURE 38
*The Pool of Bethseda* c.1735
ST BARTHOLOMEW'S
HOSPITAL, LONDON

# 103

*Satan, Sin and Death (A Scene from Milton's 'Paradise Lost')* c.1735–40
Oil on canvas 61.9 × 74.5
TATE. PURCHASED 1966

This remarkable, unfinished canvas pictures
the scene in Milton's *Paradise Lost* in which Sin
– 'woman to the waist, and fair, | But ended
foul in many a scaly fold | Voluminous and
vast, a serpent armed with mortal sting' –
intervenes between the armed figures of Satan
and Death as they prepare to fight at the gates
of hell.[4] She is shown on the point of revealing
to Satan that she is both his daughter and a
former lover, and that the skeletal figure of
Death is the offspring of their incestuous
relationship.

David Bindman has noted that Hogarth's
choice of topic may well have been suggested
by the painter and theorist Jonathan
Richardson, whose *Explanatory Notes on
Paradise Lost*, published in 1734, recommended
this particular scene to history painters.[5] In
taking up this challenge, Hogarth was drawing
on earlier graphic illustrations of the scene,
in particular an engraving after a design by
Sir John Medina that adorned a regularly
re-published edition of the poem.[6] While
reproducing such details as Satan's dress and
Death's pose from these precedents, Hogarth
nevertheless departs from them by focusing
not so much on the conflict between Satan and
Death, but on the moment of Sin's dramatic
intervention. As Ronald Paulson has
observed, the resultant image offers an echo of
the artist's *Beggar's Opera* paintings (no.38), in
which the figures of Polly Peachum and Lucy
Lockit are also shown intervening between,
and pleading with, pairs of men.

Here, however, the drama of feminine
intervention and revelation is translated into
a sublime and grotesque register, and
complicated by the abhorrent narratives
accruing to each character. Does Sin demand
to be understood only as a foul and bestial
figure or rather, as Hogarth's painting and
Milton's text both suggest, as at least a partly
tragic victim, eager to prevent an unknowing
parricide and desperate to stem the flow of
horrific events from which she enjoys no 'rest
or intermission'?[7] Interestingly, in Hogarth's
canvas she is pictured as if trapped and
imprisoned by the many-headed tentacles that
wrap themselves around her torso and writhe
from her waist; furthermore, her expression
and her gestures are tender and imploring,
rather than malicious or manipulative. Here,
then, Hogarth attempts to fuse a feminised
iconography of sentiment with a sublime and
grotesque imagery of hell-fire, violence and
monstrous masculinity.

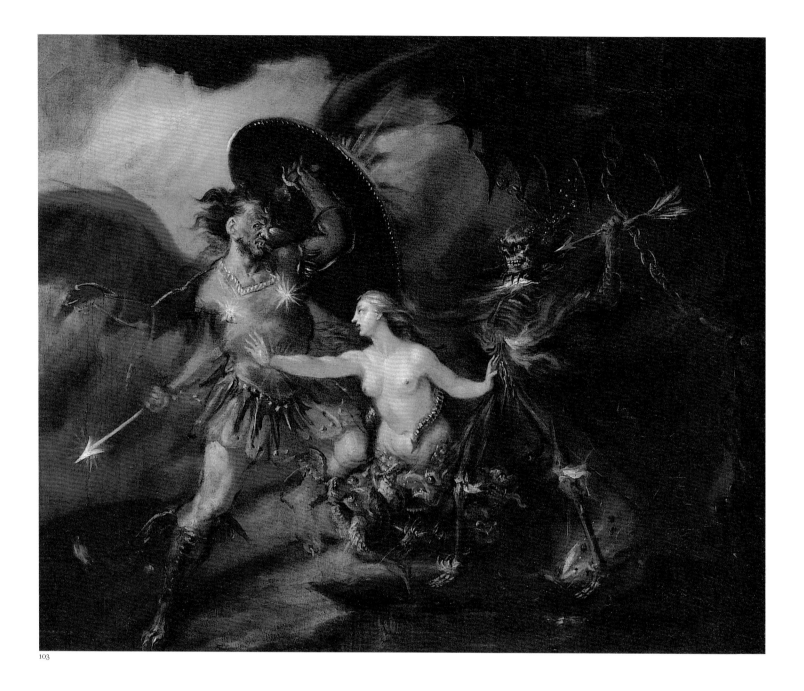

103

## 104

*A Scene from 'The Tempest'* c.1730–5
Oil on canvas
80 × 101.6

NOSTELL PRIORY, THE ST OSWALD
COLLECTION (NATIONAL TRUST. ACQUIRED
WITH THE HELP OF THE ART FUND IN 1971)

This was an important picture for the artist, in that it was an exercise in small-scale history painting executed for one of Hogarth's small band of devoted aristocratic patrons, the 2nd Earl of Macclesfield. Elizabeth Einberg points out that the work was prominently displayed in the dining room of the earl's London house, and we can imagine that Hogarth hoped it would stimulate future commissions of a similar kind.[8] Though these never materialised, the painting itself is a rich and remarkable one, unjustly neglected in the standard scholarship on the artist.

Hogarth here paints a scene from Shakespeare's *The Tempest* in which – as in *Satan, Sin and Death* (no.103) – a central female figure plays a pivotal and complex role. The depicted moment is adapted from Act 1, Scene ii, when *The Tempest*'s beautiful and virginal heroine, Miranda, first encounters her future husband, the royal prince Ferdinand, who has just been washed up on the remote Mediterranean island where Miranda and her father, the magician-like Prospero, live in exile. Hogarth places Miranda's seated, partially unclothed figure within a cordon of male figures that includes on the left the instantly besotted Ferdinand; her father, who hovers over his daughter's shoulder with a wand in his hand; and, on the right, Caliban, the 'savage and deformed native of the island' who acts as one of Prospero's servants. Caliban's fellow servant, Ariel, sings and plays music overhead.

In the painting Miranda is the focus of a trio of possessive male looks: that of the protective but manipulative Prospero; that of Ferdinand, who, having seen her, instantly declares that he wishes to possess her as his wife, 'if a virgin'; and the leering, aggressive look of Caliban, who is described in Shakespeare's text as having earlier tried to rape Miranda, and who is painted as if still desperate to sexually possess her tantalisingly exposed body. Furthermore, Hogarth, following Shakepeare's lead, assigns Miranda an unusual degree of erotic agency: she seems to be depicted at the moment when she first sees Ferdinand and exclaims 'I might call him a thing divine, for nothing natural I ever saw so noble': her cheeks are flushed, she raises one hand in astonishment, and – perhaps most suggestively of all – she spills the bowl of milk with which she has been feeding a pet lamb. David Dabydeen has recently argued that Hogarth uses such details to link Miranda's flush of desire to the sensuous appetites of Caliban himself, observing that the spillage of the liquid from the lamb's bowl echoes 'in pointed detail the escape of spittle from Caliban's mouth. Typically, spillage in Hogarth's art signifies sexual desire: here, Miranda is as aroused by Ferdinand's presence as Caliban is aroused by hers.'[9]

Another important aspect of the painting is its engagement with the theme of racial difference. As many scholars of Shakespeare's text have pointed out, the relationship between the authoritative, white figures of Prospero and Miranda and the dark-skinned 'native' servant, Caliban, is powerfully resonant of Western, colonial prejudices and fantasies concerning the black male's sexual proclivities and innate primitivism. In Hogarth's painting these resonances intermingle with the other forms of sexual desire and masculine possession on display.

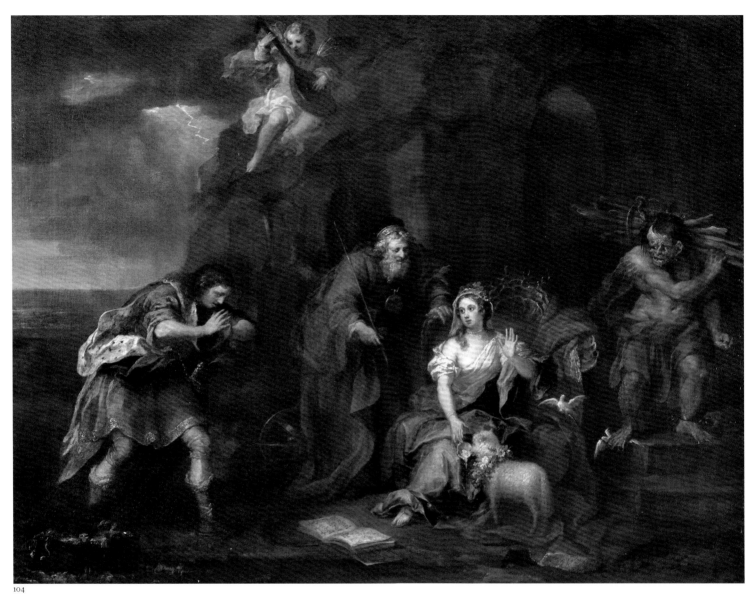

104

## 105

*David Garrick as Richard III* 1745
Oil on canvas
190.5 × 250.8
NATIONAL MUSEUMS LIVERPOOL
(WALKER ART GALLERY)

## 106

William Hogarth, assisted by Charles
Grignion (1721–1810)
*Mr. Garrick in the Character of Richard the 3d*
(second state) 20 June 1746
Etching and engraving
41.9 × 52.8
ANDREW EDMUNDS, LONDON

This monumental canvas, and the engraving that quickly followed in its wake, provide a spectacular portrait of eighteenth-century Britain's most famous actor. At the same time, they offer a complex representation of a particularly resonant literary and historical 'character' – that of Shakespeare's Richard III.

David Garrick had burst onto the capital's theatrical scene in 1741 with his portrayal of Shakespeare's *The Tragedy of Richard III*, a performance that contemporaries hailed as introducing a new degree of realism and expressiveness onto the English stage. Garrick quickly established himself as London's leading actor, and in 1745 extended his power within theatrical culture by taking over the management of Drury Lane Playhouse. Hogarth's painting, produced in the same year, pictures the actor in the role that first brought him acclaim, and at the moment in Act V, Scene v, of *Richard III* when the tyrannical king awakes from a nightmare-infested sleep on the battlefield at Bosworth. Having been accosted by the ghosts of his many victims during his dream, Richard starts up in his tent, sputtering a series of commands and imprecations, before launching into a fearful, melancholy speech:

> Give me another horse! Bind up my
>    wounds!
> Have mercy, Jesu! – Soft, I did but
>    dream.
> O coward conscience, how dost thou
>    afflict me?
> The lights burn blue. It is now dead
>    midnight.
> Cold fearful drops stand on my
>    trembling flesh.

Hogarth captures Richard's terror – and Garrick's communication of that terror – through a combination of telling pictorial details. Thus, the king's gesture of holding onto his sword with his left hand suggests not only his instinctive resort to arms when under threat but also a desperate groping for support. The king's face, illuminated by bright candlelight, is expressive of hallucinatory nightmare and semi-conscious speech: his wide eyes tell of the parade of ghosts he has just been witnessing in his dreams, while his mouth is parted, as if muttering his first, startled words on awakening. Most eloquent and remarkable of all is the palm of the king's right hand – placed right in the middle of the canvas and in perfect parallel to the picture plane – which, in staving off the ghostly accusers that still prey on his mind and stand before his eyes, pushes against nothing but air.

If Richard's expression and gestures in this painting can be linked to Garrick's innovative acting style, they also evoke the more venerable imagery of the shocked face and flailing body, the closed fist and the open palm, found in the history paintings of Old Masters such as Annibale Carracci and Nicolas Poussin. Hogarth's ambition to produce a piece of high art that might bear such pictorial comparison is confirmed by his decision to depict his protagonist in the historical setting of Bosworth Field itself, rather than in the context of a contemporary playhouse production of Shakespeare's play. The artist crowds his work with the costumes, props and atmospheric effects appropriate to a piece of serious historical painting: the statue of the crucified Christ that chimes with Richard's words, 'Have mercy, Jesu!'; the magnificent crown, robes, quasi-historical ruff, slashed doublet and hose; the shining suit of armour; the royal tent, reminiscent of that found in such famous history paintings as Charles Le Brun's *Alexander before the Tent of Darius* (1660–1); the encamped army in the distance; and the dark, troubled sky. Here, such symbols enrich and complicate the depiction of Shakespeare's brutal but compelling anti-hero, dramatising the tragic incongruity between Richard's violent and haunted person and the virtuous roles, both civic and military, that an English king was expected to perform. In a telling detail Richard's terror-stricken face is juxtaposed with the badge of the Order of the Garter, which shows a heroic knight on horseback, a chivalric ideal to which Richard – whose last words are famously 'A horse! A horse! My kingdom for a horse!' – offers a distorted and dictatorial mirror image.

Even as it promoted itself as an ambitious history painting centering on a great literary and historical 'character', Richard III, Hogarth's work functioned as a flamboyant personal portrait of Garrick himself. Throughout his career, the actor took an active involvement in the construction of his public image, sitting in a variety of roles for a host of painters and ensuring that engravings and mezzotints taken from these works regularly reached the print-shop windows. Both Garrick and his artists benefited from the publicity that portraits of the actor inevitably attracted, and Hogarth, recognising this, was quick to ensure that an especially high-quality engraving was produced of his spectacular canvas (no.106). While he asked the distinguished engraver Charles Grignion to carry out the bulk of the work on this print, the engraving's strap-line confirms that Hogarth himself contributed to what emerged as an especially elegant example of graphic art. Indeed, according to George Vertue, the print proved that locally produced engraving had now 'come to an equal perfection in most particulars to any foreign works of Italy france or Dutchlanders'.[10]

Interestingly, the subscription ticket to this engraving indicates Hogarth's concern to maintain a dual status for his picture as a history painting and a portrait. In the ticket Hogarth's palette hangs *between* a furled scroll signifying Shakespeare's text and a personalised dramatic mask that alludes to Garrick himself. Hogarth's work, it is implied, simultaneously engages with both of these subjects.

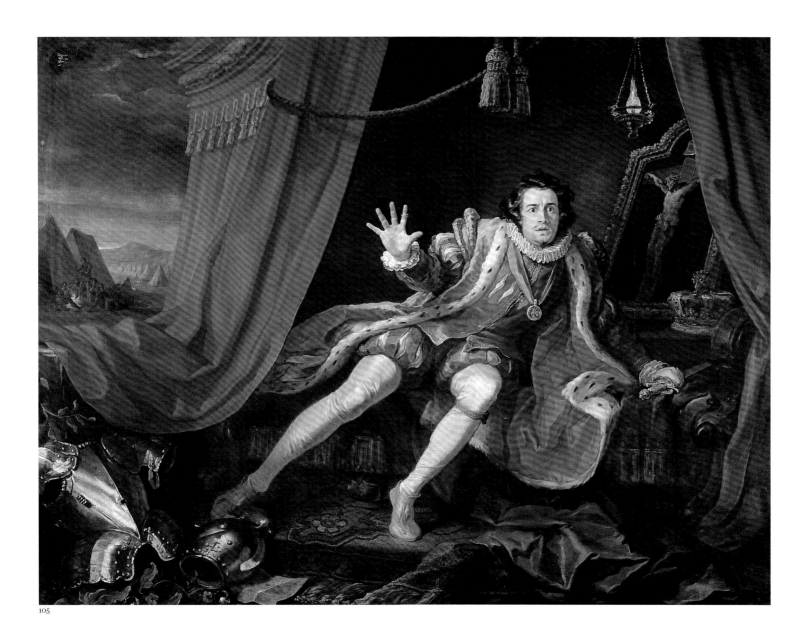

105

# 107

*Moses Brought to Pharaoh's Daughter* 1746
Oil on canvas
172.7 × 208.3
THE CORAM FAMILY IN THE CARE OF THE
FOUNDLING MUSEUM, LONDON

This painting, designed to hang in the Court Room of the Foundling Hospital for abandoned children, offers a poignant meditation on the dynamics of charity and childhood. The biblical scene it illustrates is the moment when the child Moses is about to be handed over to his adoptive mother, an Egyptian princess, whom we see sitting with her right arm outstretched towards the anxious child. Moses has been brought to the princess by a wet nurse who is shown being paid for her services and who, unbeknown to the princess, is the child's actual mother – Hogarth paints her with tears on her cheeks as she receives her money from the rather threatening, and stereotypically Jewish, figure of the steward. On the other side of the picture we see a black servant gossiping about Moses's uncertain parentage to one of the princess's female attendants. The setting is that of a pharaoh's palace and its environs, dotted with quasi-antiquarian details evocative of ancient Egypt.

In *Moses Brought to Pharaoh's Daughter* Hogarth seems concerned to explore two of the perspectives generated by charitable activity: on one hand, that enjoyed by the benevolent person or institution; on the other, that of the object of charity – in this case, a vulnerable child. Thus, Pharaoh's daughter is someone who is undoubtedly meant to embody the ethos of the Foundling Hospital itself: the tender gaze she directs at the approaching child, and her open-palmed gesture of welcome offer an idealised and historicised analogue for those directed at modern, English foundlings by the polite subscribers and visitors to the hospital. More interestingly, perhaps, Hogarth also explores the anxiety-ridden perspective of Moses himself, who is shown on the point of crossing a profound threshold in his life: just like his modern successors, he will move from the physically intimate existence he has temporarily enjoyed with his real mother to an unfamiliar, intimidating and hierarchical world populated by strangers. Hogarth dramatises this notion of childhood anxiety and transition through a brilliant manipulation of gesture, space and pictorial detail. Here, as well as observing the intensity with which Moses clings on to his mother's dress with one hand, we need to

note the yawning space across which his other hand will have to reach if it is to meet the princess's extended fingertips, themselves exquisitely placed right on the cusp of the shadowed column that marks the boundary between her world and his. Look, too, at the way in which Hogarth places Moses's feet right at the edge of the platform on which the princess sits – his next step will clearly be a monumental one, taking him from one sphere or level of existence to another. And then let us imagine what the child actually *sees* from where he stands. While his field of vision is dominated by the smiling face of the princess, what he must also see – and what she is not aware of him seeing – are the more threatening figures and objects that emerge from the shadows and drapery surrounding her: the malevolently whispering servant, the strange little winged and serpentine statue that seems to stare back at the boy, the sculpted golden crocodile that snarls from the throne's edges. No wonder Moses looks so anxious!

Hogarth, we can now conclude, is as interested in the gap between these two figures, and their perspectives, as he is in the values of benevolence and vulnerability they embody. Typically, he focuses on the moment *just before* his two protagonists are bound together, thereby emphasising their expectancies and uncertainties, and leaves it to his viewers to complete the pictorial storyline and imaginatively to unite the open, outstretched hand of the princess with Moses's uncertain, free hand, shown just emerging into the light. In doing so, of course, these viewers would find themselves rehearsing in their minds a highly idealised version of the charitable activities being practised at the hospital on a daily basis; yet through his focus on Moses's and his mother's anxieties, and through picturing dubious figures and objects circling threateningly around his virtuous protagonists, Hogarth also alludes to the tragedies and the dangers that shadowed the workings of benevolence, both ancient and modern.

Six years after it was painted, Hogarth collaborated with the engraver Luke Sullivan on an elaborate print of *Moses Brought to Pharoah's daughter*, which was published in the spring of 1752 alongside Sullivan's engraving of *Paul before Felix* (no.109). Hogarth clearly saw them as complementing each other, both artistically and thematically.

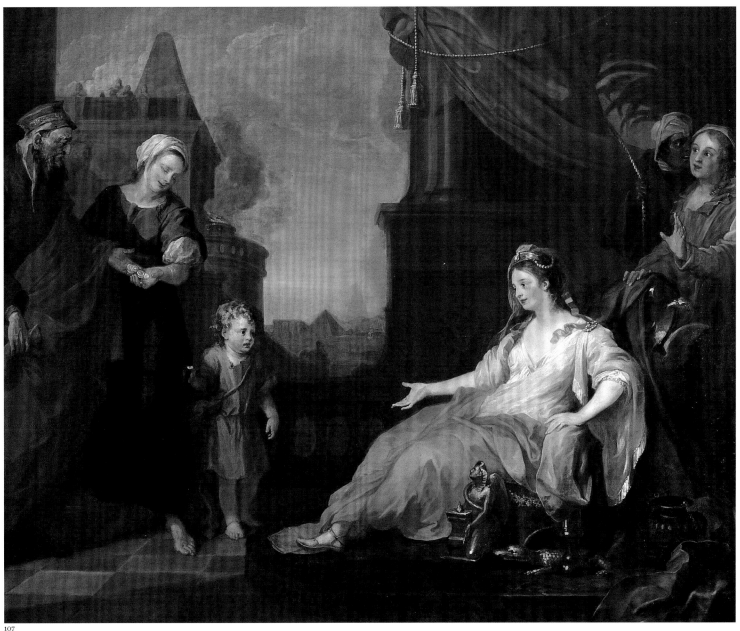

107

## 108

*Paul before Felix* (second state)
5 February 1752
Etching and engraving
42.2 × 52.4
ANDREW EDMUNDS, LONDON

## 109

Luke Sullivan (1705–1771) after
William Hogarth
*Paul before Felix* (second state)
5 February 1752
Etching and engraving
36.1 × 47.3
ANDREW EDMUNDS, LONDON

## 110

*Paul before Felix [Burlesqued]* (fourth state)
1 May 1751
Etching and engraving
25.4 × 34.3
ANDREW EDMUNDS, LONDON

This trio of prints, based on the enormous painting of the same name (fig.39), usefully illustrates Hogarth's continual changes of mind regarding the images he produced, and his sensitivity to perceived or anticipated criticism. They also record and respond to one of the artist's most prestigious and public commissions. Hogarth painted *Paul before Felix* for the lawyers of Lincoln's Inn, and the picture continues to hang in the great hall at Lincoln's Inn Fields. Given the source of his patronage, it is not surprising to find that Hogarth decided to represent a biblical scene set in a packed courtroom.

Hogarth's painting and engraving depict the New Testament figure of St Paul pleading his and Christianity's case before the tyrannical Roman governor of Caesarea, Felix (Acts 24). Paul had been brought to trial for ignoring Jewish laws, and the Roman advocate Tertullus has just finished speaking on behalf of the Jewish elders. The lawyer leans on his lectern as the Christian saint, pictured with chained, gesticulating hands, replies to the court. Before him sit in judgement not only Felix, shown wearing a laurel wreath on his head, but also – in the painting and in Hogarth's initial engraving (no.108) – the seductive figure of his wife Drusilla, a Jewish woman who had married Felix while still wed to her first husband. An elderly judicial assessor slumps nearby and a caricatured Jewish elder, with clasped, griping hands, stands anticipating Paul's conviction. However, as the caption of the engravings makes clear, Paul's words have a disabling effect on Felix, forcibly reminding the governor of his own sinfulness and guilt: as the saint 'reasoned of righteousness, temperance, and judgement to come, Felix trembled'. Around this

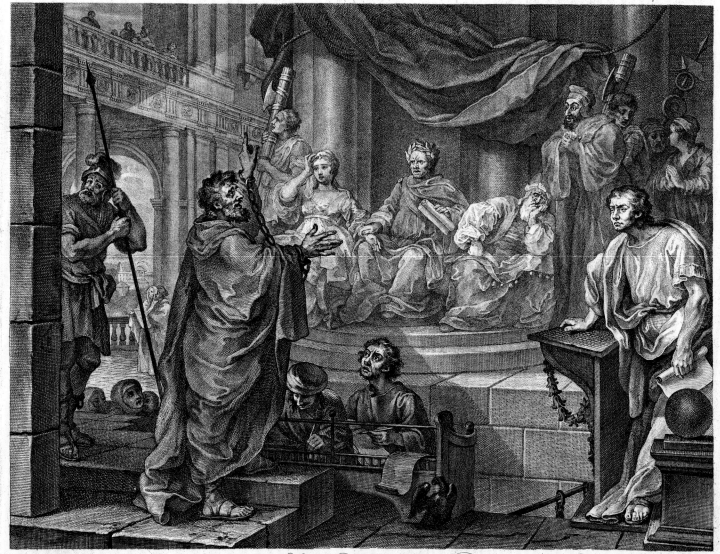

And as he reasoned of righteousness, temperance, and Judgment to come, Felix trembled.
Engraved by Wm Hogarth from his Original Painting in Lincoln's Inn Hall. and Publish'd by him Feby ye 5. 1752.

108

central grouping Hogarth includes figures suggestive of the wider audience to which Paul's Christian message was ultimately geared, including a transfixed court scribe, an elderly and attentive Roman guard, and the ordinary men and women who, their heads just visible near the old guard's feet, have gathered to watch this unprecedented assault on their leader's authority.

As has long been recognised, the subject, figures and composition of Hogarth's canvas invoke comparison with the most famous of all historical paintings in eighteenth-century England – Raphael's Cartoons, long since on display at Hampton Court. The Renaissance artist's series had similarly pictured St Paul preaching before alien and intimidating audiences, and the figural, gestural and spatial vocabulary of Raphael's works provided Hogarth with one pictorial template for his image. There

was, however, an even more local and intimately related precedent: the paintings of the same saint produced earlier in the century for the inner dome of St Paul's Cathedral. These were the work of Hogarth's distinguished father-in-law Sir James Thornhill and, as Richard Johns has recently explored in detail, they were also closely modelled on Raphael's example.[11] Thornhill's *Paul before King Agrippa* (fig.40) presents a combination of pictorial elements that is suggestively similar to that found in Hogarth's work, including not only the figures of Paul and an elevated Roman antagonist, but also a seated queen, a standing, bearded elder, a helmeted guard, a balconied archway and a pair of draped columns. Hogarth, in duplicating these elements so precisely in *Paul before Felix*, no doubt sought to define his work as part of a particular, superior pictorial tradition

FIGURE 39
*Paul Before Felix* 1748
LINCOLN'S INN, LONDON

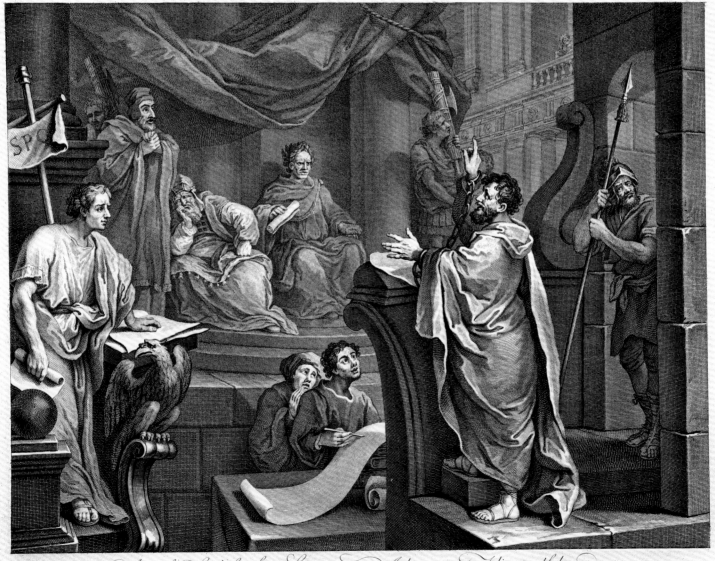

*And as he reasoned of righteousness, temperance, and Judgment to come, Felix trembled.*

109

stretching back through Thornhill to Raphael, and as a worthy successor to the kind of public art produced by his knighted relative.

Having completed *Paul before Felix*, however, Hogarth worried away at his picture, as if uncertain about whether he had succeeded in producing a work of appropriate decorum. Thus, having himself produced an engraving of the painting, he returned to the canvas and made several changes to it. He then asked the engraver Luke Sullivan to make a second, 'official' engraving of the painting, which itself departed in significant ways from the final version of the canvas and was published in 1752. Hogarth's anxieties are understandable. His decision to depict a corrupted and tyrannical court hardly offered a heroic model with which the Lincoln's Inn benchers could identify themselves. Furthermore, his painting, however indebted to Thornhill and Raphael, varied in crucial respects from their decorous pictorial models: here we can note in particular Paul's contorted, highly particularised face, so different from the more obviously heroic portraits of the saint found in the work of the two earlier artists. As if recognising that his canvas, like so many of his other history paintings, was loaded with what his critics would deem inappropriate satire and physiognomic excess, Hogarth made revisions that took an increasingly conservative direction. This is most evident in the artist's handling of the languid, self-consciously glamorous figure of Felix's wife Drusilla, who in Hogarth's painting and initial engraving signals the Roman governor's lascivious sexual desires – an allusion that contemporaries were quick to point out was reinforced by the tellingly invasive position of Paul's outstretched hand. Remarkably, in the 'official' engraving produced by Luke Sullivan, Hogarth ordered that Drusilla be taken out of the image altogether. Other alterations also render it more classical, austere and idealised – look, for instance, at how Tertullus's face changes from the earlier, meaner portrayal captured in Hogarth's first engraving to one conveying a surprising degree of dignity.

There is one final, telling indication of Hogarth's ambitions and anxieties regarding this work. In 1751 he produced a startling subscription ticket for Sullivan's forthcoming engraving, in which *Paul and Felix* is parodied in what Hogarth describes in his publication line as the 'rediculous [*sic*] manner of Rembrandt' (no.110). In this

FIGURE 40

chaotic and obscene satiric counterpart to his original painting and Sullivan's print Felix defecates in fright, Paul is so short that he has to stand on a stool, and Tertullus is transformed into a caricatured portrait of a contemporary Jacobite and Latinist, Dr William King. We must imagine that Hogarth, in producing this shocking image, sought to emphasise the distance between his and Sullivan's dignified and self-consciously classicising pictures and this small, scratchy and grotesque 'Dutch' etching. The danger, of course, was that the subscription ticket would have precisely the reverse effect, and end up calling the decorum and authority of Hogarth's original work into question – could the viewers of the 'respectable' versions of *Paul before Felix* ever look at the protagonists of the image without remembering their ridiculous, satiric doubles?

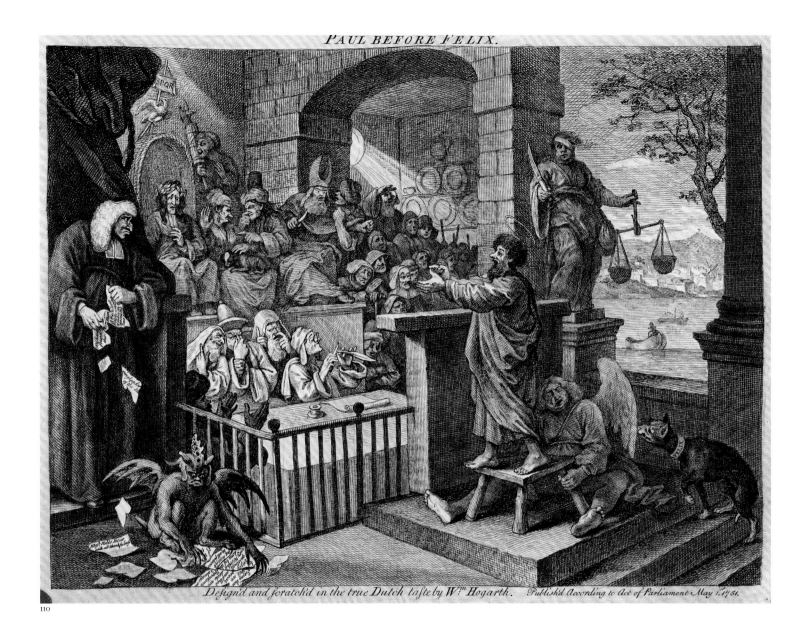

Design'd and scratch'd in the true Dutch taste by W.ᵐ Hogarth.    Publish'd According to Act of Parliament May 1.1751.

110

# 111

*Sigismunda Mourning over the Heart of Guiscardo* 1759
Oil on canvas
100.4 × 126.5
TATE. BEQUEATHED BY J.H. ANDERDON
1879

This audacious and complex painting marked Hogarth's final attempt to gain universal approbation as an English history painter; as is well known, the picture ended up generating some of the most damning critical opprobrium the artist ever suffered. The work draws on the English poet John Dryden's retelling of a tale from Boccaccio's *Decameron*, in which Sigismunda, the daughter of prince Tancred, falls in love with one of her father's attendants, Guiscardo.[12] When Tancred finds out that his daughter has secretly married the low-born Guiscardo, he flies into a rage, orders that the attendant be killed, and asks that the dead man's heart be delivered to his daughter. Sigismunda subsequently commits suicide in front of her father. Hogarth pictures his distraught, grief-stricken heroine with tears in her eyes, cradling the casket containing Guiscardo's heart to her breast. Remarkably, he shows one of her fingertips touching the exposed, glossy red heart itself.

The painting was commissioned on exceptionally generous terms by Sir Richard Grosvenor, who, inspired by the example that had recently been set by his fellow aristocrat Lord Charlemont, had told Hogarth that he could choose any subject and charge any price he desired for this work. In Charlemont's case this largesse had resulted in *The Lady's Last Stake* (no.83), which Grosvenor had seen hanging in Hogarth's studio and seems to have prompted his offer. The artist, however, rather than producing another polished satire of this sort – of the kind that Grosvenor had presumably hoped for – used the opportunity to return to the field of history painting and to focus on an especially tragic subject. In tackling this particular topic and in requesting the enormous payment of £400, Hogarth was spurred into action by the recent sale at auction of an Old Master painting of *Sigismunda* – wrongly attributed to Correggio – for the same price. In a dramatic turn-about, however, Grosvenor made it clear that he found both the work and the price demanded by Hogarth unacceptable, and the artist, bitterly disappointed, released him from his agreement.

The painting at the centre of this troubled narrative was designed by Hogarth to have a powerful emotional appeal – he later wrote that 'my whole aim was to fetch tears from the spectator'.[13] Sigismunda's wet eyes and trembling lips, together with the tender, melancholy gestures of her hands, were clearly meant to trigger a corresponding set of responses from her viewers. Fatally for Hogarth's ambitions, however, such responses were stalled by the shockingly corporeal, abject image of the glistening heart and by the sense of repulsion, even of obscenity, that seems to have been generated by the sight of her delicate white finger tip touching the swollen red organ sitting so incongruously in the jewelled casket. We can understand, perhaps, why Grosvenor felt so uncomfortable about this work, particularly when we realise that Hogarth seems originally to have depicted Sigismunda's fingers stained with the blood that still dripped from Guiscardo's heart. In this instance the dynamic interaction between the ideal and the grotesque found throughout Hogarth's history painting had become altogether too disturbing.

In 1761, determined to reassert both his and his picture's high-art credentials, Hogarth exhibited *Sigismunda* alongside a selection of his portraits and painted satires at the newly formed Society of Artists in Spring Gardens. Press responses, some of which may have been planted by Hogarth or his supporters, were uniformly enthusiastic. Thus, a writer in *Lloyd's Evening Press* wrote that 'Mr Hogarth's picture of Sigismunda weeping over the heart of her murdered husband, is a fine expressive piece', while another exclaimed: 'Would my friend Dryden could but come to life again to see his thoughts so expressed, so coloured.'[14] Other visitors to the exhibition were far less flattering, however, and the hum of criticism and controversy that seems to have surrounded the canvas as it hung in the display provoked Hogarth into an unprecedented act of anger and petulance. After ten days he withdrew the picture from the exhibition altogether, replacing it with one of the works from his *Election* series.

*Sigismunda* remained unsold in Hogarth's studio until the day he died. Given the picture's history, it is tempting to suggest that the one spectator who must have wept in front of the painting was the artist himself.

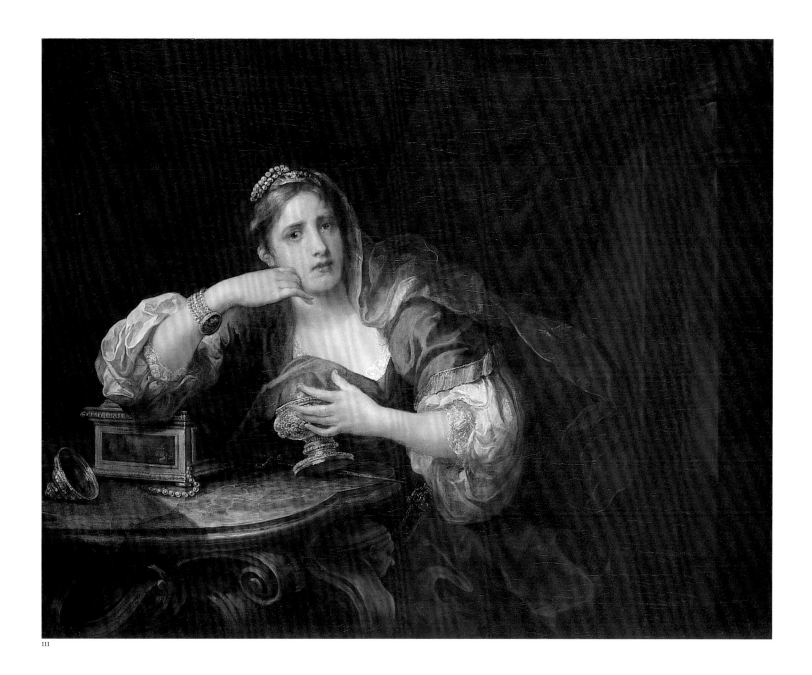

111

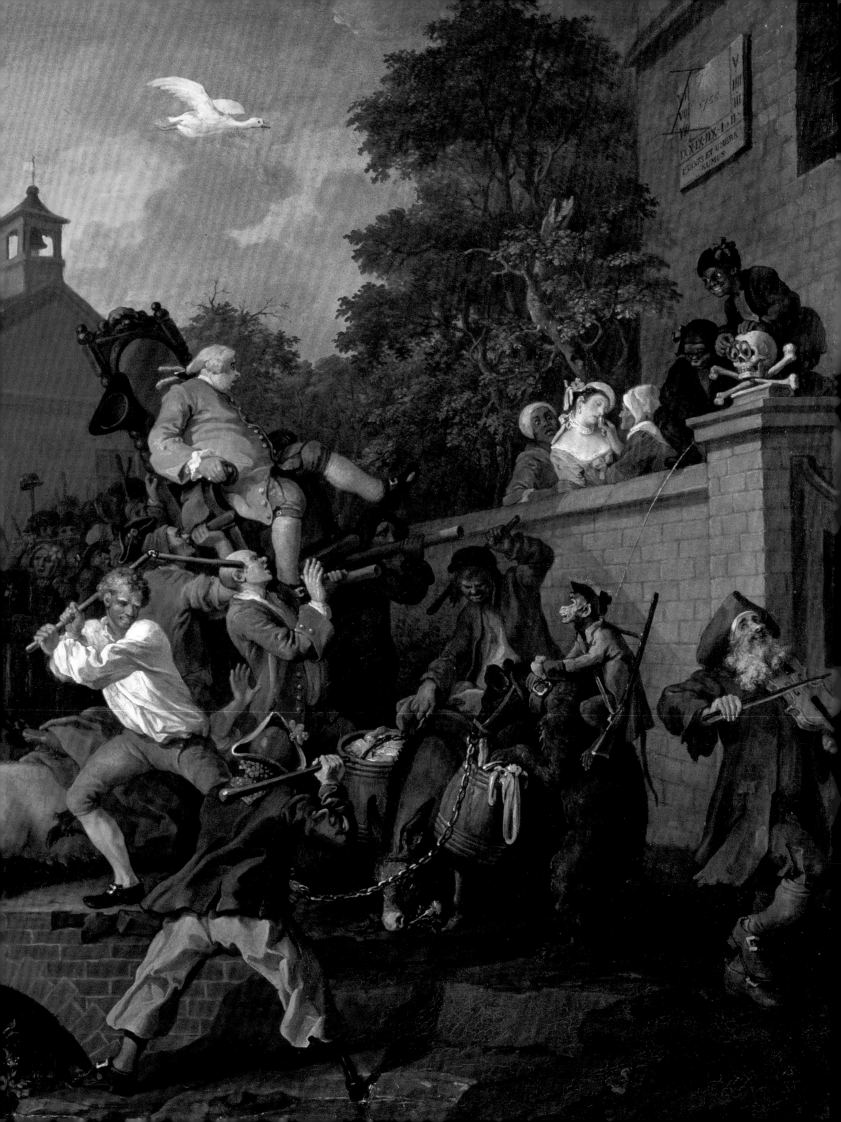

# 10
# Patriotism, Portraiture and Politics

*Mark Hallett*

In May 1761 Hogarth submitted a selection of his works to a public display of paintings and sculpture mounted by the newly formed Society of Artists.[1] The display, held in the Society's 'Great Room' at Spring Gardens, was one of the earliest public art exhibitions ever held in England, and presented the artist with new opportunities and challenges.[2] In the Great Room his paintings – for the first time in his career – hung alongside scores of pictures produced by a wide variety of contemporary artists, and were looked at and judged by a broad urban audience that included not only connoisseurs, fellow-painters and newspaper critics but also the thousands of Londoners who were willing to pay the shilling admission charge. Hogarth, typically, made sure that he enjoyed a central role in the Spring Gardens display. He produced two illustrations for the catalogue and, with seven substantial paintings, was the chief contributor to the exhibition. Two of these canvases, *Sigismunda* (no.111) and *The Lady's Last Stake* (no.83), reasserted his credentials as a history painter and as a satirical commentator on high society respectively. Meanwhile, the five other pictures that he chose to send to Spring Gardens – *O The Roast Beef of Old England* (no.112), three portraits and *An Election Entertainment* (no.120) – showcased the different directions in which his art had developed from the late 1740s onwards. In particular, they confirmed Hogarth's increasing interest in nationalistic subjects, his dramatic resurgence as a portraitist and his new focus on political satire.

The oldest of the pictures sent by Hogarth to the exhibition flaunted his credentials as a patriot artist. *O The Roast Beef of Old England ('The Gate of Calais')* of 1748, which had been produced soon after a long, bitter and inconclusive war with France, famously depicts French society in the most jaundiced of terms. The xenophobic character of *O The Roast Beef of Old England* was nothing new of course: in works like *Marriage A-la-Mode* (no.77) the artist had already offered a savage indictment of the effects of French culture on elite English society. Here, however, he focused much more explicitly on French society itself, and on the mythical English alternative symbolised by the great hunk of sirloin being carried across the centre of the picture. The exhibition of *O The Roast Beef of Old England* at Spring Gardens – at a time when France and Britain were again at war – helped secure Hogarth's late, self-

cultivated and enduring reputation as a quintessentially 'English' artist, a reputation that had been reinforced by such works as *The March to Finchley* of 1749 and the *Invasion* prints of 1756. Significantly, a poem devoted to *O The Roast Beef of Old England* published during the Society of Artists display used the painting to reassert a myth of England as a place where, unlike France,

> health and plenty cheerfully
>     unite;
> Where smiling freedom guards great
>     George's throne,
> and chains, and racks, and tortures
>     are unknown.[3]

Hogarth also exhibited three portraits at the Society of Artists exhibition. We know that one depicted his old friend John Hoadly; the other two remain unidentified. Despite the paucity of information about these works, their presence at the exhibition suggests the extent to which Hogarth, in the last decade of his life, returned to the sphere of portraiture. Indeed, in 1757 the artist had released a newspaper statement declaring that he intended to 'employ the rest of his Time in PORTRAIT PAINTING chiefly'.[4] While he was soon to chafe at this self-imposed restriction and engage in other kinds of art, Hogarth's declaration confirms his determination to succeed once again in a pictorial genre that, in this period, was being revitalised by a new generation of ambitious artists, including Joshua Reynolds and Thomas Gainsborough. Hogarth's late portraits, which include such dazzling images as his *Heads of Six of Hogarth's Servants* (no.116) and such unusual works as *Sir Francis Dashwood at his Devotions* (no.119) and *Francis Matthew Schutz in his Bed* (no.118), reveal the ways in which he continued to stretch and adapt the conventions of this most conservative of art forms.

The artist's final submission to the Spring Gardens exhibition – *An Election Entertainment* – illustrates the increasing interest he took in political subjects in the later years of his career. Up until the middle of the century, with the exception of handful of prints made in the 1720s, Hogarth had rarely ventured into the field of political satire, preferring instead to concentrate on the social satires that had first brought him fame. The *Election* series of 1754, of which *An Election Entertainment* was a part, signalled a new kind of artistic venture on his part, offering as it did a complex satirical

indictment of modern electoral corruption, and a detailed critique of the Whig and Tory party machines. This turn to political subject matter was to become more pronounced and controversial in the years that immediately followed the Society of Artists exhibition. The publication of *The Times* (no.124–5), *John Wilkes Esq.* (no.126) and *The Bruiser* (nos.129–31) saw Hogarth becoming actively involved in an increasingly bitter, personalised and politicised war of images and texts, in which the artist came under sustained attack for having entered into what his greatest critic, John Wilkes, called 'the poor politics of the faction of the day'.[5]

Wilkes's assault on the artist alerts us to the increasingly polarised responses Hogarth was attracting in the final decade of his life. For even as he continued to experiment and break new ground in his work, and to garner European-wide acclaim, he was also becoming the target of increasingly vitriolic attacks on both his art and character. By the time he died, three years after the Society of Artists exhibition closed, Hogarth was both the most celebrated and most vilified artist in Britain. It is perhaps no surprise, then, to find that his last work, *The Bathos* (no.134), is also one of his darkest, steeped in melancholy and self-doubt.

# 112

*O The Roast Beef of Old England*
*('The Gate of Calais')* 1748
Oil on canvas
78.8 × 94.5
TATE. PRESENTED BY THE DUKE OF
WESTMINSTER 1895

In the summer of 1748, during an armistice that followed the War of the Austrian Succession, Hogarth and a group of fellow-artists travelled to Paris. Hogarth, in his later account of the trip, declared that he was shocked by what he had found: a society in thrall to the 'farcical pomp of war' and distinguished by a 'parade of religion and bustle with very little business'.[6] Together with his friend Francis Hayman, he decided to head back to Britain earlier than the rest of the group. While waiting in Calais for a boat home, Hogarth sat down to sketch the old city gate, built by the British during their occupation of the city and still bearing the English coat of arms. Suddenly, he was seized by a French soldier and 'carried to the governor as a spy'.[7] Having convinced his suspicious captors that he was an artist rather than a secret agent, he was summarily despatched to England, 'where I no sooner arrived but set about a picture'.[8] The resultant painting, which famously dramatises his uncomfortable visit to France, offers a particularly acidic form of pictorial revenge on his recent hosts.

Hogarth's point of view is that of someone standing in an archway of the city's outer wall – and here he may have been adapting a pictorial device used regularly by the Italian artist Antonio Canaletto, then resident in London. From this shadowed, suggestively surreptitious vantage point, we look out at a scene dominated by the dramatic silhouette of Calais Gate itself, and loaded with xenophobic detail. At the centre of the image a French cook buckles under the weight of an English sirloin steak, destined for an inn catering to visitors from across the Channel. A contemporary poetic commentary on the painting gleefully noted the cook's 'hungry look', and the gesture of the corpulent local friar who, with a 'greedy eye' and lolling tongue, 'the solid fat his finger pres'd'.[9] Two soldiers in the French army, the smaller of whom is actually an Irish mercenary, break off from sipping the meagre gruel that has just been doled out from the 'kettle' being carried away, and gape at the appetising but unattainable food passing in front of their eyes. Nearby, a fugitive Scottish Jacobite clasps his hands together in despair while eating what Hogarth described as the 'scanty' fare typically found in France: a raw onion and a stale hunk of bread.

On the other side of the image a ragged French sentinel is similarly distracted by the sight of the sirloin, and, skulking in the shadows, a clutch of fishwives are cackling together over the marked resemblance they have discerned between a ray-fish and the friar's gluttonous face. Most famously of all, Hogarth inserts what he describes as 'my own figure in the corner' – a portrait, he sardonically notes, that 'is said to be tolerably like'.[10] Through the gate a procession of Catholic priests is seen carrying a cross through the streets. Their glimpsed presence, together with the soldier's hand that, unseen by the pictured artist, slyly reaches out to grasp his shoulder, provides a final reminder of the religious and military tyranny that, to Hogarth's eyes at least, had turned France into a land of 'poverty slavery and insolence'.[11]

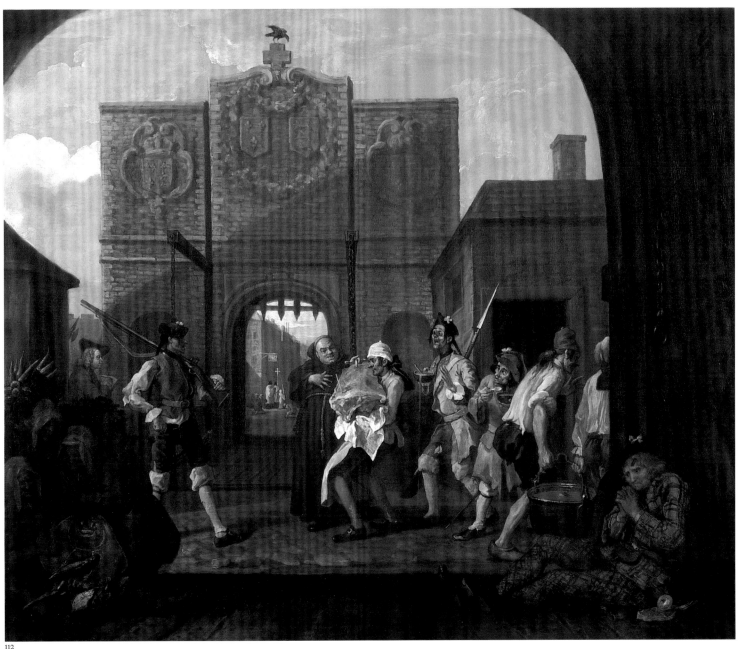

112

# 113

*The March to Finchley* 1749–50
Oil on canvas
102.5 × 135.7
THE FOUNDLING MUSEUM, LONDON

This extraordinarily busy, densely detailed painting offers a satirical companion to *O The Roast Beef of Old England*. Having attacked French turpitude and subjection, Hogarth now dramatises Britain's teeming vitality and patriotic vigour. The fictional episode depicted in *The March to Finchley* takes place late in 1745, soon after Britain had been invaded by Jacobite troops loyal to Bonnie Prince Charlie, son of the Stuart Pretender to the English throne. Hogarth's work focuses on a group of English guardsmen brought to London to help defend the city from attack. These soldiers are pictured as they gather together at Tottenham Court Turnpike, north of the capital, preparatory to taking up their military positions at the village of Finchley. They have obviously been indulging in a heavy night's drinking, fighting and whoring, and the foreground of Hogarth's painting illustrates the chaotic after-effects of such festivities: in the clear light of morning individual soldiers are seen lying drunkenly on the ground, lurching away from their family, urinating against a wall, stealing a meat pie, fondling the breasts of a milkmaid and passing a love letter to one of the prostitutes leaning out of a nearby brothel. At the same time *The March to Finchley* shows the remarkable transformation of this sprawling, inchoate mass of men into the well-drilled fighting unit that starts to take shape in the shadowed mid-ground and then marches in perfect formation across the distant, studiously illuminated landscape, where the Guards' uniforms, weapons and Union Jack glint in the sun.

In *The March to Finchley* Hogarth pursues an ambitious, dual agenda: he satirises the disparate, uniformly un-heroic soldiers who make up the English army while simultaneously celebrating their and the nation's capacity to cohere into a patriotic, disciplined and stalwart whole in times of crisis. Particular figures seem to encapsulate this duality. The regimental drummer depicted in the lower left-hand side of the canvas is someone who, his face bloated and his gait uncertain, can easily be read as a comic, somewhat ridiculous individual who has yet to recover from the night's drunken carousing. At the same time, as Elizabeth Einberg has recently suggested, he is open to being interpreted

as the kind of doughty fighter on whom the British army depends; he has misguidedly tried his luck at the bare-knuckle boxing taking place behind him and has been soundly beaten by a professional pugilist for his pains.[12] In this light, we are asked to admire the patriotic duty that impels him to leave his tearful wife and child behind, and to recognise that his drum has already begun to beat the steady, uplifting rhythm that will bring his fellow-soldiers to order.

Meanwhile, the most prominent guardsman in Hogarth's painting, shown on the arm of a young, unmarried and pregnant ballad-seller while being angrily accosted by a jealous newspaper woman, can easily be dismissed as another comic figure, reaping the dire consequences of earlier sexual misdemeanours. Again, appearances are deceptive. The cross that loops behind the newspaper-woman's back and the titles of the newspapers she carries indicate that she is a Catholic and a Jacobite; in contrast, the pregnant ballad-seller carries in her basket a print of the royal commander of the British army, the Duke of Cumberland, and a ballad inscribed with the words 'God Save our Noble King'. In showing the guardsman turning to, and walking in step with, the ballad-seller, rather than being lured away by her ferocious rival, Hogarth invites us to imagine that this soldier will remain loyal not only to his young lover and their unborn child but also to the patriotic cause that her ballads and prints help promote.

As so often, however, the artist refuses to make his pictorial moral too bombastic or cloying: thus he burdens his image with tragic figures like the doomed infant, who in the bottom right-hand corner leans over her addled mother's shoulder and reaches for a cupful of gin. Her gesture is one of many that halt the drift of *The March to Finchley* towards patriotic propaganda and reassert the picture's parallel, satiric agenda of exposing the failings and cruelties that accompany the narratives of heroism and responsibility.

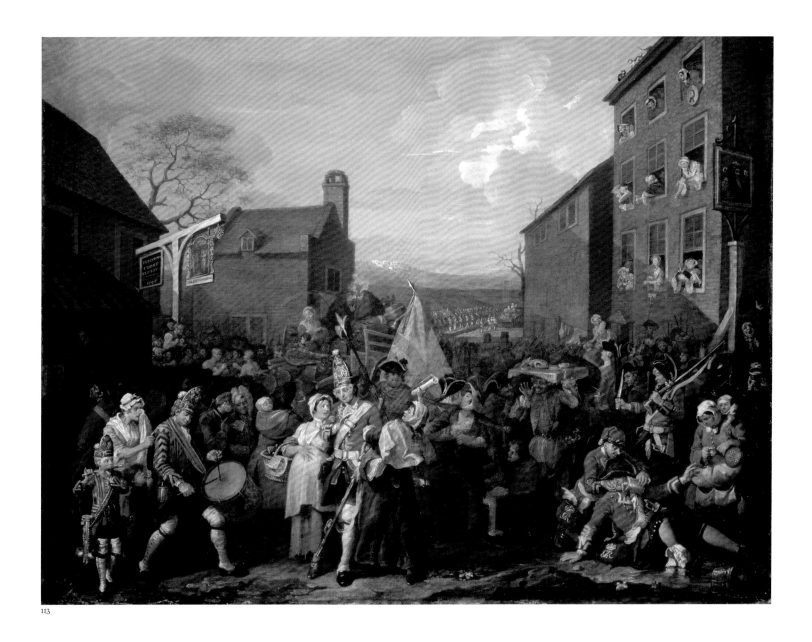

113

# 114

*The Invasion, Plate 1: France* (second state)
8 March 1756
Etching and engraving
31.9 × 39
ANDREW EDMUNDS, LONDON

# 115

*The Invasion, Plate 2: England* (first state)
8 March 1756
Etching and engraving
31.8 × 38.4
ANDREW EDMUNDS, LONDON

In the months leading up to the outbreak of the Seven Years War in May 1756, the dominant topic of public debate in Britain was the possibility of an invasion by the French. Hogarth's contribution to the substantial body of graphic satires dealing with the threat was this pair of rapidly executed prints, which respectively translate the themes and imagery of *O The Roast Beef of Old England* (no.112) and *The March to Finchley* (no.113) into a more simplified pictorial form.

In the first print, which pictures the French army gathering on the other side of the Channel, we again find the figures of a corrupt friar and a group of scrawny soldiers, and the imagery of subsistence and Catholicism, that dominated Hogarth's earlier depiction of Calais. Here the friar, rather than pressing a hunk of sirloin, runs his finger along a newly sharpened axe, one of the many instruments of torture that, along with popish icons and plans, are being dragged along to the waiting troopship. The soldiers in the foreground, their bodies an awkward flurry of limbs, huddle together underneath an inn sign advertising the infamous 'soupe maigre', while nearby a forlorn row of frogs are being roasted on a fire.

*England*, meanwhile, offers the same combination of uproarious, obscene revelry and military discipline found in *The March to Finchley*. In this instance a group of carousing soldiers and sailors are shown jeering at a crudely caricatured image of the French king painted onto the inn wall. One woman makes a lurid comparison between the sword held in the French king's left hand and the fork she holds between her lover's legs; another, with a knowing smile, measures the broad back of her guardsman lover. Food and drink are in abundance, and weapons are momentarily downed. Once again, however, this depiction of chaotic, unrestrained pleasure is fused with a counterbalancing imagery of loyalty and

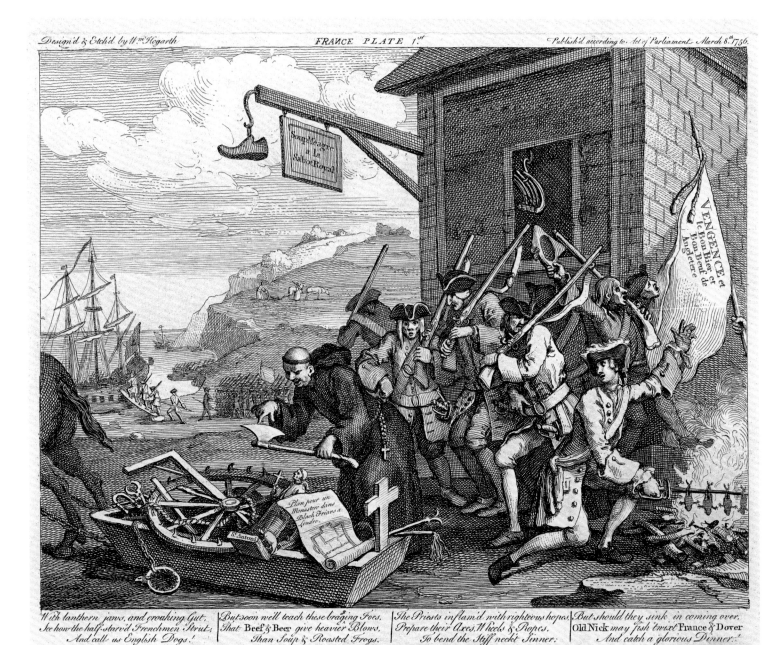

114

order. Thus, even as he sprawls rather
indecorously across the foreground, a fifer
is playing 'God Save our Gracious King'.
Elsewhere we see an eager new recruit
straining to reach the requisite height for
a guardsman, a line of troops marching in
perfect formation in the sunlight, and an inn
sign portraying the Duke of Cumberland,
the royal commander who had famously
defeated an earlier band of invaders.

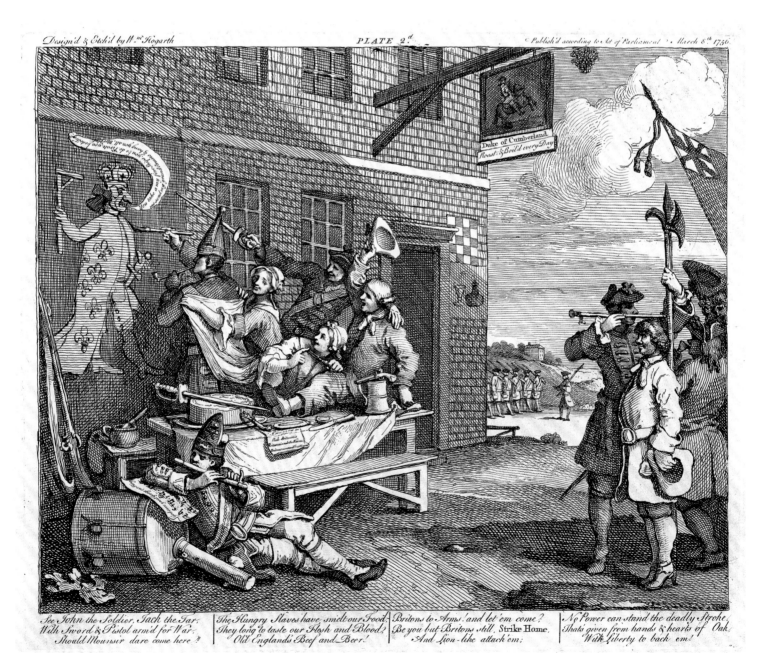

# 116

*Heads of Six of Hogarth's Servants* c.1750–5
Oil on canvas
63 × 75.5
TATE. PURCHASED IN 1892

If, in his conversation pieces, Hogarth
sought to portray the members of a new
social elite both as individuals and as a
collective body, so in this famous painting
he communicates the particular appearance
and character of his household servants
while simultaneously depicting them as a
tightly knit group, unified by their pictorial
proximity, by their shared outward gaze
and by their common loyalty to Hogarth
and his family. Writers have traditionally,
and rightly, lauded the remarkable
sensitivity of this group portrait, suggestive
of the unusual affection and humanity with
which the artist seems to have regarded
his servants. Scholars have also noted
the work's likely roles as a form of
advertisement for Hogarth's talents as a
portraitist, as a proud token of the social
status he had acquired by the end of his
career and as an investigation of 'character'
comparable to the engraved sheet of heads
he had produced in the 1730s and 1740s
(see fig.12, p.34).

Less remarked on is the extent to which
the painting promotes a particular ideal of
domestic service itself. All six servants are
depicted as if awaiting instructions from
their master or mistress, and as if they are
doing so in a properly modest and attentive
way. Strikingly, none of the figures either
bodily or visually interact with each other,
as is normally the case in Hogarth's other
group portraits – they direct their attention
to other people, as it were, rather than to
each other. It is also worth noting that,
while the artist lavishes great care on each
individual head, there is very little pictorial
space allowed between them or between
their sketched-in torsos. They are thus
given neither the air nor the 'airs' allowed to
more respectable subjects. In this sense the
painting of Hogarth's six servants operates
both as an intensely personal and
benevolent portrayal of six persons known
intimately to the artist, and as a kind of
pictorial manifesto promoting the qualities
of modesty and deference appropriate for
members of a servant class.

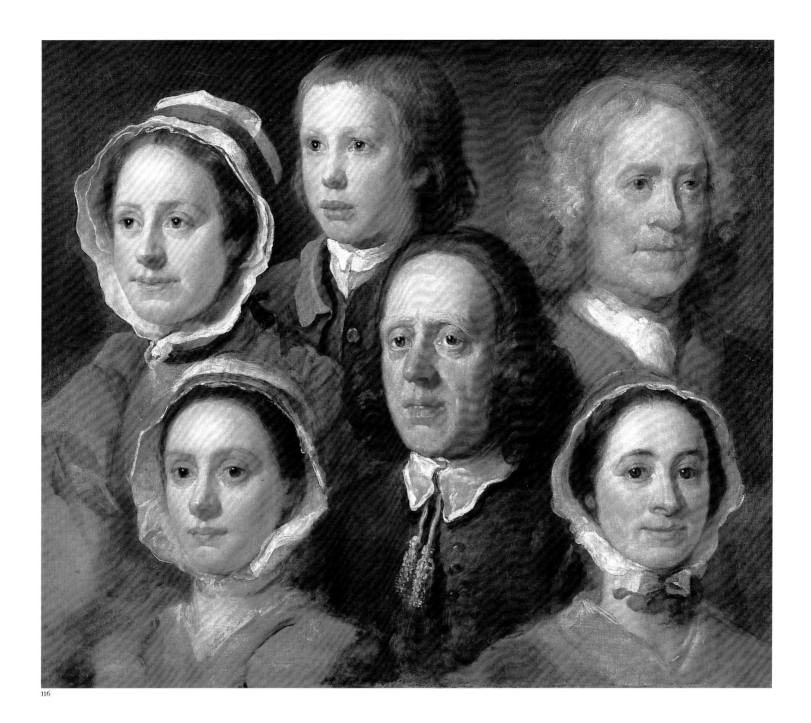

116

# 117

*David Garrick and his Wife* 1757
Oil on canvas
132.6 × 104.2
THE ROYAL COLLECTION

In a letter written on 21 April 1757 Hogarth's
friend John Hoadly describes visiting the artist's
studio that same day and finding him busy:
Hogarth, he declares,

> has got again into portraits; and has his
> hands full of business, and at a high price.
> He has almost finished a most noble one of
> our sprightly friend David Garrick and his
> Wife: they are a fine contrast. David is
> sitting at a table, smilingly thoughtful over
> an epilogue or some such composition (of
> his own you may be sure), his head
> supported by his writing hand; and Madam
> is archly enough stealing away his pen
> unseen behind. It has not so much fancy as
> to be affected or ridiculous, and yet enough
> to raise it from the formal inanity of a
> mere portrait.[13]

Only two months before, Hogarth had
announced in the press that he intended to
concentrate on portrait painting, a declaration
prompted by his increasing weariness with the
process of producing and publishing large-scale
satiric projects such as the *Election* series.[14]
This painting of the celebrated actor, famously
portrayed by the artist twelve years earlier
(no.105), and his wife Eva Maria may have been
intended to dramatise his re-entry into the
market for portrait painting and act as a
challenge to the new generation of portraitists –
including Joshua Reynolds – who had risen to
prominence over the previous decade. The work
showcases his brilliance at painting both men
and women, and his renowned ability to
introduce a sense of narrative flow into this most
'formal' of genres. Of particular note in this latter
respect is the exquisitely considered series of
hand gestures found in Hogarth's portrait,
running from Eva's left hand, curled in suspense
behind the chair-back, to the outstretched fingers
of Garrick's left hand, pointing outwards in an
appropriately theatrical gesture, as if rehearsing
the prologue to Samuel Foote's *Taste* (1752), which
he has begun writing on the desk in front of him.
 The ease, elegance and affection conveyed by
the portrait are, however, deceptive. The painting
apparently caused Hogarth considerable
difficulty, was heavily reworked and remains in
an unfinished state. Given that it shows Garrick
having ground to a halt while writing, and sitting
awaiting the return of his muse, it is perhaps
rather fitting that the incomplete state of
Hogarth's own canvas should represent a similar
stilling of the creative juices on the artist's part.

# 118

*Francis Matthew Schutz in his Bed* late 1750s
Oil on canvas
63 × 75.5
NORWICH CASTLE MUSEUM & ART GALLERY

This extraordinary portrait, in which the third cousin to Frederick, Prince of Wales, is pictured vomiting into a chamber pot while lying in bed nursing a hangover, is supposed to have been commissioned by Schutz's wife as a means of exhorting him to lead a more temperate existence. Hogarth responded to this unusual request by fusing the language of portraiture with that of satire: Schutz's persona and activities within the image conjure up a world of rakish dissolution represented in numerous satiric illustrations of the period, while the unkempt bedroom in which he is depicted echoes those found in the artist's own *Before*

and *After, A Harlot's Progress* and *Marriage A-la-Mode*. The Latin inscription on the wall near the bed reinforces the need for Schutz to abandon the habits of masculine excess – it is the first line of an ode by the classical poet Horace, in which the speaker describes giving up his youthful battles to win women's hearts and abandoning the lyre that he uses to assist his amours.[15] Appropriately, a lyre such as the one described by Horace hangs underneath this inscription.

Schutz himself is not only shown undergoing a violent form of self-purgation but is also given a pose – his aching head supported by his right arm – traditionally suggestive of melancholy. The implication seems clear: Hogarth's subject, as he mournfully reflects on the alcoholic excesses of the night before, is meant to be

thinking 'Never again!' It is hard to be too po-faced about this image, however – it seems as much a comic painting, humorously reflecting on the inevitable consequences of bad behaviour, as a pictorial sermon. Whatever the circumstances of its commission, the canvas proved too indecorous for Schutz's Victorian descendants. They hired an artist to paint in a newspaper over the chamber pot; only a recent programme of restoration returned the work to its original state.

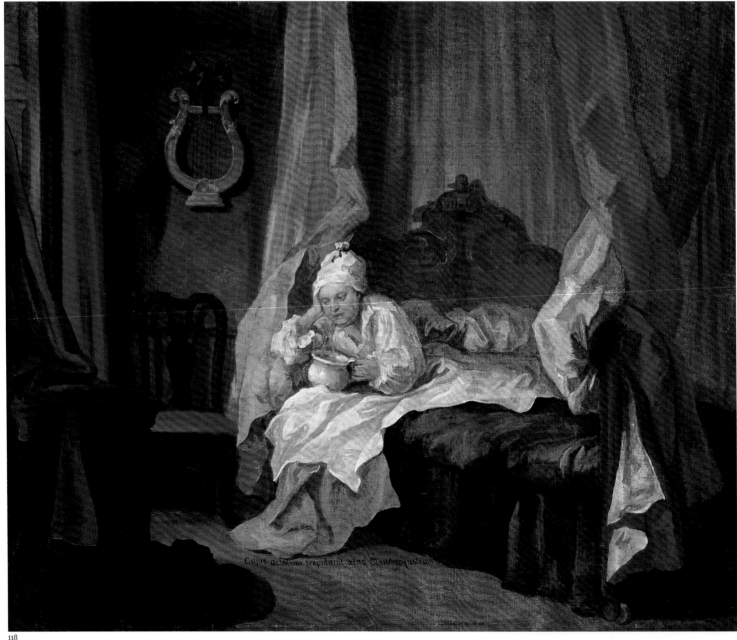

118

# 119

*Sir Francis Dashwood at his Devotions*
late 1750s
Oil on canvas
120 × 87.6
PRIVATE COLLECTION

As in his depiction of Schutz, Hogarth blends portraiture and satire in this deliberately unconventional and scandalous picture of the famous libertine Sir Francis Dashwood. The artist's sitter was closely involved in a number of aristocratic clubs that defined themselves against the decorous conventions of politeness and promoted instead the pleasures of sexual freedom, connoisseurship and paganism. In this portrait Hogarth playfully parodies Renaissance images showing St Francis at prayer in similarly isolated environments. Dashwood, rather than reading from the Bible, is facing an opened copy of the *Elegantiae Latini sermonis*, which despite its seemingly respectable title was a notorious erotic novel of the period. No doubt prompted by the novel's pornographic content, the aristocrat is staring devotedly at the vision of a nude female figure lying seductively in front of his eyes. In the foreground the lushly painted still life of fruit sliding off a silver platter reinforces this imagery of sensual and bodily indulgence, while the mask that lies behind the book of sermons alludes to the erotic and mysterious pleasures of the masquerade, which regularly featured rakes disguised in religious clothing. Meanwhile, the halo above Dashwood's head contains the satyr-like profile of the aristocrat's confidante Lord Sandwich, depicted as if whispering into his friend's ear and sharing his lingering, dominant and lascivious gaze.

8

# 120-3

*Election* series

120
*An Election Entertainment* 1754

121
*Canvassing for Votes* 1754

122
*The Polling* 1754

123
*Chairing the Members* 1754-5

Oil on canvas
Each 101.5 × 127
SIR JOHN SOANE'S MUSEUM, LONDON

In the early months of 1754 one topic dominated the pages of London's newspapers and journals: the forthcoming general election. Journalists and their readers focused in particular on the notoriously corrupt election campaign in Oxfordshire: in the words of *The London Evening Post*, 'Every British Heart is full of the Oxfordshire Election, which is become the chief subject of Conversation in the remotest corners of the Island'.[16] The rival Whig and Tory parties in Oxfordshire – and their local aristocratic supporters – were attacked for having lavished huge amounts of money on influencing and bribing local electors, particularly through the means of political feasts or 'entertainments' in which vast quantities of food and drink were consumed. Once the May election date had been called, suggested *The London Magazine*, 'nothing has been since thought of but feasting and revelling; and both parties strive to outdo each other in the expense of their entertainments. This indeed is the general method made use of to gain the favour of electors.'[17]

In this same period Hogarth was working on the first of what eventually became a set of four paintings and prints dealing with the subject of electoral corruption. *An Election Entertainment* was put on display just days before the May election. In his quartet of pictures, completed over the rest of 1754 and in early 1755, Hogarth shows the various stages of an election campaign in a fictional country town, beginning with an electoral 'treat' organised by the Whigs to garner support and ending with the scene of the victorious Tory candidates being carried aloft through the streets. In focusing on such subjects, the artist consolidated a turn towards more political topics already tentatively suggested by his *Country Inn Yard at Election Time* of 1747. In both this print and the *Election* series itself Hogarth engages with, and contributes to, a long tradition of political satire dealing with the vices attendant on

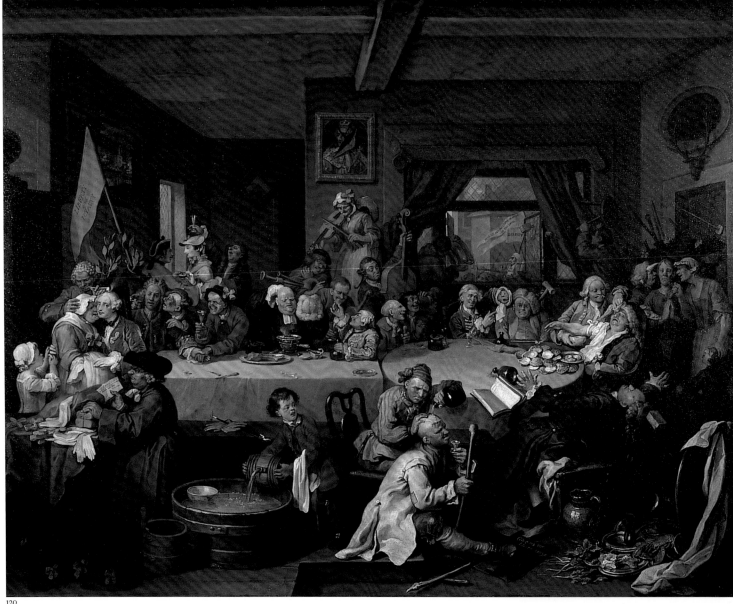

120

FIGURE 41
Anonymous
*The Humours of a Country
Election* 1734
THE BRITISH LIBRARY,
LONDON

rural election campaigns. Thus, the frontispiece to a poem entitled *The Humours of a Country Election* of 1734 (fig.41) includes a compartmentalised image of exactly the same kinds of electoral feasting and bribery that were so heavily criticised twenty years later, and another, as in Hogarth's series, of the victorious candidates being carried and cheered by an unruly plebeian mob.

Hogarth's four paintings transform such modest pictorial templates into dazzlingly complex works of art. In *An Election Entertainment* the electoral feast taking place in a hired inn – the two Whig candidates are shown on the left-hand side being kissed by a burly countrywoman and being lectured to by an inebriated, over-familiar cobbler – is awash with brilliantly realised comic detail: the political agent who is sent flying by a brick hurled through the window; the mayor who has fainted after gorging himself on a mountain of oysters;

the corpulent clergyman who wipes his sweating brow after feasting on venison; and the man who illustrates John Gay's song 'An Old Woman Clothed in Grey' by transforming his clenched hand and folded napkin into an old woman's face and bonnet.

This comic image of a claustrophobically crowded, noisy, cluttered and violent interior is succeeded by three pictures that see the narratives of political chicanery spilling into the street and across the rural landscape. *Canvassing for Votes*, the second work in the series, is set outside an inn, the Royal Oak, which has been hired by the Tories for the duration of the campaign: one of their candidates buys trinkets for the ladies who lean over the balcony, while a local farmer is offered bribes by representatives of both parties. Hogarth's canvas also implies that a corrupted political establishment has presided over

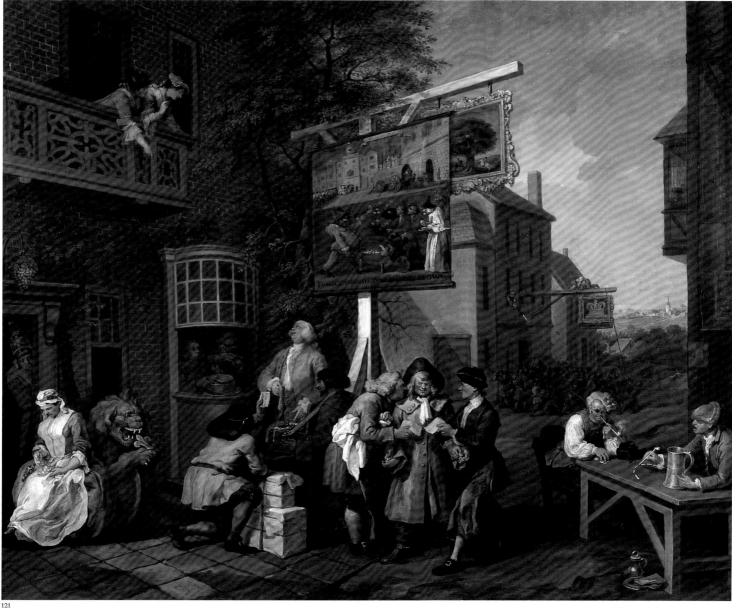

a decline in Britain's international fortunes: on the left the ship's figurehead in the form of a heroic British lion devouring the French fleur-de-lis has been turned into a humble pub seat, while on the right a barber and a cobbler nostalgically re-enact the famous naval battle of Portobello of 1739, in which Admiral Vernon defeated the French with only six ships.

This sense of a nation being failed by a current generation of political leaders is made even more explicit in the third image of the series, *The Polling*, where a broken-down coach representing Britain itself has ground to a halt. Britannia is trapped helplessly inside, while the two drivers – allegorical substitutes for the country's leaders – ignore her misfortunes and cheat at cards. Dominating the painting, however, are the details of the final stages of the campaign itself. Rival electoral processions clog the distant bridge, and in the

foreground every available local male is being dragged to a polling booth to vote. These men include a disabled veteran, an imbecile, a dying man, someone who is blind, and a forlorn figure on crutches. Within the booth, meanwhile, lawyers argue, a caricaturist sketches, and two rival candidates, isolated and uncomfortable, sit nervously as they await the result. In a brilliant pictorial detail four staves 'pierce' the lower right edge of the canvas, carried, it is implied, by a group of supporters standing below the raised platform of the booth.

In the final picture the Tory victory parade is interrupted and upset by a riotous cluster of individuals and animals. A sow and her litter charge underfoot towards a nearby stream, toppling a wildly gesticulating woman as they do so; a heavily laden donkey pauses to eat thistles; a local bruiser fights with a peg-legged sailor; and

the sailor's performing bear, a monkey on its back, takes the opportunity to feast on some offal. Unaware of this mayhem, the blind Jewish fiddler who leads the procession continues striding forward. Behind him, the most prominent of the victorious candidates – the other is visible only as a shadow cast on the distant town hall – is shown on the point of falling to the ground, one of his chairmen having been hit by the bruiser's flail. Adding to his panic, he has suddenly noticed the eerily bespectacled skull that stands on the church gatepost framed by the faces of two black chimney sweeps. Even at the moment of his success, then, the winning candidate not only undergoes an ignominious fall from grace but is forced to confront his own mortality: the melancholy message of the skull is reinforced by the inscription written on the nearby sundial: *pulvis et umbra sumus* (we are but dust and shadows).

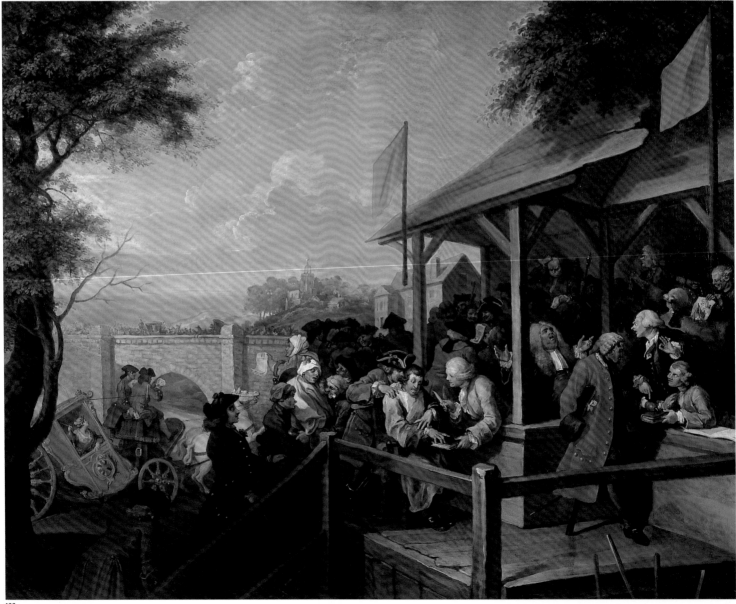

122

This meditative undertow to the final image suggests the extent of the artist's ambitions in this quartet of pictures, and his desire to offer far more than an ephemeral response to a particular political campaign. Hogarth's intellectual seriousness is complemented by an extraordinary degree of aesthetic refinement. The *Election* paintings play off the iconography of the grotesque with pictorial forms that are fastidiously elegant, often exquisite: just look at the delicate red flowers that grow under the bridge in the last picture. At the same time Hogarth's series alludes to a wide range of celebrated artistic precedents. Thus, contemporaries were quick to notice that the goose flying over the victorious candidate in *Chairing the Members* subtly parodies Charles Le Brun's image of Alexander the Great's victory at Arbela (c.1673), in which an eagle hovers directly over the triumphant hero's head. Hogarth's

series also invites comparison with various categories of seventeenth-century Dutch art, such as Jan Steen's comparably anarchic views of small-town revelry and festival, and, most subtly of all, that country's great still-life tradition. For if we turn to the bottom right-hand corner of *An Election Entertainment*, with its fallen table, flowing white tablecloth, ceramic jug, pewter dishes and beautifully painted lobster, we find nothing more than a riotous version of a painting like Abraham van Beyeren's *Still Life with Jug and Lobster* (c.1670; fig.42).

FIGURE 42
Abraham van Beyeren
(1620/1–1690)
*Still Life with Jug and Lobster* 1670
KUNSTHAUS ZÜRICH

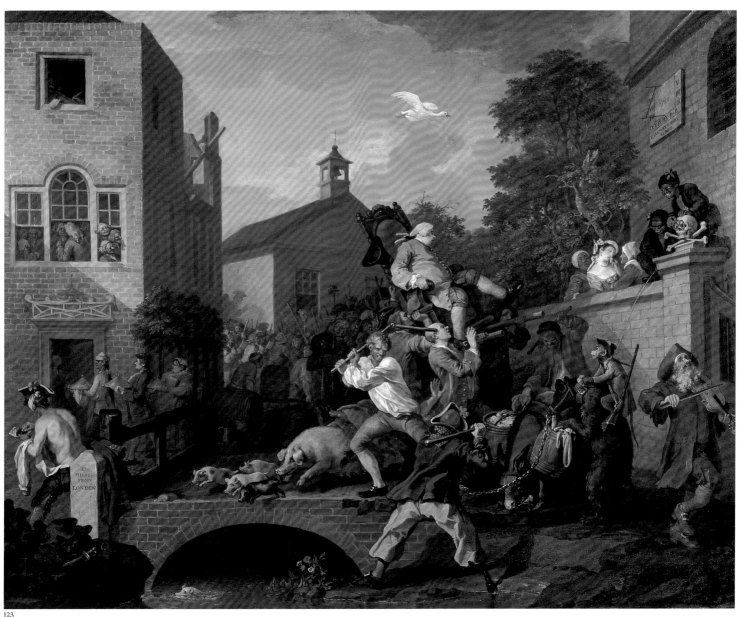

# 124

*The Times*, Plate 1 (third state)
7 September 1762
Etching and engraving
24.7 × 30.8
ANDREW EDMUNDS, LONDON

# 125

*The Times*, Plate 2 (first state) c.1762–3
Etching and engraving
Cut to 25.4 × 31.3
ANDREW EDMUNDS, LONDON

These two prints, the second of which was never finished or published in Hogarth's lifetime, represent Hogarth's most controversial interventions into political satire. Indeed, the vitriolic response generated by the first of these works profoundly shaped the character of Hogarth's last years as an artist and sharpened the bitterness with which he increasingly regarded contemporary culture.

Hogarth had been appointed Serjeant Painter to the King in 1757, and after 1760 seems to have become increasingly close to the court of the new monarch, George III, and to the ministry of George's Scottish favourite, John Stuart, Earl of Bute. *The Times, Plate 1*, which was published in September 1762, combines a resolute pictorial defence of Bute with a sustained attack on his predecessor as prime minister, William Pitt, Earl of Chatham, who had been summarily dismissed by the king in the previous year. Whereas Pitt was associated with a highly aggressive stance towards Britain's French and Spanish opponents in the current war, Bute came to power determined to bring the victorious but expensive conflict to an end. The chaotic scene of a city on fire allegorises the contemporary state of Europe, with the burning ruins in the background standing for France and Germany, and the

dilapidated house on the left symbolising the neglected British nation itself. Pitt is shown on stilts (he famously used crutches), surrounded by a baying mob and fanning the flames of war. The heroic fireman at the centre of the image – an allegorical substitute for either Bute or the king himself – is equally fervently trying to prevent the fire from enveloping the rest of the world, symbolised by the globe that stands above the nearby doorway. While the fireman, who is given the pose and the location of a heroic public statue, is assisted by a loyal band of English and Scottish troops, he himself is hosed by a trio of men, two of whom are intended to be Pitt's journalistic supporters, John Wilkes and Charles Churchill. In the shadowed right foreground of the print a crying woman and her children represent the victims of war praying for deliverance.

*The Times, Plate 2*, ostensibly offers a

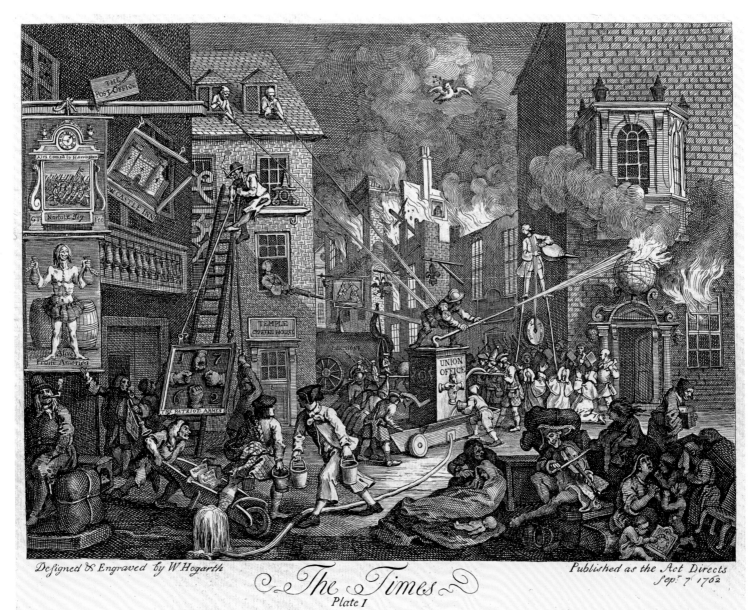

Designed & Engraved by W Hogarth

*The Times*
Plate 1

Published as the Act Directs
Sep.ʳ 7 1762

124

contrasting vision of the war's peaceful aftermath, dominated by a statue of the king and by the details of replenishment: in the words of Ronald Paulson, 'while the first plate is about a city in flames and on the verge of destruction, this plate shows construction in progress, a rainbow following a storm, and the nourishing stream of royal benevolence flowing'.[18] But, as Paulson goes on to note, the print also seems to offer a satiric critique of his previous print's hero, the Earl of Bute, and to call into question George III's dependence on a coterie of Scottish courtiers and ministers. For, under the elevated but passive eye of his royal master, Bute is depicted operating a pump that supplies water to a series of potted plants inscribed with the names of fictional Scottish placemen, many of them ex-Jacobite, implying that they are enjoying an undeserved form of public bounty.

This parallel, satirical agenda – which is maintained throughout the print's myriad details – demonstrates Hogarth's inability to peddle party propaganda on a sustained basis; it also explains, perhaps, why the print was never completed or released, for *The Times, Plate 2*, if published, would surely have attracted the king's displeasure.

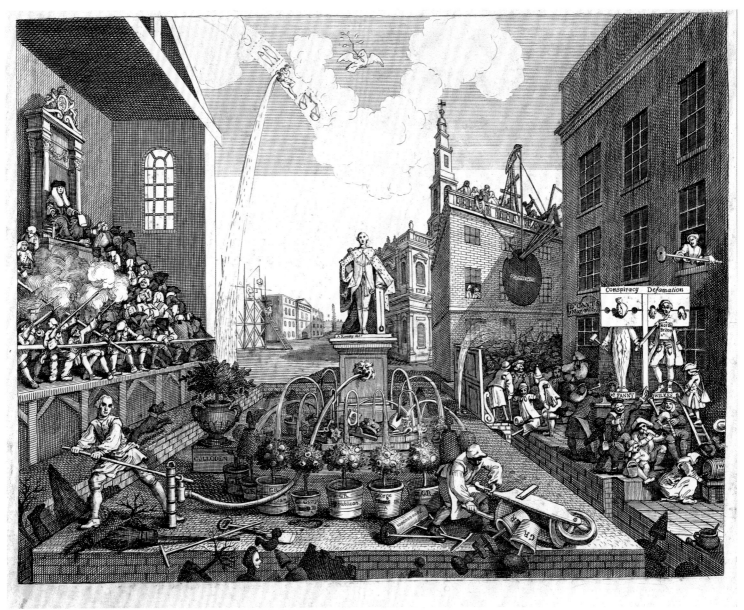

## 126

*John Wilkes Esq.* (first state) 16 May 1763
Etching with engraving
35.5 × 22.9
ANDREW EDMUNDS, LONDON

## 127

*Simon, Lord Lovat* (second state)
25 August 1746
Etching with engraving
36.3 × 23.5
ANDREW EDMUNDS, LONDON

Following the publication of *The Times, Plate 1* (no.124), the journalist John Wilkes – attacked in Hogarth's print as a propagandist lackey of Pitt's – had emerged as Hogarth's fiercest and most influential critic. In the seventeenth issue of his journal, *The North Briton*, Wilkes described Hogarth's engraving of *The Times* as 'too crowded with figures' and as 'confus'd, perplex'd and embrarrass'd'. He then went on to lambaste the artist for moving into this kind of personalised and partisan political satire:

> I am grieved to see the genius of Hogarth, which should take in all ages and countries, sunk to a level with the miserable tribe of party etchers, and now, in his rapid decline, entering into the poor politics of the faction of the day, and descending to low personal abuse, instead of instructing the world, as he could once, by manly moral satire.[19]

Hogarth made a two-fold response to such accusations. First, he pictured Wilkes as one of a pair of figures trapped in the pillory in *The Times, Plate 2* (no.125). Then he produced this searing satirical portrait, which is based on a sketch he made while attending Wilkes's trial for seditious libel in May 1763. The trial had been sparked by an attack on the king made in the forty-fifth edition of *The North Briton*, which Hogarth depicts lying alongside the issue in which he himself had been criticised.

*John Wilkes Esq.* is executed in the free, slashing lines allowed by etching, and the journalist is presented as a squinting, satanic figure, his wig shaped to suggest a pair of devil's horns, and his slouching, open-legged pose a provocative sign of his notoriously rakish and insubordinate personality. Wilkes is shown having assumed the staff and hat that are the traditional attributes of Britannia, to whom he offers a grotesque, leering

antithesis. Furthering his criticism, Hogarth pictures his subject in a way that explicitly evoked his earlier etched portrait of the Jacobite traitor, Simon, Lord Lovat, produced soon before Lovat's execution for treason in 1747. Wilkes, the artist satirically suggests, deserves a similar fate. Unfortunately for Hogarth, his adversary was acquitted to popular acclaim – indeed, as Ronald Paulson has suggested, the portrait seems to depict Wilkes at the moment of his victory.[20] More happily for

the artist, the print itself turned out to be a sensation, with more than 4,000 copies being sold immediately.

*Simon Lord Lovat*
Drawn from the Life and Etch'd in Aquafortis by Will.ᵐ Hogarth.
price 1 Shilling    Publish'd according to Act of Parliament. August 25ᵗʰ 1746.

127

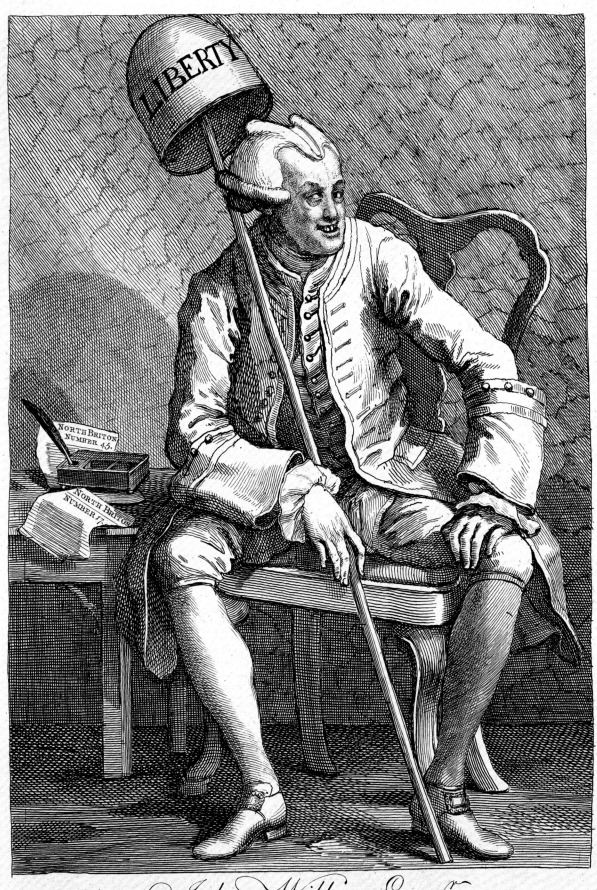

*John Wilkes Esq.*

*Drawn from the Life and Etch'd in Aquafortis by Will.ᵐ Hogarth,*

Price 1 Shilling.     *Publish'd according to Act of Parliament May ẙ 16. 1763.*

## 128

*Gulielmus Hogarth* (fourth state) 1749
Etching and engraving
38.1 × 28.7
ANDREW EDMUNDS, LONDON

## 129

*The Bruiser* (first state proof) 1763
Etching and engraving
33.7 × 26.4
THE ROYAL COLLECTION, LONDON
Not exhibited

## 130

*The Bruiser, C. Churchill* (second state)
1 August 1763
Etching and engraving
37.7 × 28.5
ANDREW EDMUNDS, LONDON

## 131

*The Bruiser, C. Churhill* (sixth state)
October 1763
Etching and engraving
37 × 28
ANDREW EDMUNDS, LONDON

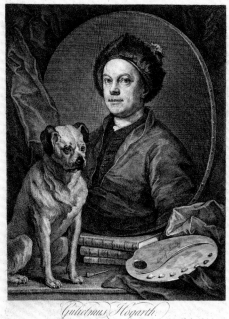

128

130

This series of images demonstrates the ways in which Hogarth could rework his prints to dramatic pictorial and satirical effect. They show him developing an ever more detailed critique of the clergyman and journalist Charles Churchill, who, following the publication of *The Times, Plate 1* (in which Churchill himself had been attacked; no.124) and *John Wilkes Esq.* (no.126), had penned a vitriolic poetic assault on the artist. Churchill's *Epistle to William Hogarth* not only lamented Hogarth's turn to political satire and his pretensions to history painting but also gave a grotesque picture of Hogarth's physical decrepitude:

> VIRTUE, with due contempt, saw
>      HOGARTH stand,
> The murderous pencil in his palsied
>      hand ...
> With all the symptoms of assur'd
>      decay,
> With age and sickness pinch'd, and
>      worn away,
> Pale quivering lips, lank cheeks, and
>      faultering tongue,
> The spirits out of tune, the nerves
>      unstrung.[21]

As in the case of John Wilkes, the artist quickly mounted a graphic response. But rather than executing an entirely new image, Hogarth turned to the copperplate that already carried his self-portrait entitled *Gulielmus Hogarth*. In a remarkable form of

self-effacement he burnished out the details of his own head and shoulders, and replaced them with the depiction of Churchill as a drunken, drooling performing bear, wearing a ripped clerical neck-band, clasping an ale-pot in one paw and an unwieldy club – the club of satire, inscribed with lies and fallacies – in the other.

In this process of substitution and transformation the pug now comes to stand for Hogarth himself, contemptuously urinating on a copy of Churchill's poem. Meanwhile, the imagery of the three books lying underneath the portrait oval is revised to allude to Wilkes's contemporary indebtedness and recent imprisonment, a message reinforced by the freshly inserted prison begging-box. Finally, in a later state of the print (no.131) Hogarth introduced what he called a 'new Petit-Piece', an engraving within an engraving that shows the artist whipping Churchill (the dancing bear) and Wilkes (the monkey) into line.[22] Hogarth's continual, almost obsessive reworking of the copperplate, as well as suggesting the depth of his antagonism towards Churchill and Wilkes, also reveals once again how his satire operated according to the aesthetic principles of assemblage and overlap, which here involve a particularly radical form of pictorial effacement and renewal.

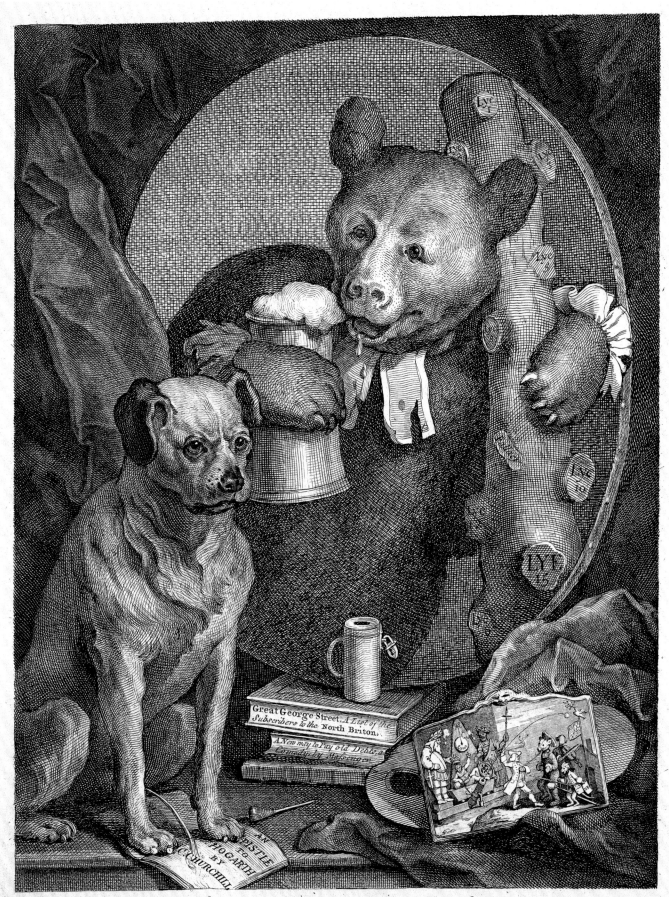

*THE* BRUISER, *C.* CHURCHILL *(once the Rev.ᵈ) in the Character of a* Russian *Hercules, Regaling*
*himself after having Kill'd the Monster* Caricatura *that so sorely Gall'd his* Virtuous *friend, the* Heaven born WILKES!
—But he had a *Club* this Dragon to Drub,    Or he had ne'er don't I warrant ye:—
*Design'd and Engraved by W.ᵐ Hogarth Price 1.ˢ 6.ᵈ*          *Publish'd according to Act of Parliament August 1. 1763.*

# 132

*Credulity, Superstition and Fanaticism:
Enthusiasm Delineated* (first state) c.1760
Etching and engraving
37.5 × 32.6
THE BRITISH MUSEUM, LONDON

# 133

*Credulity, Superstition and Fanaticism:
A Medley* (third state) 15 March 1762
Etching and engraving
38 × 32.9
ANDREW EDMUNDS, LONDON

Alongside his political and patriotic prints,
Hogarth continued to produce other kinds
of satirical engraving in the last decade of
his life, including this exceptionally rich
and extensively reworked religious piece,
which functions as a belated sequel to the
print of *The Sleeping Congregation* of 1736
(fig.43). The earlier work had lampooned
the soporific effects of an Anglican sermon;
the new print, in contrast, was intended
to ridicule the exaggerated, melodramatic
'enthusiasm' of Methodist preaching. In the
first state of the print, *Enthusiasm Delineated*
(no.132) – of which only two impressions
survive – Hogarth depicts a Methodist
meeting house in which all those present
are indulging in fraudulently excessive
forms of religious experience. The wildly
gesticulating preacher is actually a Catholic
operating in disguise: his falling wig reveals
a Jesuit's tonsure. At the same time he is
a posturing, vulgar showman who wears
a harlequin's jacket under his robes and
who peppers his frenzied speech with
metaphors that, Hogarth suggests, are
as literal and as exaggerated as the
instruments of a fairground puppeteer.

Below the preacher, in an orgy of
Nonconformist enthusiasm, a dog howls,
a bawd faints, an aristocratic rake slides his
hand towards an overheated female breast,
a repentant criminal cries into a gin bottle,
and the bestial and animated congregation
gnaw on the religious icons that we find
scattered in a succession of compromising
positions throughout the image.
A Mohammedan watches from outside the
window, aghast at the freakishness of the
religious customs on view, while two
thermometers respectively measure the
'scale of vociferation' and the congregation's
increasingly fervent responses to the
sermon.

As well as articulating a multi-layered
critique of Nonconformist preaching,
Hogarth calls into question the kinds of
pictorial rhetoric that had traditionally been
deployed to represent religious themes.

Thus, as Hogarth's handwritten caption
indicates, the figure of God hanging from the
preacher's right hand is directly quoted from
a Vatican ceiling painting then attributed
to Raphael, while the other puppets shown
hanging from the pulpit allude to figures
from works by Dürer and Rembrandt.
Similarly, the fainting woman on the left
offers a satiric version of the ecstatic female
saints found in Baroque painting and
sculpture.

Hogarth, seemingly prompted by the
disapproval *Enthusiasm Delineated* received
from ecclesiastical friends such as John
Hoadly, and shaken by the negative
responses he had received for his painting of
a canonical Renaissance subject, *Sigismunda*
(see no.111), never published this version of
the print. Instead, he decided to mute his
satire's potentially inflammatory religious
iconography and to abandon its systematic
parody of Old Master imagery, so that after
extensive revision the print's satiric attack on
Methodism became part of a broader attack
on 'credulity, superstition and fanaticism'.
The satire was now focused on the gullibility
of those who believed in fantastical hoaxes.
The fainting woman on the left is turned into
Mary Tofts, the infamous 'rabbit woman
of Goldaming', who had been pictured by
Hogarth more than thirty years earlier
(no.25). More topically, the statuettes of
Christ that so provocatively littered the
earlier version are transformed into images
of the infamous 'Cock Lane Ghost', which
was popularly supposed to have haunted the
bedroom of an eleven-year old girl and had
enjoyed a sensational, short-lived and
entirely fraudulent existence in the early
months of 1762.

132

FIGURE 43

FIGURE 43
*The Sleeping Congregation*
1736
ANDREW EDMUNDS,
LONDON

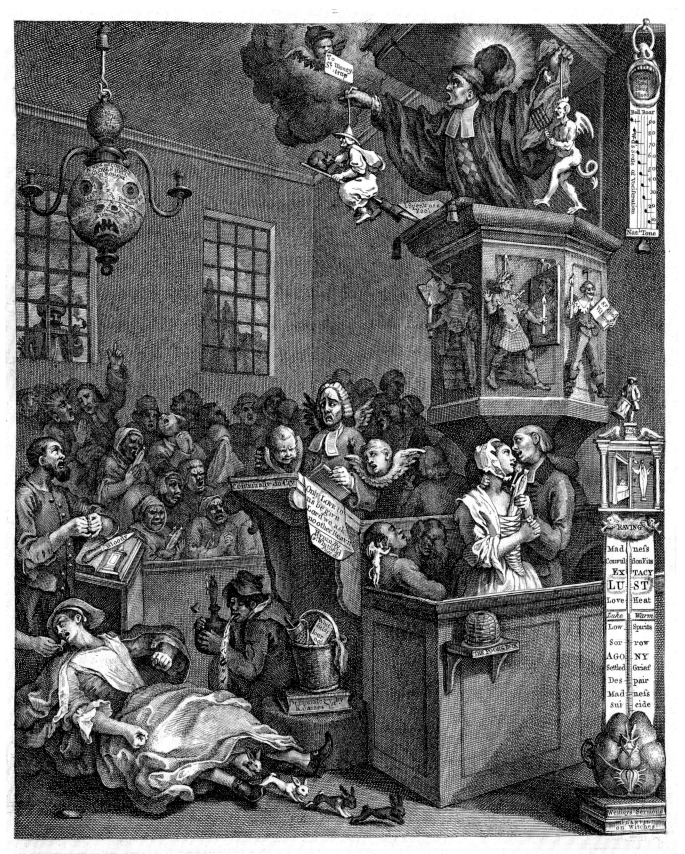

**CREDULITY, SUPERSTITION and FANATICISM.**

**A MEDLEY.**

*Believe not every Spirit, but try the Spirits whether they are of God: because many false Prophets are gone out into the World.*

1. John. Ch. 4. V. 1.

Design'd and Engrav'd by W<sup>m</sup> Hogarth.

Publish'd as the Act directs March y<sup>e</sup> 15<sup>th</sup> 1762.

# 134

*Tail Piece* or *The Bathos* 1764
Etching and engraving
31.8 × 33.7
ANDREW EDMUNDS, LONDON

Famously, this is Hogarth's final work, published some six months before his death. His print is dominated by the prone figure of Time, lying with his broken attributes. Everything has come to a close. A sign board depicts 'The World's End', a gravestone lies in the shadows and a blasted landscape is littered with smashed, ruined, and redundant objects: the crumbling church and inn, the dying trees, the cracked bell and palette, and one of Hogarth's own engravings, which like the globe is about to be consumed by flames. The sun is suffering an eclipse, and in the air the figure of Apollo sprawls lifelessly across his chariot.

*The Bathos*, as its title suggests, is ostensibly a critique of the ways in which, according to the print's caption, serious artistic subjects can be rendered ridiculous by the introduction of 'low, absurd, obscene & often prophane circumstances into them': here, we might imagine, is an example of the kind of exaggerated and 'absurd' imagery that results. More particularly, as the print's subtitle suggests, Hogarth parodies the contemporary fashion for 'sublime' forms and subjects. As a corrective, Hogarth once again promotes his famous line of beauty, which we see winding around a pyramidal shell and a cone at the base of the picture.

Another of the print's purposes was to 'serve as a Tail Piece to all the Author's engraved works, when bound up together'.[23] In this role the imagery of death and breakdown might be seen to offer a fitting, if rather gloomy, form of *memento mori*, reminding the viewer that art, like every other kind of human activity, is ultimately subject to the laws of dissolution and decomposition. At the same time the print's doom-laden air – however satiric in intent – seems to express something of the artist's own thoughts regarding his and his art's impending mortality. Time, for instance, is surrounded not only by his traditional attributes but also by an object – the painter's palette – with which Hogarth had always associated himself in his earlier self-portraits. In those images, of course, the palette had remained the central symbol of Hogarth's profession and his achievements; here, however, this same palette lies abandoned and disfigured, the last relic – like the burning print of *The Times* – of a career that has come to a bitter and controversial conclusion. By implication, the broken and exhausted figure of Time himself can be understood as an allegorical substitute for the artist, and for Hogarth's well-documented sense of weary finality as his life drew to an end.

Design'd and Engrav'd by W.ᵐ Hogarth.

Publish'd according to Act of Parliam.ᵗ March 3.ᵈ 1764.

# THE BATHOS,
## or Manner of Sinking, in Sublime Paintings,
### inscribed to the Dealers in Dark Pictures.

# Notes

HOGARTH'S VARIETY

1 William Hogarth, *The Analysis of Beauty*, ed. Ronald Paulson, New Haven and London, 1997, pp.27, 28. See also William Hogarth, *The Analysis of Beauty, with the Rejected Passages from the Manuscript Drafts and Autobiographical Notes*, ed. Joseph Burke, Oxford, 1955.

2 John Bancks, *Miscellaneous Works in Verse and Prose*, London, 1738, p.94; George Vertue, *Note Books*, Walpole Society, 6 vols., vol.3 (22), Oxford, 1934, p.46.

2 William Gilpin, *An Essay on Prints*, London, 1768, p.169.

4 Jean André Rouquet, *The Present State of the Arts in England*, London, 1755, pp.31-2.

5 *Covent-Garden Journal*, 24 March, 1752.

6 Roy Porter summarised the city's ethnic diversity in his essay, 'The Wonderful Extent and Variety of London', in Sheila O'Connell, *London: 1753*, London, 2003, p.12.

7 James Boswell, *Life of Johnson*, Everyman Edition, 2 vols., London, 1949, p.454.

8 For early seventeenth-century graphic satire, see Helen Pierce, 'Unseemly Pictures: Political Graphic Satire in England, *c.*1600–*c.*1650', unpublished Ph.D. thesis, University of York, 2004.

9 The development of graphic satire over the first half of the eighteenth century is explored in some detail in my *The Spectacle of Difference: Graphic Satire in the Age of Hogarth*, New Haven and London, 1999.

10 For artists' academies in early eighteenth-century England, see Rica Jones, 'The Artist's Training and Techniques', in Elizabeth Einberg, *Manners and Morals: Hogarth and British Painting 1700-1760*, London, 1987, pp.19–28; and Ilaria Bignamini, 'The Accompaniment to Patronage: A Study of the Origins, Rise and Development of an Institutional System for the Arts in Britain 1692-1798', unpublished Ph.D. thesis, Courtauld Institute of Art, University of London, 1988.

11 A useful illustration of this artistic cosmopolitanism is provided by noting the numerous works of foreign-born artists reproduced and discussed in Elizabeth Einberg, *Manners and Morals: Hogarth and British Painting 1700-1760*, London, 1987.

12 Thornhill's work and career have recently been discussed in Richard Johns, 'James Thornhill and Decorative History Painting in England', unpublished Ph.D. thesis, University of York, 2004.

13 See William Hogarth, 'Autobiographical notes', in *The Analysis of Beauty*, ed. Burke, p.216.

14 John Bancks, *Miscellaneous Works in Verse and Prose*, London, 1738, p.90.

15 Robert Campbell, *The London Tradesman*, London, 1747, p.99.

16 *Daily Post and General Advertiser*, 2 April 1743.

17 *General Advertiser*, 13 February 1751.

18 For details of this house, and its purchase by the artist, see Ronald Paulson, *Hogarth*, vol.2, *High Art and Low, 1732-1750*, Cambridge, 1992, pp.267-70.

19 The term 'popular print' seems to be that of Ronald Paulson, who has recently used it to introduce his discussion of *Beer Street* and *Gin Lane* in *Hogarth*, vol.3, *Art and Politics, 1750-1764*, Cambridge, 1993, p.17.

20 For the artistic schemes at the Foundling Hospital in this period, see David Solkin, *Painting for Money: The Visual Arts and the Public Sphere in Eighteenth-Century England*, New Haven and London, 1993, ch.5.

21 This remarkable collection of works is still available to be enjoyed at the Foundling Museum in Brunswick Square, London.

22 For Gainsborough's work in this period, see Michael Rosenthal and Martin Myrone (eds.) *Gainsborough*, London, 2002, section entitled 'Beginnings: The Early Years'.

23 For Hogarth's appointment to this post, and its implications, see Paulson, *Art and Politics*.

24 Hogarth's estrangement from the St Martin's Lane Academy is suggested and contextualised by Michael Kitson in his introduction to Hogarth's 'Apology for Painters', *Walpole Society Journal*, 41 (1968).

25 *St James's Chronicle*, 9-12 May 1761.

26 Hogarth, 'Autobiographical Notes', p.201.

27 Hogarth, 'Autobiographical Notes', p.231.

28 *London Chronicle*, 31 January–2 February 1765.

29 John Trusler, *Hogarth Moralized. Being a complete edition of Hogarth's works ... with an explanation pointing out the many beauties that may have hitherto escaped notice; and a comment on their moral tendency*, London, 1768. As the title and subtitle of his book suggest, Trusler famously emphasised the moral aspects of Hogarth's works.

30 See Lawrence Gowing, *Hogarth* (with a biographical essay by Ronald Paulson), London, 1971; Ronald Paulson, *Hogarth: His Life, Art and Times*, 2 vols., New Haven and London, 1971. Professor Paulson revised, rewrote and dramatically expanded his biography of the artist in his three-volume masterpiece, *Hogarth*, London and Cambridge, 1991-3, and also compiled an invaluable and detailed catalogue of Hogarth's prints, *Hogarth's Graphic Works*, 3rd revised ed., London, 1989. Ronald Paulson has dominated Hogarth studies for more than thirty years, and the present work is profoundly indebted to his magisterial scholarship on Hogarth's life and art.

31 See, in particular, Mary Webster, *Hogarth*, London, 1979; David Bindman, *Hogarth*, 1981; Elizabeth Einberg, *Manners and Morals: Hogarth and British Painting 1700-1760*, London, 1987; Elizabeth Einberg and Judy Egerton, *The Age of Hogarth: British Painters Born 1675-1709* (Tate Gallery Collections), London, 1988; David Solkin, *Painting for Money: The Visual Arts and the Public Sphere in Eighteenth-Century England*, New Haven and London, 1993; Matthew Craske, *William Hogarth*, London, 2000. See also my *The Spectacle of Difference: Graphic Satire in the Age of Hogarth*, New Haven and London, 1999, and *Hogarth*, London, 2000. Recent years have also seen the publication of a number of important collections of essays on the artist: Joachim Moeller (ed.), *Hogarth in Context: Ten Essays and a Bibliography*, Marburg, 1996; Frédéric Ogée, *The Dumb Show: Image and Society in the Works of William Hogarth*, Oxford, 1997; Bernadette Fort and Angela Rosenthal, *The Other Hogarth: Aesthetics of Difference*, Princeton and Oxford, 2001; David Bindman, Frédéric Ogée and Peter Wagner, *Hogarth: Representing Nature's Machines*, Manchester, 2001.

32 See David Bindman, *Hogarth and his Times*, London, 1997; Elizabeth Einberg, *Hogarth the Painter*, London, 1997.

WILLIAM HOGARTH AND MODERNITY

1 David H. Solkin, *Painting for Money: The Visual Arts and the Public Sphere in Eighteenth-Century England*, New Haven, 1993, p.26.

2 The term is Umberto Eco's.

3 Jürgen Habermas, *The Structural Transformation of the Public Sphere: An Inquiry into a Category of Bourgeois Society*, Cambridge, Mass., 1989. Original German edition 1962.

4 The genre, though predominantly English, also had a French following, with artists like Nicolas de Largillière (1656-1746) and Robert Tournières (1688-1752). Jean-François de Troy (1679-1752) also

adapted it for the representation of animated scenes, which Hogarth may well have seen in their popular engraved versions.

5 David Solkin (*Painting for Money*), who has written a remarkable analysis of the painting, calls it 'a veritable symphony of active fellowship'.

6 Solkin, *Painting for Money*, p.87.

7 William Hogarth, 'Autobiographical Notes', in *The Analysis of Beauty, with the Rejected Passages from the Manuscript Drafts and Autobiographical Notes*, ed. Joseph Burke, Oxford, 1955, p.209.

8 William Hogarth, *The Analysis of Beauty*, ed. Ronald Paulson, New Haven and London, 1997, pp.61, 63.

9 'All Nature is but art, unknown to thee | All chance, direction which thou canst not see | All discord, harmony not understood | All partial evil, universal good.' Alexander Pope, *An Essay on Man*, London, 1733–4, lines 289–92.

10 Hogarth, *Analysis*, p.33.

11 Charles Lamb, 'Essay on the Genius and Character of Hogarth', *The Reflector* III (1811), reprinted in John Nichols and George Steevens, *The Genuine Works of William Hogarth*, London, 1817, p.58.

12 David Bindman, *Hogarth and his Times*, London, 1997, p.29.

13 'From text to image: William Hogarth and the emergence of a visual culture in eighteenth-century England', in *Hogarth: Representing Nature's Machines*, ed. David Bindman, Frédéric Ogée and Peter Wagner, Manchester, 2001, 4. His images, as Lars Tharp has recently shown, were also visible on household objects: see Lars Tharp, *Hogarth's China: Hogarth's Paintings and Eigtheenth-Century Ceramics*, London, 1997.

14 'In Hogarth's excellent works, you see the delusive scene exposed with all the force of humour and, on casting your eyes on another picture, you behold the dreadful consequences' (Henry Fielding, *The Champion*, 10 June 1740).

15 Hogarth, *Analysis*, p.42.

1
INTRODUCING HOGARTH: PAST AND PRESENT

1 Letter from J.M.Whistler to the Committee for the Fund for the Preservation of Hogarth's House, dated 22 November 1901, call no.MS Whistler H253 (system no.02156), Center for Whistler Studies website: http://www.whistler.arts.gla.ac.uk/correspondence.

2 Richard Dorment and Margaret Macdonald (eds.), *James McNeill Whistler*, exh. cat., Tate Gallery, London, 1995, p.209. The girl depicted by Whistler is in the dress of a London costermonger; costermongers made their living selling fruit and vegetables from street barrows.

3 Elizabeth and James Pennell, *The Life of James McNeill Whistler*, London, 1908, vol.II, p.179. To underline the general neglect of Hogarth as a painter, rather than as a satirist, etc., in 1910 John Collier, then vice-president of the Society of Portrait Painters, published *The Art of Portrait Painting*. While Reynolds, Gainsborough and other British artists are discussed, Hogarth is not even mentioned.

4 Horace Walpole, *Anecdotes of English Painting, with some Account of the Principal Artists*, 1780, London, vol.IV, p.xx. For a full discussion of early biographies and other accounts of Hogarth in the late eighteenth and early nineteenth centuries, see David Bindman, *Hogarth and his Times: Serious Comedy*, London, 1997, pp.11–32.

5 Joshua Reynolds, *Discourses on Art*, ed. Robert Wark, New Haven and London, 1981, 'Discourse XIV' [1788], p.254.

6 Reynolds, *Discourses*, Discourse III (1770), p.51.

7 Quoted in Frederick Antal, *Hogarth and his Place in European Art*, London, 1962, p.253.

8 Richard Godfrey, *James Gillray: The Art of Caricature*, London, 2001, p.137. See also David Bindman, 'Hogarth's *Satan, Sin and Death* and its influence', *Burlington Magazine*, March 1970, pp.153–8.

9 Bindman, *Hogarth and his Times*, p.58; and see Sheila O'Connell's discussion of 'Hogarthomania', pp.58–60.

10 Henry Fielding, *Joseph Andrews*, London, 1742, pp.x–xi.

11 For example, in Richard and Samuel Redgrave's *A Century of British Painters*, first published in 1866, the authors described Hogarth as 'an honest, homely, matter-of-fact Englishman', whose 'guide and teacher' as an artist was 'nature' (Richard and Samuel Redgrave, *A Century of British Painters*, London, 1947, p.21). And a handbook accompanying the Manchester Art Treasures exhibition described Hogarth's anti-French and anti-Catholic stance in bald terms, saying 'he hated the French and the Jesuits, and only associated one with frogs and wooden shoes, and the other with the axe, the rack, and the Inquisition' (*A Handbook to the Gallery of British Paintings in the Art Treasures Exhibition*, London, 1857, p.32).

12 See Patrick Noon, David Blayney Brown and Christine Riding, *Constable to Delacroix: British Art and the French Romantics*, London, 2003, pp.21, 110.

13 Subsequent commentaries focus again and again on Hogarth's remarkable ability to communicate character and emotion, even if, as in the case of the French literary critic, poet and dramatist Théophile Gautier, Hogarth's work in other respects was anathema. In 1868 Gautier, a staunch Romantic, wrote an article on Hogarth, focusing on *Marriage A-la-Mode*, which he had seen during the International Exhibition of 1862. While he abhorred the moral didacticism of the series, Gautier admitted that Hogarth had 'a profound individuality' and praised his insightful depictions of the bored debauchee, Lord Squanderfield, in *The Tête à Tête* – 'La figure du jeune comte anéanti dans son fauteuil a une valeur d'execution trés remarquable' – and the dying Countess in the final scene – 'La figure de la comtesse experante effraye par la vérité de l'agonie physique, sous laquelle transparait l'agonie morale, plus doloureuse encore' (from Théophile Gautier, 'William Hogarth', *L' Artiste*, August 1868, pp.155–72, quoted in Michael Clifford Spencer, *The Art Criticism of Théophile Gautier*, Geneva, 1969, p.102).

14 Dianne Sachko Macleod, *Art and the Victorian Middle Class: Money and the Making of Cultural Identity*, Cambridge, 1996, p.51.

15 On Soane's death in 1837 the museum became the property of the British government and was opened to the public.

16 Quoted in Bindman, *Hogarth and his Times*, p.67. Frith's comment applies to all the examples quoted here, and characterises the approach taken by many artists of this period when taking a cue from Hogarth.

17 John Everett Millais and William Holman Hunt were leading members of the Pre-Raphaelite Brotherhood (formed 1848), who aimed to reform art in Britain by, for example, emphasising the moral purpose of their paintings through narratives largely based on expression and symbolism. The results are certainly more earnest in their social criticism when compared to Hogarth's acerbic approach.

18 Quoted in Pennell, *The Life of James McNeill Whistler*, pp.21–2.

19 J. Douglas Stewart, *Sir Godfrey Kneller and the English Baroque Portrait*, Oxford, 1983, p.78.

20 Quoted in David Bindman and Malcolm Baker, *Roubiliac and the Eighteenth-Century Monument: Sculpture and Theatre*, New Haven and London, 1995, p.85.

21 *The Spectator*, no.119, 17 July 1711, quoted in Aileen Ribeiro, *Dress in Eighteenth-Century Europe, 1715–1789*, London and New Haven, 2002, p.27.

22 R.W. Lightbourn, 'Introduction', in Jean André Rouquet, *The Present State of the Arts in England*, London, 1775 (facsimile reprint, London, 1970), n.p.

23 The pamphlet also mentions *The Distrest Poet, The Enraged Musician, Southwark Fair, Strolling Actresses in a Barn* and *The Four Times of Day*.

24 See Lightbourn, 'Introduction', n.p. A translation of Rouquet's *Lettres de Monsieur* was included in a German edition (1754) of Hogarth's *Analysis of Beauty*.

25 Aileen Ribeiro, *The Art of Dress: Fashion in England and France, 1750–1820*, London and New Haven, 1995, p.18.

26 Aileen Ribeiro, *Fashion and Fiction: Dress in Art and Literature in Stuart England*, New Haven and London, 2005, pp.323–4.

27 For example, Godfrey Kneller's portrait of George I's Turkish bodyguard, Mehemet (1715; The Royal Collection), shows the sitter in exotic velvet and gold-braided dress and a dark fur cap.

28 William Hogarth, *The Analysis of Beauty*, ed. Ronald Paulson, New Haven and London, 1997, p.10.

29 Quoted in David Loewenstein, *Milton: Paradise Lost*, Cambridge, 2004, p.123.

30 Quoted in Christopher Fox (ed.), *The Cambridge Companion to Jonathan Swift*, Cambridge, 2003, p.113.

31 Michael F. Suarez, 'Swift's satire and parody', in *The Cambridge Companion to Jonathan Swift*, p.113.

32 The accusations of madness were fuelled by Swift suffering from Menière's disease, a disabling brain disorder resulting in giddiness and deafness.

33 William Hogarth, *The Analysis of Beauty*, London, 1753, p.10.

34 Hogarth, *Analysis* (1753), p.4.

35 Hogarth, *Analysis* (1753), p.1.

36 Quoted in Ronald Paulson, *Hogarth's Graphic Works*, London, 1989, p.157.

37 Essex's *The Dancing-Master* was a translation of Pierre Rameau's *Maître à Dancer* (Paris, 1725).

38 Hogarth, *Analysis* (1753), p.27.

39 Hogarth, *Analysis* (1753), p.66.

40 Jenny Uglow, *Hogarth: A Life and A World*, London, 1997, pp.599–600.

41 Hogarth, *Analysis* (1997), p.92.

42 M. Friedman, *Hockney Paints the Stage*, London, 1985, p.100.

43 R. Morphet (ed.), *Encounters: New Art from Old*, exh. cat., National Gallery, London, 2000, p.270.

44 Morphet, *Encounters*, p.271.

45 V. Bruschi, 'Interview with Yinka Shonibare', in *Yinka Shonibare – "Be-Muse"*, exh. cat., Museo Hendrick Christian Andersen, Rome, 2002, pp.100–1.

2
PICTORIAL THEATRE: THE 1720S

1 Joseph Mitchell, *Three Poetical Epistles. To Mr Hogarth, Mr Dandridge, and Mr Lambert, Masters of the Art of Painting*, London, 1731.

2 Mitchell, *Three Poetical Epistles*, p.53.

3 Hogarth, 'Autobiographical Notes', in William Hogarth, *The Analysis of Beauty, with the Rejected Passages from the Manuscript Drafts and Autobiographical Notes*, ed. Joseph Burke, Oxford, 1955, p.201.

4 For the graphic culture of eighteenth-century London, see Tim Clayton, *The English Print*

*1688–1802*, New Haven and London, 1997; Sheila O'Connell, *London 1753*, London, 2003; and my *The Spectacle of Difference: Graphic Satire in the Age of Hogarth*, New Haven and London, 1999.

5 *Evening Post*, 5–7 October 1725; unnamed newspaper, 2 December 1724, quoted in John Nicols and George Stevens, *The Genuine Works of William Hogarth*, 3 vols., London, 1808–17, vol.2, p.33; *Daily Post*, 19 September 1724.

6 For this academy, and Hogarth's likely experiences within it, see Ronald Paulson, *Hogarth*, vol.1, *The 'Modern Moral Subject', 1697–1732*, New Brunswick and London, 1991, pp.100–7.

7 *A South Sea Ballad; or, Merry Remarks upon Exchange-Alley Bubbles*, London, 1720.

8 *The Freemasons: A Hudibrastic Poem*, London, 1723, pp.3, 12, 13.

9 Unnamed newspaper, 2 December 1724, quoted in Nicols and Steevens, *Genuine Works*, vol.2, p.33.

10 Sympson's print is reproduced in Paulson, *Hogarth*, vol.1, fig.83.

11 Paulson, *Hogarth*, vol.1, fig.85.

12 George Vertue, *Note Books*, 6 vols., Walpole Society, vol.3 (22), Oxford, 1934, pp.40–1.

3
THE HARLOT AND THE RAKE

1 William Hogarth, 'Autobiographical Notes', in *The Analysis of Beauty, with the Rejected Passages from the Manuscript Drafts and Autobiographical Notes*, ed. Joseph Burke, Oxford 1955, p.216 (my italics).

2 George Vertue, *Note Books*, Walpole Society, 6 vols., Oxford, 1934, vol.3, p.41.

3 The Engravers' Copyright Act, which Hogarth developed and energetically promoted in Parliament, protected independent engravers from piracy by other engravers and printsellers for a period of fourteen years from the publication date of prints.

4 *The Rake's Progress: or, the Templar's Exit*, London, 1753, canto X, p.53. This later version includes images after Hogarth's *Rake's Progress*.

5 Rochester was, for example, the patron of John Dryden, who dedicated his highly successful play, *Marriage à la Mode*, to the aristocrat (see no.73). That the Restoration rake was in Hogarth's mind at this time is underlined by the inclusion of a volume with Rochester's name on the spine in the engraved version of *Before*, published 1736 (see no.42).

6 As quoted in Ronald Paulson, *Hogarth's Graphic Works*, 3rd revised ed., London, 1989, p.99.

7 According to the author of *Scotch Gallantry display'd: or the life and adventures of ... Colonel Francis Charteris* (London, 1730), Charteris was guilty of numerous rapes and attempted rapes (occasionally at gun point), some of which occurred in his bedroom, including the rape of his servant Ann Bond, for which he was eventually convicted. Interestingly (as described in the pamphlet), she was procured 'for service' by Charteris's housekeeper soon after her arrival in London (p.35).

4
PICTURES OF URBANITY:
THE CONVERSATION PIECE

1 George Vertue, *Note Books*, Walpole Society, 6 vols., Oxford, 1934, vol.3 (22), Oxford, 1934, p.40.

2 Vertue, *Note Books*, vol.3 (22), p.41.

3 For discussions of Hogarth's early conversation pieces, see Ronald Paulson, *Hogarth*, vol.1, *The 'Modern Moral Subject' 1697–1732*, Cambridge, 1991, ch.7; Mark Hallett, *Hogarth*, London, 2000, ch.2; and David Solkin, *Painting for Money: The Visual Arts and the Public Sphere in Eighteenth-*

*Century Britain*, New Haven and London, 1993, ch.3. For a stimulating recent discussion of this category of painting, see Peter de Bolla, *The Education of the Eye: Painting, Landscape and Architecture in Eighteenth-Century Britain*, Stanford, 2003, pp.49–61.

4 Solkin, *Painting for Money*, ch.3.

5 John Brewer, *The Pleasures of the Imagination: English Culture in the Eighteenth Century*, London, 1997, p.102.

6 John Ozell, *The Art of Pleasing in Conversation* (translation and revision of French text by Pierre Ortigne de Vaumorière), London, 1735, vol.2, p.319.

7 For more on the ways in which new familial ideals were translated into pictorial form in this period, see Kate Retford, *The Art of Domestic Life: Family Portraiture in Eighteenth-Century England*, New Haven and London, 2006.

8 Vertue, *Note Books*, vol.3 (22), p.46.

9 Vertue, *Note Books*, vol.3 (22), pp.41, 46.

10 William Hogarth, 'Autobiographical Notes', in *The Analysis of Beauty, with the Rejected Passages from the Manuscript Drafts and Autobiographical Notes*, ed. Joseph Burke, Oxford, 1955, p.202.

11 Mary Webster, *Hogarth*, London, 1979, p.29.

12 Richard Dorment, *British Painting in the Philadelphia Museum of Art: From the Seventeenth through the Nineteenth Century*, Philadelphia, 1986, p.160.

13 John Bancks, 'To Mr Hogarth on his Modern Midnight Conversation', in *Miscellaneous Works in Verse and Prose, of John Bancks*, London, 1738, vol.1, p.89. For Butler, see Section 1, nos.28–34

14 John Taperell, *A New Miscellany: Containing the Art of Conversation, and Several Other Subjects*, London, 1731, p.12.

15 Dorment, *British Painting*, p.165.

16 Elizabeth Einberg, in conversation with the author. I am especially grateful to Elizabeth Einberg for her willingness to share her own important recent research on this picture, and on many other aspects of Hogarth's life and work, during the writing of this catalogue. She shall be publishing this research in her own forthcoming catalogue raisonné of Hogarth's paintings.

17 Horace, *Satires, Epistles, and Ars Poetica, with an English Translation by H. Rushton Fairclough*, London and New York, 1926, p.440; Robert Burton, *Anatomy of Melancholy*, ed. Nicolas Kiessling, Thomas Faulkner and Rhonda Blair, Oxford, 1990, vol.II, p.189.

18 Alastair Laing, *In Trust for the Nation: Paintings from National Trust Houses*, London, 1995, pp.62–3.

19 Jill Campbell, 'Politics and Sexuality in Portraits of John, Lord Hervey', *Word & Image*, 6 (1990), pp.281–97; Ronald Paulson, *Hogarth*, vol.2, *High Art and Low, 1732–1750*, Cambridge, 1992, pp.174–7.

20 Pope's attack on Hervey is to be found in his 'Epistle VII to Dr Arbuthnot', in Alexander Pope, *Works*, London, 1735, vol.II, pp.53–72.

5
STREET LIFE

1 Edward Ward, *The London-Spy Compleat, in Eighteen Parts, by the Author of the Trip to Jamaica*, London, 1703, Part I, p.2.

2 Ward, *London-Spy*, Part XII, pp.293–4.

3 Ward, *London-Spy*, Part III, pp.64–5.

4 Ward, *London-Spy*, Part I, p.2.

5 John Gay, *Trivia; Or, The Art of Walking the Streets of London*, London, 1716, Book I, p.1.

6 Ward, *London-Spy*, Part II, p.25.

7 Gay, *Trivia*, Book II, p.14.

8 Henry Fielding, *The Journal of a Voyage to Lisbon*, London, 1755, p.50.

9 *The Diary of Samuel Pepys*, ed. R.C. Latham and W. Matthews, London, first published 1970,

reprinted 1985, vol.1 (1660), p.265.

10 For further discussion of Hogarth and Laroon's *Cryes* see Sean Shesgreen, 'From representation to ridicule: Hogarth and the London Cries', in *Images of the Outcast: The Urban Poor in the Cries of London*, Manchester, 2002, pp.90–117.

11 Quoted in Shesgreen, *Images of the Outcast*, p.48.

12 William Hogarth, 'Autobiographical Notes', in *The Analysis of Beauty, with the Rejected Passages from the Manuscript Drafts and Autobiographical Notes*, ed. Joseph Burke, Oxford, 1955, p.209.

13 Henry Fielding, *The History of Tom Jones, A Foundling*, London, 1749, vol. I, bk I, pp.61–2.

14 As James Stevens Curl has noted, 'The many secret societies that existed in the seventeenth century could, in fact, be employed by any cause, and the establishment of the Grand Lodge and the "gelling" of a ritual and constitution mark a point when Freemasonry in England was reformed, registered, and cleansed of Jacobite intrigue' (James Stevens Curl, *The Art and Architecture of Freemasonry*, London, 1991, p.114). I am extremely grateful to Jacqueline Riding for the references to Hogarth and Freemasonry included in this catalogue entry.

15 Mr. D'Anvers, 'Free-Masons a dangerous Society', *The Gentleman's Magazine*, no.563, vol.VII, 16 April 1737, p.226.

16 Alexander Pope, *The Dunciad Variorum*, London, 1729, Book I, verse 200, p.17; Book III, verse 138, p.60.

17 *The Grub-street Journal, 1730–33*, ed. Bertrand A. Goldgar, 4 vols, London, 2002, no.12, vol.1 (1730), p.1.

18 Fielding, *Voyage to Lisbon*, p.50.

19 Pope, *Dunciad Variorum*, Book III, Remarks (Verse 326), p.75.

20 'But soon, ah soon Rebellion will commence, | If Musick meanly borrows aid from Sense; | Strong in new Arms lo Giant Handel stands ... To stir, to rouze [*sic*], to shake the soul he comes' (Alexander Pope, *The New Dunciad*, London, 1742, Book IV, p.6). See also Donald Burrows, *Handel*, Oxford, 1994, pp.194–214.

6
MARRIAGE A-LA-MODE

1 Daniel Defoe, *Conjugal Lewdness; or, Matrimonial Whoredom*, London, 1727, pp.394–5.

2 Quoted in *Rococo: Art and Design in Hogarth's England*, exh. cat., Victoria and Albert Museum, London, 1984, p.16.

3 John Dryden, *Marriage à la Mode*, Act II, Scene i (*The Dramatic Works of John Dryden, Esq.* London, 1735, vol. 3, pp.220–1).

4 Dryden, *Marriage à la Mode*, Act I, Scene i (*Dramatic Works*, pp.208–9).

5 Jean André Rouquet, *The Present State of the Arts in England*, London, 1755, p.104.

6 John Gay, *Fables*, no.XIV, London 1727, p.46.

7 *Mercure de France*, September 1725, vol.2, p.2257.

8 Quoted in Ronald Paulson, *Hogarth's Graphic Works*, 3rd revised ed., London, 1989, p.114.

9 Quoted in ibid, p.157.

10 Samuel Richardson, *Pamela; or, Virtue Rewarded*, 4th ed., London, 1742, vol.IV, p.325.

11 William Hogarth, 'Autobiographical Notes', in *The Analysis of Beauty, with the Rejected Passages from the Manuscript Drafts and Autobiographical Notes*, ed. Joseph Burke, Oxford, 1955, p.219.

12 Mary Webster, *Hogarth*, London, 1979, p.174.

7
THE ENGLISH FACE: HOGARTH'S PORTRAITURE

1 William Hogarth, 'Autobiographical Notes', in *The Analysis of Beauty, with the Rejected Passages from the Manuscript Drafts and Autobiographical*

*Notes*, ed. Joseph Burke, Oxford, 1955, pp.212–13. For Hogarth's portraiture of the 1740s, see in particular Ronald Paulson, *Hogarth*, vol.2, *High Art and Low, 1732–1750*, ch.7.

2  Hogarth, 'Autobiographical Notes', p.213.
3  Hogarth, 'Autobiographical Notes', p.212.
4  Hogarth, 'Autobiographical Notes', p.217.
5  Hogarth, 'Autobiographical Notes', p.218.
6  Jean André Rouquet, *The Present State of the Arts in England*, London, 1755, p.33.
7  Rouquet, *Arts in England*, pp.36–7, 37–8.
8  Hogarth, 'Autobiographical Notes', p.212.
9  Jonathan Richardson, *An Essay on the Theory of Painting*, 2nd ed., London, 1725, p.22.
10  Richardson, *Theory of Painting*, p.23.
11  This portrait, of an unidentified male sitter, is in Dulwich Picture Gallery, London.
12  Hogarth, 'Autobiographical Notes', p.218.
13  Elizabeth Einberg and Judy Egerton, *The Age of Hogarth: British Painters Born 1675–1709* (Tate Gallery Collections, vol.2), London, 1988, p.109.
14  Rouquet, *Arts in England*, p.47.
15  Elizabeth Einberg, *Hogarth the Painter*, London, 1997, p.43.
16  See ibid.
17  Mary Webster, *Hogarth*, London, 1979, p.94.
18  Quoted in John Nichols and George Steevens, *The Genuine Works of William Hogarth*, 3 vols., London, 1808–17, vol.I, p.193.
19  Van Dyck's portrait of Laud (*c.*1636) is located at the Fitzwilliam Museum, Cambridge.
20  *Letters from the Late Most Reverend Dr Thomas Herring ... to William Duncombe Esq*, London, 1777, p.88; John Duncombe's observations are quoted in Einberg and Egerton, *Age of Hogarth*, p.125.
21  Richardson, *Theory of Painting*, p.193.
22  Richardson, *Theory of Painting*, p.118.
23  Mary Webster, 'An Eighteenth-Century Family: Hogarth's Portrait of the Graham Children', *Apollo*, CXXX, no.331, 1989, pp.171–3.
24  Judy Egerton, *The British School* (National Gallery Catalogues), London, 1998, p.140.
25  As noted by Egerton, *The British School*, p.142.
26  Ibid.
27  Richard Wendorf, *The Elements of Life: Biography and Portrait-Painting in Stuart and Georgian England*, Oxford, 1990, p.182.
28  Paulson, *Hogarth*, vol.2, pp.178–9.

### 8
### CRIME AND PUNISHMENT

1  Quoted in Jonathan White, 'The "Slow but Sure Poyson": The Representation of Gin and Its Drinkers, 1736–1751,' in *Journal of British Studies*, vol.42, no.1, January 2003, p.41.
2  Quoted in Ronald Paulson, *Hogarth's Graphic Works*, 3rd revised ed., London, 1989, p.145.
3  William Hogarth, 'Autobiographical Notes', in *The Analysis of Beauty, with the Rejected Passages from the Manuscript Drafts and Autobiographical Notes*, ed. Joseph Burke, Oxford 1955, p.225.
4  Captain Alexander Smith, *A Compleat History of the Lives and Robberies of the Most Notorious Highway-Men, Foot-Pads, Shop-Lifts, and Cheats of Both Sexes*, London, 1719, vol.1, p.151.
5  Quoted in William Hogarth, *Anecdotes of William Hogarth, Written by Himself ...*, London, 1833, p.178.
6  Bernard Mandeville, *An Enquiry into the Causes of the Frequent Executions at Tyburn*, London, 1725, p.20.
7  Hogarth, 'Autobiographical Notes', p.226.
8  *Boswell's London Journal, 1762–3*, ed. Frederick A. Pottle, London, 1985, p.88.
9  Ibid.

### 9
### HIGH ART

1  Ronald Paulson remains the one scholar who has studied each of the artist's history paintings in some depth; see his *Hogarth*, 3 vols., London and Cambridge, 1991–3.
2  Joshua Reynolds, *Discourses on Art*, ed. Robert Wark, New Haven and London, 1975, Discourse XIV (1788), pp.254–5.
3  Horace Walpole, letter to George Montagu, 5 May 1761, *The Yale Edition of Horace Walpole's Correspondence*, ed. W.S. Lewis, New Haven, 1937–83, vol.9, p.365.
4  John Milton, *Paradise Lost*, Book II, lines 650–3.
5  See David Bindman, 'Hogarth's *Satan, Sin and Death* and its influence', *Burlington Magazine*, CXII, 1970, pp.153–8.
6  Medina's illustration is reproduced in Bindman, 'Hogarth's *Satan, Sin and Death*', p.155.
7  Milton, *Paradise Lost*, Book II, line 802.
8  Elizabeth Einberg, in conversation with the author.
9  David Dabydeen, 'Hogarth and the Canecutter', in Peter Hulme and William H. Sherman (eds.), *The Tempest and its Travels*, London, 2000, p.260.
10  George Vertue, *Note Books*, Walpole Society, 6 vols., Oxford, 1930–55, vol.3 (22) , p.130.
11  Richard Johns, 'James Thornhill and Decorative History Painting in England after 1688', unpublished Ph.D. thesis, University of York, 2004, pp.90–104.
12  *The Poems and Fables of John Dryden*, ed. James Kinsley, London, 1962, pp.621–40.
13  William Hogarth, 'Autobiographical Notes', in *The Analysis of Beauty, with the Rejected Passages from the Manuscript Drafts and Autobiographical Notes*, ed. Joseph Burke, Oxford, 1955, p.220.
14  *Lloyd's Evening Post*, 27–9 May 1761; *St James's Chronicle*, 23–6 May 1761.

### 10
### PATRIOTISM, PORTRAITURE AND POLITICS

1  For Hogarth at the 1761 exhibition, see my *Hogarth*, London, 2000, ch.10; Ronald Paulson, *Hogarth*, vol.3, *Art and Politics, 1750–1764*, ch.12.
2  The Society of Artist exhibitions of the period, including that of 1761, are discussed in illuminating detail in Matthew Hargraves, *Candidates for Fame: The Society of Artists for Great Britain 1760–1791*, New Haven and London, 2006; and in David Solkin, *Painting for Money: The Visual Arts and the Public Sphere in Eighteenth Century England*, New Haven and London, 1993, ch.7.
3  *The London Magazine*, April 1761, p.212.
4  *London Evening Post*, 24–6 February 1757.
5  *North Briton*, no.17, 25 September 1762.
6  William Hogarth, 'Autobiographical Notes', in *The Analysis of Beauty, with the Rejected Passages from the Manuscript Drafts and Autobiographical Notes*, ed. Joseph Burke, Oxford, 1955, p.227.
7  Hogarth, 'Autobiographical Notes', p.228.
8  Ibid.
9  Theodosius Forrest (attrib.), 'The Roast Beef of Old England', reprinted in John Nicols, *Biographical Anecdotes of William Hogarth*, 3rd ed., London, 1785, pp.291–2.
10  Hogarth, 'Autobiographical Notes', p.228.
11  Hogarth, 'Autobiographical Notes', p.227.
12  Elizabeth Einberg, 'Milton, St John and the importance of "Bottom": Another look at Hogarth's *March of the Guards to Finchley*', *The British Art Journal*, vol.V, no.3, winter 2004, pp.27–34.
13  Quoted in John Nicols and George Steevens, *The Genuine Works of William Hogarth*, 3 vols., London, 1808, vol.1, p.212.
14  *London Evening Post*, 24–6 February 1757.
15  Horace, *Odes*, III, 26 – the inscribed line is 'Vixi puellis nuper idoneus, etc.'
16  *London Evening Post*, 30 April–2 May 1754.

17  *The London Magazine*, May 1754, p.212.
18  Ronald Paulson, *Hogarth's Graphic Works*, 3rd revised ed., London, 1989, p.181.
19  *The North Briton*, no.17, 25 September 1762.
20  Paulson, *Graphic Works*, p.183.
21  Charles Churchill, *An Epistle to William Hogarth*, London, 1763, p.20.
22  Newspaper advertisement, *St James's Chronicle*, 1–4 October 1763.
23  As announced in the advertisement for the print in the *Public Advertiser*, 16 April 1764.

# Bibliography

BRIAN ALLEN
*Francis Hayman*, New Haven and London, 1987
— *Towards a Modern Art World* (ed.), New Haven and London, 1995

DONNA T. ANDREW
*Philanthropy and Police: London Charity in the Eighteenth-Century*, Princeton, NJ, 1989

ANON
*The Harlot's Progress, being the Life of the Noted Moll Hackabout, in six Hudibrastic Cantos*, London, 1732
— *The Progress of a Harlot. As she is described in Six Prints, by the Ingenious Mr Hogarth*, London, 1732
— *The Harlot's Progress; or, the Ridotto al Fresco, a Grotesque Pantomime Entertainment*, London, 1733
— *The Jew Decoy'd: or, the Progress of a Harlot, a New Ballad Opera of Three Acts*, London, 1735
— *A Dissertation on Hogarth's Six Prints*, London, 1751

FREDERICK ANTAL
*Hogarth and his Place in European Art*, London, 1962

APOLLO
vol.CXLVIII, no.437, August 1998 (special issue on *A Rake's Progress*)

ROBYN ASLESON AND SHELLEY M. BENNETT
*British Paintings at the Huntington*, New Haven and London, 2001

HERBERT ATHERTON
*Political Prints in the Age of Hogarth: A Study in the Ideographic Representation of Politics*, Oxford, 1964

JOHN BANCKS
*Miscellaneous Works in Verse and Prose*, London, 1738

JOHN BARRELL (ED.)
*Painting and the Politics of Culture: New Essays on British Art 1700–1850*. Oxford, 1992

R.B. BECKETT
*Hogarth*, London, 1949

DAVID BINDMAN
'Hogarth's *Satan, Sin and Death* and its influence', *Burlington Magazine*, CXII, 1970
— *Hogarth*, London, 1981
— *Hogarth and his Times: Serious Comedy*, London, 1997
— and Scott Wilcox (eds.) '*Among the Whores and Thieves*': *William Hogarth and The Beggar's Opera*, New Haven and Farmington, 1997
— and Frédéric Ogée and Peter Wagner (eds.), *Hogarth: Representing Nature's Machines*, Manchester, 2001

PETER DE BOLLA
*The Education of the Eye: Painting, Landscape and Architecture in Eighteenth-Century Britain*, Stanford, 2003

DAVID A. BREWER
'Making Hogarth Heritage', *Representations*, no.72, autumn 2000

JOHN BREWER
*The Pleasures of the Imagination: English Culture in the Eighteenth Century*, London, 1997

TOM BROWN
*The Works of Tom Brown, Serious and Comical*, 7th ed., London, 1730

JOSEPH BURKE (ED.)
*English Art 1714–1800*, Oxford, 1976

SAMUEL BUTLER
*Hudibras* (first published in three parts, 1662/3–78), edited and introduced by John Wilders, Oxford, 1975

ROBERT CAMPBELL
*The London Tradesman*, London, 1747

VINCENT CARRETTA
*The Snarling Muse: Verbal and Visual Political Satire from Pope to Churchill*, Philadelphia, 1983
— *George III and the Satirists from Hogarth to Byron*, Athens, Georgia, 1990

SOPHIE CARTER
*Purchasing Power: Representing Prostitution in Eighteenth-Century English Popular Print Culture*, Aldershot, 2004

TIMOTHY CLAYTON
*The English Print 1688–1802*, New Haven and London, 1997

ROBERT L.S. COWLEY
*Marriage A-la-Mode: A Review of Hogarth's Narrative Art*, Manchester, 1983

MATTHEW CRASKE
*William Hogarth*, London, 2000

DAVID DABYDEEN
*Hogarth, Walpole and Commercial Britain*, London, 1987

DIANA DONALD
*The Age of Caricature: Satirical Prints in the Reign of George III*, New Haven and London, 1996

RICHARD DORMENT
*British Painting in the Philadelphia Museum of Art: From the Seventeenth through the Nineteenth Century*, Philadelphia, 1986

JUDY EGERTON
*Hogarth's Marriage A-la-Mode*, London, 1997
— *The British School* (National Gallery catalogues), London, 1998

ELIZABETH EINBERG
*Manners and Morals: Hogarth and British Painting, 1700–1760*, exh. cat., Tate Gallery, London, 1987
— and Judy Egerton, *Tate Gallery Collections, II: The Age of Hogarth, British Painters Born 1675–1709*, London, 1988
— *Hogarth the Painter*, London, 1997
— 'Milton, St. John and the importance of "Bottom": Another look at Hogarth's *March of the Guards to Finchley*', *British Art Journal*, vol.V, no.3, winter 2004

DOUGLAS FORDHAM
'William Hogarth's *The March to Finchley* and the fate of comic history painting', *Art History*, vol.27, no.1, 2004

BERNADETTE FORT AND ANGELA ROSENTHAL (EDS.)
*The Other Hogarth: Aesthetics of Difference*, Princeton and Oxford, 2001

JOSEPH GAY
*The Lure of Venus; or, a Harlot's Progress, a Heroi-Comical Poem in Six Cantos*, London, 1733

M. DOROTHY GEORGE
*English Political Caricature to 1792: A Study of Opinion and Propaganda*, Oxford, 1959

WILLIAM GILPIN
*An Essay on Prints*, London, 1768

MICHAEL GODBY
'The First Steps of Hogarth's *Harlot's Progress*', *Art History*, vol.10, no.1 (March 1987)

LAWRENCE GOWING
*Hogarth*, exh. cat., Tate Gallery, London, 1971

MARK HALLETT
*The Spectacle of Difference: Graphic Satire in the Age of Hogarth*, New Haven and London, 1999
— *Hogarth*, London, 2000

MATTHEW HARGRAVES
*Candidates for Fame: The Society of Artists for Great Britain, 1760–1791*, New Haven and London, 2006

RHIAN HARRIS AND ROBIN SIMON (EDS.)
*Enlightened Self-Interest: The Foundling Hospital and Hogarth*, London, 1997

WILLIAM HOGARTH
*The Analysis of Beauty, with the Rejected Passages from the Manuscript Drafts and Autobiographical Notes*, ed. Joseph Burke, Oxford, 1955
— *The Analysis of Beauty*, ed. Ronald Paulson, New Haven and London, 1997

DAVID HUNTER
'Copyright Protection for Engravings and Maps in Eighteenth-Century Britain', *The Library*, 6th series, vol.9 (1987)

DEREK JARRETT
*The Ingenious Mr Hogarth*, London, 1976

ROBERT JONES
*Gender and the Formation of Taste in Eighteenth-Century Britain: The Analysis of Beauty*, Cambridge, 1998

MICHAEL KITSON
'Hogarth's "Apology for Painters"', *The Walpole Society Journal*, 41, 1968

BERND KRYSMANKSI
'We see a Ghost: Hogarth's Satire on Methodists and Connoisseurs', *Art Bulletin*, 80, 1998

DAVID KUNZLE
'Plagiaries by Memory of the Rake's Progress', *Journal of the Warburg and Courtauld Institutes*, 29, 1966

ALISTAIR LAING
*In Trust for the Nation: Paintings from National Trust Houses*, London, 1995

GEORGE CHRISTOPH LICHTENBERG
*Lichtenburg's Commentaries on Hogarth's Engravings* (translated and with an introduction by Innes and Gustav Herdan), London, 1966

M.J.H. LIVERSIDGE
*William Hogarth's Bristol Altarpiece*, Bristol, 1989

DAVID MANNINGS
'Reynolds, Hogarth and Van Dyck', *The Burlington Magazine*, vol.126, no.980, November 1984

JANE MARTINEAU *et al.*
*Shakespeare in Art*, London, 2003

JOSEPH MITCHELL
*Three Poetical Epistles. To Mr Hogarth, Mr Dandridge, and Mr Lambert, Masters of the Art of Painting*, London, 1731

JOACHIM MOELLER (ED.)
*Hogarth in Context: Ten Essays and a Bibliography*, Marburg, 1996

MARTIN MYRONE
*Body Building: Reforming Masculinitites in British Art 1750–1810*, New Haven and London, 2005

JOHN NICOLS
*Biographical Anecdotes of William Hogarth*, 3rd ed., London, 1785

— and George Steevens, *The Genuine Works of William Hogarth*, 3 vols., London, 1808–17

FRANCIS NIVELON
*The Rudiments of Genteel Behaviour*, London, 1737 (facsimile reprint by Paul Holberton Publishing, 2003)

SHEILA O'CONNELL
*The Popular Print in England, 1550–1850*, London, 1999

— *London: 1753*, London, 2003

FRÉDÉRIC OGÉE (ED.)
*The Dumb Show: Image and Society in the Works of William Hogarth*, Oxford, 1997

A.P. OPPÉ
*The Drawings of William Hogarth*, London, 1948

RONALD PAULSON
*Hogarth: His Life, Art, and Times*, New Haven and London, 1971

— *The Art of Hogarth*, London, 1975

— *Emblem and Expression: Meaning in English Art of the Eighteenth Century*, London, 1975

— *Popular and Polite Art in the Age of Hogarth and Fielding*, Notre Dame and London, 1979

— *Breaking and Remaking: Aesthetic Practice in England 1700–1820*, New Brunswick and London, 1989

— *Hogarth's Graphic Works*, 3rd revised ed., London, 1989

— *Hogarth*, vol.1, *The 'Modern Moral Subject', 1697–1732*, London, 1991

— *Hogarth*, vol.2, *High Art and Low, 1732–1750*, Cambridge, 1992

— *Hogarth*, vol.3, *Art and Politics, 1750–1764*, Cambridge, 1993

— *The Beautiful, Novel, and Strange: Aesthetics and Heterodoxy*, Baltimore, 1996

— *Hogarth's Harlot: Sacred Parody in Enlightenment England*, Baltimore, 2003

IAIN PEARS
*The Discovery of Painting: The Growth of Interest in the Arts in England, 1680–1768*, New Haven and London, 1988

MICHAEL PODRO
*Depiction*, New Haven and London, 1998

MARCIA POINTON
*Hanging the Head: Portraiture and Social Formation in Eighteenth-Century England*, New Haven and London, 1993

— *William Hogarth's* Sigismunda *in Focus*, London, 2000

JOSHUA REYNOLDS
*Discourses on Art*, ed. Robert Wark, New Haven and London, 1975

KATE RETFORD
*The Art of Domestic Life: Family Portraiture in Eighteenth-Century England*, New Haven and London, 2006

ANNIE RICHARDSON
'An Aesthetics of Performance: Dance in Hogarth's "Analysis of Beauty"', *Dance Research: The Journal of the Society for Dance Research*, vol.20, no.2, winter 2002

JONATHAN RICHARDSON
*An Essay on the Theory of Painting* (1715), 2nd ed., London, 1725

JACQUELINE RIDING
*The Handel House Museum: Companion Guide*, London, 2001

MICHAEL ROSENTHAL AND MARTIN MYRONE
*Gainsborough*, London, 2002

JEAN ANDRÉ ROUQUET
*The Present State of the Arts in England*, London, 1755

CHARLES SAUMAREZ SMITH
*Eighteenth-Century Decoration: Design and the Domestic Interior in England*, New York, 1993

SEAN SHESGREEN
'Hogarth's *Industry and Idleness*: A Reading', *Eighteenth-Century Studies*, 9, 1976

— *Hogarth and the Times of Day Tradition*, London, 1983

— *Images of the Outcast: The Urban Poor in the Cries of London*, Manchester, 2002

ROBIN SIMON
'Hogarth and Raphael, Joseph Porter and Daniel Lock', *The British Art Journal*, vol.IV, no.1, 2003

CHRISTINA SKULL
*The Soane Hogarths*, London, 1991

MICHAEL SNODIN (ED.)
*Rococo: Art and Design in Hogarth's England*, exh. cat., Victoria and Albert Museum, London, 1984

DAVID H. SOLKIN
*Painting for Money: The Visual Arts and the Public Sphere in Eighteenth-Century England*, New Haven and London, 1993

LINDSAY STAINTON AND CHRISTOPHER WHITE
*Drawing in England from Hilliard to Hogarth*, London, 1987

F.G. STEPHENS, E. HAWKINS AND M.D. GEORGE
*British Museum Catalogue of Political and Personal Satires*, London, 1870–1954

LARS THARP
*Hogarth's China: Hogarth's Painting and Eighteenth-Century Ceramics*, London, 1997

JOHN TRUSLER
*Hogarth Moralized*, London, 1768

JENNY UGLOW
*Hogarth: A Life and a World*, London, 1997

GEORGE VERTUE
*Note Books*, Walpole Society, 6 vols., ( 18, 20, 22, 24, 26, 30), Oxford, 1930–55

PETER WAGNER
*Reading Iconotexts: From Swift to the French Revolution*, London, 1995

HORACE WALPOLE
*Anecdotes of Painting in England*, 4 vols., London, 1762–71

EDWARD (NED) WARD
*The London-Spy Compleat, in Eighteen Parts*, 4th ed., London, 1709

ELLIS WATERHOUSE
*Painting in Britain 1530–1790* (with an introduction by Michael Kitson), New Haven and London, 1994

MARY WEBSTER
*Hogarth*, London, 1979

— 'An Eighteenth-Century Family: Hogarth's Portrait of the Graham Children', *Apollo*, CXXX, no. 331, 1989

RICHARD WENDORF
*The Elements of Life: Biography and Portrait-Painting in Stuart and Georgian England*, Oxford, 1990

SHEARER WEST
*The Image of the Actor: Verbal and Visual Representation in the Age of Garrick and Kemble*, London, 1991

W.T. WHITLEY
*Artists and their Friends in England, 1700–1799*, London, 1928

BARRY WIND
'Hogarth's Fruitful Invention: Observations on *Harlot's Progress*, Plate III', *Journal of the Warburg and Courtauld Institutes*, vol.52, 1989

— 'Hogarth's *Industry and Idleness* Reconsidered', *Print Quarterly*, XIV, 3, 1997

# Chronology

| | CONTEMPORARY EVENTS | HOGARTH |
|---|---|---|
| 1697 | | William Hogarth born on 10 November, son of Richard and Anne, and baptised at St Bartholomew's Church, Smithfield, in the City of London. |
| 1698 | | |
| 1699 | | |
| 1700 | | |
| 1701 | Act of Settlement ensures protestant royal succession through Sophia, Electress of Hanover. Death of Charles II, the Spanish Hapsburg king, leading to the War of the Spanish Succession (until 1714). | |
| 1702 | William III dies; Anne proclaimed Queen. First daily paper is produced, the *Daily Courant*. Godfrey Kneller starts painting members of the Kit-Cat Club (until 1721). | |
| 1703 | The 'Great Storm of 1703' ravages southern England killing thousands. | Richard Hogarth opens a Latin-speaking coffee house in St John's Gate, Clerkenwell. |
| 1704 | John Churchill is victorious over the French at the Battle of Blenheim, and created Duke of Marlborough. *Opticks* by Isaac Newton is published. | |
| 1705 | Louis Laguerre paints the staircase at Buckingham House. | |
| 1706 | English, Dutch and German troops led by the Duke of Marlborough defeat the French at the Battle of Ramillies. | |
| 1707 | Acts of Union unite England and Scotland as the Kingdom of Great Britain. Philip V unites Castile and Aragon into the single Kingdom of Spain Antonio Verrio dies at Hampton Court Palace. | The coffee house fails, and Richard Hogarth sent to the Fleet Prison for debt. The young Hogarth, with his mother and two sisters, is forced to live in debtors' lodgings nearby. |
| 1708 | Admiral Byng foils the attempt of the Pretender, James Stuart (James III), to land at the Firth of Forth. James Thornhill begins work on the Painted Hall, Greenwich (completed 1727). Charles Montagu, Duke of Manchester, brings to England from Venice Giovanni Pellegrini (until 1713) and Marco Ricci (until 1716). | |
| 1709 | Richard Steele begins writing *The Tatler*, assisted by Joseph Addison. | |
| 1710 | Statute of Anne comes into effect, the world's first piece of copyright legislation, restricting the monopoly of the Stationers' Company. The last stone is laid in the lantern on the dome of St Paul's Cathedral, in the presence of Christopher Wren. | |
| 1711 | Joseph I, Holy Roman Emperor, dies; Charles VI of Austria succeeds him. George Frideric Handel settles in London; his opera *Rinaldo* is performed at the Queen's Theatre, Haymarket, the first Italian opera composed for the London stage. Addison and Steele launch *The Spectator* (until 1714). The first academy of art in England is founded in Great Queen Street, London, with Kneller as governor. | |

| 1712 | Alexander Pope's *The Rape of the Lock* is published.<br>Sebastiano Ricci arrives in London from Venice (until 1716), and is soon commissioned to paint the monumental staircase of Burlington House. | Richard Hogarth is released from Fleet Prison, and the family move to Long Lane, Smithfield. |
|------|------|------|
| 1713 | Treaty of Utrecht is signed, ending the War of the Spanish Succession for some powers involved; French and Spanish possessions ceded to Britain, including Hudson Bay and Gibraltar.<br>The Scriblerus Club is founded by Swift, Pope, Gay and others. | William Hogarth is apprenticed to the silver engraver Ellis Gamble of the Merchant Taylors' Company. |
| 1714 | Queen Anne dies; George I proclaimed king.<br>Whig administration formed under Lord Stanhope.<br>Thornhill begins painting the dome of St Paul's (completed 1717), having beaten foreign competition for the commission. | |
| 1715 | The Jacobites Bolingbroke, Ormond and Oxford are impeached; followed by rioting, leading to the enforcement of the Riot Act (1714).<br>First Jacobite Rebellion: the Pretender (James Stuart) arrives in Scotland from France.<br>Louis XIV of France dies shortly before his seventy-seventh birthday and is succeeded by his five-year-old great grandson, who rules as Louis XV.<br>Jonathan Richardson's treatise *An Essay on the Theory of Painting* is published. | |
| 1716 | Failure of Jacobite rebellion; the Pretender flees Scotland for France; Jacobite leaders are impeached; execution of Derwentwater and Kenmure.<br>Septennial Act extends life of parliament to a maximum of seven years.<br>Lady Mary Wortley Montagu accompanies her husband to Turkey.<br>Philip Mercier settles in England from Paris. | |
| 1717 | Triple Alliance formed between England, France and Holland to uphold the Treaty of Utrecht.<br>William Kent begins working on the interiors of Houghton Hall.<br>Colley Cibber stages *The Loves of Mars and Venus* at the Drury Lane Theatre, the first performance of ballet in Britain. | |
| 1718 | Quadruple Alliance formed as the Holy Roman Emperor joins the Triple Alliance.<br>War of the Quadruple Alliance against Spain (until 1720). | Richard Hogarth dies. |
| 1719 | Daniel Defoe's novel *Robinson Crusoe* is published. | |
| 1720 | Spain joins the Quadruple Alliance, ending conflict with England<br>South Sea Bubble: in February South Sea Company takes on part of the national debt in return for exclusive trading rights in the South Seas; in June stocks in the South Sea Company reach record highs; in August stocks fall rapidly; in December Walpole restores public credit.<br>Thomas Highmore dies; James Thornhill succeeds him as Serjeant Painter, and becomes the first British artist to receive a knighthood<br>Joseph Van Aken arrives in England. | 23 April: William Hogarth issues his shop card and opens business as a copperplate engraver from the house in Long Lane, Smithfield.<br>Joins the St Martin's Lane Academy of Painting, recently established by Louis Chéron and John Vanderbank. |
| 1721 | Walpole administration formed, with Robert Walpole as first Lord of the Treasury, Britain's first Prime Minister.<br>Louis Laguerre and Grinling Gibbons die. | Produces his first satirical engraving, *The South Sea Scheme*, in response to the South Sea Bubble Scandal (autumn 1720).<br>Probably begins working on the small *Hudibras* series around this time. |
| 1722 | Atterbury Plot of Jacobites discovered; leading Jacobite sympathisers arrested; Francis Atterbury (Bishop of Rochester) banished.<br>Daniel Defoe's novel *Moll Flanders* is published.<br>Francesca Cuzzoni, the celebrated soprano, arrives in London. | Works on plates for La Motraye's *Travels* and Gildon's *New Metamorphosis*. |
| 1723 | Christopher Wren dies.<br>Godfrey Kneller dies.<br>Joshua Reynolds is born in Plympton, Devon. | |
| 1724 | Carteret becomes Lord Lieutenant of Ireland; Duke of Newcastle becomes Secretary of State; Henry Pelham made Secretary of State for War.<br>The thief and jailbreaker Jack Sheppard is hanged at Tyburn. | Produces *The Bad Taste of the Town (Masquerades and Operas)*, which is pirated.<br>His shop is now at the sign of the Golden Ball, on the corner of Cranbourne Alley and Little Newport Street.<br>Joins James Thornhill's free academy in Covent Garden. |

| | | |
|---|---|---|
| 1725 | Treaty of Hanover between England, France and Prussia.<br>City Elections Act gives more power to aldermen.<br>Bolingbroke is pardoned and returns to England to form opposition to Walpole.<br>The 'thief-taker' Jonathan Wild is hanged at Tyburn. | Hogarth's sisters Mary and Anne open a milliner's shop in Long Walk, near the Cloisters, St Bartholomew's Hospital.<br>Produces a satire on William Kent, *William Kent's Altarpiece*. |
| 1726 | Jonathan Swift's novel *Gulliver's Travels* is published. | Publishes his large plates of *Hudibras* and *Burning ye Rumps at Temple-Barr*.<br>Begins illustrations of *Don Quixote* for Jacob Tonson (abandoned 1727).<br>Produces *Cunicularii*, a satire on Mrs Tofts, the 'Rabbit Woman' of Godalming, and *The Punishment Inflicted on Lemuel Gulliver*, a satire on Robert Walpole. |
| 1727 | George I dies; George II proclaimed king.<br>William Kent publishes *Some Designs of Mr Inigo Jones*, including additional designs by himself and Lord Burlington, his patron.<br>Thomas Gainsborough is born in Sudbury, Suffolk. | Produces the satires *Masquerade Ticket; Henry VIII and Anne Boleyn*.<br>Begins to paint seriously in oils. |
| 1728 | First performance of John Gay's *The Beggar's Opera* at John Rich's Lincoln's Inn Fields Theatre.<br>First version ('three book' edition) of Alexander Pope's *Dunciad* is published. | Begins painting *The Beggar's Opera*, followed by another version a year later.<br>Is commissioned by Viscount Castlemaine to paint *The Assembly at Wanstead House*. |
| 1729 | Treaty of Seville with Spain.<br>Giacomo Amiconi (Jacopo Amigoni) arrives in England (until 1739) and is soon commissioned to paint decorative interior scenes at Moor Park Mansion, Hertfordshire. | Is present at the House of Commons investigation into the Fleet Prison, witnessing the confrontation of committee, warden and prisoners, on which he bases the painting *The Gaols Committee of the House of Commons*.<br>Elopes with Jane Thornhill, daughter of the painter James Thornhill; they marry and live in Little Piazza, Covent Garden.<br>Busy producing painted satires such as *The Denunciation*, and conversation pieces, including *The Woodes Rogers Family*. |
| 1730 | Lord Harrington replaces Townsend as Secretary of State.<br>William Kent begins working at Stowe House.<br>Louis-François Roubiliac settles in London from Paris. | Continues painting conversation pieces including *The Midnight Modern Conversation* and *The Jones Family*.<br>Begins painting *A Harlot's Progress* and *Before* and *After*.<br>Mary and Anne Hogarth move their shop to 'Little Britain', and Hogarth engraves the card announcing their change of address. |
| 1731 | Henry Fielding writes the *Grub-Street Opera*<br>Michael Rysbrack's marble monument to Isaac Newton is installed in Westminster Abbey. | He and his wife move into the Thornhill house, Great Piazza, Covent Garden.<br>Completes the painted series *A Harlot's Progress* and begins the subscription for engraved copies, the subscription ticket being *Boys Peeping at Nature*; starts engraving the series himself after failing to find an engraver. |
| 1732 | Frederick, Prince of Wales, attends a fancy-dress ball at Vauxhall Gardens, assuring its fashionable status.<br>Allan Ramsay arrives in London from Edinburgh, and trains under the Swedish painter Hans Hysing. | Completes the engraved series of *A Harlot's Progress,* which is heavily pirated.<br>Produces the subscription ticket for the engraving of *The Midnight Modern Conversation.*<br>Paints *The Cholmondeley Family*.<br>Travels on a 'peregrination' through Kent with some friends.<br>Hogarth's father in-law, James Thornhill, retires as Serjeant Painter, in favour of his son John. |
| 1733 | Excise Bill introduced by Walpole, leading to widespread opposition forcing its withdrawal.<br>Walpole narrowly escapes defeat in the House of Lords over the investigation into the South Sea Company affairs.<br>Theophilus Cibber's *The Harlot's Progress, or, the Ridotto al'fresco* is staged at the Drury Lane Theatre.<br>Joseph Nollekens settles in London. | The engraving of *The Midnight Modern Conversation* is completed and delivered, followed by many piracies.<br>Visits the thief and murderess Sarah Malcolm in her cell, and publishes a portrait engraving.<br>Is commissioned to paint a conversation of the royal family; receives permission to paint the marriage of Anne, Princess Royal, but is thwarted by William Kent and the Duke of Grafton.<br>Moves to the Golden Head, Leicester Fields, his new home, studio and shop.<br>Produces an engraved version of *Southwark Fair.*<br>Starts painting *A Rake's Progress.* |
| 1734 | Bolingbroke gives up active opposition to Walpole and retires to France.<br>The Bank of England moves into its permanent home in Threadneedle Street, London. | Completes *A Rake's Progress* painted series.<br>Offers to paint murals on the staircase of St Bartholomew's Hospital and is later elected a governor of the hospital.<br>James Thornhill dies. |

| 1735 | Second parliament under George II, Walpole maintains a substantial majority. | Is a founding member of the Sublime Society of Beefsteaks. |
| | Dryden's *Marriage à la Mode* (1672) is re-published, with a frontispiece by Gravelot. | Engravers' Copyright Act, known as 'Hogarth's Act', is passed by Parliament; engraved versions of *A Rake's Progress* are pirated, and the Act is enforced. |
| | Amiconi paints the portraits of members of the royal family and court, including Queen Caroline and Frederick, Prince of Wales. | His mother Anne dies. |
| | | Founds the second St Martin's Lane Academy of Painting. |
| | | Begins work on *Pool of Bethesda* for St Bartholomew's Hospital. |
| 1736 | Porteous Riots in Edinburgh. | Paints *The Distrest Poet*, and engraves *Strolling Actresses* and *The Four Times of Day*. |
| | Henry Ozel's *The Art of Pleasing in Conversation* is published in French and English. | Finishes the mural *Pool of Bethesda*, for St Bartholomew's Hospital. |
| | Francis Hayman moves to Drury Lane, where he paints scenery for the theatres. | Engraves *Before* and *After*. |
| | Allan Ramsay travels to Rome (until 1738). | |
| 1737 | Frederick, Prince of Wales, quarrels with his father and sides openly with Walpole. | Opens a subscription for *Strolling Actresses* and *The Four Times of Day*. |
| | Theatrical Licensing Act gives the Lord. | *Daily Post* publishes attack on Thornhill; Hogarth responds with his 'Britophil' essay defending Thornhill and English art. |
| | Chamberlain power to approve any play before it is staged. | Completes *Good Samaritan* mural for St Bartholomew's Hospital. |
| | Jean-Baptiste Van Loo arrives in England (until 1742). | |
| 1738 | Opposition raises question of Spanish ill treatment of English sailors; merchant sailor Captain Jenkins tells parliament of his ill treatment by the Spanish and shows his severed ear. | Paints *The Strode Family*; *The Western Family*; and *The Hervey Conversation Piece*. |
| | Roubiliac's statue of Handel is erected in Vauxhall Gardens. | Publishes prints of *Strolling Actresses* and *The Four Times of Day*. |
| | Allan Ramsay returns to London and sets up as a portrait painter. | |
| 1739 | Convention of Pardo is held to settle differences with Spain, but Walpole is forced to declare war on Spain – the War of Jenkins' Ear. | Is a founding governor of the Foundling Hospital. |
| | Capture of Porto Bello in Central America by Admiral Vernon. | |
| | John Wesley begins his outdoor preaching (until his death in 1791), covering the breadth of Britain and reaching thousands of people. | |
| 1740 | Death of Charles VI, Holy Roman Emperor, sparking the War of the Austrian Succession (until 1748). | Paints portrait of Captain Coram, which he presents to the Foundling Hospital along with a donation of £120. |
| | The first two volumes of Samuel Richardson's *Pamela: Or, Virtue Rewarded* are published. | Paints portraits of William Jones; George Arnold and his daughter Miss Frances Arnold; and Lavinia Fenton. |
| | Joshua Reynolds is apprenticed to Thomas Hudson (until 1743). | Is approached by Samuel Richardson to illustrate *Pamela*; this does not develop. |
| | Thomas Gainsborough arrives in London, and trains with Gravelot. | |
| 1741 | Motion of no confidence in Walpole is followed by a general election; Walpole's majority reduced to less than twenty, and he suffers defeat in seven divisions. | Is present at the opening of the Foundling Hospital. |
| | Lancelot 'Capability' Brown is appointed head gardener at Stowe and works with William Kent. | Paints portrait of Benjamin Hoadly, Bishop of Winchester. |
| | David Garrick bursts onto the London stage with his performance in *The Tragedy of Richard III*. | |
| 1742 | Walpole resigns following the corruption scandal of the Chippenham by-election; Carteret administration formed with the Earl of Willington as Prime Minister. | Paints *The Graham Children* and *Captain Lord George Graham in his Cabin*. |
| | A luxury edition containing all four volumes of Samuel Richardson's *Pamela: Or, Virtue Rewarded* is published, with illustrations by Hayman and Gravelot. | Is commended as 'comic history painter' by Henry Fielding in the preface to his novel *Joseph Andrews*. |
| | Henry Fielding's novel *Shamela* is published, a parody of *Pamela*. | Anne Hogarth moves in with the Hogarths in Leicester Fields. |
| | Handel's oratorio *Messiah* is first performed, in Dublin. | |
| | Ranelagh Gardens open in Chelsea. | |
| 1743 | George II leads the British army into battle, the last British monarch to do so, at Dettingen. | Paints *Marriage A-la-Mode* and travels to Paris in search of engravers. |
| | Henry Pelham becomes Prime Minister. | |
| | Michael Dahl dies in London, aged eighty-seven. | |
| 1744 | France declares war on Britain, 'King George's War'. | Begins portrait of Thomas Herring, later Archbishop of Canterbury. |
| | Carteret resigns over criticism of his foreign policy; Pelham administration formed. | |
| | Joseph Highmore completes his painted scenes from Richardson's *Pamela*. | |

| | | |
|---|---|---|
| 1745 | Battle of Fontenoy: the French under Marshall Saxe defeat the British under the Duke of Cumberland.<br>Second Jacobite Rebellion: the Young Pretender, Charles Edward Stuart ('Bonnie Prince Charlie') lands in Scotland and proclaims his father king.<br>The Jacobite force takes Edinburgh and marches into England as far as Derby, but turns back due to lack of support.<br>Madame de Pompadour becomes mistress to Louis XV.<br>Printed versions of Highmore's *Pamela* are issued, to popular acclaim. | Paints *The Painter and his Pug*.<br>Publication of *Marriage A-la-Mode* prints.<br>Paints *David Garrick in the Character of Richard III*. |
| 1746 | Battle of Culloden: defeat of Jacobites by the Duke of Cumberland and the flight of the Young Pretender back to France.<br>Philip V of Spain dies and is succeeded by Ferdinand VI.<br>William Hunter begins his public lectures on anatomy.<br>Antonio Canaletto arrives in London (until 1755). | The engraved version of *David Garrick in the Character of Richard III* is published; takes a holiday with Garrick in Benjamin Hoadly's house in Alresford, near Winchester.<br>Visits St Albans to sketch the political rebel Lord Lovat; sketch is subsequently engraved.<br>Begins painting *Moses Brought to Pharaoh's Daughter* for the Foundling Hospital.<br>Jean André Rouquet's *Lettres de Monsieur** à un de ses Amis à Paris*, a commentary on Hogarth's prints, is published. |
| 1747 | Britain victorious over the French at the Battle of Cape Finisterre.<br>The Jacobite, Lord Lovat, is found guilty of high treason and beheaded by axe at the Tower of London, the last man to be executed in this way in Britain. | *Moses Brought to Pharaoh's Daughter* is presented to the Foundling Hospital.<br>Publishes *Industry and Idleness*.<br>Receives a commission from Lincoln's Inn for a history painting (*Paul before Felix*). |
| 1748 | Treaty of Aix-la-Chapelle ends the War of the Austrian Succession<br>Thomas Gainsborough returns to Sudbury.<br>John Hunter moves to London from Scotland, to train in anatomy with his brother William. | Completes *Paul before Felix* for Lincoln's Inn.<br>Travels to France with a group of artist companions; is expelled from Calais on suspicion of spying; paints *The Gate of Calais*.<br>Publishes the engraved version of *The Gate of Calais*. |
| 1749 | Handel's *Music for the Royal Fireworks*, to celebrate the peace of Aix-la-Chapelle, is performed with fireworks in Green Park, London.<br>John Cleland's erotic novel *Fanny Hill* is published, causing scandal and censorship.<br>Henry Fielding's comic novel *Tom Jones* is published. | Buys a small country house in Chiswick.<br>Publishes *Gulielmus Hogarth*.<br>Starts painting *The March to Finchley*; the painting is won by the Foundling Hospital in a lottery. |
| 1750 | Samuel Johnson begins publishing *The Rambler* (until 1752).<br>Joshua Reynolds travels to Italy (until 1752).<br>Richard Wilson travels to Italy (until 1757). | Publication of the engraved version of *The March to Finchley*.<br>Rouquet publishes his *Description du Tableau de* [*March to Finchley*]. |
| 1751 | Gregorian calendar adopted, the year beginning on 1 January instead of 25 March.<br>Frederick, Prince of Wales, dies.<br>Diderot's *Encyclopédie* is published in France.<br>George Stubbs provides illustrations for Dr John Burton's *Essay towards a Complete New System of Midwifery*.<br>Joseph Wright of Derby moves to London, and trains under Thomas Hudson. | Publication of *Beer Street*; *Gin Lane*; *The Four Stages of Cruelty*; and *Paul Before Felix Burlesqued*.<br>The *Marriage A-la-Mode* series of paintings are auctioned. |
| 1752 | Georgia becomes a royal colony, the last of the thirteen American colonies.<br>Thomas Hudson travels to Italy with Roubiliac. | Begins writing *The Analysis of Beauty*. |
| 1753 | Jewish Naturalisation Act passed, but repealed the following year due to popular opposition.<br>The British Museum is established, based on the collections of Hans Sloane.<br>Joshua Reynolds establishes his portrait practice in London. | Publication of *The Analysis of Beauty*; followed by personal attacks on Hogarth and the *Analysis*, as well as favourable reviews.<br>Hogarth attacks plans by artists to set up an academy to succeed the St Martin's Lane Academy. |
| 1754 | Death of Pelham; new administration formed with the Duke of Newcastle as Prime Minster.<br>The Society for the Encouragement of Arts, Manufacture and Commerce (the Society of Arts) is established, the first meeting held at Rawthwell's Coffee House, Covent Garden.<br>Thomas Chippendale publishes his first catalogue of furniture. | Begins painting the *Election* series. |
| 1755 | Samuel Johnson's *Dictionary of the English Language* is published.<br>John Wesley's *Notes on a New Testament* is published.<br>William Chambers and Joseph Wilton bring Giovanni Battista Cipriani to London. | Publishes the engraving *An Election Entertainment*.<br>Further demands for a state academy are aired by artists.<br>Commissioned to paint an altarpiece for St Mary Redcliffe, Bristol.<br>Rouquet's *State of the Arts in England* is published.<br>Elected a member of the Society of Arts. |

| 1756 | The Seven Years War with France begins. The government falls after criticism of its handling of the war; Duke of Devonshire forms an administration with William Pitt. Fort William, Calcutta, is taken from the French; prisoners die in the 'Black Hole of Calcutta'. George Vertue dies, his extensive notebooks on British painting are subsequently bought by Horace Walpole. | Publishes two engravings of *The Invasion*. Addresses the Society of Arts, advocating reform. Completes the altarpiece for St Mary Redcliffe, Bristol. |
|---|---|---|
| 1757 | After failures to achieve success in the war, the king demands Pitt's resignation, causing widespread unrest; a new administration is formed with Pitt as Secretary of State and Newcastle as Prime Minister. Defeats for the British in India and Canada, leading to further criticism. Victory for British ally, Frederick the Great, at Rossbach and Leuthen. British victory at the Battle of Plassey, led by Robert Clive ('Clive of India'). Edmund Burke's *A Philosophical Enquiry into the Origins of Our Ideas of the Sublime and Beautiful* is published. | Resigns from the Society of Arts. Publishes an advert announcing he will paint no more histories, only portraits. Is invited to join the Imperial Academy of Augsburg. Paints portrait of David Garrick and his wife. Death of John Thornhill, brother-in-law and former Serjeant Painter. Appointed Serjeant Painter to the King; paints *Hogarth Painting the Comic Muse*. Death of Lady Thornhill. Is commissioned by Lord Charlemont to paint a last comic history painting. |
| 1758 | Second Treaty of Westminster between Prussia and Britain. British capture Louisbourg (Nova Scotia) and Fort Duquesne (Pennsylvania). | Begins painting *Piquet: or Virtue in Danger (The Lady's Last Stake)* for Lord Charlemont. |
| 1759 | General Wolfe victorious at the Battle of the Plains of Abraham and Quebec. Defeat of the French fleet by Admiral Hawke. The first volume of Lawrence Sterne's *Tristram Shandy* is published. Voltaire's novel *Candide* is published in France. The British Museum opens at Montagu House. Joshua Reynolds's three essays on art are published in Dr Johnson's *Idler*. Thomas Gainsborough moves to Bath. | Completes *The Lady's Last Stake*. Paints *Sigismunda* for Richard Grosvenor, who refuses to buy the painting; writes a poem about Grosvenor. Joshua Reynolds satirises Hogarth in *The Idler*. Begins engraving *Enthusiasm Delineated* and writing *An Apology for Painters*. |
| 1760 | Surrender of Montreal to the British; virtual loss of Canada by the French. George II dies; George III proclaimed king. Johan Zoffany arrives in England. Philip Mercier dies. Joshua Reynolds moves to Leicester Fields. First public exhibition of British painting held at the Society of Arts' Great Room in the Strand, London. | In the spring he suffers an illness, which lasts about a year. |
| 1761 | Pitt resigns over war policy; the Duke of Newcastle becomes Prime Minister. Robert Adam is appointed Architect of the King's Works jointly with William Chambers. Allan Ramsay becomes Painter to King George III. Society of Artists exhibition in Spring Gardens, London. | Participates in the Society of Artists exhibition at Spring Gardens, exhibiting seven paintings (the largest contributor) and producing two engravings, the frontispiece and tailpiece of the catalogue. Is elected to the committee of the Society of Artists. |
| 1762 | Duke of Newcastle resigns over foreign policy; the Earl of Bute becomes Prime Minister. John Wilkes starts *The North Briton* to attack the Bute administration. Horace Walpole publishes his *Anecdotes on Painting in England*, based on Vertue's notes. | Publishes the engraving *Credulity, Superstition and Fanaticism*, a satire on the Cock Lane Ghost. Sign-Painters' Exhibition is organised by Bonnell Thornton to ridicule the Society of Artists' exhibition, which opens shortly afterwards. Publishes *The Times, Plate 1*, an anti-war satire; immediately attacked by Sandby. Attacked by the political journalist John Wilkes in *North Briton (no.17)*. Suffers another bout of illness. |
| 1763 | First Treaty of Paris signed, ending the Seven Years War. Bute resigns following attacks in the press and parliament; George Grenville becomes Prime Minister. John Wilkes is arrested for attacking the king in issue no.45 of *The North Briton*. Wilkes's arrest is declared illegal by Chief Justice Pratt, and he is released, though forced into exile. | Works on *The Times, Plate 2*, which is not completed. Sketches Wilkes on trial for seditious libel at Westminster Hall; publishes the satirical portrait *John Wilkes, Esq.* The clergyman and journalist Charles Churchill attacks the artist in his *Epistle to William Hogarth*; Hogarth satirises Churchill in *The Bruiser*. Suffers a paralytic seizure. |
| 1764 | The young Mozart (aged eight) amazes audiences in London, where he also befriends Johann Christian Bach. *The Castle of Otranto* by Horace Walpole is published, the first gothic novel. | Publishes his final work *Tail Piece* or *The Bathos*. Dies during the night of 25–6 October at his house in Leicester Fields. Is buried in St Nicholas's churchyard, Chiswick, on 2 November. |

# List of Exhibited Works

Numbers in bold refer to catalogue entries.

Marcellus Laroon/Lauron (1653–1702)
Five etchings from *The Cryes of the City of London Drawne after the Life* 1688
'The famous Dutch Woman' 25 × 16.5
'London Curtezan' 25 × 16
MUSEUM OF LONDON
'Crab Crab any Crab', 25 × 17
'Knives or Cisers to Grinde', 29 × 21
'The merry Milk Maid', 27 × 16
GUILDHALL LIBRARY, CITY OF LONDON
London and Madrid only
**60**

Samuel Butler (1612–1680)
*Hudibras* 1710; first published in 1662
Bound volume, open at p.146
THE BRITISH LIBRARY, LONDON
London only
**30**

James Thornhill (1675 or 76 – 1734)
*Thetis Accepting the Shield of Achilles from Vulcan* c.1710
Oil on wood
48.9 × 49.8
TATE. PURCHASED 1975
Paris only

Marcellus Laroon/Lauron (1653–1702)
*The Cryes of the City of London Drawne after the Life* 1711; first published in 1687
Bound volume, open at the first title-page
GUILDHALL LIBRARY, CITY OF LONDON
London and Madrid only

Alexander Smith
*A Compleat History of the Lives and Robberies of the Most Notorious Highway-men [& etc]* 1719
Bound volumes, 2 volumes, open at frontispiece and title-page
THE BRITISH LIBRARY, LONDON
London and Madrid only

*Shop Card* 1720
Engraving
7.6 × 10.2
THE BRITISH MUSEUM, LONDON
London and Madrid only
**14**

Bernard Baron (1696–1762) after Bernard Picart (1673–1733)
*A Monument Dedicated to Posterity* 1721
Etching and engraving
21 × 34.3
THE BRITISH MUSEUM, LONDON
London only
**17**

*The South Sea Scheme* c.1721
Etching and engraving
26.5 × 32.7
ANDREW EDMUNDS, LONDON
London and Madrid only
**16**

*Burning ye Rumps at Temple-Barr* c.1721–6
Etching and engraving
10.8 × 12.7
THE BRITISH MUSEUM, LONDON
London only
**31**

Anonymous
*Berenstadt, Cuzzoni and Senesino* 1723
Engraving
18.7 × 26
THE BRITISH MUSEUM, LONDON
London only
**19**

*Ellis Gamble's Shop Card* c.1723
Engraving
8.9 × 12.1
THE BRITISH MUSEUM, LONDON
London and Madrid only
**15**

Gerard Vandergucht (1696–1776) after
Charles-Antoine Coypel (1694–1752)
*Don Quixote Takes the Puppets to be Turks and Attacks them to Rescue Two Flying Lovers* c.1723-5
Engraving
26.7 × 28.3
THE BRITISH MUSEUM, LONDON
London only
**23**

Jean-François de Troy (1679–1752)
*The Declaration of Love* 1724
Oil on canvas
64.8 × 54.6
WILLIAMS COLLEGE MUSEUM OF ART,
WILLIAMSTOWN, MASSACHUSETTS.
GIFT OF C.A. WIMPFHEIMER, CLASS OF 1945
London and Madrid only
**76**

*The Bad Taste of the Town*
(*'Masquerades and Operas'*) 1724
Etching and engraving
13 × 17.5
ANDREW EDMUNDS, LONDON
**18**

Study for *The Lottery* 1724
Pen and black ink over slight pencil, grey wash
22.9 × 32.4
THE ROYAL COLLECTION
London only
**21**

*The Lottery* (second state) 1724
Etching and engraving
Cut to 26.2 × 32.7
ANDREW EDMUNDS, LONDON
London and Madrid only
**20**

*The Mystery of Masonry brought to Light by ye Gormagons* (second state) 1724
Etching and engraving
Cut to 25.1 × 35.2
ANDREW EDMUNDS, LONDON
London and Madrid only
**22**

James Thornhill (1675/6 – 1734)
*Jack Sheppard* 1724
Pen and ink and chalk on paper
33 × 24.5
MUSEUM OF LONDON
London and Madrid only
**96**

*Royalty, Episcopy, and Law* c.1724-5
Etching and engraving
Cut to 18.8 × 24.6
ANDREW EDMUNDS, LONDON
London and Madrid only
**24**

Study for *Burning ye Rumps at Temple-Barr* 1725-6
Pen with brown ink, brown washes over pencil
24.7 × 21.2
THE ROYAL COLLECTION
London only
**32**

Three prints from the twelve large illustrations for
Samuel Butler's *Hudibras*
*Frontispiece* (first state) 1725/6
26.5 × 35.5
*Hudibras's First Adventure* (second state) 1726
27.2 × 31.2
*Burning ye Rumps at Temple-Barr* (second state) 1725/6
27.2 × 31.3
Etching and engraving
ANDREW EDMUNDS, LONDON
London and Madrid only
**28, 29, 34**

*Burning ye Rumps at Temple-Barr* 1726
Copperplate
28 × 52
HOGARTH'S HOUSE, LONDON, MANAGED BY CIP
WORKING IN PARTNERSHIP WITH HOUNSLOW
COUNCIL
London and Madrid only
**33**

*Cunicularii, or the Wise men of Godliman in Consultation*
December 1726
Etching and engraving
18.8 × 25.6
ANDREW EDMUNDS, LONDON
London and Madrid only
**25**

*The Punishment inflicted on Lemuel Gulliver ...*
December 1726
Etching and engraving
21.2 × 32
ANDREW EDMUNDS, LONDON
London and Madrid only
**26**

*Masquerade Ticket* 1727
Etching and Engraving
Cut to 20.5 × 26.5
ANDREW EDMUNDS, LONDON
London and Madrid only
**27**

John Gay (1685-1732)
*Fables* 1727
Bound volume, open at p.46, Fable XIV 'The Monkey
Who had Seen the World' with title illustration by
Gerard Vandergucht (1696-1776) after John Wootton
(1682-1764)
THE BRITISH LIBRARY, LONDON
London and Madrid only
**75**

John Gay (1685-1732)
*The Beggar's Opera. As it is Acted at the
Theatre-Royal in Lincoln-Inn-Fields* 1728
Pamphlet, open at 'Dramatis Personae' and
'Introduction/Beggar Player'
THE BRITISH LIBRARY, LONDON
London only

*A Scene from 'The Beggar's Opera'* c.1728
Oil on canvas
49.2 × 56.6
BIRMINGHAM MUSEUMS & ART GALLERY
London and Madrid only
**38**

*An Assembly at Wanstead House* 1728-31
Oil on canvas
64.7 × 76.2
PHILADELPHIA MUSEUM OF ART. THE JOHN HOWARD
MCFADDEN COLLECTION, 1928
**48**

*Woodes Rogers and his Family* 1729
Oil on canvas
35.5 × 45.5
NATIONAL MARITIME MUSEUM, LONDON
London and Madrid only
**47**

*The Denunciation* 1729
Oil on canvas
49.5 × 66
NATIONAL GALLERY OF IRELAND, DUBLIN
London and Madrid only
**35**

*The Christening (Orator Henley Christening a Child)*
c.1729
Oil on canvas
49.5 × 62.8
PRIVATE COLLECTION
London and Madrid only
**36**

*Mary & Ann Hogarth's Shop Card* 1730
Engraving
7.6 × 10.2
THE BRITISH MUSEUM, LONDON
London and Madrid only

*Falstaff Examining his Recruits* 1730
Oil on canvas
49.5 × 58.5
THE GUINNESS FAMILY
London and Madrid only
**37**

*The Jones Family* c.1730
Oil on canvas
72 × 91.8
AMGUEDDFA CYMRU – NATIONAL MUSEUM WALES
**50**

*Before* 1730-1
Oil on canvas
44.7 × 37.2
FITZWILLIAM MUSEUM, CAMBRIDGE
Paris and London only
**40**

*After* 1731
Oil on canvas
45.1 × 37.2 cm
FITZWILLIAM MUSEUM, CAMBRIDGE
Paris and London only
**40**

*A Scene from 'The Beggar's Opera'* 1731
Oil on canvas
57.2 × 76.2
TATE. PURCHASED 1909
**39**

John Bowles (c.1701-1779) and Thomas Bowles
(1695-1767)
*London Described, or the Most Regular Buildings [& etc.]*
1731
Bound volume, open at double-page print entitled
'Covent Garden' by Sutton Nicholls (?1688-c.1730)
GUILDHALL LIBRARY, CITY OF LONDON
London and Madrid only

*Before* c.1731
Oil on canvas
38.7 × 33.7
THE J. PAUL GETTY MUSEUM, LOS ANGELES
London and Madrid only
**41**

*After* c.1731
Oil on canvas
38.7 × 33.7
THE J. PAUL GETTY MUSEUM, LOS ANGELES
London and Madrid only
**41**

*A Scene from 'The Tempest'* c.1730-5
Oil on canvas
80 × 101.6
NOSTELL PRIORY, THE ST. OSWALD COLLECTION
(NATIONAL TRUST, ACQUIRED WITH THE HELP
OF THE THE ART FUND IN 1971)
London only
**104**

*Conversation Piece (Portrait of Sir Andrew Fountaine
with Other Men and Women* c.1730-5
Oil on canvas
47.6 × 58.4
PHILADELPHIA MUSEUM OF ART.
THE JOHN HOWARD MCFADDEN COLLECTION, 1928
**51**

*The Cholmondeley Family* 1732
Oil on canvas
71 × 90.8
PRIVATE COLLECTION
**52**

*A Harlot's Progress* April 1732
Six plates
Etching and engraving
Each approx. 32 × 38.9
ANDREW EDMUNDS, LONDON
London and Madrid only
**43**

*A Midnight Modern Conversation* c.1732
Oil on canvas
76.2 × 163.8
YALE CENTER FOR BRITISH ART. PAUL MELLON
COLLECTION
London and Madrid only
**49**

*A Performance of 'The Indian Emperor or The Conquest
of Mexico by the Spaniards'* 1732-5
Oil on canvas
80 × 146.7
PRIVATE COLLECTION
**53**

*Southwark Fair (or The Humours of a Fair)* January 1733
Etching and engraving
36.2 × 47.3
ANDREW EDMUNDS, LONDON
London and Madrid only
**65**

*Sarah Malcolm* March 1733
Etching and engraving
19.6 × 17.9
ANDREW EDMUNDS, LONDON
London and Madrid only
**95**

*The Laughing Audience* (or *A Pleased Audience*)
December 1733
Etching
18.8 × 17.1
ANDREW EDMUNDS, LONDON
London and Madrid only
**64**

*A Rake's Progress* 1734
Eight scenes
Oil on canvas
Each 62.2 × 75
*The Rake Taking Possession of his Estate*
*The Rake's Levée*
*The Rake at the Rose-Tavern*
*The Rake Arrested, Going to Court*
*The Rake Marrying an Old Woman*
*The Rake at a Gaming House*
*The Rake in Prison*
*The Rake in Bedlam*
SIR JOHN SOANE'S MUSEUM, LONDON
London only
**44**

John Dryden (1631–1700)
'Marriage A-la-Mode' in *The Dramatic Works of John Dryden*, volume 4 1735; first published in 1673
Bound volume, open at frontispiece (and title-page) with illustration by Gerard Vandergucht (1696–1776) after Hubert-François Gravelot (1699–1773)
THE BRITISH LIBRARY, LONDON
London and Madrid only
**73**

William Hogarth partly assisted by Gérard Jean-Baptiste Scotin (1690–after 1755)
*A Rake's Progress* June 1735
Eight plates
Etching and engraving
Each approx. 35.5 × 40.5
ANDREW EDMUNDS, LONDON
London and Madrid only
**45**

*Self-Portrait with Palette* c.1735
Oil on canvas
54.6 × 50.8
YALE CENTER FOR BRITISH ART. PAUL MELLON COLLECTION
**1**

*Study for 'The Pool of Bethesda'* c.1735
Oil on canvas
62 × 74.5
MANCHESTER CITY GALLERIES
London only
**102**

William Dicey (active 1730s and 1740s)
*The Humours and Diversions of Batholomew Fair* c.1735
Etching
45.5 × 56
MUSEUM OF LONDON
London and Madrid only
**66**

*Satan, Sin and Death (A Scene from Milton's 'Paradise Lost')* c.1735-40
Oil on canvas
61.9 × 74.5
TATE. PURCHASED 1966
**103**

*Before* 15 December 1736
Etching and engraving
42.6 × 32.8
ANDREW EDMUNDS, LONDON
London and Madrid only
**42**

*After* 15 December 1736
Etching and engraving
40.9 × 33
ANDREW EDMUNDS, LONDON
London and Madrid only
**42**

*The Distrest Poet* 1736
Oil on canvas
65.9 × 79.1
BIRMINGHAM MUSEUMS & ART GALLERY
London and Madrid only
**70**

*The Four Times of Day* 1736
Oil on canvas
*Morning*
73.6 × 61
UPTON HOUSE, THE BEARSTED COLLECTION
(THE NATIONAL TRUST)
*Noon*
75 × 62.2
PRIVATE COLLECTION
*Evening*
75 × 62.2
PRIVATE COLLECTION
*Night*
73.6 × 61
UPTON HOUSE, THE BEARSTED COLLECTION
(THE NATIONAL TRUST)
**67**

Balthazar Nebot (active 1730–after 1765)
*Covent Garden Market* 1737
Oil on canvas
64.8 × 122.8
TATE. PURCHASED 1895
London and Madrid only
**58**

*The Western Family* 1738
Oil on canvas
71.8 × 83.8
NATIONAL GALLERY OF IRELAND, DUBLIN
**55**

*The Four Times of Day: Morning, Noon, Evening and Night* 1738
Etching and engraving, *Evening* with colour ink and watercolour
Each approx. 48.8 × 40.9
THE BRITISH MUSEUM, LONDON
London only
**68**

*Strolling Actresses Dressing in a Barn* 25 March 1738
Etching and engraving
51 × 62.7
ANDREW EDMUNDS, LONDON
London and Madrid only
**69**

*The Strode Family* c.1738
Oil on canvas
87 × 91.5
TATE. BEQUEATHED BY REV. WILLIAM FINCH 1880
**54**

*George Arnold* 1738–40
Oil on canvas
88.9 × 68.6
FITZWILLIAM MUSEUM, CAMBRIDGE
Paris and London only
**86**

*Frances Arnold* 1738–40
Oil on canvas
88.9 × 68.6
FITZWILLIAM MUSEUM, CAMBRIDGE
Paris and London only
**87**

Josef Wagner (1706–1780) after Giacomo Amiconi (1682–1752)
*Golden Pippins* 1739
Etching
25.5 × 20.5
THE BRITISH MUSEUM, LONDON
London only
**61**

Josef Wagner (1706–1780) after Giacomo Amiconi (1682–1752)
*Shoe-black* 1739
Etching
23 × 18.5
GUILDHALL LIBRARY, CITY OF LONDON
London and Madrid only
**62**

*Captain Thomas Coram* 1740
Oil on canvas
239 × 147.5
THE CORAM FAMILY IN THE CARE OF THE FOUNDLING MUSEUM, LONDON
Paris and London only
**84**

*William Jones* 1740
Oil on canvas
127 × 102.2
NATIONAL PORTRAIT GALLERY, LONDON
**85**

*The Distrest Poet* (third state) 15 December 1740
Etching and engraving
36 × 41
ANDREW EDMUNDS, LONDON
London and Madrid only
**71**

*The Hervey Conversation Piece* c.1740
Oil on canvas
101.6 × 127
ICKWORTH, THE BRISTOL COLLECTION (THE NATIONAL TRUST)
**56**

Attributed to Jean-André Rouquet (1701–1758)
*William Hogarth* c.1740-5
Enamel on copper
Oval, 4.5 × 3.7
NATIONAL PORTRAIT GALLERY, LONDON
London and Madrid only
**3**

*The Shrimp Girl* c.1740–5
Oil on canvas
63.5 × 52.5
THE NATIONAL GALLERY, LONDON
Paris and London only
**63**

*Lavinia Fenton, Duchess of Bolton* c.1740–50
Oil on canvas
73.7 × 58.4
TATE. PURCHASED 1884
**88**

William Hogarth ?assisted by Gérard Jean-Baptiste
Scotin (1690–after 1755)
*A Rake's Progress* Plate 4, early 1740s
Etching and engraving
35.8 × 41
ANDREW EDMUNDS, LONDON
**46**

*Mrs Salter* 1741 or 1744
Oil on canvas
76.2 × 63.5
TATE. PURCHASED 1898
**89**

*Mary Blackwood, Mrs Desaguliers* c.1745
Oil on canvas
Diameter 68.5
PRIVATE COLLECTION
London only
**90**

*Benjamin Hoadly, Bishop of Winchester* 1741
Oil on canvas
127.3 × 101.5
TATE. PURCHASED 1910
**91**

*The Enraged Musician* 30 November 1741
Etching and engraving
35.9 × 41.1
ANDREW EDMUNDS, LONDON
London and Madrid only
**72**

Louis-François Roubiliac (1702–1762)
*William Hogarth* c.1741
Terracotta
71.1 high
NATIONAL PORTRAIT GALLERY, LONDON
London only
**2**

*Taste in High Life* c.1742
Oil on canvas
63 x 75
PRIVATE COLLECTION
London and Madrid only
**74**

Claude-Prosper-Jolyot de Crébillon fils
(1674–1762)
*The Sopha: A Moral Tale*, English edition 1742
Bound volume, open at title-page
THE BRITISH LIBRARY, LONDON
London only

Samuel Richardson (1689–1761)
*Pamela; or, Virtue Rewarded*, volume IV, sixth edition
1742
Bound volume, open at p.372 showing an engraved
illustration after Hubert-François Gravelot (1699–1773)
THE BRITISH LIBRARY, LONDON
London and Madrid only
**79**

*The Graham Children* 1742
Oil on canvas
160.5 × 181
THE NATIONAL GALLERY, LONDON. PRESENTED BY
LORD DUVEEN THROUGH THE ART FUND, 1934
**93**

*The Mackinen Children* c.1742–3
Oil on canvas
182.9 × 143.5
NATIONAL GALLERY OF IRELAND, DUBLIN
**94**

*Characters and Caricaturas* April 1743
Etching and engraving
26.1 × 20.5
ANDREW EDMUNDS, LONDON
London and Madrid only
**Fig.12**

Joseph Highmore (1692–1780)
*VII Pamela in the Bedroom with Mrs Jewkes and Mr B.*
1743–4
62.7 × 75.7
*XI Pamela Asks Sir Jacob Swinford's Blessing* 1743–4
63.2 × 75
Oil on canvas
TATE. PURCHASED 1921
London and Madrid only
**82**

*Marriage A-la-Mode* 1743–5
Six scenes
*The Marriage Settlement* 69.9 × 90.8
*The Tête à Tête* 69.9 × 90.8
*The Inspection* 69.9 × 90.8
*The Toilette* 70.5 × 90.8
*The Bagnio* 70.5 × 90.8
*The Lady's Death* 69.9 × 90.8
Oil on canvas
THE NATIONAL GALLERY, LONDON
**77**

*Thomas Herring, Archbishop of Canterbury* 1744–7
Oil on canvas
127 × 101.5
TATE. PURCHASED 1975
**92**

*The Painter and his Pug* 1745
Oil on canvas
90 × 69.9
TATE. PURCHASED 1824
**4**

*David Garrick as Richard III* 1745
Oil on canvas
190.5 × 250.8
NATIONAL MUSEUMS LIVERPOOL
(WALKER ART GALLERY)
London only
**105**

Bernard Baron (1696–1762), Simon-François Ravenet
(1706–1774) and Gérard Jean-Baptiste Scotin
(1690–after 1755), with William Hogarth
Six prints, *Marriage A-la-Mode* 1 April 1745
Plates 1 and 6 by Scotin
Plates 2 and 3 by Baron
Plates 4 and 5 by Ravenet
Etching and engraving
Each approx. 38.5 × 46.5
ANDREW EDMUNDS, LONDON
London and Madrid only
**78**

*The Staymaker (The Happy Marriage: The Fitting
of the Ball Gown)* c.1745
Oil on canvas
69.9 × 90.8
TATE. PURCHASED WITH ASSISTANCE FROM
THE NATIONAL ART COLLECTIONS FUND 1942
London and Madrid only
**80**

*The Dance (The Happy Marriage: The Country Dance)*
c.1745
Oil on canvas
67.7 × 89.2
TATE. PURCHASED WITH ASSISTANCE FROM THE
NATIONAL HERITAGE MEMORIAL FUND 1983
London and Madrid only
**81**

*Captain Lord George Graham in his Cabin* c.1745
Oil on canvas
68.5 × 88.9
NATIONAL MARITIME MUSEUM, LONDON
London and Madrid only
**57**

Joseph Nicholls (active 1726–1755)
*A View of Charing Cross and Northumberland House* 1746
Oil on canvas
60.9 × 73.6
THE ROYAL BANK OF SCOTLAND GROUP
London and Madrid only
**59**

*Moses Brought to Pharaoh's Daughter* 1746
Oil on canvas
172.7 × 208.3
THE CORAM FAMILY IN THE CARE OF THE
FOUNDLING MUSEUM, LONDON
London only
**107**

William Hogarth, assisted by Charles Grignon
(1721–1810)
*Mr. Garrick in the Character of Richard the 3d*
(second state) 20 June 1746
Etching and engraving
41.9 × 52.8
ANDREW EDMUNDS, LONDON
London and Madrid only
**106**

*Simon Lord Lovat*, first state August 1746
Etching
33.7 × 22.5
ANDREW EDMUNDS, LONDON
London and Madrid only

Louis-Philippe Boitard (active 1734–1760)
*The Cov[en]t Garden Morning Frolick* 1747
Etching
GUILDHALL LIBRARY, CITY OF LONDON
London and Madrid only
**Fig.26**

*The Industrious Apprentice Married and
Furnishing his House* c.1747
Pen with brown ink and grey wash within
rough pen border
21 × 29
THE BRITISH MUSEUM, LONDON
London only

*Industry and Idleness* 30 September 1747
Twelve prints
*Plate 1. The Fellow 'Prentices at their Loom*
*Plate 2. The Industrious 'Prentice performing the Duty of a Christian*
*Plate 3. The Idle 'Prentice at Play in the Church Yard, during Divine Service*
*Plate 4. The Industrious 'Prentice a Favourite and entrusted by his Master*
*Plate 5. The Idle 'Prentice turn'd away, and sent to Sea*
*The Industrious 'Prentice out of his Time & Married to his*
*Plate 6. Master's Daughter*
*Plate 7. The Idle 'Prentice return'd from Sea, & in a Garret with a common Prostitute*
*Plate 8. The Industrious 'Prentice grown rich, & Sheriff of London*
*Plate 9. The Idle 'Prentice betray'd by his Whore, & taken in a Night Cellar with his Accomplice*
*Plate 10. The Industrious 'Prentice Alderman of London, the Idle one brought before him & Impeach'd by his Accomplice*
*Plate 11. The Idle 'Prentice Executed at Tyburn*
*Plate 12. The Industrious 'Prentice Lord-Mayor of London*
Etching and engraving
Each approx. 26.5 × 34.5
ANDREW EDMUNDS, LONDON
London and Madrid only
**97**

*O The Roast Beef of Old England (The Gate of Calais)* 1748
Oil on canvas
78.8 × 94.5
TATE. PRESENTED BY THE DUKE OF WESTMINSTER 1895
**112**

*Gulielmus Hogarth* (fourth state) 1749
Etching and engraving
38.1 × 28.7
ANDREW EDMUNDS, LONDON
London and Madrid only
**128**

*The March to Finchley* 1749–50
Oil on canvas
102.5 × 135.7
THE FOUNDLING MUSEUM, LONDON
London and Madrid only
**113**

*Heads of Six of Hogarth's Servants* c.1750–5
Oil on canvas
63 × 75.5
TATE. PURCHASED IN 1892
**116**

*Beer Street* and *Gin Lane* 1 February 1751
Two prints
Etching and engraving
Each approx. 38 × 32.1
ANDREW EDMUNDS, LONDON
London and Madrid only
**98**

*The Four Stages of Cruelty* 1 February 1751
Four plates
*First Stage of Cruelty*
*Second Stage of Cruelty*
*Cruelty in Perfection*
*The Reward of Cruelty*
Etching and engraving
Each approx. 38 × 32
ANDREW EDMUNDS, LONDON
London and Madrid only
**99**

John Bell (active 1750s) after William Hogarth
*Cruelty in Perfection* and *The Reward of Cruelty* 1751
Two prints
Woodcut
Each approx. 45 × 38
ANDREW EDMUNDS, LONDON
London and Madrid only
**100**

Four drawings for the *Four Stages of Cruelty* c.1751
*First Stage of Cruelty*
Red chalk
*Second Stage of Cruelty*
Red chalk, incised
*Third Stage of Cruelty or Cruelty in Perfection*
Red chalk, incised and squared
*Fourth Stage of Cruelty or Reward of Cruelty*
Red chalk, incised and squared
Each approx. 35.6 × 30.2
THE MORGAN LIBRARY AND MUSEUM, NEW YORK
London and Madrid only

Luke Sullivan (1705-1771) after William Hogarth
*Moses Brought Brought to Pharaoh's Daughter* February 1752
Etching and engraving
15 × 20
ANDREW EDMUNDS, LONDON
London and Madrid only

*Paul Before Felix [Burlesqued]* (fourth state) 1 May 1751
Etching and engraving
25.4 × 34.3
ANDREW EDMUNDS, LONDON
London and Madrid only
**110**

*Paul Before Felix* (second state) 5 February 1752
Etching and engraving
42.2 × 52.4
ANDREW EDMUNDS, LONDON
London and Madrid only
**108**

Luke Sullivan (1705-1771) after William Hogarth
*Paul Before Felix* (second state) 5 February 1752
Etching and engraving
36.1 × 47.3
ANDREW EDMUNDS, LONDON
London and Madrid only
**109**

*The Analysis of Beauty* 1753
Bound volume, open at the title-page and *Analysis of Beauty, Plate I* [The Sculptor's Yard]
THE BRITISH LIBRARY
London and Madrid only
**5 and fig.2**

*Analysis of Beauty, Plate II* [The Country Dance] 1753
Etching and engraving
36.8 × 49.5
PRIVATE COLLECTION
London and Madrid only
**6**

Paul Sandby (1731–1809)
*The Analyst Besh[itte]n in his own Taste* 1753
Etching and engraving
Cut to 26.3 × 18
ANDREW EDMUNDS, LONDON
London and Madrid only
**7**

*Election* series 1754-5
Four scenes
*An Election Entertainment* 1754
*Canvassing for Votes* 1754
*The Polling* 1754
*Chairing the Members* 1754-5
Oil on canvas
Each 101.5 × 127
SIR JOHN SOANE'S MUSEUM, LONDON
London only
**120–3**

*The Invasion, Plate 1: France* (second state) 8 March 1756
Etching and engraving
31.9 × 39
ANDREW EDMUNDS, LONDON
London and Madrid only
**114**

*The Invasion, Plate 2: England* (first state) 8 March 1756
Etching and engraving
31.8 × 38.4
ANDREW EDMUNDS, LONDON
London and Madrid only
**115**

*David Garrick and his Wife* 1757
Oil on canvas
132.6 × 104.2
THE ROYAL COLLECTION
Paris and London only
**117**

*Hogarth Painting the Comic Muse* c.1757
Oil on canvas
45.1 × 42.5
NATIONAL PORTRAIT GALLERY, LONDON
**8**

*Sir Francis Dashwood at his Devotions* late 1750s
Oil on canvas
120 × 87.6
PRIVATE COLLECTION
**119**

*Francis Matthew Schutz in his Bed* late 1750s
Oil on canvas
63 × 75.5
NORWICH CASTLE MUSEUM & ART GALLERY
London and Madrid only
**118**

*Wm Hogarth/ Sergeant Painter to his Majesty* 1758
Etching and engraving,
ANDREW EDMUNDS, LONDON
London and Madrid only

*Piquet: or Virtue in Danger (The Lady's Last Stake)* 1759
Oil on canvas
91.4 × 105.4
ALBRIGHT-KNOX ART GALLERY, BUFFALO, NEW YORK.
GIFT OF SEYMOUR H. KNOX, JR., 1945
**83**

*Sigismunda Mourning over the Heart of Guiscardo* 1759
Oil on canvas
100.4 × 126.5
TATE. BEQUEATHED BY J.H. ANDERDON 1879
**111**

*The Cockpit* (or *Pit Ticket*) 5 November 1759
Etching and engraving
31.8 × 38.5
ANDREW EDMUNDS, LONDON
London and Madrid only
**101**

Paul Sandby (1731–1809)
Four prints from *Twelve Cries of London Done from the Life, Part 1st* 1760
Etching
Title-page, 33.5 × 28
'Fun Upon Fun, or the first and second part of Mrs Kitty Fisher's Merry Thought [& etc.]' 28 × 21.5
'Rare Mackarel Three a Groat/ Or Four for Sixpence', 27.8 × 21.3
'Will your Hounour buy a Sweet Nosegay/ or a Memorandum Book', 23 × 17
MUSEUM OF LONDON
London and Madrid only
**Fig.29**

*Credulity, Superstition and Fanaticism: Enthusiasm Delineated* (first state) c.1760
Etching and engraving
37.5 × 32.6
THE BRITISH MUSEUM, LONDON
London and Madrid only
**132**

*Credulity, Superstition, and Fanaticism: A Medley* (third state) 15 March 1762
Etching and engraving
38 × 32.9
ANDREW EDMUNDS, LONDON
London and Madrid only
**133**

*The Times, Plate 1* (third state) 7 September 1762
Etching and engraving
24.7 × 30.8
ANDREW EDMUNDS, LONDON
London and Madrid only
**124**

*The Times, Plate 2* (first state) c.1762–3
Etching and engraving
Cut to 25.4 × 31.3
ANDREW EDMUNDS, LONDON
London and Madrid only
**125**

*The Bruiser* (first state proof) 1763
Etching and engraving
33.7 × 26.4
THE ROYAL COLLECTION, LONDON
Not exhibited
**129**

*The Bruiser, C. Churchill* (second state) 1 August 1763
Etching and engraving
37.7 × 28.5
ANDREW EDMUNDS, LONDON
London and Madrid only
**130**

*The Bruiser, C. Churchill* (sixth state) October 1763
Etching and engraving
37 × 28
ANDREW EDMUNDS, LONDON
London and Madrid only
**131**

*John Wilkes Esq.* (first state) 16 May 1763
Etching with engraving
35.5 × 22.9
ANDREW EDMUNDS, LONDON
London and Madrid only
**126**

*Simon, Lord Lovat* (second state) 25 August 1746
Etching with engraving
36.3 × 23.5
ANDREW EDMUNDS, LONDON
London and Madrid only
**127**

*Tail Piece* or *The Bathos* 1764
Etching and engraving
31.8 × 33.7
ANDREW EDMUNDS, LONDON
London and Madrid only
**134**

David Hockney (born 1937)
*A Rake's Progress* 1961–3
Sixteen prints, etching and aquatint
Each approx. 30 × 40
*Plate No.1. The Arrival*
*Plate No.1a. Receiving the Inheritance*
*Plate No.2. Meeting the Good People (Washington)*
*Plate No.2a. The Gospel Singing (Good People) (Madison Square Garden)*
*Plate No.3. The Start of the Spending Spree and the Door Opening for a Blonde*
*Plate No.3a. The Seven Stone Weakling*
*Plate No.4. The Drinking Scene*
*Plate No.4a. Marries an Old Maid*
*Plate No.5. The Election Campaign (with Dark Message)*
*Plate No.5a. Viewing a Prison Scene*
*Plate No.6. Death in Harlem*
*Plate No.6a. The Wallet Begins to Empty*
*Plate No.7. Disintegration*
*Plate No.7a. Cast Aside*
*Plate No.8. Meeting the Other People*
*Plate No.8a. Bedlam*
TATE. PURCHASED 1971
London and Madrid only
**9**

David Hockney (born 1937)
*Programme cover for the Glyndebourne Festival Opera production of* The Rake's Progress 1975
Offset lithography on paper
30 × 25
TATE LIBRARY AND ARCHIVE
Madrid only
**10**

David Hockney (born 1937)
*Poster for the San Francisco Opera production of 'The Rake's Progress' 1982 featuring Hockney's design for the 'Bedlam' scene*
Ink on paper
99.1 × 86.4
PRIVATE COLLECTION
Madrid only
**11**

Yinka Shonibare (born 1962)
*Diary of a Victorian Dandy* 1998
*11.00 hours*
*14.00 hours*
*17.00 hours*
*19.00 hours*
*03.00 hours*
C-type photographic prints
Each 183 × 228.6
COLLECTIONS OF PETER NORTON AND EILEEN HARRIS NORTON, SANTA MONICA. COURTESY OF STEPHEN FRIEDMAN GALLERY, LONDON AND JAMES COHAN GALLERY, NEW YORK
**13**

Paula Rego (born 1935)
*The Betrothal: Lessons: The Shipwreck, after 'Marriage a la Mode' by Hogarth* 1999
Pastel on paper on aluminium
Overall display 165 × 500
TATE. PURCHASED WITH ASSISTANCE FROM THE NATIONAL ART COLLECTIONS FUND AND THE GULBENKIAN FOUNDATION 2002
London and Madrid only
**12**

# Lenders and Credits

# Index

Bold numbers denote main entries.

**A**

Addison, Joseph 25, 28; nos.1, 2, 18, 60, 70
  portrait by Kneller no.1; fig.17
Ahlers, Cyriacus no.25
*Altarpiece of St Mary Redcliffe* 197; fig.37
Amiconi, Giacomo (Jacopo) 142; nos.72, 102
  *Golden Pippins* nos.61, 63
  *Shoe-Black* nos.62, 63
*The Analysis of Beauty* 13–14, 20, 27, 29; nos.3, 4, **5**, 8, 11, 63
  *The Analyst Besh[itte]n: in his own Taste* (Sandby) 20; no.**7**
  composed variety 13
  *The Country Dance* 14; nos.5, **6**, 81
  the line of beauty 13, 29; nos.5, 8, 81
  'On Colouring' no.8
  *The Sculptor's Yard* 14; no.5; fig.2
  title page 13; nos.4, 5; fig.1
Angellis, Pieter 26; no.58
  *The Vegetable-Seller* no.63; fig.28
Angerstein, John Julius 36
Anti-Gallican League 142
Aristotle no.40
Arnold, Frances no.87
Arnold, George no.86
*Ashley Cowper with his Wife and Daughter* 27
*An Assembly at Wanstead House* nos.**48** 54
Auden, W.H.
  *The Rake's Progress* (libretto) no.11
Austrian Succession, War of the no.73
'Autobiographical Notes' 21, 27, 55, 159; nos.84, 99

**B**

*The Bad Taste of the Town* ('Masquerades and Operas') nos.**18**, 20, 27, 37, 72, 74
bagnios 142; nos.77–8
Bancks, John 13, 16; no.49
Baron, Bernard nos.1, 67, 78
  *A Monument Dedicated to Posterity* (after Picart) nos.**17**, 22
  *Marriage A-la-Mode* engravings no.78
Bartholomew Close 15
Bartholomew Fair nos.5, 66
Bayly, Dr Lewis
  *The Practice of Piety, directing a Christian how to Walk, that he may please God* no.40
Bedlam 119–20; nos.44, 65
Beefsteaks *see* The Sublime Society of Beefsteaks
*Beer Street* 19, 119, 181, 182; nos.8, 61, **98**
*Before* and *After* 28; no.118
  etching and engraving 34; no.**42**
  oil on canvas (c.1730–1) no.**41**
  oil on canvas (1730–1) no.**40**
*The Beggar's Opera* 16, 27, 36, 56; nos.37, 53, 77, 82
  *A Scene from The Beggar's Opera VI* (1731) 16; no.**39**
  *A Scene from 'The Beggar's Opera'* (c.1728) 16; nos.**38**, 103
  detail 54
Bell, Steve
  *Free the Spirit, Fund the Party* 37; fig.16
*Benjamin Hoadly, Bishop of Winchester* 160; no.**91**
Benoist, Antoine no.82
*Berenstadt, Cuzzoni and Senesino* (Anonymous) no.**19**
Bertie, Lord Albermarle no.101
Beyeren, Abraham van
  *Still Life with Jug and Lobster* no.123; fig.42
biblical subjects 17, 19; nos.10–11
Bindman, David 21; no.103
Birdcage Walk no.101
Blandy, Mary no.95
Bloomsbury no.98
Boccaccio, Giovanni
  *Decameron* no.111
Boitard, Louis Philippe 121
  *The Covent Garden Morning Frolick* fig.26
Bolton, Charles Paulet, 3rd Duke nos.39, 88
Bonnart, Jean-Baptiste
  *Cris de Paris* no.60
Bosse, Abraham
  *The Cries of Paris* no.60
Boswell, James no.101
Boucher, François nos.67, 73
  *Lady Fastening her Garter (La Toilette)* nos.77, 82; fig.33
*Boys Peeping at Nature* 73; fig.22
Brebiette, Pierre
  *The Cries of Paris* no.60
Breughal, Pieter the Elder 34
Brewer, John 95
Bridewell Prison 182; no.43
Bridgeman, Charles 24
Broughton's Amphitheatre no.99
Brown, Ford Madox
  *Work* 33

Brown, Lancelot 'Capability' 24
*The Bruiser* 216; no.**129**
*The Bruiser, C. Churchill* nos.**130–1**
Bunyan, John
  *The Pilgrim's Progress* 75
Burlington, Richard Boyle, 3rd Earl no.18
Burton, Robert
  *Anatomy of Melancholy* no.52
Bute, John Stuart, 3rd Earl no.124
Butler, Samuel no.49
  *Hudibras* nos.30, 37
Bysshe, Edward
  *The Art of English Poetry* nos.70–1

**C**

Calais no.112
Callis, Anne no.55
Campbell, Colen no.48
Campbell, Jill no.56
Canaletto (Giovanni Antonio Canal) 33, 121; nos.59, 112
  *The Thames and the City of London from Richmond House* 121; fig.25
*Captain Lord George Graham in his Cabin* no.**57**
*Captain Thomas Coram* 17–18, 37, 159, 160; nos.2, **84**, 85, 86
Carracci, Annibale nos.60, 105
Castlemaine, Richard Child, Viscount 96; no.48
castrati 142; nos.44, 72
Castrucci no.72
Cecil, Lady Anne no.54
Cervantes, Miguel de
  *Don Quixote* nos.22, 28
Cézanne, Paul 23
*Characters and Caricatures* 25, 35; fig.12
Chardin, Jean-Baptiste-Siméon 34
  *The White Tablecloth* 142; no.77; fig.32
Charing Cross 15, 119; nos.59, 67–8
Charing Cross Road no.67–8
Charlemont, James Caulfield, 1st Earl nos.84, 111
Charles I nos.59, 67
Charles II no.73
Charteris, Colonel Francis 74; nos.40, 43
Cheapside 119; no.97
Cheere, John no.5
Cheron, Louis 15–16
Chiswick
  Hogarth's house 19, 21, 33; fig.5
Cholmondeley, Colonel James no.52
*The Cholmondeley Family* no.**52**
*The Christening (Orator Henley Christening a Child)* 56; no.**36**
Churchill, Charles 20–1; nos.124, 129–31
  *Epistle to William Hogarth* no.128
Cibber, Caius Gabriel
  *Melancholy Madness* no.44
  *Raving* no.44
Cibber, Colley
  *The Lady's Last Stake* no.84
Cibber, Theophilus
  *The Harlot's Progress; or, the Ridotto al'fresco* 73
City of London 15
classical art and architecture 120–1; nos.18, 44
Claude Lorrain 33
clubs 24, 25, 56, 95; nos.1, 49
Cock, Christopher no.51
Cock Lane Ghost no.133
*The Cockpit* (or *Pit Ticket*) 121; no.**101**
coffee houses 24, 25, 95
  Old Slaughter's nos.2, 5
  print auctions 55
  Richard Hogarth's 15, 182
  Tom King's nos.67–8
*commedia dell'arte* no.18
conduct books 24, 141, 142; no.5
Conduitt, John no.53
Congreve, William 25, 33; nos.18, 72
*Conversation Piece (Portrait of Sir Andrew Fountaine with Other men and Women)* no.**51**
conversation pieces 16–17, 24–7, 95–6; nos.1, 47–57
Coram, Thomas 16, 160
  portrait by Hogarth 17–18, 37, 159; nos.2, **84**, 85
Correggio, Antonio da
  *Jupiter and Io* no.77
  *Lot and his Daughters* no.77
*Country Inn Yard at Election Time* no.120
Covent Garden 15, 16, 119; nos.58, 67–8
Coypel, Charles-Antoine
  *Don Quixote Takes the Puppets to be Turks and Attacksthem to Rescue Two Flying Lovers* no.23
Craske, Matthew 21
Crébillon *fils* (Claude Prosper Jolyot) no.77
  *Le Sopha* no.77
*Credulity, Superstition and Fanaticism* nos.**132–3**
Cries genre 121; nos.60–2

crime and punishment 181-2; nos.95-100
    executions 182; no.97
    *see also* prisons
crowd scenes 27-8
Cumberland, William, Duke of nos.53, 113, 115
*Cunicularii, or the Wise men of Godliman in Consultation* no.**25**
Cutlerian theatre no.99
Cuzzoni, Francesca nos.19, 44

**D**
Dabydeen, David no.104
Dalton, James no.43
*David Garrick and his Wife* no.**117**
*David Garrick as Richard III* (oil on canvas) 36, 197; nos.4, **105**
    detail 196
Defoe, Daniel
    biography of Jack Sheppard 182
    *Conjugal Lewdness; or, Matrimonial Whoredom* 141
    *Moll Flanders* 24, 25; no.97
    *Robinson Crusoe* 24
Delacroix, Eugène 36
Deloraine, Mary, Lady no.53
*The Denunciation* 56; no.**35**
Desaguliers, Dr John Theophilius no.56
Desaguliers, Mary Blackwood, Mrs no.90
Desaguliers, Captain Thomas no.90
Dicey, William
    *The Humours and Diversions of Bartholomew Fair* no.**66**
*The Distrest Poet* no.72
    etching and engraving no.**71**
    oil on canvas no.**70**
dogs in works by Hogarth nos.4, 41, 57, 98, 128-31
Dorment, Richard nos.48, 51
Dryden, John nos.4, 18, 72, 111
    *The Indian Emperor* no.53
    *Marriage A-la-Mode* 141; no.73
Duncombe, Revd John no.92
Dürer, Albrecht no.132
Dutch and Flemish genre artists 26, 34; no.123
Dutch War, Third no.73

**E**
East End 18
Egerton, Judy 21; nos.88, 93
Egg, Augustus
    *Past and Present* 37
Einberg, Elizabeth 21; nos.52, 88, 90, 104, 113
*An Election* 20, 25, 27, 34, 36-7, 215-16; no.111
    *Canvassing for Votes* no.**121**
    *Chairing the Members* 214; no.**123**
    *An Election Entertainment* 215; no.**120**
    *The Polling* no.**122**
*Elegantiae Latini sermonis* no.119
English school 24
Engravers' Copyright Act (Hogarth's Act) (1735) 73
engravings 15, 28, 33, 55; no.1
    after paintings 18
    audience for 181
    boom in market for Hogarth's prints 35
    coloured ink and watercolour no.68
    convict portraiture 182; nos.95-6
    definitive portfolio 21
    French engravers 18, 142; nos.78, 82
    frontispiece for folios of nos.4, 5
    Hogarth's apprenticeship 15, 55; no.15
    Hogarth's shop card 55; no.**14**
    overseas market no.3
    penman, Hogarth as no.14
    pirated versions 73
    price 181
    print market 28, 55; no.14
    reworked nos.128-31
    serial works 73-5
    shop card for Ellis Gamble no.**15**
    subscription tickets 73; nos.64, 110; fig.22
    woodcuts after 181
Enlightenment 24
*The Enraged Musician* 119, 121; nos.60-1, 63, 69, **72**
Essex, John
    *The Dancing Master* no.5
exhibition at Society of Artists 20, 215, 216; no.111

**F**
*Falstaff Examining his Recruits* 56; no.**37**
Farinelli, Il (Carlo Broschi) nos.44, 72
*The Farthing Post* no.44
Fawkes, Isaac no.18
Fenton, Lavinia 160; nos.38-9, 88
Fermor, Lady Sophia no.53
*fêtes galantes* 26; nos.40-2, 63, 67, 76
Field, James 182; no.99

Fielding, Henry 27, 28, 35, 121; no.8
    *Amelia* no.95
    *An Apology for the Life of Mrs Shamela Andrews* no.79
    *Inquiry into the Causes of the Late Increase in Robbery* 181, 182
    *Joseph Andrews* 24, 25; no.79, 35
    *Journal of a Voyage to Lisbon* no.72
    *Tom Jones* 24, 25; no.67
Figgs, James no.65
Fish Street Hill no.97
Fishmonger's Hall no.97
Fleet Prison 15, 182; no.44
Fonmon Castle no.50
Fontenoy, Battle of 142; no.73
Foote, Samuel
    *Taste* no.117
foreign artists 16, 17
foreign taste and art forms 142, 160; nos.18-19, 44, 67, 73-8
Foundling Hospital 16, 18, 19-20; nos.84, 85, 86, 107
Fountaine, Sir Andrew 96; no.51
*The Four Stages of Cruelty* 19, 25, 181, 182; nos.95, 98, 101
    etching and engraving no.**99**
    *First Stage of Cruelty* 192, 193
    *Second Stage of Cruelty* 192, 193
    Stage 3: *Cruelty in Perfection* 193, 194
    Stage 4: *The Reward of Cruelty* 193, 194; no.101
    woodcuts after 181; no.**100**
*The Four Times of Day* 16, 25, 119, 120; nos.13, 58-9, 61
    authorised copies no.2
    etching and engraving nos.**68**; 78
    oil on canvas no.**67**
    *Evening* 130, 133, 135
    *Morning* 119, 130, 131; nos.58, 63
    *Night* 27, 130, 134, 135; no.59
    *Noon* 119, 130, 132, 135; nos.61, 63; detail 118

Fox, Henry no.56
Fox, Stephen no.56
*Frances Arnold* no.**87**
*Francis Matthew Schutz in his Bed* 215; no.**118**
Freemasonry nos.22, 56, 67
French taste and culture 142, 215; nos.67, 73-8
    Anti-Gallican League 142
    *The Invasion: France* no.**114**
    *O The Roast beef of Old England* no.112
Frith, William Powell
    *Derby Day* 33
    *Hogarth before the Commandant at Calais* 37
    *The Road to Ruin* 37
Fry, Roger 23

**G**
Gainsborough, Thomas 20, 215; nos.63, 73
Gamble, Ellis 15, 55
    shop card for no.**15**
gambling nos.44, 101
Garrick, David 34; 105
    portraits by Hogarth nos.4, 105-6, 117
Garrick, Eva Maria no.117
Gauguin, Paul 23
Gay, John 56, 121; nos.67, 70
    *Fables* no.75
    *The Beggar's Opera* 16, 182; nos.38, 53, 72, 88, 99
    *Trivia; Or, The Art of Walking the Streets of London* 120-1
genre paintings 34, 36
    Hogarth as subject of 37
*The Gentleman's Magazine* 24
George II no.98
George III no.124
*George Arnold* 160; nos.3, 85, **86**
Géricault, Théodore 36
Gillray, James 35
    *Sin, Death, and the Devil* 35; fig.11
Gilpin, William 13-14
Gin Act (1751) no.98
'gin epidemic' 181; nos.98, 113
*Gin Lane* 14, 15, 19, 27, 37, 181, 182; nos.**98**, 99
    detail 180
'Glorious Revolution' 24, 26; no.73
Gonson, Justice John 74; no.43
*The Good Samaritan* 17; no.102; fig.3
Gormagons nos.22
Gowing, Lawrence 21
*The Graham Children* 18, 160; nos.**93**, 94
Graham, Daniel no.93
Graham, Lord George no.57
Grand Manner style 34
Gravelot, Hubert-François
    frontispiece to Dryden's *Marriage A-la-Mode* no.**73**
    illustrations to Richardson's *Pamela* 142; nos.79, 82
Greuze, Jean-Baptiste 29, 34
    *Les fils ingrat* 29; fig.8

*Les fils puni* 29; fig.9
*Le malheur imprévu* 34
Grignion, Charles no.105
Grosvenor, Sir Richard 20; no.111
*The Grub Street Journal* nos.70-1
Grub-Street journalism 119
Guardi, Francesco 33
Guildhall nos.14, 15
Guillain, Simon no.60
*Gulielmus Hogarth* no.**128**
Gwyn, Nell 75

**H**
Habermas, Jürgen 25
Halifax, Lord 25
Hallett, Mark 25
Halley, Sir Edmund no.85
Hamilton, Gawen 96
    *A Conversation of Virtuosis* no.1
Handel, George Frideric 88; nos.2, 45, 72
    *Messiah* no.72
'The Happy Marriage' no.82
    *The Dance (The Country Dance)* 14; no.**81**
    *The Staymaker (The Fitting of the Ball Gown)* no.**80**
*A Harlot's Progress* 16, 25, 28-9, 55, 73-4, 75, 119, 141, 182; nos.3, 40, **43**, 44, 69, 74, 82, 118
    literary and theatrical responses 73
    pirated versions 73
    subscription ticket 73; fig.22
Haydon, Benjamin Robert
    *Chairing the Member* 37
    *The Mock Election* 37
Hayman, Francis 19, 112; no.2
    illustrations to Richardson's *Pamela* no.79
    *Self-Portrait* no.8
Hays, Catherine no.95
*Heads of Six of Hogarth's Servants* 25, 215; no.**116**
    detail 22
Heemskerk, Egbert van, II 26
Heidegger, John James nos.18, 27
Herring, Thomas, Archbishop of Canterbury 160; no.92
*The Hervey Conversation Piece* 27; no.**56**
Hervey of Ickworth, John, Baron no.56
Highmore, Joseph 19
    *Pamela Asks Sir Jacob Swinford's Blessing* no.**83**
    *Pamela in the Bedroom with Mrs Jewkes and Mr B.* no.**82**
    *Pamela Greets her father* no.82
    *Pamela* illustrations no.77
    portraits 159
history painting 15, 17, 19-20, 25, 159-60, 172, 197-8; nos.1, 105, 107-11, 128
Hoadly, Benjamin Bishop of Winchester 160; no.91
Hoadly, John 215; nos.117, 132
Hockney, David 37
    *A Rake's Progress* nos.**9-11**; figs.20, 21
    *Kerby (after Hogarth) Useful Knowledge* no.11
Hog lane no.67-8
Hogarth, Anne (mother) 15
Hogarth, Anne (sister) 15, 16
Hogarth, Jane (wife) 16, 21
Hogarth, Mary (sister) 15, 16
*Hogarth Painting the Comic Muse* nos.1, **8**
Hogarth, Richard (father) 15, 182
Hogarth, William
    apprenticeship 15, 55; no.15
    birth and childhood 15
    character 20
    death 21; no.134
    financial success 16, 17, 18
    marriage 16
    Serjeant Painter to the King 20; nos.8, 124
    as teacher 17
'Hogarthomania' 35
Holborn nos.99-100
Hopkins, Thomas 25
Horace no.118
    *Epistles* no.52
hospitals as sponsors and venues 17, 19-20, 197; no.107
Howson, Peter
    *A night that never ends* no.9; fig.19
*Hudibras* nos.11, **28-34**, 37
*Hudibras*
    *Burning ye Rumps at Temple-Barr* nos.**31-4**
    *The Committee* no.37
    frontispiece no.**28**
    *Hudibras's First Adventure* no.29
Hudson, Thomas 159, 160
Huguenots no.67
*The Humours of a Country Election* no.120; fig.41
Hunt, William Holman
    *The Awakening Conscience* 37; fig.14

**I**

Industry and Idleness 18–19, 25, 27, 29, 37, 119, 121, 181–2; nos.80, 95, **97**, 98
  Plate 1: *The Fellow 'Prentices at their Looms* 184–5
  Plate 2: *The Industrious 'Prentice performing the Duty of a Christian* 185
  Plate 3: *The Idle 'Prentice at Play in the Church Yard during Divine Service* 185
  Plate 4: *The Industrious 'Prentice a Favourite, and entrusted by his Master* 185, 186, 187
  Plate 5: *The Idle 'Prentice turn'd away and sent to Sea* 185, 186, 187
  Plate 6: *The Industrious 'Prentice out of his time, Married to his Master's Daughter* 186, 187
  Plate 7: *The Idle 'Prentice return's from Sea, & in a Garret …* 186, 187
  Plate 8: *The Industrious 'Prentice grown rich & Sheriff of London* 186, 187–8
  Plate 9: *The Idle 'Prentice betray'd by his Whore …* 186, 187–8
  Plate 10: *The Industrious 'Prentice Alderman of London …* 187, 188
  Plate 11: *The Idle 'Prentice Executed at Tyburn* 188–9
  Plate 12: *The Industrious 'Prentice Lord Mayor of London* 188–9
Insolvent Debtors Bill (1712) 15
*The Invasion* 215
  Plate 1: *France* no.**114**
  Plate 2: *England* no.**115**
Islington 119; nos.67–8
Italian art, music and architecture 142; nos.18–19, 44, 51, 72, 74

**J**

Jacobitism 142; nos.59, 67, 73, 110, 112, 113, 127
James II no.73
*John Wilkes Esq.* 216; nos.**126**, 128
Johns, Richard no.108
Johnson, Samuel 15
*The Jones Family* no.**50**
Jones, Squire Robert no.50
Jones, William no.85

**K**

Kallman, Chester
  *The Rake's Progress* (libretto) no.11
Kelly, John
  *Pamela's Conduct in High Life* no.79
Kent, William 24; nos.1, 18
Kildare, Elizabeth, Countess of 75
King, Dr William no.110
Kit-Cat Club 25
  portraits 25; no.1; fig.17
Kneller, Godfrey nos.60, 84
  *Joseph Addison* no.1; fig.17
  Kit-Cat Club portraits 25; no.1; fig.17

**L**

Laing, Alistair no.56
Lamb, Charles 28
Lancret, Nicolas no.40
  *Les Heures du Jour* (*The Four Times of the Day*) 149; nos.67, 77; fig.31
  *Seasons* no.67
landscape garden, English 24, 28; no.51
Laroon (Lauron), Marcellus 26
  *The Cryes of the City of London Drawne after the Life* 121; nos.**60**, 65, 72; fig.30
*The Laughing Audience (or A Pleased Audience)* nos.**64** 65
*Lavinia Fenton, Duchess of Bolton* 160; no.**88**
Le Brun, Charles
  *Alexander before the Tent of Darius* nos.105, 123
Le Sueur, Hubert
  *Charles I* nos.59, 67
Leicester Fields (Leicester Square) 16, 21; no.58
Lely, Sir Peter no.90
  *Elizabeth, Countess of Kildare* 75; fig.24
Lempster, Lord no.53
Lennox, Lady Catherine no.53
Leonardo da Vinci
  *The Last Supper* no.101
*levée* no.44
liberty, individual 24–5
Licensing Act (1695) 24
Licensing Act (1737) no.69
Lightbourn, R.W. no.3
Lillo, George
  *The London Merchant; or The History of George Barnwell* 181–2
Lincoln's Inn 20; no.108; fig.39
the line of beauty 13, 29; nos.5, 8, 81
literature
  Hogarth's links with 28, 33; nos.1, 4, 67, 70
  novels 24, 25, 28
Locke, John 24, 25

Lomazzo, Gian Paolo no.5
London 15, 18, 119–21
  Cries genre 121; nos.60–2
  poverty and overcrowding 181
  *see also* individual place names
London bridge 18
*The London Spy* journal 119–20, 121; no.70
Lord Mayor's procession 119; no.97
*The Lottery*
  study for no.**21**
*The Lottery* no.**20**
Lovat, Simon, Lord no.127

**M**

Macclesfield, George Parker, 2nd Earl nos.85, 104
*The Mackinen Children* 160; no.**94**
Macleane, James 182
Malcolm, Sarah 182; no.95
Malone, Edmund 35
Malpas, George Cholmondeley, Viscount no.52
Manchester Art Treasures exhibition (1857) 36
Mandeville, Bernard
  *An Enquiry into the Causes of the Frequent Executions at Tyburn* no.97
Manningham, Sir Richard no.25
*The March to Finchley* 20, 27, 36, 121, 215; no.**113**, 114
Marlborough, Charles Spencer, 3rd Duke no.56
*Marriage A-la-Mode* 18, 19, 25, 27, 28–9, 37, 141–2, 160, 181, 215; nos.3, 12, 67, 76, 118
  etching and engraving 142; no.**78**; fig.4
  'The Happy marriage' series no.80–1
  oil on canvas 36, 140; nos.**77**, 82
  Scene 1: *The Marriage Settlement* 27, 29, 142, 146–7; nos.12, 74
  Scene 2: *The Tête à Tête* 27, 147–8; no.84
  Scene 3: *The Inspection* 148–9
  Scene 4: *The Toilette* 12, 18, 148, 149–50; nos.12, 74, 80–1; fig.4
  Scene 5: *The Bagnio* 150–2; nos.12, 81
  Scene 6: *The Lady's Death* 140, 142, 151, 152, 182; nos.79, 80
*Mary Blackwood, Mrs Desaguliers* no.**90**
Marylebone Old Church no.44
*Masquerade Ticket* no.**27**
masquerades 142; nos.18, 27, 43, 77
Medina, Sir John no.103
Mercier, Philip 26
Methodism nos.132–3
Middleton, Sir Hugh no.67
*A Midnight Modern Conversation* 27; nos.**49**, 57
Millais, John Everett
  *Married for Rank, Married for Money* and *Married for Love* 37
Milton, John no.72
  *Paradise Lost* 17, 35; nos.4, 103
Misaubin, Dr Jean no.43
Mitchell, Joseph
  'Poetical Epistles' 55
modern moral subjects 16, 24, 35, 73–5
modernity, English tradition 23–5
Molière 33
Montagu, Duke of no.53
The Monument nos.15, 97
Morell, Dr Thomas no.5
*Moses Brought To Pharaoh's Daughter* (engraving) no.107
*Moses Brought To Pharaoh's Daughter* (oil on canvas) 14, 19–20; no.**107**
Mosley, Charles 121
*Mr. Garrick in the Character of Richard the 3rd* (etching and engraving) no.**106**
*Mrs Salter* 37; no.**89**, 90
  detail 158
multi-focal compositions 33
Murder Act (1752) 182
Murillo, Bartolomé Esteban
  *Self-Portrait* no.4; fig.18
Murray, Revd T.B.
  *The Two Apprentices …* 37
*The Mystery of Masonry Brought to Light by ye Gormagons* nos.**22**, 26

**N**

narrative in Hogarth's work 28–9
National Gallery collection 36
Nebot, Balthazar 121
  *Covent Garden Market* nos.**58**, 59
Needham, Elizabeth 'Mother' 74; no.43
Newgate Prison 182; nos.95, 97, 99
Newton, Isaac 24, 25; nos.1, 53, 85
Nicholls, Joseph 121
  *A View of Charing Cross and Northumberland House* no.**59**
Nichols, John no.24
Nivelon, Francis
  *The Rudiments of Genteel Behaviour* no.5
Northumberland House no.59

**O**

*O The Roast Beef of Old England* ('The Gate of Calais') 37, 215; nos.**112**, 113, 114
Oak-Apple Day no.67
oriental decorative arts 142; nos.74, 76, 77
Otway, Thomas no.18
Overton, Philip no.28

**P**

*The Painter and his Pug* no.81
  engraving nos.4, 5, 128
  oil on canvas nos.1, 3, **4**, 8
  paintings 15, 33, 37, 55–6; no.1
    Hogarth's training 15–16
    oil sketch no.63
    portraits *see* portraiture
Paris no.112
patriotism 18, 20, 215; nos.112–15
patrons 20, 96; nos.104, 111
  hospitals as sponsors and venues 197
  portraiture 160
*Paul before Felix*
  etching and engraving no.**108**
  etching and engraving (Sullivan after Hogarth) nos.107, **109**
  oil on canvas 20; no.108; fig.39
  subscription ticket (*Paul before Felix [Burlesqued]*) no.110
*Paul before Felix [Burlesqued]* no.**110**
Paulson, Ronald 21; nos.56, 94, 103, 127
Pennington, Harper 37
Pepys, Samuel nos.59, 60
*A Performance of 'The Indian Emperor or The Conquest of Mexico by the Spaniards* nos.**53**, 54
periodicals 24, 25, 28; 119–20, 121; no.70
Phillips, Charles 96
Picart, Bernard
  *A Monument Dedicated to Posterity* nos.17, 22
Piles, Roger de no.5
*Piquet: or Virtue in Danger (The Lady's Last Stake)* 215; nos.**84**, 111
Pitt, William (Pitt the Elder) 20; no.124, 126
Plumptre, Archdeacon C. no.55
Pò, Anna-Maria Strada del no.44
politeness, concept of 26–7, 95–6, 119; no.48–50, 54
political subjects 20–1, 215–16; nos.112–15, 120–5, 128
Pomfret, Earl of no.53
*The Pool of Bethesda* 17; fig.38
  study for no.**102**
Pop art no.9
Pope, Alexander 27; nos.2, 56
  *The Dunciad* nos.70–1
  *The Dunciad Variorum* no.72
  *The New Dunciad* no.72
Porpora, Niccola no.44
portraiture 15, 17–18, 25, 159–60, 197–8, 215; nos.116–17
  convict portraiture 182; nos.95–6
  drapery specialists 159
  informal dress nos.2, 4, 8
  lay-man 159
  *les talons rouges* nos.76, 77
Portsmouth, Louise de Kéroualle, Duchess of 75
Poussin, Nicolas no.105
Powell, Jonathan no.54
Prévost, Antoine François
  *Manon Lescaut* no.77
Price, Captain William no.51
prints *see* engravings
prisons
  Bridewell 182; no.43
  Fleet 15, 182; no.44
  Newgate 182; nos.95, 97, 99
prostitution 74, 119, 141; nos.43, 44, 63, 69, 97, 113
Protestantism 24
Pulteney, William 25
*The Punishment inflicted on Lemuel Gulliver …* nos.4, **26**, 27

**R**

*The Rake Reform'd* 74
*A Rake's Progress* 16, 25, 28–9, 73, 74–5, 141; nos.9–11, 13, 40, 65, 72, 74
  etching and engraving nos.3, **45–6**, 78
  oil on canvas 36, 72; no.**44**
  Scene 1: *The Rake Taking Possession of his Estate* 86
  Scene 2: *The Rake's Levée* 86–8, 89, 90; no.77
  Scene 3: *The Rake at the Rose Tavern* 72, 88–9
  Scene 4: *The Rake Arrested, Going to Court* 89–91, 92, 119; no.61; fig.27
  Scene 5: *The Rake Marrying an Old Woman* 90, 91–2
  Scene 6: *The Rake at the Gambling House* 91–2
  Scene 7: *The Rake in Prison* 92–3, 182
  Scene 8: *The Rake in Bedlam* 93, 119
  subscription ticket no.64
*The Rake's Progress, or Templar's Exit* 74; fig.23

Ramsay, Allan 159; no.90
Raphael no.132
    Cartoons no.108
Ravenet, Simon François
    Marriage A-la-Mode engravings no.78
Rawlings, Nan no.101
realism 24
Rego, Paula 37
    Abortion Series no.12
    The Betrothal: Lessons: The Shipwreck, after 'Marriage
    a la Mode' by Hogarth no.12
Rembrandt van Rijn nos.110, 132
    The Artist in his Studio no.8
Restout, Jean no.73
Reynolds, Sir Joshua 35, 197–8, 215; nos.63, 117
    Discourses 34
Ribeiro, Aileen no.3
Rich, John 16; nos.1, 18, 38, 44
Richardson, Jonathan
    Essay on the Theory of Painting 26; no.92
    Explanatory Notes on Paradise Lost no.103
    on portraiture and history painting 159–60
    Two Discourses no.5
Richardson, Samuel 27, 28
    Clarissa 24
    Pamela: or, Virtue Rewarded 24, 141–2; nos.77, **79**, 82–3
Richmond, Duke and Duchess of no.53
Rochester, John Wilmot, 2nd Earl 75; no.40
Rock, Dr Richard nos.43, 67
Rococo style 142; nos.73, 76, 77
Rogers, Captain Woodes no.47
Roman Catholicism 24; nos.112, 113, 114, 132–3
Roubiliac, Louis-François no.3
    William Hogarth no.2
Rouquet, Jean André nos.73, 89
    The Present State of the Arts in England 159; no.3
    William Hogarth (attributed) no.**3**
Royal Academy 34, 35
Royal Cockpit no.101
Royal Society 24; no.85
Royalty, Episcopacy and Law no.**24**

S
Sacheverell, Dr no.43
Sadler's Wells no.67
St André, Nathaniel no.25
St Bartholomew's Hospital 17, 172; nos.1, 97, 102
St George's, Bloomsbury no.98
St Giles see St Giles-in-the-Fields
St Giles-in-the-Fields nos.67–8, 98, 99
St James's Palace 119
St Martin-in-the-Fields 119; nos.72, 98
St Martin's Lane 15
St Martin's Lane Academy 15–16, 17, 20, 56, 159; nos.1, 2, 5, 73
St Paul's Cathedral nos.5, 15, 61, 108; fig.40
St Paul's, Covent Garden nos.58, 67–8
Salter, Elizabeth no.89
Salter, Revd Samuel no.89
Sandby, Paul
    The Analyst Besh[itte]n in his own Taste 20; no.**7**
    London Cries: 'Last Dying Speech and Confession' 182; fig.36
    London Cries: 'Rare Mackarel Three a Groat Or Four
    for Sixpence' nos.61, 63; fig.29
Sandwich, John Montagu, 4th Earl no.119
Sarah Malcolm 182; no.**95**
Satan, Sin and Death (A Scene from Milton's 'Paradise Lost') 35;
    nos.4, **103**, 104
Satire on a False Perspective no.11
satirist, Hogarth as 15, 33, 34–5, 55, 56, 119, 198, 215; nos.1, 4, 84,
    128
A Scene from 'The Tempest' no.**104**
Schutz, Francis Matthew no.118
Scotin, Gérard Jean-Baptiste nos.45–6, 78
    Marriage A-la-Mode engravings no.78
Self-Portrait with Palette no.1
self-portraits nos.1, 4, 8, 112, 134
Senesino, Il (Francesco Bernardi) nos.19, 44, 72
serial works 16, 18–19, 25, 28–9, 73–5; no.67
servants, depictions of nos.54, 55, 116
    black servants 142; nos.74, 77, 104
Seven Years War 215; nos.114–15, 124
Shaftesbury, Anthony Ashley-Cooper 3rd Earl no.5
Shakespeare, William 56; nos.4, 18, 65
    Antony and Cleopatra no.4
    Henry IV, Part 2 no.37
    Richard III nos.4, 105
    The Tempest 17; no.104
    The Tragedy of Richard III nos.105–6
Sheppard, Jack 182; no.96
Shonibare, Yinka 37
    Diary of a Victorian Dandy no.**13**
    The Swing (after Fragonard) no.13

shop cards
    Ellis Gamble's no.**15**
    Hogarth's no.**14**
The Shrimp Girl 33, 37; no.**63**
    detail 32
Sickert, Walter
    The Camden Town Murder 23; fig.6
Sigismunda Mourning over the Heart of Guiscardo 20, 198, 215;
    nos.**111**, 132
Simon, Lord Lovat no.**127**
singerie nos.74–5
Sir Francis Dashwood at his Devotions 215; no.**119**
The Sleeping Congregation no.132; fig.43
Smithfield Market 15
Smyth, Dr Arthur no.54
Soane, Sir John
    collection 36
Society of Artists 20, 215, 216; no.111
Soho 119; nos.67–8
Soldi, Andrea
    Edmund Gibson, Bishop of London no.92; fig.35
Solkin, David 21, 25, 26, 95
Somers, Lord 25
South Sea Bubble 55; nos.16, 18, 20, 22, 24
The South Sea Scheme 55; nos.**16**, 18, 20
Southwark Fair (or The Humours of a Fair) 27–8, 36, 120, 121;
    nos.5, 60, 63, **65**, 69
    subscription ticket no.64
The Spectator journal 24, 25; no.70
Spitalfields no.97
Steele, Richard 28; nos.1, 70
Steen, Jan no.123
Sterne, Laurence
    Tristram Shandy 25
Strand 15
Stravinsky, Igor
    The Rake's Progress no.11
Strode, Colonel Samuel no.54
The Strode Family 27; nos.**54**, 55, 56, 87
    detail 94
Strode, William 96; no.54
Strolling Actresses Dressing in a Barn 119, 120; nos.63, **69**
Stuart dynasty 24; nos.59, 67, 73, 113
Suarez, Michael no.4
The Sublime Society of Beefsteaks no.1
Sullivan, Luke nos.107, 109
Surgeons, Company of 182; no.99
Swift, Jonathan 120–1; nos.4, 67
    'Description of a City Shower' 120
    'Description of the Morning' 120
    A Tale of a Tub no.4
    Travels into Several Remote Nations of the World
    (Gulliver's Travels) nos.4, 26
Sympson, Joseph, Jr.
    The Christening (after Hogarth) no.35
    The Denunciation (after Hogarth) no.35
syphilis 74, 141, 142; nos.43, 67, 69, 77

T
tableaux de mode nos.40–2, 67, 76
Tail Piece or The Bathos 126; no.**134**
les talons rouges nos.76, 77
Taperell, John
    'The Art of Conversation' no.50
Taste in High Life no.67, 74, **76**
The Tatler journal 24, 25; no.70
Taylor, George no.99
Tempest, Pierce no.60
Teniers, David, the Younger no.74
theatre
    Hogarth's links with 16, 33, 56, 181–2; nos.1, 4, 37–9, 73
    Licensing Act (1737) no.69
    Sadler's Wells no.67
Thomas Herring, Archbishop of Canterbury 18, 160; no.**92**
    detail 161
Thornhill, James 16, 17; no.8
    Jack Sheppard 182; no.**96**
    Paul before King Agrippa fig.40
    Portrait of Christopher Wren no.84; fig.34
Thornhill, Jane see Hogarth, Jane
Thornhill, John no.8
The Times 20, 216
    Plate 1 nos.**124**, 126, 128
    Plate 2 nos.**125**, 126
Tofts, Mary nos.25, 133
toilette nos.77–8
Tonson, Jacob nos.1, 4
Tories 216; nos.120–3
Tottenham Court Turnpike no.113
Troy, Jean-François de no.40
    After the Ball no.76
    Before the Ball no.76

The Declaration of Love 142; no.**76**
The Game of Pied-de-Boeuf no.76
The Rendezvous at the Fountain no.76
Truchy, Louis no.82
Trump nos.4, 128–31
Trusler, John
    Hogarth Moralised 21
Tyburn 119, 182; nos.77, 97
Tyers, Jonathan no.2

U
Uffenbach, Zacharias Conrad von no.60
Uglow, Jenny no.8
unity of action, concept of 28
urban scenes 119–21, 198; nos.63–72

V
van Aken, Joseph 26; no.58
Van Dyck, Anthony 25, 159; nos.1, 69, 90, 94
    portrait of Archbishop Laud no.92
    Rachel, Countess of Southampton, as Fortune no.69
Van Gogh, Vincent 23
Van Loo, Jean-Baptiste 159, 160
Vanburgh, John 25
    The Relapse, or Virtue in Danger 74
Vanderbank, John 16
Vandergucht, Gerard
    Don Quixote Takes the Puppets to be Turks and Attacks them
    to Rescue Two Flying Lovers (after Coypel) no.**23**
Vauxhall Gardens no.2
Veil, Sir Thomas de no.67
venereal disease see syphilis
Vernet, Claude-Joseph
    Four Times of Day no.67
Verrio, Antonio no.84
Vertue, George 13, 26, 73, 95, 96; nos.1, 2, 35, 105
Voltaire 25; no.4

W
Wagner, Josef
    Golden Pippins (after Amiconi) nos.**61**, 63
    Shoe-Black (after Amiconi) nos.**62**, 63
Wales, Frederick, Prince of no.56
Walpole, Horace 34, 198; no.56
    Anecdotes on Painting in England 33
Walpole, Sir Robert 25; nos.26, 56, 69
Wanstead House no.48
War of the Austrian Succession no.112
Ward, Edward Matthew
    Portrait of Thomas Coram in Hogarth's Studio 37; fig.15
Ward, Edward 'Ned' 121
    A Walk to Islington 119
    The London Spy 119–20, 121; no.70
    The Merry Travellers 119
    The Poet's Ramble after Riches no.70
Ware, Isaac no.2
Watteau, Antoine 26; nos.40, 74, 76
Webster, Mary 21; nos.47, 84, 91, 93
Wendorf, Richard no.94
West End 15, 16, 18
The Western Family no.**55**
Western, Thomas no.55
Wharton, Duke of nos.22
Wheatley, Francis no.63
Whigs 25, 216; nos.26, 120–3
Whistler, James McNeill 33, 37
    The Chelsea Girl 33
    Wapping 33; fig.10
Whites' gambling house no.44
Whittington, Richard 'Dick' 182; no.97
wigs no.3
Wilkes, John 20–1, 216; nos.124, 126, 128
    The North Briton no.126
Wilkie, David 36
    Chelsea Pensioners Reading the Waterloo Dispatch 33, 36
    The Village Holiday 36; fig.13
William III of Orange (King William III from 1689) 26; no.73
William Jones nos.**85**, 86
Wills, John 19
Winnington, Thomas no.56
Wollaston, William 96; fig.7
The Wollaston Family 26; fig.7
Woodes Rogers and his Family no.**47**
Wootton, John
    The Monkey Who had Seen the World no.**75**
Wren, Sir Christopher
    Sheldonian portrait no.84; fig.34